GERMANY 1918-1933
SOCIALISM OR BARBARISM

ROB SEWELL

Wellred Books
London

Germany 1918-1933: Socialism or Barbarism
Rob Sewell

First edition
Wellred Books, 2018

UK distribution: Wellred Books, wellredbooks.net
PO Box 50525
London
E14 6WG
books@wellredbooks.net

USA distribution: Marxist Books, marxistbooks.com
WR Books
250 44th Street #208
Brooklyn
New York
NY 11232
wrbooks17@gmail.com

DK distribution: Forlaget Marx, forlagetmarx.dk
Degnestavnen 19, st. tv.
2400 København NV
forlag@forlagetmarx.dk

Cover design by Benjamin Curry.

Layout by Jack Halinski-Fitzpatrick.

All images used are from the David King Collection. Purchased from
David King by Tate Archive 2016, or from the public domain.

Printed by Huella Digital, Zaragoza, Spain

ISBN: 978 1 900 007 95 5

"Bourgeois society stands at the crossroads, either as a transition to Socialism or regression into Barbarism." (Rosa Luxemburg, *The Junius Pamphlet*, 1916.)

CONTENTS

PREFACE

> There was once a nanny-goat who said,
> In my cradle someone sang to me:
> "A strong man is coming.
> He will set you free!"
>
> The ox looked at her askance.
> Then turning to the pig
> He said:
> "That will be the butcher."
>
> Bertolt Brecht

Behind Bertolt Brecht's humour is always a serious point. The words are a swipe at the fascist propaganda, which attempted to reassure the middle classes while their throats were being cut. Brecht is not interested in lulling people to sleep, but wishes to awaken them. The task of this book is also to awaken an interest – in the German Revolution and its aftermath – and provide an understanding of what went on.

Old Hegel, the great German philosopher, once commented that the only thing you learn from history is that people do not learn from history. This could be the reason why history tends to repeat itself, first as a tragedy, then as a farce, to quote Marx. But our task is precisely to learn from history.

Bourgeois historians say there are no laws governing history. But that is not the case. There is causality in history, and it is our task to uncover its laws. Marx and Engels explained that societies, as with nature, evolve according to material laws, meaning that societies are not eternal, but arise, develop, and enter into crisis. Our fate is not determined. Men and women make history,

but under conditions not of their own choosing. It is through experience that they learn and begin to take destiny into their own hands.

History deals with real relationships, rather than simply the high-sounding dramas of princes and states. And Marxism allows us to get our bearings, to navigate our way and make sense of the labyrinth of events.

As Marx explained, "philosophers have only interpreted the world in various ways. The point, however, is to change it." (K. Marx, *Theses on Feuerbach.*) The author of this book belongs to the school of historical materialism. He approaches the German Revolution as a revolutionary, and sees no reason to conceal it. This allows him to lay bare the dynamics of the revolution, in which is reflected the movement of the masses, the rise and fall of parties, and the struggle between the classes.

Revolutions, like earthquakes, are rare occurrences. They arise from deep crises within society, where class contradictions have been strained to breaking point. We are living in a similar epoch today. The capitalist system worldwide is in an impasse and is preparing revolutionary explosions. For those who want to 'make history', there is no better preparation than to study revolutions and, above all, to learn the lessons. The 1918 German Revolution is a good place to start.

This book does not claim any spurious objectivity. It draws on the legacy of Marxism, especially its great teachers, who directly experienced and analysed these events. In that sense it cannot lay claim to 'originality'. The early Congresses of the Communist International were a school, where all the main theoretical and tactical questions were thrashed out, with the direct participation of Lenin and Trotsky. In the face of persecution, Trotsky rescued all that was best from this astonishing period and went on to analyse the rise of fascism in the early 1930s, attempting to reach the ranks of the Communist workers.

He once wrote that, such was the heroism of the Spanish proletariat between 1931 and 1937, they could have carried out ten revolutions. The same could be said of the German proletariat between 1918 and 1923, but more so. Here we experience a roller coaster ride of workers' and soldiers' councils, mutinies, general strikes, uprisings, red armies, soviet republics, coups and class battles on an unprecedented scale.

The German revolution of 1918 placed power into the hands of the working class, but they lost it. The German proletariat had more chances to take power than any other in the world. Its failure to do so lead to the most ghastly and brutal of fascist reactions. This was nothing to do with the will or determination of the working class to fight, which was exemplary, but the criminal role of its leaders.

While some will be familiar with the facts of the 1918 November Revolution in Germany, few would be as familiar with the events of 1919 and later. 1919 was an apocalyptic year for capitalism. While the November Revolution was defeated, in 1919 the proletariat controlled swathes of Germany in heroic battles with the Freikorps and Reichswehr. Apart from fighting in Berlin, in the famous 'Spartacist week', there were street battles in most industrial districts; the Saxony Communists controlled part of the region in April 1919, fighting solidly for nine days; in Bavaria, the struggle lasted for two months, where Kurt Eisner, then Leviné, set up a Soviet Republic, but was overthrown by the Freikorps; there were revolts in Oldenburg and East Frisa; while Workers' and Soldiers' Councils in Rhine-Hesse, Oberhessen, the Palatinate, Hesse-Nassau, and Württemberg decided to break away and form a Hessian Soviet Republic. In March and April 1920, a regional Red Army conquered the Ruhr and drove out the government forces. A solid general strike defeated the Kapp Putsch in 1920 and the German workers could easily have taken power. In March 1921, there was an uprising in Hamburg. 1923 was another pinnacle, the year of revolutionary struggles and missed opportunities. The history of Germany, especially between 1918 and 1933, contains the richest of lessons, probably of any country in the world.

Since the time of Marx, the German labour movement had so many advantages. Friedrich Engels wrote that:

> The German workers have for the moment been placed in the vanguard of the proletarian struggle. How long events will allow them to occupy this post of honour cannot be foretold. But let us hope that as long as they occupy it, they will fill it fittingly.

Engels stressed the need to treat socialism as a science, which must be studied. If the German workers progressed in this way, he explained:

> [T]hey will occupy an honourable place in the battle line; and they will stand armed for battle when either unexpectedly grave trials or momentous events demand of them increased courage, increased determination and energy. (K. Marx and F. Engels, *Collected Works*,[1] pp. 631-632.)

Tragically, the leaders of German Social Democracy, supposedly the heirs of Marx and Engels, faced with voting for war credits in August 1914, capitulated and the banner of international socialism was soiled.

Although the British working class is the oldest in the world, it never reached the heights of the German movement in terms of theory or organisation. The British revolutionary traditions pale in comparison.

1 Henceforth referred to as MECW.

Germany stands out as displaying the greatest potential for success, but also displaying the greatest tragedy. After all, the German Social Democracy was the strongest in the world. It was prized by all. Similarly, the German Communist Party was once the most powerful in the world, outside of the Soviet Union. And yet, the working class was crushed under the iron heel of fascism.

If it demonstrates anything, it surely demonstrates the importance of ideas. You can have the strongest organisation in the world, but without correct ideas you will lose. Mass organisations, with a mighty apparatus, have been reduced to dust. Correct ideas alone are also not enough; they need organisation. Ideas without organisation are like a knife without a blade. One must go hand in hand with the other, although the correct ideas must be the foundation.

Deservedly so, the Russian Revolution, the greatest event in history, has been the centre of attention and study for Marxists. The Bolsheviks, under Lenin and Trotsky, showed in practice how the working class could succeed in taking power and hold onto it. Rightfully, this is why we have examined the rich heritage of Bolshevism. Nevertheless, it would be no exaggeration to say that the defeat of the German Revolution of 1923 was as significant an event in the negative sense as the victory of the Russian Revolution of October 1917 was in the positive.

In many ways, however, the German Revolution has tended to be neglected. Much less attention has been paid to it than ought to be the case. The reason is probably to do with the fact that there is very little literature by comparison in the English language about this subject. Pierre Broué's magnificent book provided a valuable contribution when it was released in English in 2006.

Unfortunately, the book ends in 1923. Trotsky's writings on Germany between 1931 and 1933 are also invaluable and are available online. For the most part, the history of the period is scattered across different sources, many of the best in the German language, and therefore here we have one of the reasons for the present book.

This book is not for pessimists. History is littered with failures and defeats. It did not have to be like that. The defeat of the German Revolution and the victory of fascism were by no means inevitable. Had the German Revolution succeeded, the entire course of subsequent world history would have been different. But that did not happen.

If we want to be successful, then we need to prepare ourselves, and consciously strive to build the forces nationally and internationally that can change the course of history. The work in building up such an International

has been systematically undertaken today by the International Marxist Tendency (IMT), which has loyally kept the ideas of genuine Marxism alive throughout these years. The IMT, which bases itself on the genuine traditions of Trotsky's Fourth International, now operates in almost forty countries and on every continent.

The task of changing society falls to the new generation, which, first and foremost, has to prepare itself for the stormy events that confront us. This book is a modest contribution to this endeavour, as well as preserving a part of our revolutionary heritage.

The author first heard about the German Revolution from Ted Grant, who maintained the flame of genuine Marxism alive in the most difficult years. The author was proud to have known and worked with him. His 'The Menace of Fascism', written in 1948, will remain a classic.

This book would not have been possible but for the help and encouragement of a number of people. In particular, thanks are due to Alan Woods, who first suggested the idea of a book; Fred Weston for carefully going over the text; Hans-Gerd Öfinger and Marie Frederiksen for their valuable suggestions and comments; to Sue Norris and Aaron Kyereh-Mireku for proofreading; to Steve Jones for the glossary; and Jack Halinski-Fitzpatrick for laying out and seeing the final draft through to publication.

INTRODUCTION

> In this hour, socialism is humankind's only saviour. Above the collapsing walls of capitalist society, we can see the words of the *Communist Manifesto* blazing like a fiery writing on the wall: 'Socialism or demise into barbarism!'
>
> Rosa Luxemburg, 'What Does the Spartacus League Want?'

OPENING DRAMA

In the years following the blood-soaked carnage of the First World War, a spectre stalked Europe, the spectre of Bolshevism. But try as they may, the ruling classes could not exorcise it. To their dismay, like Banquo's ghost at the banquet, it cast an eerie shadow over their proceedings.

Lloyd George remarked to the French Premier Clemenceau in March 1919:

> The whole of Europe is filled with the spirit of revolution…
>
> The whole existing order in its political, social and economic aspects is questioned by the mass of the population from one end of Europe to the other. (Quoted in E.H. Carr, *The Bolshevik Revolution*, vol. 3, p. 136.)[1]

1 Lloyd George went on to stress: "If Germany goes over to the Spartacists it is inevitable that she should throw in her lot with the Russian Bolsheviks. Once that happens all Eastern Europe will be swept into the orbit of Bolshevik revolution, and within a year we may witness the spectacle of 300 million people organised into a vast Red Army under German instructors and German generals, equipped with German cannon and German machine guns… The news which came from Hungary yesterday shows that this is no mere fantasy." (Quoted in A. Read, *The World on Fire*, p. 160.)

This fear of Bolshevism was not isolated and even stretched across the Atlantic. The American President Woodrow Wilson, again in March 1919, echoed the threat: "We are running a race with Bolshevism, and the world is on fire." (Quoted in A. Read, *The World on Fire: 1919 and the Battle with Bolshevism*, p. 160.) The flames were lapping at their heels, threatening to consume them. "Every day the situation grows worse, until many people are ready to declare that the United States will be the next victim of this dangerous malady," wrote the *New York Times*. (ibid., p. 51.)

A few years later, the Bolshevik leader, Leon Trotsky, concurred with their 'ungodly' fears. "Those were the days of panic, the days of a truly insane fear of Bolshevism, which then loomed as an extremely misty and therefore terrifying apparition." (L. Trotsky, *The First Five Years of the Communist International*, vol. 1, p. 176.)

For the bourgeois representatives, the apparition was real enough, and the world was truly ablaze. Monarchies were reduced to ashes, consumed in the revolutionary inferno following the Bolshevik Revolution of October 1917, and the German Revolution of November 1918. The flames of revolution were sweeping away everything in their path and transforming the course of European and world history. Not one stone upon another would remain of the old Empires.

We should begin by dispelling a myth, however. It was not the Generals and Admirals who put an end to the slaughter and bloodshed of the First World War – in which more than 17 million lost their lives and more than twice that number were wounded, gassed and maimed – but the revolutionary uprising of the heroic soldiers, sailors and workers of Germany. The General Staffs on both sides were quite prepared to continue the war to the last drop of someone else's blood. The real unsung heroes – the revolutionary masses – are not mentioned in any official celebrations or even histories.

NEWS FROM GERMANY

The earth-shattering events of the German revolution in November 1918 were a powerful inspiration to the Russian masses, who were desperate to break loose from their isolation and extend the proletarian revolution westwards. It was the first in a series of spontaneous revolutionary waves that crashed into the barriers of capitalism.

In Moscow, Lenin had almost finished his reply to the attacks of Karl Kautsky, the past head of the Second International – *The Proletarian Revolution and the Renegade Kautsky* – when he received the news from Germany. He immediately put down his pen, but then resumed writing after a brief pause:

The above lines were written on 9 November 1918. That same night news was received from Germany announcing the beginning of a victorious revolution, first in Kiel and other northern towns and ports, where the power has passed into the hands of Soviets of Workers' and Soldiers' Deputies, then in Berlin, where, too, power has passed into the hands of a Soviet.

He then added:

The conclusion which still remained to be written to my pamphlet on Kautsky and on the proletarian revolution is now superfluous. (V. Lenin, *The Proletarian Revolution and the Renegade Kautsky*, in *Lenin Collected Works*,[2] vol. 28, p. 319.)

For Lenin, there seemed no point in answering the distortions of Kautsky when the revolution was on the verge of victory.

As Chairman of the Council of People's Commissars, Lenin issued an urgent appeal to the Russian workers:

News came from Germany in the night about the victory of the revolution there. First Kiel radio announced that power was in the hands of a council of workers and soldiers. Then Berlin made the following announcement: "Greetings of peace and freedom to all. Berlin and the surrounding districts are in the hands of the Council of Workers and Soldiers' Deputies..."

Please take every step to notify German soldiers at all border points. Berlin also reports that German soldiers at the fronts have arrested the peace delegation from the former German government and have begun peace negotiations themselves with the French soldiers. (LCW, vol. 28, p. 179.)

As soon as this electrifying news spread, tens of thousands of Russian workers spontaneously took to the streets in jubilation. The mood reached fever pitch. In describing its dramatic impact, the Bolshevik Karl Radek recalled:

From every corner of the city demonstrations were marching towards the Moscow Soviet... Tens of thousands of workers burst into wild cheering. Never have I seen anything like it again. Until late in the evening workers and Red Army soldiers were filing past. The world revolution had come. The mass of the people heard its iron tramp. Our isolation was over. (J. Riddell [ed.], *The German Revolution and the Debate on Soviet Power*, p. 15.)

Lenin wrote to Sverdlov, convinced that the world revolution was imminent:

The international revolution has come so close in one week that it has to be reckoned with as an event of the next few days... We are all ready to die

2 Henceforth referred to as LCW.

to help the German workers advance the revolution which has begun in Germany. In conclusion: (1) Ten times more effort to secure grain (clean out all stocks for ourselves and for the German workers). (2) Ten times more enrolments for the army. We must have by the spring an army of three million to help the international workers' revolution. (LCW, vol. 28, pp. 364-365.)

Lenin and the Bolsheviks knew full well that the centre of gravity of the European revolution was not in backward Russia, but in industrially advanced Germany. While the Russian Revolution provided the opening shot of the world revolution, the decisive battle would be fought out in the heart of Europe, namely with the victory of the German revolution. It was therefore here that the attention of the revolutionary masses worldwide was concentrated. In 1918-1923, Germany can rightly be considered the epicentre of the world revolution and the key to the international situation.

DUAL POWER

On 9 November 1918, the hopes for a victorious German 'October' were initially very high. As with the February Revolution in Russia, the German masses poured onto the stage of history. They took destiny into their own hands. A red flag flew over every barracks and over every ship in the German Imperial Navy. Alongside a feeble bourgeois government, a network of workers' and soldiers' councils had sprung up in all the main cities and towns of Germany. The authority of the old state apparatus had collapsed and power was now in the streets, patrolled by armed workers and soldiers. It was a classic example of 'dual power', with the old and new class forces vying for dominance. In Berlin, a new government of People's Commissars had been appointed by the Executive Committee of the Workers' and Soldiers' Councils. Events moved quickly as the Hohenzollern dynasty followed the Romanovs into oblivion. The Emperor, Kaiser Wilhelm II, fled to the Netherlands, followed by the rulers of four German kingdoms, five Grand Duchies and twelve Principalities.

Following the example of the Russian, Austro-Hungarian and Ottoman empires, another age-old absolutism, that of the Hohenzollerns, had been reduced to dust. Under the hot breath of revolution, King Ludwig III of Bavaria, whose House of Wittelsbach had ruled for more than a thousand years, simply packed his bags and departed. He had been deposed by a revolutionary Bavarian government, known as the 'Council of Workers and Soldiers'. The King of Württemberg pleaded on his hands and knees that no red flag should fly over his vacated palace. The reason for this humble request

was that the palace, despite his absence, should be respected as his private property. But the Revolution chose to ignore such formalities.

The Kaiser's brother, Prince Heinrich was forced to flee for his life, disguised with false whiskers and a red flag flying on his automobile. In that way, under the cover of darkness, he was able to escape to Denmark undetected. The old order was at an end. Everywhere the imperial flags were being pulled down and replaced with red flags.

Kaiser[3] Wilhelm II, Emperor of all Germany, was forced to abandoned his Royal palace at Potsdam and the question of his abdication was on everyone's lips. Wilhelm had been reluctant to abandon his throne, but soon realised that this might be a lost cause. Initially he had some fleeting thought that he may have been allowed to remain as the King of Prussia, Germany's largest state, but this illusion soon evaporated when the chancellor, Prince Max von Baden, appointed by Wilhelm, had the temerity to announce the Kaiser's demise without the decency of telling him. After all, someone had to put the Hohenzollerns out of their misery, otherwise the workers and soldiers would take it upon themselves, as in Russia.

But the idea of playing the role of the sacrificial lamb did not sit well with the head of the most powerful monarch in Europe. "Treason, gentlemen, barefaced, outrageous treason!" cried Wilhelm as he tried to clutch onto power with the support of the generals, but they too soon disowned him.

EMPEROR WITH NO CLOTHES

During the final death rattle of the old regime, a desperate and deluded Kaiser approached Generals Groener and Hindenburg with an insane plan to reconquer the rebellious cities by dispatching "picked troops to Verviers, Aix-la-Chapelle and Cologne, all with the most modern equipment, smoke bombs, gas, bombing squadrons and flame-throwers… They would be able to restore order." Hindenburg said nothing. Looking rather solemn, General Groener answered: "Sire, you no longer have an army." (R. Watt, *The Kings Depart*, p. 190.) Although the Kaiser could not stomach the bitter truth, he now counted for nothing. He was like the emperor without clothes, or in his case, without an army.

Wilhelm must have felt, as did his predecessor King Louis XVI and his mistress, Madame de Pompadour, *après moi, le déluge* [after me, the deluge]. But the disaster had already arrived. The next day, this sorry figure boarded a train to the Netherlands, where he remained, never to return. Up until 1914 he had rightfully been considered the most powerful monarch in the world. But the age of empire had abruptly come to an end.

3 The title 'Kaiser' is the German word for 'emperor'.

Wilhelm's irrational behaviour was the same as all those monarchs whose regimes were doomed. "The tsar procrastinates," Leon Trotsky wrote in similar vein about the fate of the Russian monarchy. "He is still reckoning in days and weeks, while the revolution is keeping its count in minutes." (L. Trotsky, *The History of the Russian Revolution*, vol. 1, p. 93.)

"Around me treason, cowardice, deceit," wrote Nicholas II in his diary. (ibid., p. 99.) The same words had been uttered by Wilhelm as he departed the scene, and probably by Louis XVI for that matter. They all headed towards the abyss "with the crown pushed down over their eyes." (ibid., p. 102.)

By comparison, these events constituted the comic opera of the German Revolution; more seriously, official government communications were breaking down, especially outside of the capital. Power was slipping away from the once all-powerful central authorities. On 8 November, while the Kaiser was still dithering, the Ministry of War dispatched a distressing report to the increasingly isolated and feeble government of Prince von Baden:

9:00 a.m.: Serious riots at Magdeburg.

1:00 p.m.: In [the] Seventh Army Corps Reserve District rioting threatened.

5:00 p.m.: Halle and Leipzig Red. Evening: Düsseldorf, Halstein, Osnabrück, Lauenburg Red; Magdeburg, Stuttgart, Oldenburg, Brunswick and Cologne all Red.

7:10 p.m.: General officer commanding Eighteenth Army Corps Reserve at Frankfurt deposed. (R. Watt, p. 186.)

The Revolution overturned everything in its wake. On 7 November, in the capital of Bavaria, the King was forced to flee and a republic under the leadership of left socialist Kurt Eisner was declared. At about 10 o'clock in the night, Eisner and his new council, escorted by some sixty armed workers, marched into the Landtag, the state parliament, and called for order. He announced:

The Bavarian revolution is victorious. It has put an end to the old plunder of the Wittelsbach kings. Now we must proceed to build a new regime… The one who speaks to you at this moment assumes that he is to function as the provisional prime minister. (A. Read, p. 36.)

Nobody lifted a finger. No one uttered a word. The next day, the city awoke to red flags flying over the public buildings and churches, with posters proclaiming the new socialist republic.

THE ARMISTICE

Meanwhile, on 8 November, the German delegation had arrived at Marshall Foch's railway carriage in the Forest of Compiègne, approximately sixty kilometres north of Paris. Marshal Ferdinand Foch was the Commander-in-Chief of the Allied Armies in France. This meeting was altogether a far more sombre affair. This is where frank discussions were taking place over the terms of the armistice presented by the Allies to the German High Command. In effect, the Allies were demanding nothing less than complete, humiliating and unconditional surrender. According to them, all occupied territory, including Alsace-Lorraine, was to be evacuated by the Germans within fifteen days. In addition, the Allied generals demanded that the German military immediately surrender the 30,000 machine guns in its possession.

This led to some frank exchanges. The Germans, for their part, argued that they should be allowed to retain an armed force strong enough to deal with the danger of Bolshevism. After all, should the Revolution seize power in Germany, it would spread to France and further afield. But this argument was dismissed by the Allies. The German generals again repeated the cold facts that if they were forced to surrender their machine guns, "there would not be enough left to fire on the German people should this become necessary." In face of this truly compelling argument, agreement was reached that 5,000 machine guns should be retained for this express purpose.

Churchill, who feared Bolshevism more than the plague, had come to a similar conclusion in London. At a Cabinet meeting he stressed the possibility of building up the German Army, as it was "important to get Germany on her legs again for fear of the spread of Bolshevism." (ibid., p. 38.) For him, his seething hatred of Bolshevism and what it stood for surpassed every other consideration.

Until the Armistice was signed, the warring parties were still formally at war. However, protocol clearly stated that only an officially constituted German government could sign it. But there was no government. Everything was in a state of chaos and revolution was spreading rapidly throughout the country. The Allies had to act quickly, with or without protocol.

On 11 November 1918, at 5:12 in the morning, the Armistice was signed in the railway sidings at Compiègne. It required the Germans to evacuate France and retire behind the Rhine. They had to relinquish the bulk of their aircraft, numbering 1,700 planes, together with the most modern of their fleet. This amounted to over six battlecruisers, ten battleships, eight light cruisers, and fifty destroyers. All her submarines were to be surrendered. It was a foretaste of what was to happen in Paris, when Germany was subjected to the humiliation of the Versailles Peace Treaty.

But events had overtaken the Armistice. The war had given birth to revolution. In Germany, the old regime had crumbled and had placed power into the hands of the revolutionary workers, soldiers and sailors. The German Revolution – unfolding hour by hour – represented the greatest blow to capitalism since the Russian Revolution of October 1917. If Germany succumbed to Bolshevism, then the revolution would prove unstoppable. Everything was in the balance. Lenin announced that he was even prepared to sacrifice the "besieged" revolution in Russia for a successful revolution in Germany. He knew full well that a victory in Germany, in the centre of Europe, would have sealed the fate of the European bourgeoisie and then the world. Such was the historic importance of these breath-taking events.

On Armistice Day, Beatrice Webb, the English Fabian reformer, wrote in her diary about the panic seizing hold of the British bourgeois establishment:

> Thrones are everywhere crashing and the men of property everywhere secretly trembling. How soon will the tide of revolution catch up with the tide of victory? That is the question which is exercising Whitehall and Buckingham Palace and causing anxiety even among the more thoughtful democrats. (ibid., p. 2.)

Bruce Lockhart, the British diplomat, also noted in his diary after a meeting with the King, "The King was very nice... has a wholesome dread of Bolshevism." (R.H.B. Lockhart, *The Diaries of Sir Robert Bruce Lockhart*, p. 47.)

There was certainly a deep sense of foreboding, not only in Buckingham Palace, but in the ruling classes of Europe. Their world had never seemed so fraught with danger. It reflected their fears that Bolshevism was at the gates and the rule of bankers and capitalists was about to come to an end. "The most serious question of the hour... is how far Europe is infected with Bolshevism," stated a report from London in the *New York Times*. (A. Read, p. 38.)

In Scotland, workers on Red Clydeside were inspired by the events in Russia and Germany. When John Maclean, the Marxist and internationalist, was released from prison on 3 December 1918, he addressed the crowd in Glasgow and ended with the cry: "three hearty cheers for the German Socialist Revolution!"

In *The Call* newspaper, Maclean wrote an article entitled 'Now's the Day and Now's the Hour!' in which he stated:

> We witness today what all Marxists naturally expected, the capitalist class of the world and their Governments joined together in a most vigorous active attempt to crush Bolshevism in Russia and Spartacism in Germany.

> Bolshevism, by the way, is Socialism triumphant, and Spartacism is Socialism in process of achieving triumph. This is the class war on an international basis, a class war that must and will be fought out to the logical conclusion – the extinction of capitalism everywhere. (N. Milton, *John Maclean*, pp. 185-186.)

In Germany, the victory of the revolution seemed assured as state power fell into the hands of the workers and soldiers. And yet, tragically, despite everything, the German proletariat failed to consolidate its hold on power. The revolution stopped halfway and the opportunity was tragically lost. "No one in the German Labour movement knew how to use the power which suddenly, on 9 November 1918, fell into their hands," commented the historian Evelyn Anderson. (E. Anderson, *Hammer or Anvil*, p. 38.) The leaders of the Social Democracy had actively opposed the Revolution, but they ended up leading it. They did everything in their power to divert the movement into safe 'democratic' channels along the lines of a bourgeois republic, where they would play the role of a 'loyal opposition' or even be part of a governing coalition. In the absence of a real revolutionary party, the opportunity was lost to establish a socialist republic in the centre of the European continent.

WORKERS HELD POWER

In the course of the German revolution, the workers' and soldiers' councils, which initially held the reins of power, simply handed them over to the Social Democratic leaders, who they trusted, but who in turn used their authority to rescue capitalism. These spineless reformists, who had in practice long ago abandoned the idea of proletarian revolution and Marxism, managed to rip defeat from the jaws of victory and prepare the way, not for 'democracy', but for naked and bloody reaction.

This was the exact opposite of what had happened in Russia when the Bolsheviks took power on behalf of the soviets and put an end to the rule of the landlords and capitalists. The Russian February was followed by the Russian October. The German 'February' failed to make that transition. The betrayal of the German Social Democrats was to prepare the ground for defeat and terrible retribution. These tragedies and lost opportunities were to lay the basis later on for the victory of German fascism, and with it the horrors of concentration camps and gas chambers. *If the German Revolution had been successful, it would have changed the entire course of the history of the twentieth century.* The German failure can therefore be considered one of the greatest – if not the greatest – tragedies of our time.

Nowadays, it has become increasingly fashionable amongst certain bourgeois historians to say that the events of November 1918 did not constitute a revolution. Even the radical 'left' can be ambivalent. "The jury is still out on whether it really was a revolution," states Gabriel Kuhn. (G. Kuhn [ed.], *All Power to the Councils! A Documentary History of the German Revolution 1918-1919*, p. xi.) And what jury is that? The concept of revolution seems to worry them. To the official 'sociologists', the term provokes a condescending smile, as would childish pranks. Not surprisingly, to the conservative mind, revolution is some kind of collective madness. This caricature is of course entirely false. It is not madness that is expressed but the instinctive desire of the oppressed class to change society.

If we consider that the basic premise of a revolution is the entry of the masses onto the stage of history, then the events of 1918 in Germany constituted a gigantic – and classic – revolutionary movement. The awakening of the masses and their active participation in politics is the most decisive feature of revolution, including the German Revolution. The revolution itself is a colossal school in which millions of ordinary men and women rapidly learn through their daily experience. Every single day a new revelation and a new lesson is learned. A new order begins to take shape and crystallise. Through the efforts and initiative of the masses alone, the revolution places power into their hands. As a consequence, it succeeds in breaking the political domination of the Junker class and sweeps away the monarchy. Leon Trotsky – who had direct experience of leading a revolution – answered the question in the following manner:

> *The most indubitable feature of a revolution is the direct interference of the masses in historical events.* In ordinary times the state, be it monarchical or democratic, elevates itself above the nation, and history is made by specialists in that line of business – kings, ministers, bureaucrats, parliamentarians, journalists. But at those crucial moments when the old order becomes no longer endurable to the masses, they break over the barriers excluding them from the political arena, sweep aside their traditional representatives, and create by their own interference the initial groundwork for a new régime. Whether this is good or bad we leave to the judgment of moralists. We ourselves will take the facts as they are given by the objective course of development. *The history of a revolution is for us first of all a history of the forcible entrance of the masses into the realm of rulership over their own destiny.* (L. Trotsky, *The History of the Russian Revolution*, emphasis added.)

If we take this scientific definition, the events in Germany in November 1918 certainly constituted a revolution. Unfortunately, it stopped short, halfway.

It did not destroy the economic power of the bankers and capitalists. The fact that the German revolution was not carried through to a successful *conclusion*, as in Russia in 1917, is another matter. It simply proves that you cannot carry through half a revolution. A revolution must go all the way or it will fail. There is no halfway house.

It also demonstrates that victory does not fall like a ripe fruit from a tree. Even when every element of capitalist society has disintegrated, and the workers are prepared to take the power, it requires, above all, a determined and conscious revolutionary leadership, which is prepared to go to the very end.

Although the 1918 revolution was defeated, other revolutionary opportunities, equally as important, emerged in 1919, 1920 and in particular 1923. Trotsky believed revolutionary possibilities could have existed in German even up until the victory of Hitler. The German working class had shown itself more than ready to lead mankind out of an epoch of hunger and blood. The blame does not lie with them. In fact, nothing more could be asked of them. These opportunities were cynically squandered by their leaders. Once again, German capitalism was allowed to survive, but at such terrible human cost.

BARBARISM

The German 'October' was not realised, not because of the lack of resolve of the masses, which showed no limits, but because of the betrayals and blunders at the top of both the reformist and Communist parties. It was these defeats, which eventually drove the frenzied ruined middle classes into the arms of the fascists and prepared the way for the victory of Hitler. But even then, Hitler could have been stopped in his tracks if it hadn't been for the criminal role of the workers' leaders. Despite having weapons and armaments, as well as their own military formations, they allowed the fascists to come to power *without a fight*. The German workers were led like lambs to the slaughter. The leaders of the Social Democrats refused to fight as, according to them, resistance would have led to civil war and bloodshed. Bloodshed! It was the very failure to act decisively that made bloodshed inevitable. Millions of workers would perish as a result of fascist barbarism.

The leaders of the Communist Party, who had embraced Stalinism during the 1920s, ignored the calls of Leon Trotsky for a united front of workers' organisations against fascism, but instead continued to denounce the socialists as 'social fascists', and as the *main* enemy. Trotsky made a forceful appeal to the Communist workers:

Worker-Communists, you are hundreds of thousands, millions; you cannot leave for any place; there are not enough passports for you. Should fascism come to power, it will ride over your skulls and spines like a terrific tank. Your salvation lies in merciless struggle. And only a fighting unity with the Social Democratic workers can bring victory. Make haste, worker-Communists, you have very little time left! (L. Trotsky, 'Germany: The Key to the International Situation', 8 December 1931.)

But his appeal for a united front was dismissed by the Stalinist leaders as 'counter-revolutionary' propaganda.

The accession to power by Hitler in January 1933 – "without breaking a window pane," to use his own words – constituted the most humiliating capitulation in history, even worse than the betrayal of 4 August 1914. Even then, after everything that had happened, the Stalinists dismissed the fascist victory with the astonishing words, "After Hitler, our turn!" This betrayal destroyed any possibility of a German revolution.

By 1935, fearing a possible war with Germany, Stalin looked for an alliance with the so-called 'western democracies'. To demonstrate his friendship towards the imperialist countries, he was prepared to sacrifice the Spanish Revolution. This change entailed another zig-zag in policy, as 'social fascism' was dropped in favour of the Popular Front. Stalin moved very quickly from denouncing Trotsky for having called for unity of the German communists with the Social Democrats in a united front of the workers' organisations against the Nazis, to the broadest possible alliance, the Popular Front of communist and socialist organisations with 'progressive' bourgeois politicians, Liberals, and Church leaders against fascism. Such a policy prepared the defeat in Spain – and elsewhere – and prepared the way for the Second World War and 80 million dead.

LEARN FROM HISTORY

"Ours is not to laugh or cry, but to learn," said the philosopher Baruch Spinoza. It is necessary for the new generation to understand what happened in Germany and learn its lessons for today. "Achieving a greater awareness of the past," wrote Alexander Herzen, "we clarify the present; digging deeper into the meaning of what has gone before, we discover the meaning of the future; looking backward, we move forward." (R. Medvedev, *Let History Judge*.)

Today we are at the crossroads of two epochs. The old post-war stability has finally come to an end. In the face of the biggest crisis of capitalism in its history, there is chronic instability and a sharp polarisation everywhere. The scene is being set once more for revolutionary convulsions worldwide.

Titanic events will transform the consciousness of millions, as society enters an intense period of class struggle. The working class will need to prepare itself for this, and the lessons of 1918-1923 can play an indispensable role. A period of profound upheaval is opening up in front of us. There are, of course, significant differences between today and the 1930s, most notably the greatly increased strength of the working class. This change in the class balance of forces is of decisive importance.

We reject the view of the petty-bourgeois moralists and liberals who frown upon revolutions, as if against the laws of nature. In fact, revolutions are the motive force of history, and history is about to give such people some sharp lessons in dialectics.

As with the 1917 October Russian Revolution, the 1918 German Revolution marked an opening of a convulsive chapter in European and world history. We are entering a similar stormy period today on a global scale, and it is one of the main reasons we are publishing this book. Moreover, this is not simply a historical work, but a political one. The ebb and flow of history, governed by its own laws, has great relevance for today. This has nothing to do with fate, as it is people who *make* history. Furthermore, the book's publication marks a celebration: the centenary of the German revolution of November 1918, when the workers, sailors and soldiers, "stormed heaven," to borrow the phrase of Marx. They came so close to changing the world, but they were robbed of this victory. This tragedy eventually led to fascist barbarism and all the horrors associated with it. It is therefore the responsibility of the new generation of socialists and communists, educated and enriched by the past, to complete this long overdue goal begun by those past heroes who dared storm heaven.

Rob Sewell, October 2018

CHAPTER ONE: THE RISE OF GERMAN SOCIAL DEMOCRACY

It was the best of times, it was the worst of times, it was the age of wisdom, it was the age of foolishness, it was the epoch of belief, it was the epoch of incredulity...

Charles Dickens, *The Tale of Two Cities*

Germany, the birthplace of Marxism. It was here that Marx and Engels originally developed the ideas of scientific socialism. This eventually led to the establishment of the Communist League, the publication of the *Communist Manifesto* and the birth of the Marxist movement.

While living in exile, both Marx and Engels paid special interest to the developing movement in Germany, regarded in many ways as their adopted 'child'. Before 1860, there was no real organised labour movement in this patchwork of states, kingdoms and principalities. It was through their preparatory work, especially during the years of the International Workingmen's Association, that the foundations were laid for the creation of organisations of the proletariat, including in Germany. It is no accident that Marx acted as the corresponding secretary for Germany on the General Council of the First International.

Two socialist groups had crystallised in Germany, one based around Ferdinand Lassalle,[1] which held progressive but confused views, and the

1 Ferdinand Lassalle had been the President of the General Association of German Workers, which was established in May 1863. He was a born leader, embraced the cause of the working class, but his 'socialism' was of the more romantic and opportunist kind. He was killed in a duel the following year, August 1864.

other around August Bebel and Wilhelm Liebknecht, which was known as the Eisenach Party. The latter were the followers of Marx and Engels. Following unity negotiations, in the spring of 1875, the founding Congress of the German Social Democratic Party was held at Gotha, that fused the two groups together. The unified party was viewed as the embodiment of revolutionary Social Democracy. Marx and Engels worked to maintain the revolutionary line within the new party. They helped combat the influences of Lassalleanism and then the revisionist ideas of Herr Dühring, described by Engels as "bumptious pseudo-science", which were becoming fashionable in certain quarters. Thus appeared Engels' classic work entitled *Anti-Dühring*, which became a textbook of scientific socialism. As a result of its historic links with Marx and Engels, German Social Democracy[2] was considered the most authentic representative of 'orthodox' Marxism in the international workers' movement.

The German party became the most powerful section of the Second International, which was established in 1889 and grouped together all the socialist parties prior to the First World War. Standing at the head of the International, the party was greatly admired by millions worldwide, including Lenin, who regarded it as a model party.

While the Russians, Poles and others were struggling to assemble handfuls of members and supporters into small party organisations, the German party was a mass party *par excellence*. In practise, it formed the epicentre of the world socialist movement around which all others gathered.

Friedrich Adler, the Austrian leader, wrote:

> The German Social Democratic Party was the very ideal of all the socialist parties of the International. It brought to life what others visualised as an idea. This magnificent movement, consciously striving for the realisation of its historic mission to the world, undeflectable and unconquerable in its progress, concentrated all its strength and thought on a single aim: the emancipation of the working class. (J. Braunthal, *In Search of the Millennium*, p. 100.)

By 1912, the German Social Democracy had reached its pinnacle. The Socialist revolution seemed assured. It had one million members and millions of supporters, making it the biggest party adhering to Marxism in the world. Its apparatus numbered almost 4,000 full-time party workers, assets worth more than 21 million gold marks, ninety daily newspapers with a circulation of over 1.4 million subscribers, and sixty-two printing offices. It had dozens

2 The term Social Democracy at this time meant revolutionary socialist. All the revolutionary Marxists were called Social Democrats before 1914. It was in 1919, with the creation of the Communist Third International that they began to call themselves Communists.

of periodicals, together with its own socialist news agency, and an impressive Central Socialist School for the education of party members. In the election of 1912, the SPD achieved a vote of 4.3 million, more than one third of the total electorate, which provided it with 110 deputies in the Reichstag, or parliament. The trade unions, which the party helped to organise and sustain, had a membership of over 3 million, which made them among the largest in the world, a reflection of the general strength of the German proletariat.

Despite the existence of the Reichstag, Germany was ruled by a reactionary autocracy with a monarchy at its head. In 1871, the king of Prussia was proclaimed emperor of the newly united Germany. The Reichstag, or 'Imperial Assembly', was aptly described by Wilhelm Liebknecht as "the fig-leaf of absolutism". Power rested with the Emperor, the Kaiser, and the landed Prussian Junkers, who presided over a patchwork of duchies, principalities and kingdoms. The Reichstag was nothing more than an inconsequential talking shop, where the Emperor had the sole right to appoint the chancellor, or head of the government. The Imperial government served the interests, not only of the landed aristocracy, but also the industrialists, bankers and financiers, who had grown very powerful over the years. The head of the Kaiser's government was the faithful Otto von Bismarck, the 'Iron Chancellor', who could not be toppled, even with a majority vote.

The rising workers' organisations were feared and regarded as a threat by these powerful class interests. Therefore, in order to curb the socialist movement, Bismarck introduced an Anti-Socialist Law ('The Exceptional Law Against the Socialists') in October 1878, which outlawed and shackled the activities of the SPD and the trade unions. According to Bismarck's legislation, these organisations were "designed to subvert the existing political and social order" and therefore had to be curtailed. "The pathological ideas of Socialism", states the draft Bill, "the enemy of Society and the State, cannot be stamped out by common law. Hence the urgency of this law of exclusion." (A.R. Oliveira, *A People's History of Germany*, p. 52.) Using the full force of the law, Bismarck moved quickly to clamp down on all working-class political and cultural organisations, and shut down its press. During the twelve long, repressive years under the Anti-Socialist Law, 1,500 worker activists were imprisoned and 150 Social Democratic newspapers closed down. Many other activists escaped abroad, out of the way of the authorities. From there, underground papers were edited, produced and smuggled back into Germany. Such papers were passed from hand to hand, satisfying the growing thirst for radical ideas from the working class.

But Bismarck's law, rather than weakening the workers' organisations, provoked great sympathy for the socialists, who emerged greatly strengthened.

Social Democracy grew substantially in these underground conditions and became increasingly recognised as the focal point of opposition to the autocratic regime. Despite the law, the Social Democratic Party, in accordance with the Constitution was allowed to maintain its group in the Reichstag. This allowed them to skilfully combine legal and illegal methods of work.

As their popularity grew, so did their votes, their membership and party organisation. During this period, the SPD had increased its membership by more than a million. On the trade union front, the Free Trade Unions, later known as the Allgemeiner Deutscher Gewerkschaftsbund, or ADGB, which had close links to the Social Democrats, saw their membership rise from 50,000 in 1878 to 278,000 by 1891, a year after the anti-socialist laws were finally repealed. At the time of the introduction of the law, there were forty-two Social Democratic newspapers; following the repeal the number had risen to sixty.

The repeal itself was forced upon Bismarck because the law was becoming increasingly counterproductive. This did not mean, however, that the socialist movement was free from harassment and persecution. On the contrary, the successes of German Social Democracy caused great alarm in ruling circles. The Emperor even issued a personal warning that if the Social Democrats should gain a majority, they would immediately "proceed to plunder the citizens". He went on bizarrely, "I shall have loopholes cut in the palace walls and we'll see how much plundering will take place." (Quoted in R. Watt, p. 113). The Emperor's alarmist tactics, however, only served to increase the support for the socialists.

The repeal of the Anti-Socialist Law allowed the party to more fully capitalise on its growing popularity and establish wider points of support, especially on the parliamentary front. At each successive election, the party increased its representation in the Reichstag and the provincial legislatures. In 1871, when the Reichstag was first set up, there were only two Social Democrat deputies out of 397, elected with 124,000 votes. But in the elections of 1890, the SPD's popular vote jumped to one-and-a-half million (twenty per cent of the popular vote), and the number of its deputies rose from twelve to thirty-five. Bismarck, having failed to suppress the movement by legislation, now considered crushing the movement using 'blood and iron', but was overruled by the Kaiser, who feared a backlash. Humiliated, von Bismarck resigned.

The SPD was able to use its electoral gains as an important platform in the Reichstag for propaganda and as a focal point for the struggle against the government. As a result, the democratic struggle against the autocracy assumed the character of a class struggle. Their deputies, such as Bebel and

Liebknecht, would make revolutionary speeches in the Reichstag, which would then be printed and distributed in their hundreds of thousands. In early 1893, a debate on the socialist society of the future lasted five days. Such was the impact of Bebel's speech, it was published as a pamphlet in 3.5 million copies and sold for five pfennigs each.

GROWTH OF GERMAN CAPITALISM

The unification of Germany under Bismarck in 1871 paved the way for an immense industrial expansion. German capitalism took giant steps forward, and with the development of modern technique and huge industrial and commercial enterprises, it was threatening to outstrip Britain, the dominant imperialist power of the time. The production of iron ore rose from 1.5 million tons in 1871 to 14.8 million in 1910. Steel production increased between 1886 and 1912 by a massive 1,335 per cent, coal production by 218 per cent (as against Britain's seventy-three per cent), while total exports rose by 185 per cent. Before the First World War, industrial production in Germany had increased six-fold over the previous four decades, leaving her second only to the United States both in industrial production and in the production of iron and steel. At the same time, Germany was ranked first in the export of machinery and electrical equipment. It was emerging as a major imperialist power in its own right. But Germany had come onto the scene very late in the day. Her colonial possessions – which were all held down brutally – only amounted to some areas of China and a slice of south-west Africa, the Cameroons, Togoland, New Guinea and a few others. The world had already been carved up by the other imperialist powers, which was soon to lead to frictions and, eventually, a head-on collision.

The expansion of German industry meant that the percentage of the population employed on the land dropped from fifty per cent in 1870 to thirty-three per cent in 1913. This development also gave rise to a fresh young working class, free from weighty traditions, unlike the British workers. This lack of baggage allowed them to quickly develop a militant working-class consciousness, as well as a loyalty to their newly-founded organisations.

The growth of capitalism, while creating a powerful labour movement, also gave rise to a period of relative social peace, which remained the case in Europe from the defeat of the Paris Commune in 1871 to the end of the upswing in 1912. This relative stability certainly assisted the growth of the trade unions and social democratic parties.

However, the rise of social democracy during a period of general upswing of the capitalist system had another side to it, which was to have unfortunate consequences for the movement. It helped shape the conservative outlook of

the top layers of the Social Democracy and the trade unions. They became increasingly convinced of the longevity of the capitalist system and its ability to grant reforms. The more they adapted to capitalism, the more they came under its pressures.

Instead of preparing the German workers for the conquest of power, the leadership concentrated on winning reforms within the confines of capitalism. Such gains certainly added to the prestige of the Social Democracy. Even the welfare reforms introduced by Bismarck, such as old age pensions and health and accident insurance, known as 'state socialism', were widely regarded as due to the pressure of organised labour despite the fact they were intended to cut the ground from under the workers' movement. This then also strengthened the illusions in reformism, and the idea that life for the working class could be improved incrementally, without the overthrow of capitalism.

The fight for reforms is an essential part of the workers' struggle for emancipation. Every advance, however small, whether over improved pay or conditions, is a step forward. The struggle to change society is unthinkable without the day-to-day struggles of the working class for advancement under capitalism. As Rosa Luxemburg explained:

> Can we contrapose the social revolution, the transformation of the existing order, our final goal, to social reforms? Certainly not. The daily struggle for reforms, for the amelioration of the condition of the workers within the framework of the existing social order, and for democratic institutions, offers to the Social Democracy an indissoluble tie. The struggle for reforms is its means; the social revolution, its aim. (R. Luxemburg, *Reform or Revolution*.)

The struggle for reforms, as Rosa Luxemburg correctly said, must be linked to the need to overthrow the capitalist system as reforms under capitalism cannot be considered permanent. What is given by the left hand can be easily taken away by the right hand, especially in times of crisis. That was the case in 1918 when the German bourgeoisie were forced to grant the eight-hour day and other important concessions, which were then snatched back starting in 1923. The problem was that, for the leaders of Social Democracy, the struggle for reforms became an end in itself. They lost sight of the ultimate aim of changing society. Over time, the actions of the Social Democratic and trade union leaders became completely devoid of any revolutionary content or perspective. They had adapted themselves to their environment.

The character of the social democratic movement also began to change. The apparatus of both unions and party had increased enormously in the pre-war period. The party and its press had more than 10,000 full-time staff. Added to this were more than 3,000 trade union officials. That constituted

a formidable force. But with the very successes in building powerful organisations, with their increased membership, greater resources and funds, came an ever-more powerful bureaucracy. In turn, it increasingly attracted place-seekers and careerists, which began to infest the movement.

The labour and trade union bureaucracy began to develop its own conservative vested interests as the revolution became increasingly distant from its daily experience. The methods and habits of administration, which is the main social function of the bureaucracy and the source of its pre-eminence, inevitably leave powerful imprints on its entire way of thinking. Thus, the movement was being transformed gradually from an instrument for social revolution into a reformist apparatus whose function was to mediate between the classes.

The author Evelyn Anderson observed that:

> While all these successes – direct and indirect – strengthened the prestige of the labour movement, they also affected its political outlook. Gradually, workers began to realise that they had very much more to lose than their chains. Even most of those who had received a thorough socialist and Marxist training at the party schools and trade union colleges were impressed by the success of the industrial struggles, which gave them the feeling that there was no limit to perpetual progress, provided Germany could rid herself of the remnants of an obsolete feudalism. (E. Anderson, p. 11.)

Before the War, German Social Democracy, especially its upper echelons, went through a process of political adaptation and degeneration. For the party leaders and functionaries, the language of socialist revolution was used mostly at May Days and at labour movement celebrations, but in their daily lives they grew accustomed to bourgeois society. Marx had long ago explained the process in the following words: "social being determines social consciousness".

This dichotomy between reform and revolution also reflected itself in the party's programme, which was divided into two distinct parts, independent of each other. There was a 'minimum' programme that limited itself to demands for reforms within the framework of capitalism; and there was a separate 'maximum' programme that argued for the ultimate goal of socialism in the indefinite future. This dual approach was developed by Karl Kautsky, the party's leading theoretician, and embodied in the decisions of the first Social Democratic Congress at Erfurt in 1891.

Between the 'minimum' and 'maximum' programmes there was no transitional bridge with which to link both together. There was nothing to help the masses in their daily struggle to find the road to the socialist

revolution. But social democracy had no need of such a bridge, as the overthrow of capitalism was not considered as a practical proposition. "This separation was to dominate the theory and practice of social democracy for decades," wrote the Marxist historian Pierre Broué. (*The German Revolution 1917-1923*, p. 17.)

MARX AND ENGELS

This incipient opportunism had been noticed by Marx and Engels during their involvement with the party. They were very well aware of such dangers and tried to curb them. From the beginning, Marx and Engels had taken the German leadership to task for their backsliding, reflected in political softness and ideological weakness, and especially in their tendency to sacrifice principles for short-term gains. *The Critique of the Gotha Programme* written by Marx in 1875 is the most well-known example of their critical attitude to the German leaders. As Marx wrote:

> After the Unity Congress has been held, Engels and I will publish a short statement to the effect that our position is altogether remote from the said programme of principles and that we have nothing to do with it…

> Apart from this, it is my duty not to give recognition, even by diplomatic silence, to what in my opinion is a thoroughly objectionable programme that demoralises the party. ('Letter to W. Bracke', 5 May 1875, *Marx and Engels Collected Works*,[3] vol. 45, p. 70.)

At one point, so sharp were the exchanges that they threatened to break off all political relations. This was due to the fact that the German leaders made too many political concessions to the Lassalleans within the party.

In the voluminous *Correspondence* of Marx and Engels we can find far sharper criticisms of such opportunism. While they loyally defended the leadership of the German party in public, neither of them were prepared to sacrifice their principles for anyone's expediency. The *Correspondence* shows that there were many other occasions when they threatened a break with their co-thinkers in Germany. Despite these sharp differences, Marx and Engels nevertheless preferred to correct these mistakes by exerting pressure through individual advice and correspondence, hoping that by such means the German leadership would learn from their own mistakes.

While Marx and Engels firmly criticised the opportunist tendencies within the party, they also attacked with equal firmness those who engaged in ultra-leftism and phrase-mongering, such as Johann Most, who had come

3 Henceforth referred to as MECW.

under anarchist influences. Marx's scrupulous attitude to ideas and principles meant that nothing was left unturned.

In the late 1870s, due to Marx's growing health problems, it was left to Engels to answer the extremely muddled ideas of Professor Dühring, who had acquired a certain following within the German Social Democracy. This resulted in a brilliant defence and exposition of scientific socialism, later published in book form under the title of *Anti-Dühring*, a classic of Marxist literature. A section of the leadership, especially the intellectuals and academics whom Engels contemptuously branded as the "Katheder Sozialisten" (armchair socialists) used the Anti-Socialist Laws to water down the party's programme and cover up its goals on the grounds of expediency. It was this opportunist tendency in Germany that worried Marx and Engels the most. From London, they mercilessly criticised the opportunists and put pressure on Bebel and Kautsky to keep the party on the right track.

This opportunist tendency revealed itself most sharply, and not accidentally, in the Social Democratic Parliamentary group. The rarefied atmosphere of bourgeois parliaments was always a problem for the revolutionary movement. It was in such places that the pressures of alien ideas were at their most intense and the heat of the class struggle at their weakest. Therefore, in such an environment there was always the threat that Social Democratic deputies would bend under pressure or even become corrupted. Marx and Engels were extremely critical of these layers within the German party, who tended to be opportunist in nature and displayed an eagerness for political independence from the party.

"They are already so far infected with parliamentary cretinism as to believe themselves above criticism," wrote Marx angrily to Sorge. (MECW, vol. 45, p. 414.) "Or has German Social Democracy indeed been infected with the parliamentary disease, believing that, with the popular vote, the Holy Ghost is poured upon those elected…?" they both jointly wrote to the German leaders. (MECW, vol. 45, p. 400.)

The party, due to its successes, had attracted a petty-bourgeois layer that had little understanding of Marxism, but nevertheless rose to key positions within the movement. They tended to bring all kinds of alien ideas from their middle-class backgrounds with them. On one occasion, in September 1879, Marx and Engels were so angry about such influences that they wrote a 'Circular Letter' to Bebel, Liebknecht and other party leaders in the sharpest fashion possible. It had come to light that the Social Democratic newspaper produced in Zürich under the control of young revisionists (Karl Höchberg, Kaul August Schramm, and the young Eduard Bernstein) was coming out with hair-raising ideas. Höchberg, who, as Marx expressed it, had "bought"

his way into the party by his money, demanded that socialism should be made a movement of "humanity in general" based on the "sense of justice" of both the oppressed and the representatives of the "upper classes". (K. Marx and F. Engels, *Selected Correspondence*, p. 309.)

Marx and Engels were so angry that they accused Liebknecht of a cover-up. They then launched an attack on these petty-bourgeois literary types, who had wormed their way into positions and become a law unto themselves, as "counter-revolutionaries". This Zürich editorial board of three showed utter contempt for the 'uneducated' working class in its editorials and articles and even went as far as to urge the party to recruit instead the "enlightened bourgeois". They also declared that the party had correctly rejected "the path of forcible, bloody revolution," and instead decided "to tread the path of legality, i.e., of reform." (MECW, vol. 45, p. 404.)

"If they think as they write, they ought to leave the party or at least resign from office," complained Marx and Engels. "If they don't, it is tantamount to admitting that they intend to use their official position to combat the party's proletarian character. Hence the party is betraying itself if it allows them to remain in office." (MECW, vol. 45, p. 403.)

Marx and Engels continued:

[W]hen people of this kind, from different classes, join the proletarian movement, the first requirement is that they should not bring with them the least remnant of bourgeois, petit-bourgeois, etc., prejudices, but should unreservedly adopt the proletarian outlook. These gentlemen, however, as already shown, are chock-full of bourgeois and petty-bourgeois ideas.

They added:

How the party can suffer the authors of this article to remain any longer in their midst seems to us incomprehensible. (MECW, vol. 45, pp. 407-408.)

They went on to warn the German leaders:

So, the gentlemen are forewarned and, moreover, are well enough acquainted with us to know that this means bend or break! If they wish to compromise themselves *tant pis* [so much the worse]! In no circumstances shall we allow them to compromise us. (MECW, vol. 45, p. 414.)

Höchberg was removed from the editorial committee and all the influential leaders of the party – Bebel, Liebknecht, Bracke, etc. – repudiated his ideas. Subsequently, Höchberg and Schramm left the workers' movement, but Bernstein, temporarily refrained from advocating opportunism, rose to become one of the leaders of German Social Democracy. It would be only

after Engels' death that Bernstein would come out clearly with a revision of Marxism.

This was not the last time that Marx and Engels criticised the opportunist backsliding of the Germans, who had failed to defend revolutionary Marxism or display the necessary resoluteness, firmness, and revolutionary spirit. This attitude was displayed in their complete unpreparedness for illegal struggle, especially in response to the Anti-Socialist Law. Therefore, Marx and Engels took it on themselves to school the German leadership, praising them when deserved, but criticising them when necessary. "Again, you know that Marx and I have voluntarily conducted the defence of the party against its opponents abroad throughout the party's existence, and that we have never asked anything of the party in return, save that it should not be untrue to itself," explained Engels to Bebel. (MECW, vol. 45, p. 420.)

And further, in December 1879:

> We regret very much being unable, at this time of repression, to give you our unqualified support. So long as the party in Germany remains true to its proletarian character, we were prepared to set aside all other considerations. But now that the petty-bourgeois elements you have admitted have come out in their true colours, it's a different matter. The moment they are permitted to insinuate their petty-bourgeois ideas piecemeal into the organ of the German party, that organ, by the same token, is closed to us, no more nor less. (MECW, vol. 45, p. 430.)

Despite these pressures, things did not improve to any real extent. In regard to *Vorwärts*, the party's daily, Engels was disgusted. "Never had a large party such a miserable organ," he wrote to Laura Lafargue, Marx's daughter. (MECW, vol. 49, p. 154.)

This gives a clear indication of the approach by the founders of scientific socialism to the German Social Democracy and its defects, and how they tried to deal with it.

ENGELS DISTORTED

Following Marx's death, Engels repeatedly came face to face with this crass opportunism. He made a number of criticisms of the 'Erfurt Programme' of 1891. Although much improved on the 'Gotha Programme', it still had its weaknesses and a tendency towards opportunism.

> This forgetting of the past, the principal considerations for the momentary interests of the day, this struggling and striving for the success of the moment regardless of later consequences, this sacrifice of the future of the movement for its present, maybe 'honestly' meant, but it is and remains opportunism,

and 'honest' opportunism is perhaps the most dangerous of all! (MECW, vol. 27, p. 227.)

The same features are present when, later on, he was approached by Richard Fischer, the Executive secretary of the party, with a request to water down his language in the 'Introduction' to Karl Marx's *The Class Struggles in France, 1848 to 1850*. Fischer feared that certain terminology would be used by the government to reimpose restrictions on the party. On this occasion, Engels felt obliged to accept the request to omit certain passages, which dealt mainly with the armed struggle of the working class. Engels, however, felt the 'Introduction' "suffered somewhat" as a result of these omissions.

He wrote to Fischer:

> I have taken as much account as possible of your grave objections although I cannot for the life of me see what is objectionable about, say, half of the instances you cite. For I cannot after all assume that you intend to subscribe heart and soul to absolute legality, legality under any circumstances, legality even *vis-à-vis* laws infringed by their promulgators, in short, to the policy of turning the left cheek to him, who has struck you on the right. True, the *Vorwärts* sometimes expends almost as much energy on repudiating revolution as once it did – and may soon do again – on advocating the same. But I cannot regard that as a criterion.
>
> My view is that you have nothing to gain by advocating complete abstention from force. Nobody would believe you, *nor* would *any* party in any country go as far as to forfeit the right to resist illegality by force of arms. (MECW, vol. 50, p. 457.)

It must have been embarrassing to make such basic points to the Executive secretary of the party. But the epigones of the Second International were attempting to transform Marx and Engels from revolutionaries into garden-variety evolutionists. But Engels didn't leave it there. In fact, he wrote a letter of protest to Karl Kautsky about the censorship:

> I was amazed to see today in the *Vorwärts* an excerpt from my 'Introduction' that had been *printed without my prior knowledge* and tricked out in such a way as to present me as a peace-loving proponent of legality *quand même* [come what may]. Which is all the more reason why I should like it to appear in its entirety in the *Neue Zeit* in order that this disgraceful impression may be erased. I shall leave Liebknecht in no doubt as to what I think about it and the same applies to those who, irrespective of who they may be, gave him this opportunity of perverting my views and, what's more, without so much as a word to me about it. (MECW, vol. 50, p. 486.)

He also wrote to Paul Lafargue in France on 3 April 1895:

> [Wilhelm] Liebknecht has just played a fine trick on me. He has taken from my introduction to Marx's articles on France 1848-50 everything that could serve his purpose in support of peaceful and anti-violent tactics at any price which he has chosen to preach for some time now... (MECW, vol. 50, pp. 489-490.)[4]

Engels was of course in favour of using universal suffrage and parliament to promote the revolutionary cause, but he nevertheless rejected parliamentary cretinism and opportunism. For him, the use of parliament was always linked to the overthrow of capitalism. But the revolution, in defending itself, should use all means necessary. He wrote to Paul Lafargue:

> Do you realise now what a splendid weapon you in France have in your hands for forty years in universal suffrage; if only people had known how to use it! It's slower and more boring than the call to revolution, but it's ten times more sure, and what is even better, *it indicates with the most perfect accuracy the day when a call to armed revolution has to be made*; it's even ten to one that universal suffrage, intelligently used by the workers, will drive the rulers to overthrow legality, that is, to put us in the most favourable position to make the revolution. (MECW, vol. 50, p. 29, emphasis added.)

Even here we see how Engels carefully takes up the question of violence, in putting the blame on the ruling class who will act "to overthrow legality" when the time comes, and when the call to defend the revolution will be necessary.

Despite Engels' wishes, his 'Introduction' was never published in full. When he wrote to Lafargue, Engels told him to "wait for the complete article before judging it – it will probably appear in *Neue Zeit*." (MECW, vol. 50, p. 490.) But when Kautsky eventually published the piece in *Neue Zeit*, it contained the same omissions. Engels' protests were deliberately hidden from the rank and file of the German party. In fact, it was not until 1924 that Riazanov brought Engels' manuscripts to light and published them in their original form. While the leadership used Engels' politically diluted 'Introduction' to advance their opportunist and reformist standpoint, it was only Rosa Luxemburg, to her credit, who instinctively refused to accept this truncated version as a true reflection of Engels' views, despite being unaware of Engels' criticisms. She explained:

4 In spite of Engels' request that his text be published in its entirety in the *Neue Zeit*, Kautsky continued the censorship by publishing the same version that had been published in the *Vorwärts*, a clear indication of his own opportunist tendencies.

Engels did not live to see the results, the practical consequences of the use of his introduction. I am certain that if one knows the works of Marx and Engels, just as if one knows the living revolutionary spirit which breathes from all their work, one is bound to be convinced that Engels would have been the first... to protest with all his power against the interpretation which led to Titan reliance on parliamentary means. He would have pulled back the coach with all the means at his disposal, to prevent it slipping into the mud... (J.P. Nettl, *Rosa Luxemburg*, p. 754.)

REVISIONISM

The opportunist tendencies were therefore certainly present. However, the growing conservatism of the German Social Democracy found its clearest expression in the late 1890s in the ideas of Eduard Bernstein, a party leader, who, as we have seen, began to argue for a complete revision of Marxism. These ideas simply articulated the outlook of the party bureaucracy and out-and-out reformist layers within the SPD. Let us not forget that Bernstein was one of the Zürich editors who Marx and Engels had previously criticised so sharply. While they were alive, Bernstein kept suitably quiet and hid his ideas, briefly becoming an editor of another party newspaper. Such was his influence within the party leadership that he even became one of the executors of Engels' estate, which was placed at the disposal of the Socialist International. After Engels' death, Bernstein felt more confident in openly challenging and revising the principles of the Marxist movement.

It is clear that Bernstein had been very impressed by the economic boom that was taking place in Germany at the time. During the stagnation of 1873-1882, the economy had grown by a mere three per cent over the course of a decade. By comparison, the boom period between 1887 to 1896 saw a thirty-six per cent growth in the economy. This upswing served to strengthen the revisionist tendencies within the labour and trade union movement, which were mesmerised by a 'golden age' of uninterrupted growth.

Bernstein began his assault against Marxist 'orthodoxy' in a series of articles entitled 'The Problems of Socialism', published in the theoretical journal of the party, *Die Neue Zeit,* between 1896 and 1897. Kautsky was the editor of this theoretical journal, and gave Bernstein a free hand to express his views without bothering to furnish a reply. He was also a personal friend of Bernstein and even thanked him for his "contribution", which he regarded as a thoughtful addition to a wider discussion. Another SPD paper, *Leipziger Volkszeitung,* again took a very soft approach to Bernstein's criticisms:

Interesting observations which nonetheless terminate in a mistaken conclusion; something that is always liable to happen especially to lively

Eduard Bernstein

and critical people, but there is no more to it than that. (Quoted in *Rosa Luxemburg Speaks*, p. 35.)

"No more to it than that"! This mealy-mouthed response – or lack of it – simply emboldened the revisionist tendency within the party. As with all revisionists, Bernstein urged the German Social Democracy to recognise the "new reality" that had emerged since Marx's time. For him, Marx's ideas were rendered obsolete by the march of events. They were out of date and needed to be discarded. This was the first step to a complete abandonment of revolutionary Marxism. Bernstein argued that capitalism had been able to adapt, and with the development of the credit system and improvement in communications, it was now able to avoid catastrophic slumps and crises of overproduction. In fact, according to him, with the development of trusts and cartels, capitalism was able to resolve its contradictions and develop more harmoniously. In other words, capitalism was no longer a system which was inherently crisis prone, as Marx had claimed. Furthermore, according to Bernstein, class lines were becoming increasingly blurred as the trade unions became successful vehicles for winning reforms. Thus, the class struggle was becoming more obsolete. Capitalists, rather than a ruling class, were becoming mere managers and administrators, a foretaste of the later theory of 'managerial capitalism'. He rejected Marx's 'theory of impoverishment', which was – and has been ever since – the subject of a fierce ideological barrage against Marxism.

The mistake of Bernstein was to take a fleeting tendency of improvement as a permanent feature; he also mistakenly identified the conditions of the aristocracy of labour as those of the proletariat as a whole. Along with rejecting Marx's theory of crisis, he also challenged the philosophical foundations of Marxism, namely dialectical materialism. From criticising this or that aspect, he ended up rejecting the whole of Marxism. So, he urged Social Democracy to find the courage to "emancipate itself from outworn phraseology, and to come out in its true colours as a democratic socialist reform party." (Quoted in R. Watt, p. 115.)

Bernstein formulated his opportunism in his famous, but meaningless phrase: "*The final goal, no matter what it is, is nothing; the movement is everything.*" He was the early forerunner of all those later reformist leaders who capitulated to capitalism. Today's bourgeois apologists have therefore invented nothing new, but simply rehash those ideas better expressed by Bernstein more than 100 years ago. This revisionism – directly linked to opportunism – has served as the theoretical basis for the assault on Marxism ever since.

It is perhaps no accident that Eduard Bernstein had spent many years in exile in London, and had been influenced by the reformist trade unions, the Fabians and British liberal democracy. This experience helped shape his ideas. But it was in Germany that his assault on Marxism caused the most excitement, especially his articles carried in the party press. For a growing layer within the party, Bernstein's ideas were more in tune with the times than the prognosis of the *Communist Manifesto*. He found support for his ideas from a number of prominent trade union leaders as well as SPD deputies, not least from southern Germany. The latter had a particular interest in revisionism.

The Social Democrats of south Germany had developed their own opportunist leanings. Although at a national level, the party was effectively excluded from all government involvement, on a state level, particularly in the south, it was invited to support the liberals in coalition agreements. Traditionally, the SPD refused to vote for any budget that raised taxes on workers and peasants to uphold the tyranny of the German state. But SPD deputies in Bavaria, Baden and Württemberg pleaded 'special conditions' to vote for provincial budgets, allowing them to squeeze out concessions and get a 'better' budget. This became known as 'South German exceptionalism' and was eventually permitted following decisions of the party Congresses of 1894 and 1895. These right-wing tendencies within the party became the bedrock of Bernstein's support.

INTERNATIONAL RESPONSE

As soon as Bernstein's revisionism had garnered support it was attacked not only in Germany but throughout the International. Plekhanov, the father of Russian Marxism, wrote an article entitled 'Why should we thank him?', which not only attacked Bernstein but also criticised Kautsky for not answering these ideas sooner. Plekhanov even wrote to Kautsky directly:

> You say your readers have no interest in philosophy... then you must force them to take an interest... If you want me to write against Bernstein you must give me full freedom of speech. Bernstein must be destroyed... and I will gladly undertake this task if you let me. (Plekhanov to Kautsky, dated 16 September 1898, as quoted in J.P. Nettl.)

Kautsky's failure to respond was not simply a short delay of a matter of weeks, or even months, which would be long enough, but it took this key 'theoretician' about eighteen months to offer a reply. This irresponsible delay allowed Bernstein's ideas to circulate freely and widely without any official response. His articles were even produced as a book, *Die Voraussetzungen des Sozialismus und die Aufgaben der Sozialdemokratie*. Kautsky had started publishing Bernstein's articles in 1896, but the above letter from Plekhanov offering to "destroy" Bernstein was written in September 1898, almost two years later.

During Kautsky's eighteen-month delay in publicly replying to Bernstein there was an exchange of letters between the two which is quite revealing. In a letter Kautsky wrote to Bernstein on 28 January 1898 he explained that Bernstein's supporters were concerned more that he would lose the prestige he had within the party, than with the content of his ideas. And most significantly he wrote, "It seems to me that what divides us is not opinions and conclusions, but the tone with which we espouse them." (Quoted in M. Waldenberg, *Il Papa Rosso Karl Kautsky*, p. 138.)

Throughout these eighteen months, Kautsky was in fact trying to get Bernstein to tone down his articles, but Bernstein would have none of it. In a reply to Kautsky a week later on 5 February, he states clearly that he considers himself a "social reformer" and does not believe in "a radical change". (ibid., p. 139.) The reason why Bernstein refuses to change anything in his articles is that he was fully aware of the fact that he was merely expressing in a theoretical manner what many SPD bureaucrats were already doing in practice. The problem for leaders like Bebel was that such open discussion of the reformist essence of the policy of the party risked opening up a sharp debate within the SPD. In Germany the first public criticism of Bernstein came from Parvus,

who stated that "if Bernstein were right, it would mean the end of socialism." (ibid., p. 137.)

Thus, Bebel also appealed to Kautsky to reply to Bernstein, warning him that if he didn't then the more 'extreme' wing would do it. Above all, Bebel wanted to bury the debate with an authoritative statement from Kautsky and then get back to business as usual. The party congress was coming up in October 1898, and the last thing he wanted was a debate on the floor of the congress on the ideas raised by Bernstein, which would involve discussing party tactics, reform and revolution, the nature of the capitalist state and so on. Parvus had tried to get a resolution passed along these lines at a branch of the party in Saxony, but to Bebel's satisfaction it was not passed.

In spite of Bebel's manoeuvres, however, the wider debate could not be stopped. Plekhanov was joined in battle by others, including Antonio Labriola in Italy and Jules Guesde, and even the reformist Jean Jaurès in France. But the most searing criticisms of Bernstein was to come from the German revolutionary left, headed first and foremost by Rosa Luxemburg, who achieved international recognition for her political firmness and determination. This is precisely what Bebel had feared and explains why he wanted Kautsky to deal with Bernstein.

Of Polish origin, Rosa Luxemburg had earned her political authority working in underground conditions, being a founding member of the Social Democratic Party of Poland and Lithuania. She moved to Berlin in 1898, just in time to play a full role in answering Eduard Bernstein's revisionism. She was politically very astute and understood that these theories, if accepted by Social Democracy, would inevitably lead to a complete break with Marxism.

Rosa Luxemburg also recognised the international significance and meaning of Bernstein's revisionism:

> Bernstein's book is of great importance to the German and the international labour movement. It is the first attempt to give a theoretic basis to the opportunist currents common in the Social Democracy.

> These currents may be said to have existed for a long time in our movement… But it is only since about 1890, with the suppression of the Anti-Socialist Laws, that we have had a trend of opportunism of a clearly defined character. ('Reform or Revolution', in *Rosa Luxemburg Speaks*, p. 86.)

The SPD leaders prevaricated for almost two years and hoped that the whole dispute would blow over. But the opposite was the case. Finally, when Karl Kautsky and August Bebel could not delay any longer, they were eventually forced to come out openly against Bernstein's revisionism. Up until that time not a single one of the party's newspapers or journals were actually answering

Bernstein's ideas – apart from *Sächsische Arbeiterzeitung*, edited by Parvus, a Russian émigré. But this became untenable.

KARL KAUTSKY

Karl Kautsky and August Bebel led what could be called the 'Centre' grouping within the party, standing between Bernstein's open revisionists and the party's Left Wing lead by Rosa Luxemburg. The 'Centre' controlled the party, with Kautsky being seen as the intellectual and theoretician and Bebel, with his proletarian roots, as a key leader dedicated to the building of the party. They made up the Old Guard. But this 'Centre' tended to bend opportunistically for the sake of 'unity'. It was precisely this that alarmed Marx and Engels, when they were alive.

Even when Kautsky eventually responded politically to Bernstein, the response was somewhat reserved. This was very characteristic of the 'Centre' group. There was clearly hesitation on Kautsky's part in criticising his old friend Bernstein, possibly for fear of causing offence. But Kautsky's reluctance had deeper political roots. Bernstein was only expressing sharply in theory what the SPD was actually carrying out in practise, namely a reformist policy. They had increasingly ceased to be revolutionary Marxists, but, like the Catholic Church, which had broken from the communism of the early Christians, they needed to maintain an outward appearance and loyalty to the past. Kautsky was therefore reluctant to engage in an all-out fight against Bernstein on the lines of the party's Left Wing. Deep down he regarded Rosa Luxemburg's full-frontal attack on revisionism, with all the clarity of her ideas, with disdain. Above all, he was irritated by such an unwarranted intervention that only served to cast light on his own deficiencies.

Even at the Stuttgart Congress in 1898, Kautsky's attack on Bernstein was rather muted. He explained that:

> Social Democracy will do everything possible to carry out democratic and economic reforms and to organise the proletariat. And Bernstein has a completely false idea of the party. He believes that we are contemplating a clash with armed authority, and that development will not be so rapid as many suppose. This is a question of *temperament*, not of viewpoints. (A.R. Oliveira, p. 60, emphasis added.)

For old times' sake, Kautsky was not willing to renounce the 'Marxist' tradition, at least not in words. His criticism of Bernstein boiled down to a refusal to renounce the party's heritage, to which they still had a sentimental attachment. This was not a defence of genuine Marxism but a conservative defence of the status quo, which reduced the ideas of scientific socialism to

some kind of icon. In Kautsky's hands, Marx's legacy had become a tablet of stone, rather than a revolutionary guide to action. It had an abstract, scholastic character, and lacked any revolutionary content. Bebel too revealed his philistinism and theoretical weakness by regarding Bernstein as a threat, not because of his erroneous ideas, but because it encouraged disunity and damaged the morale of the party. For Bebel, the party, for better or worse, was everything, even if it meant sacrificing its principles. "Up to now we see no reason to change our point of view, our tactics or our name," stated Bebel at the Hanover Congress. "We remain what we were." (Quoted in A.R. Oliveira, p. 62.)

As Rosa Luxemburg later wrote, the party 'Centre' was hostile to revisionism chiefly because it was itself incurably conservative. For her, the 'Centre' was the axis of Kautsky and Bebel, which dominated the party. Her close friend, Clara Zetkin, put it succinctly:

> What they want, it sounds laughable I know, is revolution without revolution… the revolutionary vocabulary of Marxism is maintained with religious fervour, but its meaning has evaporated. (S. Taylor, *Germany 1918-1933: Revolution, Counter-Revolution and the Rise of Hitler*, p. 7.)

Rosa Luxemburg's attack on Bernstein was more strident and far sharper than that of Kautsky and Bebel. She did not pull her punches. "In the controversy with Bernstein and his followers," she wrote, "everybody in the party ought to understand clearly it is not a question of this or that method of struggle, or the use of this or that set of tactics, but of the very existence of the Social Democratic movement." (*Rosa Luxemburg Speaks*, p. 36.) In other words, for Luxemburg, it was not a secondary matter, but a life and death struggle. Her articles were collected and published in 1900 under the title, *Reform or Revolution*. Her writings soon established her as one of the foremost Marxist theoreticians.

The party leadership considered Bernstein not as someone to be fought and defeated, but as a misguided comrade in arms who should be coaxed back into the fold. Kautsky's attitude is clearly revealed in a letter he wrote to Axelrod on the 9 March 1898, congratulating him on his articles on Bernstein in the following terms:

> I am most interested in your opinion of Eddie [Bernstein]. Indeed, I'm afraid we're losing him… However, I have still not given him up as a bad job and I hope that when he enters into personal – if only written – contact with us, then something of the old fighter will return to our Hamlet (sic), and he will once again direct his criticism against the enemy and not against us. (Quoted by A. Woods, 'Rosa Luxemburg – Reform or Revolution'.)

Karl Kautsky

Karl Kautsky had become a typical *centrist*. He espoused 'Marxism' in words and phrases, but had become reformist in deeds. He could talk with great authority about the Roman Republic and the rise of Christianity, but the nearer he approached present-day affairs, the more ambiguous and vaguer he would become. He presented himself as a faithful disciple of Marx and Engels, which gave him colossal authority. After all, he was regarded as the party's key theoretician, an intelligent journalist, economist and historian. He was the editor of *Die Neue Zeit*, and the author of many theoretical works on Marxism. While Rosa Luxemburg saw his weaknesses at close hand, and therefore fully recognised them, Kautsky was still regarded internationally as a great authority and theorist of Marxism.

These weaknesses were to be laid bare in the midst of the *reality* of war and revolution. During the First World War, in complete contrast to Luxemburg and Liebknecht, he put forward, not an internationalist position, but a semi-pacifist one. Of course, this was still dressed up in Marxist language. And instead of welcoming the October Russian Revolution, he vehemently opposed it. The living reality of revolution did not correspond with his armchair view of the class struggle. In his book, *The Dictatorship of the Proletariat*, he attacked the Soviet Republic, using not the method of Marxism, but of abstract petty-bourgeois liberalism. He simply repeated the ideas of the Mensheviks, who became sworn enemies of Bolshevism.

Kautsky's later works reflected this theoretical degeneration and are characterised by theoretical and political decline. In essence, he robbed Marxism of its revolutionary living spirit. He recognised everything in Marxism *except* its revolutionary methods of struggle. He therefore reduced scientific socialism to a barren theory devoid of its revolutionary essence. This vulgarised Marxism was an attempt to reconcile reform and revolution. It was a 'Marxism' that could get by in the epoch of reforms, but as soon as that epoch came to an end and entered an epoch of capitalist crisis and shocks, it revealed its reactionary nature. It was this new epoch of crisis that exposed the reformist character of the German Social Democracy, including the bankruptcy of its main theoretician, Karl Kautsky.

Rosa Luxemburg understood the role of Kautsky long before Lenin, and that was because she was able to see his opportunism at close quarters. In October 1914, Lenin wrote to Shlyapnikov:

> I hate and despise Kautsky now more than anyone, with his vile, dirty, self-satisfied hypocrisy... Rosa Luxemburg was right when she wrote, long ago, that Kautsky has the "subservience of a theoretician" – servility, in plainer language, servility to the majority of the party, to opportunism. Just now there is *nothing* in the world more harmful and dangerous for the *ideological* independence of the proletariat than this rotten self-satisfaction and disgusting hypocrisy of Kautsky, who wants to smother and cover up everything, to tranquillise the awakened conscience of the workers by sophistries and pseudo-scientific chatter. (LCW, vol. 35, pp. 167-168.)

DIFFERENCES WITH LENIN

Rosa Luxemburg had her political differences with Lenin, including his drive to build a centralised party of professional revolutionaries in Russia. But her views on this question were clearly coloured by her negative experiences of the monolithic German Social Democracy, which acted as a leaden weight on the shoulders of the working class. She feared that the *degree* of centralism proposed by Lenin would choke the life out of the party, as was happening in Germany. Instead, she laid stress on the spontaneous movement of the proletariat in opposition to the conservative and ossified machinery of the German Social Democratic Party. It is no accident that her criticisms of Lenin in 1904, published in *Die Neue Zeit* and the Menshevik-controlled *Iskra*, were peppered with numerous references to the problems of the German party. What she failed to see was that this party was displaying, not democratic centralism, but the traits of bureaucratic centralism. She feared that what Lenin was offering was a version of this. Thus, she warned, "Granting, as

Rosa Luxemburg

Lenin wants, such absolute powers of a negative character to the top organ of the party, we strengthen, to a dangerous extent, the conservatism inherent in such an organ." (*Rosa Luxemburg Speaks*, p. 122.)

Rosa Luxemburg was not alone in these criticisms of centralism. The young Trotsky also had grave doubts at this time. But he later recognised the absolute correctness of Lenin's position. As Trotsky explained:

> Lenin was right again. Without a strong centralised party, we could never have taken power. Centralism means focusing the maximum organisational effort toward the 'goal'. It is the only means of leading millions of people in combat against the possessing classes. (L. Trotsky, *The Crisis of the French Section 1935-36*, p. 68.)

History was to prove Lenin correct in practice. The Bolshevik Party, based on democratic centralism, led the Russian proletariat to power, while Rosa Luxemburg's loose grouping failed to displace the leadership of the German reformists, and this weakness eventually led to the shipwreck of the German revolution of 1918. She underestimated the importance of the centralised party, but to be fair, she was not alone. Out of all the leaders of the Second International, it was *only* Lenin who really understood the question of the importance of the party. In 1918, just before her death, Rosa Luxemburg

learnt a painful lesson in her belated efforts to construct a centralised revolutionary party, the German Communist Party. These differences, however, did not prevent their common struggle against opportunism, for instance at the Stuttgart International conference in 1907, nor from having cordial relations. The German party Congresses of 1898, 1899, 1901, 1903, as well as the 1904 Congress of the Second International, passed resolutions condemning the revisionism of Bernstein. But these resolutions meant very little in practice. They were simply ticking the boxes. The Hanover resolution entitled 'Attacks on the Fundamental Views and Tactics of the Party', passed in October 1899, by 216 votes to twenty-one, rejected the demands of the revisionists, but failed to criticise and expose Bernsteinism as such.

"...the views expounded by Bebel have the support of the vast majority of the Congress," stated a report. A few lines later, "...David defended Bernstein's views... First of all, he tried to show that... Bernstein and his friends, after all is said and done, stand on the basis of the class struggle..." (*Rabocheye Dyelo*, No. 4-5, December 1899, quoted in V. Lenin, *What is to be Done?*, p. 15.)

"It is debatable, from the standpoint of the interests of the German party," warned Lenin, "whether diplomacy was appropriate and whether, in this case, a bad peace is better than a good quarrel." (ibid., p. 15.)

Lenin could see the tendency to paper over differences in the cause of 'diplomacy'. Revisionism still persisted and was even tolerated in the movement as Lenin had feared. The SPD secretary, Ignaz Auer, expressing the real cynical feelings of the party bureaucracy, wrote to Bernstein in 1899, "My dear Ede, one does not formally make a decision to do the things you suggest, one doesn't *say* such things, one simply *does* them." (Quoted in *Luxemburg Speaks*, p. 35.) This clearly shows how rotten things had become at the top of the party, characterised by a growing cynicism and a lack of principle.

The Dresden Congress of 1903 closed the debate on Bernstein, at least formally, by condemning the revisionists' attempt to "replace the policy of conquering power through victory by a policy which accommodates itself to the existing order." But these were just words and nobody believed them, least of all the leadership.

The 'revisionist' Dr. Eduard David welcomed the outcome of the Congress with the words:

> The short flowering of revisionism has, most fortunately, passed... The party can now devote itself to positively exploiting and extending its parliamentary power. (P. Broué, p. 19.)

In other words, let us put aside our disagreements and get down to the real work of developing the important parliamentary work. This outcome also suited the party bureaucracy, who wanted peace and quiet to get on with their daily routine.

LENIN AND KAUTSKY

In the Second International, Kautsky was regarded by his political foes as the 'Pope of Marxism', such was his 'infallible' authority. Prior to 1914, he was regarded as the outstanding and unchallenged leader, not only of the German party, but also of the International. His struggle against Bernstein was supported by Lenin, who was an ardent follower of Kautsky. "Until 1914 Lenin regarded Kautsky as an authority – in foreign affairs," noted Trotsky. (L. Trotsky, *Notebooks, 1933-1935*, p. 82.) Prior to 1914, Lenin viewed the Bolsheviks as the 'Bebel-Kautsky' wing of the Russian Social Democracy in opposition to the Menshevik opportunists. August Bebel was a founding member, greatly admired by Engels for his instincts, who presided alongside Kautsky as the party's main leaders. Bebel was first and foremost a party man, who tended to look for a compromise to problems, hoping to paper over differences for the sake of unity.

Lenin had quoted Kautsky as an authority in his 1902 book, *What is to be Done?*, even borrowing from him the mistaken idea that the working class cannot develop a socialist consciousness. Lenin later admitted that on this question he had bent the stick a bit too far.

To show the affinity between Lenin and the German party leaders, it is worth looking at some of his quotes. In his pamphlet, *Two Tactics of Social Democracy in the Democratic Revolution*, written in 1905, Lenin protested:

> When and where did I ever claim to have created any sort of special trend in international Social Democracy *not identical* with the trend of Bebel and Kautsky? When and where have there been brought to light differences between me, on the one hand, and Bebel and Kautsky, on the other...? (LCW, vol. 9, p. 66.)

Lenin stated on 7 December 1906:

> The fact is that right from the very beginning we declared we are not creating a special 'Bolshevik' trend, always and everywhere we merely uphold the point of view of the *revolutionary Social Democracy*. And right up to the social revolution there will inevitably always be an opportunist wing and a revolutionary wing of Social Democracy. (LCW, vol. 11, pp. 361-362.)

Two weeks later, on 20 December 1906, Lenin greeted Kautsky's answer to Plekhanov's questions on the character of the Russian revolution. "Kautsky's

analysis satisfies us completely," he wrote. "He has fully confirmed our contention that we are defending the position of revolutionary Social Democracy against opportunism, and not creating any 'peculiar' Bolshevik trend." (LCW, vol. 11, p. 373.)

This view of the German party was summed up by Trotsky, when he said:

> For us Russians, the German Social Democracy was mother, teacher, and living example. We idealised it from a distance. The names of Bebel and Kautsky were pronounced reverently. (L. Trotsky, *My Life*, p. 186.)

This solidarity was quite understandable when viewed from afar, but Rosa Luxemburg had no such illusions. She was a friend of Kautsky and his family and knew him very well, especially his opportunism. But this was not simply the case of one individual, for the whole party was infected.

Luxemburg wrote to Clara Zetkin at the beginning of 1907:

> I feel the pettiness and the hesitancy of our party regime more clearly and more painfully than ever before. However, I can't get so excited about the situation as you do because I see with depressing clarity that neither things nor people can be changed – until the whole situation has changed, and even then, we shall just have to reckon with the inevitable resistance of such people if we want to lead the masses on. I have come to that conclusion after mature reflection. The plain truth is that August [Bebel], and still more the others, have completely pledged themselves to parliament and parliamentarism, and whenever anything happens which transcends the limits of parliamentary action they are hopeless – no, worse than hopeless, because they then do their utmost to force the movement back into parliamentary channels, and they will furiously defame as 'an enemy of the people' anyone who dares to venture beyond their own limits. I feel that the masses of the people, and, of course, still more the masses who are organised in the party, are tired of parliamentarism, and would welcome a new line in party tactics, but the party leaders and still more the upper stratum of opportunist editors, deputies, and trade union leaders are like an incubus. We must protest vigorously against this general stagnation, but it is quite clear that in doing so we shall find ourselves against the opportunists as well as the party leaders and August [Bebel]. As long as it was a question of defending themselves against Bernstein and his friends, August and Co. were glad of our assistance, because they were shaking in their shoes. But when it is a question of launching an offensive against opportunism then August and the rest are with Eddie [Bernstein], Vollmar, and David against us. That's how I see matters, but the chief thing is to keep your chin up and not get too excited about it. Our job will take years. (P. Frölich, *Rosa Luxemburg*, p. 148-149.)

BREAK WITH KAUTSKY

"Kautsky's friendship with Rosa Luxemburg coincided with the best period of his intellectual activity", noted Trotsky. (L. Trotsky, *My Life*, p. 187.) But as can be seen, Rosa Luxemburg had no illusions about the party, its leadership, nor the difficulties ahead. Her fight against opportunism within the party was especially heated after 1905, when she raised the importance of the general strike as a weapon. But the struggle really burst out openly in 1910, when the party leadership refused to publish her articles in favour of a political strike. It was at this time that a break came with Kautsky. A very bitter argument broke out between them over the question of the fight for the suffrage in Prussia, where the electoral system was clearly rigged against Social Democracy. While in the elections to the Prussian Diet (assembly) in 1908 the Social Democrats gained six deputies, with 600,000 votes, the Conservatives gained 212 seats with only 418,000 votes. This scandal led to widespread demonstrations all over Prussia demanding electoral change. Under these circumstances Luxemburg raised the idea of a general strike to advance the movement. The party leadership, led by Kautsky, argued against any strike, a line which was then confirmed at the party Conference.

"Bolshevism and Menshevism and the left wing of the German and international Social Democracy," explained Trotsky, "took definite shape on the analysis of the experiences, mistakes, and tendencies of the 1905 revolution." (L. Trotsky, *The Third International After Lenin*, p. 167.)

Out of this sharp struggle emerged the need for a more organised opposition within the party. It forced Rosa Luxemburg to found a left grouping, along with Clara Zetkin, Pannekoek, Franz Mehring and Julian Marchlewski (alias Julius Karski). However, this group was more a circle of political friends than a real organised tendency. They didn't even have a newspaper or journal. Given the traditions of the SPD, there was always an aversion to establishing any kind of organised faction. Such feelings certainly held them back.

Pierre Broué wrote that:

This fundamental conception of activity, this identification of the party with the mass movement, and their deep devotion to the organisation in which, despite its bureaucratic excrescences, they continued to see the expression of the revolutionary Social Democratic workers' movement, led them to reject the prospect of organising a faction. They rejected the possibility of setting up, even in an informal and loosely-defined manner, a revolutionary tendency in Germany or international Social Democracy which would bring them into association with the Bolsheviks. (P. Broué, pp. 39-40.)

This weakness, in contrast to Lenin's organisation of the Bolshevik faction in the RSDLP, was to have grave consequences in the future. Rather than a conscious plan, it took major revolutionary events – much later – to push them further in the direction of the organisation of the Spartacus League, and then onto the formation of the Communist Party.

Ironically, Luxemburg's break with Kautsky received no support from the Russian Social Democrats, not even from Lenin, who thought her criticisms at the time were exaggerated. But it was Rosa Luxemburg and not Lenin who was correct on this point.

Luxemburg not only criticised the opportunism of Kautsky and the so-called 'Centre', but she also came out forcefully against the conservative conduct and approach of the trade union bureaucracy. "Thanks to objective processes at work in capitalist society, (the trade union struggle) is transformed into a kind of labour of Sisyphus," explained Rosa Luxemburg. "However, this labour of Sisyphus is indispensable if the work is to obtain at all the wage-rate due to him in the given situation of the labour market," she continued. (P. Frölich, p. 77.) The trade union leaders, however, did not take too kindly to this comparison to Sisyphus, a king in Greek mythology who was condemned to roll an immense boulder up a hill, only to watch it roll back down again, repeating this action for eternity. In fact, they were furious. Their narrow trade-union outlook excluded any possibility of revolutionary understanding or perspective. Their heads were filled with negotiations, compromises and class collaboration. It was therefore no accident that these 'leaders' would end up supporting their own ruling class in the imperialist war.

MILLERANDISM

At the turn of the century, the International was shaken by events in France. In 1899, the French Socialists took the unprecedented decision – the first time ever in the workers' movement – to enter a bourgeois government, the Radical Ministry of Waldeck-Rousseau. Alexandre Millerand accepted the position of Minister of Commerce, sitting side-by-side in a cabinet with the Minister of War, General Gallifet, who was responsible for the execution of some 30,000 Communards in 1871. For many, the entry of socialists into such a blood-stained government was a step too far. Jean Jaurès, the leader of the Socialist Party, however, naively praised this entry "into the fortress of bourgeois government". The French Socialist leaders tried to justify their actions using the Dreyfus scandal[5] to call for a defence of the republic. "The

5 The Dreyfus Affair began in 1894 when Captain Alfred Dreyfus, a Jewish officer, was convicted in a secret court martial of selling secrets to a foreign power, and sentenced to life on Devil's Island. This was a frame-up to protect another officer – a non-Jewish aristocrat – involving the General Staff. A scandal erupted that shook French society, pitting the

Republic must be defended!" was their cry, but this only served as a cover for their class collaborationist policies.

This entry of Socialist representatives into a bourgeois government was condemned by the revolutionary wing of the International but was greeted enthusiastically by reformists everywhere. For them, it simply demonstrated the 'common ground' between the classes and their united defence of bourgeois democracy.

Lenin wrote:

> If Bernstein's theoretical criticism and political yearnings were still unclear to anyone, the French took the trouble strikingly to demonstrate the 'new method'.

> Millerand has furnished an excellent example of practical Bernsteinism. Not without reason did Bernstein and Vollmar rush so zealously to defend and laud him. Indeed, if Social Democracy, in essence, is merely a party of reform and must be bold enough to admit this openly, then not only has a socialist the right to join a bourgeois cabinet, but he must always strive to do so. (V. Lenin, *What is to be Done?*, p. 9.)

The Left denounced this entry as a betrayal and a trap for the workers. The Socialists, they said, were simply being used by the bourgeoisie as a cover for a government amnesty for the Dreyfus criminals, its imperialist intervention against China and its support for Russian tsarism. As expected, as soon as the Socialists were discredited by these actions, they were contemptuously cast aside. The whole episode served to simply compromise the Socialists in the eyes of the working class.

"Jaurès, the tireless defender of the republic, is preparing the way for Caesarism," stated Luxemburg bluntly. "It sounds like a bad joke, but the course of history is strewn with such bad jokes." (Quoted in P. Frölich, p. 84.)

But a few years later, even Jaurès became disenchanted with such collaboration and broke his ties with Millerand, Briand and Vivani who had also joined the bourgeois cabinet. They were eventually expelled from the Socialist Party and denounced by Jaurès as "traitors who let themselves be used to serve the interests of capitalism."

The Millerand episode in France, as with the Bernstein controversy in Germany, went down in the history of the International as a major watershed. What these episodes illustrated was the fact that the same process of political

army, clergy and aristocracy against the liberals led by Zola and the socialists led by Jaurès. At its peak, Waldeck-Rousseau headed a government to pardon Dreyfus to "defend the Republic" and defuse the situation. He was finally released from prison in 1899 and fully vindicated in 1906. Lenin believed the scandal was of such proportions that it could have provoked a revolutionary situation and the overthrow of French capitalism.

degeneration that was affecting German Social Democracy was also taking place in the other parties of the Second International. Opportunism was an international phenomenon, as would be glaringly revealed in August 1914.

THE GENERAL STRIKE

The question of the general strike had had a long history in the workers' movement. It had been raised by the English Chartists who called for a month-long general strike, a 'Sacred Month'. It was raised in the First International. It was in particular championed by the syndicalists as a revolutionary alternative to the parliamentary method of struggle. The Marxist wing had always opposed the syndicalists on this, arguing instead for a political movement to advance the socialist revolution. Nevertheless, there were those on the left in Germany who raised the general strike, not as an alternative, but as an additional weapon in the arsenal of the working class. As a result, in 1904, Karl Liebknecht and Clara Zetkin moved a resolution at the party's annual Congress arguing that the party should review afresh the use of the general strike as a political weapon. This proposal was defeated. The same proposal was submitted again in early 1905 and was again defeated. However, within a few months, a similar resolution, this time moved by August Bebel, was passed overwhelmingly at the Jena Congress. The reason for this change was the widespread sympathy for the 1905 Russian Revolution and its impact in Germany. "The Red ghost of the Russian revolution," remarked Luxemburg, "hovered over the deliberations at Jena." (J. Riddell [ed.], *Lenin's Struggle for a Revolutionary International, 1907-1916*, p. 32.)

Luxemburg, who had seen first-hand the events in Russia, was so inspired by the broad sweep and intensity of the Russian strike wave that she wrote a pamphlet entitled *The Mass Strike, the Political Party and the Trade Unions*, highlighting the vital importance of such a movement in the transformation of society. Above all, she underlined the importance of spontaneity in the working class, which was a positive characteristic of the class struggle. She felt these had important lessons for the German working class. However, with the defeat of the 1905 revolution, opinion in the German party now swung in the direction of the trade union leaders, who argued that, in the words of Karl Legien, a "general strike was general nonsense".

They were hostile to the idea of a general strike for a number of reasons. Many viewed the role of the trade unions as industrial and not political. They were also committed to a policy of class collaboration rather than class confrontation. But the main reason for their opposition was that an all-out general strike posed the question of power, namely, who controls society,

and it was this that terrified them more than anything else. They wanted to reform capitalism, not overthrow it.

Moreover, in 1906, at a secret meeting, the party leaders, together with the trade union leaders, agreed that a general strike would never be used without the approval of the trade unions. This meant in practice that the general strike would be a dead issue, which suited the interests of the Social Democratic leaders, who were more interested in parliamentarism than extra-parliamentary action. The Mannheim Party Congress in 1906 confirmed this decision and showed clearly that the party leadership was strongly under the influence of the trade unions. The platform stated:

> If the Executive Committee [of the party] considers that the situation demands a general revolutionary strike, it will get into contact with the General Commission of Trade Unions and will adopt the necessary measures to achieve the desired victory.

Therefore, the division in the labour movement between 'Marxists' and 'revisionists' was deceptive. The real division was between revolutionaries and the different varieties of reformism, which based themselves on capitalism.

ANTI-WAR FEELINGS

Opposition to war and militarism had become burning questions during these years. They had been discussed at a special session of the International Congress at Stuttgart in 1907, where four resolutions on this question were submitted to the Congress Commission. For the most part, they shared a common analysis, but differed sharply over the course of action needed in the event of war. Two resolutions mentioned a general strike, but the other two by August Bebel and Jules Guesde left the tactics open. The one presented by Bebel and drafted by the Executive Committee of the German party concluded that:

> [S]hould war threaten to break out, the workers and their parliamentary representatives in the affected countries are duty bound to do everything possible to prevent the outbreak of war, using the means that they consider to be most effective. Should war break out nonetheless, they will intervene for its rapid termination. (J. Riddell [ed.], *Lenin's Struggle*, p. 23.)

In the Commission debate, Bebel stated that, in the event of war, the German Social Democracy would struggle against the prevailing militarism. "Beyond that, however, we must not allow ourselves to be pressured into using methods of struggle that could gravely threaten the activity and, under certain conditions, the very existence of the party," he stated. Preserving the legality of the party seemed to override everything for him. In replying to

Rosa Luxemburg's criticisms, he said: "If such a war breaks out, then much more will be at stake than mere trifles like insurrection and mass strikes." (J. Riddell [ed.], *Lenin's Struggle*, p. 26 and p. 33.)

This view reflected the abstract notions of the German centrist leaders, who were fond of talking in generalities about war and peace. Lenin and Luxemburg both recognised the weakness of Bebel's resolution, whose 'tactics' were open to different interpretations. "This made it possible to read Bebel's orthodox propositions through opportunist spectacles," remarked Lenin at the time. As a result, Rosa Luxemburg proposed a series of concrete amendments to strengthen and clarify Bebel's original resolution on behalf of herself, Lenin and Julius Martov. In addition, the amendments also went further than the two other resolutions proposed by the French.

Lenin, who was on the Commission dealing with resolutions on Militarism and International Conflicts, reported:

> The remarkable and sad feature in this connection was that German Social Democracy, which hitherto had always upheld the revolutionary standpoint in Marxism, proved to be unstable, or took an opportunist stand. The trade union half of the German delegation were the most adamant supporters of opportunist views. (LCW, vol. 13, p. 79.)

This was in 1907, seven years before the outbreak of war.

The amendments were drafted and then shown to Bebel to see if he would accept them. Originally, they were harder hitting in terms of revolutionary action and agitation. "I cannot endorse this," said Bebel, "for if I did the prosecutor's office would outlaw our party organisation, and we want to avoid that unless something really serious has happened." (J. Riddell [ed.], *Lenin's Struggle*, p. 47.) Lenin consulted with lawyers and there were repeated alterations to keep the text within the law. Bebel then agreed to the final draft.

The amendments put forward by Lenin, Luxemburg and also Martov, which served to strengthen the resolution, stated 1) that militarism is the chief weapon of class rule and subjugation of the working class; 2) the need for propaganda in the spirit of socialism among the youth; 3) it was the duty of the International "to exert every effort in order to prevent its outbreak. They must employ the means they consider most effective, which naturally vary according to the sharpening of the class struggle and the general political situation" and that "in case war should break out anyway, it is their duty to intervene for its speedy termination and to strive with all their power to utilise the economic and political crisis created by the war to rouse the masses and thereby to hasten the downfall of capitalist class rule." (J. Riddell [ed.], *Lenin's Struggle*, p. 35.)

August Bebel

The resolution, as amended, was passed unanimously, amid prolonged, stormy applause. They had agreement, but it was only on paper.

Over the next few years, in the run up to 1914, many speeches would be made attacking militarism and the dangers of war. On 9 November 1911, the ageing August Bebel made a rousing speech to the Reichstag, which concluded:

> And so, on all sides, armament and rearmament; and they will arm to the point when, one day one side or the other will say: 'Better an end to this fear than fear without end'… Then will come catastrophe! (H. Afflerbach and D. Stevenson [ed.], *An Improbable War?: The Outbreak of World War I and European Political Culture Before 1914*, p. 194.)

The catastrophe of war eventually came, as Bebel had predicted, but accompanying it came the catastrophe and collapse of the Second Socialist International.

A similar hard-hitting, anti-war Manifesto was endorsed at the Extraordinary International Congress held in Basel in 1912. It openly stated that nothing can serve to justify a war "for the sake of the profits of the capitalists and the ambitions of dynasties," which is the basis of the imperialist, predatory policy of the Great Powers. The Basel Manifesto repeats

the words of the Stuttgart resolution that, in the event of war, socialists must take advantage of the "economic and political crisis" it causes so as to "hasten the downfall of capitalism." In fact, the only item on the agenda of the Congress was the struggle against the danger of war. After Jean Jaurès delivered his report, a radically worded resolution was adopted, which called on the working class to use its power for a revolutionary struggle against war. On the opening day of the Congress, such was the feeling that a large anti-war demonstration took place, accompanied by a big international protest meeting.

THE GREAT BETRAYAL

Even as late as 29 July 1914, a few days before the declaration of war, the Bureau of the Socialist International met in Brussels and passed a resolution stating that, "The International Socialist Bureau charges proletarians of all nations concerned not only to pursue but even to intensify their demonstrations against war…" But such protests were simply symbolic. The leaders of the International in reality felt themselves completely helpless. Some were looking for a miracle to get them out of their predicament, but none came. Their plight only reflected their political and moral bankruptcy. These leaders were supposed to be 'Marxists' and 'revolutionaries', but they were nothing of the kind. Marx had sown dragon's teeth, but had harvested flees.

Within two days of the Socialist Bureau meeting, Jaurès was assassinated in Paris by a right-wing fanatic, Raoul Villain. The International was completely paralysed. The resolutions proved to be just meaningless words. They were facing a calamity, which would put everyone and everything to the test, with war being the greatest test of all. Despite all the anti-war pronouncements, the declaration of war at the beginning of August 1914, instead of marking a collective call for international opposition, resulted in a deafening capitulation. All the resolutions, promises and speeches against the war, once it finally arrived, were rejected one after the other as leaders from different countries lined up behind their national bourgeoisie.

The International, which began so promisingly, was shattered on 4 August 1914. A paralysed working class, disorientated by the situation, was bound over to militarism and imperialism, all in the name of 'national defence'. They not only faced the full weight of militarism, but the mighty apparatus of their own parties and the prestige of the International. It was the greatest tragedy – the greatest betrayal – to have befallen the international socialist movement.

Given the inevitable war hysteria, and the patriotic fever that gripped the country, the call for a general strike to stop war would have been pointless. However, that was no excuse for not doing anything. A real International leadership would have at least made a stand. They would have opposed it politically, argued against it, which would have put down a marker for the future and preserved the clean banner of Social Democracy. It would have preserved the political integrity of the international working-class movement until the tide had turned. As leaders this was their first and foremost responsibility. But they failed miserably.

As Leon Trotsky wrote in *War and the International*, written in 1915:

> Had the socialists limited themselves to expressing condemnation of the present war, had they declined all responsibility for it and refused the vote of confidence in their governments as well as the vote for the war credits, they would have done their duty at the time...

> The ties binding the International together would have been preserved, the banner of socialism would have been unstained. Although weakened for the moment, the Social Democracy would have preserved a free hand for a decisive interference in affairs as soon as the change in the feelings of the working masses came about. And it is safe to assert that whatever influence the Social Democracy might have lost by such an attitude at the beginning of the war, it would have regained several times over once the inevitable turn in public sentiment had come about. (L. Trotsky, pp. 52-53.)

When war came, Kautsky attacked the left for supposedly urging the masses, in reply to war, to organise a revolution "in twenty-four hours", and institute "socialism", otherwise the masses would be displaying "spinelessness and treachery".

Lenin replied to this nonsense:

> Kautsky's Left opponents know perfectly well that a revolution cannot be 'made', that revolutions *develop* from objectively (i.e., independently of the will of parties and classes) mature crises and turns in history, that without organisation the masses lack unity of will, and that the struggle against a centralised state's powerful terrorist military organisation is a difficult and lengthy business. Owing to the treachery of their leaders, the masses *could not* do anything at this crucial moment, whereas this 'handful' of leaders *were in an excellent position* and in duty bound to vote against the war credits, take a stand against a 'class truce' and justification of the war, express themselves in favour of the defeat of *their own* governments, set up an international apparatus for the purpose of carrying on propaganda in favour of fraternisation in the trenches, organise the publication of illegal

literature on the necessity of starting revolutionary activities, etc. (LCW, vol. 21, pp. 240-241.)

But the leaders of the International were not up to the task of opposing the war. They lacked the will to carry out such an honourable and courageous stand. Years of opportunist adaptation had taken its toll. It took a calamity to expose the reality. They had long ceased to be revolutionaries, but now they had shamelessly become open servants of the bourgeoisie, not opposing, but justifying the imperialist war and slaughter.

EPOCH OF IMPERIALISM

After a period of intense rivalry and international tension, the world war had finally erupted. The world conflagration was a clear indication of the impasse of world capitalism, where the productive forces – the key to the development of society – had outgrown the nation state and private ownership of the means of production. They were in rebellion against the confines of the system, which had now reached its limits. The imperialist war marked a turning point. It marked the dividing line between one epoch and another, and marked the end of the progressive stage of capitalism. The world war represented its highest stage, the epoch of imperialism, as Lenin had explained. This stage was characterised by the domination of international finance capital, world rivalries, world war and world revolution.

The planet had been divided up by the imperialist powers, so that only a redivision was possible.

> Monopolies, oligarchy, the striving for domination and not for freedom, the exploitation of an increasing number of powerful nations – all these have given birth to those distinctive characteristics of imperialism which compel us to define it as a parasitic or decaying capitalism. (LCW, vol. 22, p. 300.)

Imperialism had opened up an epoch of wars and proletarian revolutions.

Interestingly, the centrist Kautsky had developed his own theory of imperialism – so-called ultra-imperialism – which, given the domination of monopolies would lead not to intense rivalry, in his view, but a more harmonious, peaceful and 'planned' development of capitalism. This theory was completely blown apart by events.

German capitalism, which had arrived on the scene historically very late, had effectively missed out on the division of the globe by the imperialist powers, especially Britain. By the time of the First World War, Germany's empire was one tenth of the size of Great Britain's, with a population of only 12.3 million, compared to Britain's empire of 393.5 million.

> The more highly-geared the productive forces of Germany become, and the more dynamic power they acquire the more they are strangled within the state system of Europe – a system akin to some 'system' of cages within an impoverished provincial zoo. (L. Trotsky, *Germany 1931-32*, p. 45.)

The only way German capitalism could break out of the straitjacket of its national confinement was by a violent redivision of the world.

This explains the emergence of military blocs, with the formation of the British 'Entente Cordiale' treaty of friendship with France in 1904 and the Anglo-Russian Treaty of 1911, with Britain forming the linchpin. World war was only a matter of time. The assassination of Archduke Franz Ferdinand on 28 July 1914 was simply the excuse for the Austrian declaration of war on Serbia. In reality, any incident could have triggered the outbreak of war. It clearly reveals the relationship, in Marxist terminology, between accident and necessity. The assassination was an 'accident', which could or could not have happened. However, the accident revealed the deeper 'necessity' of the contradictions of imperialism that were ready to explode. All the objective factors were present. The 'accident' simply set in motion a series of events, resulting in a far wider conflagration, a war between the great powers. It was to last for four years and three months.

ALL EYES ON GERMAN SPD

In every belligerent country, with a tiny exception, the leaders of Social Democracy capitulated to their own bourgeoisie, jettisoning the ideas of class struggle, solidarity and internationalism. On 1 August, Germany declared war on Russia. Millions of German and Russian troops were on the move and European war was inevitable. The eyes of the world's socialists were fixed on the German Social Democracy, which had pledged not to submit to the war without resistance. Its official position had long been a policy of "not a man nor a farthing for this system", including its wars.

On 4 August, the SPD chairman, Hugo Haase, read out a statement in the Reichstag on behalf of the parliamentary party:

> We are faced with the iron fact of war. We are threatened with the horrors of hostile invasions. We do not decide today for or against war; we have merely to decide on the necessary means for the defence of the country. Much, if not everything, is at stake for our people and their freedom, in view of the possibility of a victory of Russian despotism which has soiled itself with the blood of the best of its own people.

> It is for us to ward off this danger and to safeguard the culture and independence of our country. Thus, we honour what we have always pledged:

in the hour of danger we shall not desert our fatherland. We feel ourselves in agreement with the International which has always recognised the right of every nation to national independence and self-defence, just as we condemn also in agreement with the International, any war of conquest. We demand that, as soon as the aim of security has been achieved and the opponents show themselves ready for peace, this war should be ended by a peace which makes it possible to live in friendship with neighbouring countries...

Guided by these principles, we shall vote for the war credits. (E. Anderson, pp. 17-18.)

The statement was loudly and enthusiastically applauded by the bourgeois deputies. Despite its references to the International, opposition to wars of conquest and national independence, the intention was clear: support for the imperialist war. Not a single voice of dissent was heard in the Reichstag. For the International Socialist movement, it came like a hammer blow. With one single act it would shatter everything they supposedly stood for.

Of course, they attempted to cover up their guilt. But nothing could disguise the betrayal of internationalism and the cause of the International. Nothing could hide their defence of the capitalist fatherland, including their alliance with the reactionary Junker aristocrats and bourgeois parties. They even tried to use selected quotations ripped out of context from Marx and Engels written in 1848 and 1859 and later to justify their actions.

Marx and Engels were talking in the context of the progressive bourgeois-democratic revolutions of 1848. These had the aim of destroying the forces of feudalism and absolutism. The revolution's aim was to put an end to the backwardness of Germany, which consisted of dozens of petty and despotic principalities, together with Prussia and Austria, by uniting all Germans into one democratic republic. But the 1848 revolution was defeated.

This was a period of national-democratic movements and the creation of nation states. The quotes from Marx and Engels can only be understood with reference to this historical background. When war did finally break out in 1870-1871, between France and Germany, it was an historically progressive war on the part of Germany for national unification, until Napoleon III was defeated. The French bourgeoisie and Russian tsarism had oppressed Germany for decades, keeping it in a state of disunity. Even then, at the beginning of the war, Marx and Engels approved of the refusal by Bebel and Liebknecht to vote for war credits and to uphold the independent class interests of the proletariat. Once Germany won the 1870 war and laid the foundations for a united Germany, it proceeded to annex two French provinces of Alsace and Lorraine, which was a reactionary turning-point. As soon as the war

turned into one of occupation and plunder of French territory, Marx and Engels came out emphatically against the Germans. That period of national-democratic revolution ended in 1871.

Nevertheless, the SPD leaders used these same quotes to justify their support for imperialist aggression. But these quotes could not erase the anti-war resolutions the whole International had agreed earlier, but now conveniently discarded.

Russian tsarism – which was certainly the bastion of autocracy and reaction – was viewed as the 'aggressor' by the SPD leaders, while German war aims were considered 'just', namely a defensive war against foreign aggression. But it is not *who* fired the first shot that matters in a war, which is full of provocations on either side, but what class interests are involved in that war. As the great military theorist Clausewitz explained, "war is the continuation of politics by other means". In reality, the Kaiser's so-called 'defensive war' was simply a pretext for the High Command's military ambitions and the expansionist and imperialist desires of the German ruling elite.

Slyly, the German military waited before ordering a full-scale mobilisation so as to allow the Russians to mobilise first, thereby pinning the blame on them. This is what is called the art of bourgeois diplomacy, the application of trickery and deceit, so as to place the responsibility on your opponents. This then provided the cover that guaranteed the support of the SPD for a 'defensive' war. The war aims of the adversaries involved the redivision of the world between the imperialist powers, in which German capitalism was demanding a bigger share at the expense of Britain and the other gangsters. It was a predatory war on all sides over the redivision of the spoils.

The German Social Democratic parliamentary group took its fateful decision to support the war after a soul-searching debate, and even some opposition. Some deputies advocated simply abstaining on the vote for war credits, as Bebel and Wilhelm Liebknecht had done during the Franco-Prussian war of 1870-71. But this was rejected on the grounds that this war constituted the biggest crisis in the history of the German people, and the Social Democrats, as the largest party in the Reichstag, could not abandon their responsibilities and remain neutral. Then Kautsky suggested that they could vote for the war credits on condition that the government waged a 'defensive war', but this too was rejected. The majority of deputies had made up their mind to support a 'just' war in defence of the fatherland.

At the parliamentary group meeting, out of 110 deputies, only fourteen refused to vote for the credits, which included Karl Liebknecht. The opposition, however, decided not to openly break party discipline in the Reichstag and dutifully, but reluctantly, voted in favour of the war credits.

Even Liebknecht was pressured to go along with this line. Fortunately for him, the ageing August Bebel had been spared this indignity by his timely death a year earlier.

To add to the air of confusion and hypocrisy, as the SPD deputies voted for war credits, they also declared their continued adherence to the International, socialism and peace! In this surreal atmosphere, where the 'national interest' prevailed, they had no feelings of conscious betrayal or the abandonment of socialism. The war was only seen by them as a necessary defensive measure to save German civilisation and to fight against the reactionary forces that threatened the country. Some, like Haase and Kautsky, saw the conflict as a temporary affair and that things would soon return to normal. But events showed that this was make-believe.

On 2 August, barely twenty-four hours after the declaration of war, the trade union leaders – even more eager than the SPD deputies to oblige – rushed to sign an agreement with the employers that banned strikes and lockouts for the duration of the hostilities. Collective agreements would be simply extended for that period of time. Thus, was sealed the trade union and political truce "in the national interest" (Burgfrieden), which meant the class struggle was suspended until the end of the war. With a collective sigh of relief, these bureaucrats had protected themselves and their organisations from illegality, which they sought to avoid at all costs. For them, opposition to the war was regarded as foolish, and would have solved nothing. Opposition would put at risk, in their eyes, all that had been built up, and might mean personal imprisonment or exile. They felt comfortable in betraying their principles, because these principles had in reality been betrayed long ago.

The German government and the general staff had in fact made secret plans to arrest the Social Democratic leaders on the outbreak of war. But that proved unnecessary. "I know no more parties, I know only Germans," remarked the Emperor, in a statement to the Reichstag that even impressed many of the Social Democratic and trade union leaders.

STUNNING BLOW

Elsewhere, the news of the German Social Democracy's support for war came as a shocking calamity. Pavel Axelrod, the leader of the Mensheviks at the Zimmerwald Conference, stated:

> For us, the news was a terrible, stunning blow. It appeared as if an earthquake had overcome the international proletariat. The tremendous authority of the German Social Democracy had disappeared at one stroke.

Hermann Greulich of the Swiss socialists said:

> When the news came that the Social Democrats had unanimously sanctioned the military credits we did not believe it. It was a dumbfounding blow. (J. Braunthal, *History of the International*, p. 7.)

Even Bernstein, who had adopted a pacifist approach, said some years later that "the fourth of August, 1914 was the blackest day of my life." (B. Fowkes [ed.], *The German Left and the Weimar Republic, Selection of Documents*, p. 207.)

The prestige of the German party within the International had been so boundless, that Lenin, who was in Switzerland, first thought the issue of the SPD journal *Vorwärts* announcing the news that the SPD had voted for the Kaiser's war credits was a forgery of the German general staff. The Romanian Socialist Party's newspaper also declared the *Vorwärts* report a monstrous lie. "During the last war," wrote Trotsky, "not only the proletariat as a whole, but also its vanguard, and, in a certain sense, the vanguard of this vanguard was caught unawares." (L. Trotsky, 'Bonapartism, Fascism and War', *Writings 1939-1940*, p. 411.)

The vote by the German Social Democracy in favour of war and their decision to side with Prussian militarism was widely condemned by the other Social Democratic leaders of the western democracies. But this condemnation had nothing to do with a defence of internationalism and socialism. It simply provided them with the excuse they needed to line up behind their own capitalist class, "to make the world safe for democracy," as they put it. Following the German vote, the French government's request for war credits was accepted unanimously without a debate. The French socialists, like the Germans, voted unanimously in favour and joined the *union sacrée*. The Belgians followed suit, as did the British. Only the Russian and the Serbian socialists, to their credit, voted to oppose the war. In their eyes, the British, French, and Belgian Social Democrats were as guilty as the Germans for this act of treachery. However, they tended to place the chief blame on the shoulders of German Social Democracy, the self-proclaimed leaders of the world movement. This was not because they were considered any worse than the others, but because they had been thought of as superior. They were, after all, the *model* party of the International.

A more principled stand was taken by the Italian Socialist Party through its newspaper *Avanti*. "It opposed chauvinism and exposed the selfish secret motives behind the appeals for war", explained Krupskaya. "It was backed by the majority of advanced workers." (N. Krupskaya, *Reminiscences of Lenin*, p. 291.) But on the whole, the voices against chauvinism, those of the internationalists, were still very weak and isolated.

The bitter feelings of betrayal were summed up by Rosa Luxemburg:

German Social Democracy was regarded as the embodiment of Marxian socialism. It claimed and possessed a special position as the teacher and leader of the Second International... as the Vienna *Arbeiter Zeitung* wrote on 5 August, 1914: 'German Social Democracy had been the jewel in the organisation of the class-conscious proletariat'. It served as a model for French, Italian and Belgian Social Democracy and for the working-class movements of Holland, Scandinavia, Switzerland and the United States; and the Slavic countries, the Russians and the Balkan Social Democrats looked up to it with a boundless admiration which hardly admitted any criticism... With a blind confidence did the International accept the leadership of the admired and powerful German party, which had become the pride of all socialists and the terror of the ruling classes in all countries. (E. Anderson, pp. 21-22.)

These shattered illusions were all the more bitter as the German Social Democrats were now being unashamedly and ceremoniously used by the German Emperor, Kaiser Wilhelm, to promote his imperial war aims, which he pursued to the end.

"The character of German Social Democracy did not change on 4 August, it merely revealed itself to everyone," said Friedrich Stampfer. "What did break down was the dream-wish of a revolutionary mass party which, in reality, had never existed." (ibid., p. 22.)

While there was a minority in the party who were opposed to the war, from ordinary members to local and provincial committees and even some newspaper editors, it is difficult to assess its strength due to the tough censorship imposed on the first day of the war. But the fact that even fourteen deputies were in favour of voting against, indicated certain unrest and opposition in the party.

Despite this, the bulk of the German Social Democratic newspapers rapidly fell into line in August 1914, or were purged, regurgitating all the anti-Russian propaganda from years gone by. Here are some extracts:

Bielefelder Volkswacht, 4 August: "The slogan is the same everywhere: against Russian despotism and treachery!"

Braunschweiger Volksfreund, 5 August: "The irresistible pressure of military power affects everyone. However, the class-conscious workers are not merely driven by force. In defending the soil on which they live against the invasion from the East, they follow their own conviction."

Hamburger Echo, 11 August: "We have to wage war above all against Tsarism, and this war we shall be waging enthusiastically. For it is a war for culture." (ibid., p. 18.)

After this monstrous betrayal, Rosa Luxemburg, who felt shell-shocked and isolated, described the Second International as a "stinking corpse", which had in reality delivered the proletariat bound, hand and foot, to the Kaiser's military machine.

It was naked chauvinism that now asserted itself, not only in Germany, but in other countries, a chauvinism that would burn itself out in the bloody conflagration of world war. Despite all the pious declarations of being 'just' and 'defensive', events would expose the real nature and horror of imperialist war. All the justifications became increasingly hollow as time went on. The war eventually gave birth to revolution. But this was some years away.

ZIMMERWALD

The Second International was dead. In fact, it had split into two hostile groups on the lines of the warring parties and held separate meetings. Those parties that were part of the Entente met in London in February 1915. Those parties that were in the camp of the Central Powers met two months later in Vienna.

Apostasy was rife. It even affected Plekhanov, the father of Russian Marxism, and the old anarchist Kropotkin, who put the necessity of an *Entente* victory before the principles of anarchism.

In August 1914, the numbers who remained true to the ideas of revolutionary internationalism on a world scale were reduced to a tiny handful. The betrayal had left them completely isolated and atomised. Lenin, Trotsky, Liebknecht, Luxemburg, John MacLean in Scotland and James Connolly in Ireland, together with other internationalists had been reduced to tiny groups. Nevertheless, they struggled against all the odds, including imprisonment and exile, to maintain the principles of Marxism and the ideas of internationalism.

When they finally gathered in the tiny Swiss village of Zimmerwald for an anti-war conference in the autumn of 1915, Lenin joked that the total sum of the world's internationalists could be grouped together in a few stagecoaches. Only forty-two anti-war socialists attended from twelve countries. The internationalists sought to distinguish themselves from the 'social chauvinists', or 'social patriots', as the labour and socialist leaders, who supported 'their own' ruling classes, were called. In contrast to the apostasy, they defended the fundamental principles of scientific socialism; of the class nature of imperialist war; the class nature of the state; the right of nations to self-determination and the need, above all, for international socialism.

Neither Luxemburg nor Liebknecht were present at the Zimmerwald conference, as both were in prison. Liebknecht had, however, sent a letter of solidarity to the conference which stated:

You have two serious tasks, a hard task of grim duty and a sacred one of enthusiasm and hope.

Settlement of accounts, inexorable settlement of accounts with the deserters and turncoats of the International in Germany, England, France, and elsewhere, is imperative.

It is our duty to promote mutual understanding, encouragement, and inspiration among those who remain true to the flag, who are determined not to give way one inch before international imperialism, even if they fall victims to it, and to create order in the ranks of those who are determined to hold out...

Civil war, not civil peace! Exercise international solidarity for the proletariat against pseudo-national, pseudo-patriotic class harmony, and for international class war for peace, for the socialist revolution...

The new International will arise; it can arise on the ruins of the old, on a new and firmer foundation. Today, friends, socialists from all countries, you have to lay the foundation stone for the future structure. ('Draft Manifesto of the Zimmerwald Left', in *Sotsial Demokrat*, No. 45-46, 11 October, 1915.)

While the delegates applauded, there were clear political divisions even within this gathering. The Zimmerwald Left, led by Lenin, held a consistent revolutionary position, and pushed for the vision of establishing a future Third International. In fact, it was only the Bolsheviks who called for a complete break with the Second International, now utterly bankrupt, and an organisation which could not be revived in any form. However, the majority of delegates present tended towards centrism and pacifism, and looked towards re-establishing a reformed Socialist International. They were quite politically confused. Most moved to the right and ended up in the halfway house of the 'Two-and-a-Half International', which gathered together a layer of the centrists for a time. Formally, the 'Two-and-a-Half' was constituted in February 1921, and the main component was the Austrian Social Democracy, the so-called 'Austro-Marxists'. It maintained a precarious existence, mainly on paper, and collapsed with the outbreak of the Second World War.

As Trotsky explained:

The Zimmerwald conference was a conference of very confused elements in its majority. In the deep recesses of the masses, in the trenches and so on, there was a new mood, but it was so deep and terrorised that we could

not reach it and give it an expression. That is why the movement seemed to itself to be very poor and even this element that met in Zimmerwald, in its majority, moved to the right in the next year, in the next month. I will not liberate them from their personal responsibility, but still the general explanation is that the movement had to swim against the current. (L. Trotsky, *Writings, 1938-9*, p. 253.)

LENIN AT ZIMMERWALD

Lenin was far more clear-headed and convinced of what needed to be done:

> The Second International is dead, overcome by opportunism. Down with opportunism, and long live the Third International, purged not only of 'turncoats'... but of opportunism as well. The Second International did its share of useful preparatory work in [the] preliminary organising [of] the proletarian masses during the long 'peaceful' period of the most brutal capitalist slavery and the most rapid capitalist progress in the last third of the nineteenth and beginning of the twentieth centuries. To the Third International falls the task of organising the proletarian forces for a revolutionary onslaught against the capitalist governments, for civil war against the bourgeoisie of all countries, for the capture of political power, for the triumph of socialism. (LCW, vol. 21, pp. 40-41.)

But Lenin and the Bolsheviks were in a minority at Zimmerwald. Their language, given the isolation of the movement, tended to be a little ultra-left. After all, they were not speaking to the masses, but to small groups, and to the cadres. They needed to be very sharp in the midst of all this confusion and make a clear distinction between themselves, the revolutionaries, and the social chauvinists who had betrayed the movement. There could be no halfway house, explained Lenin; there needed to be a clean break and a spotless banner. However, at this point, the revolutionary Left did not have sufficient forces to declare a new International. To do this, new independent Marxist parties would need to be established in a number of countries. And new conditions and big events would be needed before such a development could happen. Nevertheless, they took part in the Zimmerwald conference, raising the banner of a new international, and helping to form a left wing of the international movement that would become the basis of the Third International.

When Lenin proposed a new International and to "turn the imperialist war into a civil war", he only got seven votes against thirty, and among the Germans present only one, Borchardt. The other German delegates, while sympathetic to his criticisms of the Second International, and the German

Social Democracy in particular, were unwilling as yet to break and declare for a new International.

While the Zimmerwald Manifesto, produced by the conference, came out against the imperialist war, not one of Lenin's ideas – the struggle against the 'social-patriotic' leaders, the transformation of the imperialist war into a civil war, the establishment of a Third International – found any echo in the document. As Zinoviev wrote:

> The last thing the Conference wished was to declare open war on opportunism… The conveners of the conference and the majority of those present declared, and still declare, that they did not wish to create a Third International. (J. Braunthal, *History of the International*, p. 49.)

The Manifesto did not say all that it should have said, but it represented a step forward. In the end, the Manifesto, drafted by Trotsky, was adopted unanimously, both by the pacifist majority and, despite their criticisms, the revolutionary left led by Lenin.

The three-page manifesto concluded with the words:

> Working men and women! Mothers and fathers! Widows and orphans! Wounded and crippled! To all who are suffering from the war or in consequence of war, we cry out over the frontiers, over the smoking battlefields, over the devastated cities and hamlets: 'Workers of all countries unite!' (L. Trotsky, *The War and the International*, p. 89.)

The Zimmerwald Manifesto was published in socialist newspapers in Britain, Italy and the neutral countries, but it only circulated clandestinely in Germany, France and Russia. The Manifesto's appeal nevertheless evoked a powerful response to the anti-war movement, as its internationalist message echoed everywhere. As expected, the leaders of the Second International contemptuously brushed the Zimmerwald conference aside. Camille Huysmans, the secretary of the Second International, said that the gathering at Zimmerwald was a "party of sharpshooters without troops", and the official International would have nothing to do with them.

However, the Zimmerwald conference laid the basis for a second conference at Kienthal in Easter 1916, attended by forty-four delegates. The conference saw a certain shift to the left, which saw it edge closer to the position of the Bolsheviks, though they were still in a minority.

According to Zinoviev:

> [T]he second Zimmerwald conference undoubtedly represented a step forward. But can one say that the die is cast, that the Zimmerwald comrades have now finally taken the road towards a break with the official Socialist

parties, that Zimmerwald has become the nucleus of a Third International? No, in all good conscience this cannot yet be said. (Quoted in J. Braunthal, p. 51.)

Lenin also had a sober view about the prospects of a new international, which he expressed in his pamphlet *Socialism and War*:

It is perfectly clear that to create an international Marxist organisation, there must be a readiness to form independent Marxist parties in various countries. As a country with the oldest and strongest working-class movement, Germany is of decisive importance. The immediate future will show whether conditions are mature for the formation of a new and Marxist International. If they are, our party will gladly join such a Third International, purged of opportunism and chauvinism. If they are not, then that will show that a more or less protracted period of evolution is needed for that purging to be effective. Our party will form the extreme opposition within the old International, pending the time when the conditions in various countries make possible the formation of an international workingmen's association standing on the basis of revolutionary Marxism. (LCW, vol. 21, p. 330.)

Meanwhile, the centrist Kautsky was busy trying to hide the shame of the old International by trying to excuse its behaviour in wartime: "The International is not an effective weapon in war-time," he said, "it is essentially a weapon of peace." In other words, at a time when the International is needed most, it is useless.

THE SPARTACISTS

On the eve of the First World War, the leftists within the German SPD had crystallised into a loose grouping, which enjoyed certain sympathy throughout the party. By the time of the outbreak of war, this grouping became the basis of the small anti-war opposition led by Franz Mehring, Karl Liebknecht and Rosa Luxemburg. But the group was far from consolidated, which caused Luxemburg to complain bitterly at the state of the opposition:

I want to undertake the sharpest possible action against the activities of the [Reichstag] delegates. Unfortunately, I get little co-operation from my [collection of] incoherent personalities... Karl [Liebknecht] can't ever be got hold of, since he dashes about like a cloud in the sky; Franz [Mehring] has little sympathy for any but literary campaigns. [Clara Zetkin's] reaction is hysteria and the blackest despair. But in spite of all this I intend to try to see what can be achieved. (J.P. Nettl, p. 611.)

Franz Mehring, a party veteran, had broken from liberalism after studying the works of Marx and Engels. He joined the party in 1891 and began work for

the *Neue Zeit*, to which he made many important contributions on history, philosophy and literature. It is true he came to the movement late in life, and only after a great internal struggle, but once he came over to Marxism, he remained firmly committed to the end of his life. Mehring had immediately joined the fight against revisionism as soon as it emerged. Between 1906 and 1911 he was a lecturer at the party school in Berlin, which revealed his political abilities. He became one of the leaders of the left wing and was one of the first to come out openly against the Kaiser's war. During the 1918 revolution he helped to found the Communist Party, but became ill and he finally died in January 1919, a few days after the murder of Rosa Luxemburg and Karl Liebknecht. The tragic news of the fate of his comrades certainly shortened his life.

Karl Liebknecht did not so much join the Social Democratic Party, but was very much born into it. He was the son of Wilhelm Liebknecht, one of the party's founders and a close friend of Marx and Engels. In his youth, Karl championed the anti-military struggle, the principles of which were spelled out in his pamphlet *Militarism and Anti-militarism,* which was submitted to the first youth congress of the party in 1906. The publication of the pamphlet earned him an eighteen-month prison sentence, which turned him into a symbol of revolutionary internationalism and irreconcilable opposition to imperialist war. After a further term of imprisonment, he was finally released in 1912, when he was elected as a Reichstag deputy for the SPD.

Trotsky, who knew Karl Liebknecht quite well, explained:

> Although he was an educated Marxist, he was not a theorist but a man of action. His was an impulsive, passionate and heroic nature; he had, moreover, real political intuition, a sense of the masses and of the situation, and an incomparable courage of initiative. He was a revolutionary. It was because of this that he was always a half-stranger in the house of the German Social Democracy, with its bureaucratic faith in measured progress and its ever-present readiness to draw back. (L. Trotsky, *My Life*, p. 218.)

Rosa Luxemburg, on the other hand, was a key theoretician of the party, and was the author of several theoretical works on economics, politics and other questions. Being of Polish origin, 'our Rosa', as she was affectionately known, had participated in the Polish and Russian revolutionary movements. She later became a naturalised German by a marriage of convenience, and her subsequent activity became concentrated within the German Social Democracy. It was there that she participated in the debates against Bernstein and revisionism, her articles in the party press on this question being compiled

Karl Liebknecht

and published in pamphlet form, *Reform or Revolution* in 1898. This was her first important political work against reformism.

However, Luxemburg was no novice. She was imprisoned for three months in July 1904 for 'insulting the emperor'. She had also served time in Russian Poland for her activities in the 1905-1906 revolution. Following the experience of the Russian revolution of 1905, Luxemburg drew the lessons for German workers in a work entitled *The Mass Strike, the Political Party and the Trade Unions*. In this, she stressed the importance of the spontaneous movement of the working class, which arose naturally in the course of the class struggle. However, her view of spontaneity was not a mechanical concept that excluded a conscious leadership. She was not 'anti-leadership' or against 'centralism' and had no truck with anarchism. She understood the importance and dialectical relationship of the party, leadership and the masses. She nevertheless placed her confidence in the movement of the masses, which was the motive force of history. If Luxemburg leaned towards spontaneity, it was only to counter the stultifying bureaucratic nature of the mass organisations – as they evolved in Germany during the upswing of German capitalism – which acted as a brake on the movement.

A glimpse of this monolithic character of German Social Democracy was given by Gustav Noske, a Social Democratic deputy, when the party was accused of undermining the discipline in the armed forces due to its actions. Noske simply answered: "Where in Germany is there a greater measure of discipline than in the Social Democratic Party and in the modern trade unions?" (Quoted in R. Watt, p. 114.) This was true, but such 'discipline' could be both bureaucratic and oppressive.

Much has been made out of Luxemburg's 'theory' of spontaneity, which is completely false. The whole bogus idea was mischievously put into circulation by Zinoviev, the then-head of the Communist International, in the first part of the 1920s, claiming it was part of 'Luxemburgism'. The object of this legend was to increase the prestige of the Russian Communist Party and the Communist International. It was supposed to demonstrate Luxemburg's lack of understanding of the importance of the party as well as an uncritical worship of the masses, both of which was untrue.

Writing in 1913, she declared:

> Leaders who hang back will undoubtedly be pushed to one side by the advancing masses, but to wait first patiently for this definite sign that the situation is ripe may be alright for a lonely philosopher, but for the political leadership of a revolutionary party it would spell moral bankruptcy. The task of Social Democracy and its leaders is not to let themselves be dragged along in the wake of events, but deliberately to forge ahead of them, to foresee the trend of events, to shorten the period of development by conscious action, and to accelerate its progress. (P. Frölich, p. 168.)

Rosa Luxemburg was an important figure at all the congresses of the International, and was a member of the International Socialist Bureau. She even participated in the Russian party whenever possible and attended the London Congress of the RSDLP in 1907, where she met with Lenin, Trotsky, Martov, Plekhanov and the other leaders. From 1910 onwards, Rosa Luxemburg became the leader of the opposition within the German Social Democracy. While she made some mistakes in theory, these arose from genuine revolutionary considerations. She was not afraid to grapple with problems. In the words of Joseph Conrad, "It's only those who do nothing that make no mistakes, I suppose." But despite the mistakes, Lenin viewed her with great admiration, "she was – and remains for us – an eagle," he said. After her death, Lenin defended her against her so-called 'Marxist' critics, who twisted her ideas. Their relationship was the solidarity shown between one revolutionary and another. Without doubt, Luxemburg was the most

outstanding representative of the Marxist left in Germany, a remarkable figure, and a giant internationally.

These two figures, Luxemburg and Liebknecht, were destined to play a towering role right up to the moment of their deaths in January 1919, which sadly provided the German revolutionary movement and the workers' International with its finest martyrs.

Paul Frölich, a participant at the time, wrote:

> Whilst Rosa Luxemburg gave the struggle its theoretical basis, Karl Liebknecht was undoubtedly the leader in action. During the last few years before the war, during the war itself, and in the early days of the Revolution they stood shoulder to shoulder – unto death. (P. Frölich, p. 208.)

INTERNATIONALE GROUP

Within weeks of the war, Liebknecht quickly came to realise that he had made a mistake in voting for the war credits out of loyalty, a stand which had been criticised by party activists. "Your criticisms are absolutely justified," he admitted. "I ought to have shouted 'No!' in the plenary session of the Reichstag. I made a serious mistake." (P. Broué, p. 51.) But Liebknecht was not going to repeat such a mistake ever again. In early December the Kaiser's government demanded new war credits. On 3 December, a few months after the calamitous vote on 4 August, Liebknecht broke party discipline and became the sole SPD deputy in the Reichstag to openly vote against them, the famous 'one against 110'.

Liebknecht stated:

> This war is not being waged for the benefit of the German or any other peoples. It is an imperialist war, a war over the capitalist domination of the world market. We must demand a speedy peace, a peace without conquest. (J. Riddell [ed.], *Lenin's Struggle*, p. 175.)

Within a short space of time, dissent spread through the Social Democratic Party, with provincial groups passing resolutions against the war policy of the leadership. While party officials placed obstacles in the way of organising these meetings, the military authorities also banned public meetings and demonstrations. In many ways the Socialist bureaucracy had joined hands with the forces of the state. Newspapers were gagged, and *Vorwärts* was suspended for three days. Liebknecht's lone opposition in the Reichstag shone out as a beacon, despite the double repression of party machine and military machine. He would become a focal point for the growing anti-war feeling.

Although Liebknecht was called up for military service in February 1915, this did not prevent him from conducting revolutionary work. But such activities were restricted by the prohibition of public demonstrations and meetings, all intended to silence any opposition. On 19 February, Rosa Luxemburg was arrested and sent to a women's prison in the Barnim Strasse in Berlin. Other arrests followed. Clara Zetkin was picked up in July, as was Wilhelm Pieck, Ernst Meyer, Hugo Eberlein and Friedrich Westermeyer. By April, Luxemburg was smuggling revolutionary manuscripts out of prison. They could lock her up but they were not going to silence her.

In May, Liebknecht issued a leaflet advancing the slogan, "the main enemy is at home", which was then taken up by Lenin. The repression, however, intensified. In April 1915 the first and only issue of the journal *Die Internationale* edited by Rosa Luxemburg and Franz Mehring appeared, in which Rosa plainly stated the International had collapsed and needed to be rebuilt afresh. As expected, the journal was promptly suppressed by government censorship and its editors, publishers and printers were indicted on charges of high treason.

But the mood was beginning to change as rationing was introduced. Hunger was now affecting sections of the population. On 28 May 1915, over a thousand women demonstrated for peace in front of the Reichstag. A few months later, women workers demonstrated in Stuttgart and in Leipzig.

Another direct appeal against the war came in June with the publication of the so-called 'Appeal of the Thousand', which was a letter directed at the Executive Committee of the SPD, and signed by 1,000 members and officials of the party. This declared that the war had now clearly revealed its imperialist nature, and called for the party to break the political truce and declare an immediate peace. This appeal created a stir when it appeared in one of the most important party newspapers, signed by respected leaders, Karl Kautsky, Eduard Bernstein and Hugo Haase, who was both president of the party and the parliamentary party at this time.

The Luxemburg-Mehring-Liebknecht tendency within the SPD, became known as the 'Internationale Group', and was the nucleus around which the future German Communist Party was to crystallise. From a loose current in the party, it began to reach out into the working class. By mid-1915, the group had established links in 300 localities and created a substantial underground network for the distribution of literature. Even so, this should not be exaggerated, as the group was still relatively small and uninfluential as far as the masses were concerned.

On New Year's Day 1916, at Rosa Luxemburg's insistence, the group's first underground conference was held in Liebknecht's house, a very modest

affair, which took the decision to launch a clandestine journal called *Spartacus*, named after the great revolutionary slave leader. From its first appearance, the group's members became known as the 'Spartacists', a name that would identify them and remain with them throughout the war years and even after the formation of the Communist Party. Rosa Luxemburg had drawn up a list of 'guiding principles' which were smuggled out of prison, discussed, agreed and then became the programme of the Spartacist League. She was released a month after the conference, but within six months she was re-arrested and imprisoned without trial in July 1916. She remained there until she was released by the November 1918 Revolution.

The Socialist Youth, the youth wing of the Social Democracy, which had held a secret conference at Easter 1916 in Jena, came out overwhelmingly behind the Spartacist League, not least because of Liebknecht's influence. Apart from the Spartacists, there were also some smaller left-wing groups, the most well-known was the 'International Socialists' of Julian Borchardt and the 'Bremen Left' led by Jan Knief and Karl Radek. These groups were, however, more politically aligned to the Bolsheviks than Rosa's group, which tended to maintain its independence.

GROWING OPPOSITION

Within months of the war, a far larger opposition grouping began to crystallise within the ranks of the SPD. This reflected itself in growing opposition amongst the Reichstag deputies. In December 1914, only one voted against the war credits, Liebknecht. However, in March 1915, twenty-five SPD deputies voted against, including Otto Rühle, while other Social Democratic deputies walked out before the vote. This policy of physical absence was one that the party was forced to accept. In August 1915, the rebellion rose to thirty-six, and by December of that year, forty-three of the 108 SPD deputies said they would no longer respect group discipline.

Following the December 1915 vote, Karl Legien, the President of the trade union confederation, the Generalkommission der Gewerkschaften, demanded the expulsion of those who had broken party discipline. Although this was rejected, shortly afterwards, as a concession to the trade union bureaucracy, Karl Liebknecht was ceremoniously expelled as an example to the other dissidents.

Nevertheless, disillusionment with the war began to affect the masses, who became more and more restive by the day. The Spartacist League issued an appeal in the name of Liebknecht:

> Workers, party comrades and women of the people! Do not let the second Mayday of the war pass without making it into a demonstration

of international socialism and protest against the imperialist slaughter. On the first of May we stretch out a fraternal hand, beyond all frontiers and battlefields, to the people of France, Belgium, Russia, England, Serbia, and the whole world. On the first of May we call in a thousand voices:

"Make an end to the vile crime of nation murdering nation! Down with all who organise it, incite to it and profit from it! Our enemies are not the French or the Russian people – our enemies are German Junkers, German capitalists and their executive committee – the German Government.

"Into battle against these mortal enemies of freedom, into battle for everything that constitutes the well-being and the future of the workers' cause, of humanity and civilisation!

"End the War! We want peace.

"Long live Socialism! Long live the workers' International! Workers of the world unite!"
(E. Anderson, p. 32.)

On May Day 1916, after agitation conducted by the Spartacists in the factories of Berlin, a mass demonstration took place on the Potsdamer Platz of 10,000 workers demanding: 'Down with the War! Down with the government!' The tide was clearly beginning to turn.

This protest against the war was unprecedented. For this act of defiance, Karl Liebknecht, while in uniform, was arrested by the authorities at the demonstration for his anti-war agitation. Workers attempted to release him, but were unsuccessful. In June, he was sentenced to two years and six months hard labour, despite his supposed immunity as a member of the Reichstag. The reason being that his former SPD colleagues spitefully voted to strip him of his parliamentary immunity. The degree of degeneration of this gang was shown by the speech of SPD deputy Landsburg:

Gentlemen... in Liebknecht we are dealing with a man who wanted, through an appeal to the masses, to force the government to make peace, a government moreover which has repeatedly expressed its sincere desire for peace before the whole world... This war is a war for our very homes... how grotesque was this enterprise... how can anyone imagine that [Liebknecht] could influence the fate of the world, play at high policy by shovelling handbills at people, by creating a demonstration in the Potsdamer Platz... Contrast this pathological instability with our [party's official] clear-headed and sensible calm... (J.P. Nettl, p. 649.)

On the day of his trial, some 55,000 munition workers downed tools and demonstrations took place in Stuttgart. There were further strikes in Bremen

and Braunschweig. "Extremism corresponds to the present needs of the uneducated masses," wrote Karl Kautsky contemptuously, but he couldn't help admitting that, "Today in the trenches, Liebknecht is the most popular man." (P. Broué, p. 60.) But Liebknecht was simply personifying the revolution. He had become a symbol of hatred towards the Imperial government and the continuing slaughter.

As a result, the authorities clamped down, arresting dozens of Spartacist workers who were given harsh prison sentences and even dispatched to the front. But all the authorities succeeded in doing was to spread revolutionary ideas further afield into the regiments. As mentioned, in July 1916, Rosa Luxemburg was re-arrested, followed by the seventy-year-old Franz Mehring. But repression was too late, the ice had already broken, and in November, 30,000 workers demonstrated in Frankfurt-am-Main against the war.

JUNIUS PAMPHLET

The Luxemburg-Liebknecht group issued a number of documents in a series entitled 'Spartacist Letters', mostly written by Luxemburg. The most famous of these appeared in April 1916 under the title 'The Crisis of Social Democracy', but was better known as the 'Junius Pamphlet', written by Rosa Luxemburg in prison, with 'Junius' being her pseudonym. The pamphlet was written a year before its publication and was originally intended to be submitted to the Zimmerwald conference, but there was confusion about the dates. Such was its impact that this remarkable document, which called for class struggle during the war, became a socialist classic in its own right.

Luxemburg did not deal in depth with the crisis in the German Social Democracy, but concentrated on the roots and causes of the war. It destroyed the arguments of the leadership's justification for its support of the butchery.

When Lenin received a copy of the pamphlet he responded with great enthusiasm: "At last there has appeared in Germany, illegally, without any adaptation to the despicable Junker censorship, a social democratic pamphlet dealing with questions of the war!" He continued, "The author, who evidently belongs to the 'Left-radical' wing of the party takes the name of Junius," unaware at this time of the identity of the author. "On the whole, the Junius pamphlet is a splendid Marxist work, and its defects are, in all probability, to a certain extent accidental." (LCW, vol. 22, pp. 305-306.)

One of Lenin's criticisms was the lack of organisation of the revolutionary left in Germany. "A very great defect in revolutionary Marxism in Germany as a whole is its lack of a compact illegal organisation that would systematically pursue its own line and educate the masses in the spirit of the new tasks," explained Lenin. (LCW, vol. 22, p. 307.)

With many of the Spartacist leaders in prison, the practical leadership of the League now fell to Leo Jogiches, a very capable individual. In particular, he took the initiative of launching a regular printed publication, the *Spartakus-briefe*, which was transformed from an information bulletin for a small group into a political organ for the wider movement. Other key figures who assisted the organisation included Crispin, Hoernle, Niebuhr, Ernst Meyer and Clara Zetkin.

BIRTH OF USPD

The growing discontent amongst the workers at the nightmare of the trenches and the hardships at home also reflected itself in pressure on the rank and file of the SPD. This served to embolden further the opposition, not only within the Reichstag, but throughout the party at large. By March 1916 those who refused to vote for the budget in the Reichstag continued to grow. In May, Hugo Haase, clearly under pressure, launched a savage attack against this state of siege, resulting in thirty-three deputies voting with him against its renewal. Increasingly bitter, the loyal deputies, who constituted the majority, now demanded that the minority face disciplinary measures. When the majority declared that the opposition had forfeited its right to belong to the parliamentary group, it effectively expelled them. This resulted in a split, which then forced the opposition to form their own parliamentary group in the Reichstag known as the Sozialdemokratische Arbeitsgemeinschaft. There were now two parliamentary groups in the Reichstag representing the Social Democratic Party.

This expelled faction won widespread support from the party membership and it succeeded in taking control of party organisations in Berlin, Bremen and Leipzig, as well as other key industrial centres. As a result, the national leadership of the SPD engaged in a witch-hunt to drive all opposition out of the party. These attacks led to a purge of the editorial boards of newspapers, which were under the influence of the opposition. On 17 October 1916, a successful coup was carried out against the editors of *Vorwärts*; on 5 December the *Bremer Bürgerzeitung* and on 30 March 1917 the Brunswick *Volksfreund* editors were also removed. Haase called it "a second anti-socialist law". Among the major papers, only the *Leipziger Volkszeitung* remained under the control of the centrist opposition.

Vorwärts had become increasingly identified with the growing parliamentary opposition and the SPD leadership could no longer tolerate such a display of disloyalty. In collusion with the military censors, the old staff was removed and Herman Müller was chosen as editor with complete responsibility for the paper. From this time onwards, *Vorwärts* became a tool

of the right wing. It was no accident that, when workers moved in January 1919 against the government, their first act was to occupy the buildings of *Vorwärts.*

In response to these attacks, the centrist opposition held a national conference on 7 January 1917 in Berlin. Out of 157 delegates present, thirty-five were Spartacists. The tactics of the Spartacists were simply to exert pressure on the opposition to remain within the SPD and fight for its renewal. A day before the conference, Luxemburg warned against the opposition splitting away from the party, as she had always been opposed to premature splits. She feared that good workers would be left behind, and left to the mercy of the old right wing.

> Understandable and praiseworthy as the impatience and bitter anger of our best elements may be... flight is flight. For us it is a betrayal of the masses, who will merely be handed over helpless into the stranglehold of a Scheidemann or a Legien [the right-wing SPD and trade union leaders] ... into the hands of the bourgeoisie, to struggle but to be strangled in the end. One can 'leave' sects or conventicles when these no longer suit and one can always found new sects and conventicles. But it is nothing but childish fantasy to talk of liberating the whole mass of proletarians from their bitter and terrible fate by simply 'leaving' and in this way setting them a brave example. Throwing away one's party card as a gesture of liberation is nothing but a mad caricature of the illusion that the party card is in itself an instrument of power. Both are nothing but the opposite poles of organisational cretinism, this constitutional disease of the old German Social Democracy... (Quoted in J.P. Nettl, pp. 656-657.)

However, it was not up to Luxemburg or the opposition. The decision about a split was in the hands of a majority on the Executive Committee of the SPD, which took swift measures against the opposition for "factionalism". It abruptly announced that the opposition had "placed itself outside of the party", for holding a conference, without any right of appeal. The opposition was bureaucratically expelled from all bodies, and where they held a majority, those bodies were closed down and reorganised. In this way, ninety-one local organisations were expelled.

The split was therefore imposed upon the opposition. They had no real intention of splitting, but they were now faced with no alternative but to set up a new party. It was a *fait accompli.* This new party was founded in Gotha at Easter 1917. This was no small split-off grouping, as the opposition took a huge chunk from the old party. The new Independent Social Democratic Party of Germany (known by its initials as the USPD or Left Independents) began with 120,000 members. At the same time, the split damaged the so-

called majority, who were left with around 170,000 members. From then on, the old SPD was generally referred to as the 'Majority Socialists'.

FEBRUARY REVOLUTION

The split in the German Social Democracy took place as exciting news of the February Russian Revolution reached Germany and spread rapidly throughout its industrial heartlands and the armed forces. The Minister of the Interior spoke in terms of "the intoxicating effect of the Russian Revolution." (P. Broué, p. 90.) The fact that a reactionary autocracy had been brought down by a popular uprising of the people did not go unnoticed by the war weary masses of Germany. The "German proletariat must draw the lessons of the Russian Revolution and take their own destiny in hand," declared the Spartacist, Fritz Heckert. (ibid., p. 91.)

By July, the Left Independents had won support in key areas, including Greater Berlin, Halle, Leipzig, Bremen and Brunswick. The Independents, however, were a heterogeneous organisation, which included both revolutionaries and reformists. The right and left of the movement suddenly found themselves united in their general opposition to the war. Individuals like Karl Kautsky and Bernstein (who had moved to a pacifist position) decided to join the new party to provide a counterbalance to the radicals, Rosa Luxemburg and Karl Liebknecht. But the new party also attracted tens of thousands of militant workers who were seeking a revolutionary alternative to the old SPD leaders. While the right wing of the new party was politically close to the Majority Socialists, the left wing became more aligned with the Revolutionäre Obleute. The Spartacists, after some debate, also decided to join the new party and constitute itself as an independent group, hoping to win it over to a revolutionary position. A smaller, but influential current, the Bremen Left, remained outside, hoping to build a separate revolutionary party, but it proved too weak to carry out this task on its own.

The Independent Socialists' break with the SPD in effect reflected a growing ferment, not only in the ranks of the SPD, but also in the ranks of the working class, radicalised by the war and the events of the February Revolution. Under this impact, the party evolved rapidly in a centrist direction, between the position of Marxism and reformism.

Centrism has a clear political meaning for Marxists. As Trotsky explained:

> Centrism is composed of all those trends within the proletariat and on its periphery, which are distributed between reformism and Marxism, and which most often represent various stages of evolution from reformism to Marxism – or vice versa. (L. Trotsky, *Germany, What Next*, p. 145.)

As a phenomenon it normally arises in a pre-revolutionary period, resulting in political radicalisation and turmoil in the mass organisations. As a political current, centrism is an unstable entity which straddles different tendencies, from left reformism – representing the labour aristocracy – to Marxism – representing the interests of the proletariat. What is of key importance is the direction of travel in which a centrist party is moving. Due to its unstable character, it can either go over completely to become a revolutionary party or it can revert back to a classical reformist organisation. It is only a transition from one radical stage to the next, but for individual politicians and leaders, centrism can become a settled way of life. They can too often end up as ingrained centrists, continually wavering between two political poles. The new USPD was being pushed by events, step-by-step, towards a more revolutionary standpoint, although its leaders remained very confused.

These centrist leaders did not fear so much the criticisms of Rosa Luxemburg, as the growing influence of Karl Liebknecht. While they welcomed the prestige he gave to the new party, Liebknecht also represented a pole of opposition and therefore a threat to their leadership. His revolutionary reputation had not only grown in Germany, but much further afield. Such was his fame that the war-weary French soldiers talked about him in the trenches.

"And yet," said one French soldier, "look! There is one person who has risen above the whole dastardly war; who stands illuminated with all the beauty and importance of great courage... Liebknecht..." (Quoted in J.P. Nettl, p. 660.)

Lenin also increasingly came to identify the opposition to war in Germany with the name of Liebknecht. "The Spartacus group is intensifying its revolutionary propaganda. The name of Liebknecht, a tireless fighter for proletarian ideals, is daily gaining in popularity in Germany," he noted. (LCW, vol. 26, p. 291.)

STRIKE WAVE

By 1917, hunger and war weariness had engulfed the mass of the German population. On 15 April 1917, the government announced a reduction in bread rations from 1,350 grams to 450 grams. The next day, the mood became angry as demonstrations and strikes broke out affecting 300,000 workers, half of them women. "Our worst enemies are in our midst... the agitators for strikes... Whoever goes on strike when our armies are facing the enemy is a cur," snarled General Groener. The trade union leaders agreed with him. "Strikes must be avoided," they declared. (P. Broué, p. 96.)

In the trenches loss of life reached astronomical levels. The French military calculated that, between August 1914 and February 1917, one Frenchman was killed every single minute. About 465,000 German soldiers died each year of the war. Soldiers at the front were increasingly sickened by the war, its bloodshed, brutality, poison gas, hunger, lice and, above all, the incompetent general staff. The result was mutiny, riots and strikes. Protests broke out in the navy, such as the hunger strike on the Prinzregent Luitpold and a walkout on the Pillau. The ringleaders were arrested, court martialed, imprisoned and then shot. Although these protests were suppressed by the authorities, they were threatening to turn into something altogether more dangerous.

In July, the Reichstag passed a famous 'Peace Resolution', in favour of a negotiated peace without annexations. But this resolution simply remained on paper. Generals Hindenburg and Ludendorff, the real power in Germany, thought the resolution treasonable. The leaders of the Majority Socialists nevertheless continued to cling onto the coat-tails of the government – which in turn clung to those of the generals – who were determined to continue the war.

Given the economic blockade surrounding Germany, the conditions of the working class in the factories were becoming intolerable. There had been a catastrophic collapse in living standards. This 'war to end all wars' was turning into a living nightmare as real earnings dropped by between twenty and thirty per cent. Average meat consumption fell in July 1918 to a mere twelve per cent of its pre-war level, while fish consumption fell to just five per cent. Only potatoes were available and became the staple diet. Supplies of coal began to run out, and in the bitter winter of 1917-18, thousands of starving children froze to death. The people were exhausted.

Discontent rose especially in the infamous 'turnip winter' of 1916-1917. Rations were continually cut by the authorities. Prices continued to climb, while the black market flourished for the wealthy. Adult consumption stood at 1,000 calories a day and infant mortality increased by fifty per cent compared to 1913 levels. Food riots became increasingly common, as shop owners selling at speculative prices were paraded through the streets by angry crowds. Stores were plundered and set on fire as desperation rose. In Russia, however, such 'troubles' were leading not only to strikes but to revolution.

THE RUSSIAN REVOLUTION

The news of the 1917 February Revolution in Russia provided a great impetus to revolt everywhere. The overthrow of tsarism – the bastion of autocracy and European reaction – and the establishment of soviets of workers, peasants and soldiers provided enormous inspiration to all those suffering at home and

in the trenches. Despite power being handed over to a bourgeois provisional government, the revolution represented only the first stage.

Rosa Luxemburg wrote to Hans Diefenbach from prison:

> You can imagine how deeply the news from Russia has stirred me. So many of my old friends who have been in prison for years in Moscow, Petersburg, Orel and Riga are now walking the streets as free men. That is some consolation to me... Although it makes my own chances of release smaller, I am overjoyed at the freedom of the others. (P. Frölich, p. 262.)

The effects of the Russian February revolution (March in the new calendar) were widespread. In Germany, in April 1917, a wave of strikes spread to the munition industries and beyond. In Berlin alone, hundreds of thousands went on strike. Strikes then took place in Leipzig in April involving 200,000 workers, where the call went up to establish workers' councils. However, as the movement subsided, the more militant elements were arrested and despatched to the front. But these measures only provoked greater discontent and served to spread it further afield.

Nine months later, news arrived of a second successful revolution in October 1917 (November in the new calendar) which had placed Lenin and the Bolsheviks in power. This had a further electrifying effect in Germany, as in every other country. In every barracks and factory, workers discussed the victory of the Russian working class. It constituted a massive sea change in the situation; the revolution in Russia was a ray of hope in the darkness and horror of world war. Most significantly, the Soviet government's first decree was an appeal to the peoples of the world for an immediate cessation of the war and a democratic peace based on self-determination and the renunciation of annexations. The Bolsheviks then went on to publish all the secret agreements of the tsarist regime and the old Kerensky government with the Allies – exposing their duplicity – and then rejected all the territory that had been promised to Russia. Soviet Russia was defiant in leaving the war.

BREST-LITOVSK

In December 1917, however, the Soviet government was forced to negotiate a separate peace with German imperialism, which had advanced its armies into Russian territory. The young workers' state was in a very weak position and the Bolsheviks hoped revolution in other countries would soon come to their rescue. Negotiations between Russia and Germany were held at Brest-Litovsk, where the Bolshevik delegation, led by Trotsky, attempted at every turn to make a revolutionary appeal over the heads of the military chiefs to the war-weary masses.

With him travelled Karl Radek, whose luggage bags were packed with revolutionary pamphlets and leaflets, and as soon as their train stopped at Brest-Litovsk, Radek, before the eyes of the diplomats and officers assembled on the platform to greet them, began to distribute the pamphlets among the German soldiers. (I. Deutscher, *The Prophet Armed*, p. 360.)

From the first day, the Soviets made internationalist appeals to the workers of the world. They took immediate steps to produce a German language newspaper, *The Torch*, for distribution to German soldiers in the trenches of the Eastern Front. Some 500,000 copies of each issue were printed for distribution.

The announcements and proclamations at Brest-Litovsk had a powerful effect on the psychology of the international working class. In January 1918, one of the greatest strikes broke out in the munition factories in Germany, which involved more than a million workers. It was a political strike called in opposition to the Treaty of Brest-Litovsk. It was led by the metal workers' leader Richard Müller, who was also the head of the Revolutionäre Obleute (The Revolutionary Shop Stewards). He had called a meeting of metal workers which decided to take strike action over a whole series of demands, including peace without annexations or indemnities and the right of self-determination of peoples, as defined at Brest-Litovsk by the Russian representatives. These trade union militants organised themselves in opposition to the war and the political truce of the trade union and socialist leaders. Many of their members had emerged from a small group of Berlin metal workers. This organisation of revolutionary shop stewards was later to join the Independent Socialists and, like the Spartacist League, carry on a separate existence within the party.

The accumulation of hardship and suffering caused massive discontent, especially among the workers and sailors. The deprivation of basic rights, such as the right to strike, the military dictatorship, hunger and rationing as a result of the blockade, the continuation of the war, sparked off a wave of strikes throughout Germany.

In Berlin alone, 400,000 workers went on strike. Meetings took place in different factories, from which a conference was called and an Action Committee was established, which included the workers' parties. This attempt to spread the strike further, in wartime conditions, led to a clash with the government. The dominant feeling amongst the workers related by Müller was: "We need arms. We need propaganda in the army. Revolution is the only way out." (P. Broué, p. 109.) In the end, 1 million workers were involved in this political strike. However, the government was too strong to be overthrown by a strike alone.

The government threatened the strikers with martial law unless they returned to work. Under such conditions, the workers' leaders had no alternative but to end the strike without negotiations. But this soon resulted in government repression, with over 50,000 former strikers being drafted into the armed forces. Lenin commented that this strike marked:

> [A] turn of sentiment among the German proletariat. We cannot say what course the revolutionary movement in Germany will take. One thing is certain, and that is the existence of a tremendous revolutionary force there that must by iron necessity make its presence felt. (LCW, vol. 27, pp. 546-547.)

At the same time, 1 million workers in Austria-Hungary joined a general strike in support of the Bolshevik's peace proposals in January and February 1918. Tens of thousands struck in Hungary. In the factories, workers eagerly followed every scrap of news from Brest-Litovsk with profound interest. The hope for peace had generated an explosive mood. "These were the first large-scale revolts of the peoples in the Habsburg and Hohenzollern empires," wrote Julius Braunthal. (*Millennium*, p. 208.) In February, Austro-Hungarian sailors joined in the protests, temporarily controlling half of the war fleet. A sailor condemned to death for his actions in the mutiny stated before his execution, "What happened in Russia emboldened us. Over there, a new sun has risen that will shine not only for the Slavs but for all the nations, and it will bring them peace and justice." (Quoted in J. Riddell [ed.], *The German Revolution*, p. 17.)

The Brest-Litovsk Treaty was finally signed on 3 March 1918, but at terrible cost to the Soviet government. It was a humiliating agreement forced on the weak workers' state by an aggressive Germany, with the Soviets unable to resist its military advance. The old Russian army did not exist and the new Red Army was only just being assembled. In other words, they were practically defenceless. That is why they were forced to sign a harsh deal with Germany. As a result, in the north-west they lost Poland, Lithuania, and the Baltic States of Estonia, Livonia and Courland. Finland took the opportunity to cede from Russia. The Ukraine did the same. The Turks regained their 1878 frontiers in the Caucasus. German imperialism had conquered Russian territory of a million square miles in total. This robbed her of one third of Russia's population, some 55 million people. Germany seized one half of Russia's industry and nine-tenths of its coal mines, three-quarters of its iron-ore, coupled with an indemnity of six billion marks. It was a blood-price the Bolsheviks had no choice but to pay to ensure the regime's very survival. "You must sign this shameful peace," said Lenin to the Congress of Soviets,

"in order to save the world revolution by preserving its most important and at present its only fulcrum, the Soviet Republic." (Quoted in E. Wollenberg, *The Red Army*, p. 12.)

The mass strikes against the war and those that followed the Brest-Litovsk Treaty demonstrated the powerful effect of the revolutionary propaganda conducted by Trotsky during the negotiations. As Karl Liebknecht wrote from his prison cell:

> Thanks to the Russian delegates, Brest has become a revolutionary platform with reverberations felt far and wide. It has denounced the Central European powers. It has exposed the German spirit of brigandage, lying, cunning and hypocrisy. It has delivered a crushing judgement on the peace policy of the German Majority, a policy which is not so much hypocritical as cynical. (P. Broué, pp. 102-103.)

LUXEMBURG AND THE RUSSIAN REVOLUTION

Luxemburg was in prison when news of the second Russian revolution reached her. She was ecstatic that the Russian workers had taken power. It was the breakthrough she had worked for. The war had given birth to a successful revolution, which was the beginning of a new world socialist revolution. The Russian Revolution was an international beacon to the workers of the world, who had been betrayed and pitted against one another since 1914. Although still in prison, and would remain there for the next twelve months, Luxemburg was overcome with joy and emotion. The Bolsheviks had put theory into practise, the very antithesis of the actions of the reformist leaders of the German Social Democracy. Paul Frölich explained in his biography of Luxemburg that she was always sparing with her praise, but had never praised the Bolshevik revolution with such enthusiasm.

This elation was expressed by her in writings while sitting in her prison cell. She explained that the Bolshevik Party grasped the mandate and duty of a truly revolutionary party. Luxemburg, her views so distorted, should speak for herself:

> Only a party which knows how to lead, that is, to advance things, wins support in stormy times. The determination with which, at the decisive moment, Lenin and his comrades offered the only solution which could advance things ('all power in the hands of the proletariat and peasantry'), transformed them almost overnight from a persecuted, slandered, outlawed minority whose leader had to hide like Marat in cellars, into the absolute master of the situation...

> Whatever a party could offer of courage, revolutionary far-sightedness and consistency in an historic hour, Lenin and Trotsky and the other comrades have given in good measure. All the revolutionary honour and capacity which western Social Democracy lacked were represented by the Bolsheviks. *Their October uprising was not only the actual salvation of the Russian Revolution; it was also the salvation of the honour of international Socialism.* (R. Luxemburg, 'The Russian Revolution', in *Rosa Luxemburg Speaks*, pp. 374-375, emphasis added.)

She concluded her essay:

> What is in order is to distinguish the essential from the non-essential, the kernel from the accidental excrescences in the policies of the Bolsheviks. In the present period, when we face decisive final struggles in all the world, the most important problem of socialism was and is the burning question of our time. It is not a matter of this or that secondary question of tactics, but of the capacity for action of the proletariat, the strength to act, the will to power of socialism as such. In this, Lenin and Trotsky and their friends were the *first* who went ahead as an example to the proletariat of the world; they are still the *only ones* up to now who can cry with Hutten: 'I have dared!'

> This is the essential and *enduring* in Bolshevik policy. (ibid., p. 395, emphasis in original.)

While in prison, Luxemburg was nevertheless getting frustrated with her confinement. "I expect great things to come in the next few years, but how I wish that I did not have to admire world history only through the bars of my cage," she wrote. (Quoted in J.P. Nettl, p. 689.)

This incarceration was a major problem for her. Isolated in prison, lacking real information, while she certainly agreed with their principles, she began to question some of the tactics of the Bolsheviks. Unfortunately, she had no means of discussing with the Russian comrades and so could not clarify her ideas and doubts. These played on her mind and, while in prison, she wrote down her criticisms with the intention of producing a pamphlet on the revolution. Luxemburg's criticism had nothing in common with the attacks of the enemies of the revolution, including the Mensheviks. Her thoughts were the thoughts of a comrade and friend of the Russian Revolution. However, they were not based on a sound knowledge of the real situation, which was denied to her. Without question, a dialogue with the Bolshevik leaders would have certainly cleared up such doubts. Time allowing, she would have certainly travelled to Moscow and discussed personally with Lenin and Trotsky, as did Clara Zetkin. As always, Rosa Luxemburg would have been open to being convinced.

Naturally, she was careful not to express her criticisms in public as she was afraid that they could be unscrupulously used by the enemies of the movement to attack the Revolution, which she wholeheartedly supported. Those Spartacists not in prison were extremely cautious of any criticisms of the Bolsheviks, given the difficulty of obtaining unbiased and accurate information, and the need to defend the proletarian revolution against its many enemies.

When Rosa Luxemburg wrote a letter from prison for the paper somewhat critical of the Bolsheviks, the editors turned it down, and Paul Levi made a special trip to see her to dissuade her from publishing it. According to Levi, she agreed without reservation. When she was released from prison, Luxemburg never published or tried to publish her unfinished work on the Russian Revolution. In an unfinished form, they were her isolated opinions, untested in discussion.

That would have been the end of the matter but, after her tragic death, the manuscript was published, despite her wishes, by Paul Levi in 1922, under the title of *The Russian Revolution*. Levi had been a leader of the Communist Party, but was expelled in 1921 for breaking discipline. The decision to publish the manuscript appeared to be a case of sour grapes. The publication was unfair to Rosa Luxemburg, who had no say in the matter. And, as she had feared, her criticisms were subsequently taken out of context by reformists and anarchists to attack Lenin and the Bolsheviks. Leo Jogiches, Rosa's closest associate, was very much opposed to its publication, knowing full well that Luxemburg had changed her opinions and she intended to write a new book on the subject. Thus, Levi's motivation to publish can be seen to be vindictive and was not strictly honourable. The attempt to use Luxemburg to attack the Russian Revolution was criminal. Lenin was justifiably angry at its publication.

Rosa Luxemburg was completely in favour of the Russian Revolution. There can be no doubt about this. On her release from prison, she had revised her views about the dispersing of the Constituent Assembly, especially after her own experience of how the issue of a National Assembly was used in Germany. She was disturbed about the 'Red Terror', but saw it as an inevitable consequence of imperialist encirclement and civil war. She admitted to her friend and comrade Adolf Warszawski that she had changed her opinions about these concerns since her release. On the basis of experience, in the few short months she had to live, she had resolved these questions in her own mind. Luxemburg wholeheartedly and without reservation embraced the Russian Revolution and Bolshevism.

Paul Frölich underlined this point in his biography:

Never at any time did she campaign against the Bolsheviks, and she never had the faintest intention of doing so. She was always sparing with her praise, and she has never praised a party with such enthusiasm as she praises the Bolsheviks in this work. It is a misrepresentation, and one which has been sedulously spread by the reformists, to say that she condemned the whole Bolshevik policy, including the November Revolution, and that she rejected the idea of the proletarian dictatorship, and thereby justified the policy of the Mensheviks. (P. Frölich, p. 272.)

The enemies of Bolshevism have continued to this day to distort Luxemburg's ideas and dress them up as something completely different. Her ideas have been chopped up and seized upon to justify anti-Bolshevism and anti-Leninism. She has been portrayed as an implacable opponent of Lenin and Bolshevism. But this is completely false. These epigones of 'Luxemburgism' would have been completely repudiated by Luxemburg herself. We must rescue Rosa Luxemburg from such pseudo-revolutionaries, who base themselves on her doubts and mistakes, which she later repudiated.

Luxemburg had in fact grown much closer to Lenin in the last two months of her life as a friend and equal. All the old disputes had melted away into irrelevance. The brief letter she wrote to him on 20 December 1918 reveals her sentiments:

Dear Vladimir,

I am profiting from uncle's journey to send you all hearty greetings from the family, from Karl, Franz [Mehring] and the others. May God grant that the coming year will fulfil all our wishes. All the best! Uncle will report about our life and doings, meantime I press your hand.

With best regards, Rosa.
(Quoted in J.P. Nettl, p. 782.)

'Uncle' is a code reference for Hugo Eberlein, who was the only German delegate to make the journey to Moscow for the founding Congress of the Communist International.

Although Rosa Luxemburg thought the founding of the new Third International premature under the circumstances, nevertheless, together with the Bolsheviks, she saw the Russian Revolution as the beginning of the world revolution and fully embraced it. Despite her private thoughts, which were misplaced, she nevertheless concluded her assessment with tremendous praise for of the Bolshevik Revolution.

In *this* sense theirs is the immortal historical service of having marched at the head of the international proletariat with the conquest of political power

and the practical placing of the problem of the realisation of socialism, and of having advanced mightily the settlement of the score between capital and labour in the entire world. In Russia the problem could only be posed. It could not be solved in Russia. And in *this* sense, the future everywhere belongs to 'Bolshevism'. (R. Luxemburg, 'The Russian Revolution', in *Rosa Luxemburg Speaks*, p. 395.)

This is Rosa Luxemburg's last judgement and is a fitting testament of her real feelings towards Lenin and Bolshevism.

CHAPTER TWO: IN THE THROES OF REVOLUTION

> We are all extremely glad that you, comrade Mehring and the other 'Spartacist comrades' in Germany are with us, 'head and heart'. This gives us confidence that the best elements of the West European working class – in spite of all the difficulties – will nevertheless come to our assistance.
>
> Lenin to Clara Zetkin, 26 July 1918

The wind blows the tops of the trees first. The November Revolution of 1918 was no exception; it began as all revolutions do – at the top. The *ancien régime* was caught between the shocks of world war, the approaching revolution and the rigid demands of autocratic rule.

The impending collapse had signalled the destruction of yesterday's national 'unity' of August 1914, which, as the war wore on, had evaporated like droplets of water on a hot stove.

Violently muzzled and restrained by military censorship, mass pressures were finally bursting through to the surface, like the "old mole of revolution" that Marx spoke about. The whole edifice of the Hohenzollern monarchy began to crumble as the ground, once so solid, shifted under its feet.

Consciousness, which is normally very conservative, was being tested by events and rapidly transformed. The picture quickly changed as all the pent-up contradictions in German society reached a critical state. A sudden movement would bring the whole thing crashing down.

While the old order, weighed down with contradictions, was facing collapse, this did not prevent the ruling elite from desperately clinging to power. Everything was being held together by no more than inertia. No

amount of cosmetic changes, soothing words or 'reforms' were going to save the situation. The regime's attempt to extradite itself from crisis simply made matters worse.

On the war front, Germany had experienced some important advances at the beginning of 1918. On 3 March, the Central Powers had just imposed a humiliating treaty on the Russians at Brest-Litovsk, seizing huge swathes of territory including control of Poland, the Baltic States, and the Ukraine. The German attacks of late March produced the most significant gains on the Western Front since 1914. The 'Ludendorff Offensive', named after the honoured General Erich Ludendorff, consisted of a series of German military strikes along the Front. It came so near to breaking the Allied line, that Ludendorff tried a second attack. Despite the advantage of troops released from the Russian front, it was not the breakthrough they had hoped for. The Germans were unable to move supplies and reinforcements fast enough to maintain their advance, which soon petered out. "Ludendorff is a man of absolute determination," Crown Prince Rupprecht noted, "but determination alone is not enough, if it is not combined with clear-headed intelligence." (H. Strachan, *The First World War*, p. 286.) Confronted with a counter-offensive supported by one or two million fresh American troops using new artillery techniques, surrender, rather than victory, now stared Germany in the face.

Of course, such a perspective was utterly unacceptable to the German High Command, which refused to accept reality or defeat. Instead, they simply demanded a further 200,000 men each month to 'make good' the losses suffered. Between 21 March and 4 April 1918, German forces suffered over 240,000 casualties. It was a futile waste of life. For the generals, it was just a question of greater effort. They demanded 'more severe internal discipline' until victory was assured. The war had become a gigantic mincing machine of men and supplies. By the autumn, the situation had grown steadily worse. The defeat at Montdidier on the Western Front on 8 August revealed that military victory was not possible. By the end of the Allied offensive on 4 September, the Germans had sustained 100,000 casualties and the Allies just over 42,000.

The alliance of the Central Powers was starting to come apart. Turkey signed an armistice at the end of October, and Austria-Hungary followed suit. Germany was left increasingly isolated in the face of the renewed Allied onslaught.

Faced with a deteriorating situation, the military chiefs had reluctantly accepted the need to sue for peace, but it was the *terms* that were in doubt. Although the generals accepted an armistice, they still needed time to prepare for an 'honourable' end to the war. Breathing space was required before

opening negotiations with the Allies. But this perspective was to prove too optimistic and was quickly overtaken by events, namely the mighty German Revolution. War – not for the first time in history – was turning out to be the mother of revolution. The Hohenzollern regime was coming to an end.

The German autocracy's eventual demise had similar parallels with the collapse of the tsarist regime in February 1917. As with all doomed regimes, desperate measures were introduced from the top to save the situation, but the situation could not be saved. The strategy facing the ruling clique was expressed in the words of minister Hintze: "we must forestall an upheaval from below by a revolution from above." (P. Broué, p. 130.) Hintze knew which way the wind was blowing and his words revealed a particularly sharp sense of smell.

"When the house is burning you may have to put out the fire with water from a cesspool, even if it stinks a bit afterwards", stated Robert Bosch, a trusted friend of minister Haussman, the Secretary of State. In this instance, the 'cesspool stink' was democracy, while the services of the Social Democrats were to be used to 'put out the fire'. (Quoted in S. Taylor, p. 6.)

PRINCE VON BADEN

As a result, General Ludendorff, head of the army, realised that the game was up and was asked to fall on his sword. He was shunted aside and 'parliamentary' government was quickly established on 3 October 1918 with the Kaiser's cousin, Prince Max von Baden, appointed as Chancellor. This was of course nothing more than a swift manoeuvre, a cosmetic change to buy time. "It seemed revolution was at the gates: the choice was to face up to it with dictatorship or with a degree of compliance... Parliamentary government seemed the best defence," explained General von Hindenburg, after weighing up the former option. (J. Braunthal, *History of the International*, p. 118.) Dictatorship would, under the circumstances, simply add petrol to the flames. It seemed that there was no alternative to a 'revolution' from above.

Partly to appease the masses, the new Imperial government included in its ranks the Social Democrats, Philipp Scheidemann and Gustav Bauer, who greatly relished their new roles as honourable wartime statesmen. These Social Democrats were once again prepared to do their 'duty' for king and country, as long as they were granted a seat at the table of the ruling class. With the German Empire clearly on the verge of collapse, the support of the Social Democrats was needed as a left prop to ease the 'transition' to stability. In reality, the new 'liberal' government of Prince von Baden was

hardly distinguishable from the previous one. The faces had changed but the content was just the same.

The new Chancellor rushed off an urgent request to President Wilson in the United States designed to secure "a speedy and honourable peace of justice and reconciliation." (Quoted in R. Watt, p. 150.) They hoped this road was open to them as they agreed to accept Wilson's Fourteen Point Peace Programme as a basis for negotiations. But Wilson's reply, some weeks later – dated 23 October – simply poured cold water on their offer of talks, stating that it was not possible for the Allies to "deal with the military masters and monarchical autocrats of Germany." The war dragged on. After being shown the note from Wilson, Kaiser Wilhelm exclaimed angrily: "Read it! It aims to overthrow my house, and the complete overthrow of monarchy!" (ibid., p. 32 and p. 151.)

Nevertheless, the ruling class knew full well that certain sacrifices were needed to save themselves and what was left of the old regime. The dilemma was outlined clearly by Konrad Haenisch, a Social Democrat, in a confidential letter to a friend:

> The problem is to resist the Bolshevik Revolution, which is rising, ever more threatening, and which means chaos. The Imperial question is closely linked to that of Bolshevism. We must sacrifice the Kaiser to save the country. (P. Broué, p. 144.)

It was either lose the monarch or lose everything. The old regime had no choice but to act swiftly to save itself. On 23 October, the same day as they received the reply from Wilson, the government announced an amnesty for political prisoners. This included Karl Liebknecht, who was greeted on his release by 20,000 Berlin workers. He addressed the crowd, hailing the Russian Revolution and calling for a proletarian revolution in Germany. Lenin sent a message of congratulations to him, which was read out by the Soviet ambassador and diplomat Adolf Joffe.

A week earlier, a demonstration called by leaders of the USPD attracted more than 5,000 workers, who faced police attacks. They marched on the Reichstag demanding, 'Down with the war; down with the government; long live Liebknecht!'

The Bolsheviks had sent Nikolai Bukharin undercover to Germany to discuss and build links with the Spartacists and the USPD leaders. He even met the revisionist Eduard Bernstein. Bukharin told him: "You are on the verge of revolution." But Bernstein, the 'realist', shook his head and ridiculed the suggestion. (J. Riddell [ed.], *The German Revolution*, p. 30.)

The government had hoped that concessions would be enough to stabilise the situation, but they were badly mistaken. The Social Democrats had persuaded the government to release Liebknecht as, in their view, it was more dangerous to keep him in prison as a martyr, than set him free. But granting freedom to such a legendary figure was a risky business. Scheidemann, who had supported his release, was subsequently astonished to see Liebknecht carried shoulder high by 'patriotic' soldiers who had been awarded the Iron Cross. But this outward public display was nothing more than an expression of the Revolution that was about to shake Germany to its very foundations.

Not surprisingly, Karl Liebknecht was immediately co-opted onto the action committee of the Revolutionary Shop Stewards, the Revolutionäre Obleute, which worked in solidarity with the Spartacists. However, the government's amnesty did not apply to Rosa Luxemburg, who continued to be held in 'protective custody' and not released until the Revolution itself burst open her prison cell on 9 November.

Weeks earlier, as the regime reeled from one crisis to another, steps had been taken to unify the various small revolutionary groups. The initiative was taken by the Spartacists, who organised an underground national conference that was attended by representatives of the Bremen Left. The conference agreed that the subsequent "collapse of German imperialism" had "created a revolutionary situation." They put forward a programme which included the expropriation of bank capital, the mines, mills, and "all large and medium sized agricultural holdings." The gathering led to greater co-ordination and they agreed to promote a campaign to set up workers' councils "where they do not already exist". They also agreed to fight for the establishment of a German Socialist Republic, "standing in solidarity with the Russian Soviet Republic, and thereby to unleash the world proletarian struggle against the world bourgeoisie for a proletarian dictatorship against the capitalist League of Nations". (J. Riddell [ed.], *The German Revolution*, p. 31.) News of the conference reached Lenin in Moscow, who personally wrote a letter of greetings to the participants:

> We have had news today that the Spartacus group, together with the Bremen Left Radicals, has taken the most energetic steps to promote the setting up of Workers' and Soldiers' Councils throughout Germany. I take this opportunity to send our best wishes to the German revolutionary internationalist Social Democrats. The work of the German Spartacus group, which has carried on systematic revolutionary propaganda in the most difficult conditions, has really saved the honour of German socialism and the German proletariat.

He went on:

Now the decisive hour is at hand: the rapidly maturing German revolution calls on the Spartacus group to play the most important role, and we all firmly hope that before long the German socialist proletarian republic will inflict a decisive blow on world imperialism. (LCW, vol. 35, p. 369.)

TALK OF INSURRECTION

The mood was rapidly changing, especially with the release of hundreds of political prisoners. The weakness of the regime was being openly exposed, so much so that there was talk on the left of an insurrection. While the Social Democrats wanted a 'reform' of the state and the establishment of bourgeois democracy, the Spartacists, the Revolutionäre Obleute, and the left-wing Independents were determined to go much further. They wanted a full-blown socialist revolution, the overthrow of the state, and the creation of a German Soviet Republic as a step towards world revolution.

On 2 November, at a joint meeting of the leaders of the USPD and the Revolutionary Shop Stewards in Berlin, an officer from the Second Guards' battalion was present who placed himself and his unit at the disposal of the meeting for the purpose of an insurrection. He was enthusiastically welcomed by the meeting, which only needed to settle on a date. Hugo Haase, the chairman of the Independent Socialists, who was prone to waver, was now intoxicated at the thought of revolution, and proposed 11 November. Others thought that the date for the seizure of power should be 4 November. Liebknecht, however, was against a premature rising without the necessary preparations. In the end, they agreed to call for a general strike and see how the movement developed afterwards. In the end, the Revolution was to break out on 3 November, earlier than 'planned', with the naval mutiny at the northern port of Kiel.

In the period leading up to the Revolution, the regime was split and in the process of disintegration, each proposed change from above only serving to hasten its demise. The government ministers were staring into the abyss and it was impossible to think rationally. All they thought about was saving themselves, but all they succeeded in doing was to open the floodgates. As the celebrated eighteenth-century French historian, Alexis de Tocqueville, once explained: "experience teaches us that, generally speaking, the most perilous moment for a bad government is one when it seeks to mend its ways."

Trouble started to brew on the war front as the army began to collapse; disaffection spread and desertions became more frequent. During the Ludendorff Offensive, Germany had already suffered more than 300,000 casualties, about one-fifth of available troops. The loss of life continued to mount up on a daily basis. In the autumn, the defeat of the Central Powers

was looking increasingly likely. But the heads of the Allied Entente were fearful, not so much of the eventual outcome of the war, as of the outbreak of Bolshevik revolution.

On 18 October, French Foreign Minister Stephen Pichon told Lord Derby, the British Ambassador, that he was disturbed that Germany was on the brink of revolution. "What frightens him [most] is the fact, as he says, that Bolshevism is very contagious…" (A. Read, p. 25.)

Lenin was also very confident that a worldwide revolution was imminent, and he wrote:

> In these past few days world history has given tremendous momentum to the world workers' revolution… The crisis in Germany has only begun. It will inevitably end in the transfer of power to the German proletariat. The Russian proletariat is following events with the keenest attention and enthusiasm. Now even the blindest workers in the various countries will see that the Bolsheviks were right in basing their whole tactics on the support of the world workers' revolution. (LCW, vol. 28, pp. 100-102.)

These prophetic words were written on 3 October 1918, exactly one month before the mutiny at Kiel and the beginning of the German revolution.

Generals Ludendorff and Hindenburg of the Supreme Military Command, the effective dictators of wartime Germany, took measures to deflect blame for Germany's approaching defeat away from themselves. On 28 October 1918, the German High Command, without informing the Chancellor, demanded immediate action. They ordered a decisive naval battle in the North Sea, which, if successful, would sever all British communications with the Continent and alter the balance of forces. They thought that such a brave endeavour, whatever the outcome, would save the 'honour' of Germany. "Better an honourable death than a shameful peace," the naval officers were reported as saying. But this reckless gamble would put in peril the lives of tens of thousands of sailors.

Feelings were already running high among the crews who serviced the battleships, cruisers and destroyers anchored in the Baltic sea ports. The news of the Russian Revolution had already had its effect amongst the sailors. When the orders came to launch the North Sea offensive, it provoked demonstrations and a mutiny. The men on the battleships Thüringen and Helgoland refused to raise anchor for what they described as a 'death cruise', a mission without rhyme or reason. The mutiny then rapidly spread as sailors disarmed their officers and took control of the ships. Naval Command at once ordered that the mutinous ships be retaken by crack naval troops. The mutiny was finally put down and the 600-strong crews were rounded up to face immediate

court martial. Rather than put an end to the disturbances, it served to set off a chain reaction. Immediately, men at Kiel and Wilhelmshaven refused to provision the ships or put out to sea. This in turn set off a major revolt that quickly escalated into a full-scale mutiny involving the entire German fleet of 100,000. The whole situation rapidly changed from a revolt into a revolution.

Generals Paul von Hindenburg (left) and Erich Ludendorff (right)

MUTINY SPREADS

The revolutionary uprising spread to the workers onshore, who immediately set up workers' councils, stormed the prisons and released the inmates, many of whom were political prisoners. Hamburg, Lübeck, Bremen and Cuxhaven were directly affected. Posters supporting the uprising and putting forward political demands appeared everywhere. They not only called for peace but, according to a police report, "the destruction of militarism, the ending of social injustice and the overthrow of the ruling class." (S. Taylor, p. 6.)

Jan Valtin,[1] a member of the Spartacist League of Youth, relates what happened in his autobiography *Out of the Night*:

> That night I saw the mutinous sailors roll in to Bremen in caravans of commandeered trucks – red flags and machine guns mounted on the trucks. Thousands milled in the streets. Often the trucks stopped and the sailors sang and roared for free passage. The workers cheered, particularly a short, burly young man in grimy blue. The man swung a carbine over his head to return the salute. He was the stoker who had hoisted the first red flag over the fleet. His name was Ernst Wollweber…

> I circled toward the Brill, a square in the western centre of the town. From there on I had to push my bicycle through the throngs. The population was in the streets. From all sides masses of humanity, a sea of swinging, pushing bodies and distorted faces was moving toward the centre of the town. Many of the workers were armed with guns, with bayonets, with hammers. I felt then, and later, that the sight of armed workers sets off a roar in the blood of those who sympathise with the marchers. Singing hoarsely was a sprawling band of demonstrating convicts freed by a truckload of sailors from Oslebshausen prison, most of them wore soldiers' grey coats over their prison garb. But the true symbol of this revolution, which is really nought but a revolt, were neither the armed workers nor the singing convicts – but the mutineers from the fleet with their reversed headbands and carbines slung over their shoulders, butts up and barrels down…

> At the foot of the Roland statue a frightened old woman crouched. "Ach du liebe gott", she wailed piercingly "what is all this? What is the world coming to?" A huge-framed young worker who gave intermittent bellows of triumph and whom I had followed from the Brill, grasped the old woman's shoulders. He laughed resoundingly. "Revolution", he rumbled. "Revolution, Madam." (J. Valtin, *Out of the Night*, pp. 9-10.)

1 Valtin's real name was Richard Krebs, who was a former member of the German seamen's union, Seamen's International and German Communist Party.

The date of the German Revolution is normally given as 9 November 1918. But the real impetus to revolution had begun on 3 November, when the workers and sailors mutinied at Kiel, where much of the fleet was based. This was followed by the sailors at Wilhelmshaven and Hamburg. It was then that the dam broke, and the masses began to pour onto the scene.

A left radical sailor, Ernst Schneider describes the scene at Wilhelmshaven as follows:

> On their return to their ships and barracks some of the comrades heard the heavy tramp of marching troops. Shots were fired, and the cry went up, "down with the war" … Continuing towards the battleship Baden, it was seen that the small units had also been taken over by the revolutionary sailors. On board the *Baden* they elected a new commander. He was a member of the committee. (E. Schneider, *The Wilhelmshaven Revolt: A Chapter of the Revolutionary Movement in the German Navy 1918-1919*.)

It was the date when the battleship König had also provocatively raised the imperial flag, and mutineers opened fire until it was replaced with the red flag. Now the entire fleet flew the red flag of rebellion. Ashore, the sailors began to hunt down their officers, many of whom were caught, stripped of their insignia and thrown into prison. Others simply fled the scene.

Twenty thousand sailors and workers surged through the streets, stormed the armouries, seized the weapons and released prisoners. On their own

Six sailors armed with guns. They are grouped around a blackboard, which reads
"Long live freedom 5. Nov. 1918"

More de-mobilised sailors, holding up the message "the last of the Amazone". The Amazone was a barracks ship based in Kiel

initiative the revolutionaries established a Workers' and Sailors' Council, which took control of the town. The speeches of revolutionary agitators were met with roars of approval from crowded assemblies. The revolutionary mood was highly infectious. In the night, workers and sailors carrying torches swept through the narrow streets singing the 'Internationale', meeting with no resistance as they went on with their business. The following day, power was firmly in the hands of the workers in this naval stronghold. Nothing moved or happened without their permission.

The historian, Richard Watt, writes:

> In the centre of the town, a huge sailor directed traffic wearing a red sash around his waist, into which he had stuck eight officers' dirks [daggers] and two pistols. He carried a rifle and around his neck he wore the *Pour le Mérite*, Germany's highest military decoration, which he had snatched from a famous submarine captain. (R. Watt, pp. 166-167.)

REVOLUTION SPREADS

The *Völkische Zeitung* of Schleswig-Holstein wrote:

> The Revolution is on the march. What has happened in Kiel will happen in other places during the next few days, giving impetus to a movement which will traverse the whole of Germany. (Quoted in A.R. Oliveira, p. 93.)

On 4 November, the flames of revolution continued to spread, characterised by red flags flying over official Imperial buildings. On 6 November, Sailors', Soldiers' and Workers' Councils had now taken power in Hamburg, Bremen and Lübeck. On 7 and 8 November, Dresden, Leipzig, Chemnitz, Magdeburg, Brunswick, Frankfurt, Cologne, Stuttgart, Nuremberg, and Munich all followed suit. In Brunswick, the chairman of the Workers' and Soldiers' Council, August Merges, a member of the Spartacist League, assumed the title of President of the Socialist Republic of Brunswick. Its government was composed of eight 'People's Commissars'. However, it was not until 9 November, the official date of the revolution, that Workers' and Soldiers' councils were established in Berlin, the capital, at none other than the Supreme Army headquarters! For their own protection, the military started to go about in civilian clothes, while the bourgeoisie stayed indoors.

Paul Frölich, a Spartacist, at the head of a group of armed sailors, occupied the offices and print-works of the daily *Hamburger Echo* and proceeded to publish the first paper of the Workers' and Soldiers' Council of Hamburg, entitled *Die Rote Fahne, (The Red Flag)*. He summed up the universal feeling:

> This is the beginning of the German Revolution, of the world revolution. Hail the most powerful action of the world revolution! Long live socialism! Long live the German workers' republic! Long live world Bolshevism! (P. Broué, p. 142.)

The German revolution was also spurred on with the news that revolution had broken out in Austria, where the old regime had been overthrown and a Provisional government was formed under the Social Democrat, Karl Renner, with Victor Adler as Foreign Secretary and Otto Bauer as his deputy. The soldiers had established a Soldiers' Council and deputies were elected from every garrison to a National Executive, which called for the setting up of an Austrian Socialist Republic. Braunthal, who was at that time a member of the Austrian War Ministry, wrote:

> The same trend of feeling which moved the soldiers was operating among the workers. They were also strongly affected by the Bolshevik temptation, and they, too, would have preferred a Soviet Austria. (*Millennium*, p. 230.)

But, in the end, the 'Austro-Marxists' would act no better than the German Social Democrats or the Mensheviks in Russia.

The British journalist Morgan Philips Price, who worked for the Manchester *Guardian*, travelled to Berlin to write an eyewitness account of the revolution. His account provides a glimpse of the mood at the time, especially of the ordinary soldiers:

At Eyktunen I passed through the German customs, which was run by common soldiers only. During the journey through East Prussia soldiers boarded the train, turned the officers out of the compartments and made them stand in the corridors. The trains were packed with troops returning home, and the atmosphere became more revolutionary as I approached Berlin, which I reached after six days' journey. (*Dispatches from the Weimar Republic*, p. 21.)

"Events at Kiel, Lübeck, Altona, Hamburg and Hanover have as yet passed off fairly bloodlessly," wrote Count Harry Kessler, whose Royal title now counted for little. "That is the way all revolutions start." He then went on to offer his opinion: "The thirst for blood grows gradually with the strains involved in setting up the new order... The shape of the revolution is becoming clear: progressive encroachment, as by a patch of oil, by the mutinous sailors from the coast to the interior. Berlin is being isolated and will soon be only an island..." In fact, the bloodshed was not introduced by the revolution, which met no resistance, as the Count relates. Only fifteen people lost their lives in Berlin on 9 November. The bloodshed was introduced by the brutality of the counter-revolution that was to later sweep Germany, led by the infamous Freikorps.[2] It was not long before the 'patch of oil' did reach Berlin, as it spread throughout the whole of Germany.

On 4 November, Gustav Noske, an SPD deputy, had arrived in the port of Kiel, having been sent by an alarmed government eager to exert some calming influence over the town. However, Noske was soon recognised by the crowd, which sparked unexpected uproar and was carried shoulder high by boisterous workers and soldiers. In the vain hope of exercising some influence, he was forced to go along with the wishes of the insurgents, and even to accept the position of Kiel's revolutionary governor. On 5 November he broke the news by telephone to Berlin: "I have been obliged to accept the post of governor and have already had some success." (R. Watt, p. 181.) So as not to undo this 'success', he pleaded with Berlin not to send troops. He admitted later, "I had to work hard at Kiel to prevent the formation of red troop detachments." (B. Fowkes [ed.], p. 232.) For the moment, all Noske could do was to mollify the revolutionaries. Later, he would send the Freikorps to restore order in the most violent manner.

The 'liberal' cabinet of von Baden met in emergency session on 7 November, with the SPD ministers increasingly shocked by the spread of anarchy. "We have done all we can to keep the masses on the halter," stated

2 The Freikorps (Free Corps) were volunteer forces from the reactionary dregs of society. They were ultra-reactionary gangs of White-Guardist elements whose officers were drawn from the pro-monarchist military and sons of the aristocracy.

Scheidemann. (S. Taylor, p. 8.) But far more was needed to subdue the revolution and these leaders proved to be willing and obedient tools.

WORKERS' AND SOLDIERS' COUNCILS

With the collapse of the old state apparatus, power had fallen into the hands of the armed workers, sailors and soldiers. As in Russia in 1905 and 1917, the masses set up workers' councils or Soviets, the embryos of workers' power. No party or group had called them into being; they were simply a spontaneous creation of the masses brought to their feet by the revolution. The Arbeiter und Soldaten Räte (the workers' and soldiers' councils) were genuine grassroots organisations, which were established wherever workers and soldiers were present and organised. In a display of working-class democracy, factories and workplaces elected their own representatives at the point of production.

Gustav Noske

The author Evelyn Anderson explained:

During the first days of the November Revolution, workers' and soldiers' councils were elected in all workshops, mines, docks and barracks. The people were in motion. Wherever crowds assembled, they nominated spokesmen and elected delegates, who were to speak and act on their behalf as their direct representatives. This happened all over the country. (E. Anderson, p. 43.)

This was the basis of workers' democracy. Unlike bourgeois democracy, where you could, to paraphrase Marx, choose every five years which members of the ruling class were going to misrepresent you in Parliament, the delegates from these Councils were directly accountable and subject to immediate recall. Delegates were under the control of mass meetings where everyone was allowed to have their say. No one was elected for life or was in a privileged position. As there were no privileges, there was no careerism. Depending on the democratic will, representatives could be immediately replaced with others who were more in tune with the majority feeling. This was genuine proletarian democracy in action.

As Lenin explained:

[T]he Soviets, as the organ of struggle of the oppressed masses, reflected and expressed the moods and changes of opinion of the masses ever so much more quickly, fully, and faithfully than any other institution (that, incidentally, is one of the reasons why Soviet democracy is the highest type of democracy). (V. Lenin, *The Proletarian Revolution and the Renegade Kautsky*, LCW, vol. 28, p. 271.)[3]

The Councils or Soviets were the most flexible and democratic system ever devised. They were elected, not on the basis of geographical constituencies, but in factories, offices, farms and other places of work. It was a prime example of what Rosa Luxemburg called mass spontaneity and workers' self-expression. It was a product of the masses in action. As Ernst Däumig explained:

[T]he storm of November 1918 saw workers' and soldiers' councils emerge all over Germany, spontaneously and without any preparation. The revolution

3 Evelyn Anderson made the same point. "One important feature of the *Räte* (workers' councils) system is the direct and permanent control of elector over deputy. The deputy can be deprived of his mandate at a moment's notice if and when he does not exercise it in accordance with the will of his electors. The *Räte* system is therefore an even more extreme and direct form of democracy than a parliamentary system. It is the very opposite of dictatorship." (E. Anderson, p. 44.)

created its own expression with elementary force. (Quoted in G. Kuhn, p. 51.)

If democracy means the rule of the majority, then the Soviets fitted this description perfectly. The will of millions, expressed through tens of thousands of workers' assemblies, was far and away more democratic than any bourgeois parliament. As Broué explains:

> They took upon themselves powers at every level, those of the judiciary as well as of the legislature or the executive, in accordance with the very character of soviet power. (*The German Revolution*, p. 162.)

Events were moving very quickly and the situation of 'dual power' coloured everything. The Revolution had given birth to workers' and soldiers' councils throughout the country, which dispensed orders, directives and instructions. Not a wheel turned, not a whistle blew, without their say-so. The revolution was like a strike, but on a massive scale. Workers who were on strike would elect strike committees, the revolutionary masses elected their workers' councils. Within a short space of time their responsibilities and functions expanded, as their duties further encroached upon those of the old state. In some areas they even set up their own armed force, red guard or police, as in Frankfurt-am-Main, Hamburg, Düsseldorf and Halle.

In Berlin, new revolutionary committees were being set up. A Berlin Executive Committee of Workers' and Soldiers' Councils had been established, which acted as a national centre for the Councils that had been thrown up throughout the country. In the absence of any elected parliament or assembly, this body was the most representative national body in existence.

HATE IT LIKE SIN

The head of the government, Prince Max von Baden, looking for points of support, approached Ebert, the Social Democrat, and asked: "If I should succeed in persuading the Kaiser [to abdicate], do I have you on my side in the battle against the social revolution?" Ebert replied: "If the Kaiser does not abdicate the social revolution is inevitable. I do not want it – in fact I hate it like sin." (R. Watt, p. 183.)

As the *ancien régime* collapsed around him, the Kaiser was determined initially to hang on to his crown. But he had lost touch with reality. Armed soldiers were roaming the streets of Berlin, but still the Kaiser dithered, and refused to abdicate.

"The Kaiser must abdicate, otherwise we shall have a revolution," fretted the Social Democrats. (ibid., p. 184.) Max von Baden needed to act fast as

the Social Democrats, under growing pressure, were forced to resign from the government. The time for talking was over.

The armed mass demonstrations in Berlin terrified von Baden so much that he decided to tender his resignation as Chancellor with immediate effect, and hand over the reins of government to the right-wing Social Democrats. But before departing, very astutely, he pondered the options that confronted the ruling class:

> The revolution is on the verge of winning. We cannot crush it but perhaps we can strangle it... if Ebert is presented to me from the streets as the people's leader, then we will have a republic; if it is Liebknecht, then Bolshevism. But if the abdicating Kaiser appoints Ebert as Reich Chancellor, then there is still a little hope for the monarchy. Perhaps it will be possible to divert the revolutionary energies into the legal channels of an election campaign. (J. Riddell [ed.], *The German Revolution*, p. 40.)

Ebert, on behalf of the Social Democrats, replied to Prince von Baden's offer: "For the preservation of peace and order... we regard it as indispensable that the office of Imperial Chancellor and the Brandenburg command be held by members of our party." (R. Watt, p. 195.) Baden quickly agreed, believing this would be the best outcome.

EBERT BECOMES CHANCELLOR

For his part, Ebert was prepared to become Chancellor "within a monarchical constitution," but needed to consult the others leaders. They would have agreed, but they were placed in an impossible position. As the editor of *Vorwärts* explained, "We wanted to save the monarchy, but if someone called 'Long live the Republic!' there was nothing left for us to do but call with them." (ibid., p. 184.)

Without any further delay, Prince Max von Baden pre-empted the Emperor's decision by announcing the abdication on his behalf. Uninformed and bewildered, Wilhelm was astonished to hear the news of his downfall second-hand. By the 9 November, the monarchy was at an end, and the next day the Kaiser, bags packed, was at the Dutch border. He did not *formally* recognise his abdication until nearly three weeks later, possibly hoping that someone had made a dreadful mistake.

The power vacuum had to be filled urgently with a safe pair of 'reformist' hands. And as willing servants, the Social Democratic leaders were thus thrust into power. The SPD leader's first act as Chancellor was to ask Prince von Baden to accept the Regent's office, hoping to maintain a constitutional monarchy. But the prince was not keen to seize hold of a poisoned chalice

and so gracefully declined. He departed with the final words, "Herr Ebert, I commit the German Empire to your keeping." (ibid., p. 199.)

Of course, as a good Social Democrat, Ebert had made no secret of his undying support, not for the revolution, but for the Hohenzollern monarchy. He had hoped that the abdication of the Kaiser would have been replaced by some form of regency, but the revolution put an end to this idea.

This episode clearly revealed the whole psychology of Ebert and the Social Democratic leaders. Their aim was the establishment of a bourgeois democracy, with or without a monarchy, where they would play the role of loyal democrats.

Ebert began to piece together a new government. He was astute enough to realise that he needed a 'left' cover if he was to succeed. Therefore, in his proclamation he announced: "The Kaiser has abdicated; his eldest son has renounced the throne. The Social Democratic Party has assumed responsibility for government," but he had additionally "invited the Independent Social Democratic Party to join it on a wholly equal basis." (J. Riddell [ed.], *The German Revolution*, p. 44.)

An all-socialist government would be formed, hoping it would be enough to stem the tide of revolution. Ebert, as Chancellor, would always keep the left wing in check. His first act was a direct appeal to the revolutionary masses, not to urge them on, but to calm them down:

> Fellow Citizens! I invite you to help us in our difficult task, for you all know to what extent the food supply of the people is in danger. It is the primary duty of everyone to remain in the fields or the towns, and not to place obstacles in the way of the production of food or of its transport to the cities. The lack of food means misery for all. The poorest would suffer terribly, and the industrial workers would endure unheard-of hardships.
>
> Fellow Citizens! I beg of you leave the streets. A city of law and order! (*Vorwärts*, 9 November 1918, special edition, quoted in A.R. Oliveira, p. 95.)

But the masses did not stay away from the streets. On the contrary, after the factories had been saturated with leaflets calling for an insurrection, meetings were held and workers began marching to the centre of Berlin. Groups of socialists had occupied the Post Office, the Telegraph building, the Wolff Agency, the Military Command and the Palace. As described by Pierre Broué:

"The day which Marx and his friends described all their lives had come at last", explained E.O. Volkmann. "The Revolution was on the march in the capital of the empire. The firm tread, in step, of the workers' battalions echoed in the streets. They came from Spandau, from the workers' districts,

from the north and east, and marched towards the city centre, the symbol of imperial power. To the fore were Barth's assault troops, revolvers and grenades in their hands, with the women and children preceding them. Then came the masses in tens of thousands, radicals, Independents, Majority Socialists, all mingled together." (P. Broué, p. 146.)

LONG LIVE THE REPUBLIC!

As the masses assembled, Scheidemann, the other Majority Socialist leader and the Prince's Vice-Chancellor, was eating soup in the Reichstag restaurant when he heard loud cries from the enormous crowds that had encircled the Reichstag building. While Liebknecht and the Spartacists were setting themselves up in the Royal Palace, ready to proclaim a workers' republic, Scheidemann stepped in. Later he wrote: "I saw the Russian madness before me, the replacement of the tsarist terror by the Bolshevist one. No! Not in Germany." (A. Read, p. 32.) From the balcony, so as to gain the support of the ranks of the assembled workers below, he announced the news that Ebert had now agreed to become Chancellor of a socialist government.

> These enemies of the people are finished forever. The Kaiser has abdicated. He and his friends have disappeared; the people have won over all of them, in every field. Prince Max von Baden has handed over the office of Reich chancellor to representative Ebert. Our friend will form a new government consisting of workers of all socialist parties. This new government may not be interrupted in their work, to preserve peace and to care for work and bread. Workers and soldiers, be aware of the historic importance of this day: exorbitant things have happened. Great and incalculable tasks are waiting for us. Everything for the people. Everything by the people. Nothing may happen to the dishonour of the labour movement. Be united, faithful, and conscientious. The old and rotten, the monarchy has collapsed. The new may live. Long live the German Republic! (J. Riddell [ed.], *The German Revolution*, pp. 41-42.)

Following Scheidemann's intervention, Karl Liebknecht then climbed onto the Reichstag balcony and made a proclamation on behalf of the Spartacist League, which ended with the call for a German Socialist Republic:

> The rule of capitalism, which turned Europe into a cemetery, is henceforward broken. We remember our Russian brothers. They told us when they left: "If within a month you haven't done as we did, we shall break you." It only took four days. We must not imagine that our task is ended because the past is dead. We now have to strain our strength to construct the workers' and soldiers' government and a new proletarian state, a state of peace, joy and

freedom for our German brothers throughout the whole world. We stretch out our hands to them, and call on them to carry to completion the world revolution. Those of you who want to see the free German Socialist Republic and German Revolution, raise your hands! (P. Broué, p. 149.)

Amongst the assembled masses, a sea of hands was raised in favour of revolution. Shortly afterwards, a symbolic red flag was hoisted on the Emperor's flag pole.

As soon as Ebert had found out that Scheidemann had proclaimed the Republic he was furious. According to Scheidemann's memoirs:

Ebert went red in the face with anger when he heard of my act. He struck the table with his fist and shouted at me "Is this true?" When I replied that it was not only true but was the obvious thing to do, he made such a scene that I stood speechless. "You have no right to proclaim the Republic!", he shouted.

"What becomes of Germany – whether she becomes a republic or something else – a national assembly must decide." (J. Braunthal, *History of the International*, p. 122.)

Philipp Scheidemann

Philipp Scheidemann proclaims the German Republic at
the Reichstag building

The revolutionary tide was sweeping aside all before it and the proletariat was
on the move, with or without a national assembly. In Berlin, the forces at
the police headquarters surrendered to Emil Eichhorn's left-wing supporters,
handing over their weapons, and installing Eichhorn of the USPD as the
new chief of police. The jails were thrown open and hundreds of prisoners
were set free, including Leo Jogiches, the Spartacist organiser. Another, Rosa
Luxemburg, was also released from Breslau prison. On that day, the Reichstag
building surrendered without a shot being fired. If the masses had wanted
to, they could have taken power peacefully at this time, but they lacked a
revolutionary leadership.

The revolutionary fervour gripping the masses did not slacken, despite
the appeals of the Social Democratic leaders, but increased. The wife of Prince
von Blücher, horrified by the spectacle, described the scene in her diary:

> Across the compact masses of the moving crowd big military lorries urged
> their way, full to overflowing with soldiers and sailors, who waved red flags
> and uttered ferocious cries. They were evidently trying to excite the workers

to violence. These cars, crowded with young fellows in uniform or mufti, carrying loaded rifles or red flags, seemed to me characteristic. These young men constantly left their places to force officers or soldiers to tear off their [imperial] badges and took the task upon themselves if they refused… About two hundred of these big lorries must have passed beneath our windows in two hours. (R. Watt, p. 197.)

The revolution had conquered the streets and workers and soldiers could feel the potential power in their hands. The old state, gravely weakened, was helplessly suspended in mid-air. But the masses, as with their Russian counterparts after February 1917, were not fully conscious of their power. They had set up soviets or councils in every factory, barracks, and workplace. If they had been completely conscious of their power, they could have easily swept away the old order and established a workers' state in the centre of Europe. Their instincts told them that this was the direction they should take.

TRADITIONAL PARTIES

However, in the vast majority of cases, the revolutionary workers looked to the leaders of their traditional parties, the SPD and USPD, for a way forward. The misdeeds and betrayals of the past were forgotten, or at least put aside. There was a powerful instinctive feeling amongst the workers for unity. While they gave enthusiastic support to the slogans of the Spartacists, the broad masses awakened by the revolution, did not differentiate between the rival socialists. They tended to adhere to their old parties, which had served them well in the past.

> Out of sheer loyalty, hundreds of thousands of workers stuck to their old party which they had helped to build, no matter how violently they disagreed with its policy… loyalty to his organisation has become a matter of instinct to the worker. (E. Anderson, pp. 36-37.)

Again, as in Russia in February, the revolutionaries were in a small minority. The Mensheviks and Social Revolutionaries initially dominated the soviets in Russia, while the Bolsheviks were relatively isolated. Lenin adopted a policy of 'patient explanation', as experience and events would win over the workers. In Germany, it was the Majority Socialists and Left Independents who dominated the Councils, Soviets in all but name, while the Spartacists were a tiny minority. In fact, at the beginning of the revolution, they only had around fifty members in Berlin. It would take great events and a direct experience of the actions of the reformist leaders before the balance would change. In the short-term, despite the role of the SPD leaders who actually

opposed the revolution, the masses remained faithful to their traditional organisations. In this context, the USPD, which also had a significant following, played an important but secondary role.

Richard Müller, the leader of the Berlin Shop Stewards, observed:

> Social Democrats were elected as members of the workers' councils who the day before had been driven out of the factories with blows because they would not join the general strike. (S. Taylor, p. 8.)

On 10 November, a meeting of the Berlin Workers' and Soldiers' Councils, in the presence of 3,000 delegates, officially proclaimed itself the representative of the revolutionary people. Furthermore, in the absence of an *elected* government, it took the decision to appoint a Council of People's Commissars under the control of the Executive Council. This was a clear reference to the experience of the Russian Revolution.

However, the only problem was that Ebert had already been appointed the head of the Imperial government by Prince von Baden the previous day. In addition, the Majority Socialists vehemently rejected any suggestion that they should be accountable to the Council's Executive Committee, calling it 'unconstitutional'. The ministers were members of the government and a power unto themselves, as there was no constitution in existence. This meant nothing to the masses. However, the leaders of the SPD and the USPD had come to an agreement to set up a six-member cabinet, which adopted the name 'Council of People's Representatives' (Rat der Volksbeauftragten). This was then ratified by the Berlin Workers' and Soldiers' Council. The first German socialist government consisted of Ebert as Chancellor, responsible for Army and Interior ministry; Haase for Foreign Affairs and Colonies; Scheidemann for Treasury; Dittmann for Demobilisation and Health; Landsberg for Press and Information; and Barth for Social Policy.

'THEIR GOVERNMENT'

The Ebert government was viewed by the majority of workers as a government of the revolution. For the Workers' Councils, it was 'their' socialist government, appointed by them.

The workers in the factories, who had developed a collective consciousness, were more politically advanced than the soldier masses, returning from the trenches. The workers were more organised and were in tune with the revolutionary mood and its aspirations. They tended to look towards the Independent Socialists, but were also open to the agitation of the Spartacists. The soldiers, on the other hand, who were in the process of being

demobilised, were more under the influence of the SPD leaders. They proved
to be more dominant in the councils outside of Berlin.

The headquarters of the Executive Council was installed in the building
of the Prussian Landtag, the state parliament, in effect, the heart of the
revolution, and was subjected to its daily pressures, while the Council of
People's Commissars operated in a separate building, surrounded by former
bourgeois ministries and advisers, the heart of the counter-revolution, which
suited Ebert.

Rather than clear out the Augean stables of the old regime, purge the
civil service of their monarchist trappings and replace them with trustworthy
socialists and democrats, the government chose to rely on a discredited
bureaucratic apparatus, the leftovers of Prince Max von Baden. Such
'technical assistants' included men such as General von Schëuch at the War
Ministry and Dr. Solf at Foreign Affairs, who carried great influence in the
corridors of power. Government ministers soon came increasingly to rely
upon these figures, pillars of the old establishment.

However, given the impact of the revolution, the government tried to
balance between these competing forces. It simultaneously rested on the
apparatus of the old ruling class but it also had to take account of the power
of the Workers' Councils. This peculiar development was a direct product of
the 'dual power' situation existing in the country. The revolution had given
birth nominally to a government, but that same government was forced to
look in two directions, one facing towards the workers, while the other faced
towards the bourgeoisie and the army. In practice, the new Social Democratic
government was the continuation of the government of von Baden and the
old regime, but it was forced to cover itself with the cloak of revolution,
including its phrases, take the name of Council of People's Commissars,
and seek to embroil the Independent Socialists in the responsibilities of
government.

As a result of Ebert's offer, the Executive Committee of the USPD went
into emergency session to discuss the party's proposed entry into the new
government. They were under pressure to join such a government, not least
from the SPD-dominated workers' and soldiers' councils. They initially
decided to stipulate certain conditions, firstly, that Germany should be a
Socialist Republic, but such conditions were soon brushed aside. Eventually,
the Independent Socialists agreed to enter the government "to safeguard the
gains of the socialist revolution". Liebknecht had been offered a place in this
new cabinet as part of the USPD, but, despite strong pressure and a strong
feeling for workers' unity, he turned down the offer.

PEOPLE'S COMMISSARS

In the end, the government was composed exclusively of members of the two socialist parties: three Majority Socialists (SPD): Friedrich Ebert, Philipp Scheidemann, Otto Landsberg; and three Independent Socialists (USPD): Hugo Haase, Wilhelm Dittmann and Emil Barth. Barth was incidentally the only leader of the Shop Stewards who could be persuaded to serve in the government.

Once formed, under pressure from the mass movement, the 'Council of People's Representatives' (Rat de Volksbeauftragten) did not wait for a National Assembly before issuing a number of decrees. On 12 November, the new government issued a proclamation addressed to the German people: "The government which has emerged from the revolution, the political leadership of which is purely socialist, has set itself the task of putting into effect the socialist programme." It issued nine points with immediate legal effect which included the right of assembly, freedom of expression, abolition of censorship, amnesty for political offences, provisions to protect labour and other reforms. Above all, it stipulated that "a maximum working day of eight hours will enter into force on 1 January 1919." (B. Fowkes [ed.], p. 17.)

The German bosses had no other choice but to make concessions – despite their previous opposition – as a result of the pressure of the revolution. They therefore had no alternative but to come to an agreement with the trade unions on 15 November, which included union recognition, the setting up of factory committees in enterprises of more than fifty workers, the introduction of collective agreements, as well as the eight-hour day with no loss of pay. For now, the employers were forced to stomach these concessions until such time as they could be taken back.

On the same day, as concessions were granted to workers, a government telegram was sent to the German High Command, which in part read:

> Officers' disciplinary authority remains in force. Unconditional obedience while in service is of decisive importance if the army's return to the German homeland is to succeed. Military order and discipline in the army must therefore be maintained under all circumstances... Their highest duty is to work to prevent disorder and mutiny. (J. Riddell [ed.], *The German Revolution*, p. 52.)

This message to the High Command made it clear that they had the full backing of the new government and against any signs of 'disorder'. They knew it was in the army that the real power lay.

While the 'socialist unity' government of Ebert talked in radical terms, even promising socialisation of certain industries, its aim was not the

overthrow of German landlordism and capitalism, but the introduction of measures to stabilise the situation. The inclusion of the Independent Socialists allowed the right Social Democrats to lean on the masses and provided Ebert a 'left' cover for his actions. 'Independent' ministers had very little independence, but operated largely under the shadow of right-wing ministers. As Ebert remarked, "Democracy is the only rock upon which the working class can erect the edifice of Germany's future." (B. Fowkes, p. 15.) But this rock left intact the power of the ruling class.

The SPD loudly trumpeted their achievements in the press and in propaganda posters:

> Already, in only a few days!
> A people's republic. Equal suffrage. Women's suffrage. The right to vote at twenty years.
> All dynasties and royal courts have vanished. A Socialist national government. Workers' and Soldiers' councils everywhere. The privileged House of Lords eliminated. The three-class parliament dissolved.
> Freedom of assembly. Freedom of association. Freedom of the press. Freedom of religion.
> Militarism smashed. Dismissal of personages from the past. Soldiers' salaries increased.
> The eight-hour day. The law on servants abolished. Workers and employers have equal rights.
> So much has already been gained. Much more must still to be achieved.
> Close your ranks. Do not let yourselves be divided.
> Unity!
> (J. Riddell [ed.], *The German Revolution*, p. 54.)

Nobody could deny these were important gains of the revolution, but militarism had not been eradicated and the power of the old regime was still in place. These reforms were the inevitable by-product of the revolution itself. The capitalists were forced to grant big concessions or face the likely overthrow of capitalism.

Despite these reforms, Liebknecht and Luxemburg demanded the completion of the revolution and the establishment of a German Workers' Republic, but they were in a minority.

NEW BREED

Over the previous period, people like Friedrich Ebert, Gustav Noske and Philipp Scheidemann had gradually risen to the top of the Social Democratic Party. It was like scum rising to the top of a stagnant pool. As opportunists, they had adapted themselves well to the new conditions. Ebert had been

appointed general secretary of the party in 1906 and then took over as party chairman on the death of August Bebel in 1913. He was an up and coming party functionary who had ambitions for the party as well as himself. Such individuals were very much from the revisionist school, in words as well as deeds.

For this new breed of right-wing Social Democrats, bourgeois democracy was the only road to sovereign government. Over the years, their minds and instincts had become increasingly conservative. They had become in essence nothing more than liberal democrats who still happened to call themselves 'socialists' for old times' sake. They saw their role in November 1918 as putting a brake on the revolution, which they regarded as full of extremes and 'excesses'. There was a need to re-establish 'law and order' as quickly as possible. In fact, Ebert's first proclamation as Chancellor to the German people was an appeal for exactly that – calm and law and order.

A close friend of Ebert's was once asked, "Did not Ebert and Scheidemann experience a secret pleasure on this day [9 November] at the outbreak of the revolution?" "Oh, no," was the answer, "not at all. They were seized with deadly fear." (R. Watt, p. 219.) This was an accurate description of these 'leaders'.

Their role in government was driven precisely by this 'deadly fear'. An indication of the depths they were prepared to go to was revealed when Ebert rejected an offer of grain from the Soviet government in favour of an offer of American grain. While the Soviet offer came with no conditions, the US offer of help came with strings attached: food shipments would be guaranteed "on condition that public order in Germany is genuinely re-established and maintained." In other words, if the revolution continued, the grain would be cut off. But the French newspaper *Le Temps* revealed: "It was not Mr. Wilson who thought up the condition that he set. It was urged on him by the German Reich Chancellor himself." (J. Riddell [ed.], *The German Revolution*, p. 66.)

The right-wing Social Democrats increasingly acted as a mouthpiece of 'law and order', behind which stood the capitalists and the military chiefs. They were willing collaborators of the most reactionary section of society, namely the High Command of the Imperial Army. Of course, this treacherous collaboration was carried out in secret behind the backs of the party membership, who were far to the left of these so-called leaders. While the Left openly welcomed the workers' councils, the Right detested them. Ebert, Scheidemann and the others were determined to sweep them away.

The right wing were quite prepared to use the forces of the old regime, irrespective of the bloodshed, to achieve this aim. However, Ebert understood

very well that the government could not use these forces immediately. They had to bide their time for fear of provoking the masses. Therefore, rather than dispatch the Freikorps to crush the sailors and workers at Kiel, they sent the Social Democrat, Gustav Noske, to contain the situation until the movement had exhausted itself. In Berlin, the unfortunate Scheidemann had to put a brave face on the humiliation of being paraded shoulder-high by revolutionary soldiers. They had no alternative but to accept things until 'normality' was restored and the revolution subsided. "We have done all within our power to keep the masses in check," stated Scheidemann. (R. Watt, p. 183.)

EBERT AND THE GENERALS

Most ordinary Social Democratic members had no trust in the General Staff and were in favour of some kind of people's army. This was especially the case with the soldiers' councils. Of course, this was an anathema to the generals. As a result, the new 'socialist' government did not dare to demobilise the Imperial Army and organise new republican armed forces for fear of alienating the General Staff.

When Ebert, as Chancellor, met with General Groener to seek assurances of the loyalty of the armed forces, Groener explained that loyalty came with a price:

> The officer corps could only co-operate with a government which undertook the struggle against Bolshevism. The officer corps expects that the Imperial government will fight against Bolshevism and [therefore] places itself at the disposal of the government for such a purpose.

Ebert concurred, simply saying: "convey the thanks of the government to the Field Marshall." (ibid., p. 200.) The deal was done, but it was clear that the real power rested with the generals.

Some years later, general Groener shrewdly related what had happened:

> We made an alliance against Bolshevism... There existed no other party which had enough influence upon the masses to enable the re-establishment of a governmental power with the help of the army. (P. Broué, p. 169.)

Behind Ebert stood the old order masquerading as 'democrats', and behind them stood the Freikorps, the reactionary dregs of society. The velvet glove of 'democracy' covered over, for the moment, the mailed fist of a threatening dictatorship.

WHAT KIND OF DEMOCRACY?

While the paramount aim of Ebert, Scheidemann, and the other Social Democratic leaders was the calling of a National Assembly and the establishment of a bourgeois democracy, the Spartacist League fought to transfer power to a national congress of workers' and soldiers' councils and to create a genuine socialist workers' republic. For the reformist leaders, this was Bolshevism, the very thing they wanted to eradicate; they therefore worked energetically to divert the movement into harmless constitutional channels.

As the immediate threat of revolution began to subside, the German bourgeoisie and their political representatives, who yesterday had solidly supported the autocracy, now came forward as ardent 'democrats'. They had changed their monarchist colours for republican ones, anything to save the system. "I am no Socialist, but a democrat. I always was," said Prince Leopold. "Only the black, red, and gold flag[4] can save us," said Herr Wulle, who later became a leader of fascism. "I submit to the authority of the government, which I will support with all my power," explained Prince Adalbert of Prussia. "Only a government chosen by impeccable methods ensuring the triumph of the people's will can have any authority," stated the former pro-monarchist *Deutsche Tageszeitung*, which prior to 11 November 1918 had the subtitle, "for the Kaiser and the Reich!" (A.R. Oliveira, p. 114.)

The bourgeois parties were reorganised and renamed, so as to give them a 'democratic' image. The old Conservative Party, for example, full of monarchists and restorationists, reappeared under the title of 'German National People's Party', while the former Catholic Centre Party emerged as the 'Christian People's Party'. They knew which way the wind was blowing and changed their colours accordingly. In turn, they put their full weight behind the call for a National Assembly, which would be used to usher in parliamentary elections and render the workers' councils superfluous.

The question of calling a Constituent or National Assembly naturally gave rise to a bitter controversy, where the right and left took diametrically opposing sides. For or against the calling of a National Assembly became *the* central argument. The revolutionary left were vehemently against. In the words of Richard Müller, "The way to the National Assembly leads over my dead body!" (E. Anderson, p. 46.) The Majority Socialist leaders, with equal determination, were very much in favour of the National Assembly. The slogan of the Social Democratic paper *Vorwärts* was not 'All power to the soviets!' but 'All power to the people!'

4 The flag of the Weimar Republic.

Historically, in its struggle with the Junker autocracy, the demand for such a National Assembly, along with a Republic, had been a traditional part of the programme of German Social Democracy. Even Engels, in his criticisms of the Erfurt Programme of 1891, did not suggest that it was wrong, only that it did not go far enough. Amongst the broad masses, who detested the old regime, there was a natural support for a democratic assembly or parliament.

But events had turned out differently. The November Revolution had thrown up another revolutionary power in the form of the workers' and soldiers' councils, which in Russia had become the basis of workers' self-rule. Therefore, the Spartacists strongly opposed the convening of a National Assembly, arguing instead for a government of workers' and soldiers' councils or Räterepublik. Such a soviet republic would, in their view, be based upon representatives not elected on a geographical basis, but in the factories, offices and workplaces, involving those who toiled. The Soviet Republic in Russia provided a living example of such a system of proletarian rule and it was this road that the Spartacists wanted the German workers to follow.

THE PROBLEM OF THE NATIONAL ASSEMBLY

The question of the National Assembly stuck in the throats of the revolutionaries like an unwanted fish bone. The Spartacists were vehemently opposed in principle, no matter what the decision of the Congress of Workers' and Soldiers' Councils. For them, it was a question of do or die.

When Karl Radek arrived in Germany in mid-December 1918, after illegally entering the country, he was shocked by the shrill tone of their propaganda:

> Dirty and ragged, I feverishly bought a copy of *Rote Fahne*. As I drove to the hotel I looked the paper over. I was seized with alarm. The tone of the paper sounded as if the final conflict were upon us. It could not be more shrill. If only they can avoid overdoing it! ...

> It was the question of how to relate to the National Assembly that sparked controversy... It was a very tempting idea to counter-pose the slogan of the councils to that of a National Assembly. But the congress of councils itself was in favour of the National Assembly. You could hardly skip over that stage. Rosa and Liebknecht recognised that... But the party youth were decidedly against it, "we will break it up with machine guns". (Quoted in J. Riddell [ed.], *The German Revolution*, p. 159 and p. 162.)

Lenin had constantly warned the communists against running too far ahead of the masses. The revolutionary party needed to maintain its links with the

mass movement and this required flexible tactics. He explained that it was one thing to have a fully worked-out theoretical position and another to apply it to concrete conditions. This, after all, was the essence of Bolshevism.

While in Germany, the call for a National Assembly was still linked, in the eyes of the masses, with revolutionary aspirations and democracy, in Russia it turned out differently. In Russia in early 1918, when the soviets, the real democratic organs of the masses, had already carried through a social transformation, the National Assembly was seized on by the landlords, capitalists, and supporters of the 'White' generals as a vehicle for counter-revolution. With a completely changed relationship of forces, the formal 'democratic' rights of a counter-revolutionary National Assembly could not be allowed to threaten the socialist revolution.

The choice then was either that the Constituent Assembly would endorse the decisions of the Congress of Soviets or the body would be dissolved, as Oliver Cromwell had done with the English Parliament. In the event, given its refusal to endorse soviet power, it was dissolved and, as with Cromwell's dissolution, 'not a dog barked'.

The dissolution of the Constituent Assembly had nothing to do with the fact that the Bolsheviks and their supporters were in a minority. Even if they had won a majority in the Constituent Assembly elections, they would have taken a vote to dissolve the body in favour of the Soviets. The Assembly by this time was superfluous to the needs of the revolution.

Under the conditions prevailing in Germany in 1918, where the working class had not yet taken power, the question of the National Assembly was posed in an entirely different way. With the masses supporting the National Assembly, it was necessary to march shoulder to shoulder with them, participating in the elections while offering a revolutionary programme of action.

RENEGADE KAUTSKY

The dissolution of the Constituent Assembly in Russia led to fierce condemnation of the Bolsheviks, especially by the reformist leaders abroad. The most vocal of these critics was Karl Kautsky, who had, in the summer of 1918, denounced the Bolsheviks and refused to recognise the soviets as the organs of workers' democracy and self-rule. For him, they were only ad-hoc ephemeral organisations. In his book, *The Dictatorship of the Proletariat*, he deliberately twisted the ideas of Marx about workers' self-rule, omitting his idea of the dictatorship of the proletariat and the lessons of the Paris Commune. Kautsky argued from the standpoint of a bourgeois liberal in favour of 'democracy' in the abstract. He was answered very forcefully in a

rebuttal by Lenin in his book *The Proletarian Revolution and the Renegade Kautsky*, where he argued against the distortions of Marx in relation to the state, and explained that 'democracy' was itself a form of class rule. Democracy was not simply 'democracy', but a class question: you can have bourgeois democracy or workers' democracy, based on opposing class interests.

Lenin explained:

> Bourgeois democracy, although a great historical advance in comparison with medievalism, always remains, and under capitalism cannot but remain, restricted, truncated, false and hypocritical, a paradise for the rich and a snare and deception for the exploited, for the poor. (V. Lenin, *The Proletarian Revolution and the Renegade Kautsky*, LCW, vol. 28, p. 243.)

The victorious Russian workers could not use the old tsarist state machine, which needed to be done away with, but needed to create a new semi-state that would represent their own class interests, and suppress any attempts by the bourgeoisie to restore its rule.

In Germany, Kautsky's argument deliberately ignored the irreconcilable class interests represented by the workers' and soldiers' councils on the one hand, and the bourgeoisie, reflected in the Ebert government, on the other. Kautsky was not willing to recognise the situation of 'dual power' that had arisen after the November revolution. Instead he argued not for workers' rule but the need to *combine* the workers' councils with the bourgeois state. "Therefore, it is not a question of national assembly or workers' councils, but *both*," he argued. (J. Riddell [ed.], *The German Revolution*, p. 101.) But this was impossible as their interests were as incompatible as fire and water. The situation in Germany meant that either the workers' and soldiers' councils would consolidate their position and lay the basis for a workers' democracy, or the German bourgeoisie would re-establish its power and thereby dissolve the councils. There was no middle road.

NATIONAL CONGRESS OF COUNCILS

Finally, on 16 December, the National Congress of the Workers' and Soldiers' Councils was held in Berlin. It was to be a key turning point in the Revolution and was to last five days until 21 December 1918. Delegates attended from all over Germany, on the basis of one representative per 1,000 workers and one delegate per battalion. The rules for the election of delegates, however, were left to regional bodies, which resulted in a Congress that was, in many ways, out of step with the proletarian centres. The soldiers' councils also tended to lag politically behind the organised proletariat in the factories. More importantly, of the 488 delegates, only 187 were waged workers, while

ninety-five delegates were party or trade union full-time officials, mostly from the SPD. This certainly coloured its outlook and eventually affected its decisions. Out of the 488 delegates in attendance, 289 supported the SPD, ninety the USPD (including ten Spartacists) and ten the Bremen Lefts. The Majority Socialists also exploited the desire for unity, which affected large layers, especially of the politically inexperienced mass.

"The first All-German Congress which opened here on Monday," wrote Morgan Philips Price, "in respect of the balance of parties, resembles the first All-Russian Soviet Congress in June 1917." (M. Philips Price, *Dispatches*, p. 22.)

This domination of the Majority Socialists proved decisive. After a heated debate, the Congress came out strongly in support of the calling of a National Assembly and demanded that its opening should be brought forward to 19 January, 1919. This was a blow to the revolutionaries, whose slogans were having an increasing echo in the working class. It now looked as if the revolution was slipping through their fingers.

The proposal to establish a soviet republic was outlined by Heinrich Laufenberg, the chairman of the Hamburg Workers' and Soldiers' Council and supported by Ernst Däumig, from the Revolutionary Shop Stewards. In his speech, Laufenberg uncompromisingly argued that:

> The old system of government collapsed on 9 November. It must be replaced by the system of workers' and soldiers' councils. This is where power must lie, the power that we have conquered for ourselves.

He went on:

> If we proceed from this assumption, Germany can be reconstructed on the basis of the governmental power created by the Revolution, the workers' and soldiers' councils. We call it a 'Socialist Republic' but as yet that is merely a decorative title. We no longer have a monarchy, but we don't yet have a republic. The socialist state formation still needs to be created… What we have done so far is only the first step.

He then warned:

> [I]n the first few days of the revolution the bourgeoisie was too terrified to do anything. Now it is emerging from all corners. (B. Fowkes [ed.], pp. 48-49.)

But other delegates, including the soldier delegates, strongly argued for the rapid convening of a National Assembly to consolidate – in their eyes – the important gains of the revolution. Even Ebert, on behalf of the government, was allowed to speak and throw his weight in favour of the National Assembly.

The Congress was deeply under the influence of the SPD, which had paradoxically, inherited the leadership of the revolution, a revolution which Ebert and Scheidemann opposed. The growing support for the Spartacists was reflected in the mass demonstration of Berlin workers outside on the streets, but not in the delegates inside the Congress. With few delegates supporting the Spartacists, the only hope they had of influencing the Congress was with pressure exerted from outside. The demonstration was called explicitly in support of a soviet republic and was attended by an impressive 240,000, which was notably larger than the one called by the SPD, whose supporters dominated the Congress. This confirmed the comments of Paul Frölich, the Spartacist, who said that, compared to inside, the "social reality outside the Congress doors was very different." It reflected the fact that the capital was politically more advanced than the provinces, while the provinces provided a counterweight to the feelings of 'Red Berlin', where the USPD had influence. It also reflected the weight of the more conservative soldier representatives, compared to those from the factories.

This was one of the reasons why the Spartacists had a limited following in the workers' and soldiers' councils, which was mainly confined to Brunswick and Stuttgart – and they had no one on the Executive of the Councils in Berlin. Nationally, such bodies were dominated by the Majority Socialists, who were the equivalent broadly of the Mensheviks and Social Revolutionaries in Russia.

While the Congress heard Ebert, as head of the government, call for the power of the councils to be transferred to a National Assembly, the proposal submitted by the Stuttgart Council to allow Liebknecht and Luxemburg to attend with speaking rights was rejected by a considerable majority. Again, this reflected the more conservative layers in attendance. While this was a setback, it did not prevent the mass Spartacist demonstration outside sending a delegation to present its views to the Congress. Their representatives strongly demanded "all power to the workers' and soldiers' councils" and the replacement of the Council of People's Representatives, including Ebert, with an elected Executive Committee of the councils as "the highest legislative and governmental body." (J. Riddell [ed.], *The German Revolution*, p. 142.)

The Congress, however, took a more conservative line. After a heated debate, it voted to support a parliamentary democracy rather than a soviet republic. In fact, out of those present, only ninety-eight delegates were in favour of the call for a soviet republic. The Congress went on to endorse by an overwhelming majority, the proposal to turn its powers over to the new government until the election of a National Assembly, which should be brought forward from 16 February to 19 January 1919:

The General Congress of the Workers' and Soldiers' Councils of Germany, holding all power in the country, transfers the legislative and executive authority to the Council of People's Delegates until an elected national assembly will establish a new division of power.

The General Congress of the Workers' and Soldiers' Councils of Germany shall also appoint a Central Council of the Workers' and Soldiers' Councils whose task it will be to monitor the German and the Prussian cabinets. This Central Council will take on the role of parliament. It has the right to monitor the people's delegates of Germany and – until the new political structure will be finalized – the people's delegates of Prussia.

To monitor the ministries, the Council of People's Delegates will appoint assistants to the state secretaries. Two assistants will be sent to each ministry, one from the SPD and one from the USPD. Before appointing the ministers and their assistants, the Central Council has to be consulted. (Quoted in G. Kuhn, pp. 73-74.)

This proposal was passed by a massive 344 votes to ninety-one. It was to effectively bring the early first stage of the revolution to a close. With the dissolution of the Executive Council, a new Central Council was elected in its place, which became a puppet of the government. Accordingly, the Independents chose to boycott it, which effectively eliminated all opposition.

This caused the Revolutionary Shop Steward, Ernst Däumig, to remark that the workers' and soldiers' councils had voted their own "death sentence". (J. Riddell [ed.], *The German Revolution*, p. 144.) Paul Frölich concurred:

With this the workers' and soldiers' councils had committed political suicide and appointed the bourgeoisie their heir. (*Rosa Luxemburg*, pp. 307-308.)

Frölich, however, was very much on the ultra-left of the movement. In fact, the Spartacists, left-wing Independents and others went so far as to organise protests and meetings against the decisions of the Congress. The cry went up: "We have been cheated! Once more into the streets!"

The weakness of the revolutionary wing, however, meant that, with these decisions, the die had now been cast. The Congress of Workers' and Soldiers' Councils had refused to establish a soviet republic. While opposing the decisions, this should have been a signal to the Spartacists to modify their tactics towards the National Assembly, which was definitely going to take place. Rather than continue to denounce it, they should have agreed to participate in it and argued for the acceptance of a revolutionary programme from within. But they refused to go down this road.

TACTICAL MISTAKE

There is a great difference between recognising the need for soviet power and the ability to deliver it. The revolution would not be carried through to a conclusion by simply denouncing those in favour of a National Assembly. All this did was to alienate those who regarded the Assembly as a stepping stone to a democratic republic. The Spartacists regarded the National Assembly as a betrayal of the revolution, which could only succeed through the transfer of power to the workers' councils. But the masses did not fully understand this, especially the more politically backward layers. All they wanted was an end to autocratic rule and the introduction of democracy. The frustrations of the Spartacists, who could see the victory slipping away, were pushing them to make a tactical mistake. As long as large sections, especially of the soldiers, looked to a National Assembly, it was incorrect for them to reject *on principle* any idea of a struggle around it.

The illusions of the masses in a National Assembly could not simply be dismissed or denounced. Such illusions could only be dispelled on the basis of events, and, in the first instance, it was necessary for the revolutionaries to go through the experience with them.

Instead, the leaders of the SPD and the USPD were denounced as "disguised agents of the bourgeoisie" for supporting an Assembly, a policy that failed to connect with the masses, especially the ordinary Social Democratic workers. Rosa Luxemburg called the National Assembly a "cowardly detour" and "an empty shell", which it undoubtedly was. (J. Riddell [ed.], *The German Revolution*, pp. 92-93.) But the masses regarded it differently. The more conservative or traditional sections saw it as an embodiment of their wishes. The National Assembly was certainly a 'detour' in the context of the proletarian revolution, but there existed no straight line to victory, especially in the absence of a mass revolutionary party. Later, Luxemburg came out in favour of participating in this 'empty shell', on a revolutionary basis.

While the arguments for a soviet or Räte Republic had been vital in the early stages of the German Revolution, when the masses were directly open to revolutionary ideas, as soon as it became clear that the National Assembly was going to become a reality, the Spartacists should have made a tactical change. Rather than opposing the National Assembly outright, they could have combined their approach: arguing for a soviet republic, but stating at the same time that if the Assembly elections were to take place, they would participate and put forward a revolutionary alternative.

'We have done away with the reactionary monarchy, and we have established political liberty,' is what they should have said, explaining, however, that the only way they could safeguard their victory was if they

were to break the power of the enemies of democracy, who were the enemies of progress. They should have argued for a revolutionary government that would expropriate the landed estates, banks and basic industries, under workers' control. The state would need to be purged and renewed with reliable representatives of the people. Such a programme should have been carried through by the workers' and soldiers' councils, but as these were not willing to do so, then it should have been posed as a demand on the workers' parties in a revolutionary National Assembly. The main task was to explain the need to urgently implement the revolutionary programme. Only in this way could the problems of the working class be solved.

Unfortunately, the majority of Spartacists took an ultra-left approach, as did the Bremen Left – who even walked out *en bloc* from the Dresden Workers' and Soldiers' Council as they could not be associated with the 'counter-revolutionary elements' of the SPD. This was a huge mistake, which served no purpose, only to further isolate their forces. It was a clear case of 'infantile leftism', which Lenin criticised so forcefully. Although members of the revolutionary left were courageous class fighters, they lacked a clear understanding of strategy and tactics. It is true that Rosa Luxemburg attempted to curb their excesses, but even she found this very difficult. They were being swept along by the revolutionary movement and were intoxicated by events. Unfortunately, they had not gone through the rich school of Bolshevism, which had prepared the Bolsheviks to skilfully win a majority and lead the working class to power.

SOCIALISATION

Later on, the national Congress of Workers' and Soldiers' Councils debated the issue of nationalisation or the 'socialisation of the economy', which was one of the key demands of the November Revolution. Of course, the government, while not directly opposing the measure, tried to steer it into safe channels with the proposal to set up a Commission to study the question. For the government, the longer it could be delayed the better. Rudolf Hilferding, who supported the proposal, tried to discourage the idea of immediate nationalisation:

> It's [the economy's] productive capacity is practically in ruins, and the working class has been weakened by undernourishment and crippled by the war. All these circumstances render the task of socialisation uncommonly difficult. This does not mean that the undertaking is impossible; but it does mean that we need longer to complete it. Our first task is to set the economy in motion again.

Hilferding continued: "We cannot take over the whole of industry at one stroke… I am convinced that the idea of simple confiscation would be incorrect." He instead argued for a wealth tax that "would yield copious amounts, and it would achieve as much as we might attain, unevenly and incompletely, by confiscation." (B. Fowkes [ed.], pp. 24-25.)

Hilferding's gradualist approach was opposed later in the debate by his fellow USPD comrade and government minister, Emil Barth, who called for "socialisation not in months but in a few short days." Despite his forceful intervention, Hilferding's cautious line was endorsed by the Congress majority, again a reflection of the composition and mood of the delegates. Of course, all future promises of socialisation were very quickly forgotten about and were never to see the light of day.

The decision again showed how out of step with the mood within the wider working class the majority of the Congress was. They were lagging behind the real mood, especially in the factories. In fact, the deeper down you went into society, the more radical the mood was. However, there was *one* question that the delegates took a very radical, if not revolutionary, stand on. This was the character of the army. This certainly reflected the influence of the soldier masses attending the Congress, who were far more revolutionary on issues that directly affected them.

While the majority of the Congress were influenced by the SPD, their politics were far from 'conservative', especially over this question. The mass demonstration which converged on the Congress demanded, among other things, the democratic transformation of the army. This time it struck home and the Congress debate shifted dramatically to the left. In the end, the Congress supported almost unanimously the Seven Hamburg Points, a bill of rights for democratising the military. The soldiers and workers were as one in agreeing a resolution demanding: (1) the abolition of the standing army and the establishment of a people's militia, (2) that all badges of rank be removed, (3) that all soldiers be allowed to elect their officers with immediate right of recall, and furthermore (4) soldiers' councils would be responsible for the maintenance of discipline throughout the armed forces. Moreover, higher ranks should not to be recognised outside the Service.

The implementation of these points, especially the one calling for a 'People's Army', would have constituted a revolution in the armed forces, and immediately destroyed the power of the reactionary officer caste. The SPD ministers, led by Ebert, desperate to reassure General Groener that the resolution was meaningless, was instead faced with an officers' revolt. The officer caste could not tolerate such interference in the armed forces. As expected, the Social Democrats capitulated to the generals and refused to

carry out this decision of the Congress. Instead, they set out to establish even closer links with the German High Command. To further this relationship, they flagrantly defied the demands and decisions of the Congress, which was at the time the highest political authority in Germany. 'Democracy' only suited them when it was in their interests to do so.

But Wilhelm Dittmann warned Ebert:

> If the Central Committee [of the Workers' and Soldiers' Councils] agrees to General Groener's proposals [to ditch the Hamburg Points], it will sign its own death warrant, and so will the government.

Yet Ebert was not moved by such threats. He showed nothing but contempt towards the councils and the revolution, which he compared to a lunatic asylum:

> Things cannot go on like this. We are making ourselves ridiculous in the face of history and the whole world... The conduct of the Reich's affairs is exclusively a matter for the government... Workers' and soldiers' councils all over the country must stop interfering and poking around in government matters... We can take no responsibility for pranks that belong in the madhouse. (Quoted in ibid., pp. 52-53.)

LEFT-WING COMMUNISM

The ultra-left tendencies within the revolutionary left were not confined to Germany. Lenin had to deal many times with such tendencies within the young Communist parties internationally. This was the reason he wrote his book 'Left-Wing' Communism: An Infantile Disorder, precisely to deal with this question in the light of the experiences and history of Bolshevism. In order to educate the new fresh layers gravitating towards communism, Lenin explained: "Tactics must be based on a sober and strictly objective appraisal of all the class forces..." He continued, "It is very easy to show one's 'revolutionary' temper merely by hurling abuse at parliamentary opportunism." (LCW, vol. 31, p. 63.)

More seriously, it was necessary to take into consideration the existing consciousness and outlook of the working class:

> You must not sink to the level of the masses, to the level of the backward strata of the class. That is incontestable. But, at the same time, you must *soberly* follow the *actual* state of the class consciousness and preparedness of the entire class (not only of its commonest vanguard), and of all the *working people* (not only of their advanced elements).

In dealing directly with the German 'Left' communists' attitudes towards the National Assembly, he explained:

> We must *not* regard what is obsolete to us as something that is obsolete *to the class*, to the *masses*... How can one say that 'parliamentarianism is politically obsolete', when 'millions' and 'legions' of *proletarians* are not only in favour of parliamentarianism in general, but are downright [according to the German Lefts] 'counter revolutionary'!? It is obvious that parliamentarianism is *not yet* politically obsolete. It is obvious that the 'lefts' in Germany have mistaken their desire, their political ideological attitude, for objective reality. That is the most dangerous mistake for revolutionaries to make. (LCW, vol. 31, p. 58.)

Lenin felt it essential to keep a finger on the pulse of the working class so as to achieve the best results from the party's propaganda. The illusions of the masses could not be overcome by simply repeating abstract ideas. It was necessary to put forward a correct programme that would connect with the workers.

Of course, this did not concern the sectarian, who would be content to shout from the side-lines. The communists, in contrast, would seek to engage with the working class, taking their aspirations and illusions into account. This did not mean fostering such illusions, but to use them as a starting point, so as to challenge them. As the *Communist Manifesto* explained, the communists do not set up any sectarian principles of their own by which to shape or mould the proletarian movement. They distinguish themselves by bringing out the common interests of the proletariat as a whole. They are the most advanced sections which have a clear line of march. They are not separate, but an integral part of the movement.

The attempt to boycott the National Assembly when the masses were overwhelmingly in favour of participation was clearly wrong; it was an attempt to cover over their impotence with radical-sounding gestures. There was a long history of this boycott tactic within the Bolshevik Party from which to learn. In general, the only time to boycott a parliament is when you are strong enough to replace it, otherwise it is pointless. The Bolsheviks had made a mistake, for example, in supporting a boycott of the Duma in 1907, when the revolution had clearly ebbed. Lenin fought against this boycott, arguing it was more correct under the circumstances to utilise every legal opportunity to advance the revolutionary cause. But he was in a minority of one and even voted with the Mensheviks to secure its rejection. Barring a revolutionary wave against the government, which was absent, there could be no successful outcome of a boycott. Under the circumstances,

the Bolsheviks needed to use every opportunity, however small, which also meant participating in a reactionary Duma. Later, the Bolsheviks came over to Lenin's position and the boycott question was forgotten. This lesson had clear relevance for Germany.

A boycott of the National Assembly under the conditions in Germany in December 1918 and January 1919 could only guarantee the isolation of the revolutionaries from the masses who looked to the Assembly. This was particularly so when universal suffrage was being introduced for elections at national and local level. In the end, despite the boycott campaign, a massive eighty-three per cent of the population participated in the vote of January 1919, a far bigger percentage turnout than at any time in the previous history of Germany.

Similarly, the Spartacists also demanded 'Down with the Ebert Government', a slogan that in the circumstances was incorrect, and was likely to lead to adventurism. They were still a small minority and it would have been far better to have placed demands on the socialist government. This was the method of the Bolsheviks, who demanded initially not the immediate overthrow of the Provisional Government, but to kick out 'the ten capitalist ministers' and for a majority Soviet government to peacefully carry through the revolution. Lenin had warned against the misuse of such a slogan in Russia on 22 April (5 May) 1917:

> The slogan 'Down with the Provisional Government' is an incorrect one at the present moment because, in the absence of a solid (i.e. a class conscious and organised) majority of the people on the side of the revolutionary proletariat, such a slogan is either an empty phrase, or, objectively, amounts to attempts of an adventurous character. (LCW, vol. 24, pp. 210-211.)

He went on to explain that the tasks of the Bolsheviks were: (1) To *explain* the proletarian line; (2) To *criticise* the petty-bourgeois policy; (3) To carry on propaganda and agitation; (4) To *organise, organise,* and once again *organise.*

> The Provisional Government must be overthrown, but not now, and not in the usual way. We agree with Comrade Kamenev. But we must explain. It is this word that Comrade Kamenev has been harping on. Nevertheless, this is the only thing we can do. (LCW, vol. 24, p. 246.)

This was only six months before the Bolshevik revolution, and it would have been very sound advice for the young German communists, who needed to adopt not a shrill tone, but a sober attitude to the mass movement.

Lenin fought against any traits of putschism or Blanquism[5] within the Bolshevik Party, which would only have served to isolate and endanger the party. The party's main task was to win a majority to their side by *patient explanation,* and not by ultra-left talk which could seriously miseducate the cadres and disorientate the party. Again, on 24 April (4 May) 1917, Lenin wrote:

> What can be more absurd and ridiculous than this fairytale about 'civil warmongering' on our part, when we have declared in the clearest, most formal and unequivocal manner that all our work should be focused on patiently explaining the proletarian policy as opposed to petty-bourgeois defencist craze with its faith in the capitalists? (LCW, vol. 24, p. 207.)

Once again, in summing up the whole experience of Bolshevism in *'Left-Wing' Communism,* Lenin reiterated the flexible tactics that the Bolsheviks needed to pursue in order to guarantee success.

> At the beginning of the period mentioned, we did *not* call for the overthrow of the government but explained that it was impossible to overthrow it *without* first changing the composition and the temper of the Soviets. We did not proclaim a boycott of the bourgeois parliament, the Constituent Assembly, but said – and following the April (1917) Conference of our party began to state officially in the name of the party – that a bourgeois republic with a Constituent Assembly would be better than a bourgeois republic without a Constituent Assembly, but that a *workers' and peasants'* republic, a Soviet republic, would be better than any bourgeois-democratic, parliamentary republic. Without such thorough, circumspect and long preparations, we could not have achieved victory in October 1917, or have consolidated that victory. (LCW, vol. 31, p. 31.)

Unfortunately, it was the failure of Luxemburg and Liebknecht to train the Spartacist cadres sufficiently in such strategy and tactics that allowed the ultra-left elements to hold a disproportionate sway over the Spartacist League. However, we should be careful in apportioning too much blame to Liebknecht and Luxemburg, as for much of the war they were either in prison or in 'protective custody'. Nevertheless, these weaknesses would lead to serious consequences.

On 11 November 1918, the Spartacists had formally changed their name from the Internationale Group to the Spartacists League and they opened up negotiations with the Revolutionary Shop Stewards and the USPD for joint

5 Louis Auguste Blanqui (1805-1881) was a French socialist and political activist, notable for his theory of Blanquism, which was the idea that the seizure of power should be carried out by a small revolutionary minority.

work. Although they had a much wider influence than their membership, they were still a small group. The task was still how to win over a majority, and this required skilful tactics and a certain flexibility, which they lacked at the time.

COUNTER-REVOLUTION RAISES ITS HEAD

After the first flush of the November Revolution, the German High Command, in connivance with Ebert, made plans to occupy Berlin with a number of hand-picked divisions of 'loyal' troops to establish a reliable and 'firm government'. Berlin was considered as being in the grip of anarchy by the right-wing ministers that needed to be pacified. General Groener later explained:

> A scheme was hatched where ten divisions were to march into Berlin to take power from the workers' and soldiers' councils. Ebert was in agreement with this... We worked out a programme for cleaning up Berlin and the disarming of the Spartacists. (Quoted in C. Harman, *The Lost Revolution*, p. 58.)

An attempted military coup took place on 6 December 1918, when reactionary troops marched on the Chancellery, proclaiming Ebert as President. At the same time, another group stormed the House of Deputies and arrested the members of the Greater Berlin Executive Council of Workers' and Soldiers' Councils, the majority of whom were Left Independents.

Hermann Müller wrote:

> This coup was planned in support of the Ebert-Haase government to counter the campaign of the Spartacist group. The leading spirit, a certain Spiro, who was neither socialist nor communist, had called on Ebert some days previously with other members of his regiment, and had said that he would demonstrate with the soldiers in favour of the government. Spiro did his best to obtain Ebert's consent, but the latter considered such a manifestation unnecessary and explained to his visitors the desirability in such cases of workers taking their part with the soldiers. In spite of the Chancellor's recommendations, however, Spiro got his own way – a proof that reaction was still abroad. (Quoted in A.R. Oliveira, p. 100.)

While Ebert refused the Presidency under these circumstances, the coup was already in motion. Groups of government soldiers had raided the Spartacist newspaper *Rote Fahne*, arrested Liebknecht and attacked a Spartacist-led demonstration, killing sixteen workers. Spontaneously, this provoked a massive backlash. A gigantic crowd of angry sailors and workers marched on the troops, freed the executive members and foiled the coup attempt.

Rote Fahne proclaimed:

Workers, soldiers, comrades! The Revolution is in danger! ...

Preserve your handiwork of 9 November! ... The criminals are Wels[6] and company, Scheidemann, Ebert and company... Throw the guilty men out of the government! ... We must foil the conspiracy of Wels, Ebert and Scheidemann. The Revolution must be saved... Down with the coward organisers of mutinies! ... Forward to the task! To the fight! (Quoted in ibid., pp. 100-101.)

However, the editorial of the SPD newspaper *Vorwärts* of 8 December 1918 played down the events, and even blamed the Spartacists for staging a provocation:

The supporters of Spartacus know, however, that an attempted coup would have no prospect of success, and that even in the wholly improbable event of its succeeding, a Liebknecht-Luxemburg government wouldn't even last three days because it would have the whole nation against it.

The paper then went on to put the blame elsewhere:

The declaration of the Reich government which was affixed to the columns yesterday gives in brief the results of the investigation made of Friday's events. It emerges from this that a *couple of petty officials of the Foreign Office* with high-sounding aristocratic names set in motion this impertinent pseudo-coup. They are the ones who led the soldiers astray. One hardly knows what to be more amazed at: these gentlemen's lack of scruples or their incomprehensible stupidity. The harm they have done is immense. The Social Democratic government is taking pains to work in co-operation with the officials of the old regime, and an obvious prerequisite for this is naturally those officials' obedience to superior authority. (B. Fowkes [ed.], pp. 22-23, emphasis in original.)

This mealy-mouthed response to a coup showed how far the Social Democrats leaned upon the elements of the old regime. Seizing the opportunity, the Spartacists organised mass demonstrations and even strikes against the attempted putsch, much to the dismay of the 'socialist' government. The feeling of anger amongst the Berlin workers was palpable and was reflected by the 150,000 strong armed demonstration called on 8 December. The Spartacists issued an urgent appeal:

6 Otto Wels was the Social Democratic Chief of the Berlin Military Command, regarded by
 the Spartacists as the man behind the coup attempt.

Workers, soldiers, comrades! Attention! The revolution stands in great danger! Be on your guard! Our most vital interests are at stake! Everything for the revolution and socialism!

Everything – even life! Defeat the attack! Down with the conspirators! Long live socialism! The future, the final victory will be ours! (J. Riddell [ed.], *The German Revolution*, p. 117.)

Groener's troops – the shock troops of the counter-revolution – began to arrive in the capital, greeted by Ebert. It was hoped he would restore order. But within a short space of time, things began to unravel. The ordinary soldiers began to fraternise with the radicalised Berlin workers, sharing their common problems. This had the necessary effect. "The soldiers so much desired to go home that one could do nothing with these ten divisions," stated Groener. "The programme of purging Berlin of the Bolshevik elements and of ordering arms to be handed in could not be carried out." (P. Broué, p. 230.) The troops had become totally unreliable, which destroyed any plans to impose a dictatorship and forced the generals to retreat and wait for better times.

The threat of civil war from the General Staff was not without foundation. However, given the balance of forces, and the effects of the revolution, there was a certain amount of caution. If it came down to an open clash, it was not certain who would win. The initiative was still in the hands of the revolutionary masses and the forces of counter-revolution were still very much on the defensive. Groener's move proved premature.

As Hermann Müller, a staunch defender of Ebert, asked: "Where were the forces of counter-revolution?" He went on: "The bourgeoisie stood to lose everything in a civil war; the Monarchists did not even dream of counter-revolution. They were glad that the Revolution had spared their lives." (Quoted in E. Anderson, p. 52.)

While the military had no alternative but to bide its time, this did not prevent them from testing the ground. But it had become clear that they were in too much of a hurry to reassert their control. The army was in the process of demobilisation, as war-weary soldiers returned home in their droves to take part in, or be affected by the revolution.

Thus, the government had to increasingly lean on the Freikorps to assert their control. As we have seen, the latter were ultra-reactionary gangs of White-Guardist elements whose officers were drawn from the pro-monarchist military, the sons of the aristocracy, who had formed the student corps at the universities. These paramilitary gangs which had their first taste of blood fighting alongside the Whites against the Bolsheviks, were now

engaged in terrorist acts against strikers and local trade union leaders who
had leftist sympathies. From 1918 onwards, they formed the backbone of
the armed forces used by the Weimar republic to carry through the counter-
revolution. By 1923, they formed the nucleus of the 'Black Reichswehr', the
illegal paramilitary formations, which later became the basis of the fascist
gangs of Adolf Hitler.

PEOPLES' NAVAL DIVISION

Berlin was the centre of extreme turbulence and instability. There were
continual strikes and demonstrations. As far as the Ebert government was
concerned, instead of the centre of government, Berlin was very much in the
grip of anarchy. Therefore, there were continuous appeals from on high for
law and order.

Following on from the 6 December failed coup, the military leaders,
in league with the Chancellor, once more decided to assert themselves.
The pretext for this intervention came on 23 and 24 December, when
open clashes occurred between regular army troops and rebel sailors of the
Peoples' Naval Division. The Division consisted of sailors mainly from the
Kiel navy port who had come to Berlin to defend the capital against the
forces of counter-revolution. At this time, they were stationed at the Imperial
Palace, in the centre of Berlin. The government clearly saw them as a threat
to their authority. They feared their presence and therefore hatched a plan
to dislodge them from the Palace, which only served to provoke them. Large
groups of marines defiantly paraded outside the headquarters of the Military
Command, but they came under fire. One marine was killed and three
seriously wounded. In response, the angry sailors broke into the Command
Headquarters, seized the Chief of Command, Otto Wels, and demanded
he sign a document stating the division would not be transferred. But Wels
refused and was held hostage by the marines.

According to the minutes of the Cabinet meeting of 26 December,
Scheidemann banged the table saying, "in short, we must decide where we
stand on the question of deserters… a completely unscrupulous gang." (S.
Taylor, p. 12.)

The government was lining up for another confrontation. On the pretext
of releasing Wels, Ebert ordered government troops under General Lequis to
intervene using force. But, after an ultimatum was delivered to the marines
to hand over Wels, an artillery bombardment started, which destroyed parts
of the building. In the exchanges, dozens of combatants lost their lives.
This bloodshed caused outrage and large crowds encircled Lequis' soldiers,
and fraternised with them. Late arrivals began to side with the mutineers.

Under such pressure, the troops became increasingly unreliable and groups of soldiers began to lay down their weapons. Many refused to obey their officers and the assault on the Naval Division came to a chaotic end. In the end, despite the casualties, the rebellious sailors were victorious and Wels was released. Four days later, he resigned his post.

On Christmas Day, Spartacists and marines occupied the *Vorwärts* building, claiming it had published an article attacking the marines. On 26 December, an issue of the *Vorwärts* printed in red ink appeared for the first time in Berlin.

The General Staff were furious at this ignominious retreat and Lequis was relieved of his command. They were hell-bent on revenge for the humiliation they had suffered. This was not the first time that the army was deployed in this way, and it would not be the last. But the Berlin workers were particularly embittered by the use of regular troops against revolutionary sailors.

The outrage over this attack had serious political repercussions. On 29 December 1918, the USPD ministers resigned from the government in protest at this "bloodbath". This represented a deep governmental crisis, in which half the ministers had handed in their resignations. But the government did not fall as there was no political alternative. In the end, Ebert rushed to replace the Independent ministers with Majority Socialists, which included Gustav Noske, the 'bloodhound' of the counter-revolution, who was put in charge of military and naval affairs.

The right-wing Social Democrats now took full responsibility for pursuing the course of counter-revolution. They had clearly demonstrated their willingness, as and when necessary, to spill workers' blood with the aid of the military.

Noske was about to play a particularly pernicious role. He was appointed the new Minister of Defence from where he built up an intimate relationship with the German High Command. In this capacity, he was put in charge of the notorious Freikorps, and was soon to become the most hated man in Germany. "I won't shirk from the responsibility!" he exclaimed. Noske turned to Ebert, "Don't worry! Now you will see that the wheel is going to turn!" (P. Broué, p. 238.)

The new right-wing Social Democratic government gave increased confidence to the counter-revolution. Towards the end of December 1918 an alliance of monarchists and counter-revolutionary elements of various descriptions (together with the SPD leaders), conducted a vicious witch-hunt against the Spartacist League, the representatives of German Bolshevism. An organisation called the 'Anti-Bolshevik League', financed with government money, plastered walls with posters in towns and villages, slandering the

Spartacist leaders. The Majority Socialists, especially in the newspaper *Vorwärts*, took an active role in this witch-hunt and strenuous efforts were made to mobilise the forces of counter-revolution.

The burial of the victims of the assault on the People's Naval Division took place on 29 December. At one procession organised by the SPD, the so-called 'Vigilant Committee' distributed leaflets blaming the Spartacists for the deaths and inciting the murder of Karl Liebknecht and his comrades:

> The Christmas provocations of the Spartacists will lead the people into the abyss... The brutal violence of this band of criminals can be met only by counter-violence... Do you want peace? Then see to it, every man of you, that the violence of Spartacists is ended... Do you want liberty? Then do away with the armed loafers who follow Liebknecht... (P. Frölich, p. 318.)

WITCH-HUNT BEGINS

A murderous atmosphere was being deliberately fostered against Liebknecht and Luxemburg, regarded as the leaders of the revolutionary movement. It was the equivalent of the July Days in Russia, where the Bolsheviks were driven underground and Lenin was forced into hiding. Huge sums of money were poured into the campaign against the Spartacists, which openly advocated the assassination of its leaders. Giant posters appeared like this one:

> Workers! Citizens!
> The downfall of the Fatherland is imminent!
> Save it!
> It is not being threatened from without, but from within:
> By the Spartacist Group.
> Strike its leader dead!
> Kill Liebknecht!
> You will then have peace, work and bread!
> Signed: Soldiers from the Front.
> (J. Riddell [ed.], *The German Revolution*, p. 263.)

Many politically backward and reactionary layers were driven into a frenzy by such propaganda, especially those disgruntled and embittered soldiers returning from the front who had never heard of Liebknecht or the Spartacists. They were consciously worked up into a state of hysteria about the Spartacists, who were falsely accused of starting a bloody rebellion aimed at plunging the country into chaos. The counter-revolution was displaying its teeth as it prepared to strike.

COMMUNIST PARTY FOUNDED

The situation in Germany became extremely polarised. The Spartacist League, using the authority of Liebknecht and Luxemburg, sought to spread its revolutionary message to the masses. Despite addressing mass rallies and demonstrations on a daily basis, their support was still relatively limited. The masses were still very much under the influence of the Majority Social Democrats and the Left Independents, although there was a growing shift to the left, especially among the more advanced layers.

The whirlwind of events plunged the Spartacist League into exhausting daily interventions. Eventually, the printers at the *Scherl* refused to set up *Rote Fahne*, so from 18 November it was printed at *Kleines Journal*. The new paper bore the words, "Editors: Karl Liebknecht and Rosa Luxemburg." The first of the new issue boldly proclaimed in an article by Luxemburg:

> The abolition of capitalist rule and the creation of a socialist order of society – this and nothing else is the historical theme of the German Revolution. It is a tremendous task and it cannot be performed overnight with a few decrees from above, but only by the conscious action of the toiling masses in town and country, and the highest degree of intellectual maturity and idealism on the part of those masses pursuing their aim through all vicissitudes until final victory. (Quoted in P. Frölich, p. 294.)

In late December 1918, under the influence of the October Revolution in Russia, pressure mounted within the Spartacist League to transform itself from a loose-knit federal organisation into a centralised Communist Party on the lines of the Bolsheviks. Initially, they were going to wait for the normal conference of the USPD before advancing the idea of a new party, but this plan was discarded under pressure from Radek, who wanted the process sped up. Given his links with the Bolsheviks, he had a great deal of authority.

Ever since the 9 November Revolution, heated political debate had taken place in the USPD, especially involving the Spartacists. On 14 December, at a Berlin conference of the USPD, a massive argument broke out over the question of the National Assembly. So heated was the discussion, that Haase, the chairman, appealed to the Spartacists to leave the party. This was hardly a comradely gesture. Although the left wing was defeated over their opposition to the National Assembly, it led to a very polarised situation, leading to sharp exchanges. The League seized on this to demand that the USPD leaders organise an emergency National Congress to discuss the critical situation in the country. This was in the form of an ultimatum and they demanded a reply within twenty-four hours.

As expected, the USPD leadership feared a Congress. If they were defeated, they could lose support to the left wing, namely the Spartacists. They therefore rejected the call. In response, the Spartacists went ahead and organised their own conference which opened on 29 December. This was attended by 127 delegates, including delegates from the Free Socialist Youth, the Bremen Left and the Hamburg Left Radicals. It was here that they took the decision to set up the Communist Party of Germany (Spartacist League), Kommunistische Partei Deutschlands, (KPD).

Rosa Luxemburg was initially against the idea of launching a new party, fearing they would be politically isolated. Leo Jogiches, another experienced leader, was also firmly against the proposal. They could see the masses flooding in their millions into the trade unions. They could also see the advanced layers of workers moving into the USPD, which they saw as a revolutionary party. There were still very favourable opportunities for fruitful work in these organisations, especially the Independents, and yet they were deciding to abandon this party. However, the setting up of a new German Communist Party was championed by Karl Radek, whose arguments, backed with the authority of the October Revolution, carried the day.

Luxemburg's hesitation cannot be dismissed out of hand. This had nothing to do with a sentimental attachment to the old party. The potential for fruitful faction work in the USPD was self-evident. The rank and file Spartacists were still quite confused politically, as well as being very ultra-left, and would benefit from testing out their ideas with the rank and file of the Independents. There was still much work to be done in educating these layers. But these layers were very impatient and keen to leave the 'reformist' USPD and form a revolutionary Communist Party.

Luxemburg had a point about the danger of political isolation, as the subsequent events were to prove. It was not a principled question whether the Spartacists were an open, independent party or not. Lenin's call for a split in the Second International from 1914 onwards was in order to pull the masses away from the reformist leaders, but it had nothing to do with salving the conscience of revolutionaries. It was a political question.

The Spartacists were, after all, a very small group of at most a few thousand. For them to launch an independent party was not going to change the political balance of forces in Germany or offer an easy solution to the impasse of the revolution. In Britain, for example, the communists were also a small group. Although they organised the Communist Party of Great Britain in August 1920, Lenin immediately called on them to apply for affiliation to the Labour Party, so as to get closer to its radicalised rank and file. This showed Lenin's complete organisational and tactical flexibility.

The real Lenin was always firm on principles, but flexible on tactics and organisation.

At the beginning of the revolution, the Spartacists had decided to remain inside the USPD for as long as possible. But it was the pressures and frustrations arising from the revolution that created the mood of impatience. Rosa Luxemburg was attempting to combat this impatience, but it proved a losing battle.

It could be justifiably argued that if the Spartacists had remained within the USPD, and organised a *more coherent faction earlier*, the *mass* split within the USPD in October 1920 would have come far sooner – and so would the creation of a mass Communist Party in Germany.

While operating as the Spartacist left opposition within the USPD, this could have given them a certain 'protective' cover. Striking out on their own as a small group made them much more vulnerable and exposed to the blows of the state and the counter-revolution. "The Spartacist League was still rudimentary, and consisted chiefly of innumerable small and almost autonomous groups scattered all over the country," explained Paul Frölich. (*Rosa Luxemburg*, p. 293.) Although their influence was a lot larger, they were not in a position to lead a revolution. There was a lot of ground work still to be done to build up their forces. Furthermore, the building of a revolutionary organisation in the middle of a revolution is extremely difficult. While the masses are open to revolutionary ideas, the pull of the traditional mass organisations is enormous. Cadres, the backbone of a revolutionary party, cannot be created overnight; it can take years to create a cadre. This was precisely the strength of Russian Bolshevism, which created the organisation and cadres before the 1917 revolution. Lenin was indispensable for the revolution's success, but without the party he would not have been able to shape events. Clearly, since her release from prison, Luxemburg's prime consideration was to assemble, as quickly as possible, the cadres of a proletarian vanguard. This task, which took the Bolsheviks nearly two decades to accomplish, needed to be completed in a matter of months or a few years at most. Thus, the small group of Spartacists were thrown into the maelstrom of events, desperately hoping to affect the course of the revolution with insufficient forces.

A revolution acts to rapidly transform the consciousness of the masses. But, experience shows that there needed to be a conscious revolutionary leadership to lead the masses to power. Such a leadership cannot be simply improvised, but has to be built with the material at hand, and that was the uphill task confronting Rosa Luxemburg. This was on top of the multitude of other tasks on her shoulders.

REBELLIOUS YOUTH

The Spartacist League had attracted many rebellious young people to its banner, hostile to reformism, but politically raw with very little knowledge of Marxism.

Rosa Leviné-Meyer wrote:

> Like many other ardent communists, I knew very little of its programme and felt no compulsion to study its procedures. It is surprising how little one wants to know when one hardly knows nothing. (R. Leviné-Meyer, *The Life of a Revolutionary*, p. 71.)

Frölich also summed up the difficulty quite well:

> The Spartacist League was a loose organisation of a few thousand members only. Its core was the old Left Wing of Social Democracy, a Marxist *elite* schooled in Rosa Luxemburg's tactical ideas. The majority of the Socialist Youth joined forces with the League, which then recruited additional supporters amongst the many young people who had been driven to the Left Wing of the working-class movement by their opposition to war. During the war years, all these elements had run risks and incurred dangers quite new to the working-class movement in western Europe. They were all enthusiastic adherents of the Revolution, though many of them still had very romantic ideas about it. (*Rosa Luxemburg*, p. 310.)

Frölich himself held 'romantic' ideas at this time. The leadership around Luxemburg tried to temper this 'romanticism' and impatience – which included ultra-left moods in the direction of putschism – by stressing the need to win a political majority within the working class as a prelude to the conquest of power. The programme, drafted by Rosa Luxemburg, strongly emphasised this central idea:

> The proletarian revolution can only win through to full clarity and maturity by stages, step by step, by taking the road to Golgotha, through its own bitter experience, through defeats and victories. The victory of the Spartacist League stands not at the beginning but at the end of the revolution: it is identical with the victory of the great mass of the millions of the socialist proletariat...

> The Spartacist League will never take over the government in any other way than through the clear, unambiguous will of the great majority of the proletarian masses in Germany, never otherwise than by virtue of the proletarians' conscious assent to its ideas, goals and methods of struggle. (Quoted in B. Fowkes [ed.], p. 284.)

Many of the young members, however, were not so convinced by such an approach. Few were politically educated and were largely driven by their own instincts. As with other newly-formed Communist parties, the German party was saturated with ultra-left tendencies, opposing participation in parliament or in the trade unions, and even some favouring a loose federal organisation instead of a party based on democratic centralism. It was very much a mixed bag of rather raw material which needed to be educated and knocked into shape.

NEW BORN

Once the decision to form a separate Communist Party was taken, both Luxemburg and Liebknecht were fully committed to it. The founding Congress of the German Communist Party opened in Berlin on 30 December 1918. There were eighty-three delegates from the Spartacist League and twenty-nine from the International Communists of Germany (IKD). This was the new name taken by the Bremen Left and other independent groupings. They had remained outside of the USPD and their ideas were influenced by anarcho-syndicalism.

Ernst Meyer wrote:

> As a result of the tumultuous events of those days, the founding Congress was as good as completely unprepared. Most delegates were organisers of small local groups. A firm and united ideology was entirely absent. (J. Riddell, [ed.], *The German Revolution*, p. 167.)

Most of the delegates were young, with three-quarters under the age of thirty-five and only one (Jogiches) was over fifty years old. Half were industrial workers.

Apart from voting to establish the party and then choosing its name, the Congress went on to debate the most contentious point, namely their attitude to the National Assembly.

Firstly, Paul Levi moved the proposal to participate in the Assembly elections, but was interrupted many times throughout his contribution. Then Otto Rühle intervened to oppose participation.

In moving the boycott resolution, he said "we have had enough of compromises and opportunism". He continued, "We will establish the new government here in Berlin. We still have fourteen days left [before the elections]." (ibid., p. 175.)

Rosa Luxemburg intervened energetically to support Levi. She welcomed the enthusiasm on display at the Congress, but with certain reservations. "I am happy and yet I am dismayed. I am convinced that you want a sort of

radicalism that is a little too quick and easy. In particular, this is shown by the interjections." (ibid., p. 177.) She said that there were no real differences as to their aims, but only how to achieve them. The task she said was "to blow up that bastion from within." But the majority of the delegates were not convinced.

Despite the caution of the party's programme against adventurism, delegates were swayed by emotional speeches laced with verbal ultra-leftism. Why participate in a reactionary assembly which should be overthrown, they reasoned? Despite Rosa Luxemburg's intervention, they voted overwhelmingly to boycott the National Assembly elections due in January by sixty-two votes to twenty-three.

Following the vote, she stated, "Comrades, you take your radicalism rather too easily." Leo Jogiches was so shocked, he thought the setting up of the Communist Party was premature. But Rosa simply shrugged her shoulders, declaring that a new-born baby always squalled at first. In a letter to Clara Zetkin, Rosa Luxemburg described the vote as "somewhat childish, half-baked, narrow-minded radicalism," but she hoped this would soon subside. (J.P. Nettl, pp. 757-758.)

In this viewpoint she was supported by Lenin, who later wrote that:

> [C]ontrary to the opinion of such outstanding political leaders as Rosa Luxemburg and Karl Liebknecht, the German 'Lefts', as we know, considered parliamentarianism 'politically obsolete' even in January 1919. We know that the 'Lefts' were mistaken. (LCW, vol. 31, p. 57.)

Two further ultra-left motions were debated at the Congress, which tried to declare membership of the trade unions incompatible with membership of the Communist Party. According to them, Communists were not to join the trade unions, but to join the workers' councils instead, and "continue in the most determined manner the work of fighting against the trade unions." Frölich declared in his intervention that the slogan should be "Get out of the unions!" (J. Riddell, [ed.], *The German Revolution*, p. 188.) Rieger, from Berlin, stated that belonging to the reformist trade unions was incompatible with communist membership. The congress seemed to be shifting more and more towards an extreme ultra-left position the longer it went on.

This majority feeling to abstain from the unions was expressed at a time when *millions* of radicalised workers were streaming into the unions! Before the November revolution there had been 1.5 million trade union members; by the end of December 1918, there were 2.2 million; by the end of 1919, 7.3 million. The trade unions were being filled out and transformed by the masses. By 1920, the 'Free' Trade Unions (ADGB) reached a peak of over 8

million members. In addition, there were other unions, such as the 'Christian' Union Federation (CGB) that gathered over a million members by 1920.

The task of communists was not to boycott these radicalised millions who were entering the unions, but precisely to join and participate in their struggles. To boycott the unions would simply mean boycotting the masses. But many in the newly-formed German Communist Party, intoxicated by the revolution, failed to recognise this fact. They failed to understand that if the party wanted to win the masses, it would need to do serious work in the unions. It was with the greatest of difficulty that the party leadership managed to prevent these ultra-left resolutions being put to the vote by placing them in the hands of a trade union commission. "It demonstrated glaringly the youth and inexperience of the party," observed Radek, who, along with Bukharin, Rakovsky, Joffe and Ignatov, attended the Congress as a fraternal delegation from the Bolshevik Party. (P. Broué, p. 221.)

The correct orientation to the trade unions was not carried out until the Congress in October 1919, nearly a year later, where the KPD finally agreed to carry out revolutionary work in the SPD-led reformist unions.

Following in the footsteps of the Russian party, they decided to adopt Communist Party as their name. They discarded the old label of 'Social Democrat', which had now become associated with the reformists and betrayers of socialism. This represented a move back to the early years of the Marxist movement, when Marx and Engels changed the name of the League of the Just to the Communist League in 1847.

Faced with the youthful exuberance laced with ultra-leftism of the German Communist Party, Luxemburg and Liebknecht had no alternative but to bide their time. They hoped that events would show the leadership had been correct and the majority of the ranks of the party would learn from their own experience. Unfortunately, while this was the first phase of the Revolution, time was nevertheless not on their side.

Despite all these weaknesses, the founding of the Communist Party of Germany, under Luxemburg and Liebknecht, was a very important turning point internationally. Outside of Russia, the German party, despite its size, was still the strongest and most authoritative of all the communist groups abroad. Its founding congress proved an important step in the decision of the Bolsheviks to bring forward the founding of the Third International in March 1919.

Within two weeks of the KPD Congress, the newly-formed party was to experience a baptism of fire in the events known as the 'Spartacist week' and the tragic murder of their historical leaders, Liebknecht and Luxemburg.

CHAPTER THREE: COUNTER-REVOLUTION RAISES ITS HEAD

The revolution, which is not achieved at a single stroke but is the long and stubborn fight of a class oppressed for millennia and therefore not fully conscious from the outset of its task and its strengths, is subject to ups and downs, ebbs and flows.

Paul Levi, October 1919

…it is unquestionable that in the era of the First Congress (1919) many of us reckoned – some more, others less – that the spontaneous onset of the workers and in part of the peasant masses would overthrow the bourgeoisie in the near future.

Leon Trotsky, *The First Five Years*, vol. 2

In all revolutions, the internal dynamics are very similar. In particular, where events are drawn out, especially after the initial flush of victory, the masses can feel the gains of the revolution slipping through their fingers. The November Revolution in Germany was only half-completed, which left power still in the hands of the bourgeoisie. Even the French Jacobins had warned that "those who half make a revolution dig their own graves". The advanced sections of the proletariat, realising the revolution was in danger of unravelling, attempted to retake the initiative. Such was the situation in late December 1918 and early January 1919 in Berlin, where the forces of revolution and counter-revolution battled it out for supremacy.

As Pierre Broué explained:

> The break-up of the coalition government and the dispersion of the myth of unity, together with the suicide of the Councils at their own Congress, left the Berlin workers with nothing but their weapons and a sharp feeling of imminent danger for which they could see no political remedy. In December 1918 in Berlin, as in Petrograd in July 1917, the radicalised masses saw in armed struggle the simplifying short-cut which would cut the Gordian knot of the political arguments in which they no longer wanted to be involved. But, in Berlin, there was no Bolshevik party to open up a perspective of political struggle, nor to lead them into a necessary retreat after the setbacks of the first armed demonstrations and the consequences thereof, which could easily have been foreseen. (P. Broué, p. 236.)

As Broué explained, there are clear parallels which can be drawn between the Russian and German revolutions, especially in regards to the 'July Days'. During the Russian Revolution, in June and early July 1917, advanced layers of workers, particularly in Petrograd, moved in the direction of overthrowing the Provisional Government. At this time, workers in revolutionary Petrograd organised armed mass demonstrations against Kerensky in response to the attempt by the Provisional Government to provocatively move out the Machine Gun Regiment to the front. Lenin nevertheless saw the dangers of a premature move to seize power: "We must be especially attentive and careful, so as not to be drawn into a provocation... one wrong move on our part can wreck everything..." (Quoted in A. Rabinowitch, *Prelude to Revolution*, pp. 121-122.)[1]

The Bolsheviks, however, did not stand aside from the revolutionary workers of Petrograd but, on the contrary, intervened at the head of the demonstrations in order to ensure their peaceful and organised character. That did not prevent reaction moving against the Bolshevik Party in early July, but at least it was able to maintain intact the advance guard of the Russian proletariat. The repression against the Bolsheviks, which forced Lenin into hiding, and the arrest of a number of Bolshevik leaders, became known as the 'July Days'. However, the Bolshevik Party's actions won it enormous prestige amongst the working class, and prepared the ground for winning the majority of workers and peasants to the side of the party and preparing the ground for the success of the October Revolution.

Again, similar processes can be seen in the Spanish Revolution during May 1937 in Barcelona. There the Republican government, under the pressure of the Stalinists, who acted as a counter-revolutionary force, attempted to seize back the Barcelona telegraph exchange from the anarchists. This provocation resulted in a prolonged armed clash with the Republican government, and

1 This speech is not contained in Lenin's *Collected Works*.

ended with the bloody suppression of the revolt, the banning of the workers' organisation, the POUM, and the murder of its leaders. This time, because there was no strong Bolshevik Party, the defeat in May was a crushing blow to the advanced sections of the Spanish working class. It was to lay the basis for the defeat of the Spanish Revolution and the final victory of Franco in 1939.

THE SPARTACIST UPRISING

> Every day after 9 November gave the German workers a vivid feeling as though of something slipping from their hands, being withdrawn, sliding through their fingers. The desire to keep what they had won, to fortify themselves, to put up resistance, was growing from day to day. And this defensive tendency lay at the bottom of the January fights of 1919. (L. Trotsky, *The History of the Russian Revolution*, vol. 2, p. 88.)

In Berlin in early January, there existed a state of acute crisis. The three USPD ministers had not long resigned from the government. Fears and rumours of a military coup had begun to circulate, the campaign by the extreme right against the Spartacists was in full swing, and an anxious and frustrated mood began to develop amongst the advanced workers. After its formation, the German Communist Party began to conduct a campaign against the Social Democratic government and for the workers to seize power and complete

Spartacists in Berlin preparing defensive positions

the socialist revolution. The military top brass, in league with the right-wing Social Democratic ministers, was preparing a bloody reckoning with the Spartacists and the ranks of the Left Independents in order to strike a decisive blow against the revolution as a whole and prepare the way for a military 'solution'.

This plan was later revealed in 1925 by General Groener at the so-called Dolchstoss trial in Munich. He described under oath the conspiracy hatched between the General Staff and Ebert and Noske:

> On 29 December Ebert summoned Noske to lead the troops against the Spartacists. On that same day the volunteer corps assembled, and everything was now ready for the opening of hostilities.

Again, another general, General Georg Maercker, in his memoirs recorded:

> In the very first days of January, a meeting attended by Noske, who had just returned from Kiel, took place at General-Staff Headquarters in Berlin with the Freikorps leaders concerning the details of the march (into Berlin). (Quoted in P. Frölich, *Rosa Luxemburg*, Pluto Press ed., pp. 285-286.)

Gustav Noske, who, on 6 January, had assumed the title of 'People's Commissar of Defence', answered the call to deal with the Berlin workers

Spartacist irregulars holding a street in Berlin

Spartacists form barricades

Spartacists behind a barricade made out of newspapers during the uprising

with the words: "One of us has to be the bloodhound. I won't shirk the responsibility!" (R. Watt, p. 239.) Noske was to relish this new-found role as the minister for the counter-revolution.

At the end of December, a price of 10,000 German marks had been put on the head of Karl Radek, the Bolshevik representative in Germany, by the Anti-Bolshevik League, which had been founded by exiled Russian aristocrats. This counter-revolutionary organisation had its own intelligence service, which, according to its founder, constituted an "active anti-communist counter-espionage organisation". (P. Broué, p. 171.)

DISMISSAL OF EICHHORN

At the same time, a campaign of denigration was carried out against Emil Eichhorn, the left-wing police president of Berlin and a member of the Left Independents. This was used to lay the basis for his removal. Eichhorn was regarded as a threat because he had organised a new 'left' police force of 2,000 workers and soldiers committed to the revolution, and of course posed an obstacle to the central authorities. The potential danger was accentuated especially after the Left Independents had withdrawn from the government. The action against Eichhorn was to be used as the provocation to push the Spartacists, the ranks of the Left Independents and the Berlin workers into an armed rebellion. This would be the justification for the military to step in and crush the movement. This was, nonetheless, a very risky strategy, given the recent fiasco over the Naval Division.[2]

On 4 January, 1919, after a series of false charges, Eichhorn was called upon by the Ministry of the Interior to resign his post. The right-wing Social Democrat, Eugen Ernst, was to be appointed in his place. This was a man who a few years later supported the Kapp Putsch, an indication of his true political loyalties. Eichhorn, who had mass support, refused to move. As far as he was concerned, he had been installed by the revolution and would only leave at the behest of the revolution, not the orders of the Minister of the Interior.

At the time of this provocation, the Berlin Executive Committee of the USPD, already in discussions with the Revolutionary Shop Stewards, immediately adopted a resolution supporting Eichhorn. They shortly met with the leaders of the newly-founded KPD to discuss joint action over this blatant attack on the revolution. With the refusal of the SPD government to back down, the Berlin Executive Committee, together with the Revolutionary Shop Stewards and the KPD, called for a mass protest demonstration on 5 January. This resulted in hundreds of thousands of workers marching

2 See pp. 127-130 of this book.

to the police headquarters. A 'Revolutionary Committee' was established representing the organisations in Berlin: Left Independents, the KPD and the Revolutionary Shop Stewards. They were informed that the capital's garrison was supporting their stand and that they could rely on military assistance from Spandau and Frankfurt. The Committee therefore decided, with this apparent support, to resist the dismissal and use the opportunity to overthrow the Ebert-Scheidemann government. Liebknecht, carried away by the movement, supported the idea.

At the same time, groups of armed workers had occupied the editorial offices of the hated *Vorwärts,* the SPD newspaper. Apparently, agents provocateurs were also at work, urging on the workers. But the workers needed little encouragement and were eager for action. After a period, the armed protesters were persuaded to end their occupation, but this did not last long. Following the stalemate, a further occupation was carried out which faced little resistance. Other important bourgeois news printing offices in the newspaper district were also occupied. These actions were never planned or directed by the Spartacist League, although many of its members were involved.

The next day 500,000 workers took to the streets, many armed, as many large factories went on strike. It was one of the biggest demonstrations of the revolution. This situation had clear parallels with the June demonstrations in Russia in 1917 and signalled the beginning of the so-called 'Spartacist Revolution'. The next twenty-four hours would decide everything.

Emil Eichhorn, as Radek recalls:

[H]ad armed the Berlin workers, the Independents and the Spartacists... There were such tremendous masses participating in the demonstration that it appeared possible to seize power in Berlin. Only unarmed crowds of Social Democratic workers guarded the government in the Wilhelmstrasse. There were no soldiers round the governmental buildings... (J. Braunthal, *History of the International 1914-1943*, p. 129.)

Another eyewitness, Arthur Rosenberg, recalled:

There is a general feeling in Berlin that the second revolution had begun... We supposed that the three [revolutionary] organisations would now jointly set up a Red government and carry the revolution through to the bitter end... (ibid., p. 129.)

Further demonstrations were called by the Revolutionary Committee, which then went into permanent session, but without clear plans or objectives. The masses were ready, but the leadership began to dither. Finally, a decision was

taken by the Committee, headed by Georg Ledebour, Karl Liebknecht and Paul Scholze, to overthrow the Ebert government and replace it with a new workers' government. They even prepared a typewritten declaration to that effect to be made public as soon as the overturn was accomplished:

> The Ebert-Scheidemann government has made itself intolerable. The undersigned Revolutionary Committee representing revolutionary workers and soldiers (Independent Social Democratic Party and Communist Party) announces that it has been deposed. The undersigned Revolutionary Committee provisionally assumes the functions of government. Comrades! Workers! Close ranks round the decisions of the Revolutionary Committee! Signed: Liebknecht, Ledebour, Scholze. (P. Broué, p. 245.)

Given the turn of events, the communiqué was never published. Nevertheless, a copy found its way into the hands of the SPD, which published it on 14 January, as part of the witch-hunt against the Spartacists, and 'proof' of the conspiracy.

The workers not only occupied the offices of *Vorwärts* and the press quarter, but also the Reich printing office, the railway headquarters, food warehouses, and other such buildings. Even the Reichstag was occupied for a brief period. Gustav Noske later wrote:

> Great masses of workers... answered the call to struggle. Their favourite slogan 'Down, down, down' (with the government) resounded once more. I had to cross the procession at the Brandenburg Gate, in the Tiergarten, and again in front of general staff headquarters. Many marchers were armed. Several trucks with machine guns stood at the Siegessaule. Repeatedly, I politely asked to be allowed to pass, as I had an urgent errand. Obligingly, they allowed me to cross through. If the crowds had had determined, conscious leaders, instead of windbags, by noon that day Berlin would have been in their hands. (J. Riddell [ed.], *The German Revolution*, p. 248.)

This really summed up the situation. The government was hanging by a thread. Fearing the end, the petrified members of the government had abandoned their office buildings for the safety of a private home.

Morgan Philips Price, a British reporter with Bolshevik sympathies, also witnessed the events and wrote in his diary:

7 January

> Great demonstrations both sides again. Workers occupy some railway stations. Government brings in troops. Fraternisation. Some firing and casualties. Groups in street discussions, questions such as wages, hours,

capitalist system. Masses appear to be realising economic issues of Revolution. Went to *Vorwärts* office.

8 January

Went to *Vorwärts* office. Chaos! Impression that no organisation exists. Wrote article. Demonstration, firing and fraternising continue. Most of the troops declare themselves neutral. Independents mediating.

9 January

General feeling of depression everywhere. Shooting begins at midday around Anhalter station and newspaper quarter. Government trying to hold railway station till fresh troops arrive. Hopes of Left and Red Guards depend on fraternisation. Government is organising White Guards from officers and sons of bourgeoisie. Kurfürstendamm is full of military, calling for volunteers in street. Counter-revolutionary front is slowly uniting. (M. Phillips Price, *Dispatches*, p. 29.)

TRAITORS TO THE PROLETARIAT

The official position of the KPD at this time, while supporting the movement, was against a premature attempt to overthrow the Social Democratic government. This was clearly correct given the balance of forces nationally. A leaflet issued by the KPD at the time explained that:

> [I]f Berlin workers were today to disperse the National Assembly and throw the Ebert-Scheidemann people into prison, while the workers of the Ruhr and Upper Silesia and the rural workers of Germany east of the Elbe remained inactive, the capitalists would be able tomorrow to subdue Berlin through hunger. (J. Riddell [ed.], *The German Revolution*, p. 244.)

The general content of the KPD's newspaper *Rote Fahne,* however, was full of attacks on the government and urged the workers to take ever-more militant action. The line between a mass armed demonstration, occupations and an insurrection became increasingly blurred. A joint appeal issued on 9 January began by denouncing Ebert and Scheidemann, "both stained with the blood of their brothers," as "traitors to the proletariat, these miserable underlings of capitalist intrigue, these embodiments of the counter-revolution." It continued, "They belong in prison, or on the scaffold. But instead they intend to establish their domination on the very corpses of their victims, and create a violent regime resting on bayonets, machine guns and cannons..." It concluded by urging the workers:

We must fight to the last! ... Onwards to the decisive struggle! ... Show the scoundrels your strength! Take up arms! Use your weapons against your deadly enemies, the Eberts and Scheidemanns! ... Be armed, be ready, take action, take action, take action! ... Out onto the streets for the final battle, for victory! (Quoted in B. Fowkes [ed.], pp. 79-81.)

This was signed in the name of the Revolutionary Shop Stewards and the representatives of the big factories of Greater Berlin, the Central Leadership of the Independent Social Democratic organisations of Berlin and surrounding districts, and finally, the Zentrale[3] of the Communist Party (Spartacus League).

The very fiery language, which called for the use of arms against the government, left little to the imagination, and appealed to the masses to go to the end.

Alarmed by this turn of events, Radek wrote to the Central Committee of the party urging them to stage an organised and orderly retreat.

The Berlin movement has landed in a blind alley. I was therefore compelled as early as Monday [6 January] to bring to the attention of various Central Committee comrades my opinion that it was necessary to break off the fight... The only restraining force that can prevent this misfortune is you, the Communist Party. You have enough insight to know that the fight is hopeless... Of course, I am aware of how difficult it is now, after so many sacrifices, to stand up before the masses and sound the retreat. I know that this will lead to a decline in morale. But such depression is nothing compared to what the masses will say to themselves after the blood-letting. They will say that blind leaders incited them to hopeless battle, or that leaders saw the abyss but that out of revolutionary egotism they could not make up their minds to call, 'Halt!' All considerations of revolutionary egotism must take a secondary position to the real relationship of forces. (J. Riddell [ed.], *The German Revolution*, pp. 256-257.)

But, Radek's advice was rejected. The Left Independents and the Revolutionäre Obleute who were close to Eichhorn were pressing for more militant action. The two KPD representatives on the committee, Karl Liebknecht and Wilhelm Pieck, without the Party's mandate, backed the resolution supporting the overthrow of the Ebert government. For them, decisions had to be made under fire. They had no time to consult, and appeared to have been carried away by the situation. They had either misjudged things, or felt they had no

3 The *Zentrale* was the name given to the leading body elected by the party conferences in the early years of the KPD. From 1925, it was called the *Zentralkomitee* (ZK), or Central Committee.

Karl Liebknecht speaking in Berlin in 1919

other choice, but in so doing they had fallen for the government's provocation without any necessary preparation. Liebknecht was in the midst of the action and in constant danger. He was a direct part of the struggle and this suited his character. He was an instinctive workers' leader, a man of action. The revolution was not simply an event, but something that affected him deeply and personally. He did not consider himself a theoretician and perhaps lacked a deeper understanding of the tactics and strategy that were needed to carry through a successful revolution. The situation caught him unprepared. He lacked the political insight and perspicacity to enable him to understand the overall situation, weigh it up and act accordingly. The movement paid a great price for this serious lack of judgement.

DELIBERATIONS

The Revolutionary Committee had endless discussions, but failed to give any coherent direction to the mass movement, which eventually began to dissipate. The masses after all, could not be kept in a permanent state of readiness. What they needed at this time was firm leadership and direction. The continual vacillation had catastrophic consequences in confusing and disorientating the Berlin workers. As Marx had warned, insurrection is an art, and not to be played with. But the Revolutionary Committee was

oblivious to such advice and things were carried out without any regard for the consequences.

To make matters worse, the Central Committee of the Councils and the Berlin Executive Committee actually came out in support of Eichhorn's dismissal. The Marstall sailors also protested that they were involved in decisions against their will, which added further to the confusion. The mass movement began to fracture and the initiative was slipping away.

Rote Fahne later described the demonstration as "the greatest worker's mass action in history." The workers and soldiers "were ready to do anything, to sacrifice anything for the revolution, even their lives. It was an army of 200,000 men, such as no Ludendorff had ever beheld," continued the paper. But it then went on to describe what happened:

> And then an outrage took place. From 9:00 a.m. the masses stood in the cold and light drizzle. And somewhere the leaders sat and deliberated. The drizzle intensified and still the masses stood there. But the leaders were deliberating. Midday arrived, and to the cold was now added hunger. And the leaders deliberated. The masses were feverish with excitement: they wanted a deed, even merely a word to appease their anxiety. But no one knew what to do. For the leaders were deliberating. The drizzle picked up again, and it was twilight. Sadly, the masses went home. They had intended a great deed, but had accomplished nothing. For the leaders had been deliberating... Deliberating, deliberating, and deliberating. (Quoted in ibid., pp. 248-249.)

Rosa Luxemburg also attacked the Revolutionary Committee for failing to provide leadership. "We see and hear nothing," she said. "The workers' representatives may well be thoroughly and extensively *discussing* but now is the time to *act*..." (ibid., p. 251.)

The national USPD leaders, who had nothing to do with the action in Berlin, decided to go behind the backs of the Revolutionary Committee and negotiate a truce directly with the government. When informed of these negotiations, the Berlin Independents on the Revolutionary Committee supported the initiative of their national leadership. Liebknecht and Pieck strongly opposed the idea. How could anyone negotiate with a government that they had twenty-four hours earlier planned to overthrow? The proposal to negotiate was taken to the Shop Stewards meeting, which also voted in favour. When negotiations began at midnight 6-7 January, the government demanded that all the newspaper buildings had to be vacated before any further talks could take place. The talks soon broke down. To complicate matters even further, once those workers occupying the buildings found out about the negotiations, they were furious and demanded their leaders be

removed. The confused situation propelled the occupying forces into open physical clashes with the military authorities. For the Ebert government, the negotiations were simply a ploy to string things along until the military were ready to move.

'DOGS OF WAR'

While the workers' leaders talked aimlessly, the forces of counter-revolution, under the direction of Noske, were preparing for a bloody confrontation with the Berlin workers. The Freikorps had been gathering outside the capital. Now was the moment, in the words of Shakespeare, for them to unleash 'the dogs of war'. It was the start of a terror campaign, similar to those unleashed in Finland against the revolutionaries. The government's task, as they saw it, was to 'pacify' the city before the National Assembly elections which were scheduled for 19 January, just over a week away.

On 10 January, the Freikorps entered Berlin and an attack was opened up by the Potsdam regiment, led by Major von Stephani. Stephani was later to become one of the leaders of the notorious Stahlhelm organisation, but for now was fighting under the black, red and gold republican flag. But the revolutionary workers remained defiant saying, "Rather than surrender we will let ourselves be buried in the ruins of the building!" On 11 January, Noske moved in with a further contingent of Freikorps troops led by the monarchist Generals, von Röder, von Wissel, and von Hülsen. The government was determined to take back the *Vorwärts* building by military force, no matter the bloodshed. The building was mercilessly shelled from the early hours of the morning. Heavy artillery and mortar attacks by government troops resulted in enormous damage and scores of injuries. In the end, the situation became hopeless for the occupying rebels and the 350 or so who remained in the building had no alternative but to surrender. After two hours of constant bombardment, the white flag was hoisted, but they were shown no mercy.

Rosa Luxemburg wrote:

> The massacred mediators, who had been trying to negotiate the surrender of the *Vorwärts* building, were clubbed beyond recognition by the rifle butts of the government's rampaging troops so that their bodies cannot be identified. Prisoners were put up against the wall and slaughtered so violently that bits of skull and brain tissue splattered everywhere. (ibid., pp. 264-265.)

As far as the counter-revolution was concerned, there were to be no negotiations.

By 12 January the siege was over. Within a matter of days, *officially*, 156 people had been killed and hundreds wounded, but this was a gross

underestimate. The Monarchists in charge avenged themselves on the Communists. Of the 300 or so prisoners captured in the *Vorwärts* building, groups were marched to the nearby Dragoon barracks and maltreated. An undisclosed number were shot in the courtyard. This was the meaning of the Freikorps 'pacification'. Noske quipped: "It is quite true that many of them are monarchists, but when you want to reconstruct you must fall back on the men whose profession it is [to deal with the situation]." (R. Watt, p. 263.)

Noske and the Generals had hatched a plan to reconquer Berlin by force and teach the workers a lesson they would never forget. To quote Paul Frölich, "The White Terror had begun".

It was clear that the so-called 'Spartacist Rebellion' was not a conscious strategy pursued by the Spartacists. The events were certainly started by government provocation, intended as a pretext to crush the movement. But this was not the only element involved. There was anger in the Berlin working class and in January it reached boiling point. There was also a feeling of frustration that the revolution was being lost. Although the 'uprising' did not have the approval of the Spartacist leadership, they were not prepared to abandon those risking their lives on the front line. Once the defence of the *Vorwärts* building was underway, the Spartacists felt they were obliged to give it unconditional support. In fact, the occupation of the *Vorwärts* building was headed by Eugen Leviné of the KPD. Therefore, the defence of the uprising became a point of principle for the party. Despite Radek's appeal, things had now gone too far to pull back.

Leon Trotsky explained:

> Spartacist Week began, not in the manner of a strategy calculated by the party, but in the manner of a pressure from the indignant lower ranks. It developed around a question of third-rate importance, that of retaining the office of chief of police, although it was in its tendencies the beginning of a new revolution. Both organisations participating in the leadership, the Spartacus League and the Left Independents were taken unawares; they went further than they intended and at the same time did not go through to the end. The Spartacus men were still too weak for independent leadership. The Left Independents baulked at those methods which could alone have brought them to the goal, vacillated, and played with the insurrection, combining it with diplomatic negotiations. (L. Trotsky, *The History of the Russian Revolution*, vol. 2, p. 88.)

HOW COULD YOU?

When Liebknecht returned to the offices of *Rote Fahne* with news of what had happened, Luxemburg was very critical of him for taking matters too far

and endorsing the insurrection. "But Karl, how could you? What about our programme?" she protested. (R. Watt, p. 266.) Radek too was opposed to the action, using the example of the Bolsheviks in July 1917. "Nothing can stop him who is weaker from retreating before a stronger force," he said. He was also supported in this by Paul Levi.

But it was too late. The damage had been done. The Berlin action, although heroic, was the action of a small group of hundreds, without active support, or more importantly, without clear revolutionary leadership. The majority of the organised working class of Berlin remained passive. There was certainly sympathy for the struggle, especially in the face of the brutal repression by the authorities, but that was not the same as willing active support.

In a final article, Luxemburg attempted to draw a balance sheet of the 'Spartacist Week', the title of which, 'Order Prevails in Berlin', summed up the situation:

> What was this recent 'Spartacus week' in Berlin? What has it brought? What does it teach us? While we are still in the midst of battle, while the counter-revolution is still howling about their victory, revolutionary proletarians must take stock of what happened and measure the events and their results against the great yardstick of history.

> Was the ultimate victory of the revolutionary proletariat to be expected in this conflict? Could we have expected the overthrow [of] Ebert-Scheidemann and the establishment of a socialist dictatorship? Certainly not, if we carefully consider all the variables that weigh upon the question. The weak link in the revolutionary cause is the political immaturity of the masses of soldiers, who still allow their officers to misuse them, against the people, for counter-revolutionary ends. This alone shows that no lasting revolutionary victory was possible at this juncture. On the other hand, the immaturity of the military is itself a symptom of the general immaturity of the German revolution…

> Does that mean that the past week's struggle was an 'error'? The answer is yes if we were talking about a premeditated 'raid' or 'putsch.' But what triggered this week of combat? As in all previous cases, such as 6 December and 24 December, it was a brutal provocation by the government…

> Faced with the brazen provocation by Ebert-Scheidemann, the revolutionary workers were forced to take up arms. Indeed, the honour of the revolution depended upon repelling the attack immediately, with full force in order to prevent the counter-revolution from being encouraged to press forward, and

lest the revolutionary ranks of the proletariat and the moral credit of the German revolution in the International be shaken.

She concluded:

> The leadership failed. But a new leadership can and must be created by the masses and from the masses. The masses are the crucial factor. They are the rock on which the ultimate victory of the revolution will be built. The masses were up to the challenge, and out of this 'defeat' they have forged a link in the chain of historic defeats, which is the pride and strength of international socialism. That is why future victories will spring from this 'defeat.'

> 'Order prevails in Berlin!' You foolish lackeys! Your 'order' is built on sand. Tomorrow the revolution will 'rise up again, clashing its weapons,' and to your horror it will proclaim with trumpets blazing: 'I was, I am, I shall be!' (R. Luxemburg, 'Order Prevails in Berlin', published in *Rote Fahne*, 14 January 1919.)

Despite Rosa Luxemburg's optimism, brutal 'Order' did very much prevail. The Social Democratic leaders were prepared to stoop to new depths to crush the revolution and 'Democracy' was made secure over the backs of revolutionary workers.

The counter-revolution quickly took revenge on behalf of the capitalists, who had been terrified by the revolution. The Spartacists were to pay dearly for their support of militant action. In a short space of time, two leading KPD members, Leo Jogiches and Hugo Eberlein, were arrested. The government minister Philipp Scheidemann, in echoing the demands of the reaction, had put an unofficial price of 100,000 German marks on the heads of Liebknecht and Luxemburg, on top of the previous offer of the 'Association for Combating Bolshevism' of 10,000 marks for anyone aiding in the arrest of Liebknecht. As in the 'July Days' in Russia, the slanders poured down over the heads of the Spartacists like the waters of Niagara, to quote Trotsky, unbridled and shameless. The SPD paper *Vorwärts* joined in the hue and cry against the Spartacist leaders. On 13 January this 'socialist' newspaper, to incite murder, published a poem which ended with a verse:

> Many hundred corpses in a row,
> Proletarians!
> Karl, Radek, Rosa and company.
> Not one of them is there, not one of them is there,
> Proletarians! (J. Riddell [ed.], *The German Revolution*, p. 263.)

Another played on anti-Semitic feelings using Germanised equivalents of the original Jewish names of Trotsky (Bronstein) and Radek (Sobelson):

I saw the masses marauding
Behind Karl, blind war god,
Dancing to the Pied Piper's flute,
Who slyly promised them the world.
They bowed before blooded idols,
Grovelled before all that humanity scorns,
Before Russia's Asiatics and Mongols,
Before Braunstein,[4] Luxemburg, and Sobelson.
Go back, you raging hoards!
You cry for freedom, only to kill it!
(ibid., p. 263.)

Philips Price again briefly records the situation as it unfolded on a daily basis:

14 January

Talked with Däumig who says workers very depressed. Whole tactics of Spartacus he considers disastrous. Mass of soldiery not ready for next step of revolution.

15 January

Reign of White Terror. Arrests everywhere. Meanwhile railway strike for higher wages. That is when the victors will find their victory is Pyrrhic.

LUXEMBURG, LIEBKNECHT MURDERED

Then came the tragic news:

16 January

Stunned by appalling news of foul murder of Liebknecht and Luxemburg. Too staggered to conceive the fact, except to feel instinctively that this fiendish crime will do more than anything else to unite all ranks of Revolution against this accursed hydra of Prussian militarism which Allies cannot kill because they are themselves brother hydra. Saw Müller Senior [Richard], who saw Liebknecht's body and can affirm that shots were fired from a short distance. (M. Philips Price, *Dispatches*, pp. 30-31.)

The final article written by Karl Liebknecht was published on 15 January, the very day that he and Rosa Luxemburg were tracked down and murdered by the Freikorps. The main content of the article was to lay bare the hysterical campaign against the Spartacists. It began:

4 'Braunstein' is used in the original to mean Bronstein.

All-out war on the Spartacist League! 'Down with the Spartacists!' they howl through the streets. 'Catch them! Whip them! Stab them! Shoot them! Run them through! Run them down! Tear them to shreds!'

He then warned:

Yes! The revolutionary workers of Berlin were beaten...

And every drop of their blood is a seed of discord for today's victors, like dragon's teeth, because from them will grow those who will avenge the fallen; from every shredded fibre, new warriors will arise to carry on the lefty cause, a cause as eternal and everlasting as the firmament.

The vanquished of today shall be the victors of tomorrow, for they will learn from defeat...

Whether or not we are alive when it arrives, our programme will live, and it will reign in a world of redeemed humanity. Despite everything!
(J. Riddell [ed.], *The German Revolution*, pp. 269-271.)

In the previous days the atmosphere had become extremely dangerous following the 'Spartacist Uprising'. The slanders multiplied by the hour. It clearly wasn't safe and Luxemburg spent a few nights at various hostels, only calling at her flat to pick up clothes and letters. Each night, the Spartacist leaders were housed secretly by different comrades and sympathisers. Now the government was hunting them and they were on the run.

More seriously, as we have seen, they had a price on their heads. Following the 'Uprising', the KPD headquarters were occupied and ransacked by the military, and this led to the arrest of Jogiches and Eberlein. Despite Luxemburg and Liebknecht being kept in a 'safe' house in Berlin, the Freikorps tightened their grip on the city. The searches were stepped up and Liebknecht's wife and son were taken into custody. It was like a tightening noose. Eventually, their whereabouts were discovered and troops broke into the apartment and arrested them on 15 January at nearly nine in the evening.

When they were seized, both Liebknecht and Luxemburg were taken to the Eden Hotel, headquarters of the Cavalry Guards Division for 'investigation', before supposedly being transferred to the Moabit prison. But the transfer was a deception, as the officers had already agreed on their assassination. "See to it that these swine do not reach the prison alive," Captain Lieutenant Heinz von Pflugk-Harttung was reported to have said. In the headquarters, the revolutionaries were mistreated, faced hysterical denunciations and a torrent of abuse. From then on, their fate was sealed. They would not be allowed to escape the iron grip of their captives alive.

Liebknecht was the first to be taken out of the back door of the building, escorted by Captain Pflugk-Harttung and other soldiers. As he stepped on to the pavement, Otto Runge, a sentinel, beat him over the head with a rifle butt. Liebknecht placed his hands over the wound from which blood was pouring freely. He was then bundled into a waiting car. He was driven a short distance to the Tiergarten, before he was forced out and shot, allegedly 'trying to escape'. At 23:20 that night, an unknown man deposited his lifeless body at the Kurfürstendamm Infirmary.

Rosa Luxemburg suffered a similar fate. She was led out of the Hotel after being beaten. As she left the building a soldier used the butt of his rifle to beat her semi-conscious to the ground. She was likewise bundled into a car, struck with the handle of a revolver and then a bullet was put through her head. On the orders of Lieutenant Kurt Vogel her blood-stained body was thrown into the ice-covered waters of the Landwehr Canal from the Lichtenberg Bridge, where her remains were not recovered until 31 May.

The counter-revolution had carried out its bloody revenge of beheading the revolution. The bourgeois paper *Tägliche Rundschau* simply stated that "The day of judgement on Luxemburg and Liebknecht is over. Germany has peace, it can breathe again." (J.P. Nettl, pp. 775-776.)

A travesty of a court-martial trial was held on 9 May 1919 for the killers of Luxemburg and Liebknecht. The two principal defendants, Captain Lieutenant von Pflugk-Harttung and Lieutenant Kurt Vogel arrived in court "laughing, their chests decorated with medals. They gave the impression of going to a wedding rather than a murder trial," stated a witness. The court was packed full. During the trial, Pflugk-Harttung, the barefaced liar, admitted shooting Liebknecht "for trying to escape". He was then acquitted "with great applause at the verdict". Meanwhile, Vogel admitted driving Luxemburg's body to the canal, but claimed another officer had been the one to shoot her. The jury could not make up its mind whether Luxemburg had already died from the earlier blows to the head. He was therefore sentenced to two years and four months in prison.

He didn't serve his sentence, however, as Vogel was allowed to escape from prison and cross the border to Holland, where he laid low until everything had blown over. He then returned to Germany a free man. Another defendant, Private Runge, who had bludgeoned the captives, escaped a murder verdict and was sentenced to two years imprisonment. In the end, only the private soldier went to prison, but he only served several months for his crime before being released. (A. Read, pp. 201-202.)

The general staff officer of the Cavalry Guard, a man named Captain Waldemar Pabst, who arrested Luxemburg and Liebknecht, gave an

interview to *Der Spiegel* in 1962. He claimed he interrogated Luxemburg and Liebknecht, as well as Wilhelm Pieck, at the Eden Hotel. He also claimed that Pieck betrayed his comrades and as a result was released, but this cannot be confirmed. He ordered that the prisoners be delivered to the governor at Moabit prison. The *Spiegel* interview then records, in his view, what happened next.

Pabst: At the entrance of the Eden Hotel there was a guard, soldier Runge. That man hit Rosa Luxemburg over the head with the butt of his gun when she left the hotel. This was not included in my programme. Someone who is now dead bribed the soldier to kill Liebknecht and Luxemburg.

Question: Did you not order yourself that these two should be murdered?

Pabst: You mean the actual order? I refuse to say anything about this.

Question: Did you give any order that those two should be, let us say, killed?

Pabst: I tell you I refuse to say anything about this... You know exactly what the situation was. The whole of Germany knew...

Question: The whole of Germany knew that they had been murdered.

Pabst: The essential thing is this: was it necessary or was it not?

Question: You thought it was necessary and your order went further than "Hand them over to Moabit"?

Pabst: That was the order I gave in the presence of my orderly office. What I discussed with the gentlemen who had volunteered for the transport – and they were all volunteers – is a matter between them and myself.

Question: You did not discuss anything with the soldier Runge?

Pabst: Really, gentlemen, you don't think that I would have given such a stupid order as to bash Luxemburg's head outside the hotel *coram publico*? I was not that stupid. The Transport Command reported that Liebknecht had been shot while trying to escape. And that Luxemburg had been shot by an unknown man who had jumped on the running board of the car after she had been hit by a soldier and was unconscious. The leader of the Transport Command had then thrown her into the canal...

Question: What did your superiors say about your orders?

Pabst: That it was right the way I had done it... There were proceedings before a tribunal according to the wishes of Herr Noske.

Question: The soldier got two years' imprisonment but the officer who shot Rosa Luxemburg and then threw her body in the canal got a suspended sentence which he never served. Who helped him?

Pabst: An order by Herr Noske.
(*Der Spiegel*, 20 April 1962, quoted in *Tribune*, 17 August 1962.)

The German proletariat had lost two of its most outstanding leaders at the hands of the counter-revolution and with the full compliance of the Social Democratic ministers. The revolutionary movement would neither forget nor forgive this treachery.

"Today, we hear the subterranean rumbling of the volcano; tomorrow will come the explosion that will bury them all in glowing ash and rivers of lava," concluded Liebknecht in his last article on 15 January. (J. Riddell [ed.], *The German Revolution*, p. 271.) It was a fitting epitaph.

Three days later, on 18 January 1919, Trotsky addressed the Petrograd Soviet as word arrived confirming the murders of Luxemburg and Liebknecht. He paid them the highest tribute:

> For us Liebknecht was not just a German leader. For us Luxemburg was not just a Polish socialist who stood at the head of the German workers. No, they are both kindred of the world proletariat and we are all tied to them with an indissoluble spiritual link. Till their last breath they belonged not to a nation but to the International! (L. Trotsky, *Political Profiles*, p. 139.)

FRIEDRICHSFELDE

On 25 January, 1919, thirty-two individuals killed in the January fighting were buried alongside Karl Liebknecht in the Friedrichsfelde Central Cemetery in Berlin. A mass of Berlin workers followed his hearse, walking shoulder to shoulder. At Liebknecht's side was placed an empty coffin. This was reserved for Rosa Luxemburg's body, which was finally laid to rest on 13 June, almost five months later. On 10 March, Leo Jogiches, who took over the leadership of the KPD, was arrested and shot in cold blood. He was also laid to rest at Friedrichsfelde. Out of spite, the cemetery was raised to the ground by the Nazis, but was later restored by the East German regime, and remains a place of vigil to this day.

It is a tragedy that Luxemburg and Liebknecht did not go into hiding away from Berlin. Liebknecht had already experienced an attempt on his life on 7 December, after being seized, but was later released. Death threats had also been made against Luxemburg.

Lenin and the Bolsheviks were faced with a similar deadly situation in July 1917. Fortunately, the party decided that Lenin would go into hiding, given the warrant for his arrest and the threats on his life. He left Petrograd and went to Finland. This was not 'desertion' but a responsible act of self-preservation of the Bolshevik leader that was taken by the party. If Lenin had not gone into hiding, he would have certainly suffered the same fate as Luxemburg and Liebknecht. This would have had fatal consequences for the Russian Revolution. Likewise, if Luxemburg and Liebknecht had lived, it would probably have guaranteed the success of the German Revolution and changed the course of history. Marxism does not deny the role of the individual in history. The examples of the Russian and German revolutions show in positive and negative ways the key role of individuals under critical historical conditions, where the subjective factor becomes decisive.

Without Lenin, there would have been no October Revolution. This is not a sentimental question. Leadership and political authority reach their highest importance in a revolutionary period. Lenin in April 1917 had to rearm the party, and orientate it towards a second revolution. There was much resistance from the old guard. Only Lenin, with his decades of political authority was able to overcome this. This authority was again used to sweep aside resistance within the Bolshevik leadership.

This assessment applies especially to Luxemburg who had great authority. Her loss was a terrible blow. The others who followed her in the leadership of Communist Party were of a lesser stature and ability. Paul Levi was certainly very intelligent, but he was still young and very much full of himself. The others, like Brandler and Thalheimer, were also lacking politically and later became scapegoats, incapable of resisting the pressures of Zinoviev or Stalin, which led to even more terrible defeats.

The deaths of Rosa Luxemburg and Karl Liebknecht marked an end to the first phase of the German Revolution. It was an important turning point, where the initiative now swung over to the forces of reaction.

LUXEMBURG'S 'ERROR'

There are those who have drawn completely erroneous conclusions from the so-called 'Spartacist Uprising'. Undoubtedly, had the existence of a mass revolutionary party on the lines of the Bolsheviks been in existence in 1918-19, this could have transformed entirely the situation in Berlin and the rest of the country. But this was not the case. The question therefore arises of why such a party was built in time in Russia, but not in Germany. Chris Harman in his book, *The Lost Revolution,* takes Rosa Luxemburg to task:

Her tactical error is not to be explained by anything that happened in December or January, but by a much earlier error – when in 1912 and 1916 she underrated the importance of building an independent revolutionary socialist party... The contrast with Lenin's repeated insistence on the political *and* organisational independence of revolutionaries from 'centrists' could not have been sharper, and helped prepare the ground for the tragic quandary faced by Rosa Luxemburg and the German revolution in 1919. (C. Harman, p. 95.)

But this is a false and simplistic way of looking at the situation, and repudiates the whole experience of Bolshevism. It is certainly true that Rosa Luxemburg failed to build a strong organisation. There is no doubt about this. This was not due to the fact that she had not *broken* earlier with Social Democracy to form an independent group, but arose from her failure to create a well-organised and politically homogeneous *faction within* the SPD at a much earlier date. This was her real failing. The Internationale Group was not established until early 1916, and even then, it was a very loose federation of small groupings. In that sense, unlike Lenin, she underestimated the importance of organisation and the building of a strong opposition faction within the SPD and then the USPD.

If Rosa Luxemburg and Karl Liebknecht had organised such a faction from, say 1905, things could have been completely different. As explained, she shied away from such an organisation until very late in the day.

As Paul Levi explained:

[I]t can be advantageous for radical or Communist groups in opposition to stay within the large parties, so long as it remains possible for them to present themselves openly, and to carry on their agitation and propaganda work unhampered. (P. Broué, p. 453.)

In other words, the German revolutionaries should have followed the example of Lenin and the Bolsheviks. But that did not happen and there lies the weakness.

Chris Harman fails to recognise that Bolshevism evolved not as a *separate* party, but acted between 1903 and 1912 as a *faction* within the framework of the Russian Social Democratic Labour Party. Lenin's Bolsheviks formed the revolutionary wing of Social Democracy and carried out a theoretical and political struggle with the Mensheviks *within the same organisation*. It was not until 1912 that the Bolshevik faction constituted itself as an independent party.

As explained, on the international arena Lenin still considered himself a supporter of Karl Kautsky, right up to 1914. Up until then, Lenin regarded

the German SPD under the Bebel-Kautsky leadership as the model for every party of the Second International. The Bolshevik criticism of the Mensheviks was seen in the same light as Kautsky's attacks on the revisionists around Bernstein.

The creation of the Bolshevik faction after 1903 served to fuse together a group of cadres around Lenin. Despite its weaknesses, it laid the basis for the independent party to emerge in 1912 and, under the leadership of Lenin and Trotsky, providing the means by which to politically win over the majority of the working class in 1917.

When *mass* Communist parties were formed in Germany, France, Czechoslovakia and Italy, between 1920-21, they did not emerge from small groupings or sects, isolated from the mass organisations, but emerged from enormous splits within the old Social Democracy – the traditional parties of the working class. The reason why the British Communist Party remained a small grouping was because of its failure to win over a significant layer of workers in the Labour Party. Even after its formation as an independent party in 1920, Lenin forcefully argued that the new Communist Party should *affiliate* to the British Labour Party. This, too, was the position adopted, after a thorough debate, at the Second Congress of the Communist International.

This experience stands in complete contradiction to Harman's misinterpretation of Lenin. The approach of Lenin and Trotsky was an attempt to create a mass British Communist Party by winning over Labour's rank and file on the basis of events. This would be best served by the British Communists entering the Labour Party. Lenin's approach was to combat the ideas of reformism and revisionism, but never to isolate the forces of Marxism from the ranks of the working class. Harman fails to grasp the essence of what Lenin was raising, for he cannot understand the need for a prolonged period of organised work *within* the old organisations of the working class.

NATIONAL ASSEMBLY ELECTION

Following the blood-letting in Berlin during the 'Spartacist Week', new elections for the National Assembly took place on 19 January. This was only four days after the tragic assassination of Liebknecht and Luxemburg. However, the KPD wrongly boycotted the elections, against Luxemburg's advice, and completely isolated themselves from the struggle on the electoral front. The SPD, in contrast, polled 11.5 million votes, whereas the Left Independents got just under 2.5 million votes. Thus, the two main workers' parties, which at least formally stood for 'Marxism' and socialism, polled around forty-five per cent of all the votes cast. The right-wing bourgeois parties only managed to scrape together a mere fifteen per cent of the vote.

Again, this reflected the favourable class balance of forces that existed at the time. Such was the turmoil that brought the Weimar Republic into being.

The first act of the SPD, the largest party, was to approach the Left Independents to explore the possibilities of them entering a new coalition government. They were again looking for a left cover. But when the Independents refused, approaches were made to the bourgeois parties: The Democratic Party and the Centre Party, which agreed not only to participate, but even accepted the programme of socialisation of those 'industries ripe for socialisation', at least in words. The fact that these capitalist parties were forced to embrace nationalisation and 'socialism' in words reflected the intense heat still emanating from of the November Revolution.

The National Assembly met on 4 February, when Ebert was elected President, while Scheidemann was appointed Chancellor on 11 February.

FREIKORPS INTERVENE

January 1919 had been the month of retribution. Noske, as Minister of War, had obtained the consent of the Assembly to allow him to reorganise the army. Using these new powers, he immediately scrapped the Seven Hamburg points to democratise the armed forces, abolished the power of the Councils and fully restored the authority of the officer caste. This was in preparation for the army to destroy the revolution and finally do away with the elements of 'dual power' represented by the Workers' Councils. According to the Cabinet minutes of 21 January 1919, Noske said:

> [F]or Berlin we require 10,000 men… Maercker's corps will protect Weimar, and it will re-establish order in Halle and Braunschweig in passing. We will restore order in Bremen in the course of this week, and then only Cuxhaven will be left, because we are prevented from attacking via Altonia. We might restore order there via Schleswig, and if necessary the resistance in Hamburg will be put down by force… (S. Taylor, p. 19.)

Over the next few months, one punitive bloody assault after another was carried out by the Freikorps and other 'loyal' army divisions, beginning, as planned, in Bremen in early February 1919, where government troops marched in and removed the Workers' and Soldiers' Council. Such counter-revolutionary actions followed in Bremerhaven and Cuxhaven. From there, Freikorps troops were dispatched to central Germany, moving from town to town destroying the Councils and 'restoring' law and order. The workers did not give up their gains without a fierce struggle in which thousands of courageous workers lost their lives in prolonged street battles. The legacy of bitterness continued in these areas for years to come.

Julius Braunthal was asked to go to Berlin to convey to Noske the horror with which the Austrian forces watched the organisation of the Freikorps:

> The first impression which I received from Berlin was of a big city in the midst of a civil war. Here and there, there was still barbed wire in the streets. Big posters on the walls called Noske a counter-revolutionary bloodhound, while other posters cursed the Bolsheviks as the scourge of the earth. There were many nationalist posters, calling on the German youth to join the Free Corps. The streets in which the offices of the daily newspapers were housed displayed the scars of recent street battles.
>
> "Don't talk about the Anschluss," Noske said to me when I had my interview with him. "I'm not interested in Austria. I've enough to do to restore order in Germany."
>
> During the conversation in his office in the Bendlerstrasse I received a little lesson in how he did it. While we were talking, the telephone rang, and Noske, after having listened for a while, shouted into the mouthpiece, "Why bother with the fear of strikes? Forget about them and go to it! You are responsible to me that order is restored at once!" A little later this Adjutant came in and whispered something to him, and Noske, in his booming voice, commanded him to send some more troops to Merseburg.
>
> "There you have your Workers' Councils," he said angrily to me. "They're making trouble everywhere. They're ruining Germany."
>
> When I interposed that we, too, had trouble, but that we were anxious to avoid bloodshed, he became furious and struck the desk with his fist.
>
> "We try to persuade the workers, and mostly we succeed," I said.
>
> "But they set the whole of Germany ablaze!" he shouted.
>
> I felt that the continuation of the conversation was a waste of time. When I pointed to the dismay his Free Corps had caused among the Austrian socialists, he indicated that we should mind our own business. When I predicted that his Free Corps would break the neck of the Republic, he retorted, "Leave it to me, the leaders of the Free Corps are better Germans than the revolutionaries." (J. Braunthal, *In the Search of the Millennium*, pp. 239-241.)

The Freikorps became the spearhead of the counter-revolutionary offensive, organised and financed by business. Ignoring the Reich government, capitalists paid and armed these gangs of veterans, outcasts and adventurers as a weapon against the working class, and, where possible, military support for the White forces of counter-revolution. In June 1919, for example, they

dispatched the 50,000 strong 'Baltikum' corps to fight in Lithuania against the Soviets. In Latvia, they burned, raped and pillaged. They burned houses, destroyed bridges and telephone poles. They threw bodies into wells, followed by hand grenades. According to Ernst von Salomon:

> We killed what fell into our hands... We saw red, we had nothing in the heart of human emotions... what were earlier houses, were rubble, ash and smouldering beams, like festering sores in the bare field... We had lit a bonfire, there was burning more than dead material, there also was burning our hopes, our desires... the laws and values of the civilised world... We retreated, bragging, intoxicated, loaded with booty. (E. von Salomon, *Die Geächteten,* quoted in G.L. Waite, *Vanguard of Nazism.*)

In 1923 their 'volunteer corps' were used to resist the French occupation of the Ruhr, and deflect the struggle on nationalist lines. These paramilitary outfits were grouped together in four main formations. Firstly, there was the Landesjägerkorps led by General Märker, who had taken part in the suppression of the 'Spartacist uprising' in Berlin and then moved his forces to middle Germany. Then there was the Marinebrigade Erhardt, which had broken up the People's Marine Division in Berlin and carried out the murders of Luxemburg and Liebknecht. Next was the Garde Kavalerie Schützen Division. And lastly, the Orgesh, formed in the summer of 1919, under the command of Colonel Escherish.

At this time, another organisation was formed called the Stahlhelm, Bund der Frontsoldaten, the German word for 'Steel Helmet, League of Front Soldiers', which was created to carry out the serious military training of the forces of the counter-revolution. It became part of the 'Black Reichswehr', and operated as the armed wing of the National Party (DNVP).

The Freikorps were made up from the most degenerate mercenary elements, many of whom had cut their teeth fighting the Bolsheviks in the Baltic States. These hired thugs, like the Black Hundreds in Russia, had helped to brutally put down the proletarian revolution in Finland. Many of these soldiers from General Rüdiger von der Goltz's 'Iron Division' still wore the swastika emblems of the Baltic Freikorps on their steel helmets. Noske was to rely on them to restore 'law and order' throughout Germany.

According to Rudolf Mann, an officer in the notorious Erhardt Brigade:

> The Majority Socialist Noske was the man who helped us. It was his service in putting the right men in the right military posts, gave them complete authority and abundant money for their work. Without this, the Revolution would have overwhelmed Germany. We were never sworn in and were spared

that notorious oath to the Constitution, although it was asked of us by the Government. (M. Philips Price, *My Three Revolutions*, p. 169.)

'SCHIESSBEFEHL'

The Freikorps became notorious for their brutality and barbaric actions against the working population. Such actions led to a further radicalisation on the left. Such was the feeling in Berlin that the idea of a general strike was raised to help defend the workers of central Germany from these mercenaries. At the end of February 1919, 1,500 delegates gathered at the general assembly of the Berlin Workers' Councils to discuss solidarity action. The political composition of these Councils had changed since November 1918 as the Social Democratic delegates were replaced increasingly by Left Independents and Communists. Therefore, the policy agreed at the reconvened assembly included such radical demands as the organisation of a workers' militia, the dissolution of the Freikorps and the freeing of all political prisoners. To carry out these demands, ninety per cent of those present at the assembly favoured the calling of a general strike. Within the space of twenty-four hours a massive strike had gripped the whole of Berlin.

During the general strike in Berlin, barricades were erected and fighting broke out. The response of the government was very swift, granting Noske, as Commander-in-Chief, dictatorial powers over the whole of Berlin. He immediately banned all meetings and demonstrations and dispatched troops to the capital. On 4 March, he gave orders for 30,000 Freikorps troops to enter the city. This action provoked hand-to-hand fighting, which involved workers and sailors. On 9 March, the Workers' and Soldiers' Council decided to call an end to the strike based on several conditions, but this failed to placate Noske and the Freikorps. On the contrary, he announced his 'Schiessbefehl', an instruction that stated "The brutality and bestiality of the Spartacists who fight against us compel me to give the following order: any person who is caught with arms in his hands in the struggle against the government will be shot on the spot." (P. Broué, p. 276.) In one engagement alone, over 1,200 people were shot down in cold blood, including a group of twenty-nine sailors. By the time the fighting had ended, some 3,000 workers had been killed and at least 10,000 wounded. On 10 March, Jogiches, the chairman of the Communist Party, was murdered in a police station, again, supposedly "while trying to escape". The young KPD had in effect lost its leadership, including Franz Mehring, who died broken-hearted after Rosa Luxemburg's murder.

The repression was described by the eyewitness Philips Price in his book *Germany in Transition*:

Noske called the Berlin press representatives on 8 March and told them that the government troops were fighting Spartacus. He gave them a long list of names of sixty policemen[5] said to have been murdered in the most bestial manner in the Lichtenberg suburbs by 'Red Guards'. The effect was instantaneous... within twenty-four hours the few Spartacist leaders who had survived the January week, and among whom was the able friend of Rosa Luxemburg, Leo Jogiches, were arrested and brutally murdered by agents of the secret police. The necessary atmosphere in which this murder could be shrouded has been created. Under the cover of this hue and cry against Spartacus the non-Spartacist Republican Guards were disarmed and carried off, and in large numbers mown down before machine-guns against the walls of the Berlin prisons. (Quoted in M. Philips Price, *Dispatches*, p. 38.)

Count Harry Kesller noted that:

The last two days have seen more bloodshed in Berlin than any since the start of the revolution... All the abominations of a merciless civil war are being perpetrated on both sides. The hatred and bitterness being sown now will bear harvest. The innocent will expiate these horrors. It is the beginning of Bolshevism.

But it was a one-sided 'civil war', with the reaction baying for blood. "They must all be killed," General Lüttwiz told an American reporter. "I am glad they are still fighting for it gives us a chance to kill more of them." (A. Read, pp. 122-123.)

Amid the destruction, a new young leadership was to emerge within the Communist Party around Paul Levi, with Ernst Meyer, Wilhelm Pieck and Hugo Eberlein, who was still in Moscow. Of the older generation, only Clara Zetkin remained. Given the reactionary situation, the party spent the majority of the year working in underground conditions.

It was during these events that Kammerherr Elard von Oldenburg-Januschau, a rich landowner and close friend of von Hindenburg, commented ironically in the newspapers:

Well, and who is now protecting the government and the Fatherland against [the] Spartacists? The very same people whom the *Vorwärts* is accustomed to denounce as Junkers and the friends of the Junkers. (Quoted in E. Anderson, p. 59.)

5 In fact, this number was deliberately exaggerated for effect. Five police officers were killed in street fighting in Lichtenberg.

Following from the first shock of the revolution, the big industrialists and landowners were preparing to recover what they had lost in an all-out offensive against the proletariat. They had been forced to grant reforms during the Revolution, including granting the eight-hour day, recognition of union agreements, unemployment insurance, elected 'works committees', etc., but the tide was now turning. They now used force to take back what they had given. Stinnes, the iron and steel magnates of the Ruhr, declared openly:

> Big business and all those who rule over industry will someday recover their influence and power. They will be called back by a disillusioned people, half-dead with hunger, who will need bread and not phrases. (D. Guerin, *Fascism and Big Business*, pp. 34-35.)

As former government Minister, Dernburg, who was close to the industrialists, declared openly: "Every eight-hour day is a nail in Germany's coffin!" (ibid., p. 35.)

The view of the German capitalists was summed up by Krupp, an armament magnate. He told his workers: "We want only loyal workers who are grateful from the bottom of their hearts for the bread which we let them earn." (ibid., p. 34.)

WORKS COUNCILS

The Social Democrats were always keen to play the role of guardians of capitalism. They wanted a return to the 'normality' that existed before the war. Part and parcel of this was an attempt to do away with the Workers' and Soldiers' Councils. Instead, they put forward the idea of *Works* Councils which were enshrined in Article 165 of the Weimar Constitution.

The Social Democrats, in cahoots with the trade union leaders, were desperate to promote these Works Councils or 'shop committees', which would be far easier to control. They would also provide a valuable link in the machinery of class collaboration, based on the 'common interests' between employers and workers. The proposed legislation would give the workers some illusory 'control', but in reality, it was an attempt to bind them to the capitalist system. In turn, these Works Councils were to be overseen by a National Economic Council and officially incorporated into the Constitution. But things didn't go as planned.

There was an enormous struggle over the Works Council Bill that was being presented to the Reichstag. While it made certain cosmetic concessions to the workers, it had been emasculated by a series of pro-business amendments, so much so that the Independents said it was "simply anchored

to the existing private capitalist system without any regard to the interests of the community in general." (M. Philips Price, *Dispatches*, p. 62.)

The capitalists, who were now in no mood to concede, were vehemently opposed to giving up any of their rights to manage, however limited. The workers also regarded the idea Works Councils with suspicion and even hostility. They were completely different to the Workers' Councils thrown up by the November revolution. Reflecting this growing opposition, the Left Independents, the Communists, and the Central Committee of the Berlin Workers' Council vigorously opposed their introduction, and organised mass demonstrations and strikes in protest outside the Reichstag building.

Price, who was present, described the aftermath of the scenes of commotion on 13 January 1920:

> The pavements round the Reichstag buildings last night were covered with blood, following on a struggle between the soldiers and the crowd... In order to press their views on the Reichstag the workers of Berlin and district: metal, transport, water, gas, railway and shop industries – in fact the greater part of the working-class population of the city – struck work yesterday morning for one day. Great processions began towards midday to move from all parts of Berlin towards the centre of the city. By two o'clock the scene round the Reichstag resembled those of the revolution in 1918.

> Certain delegates of the Workers' Councils tried to get access to the Reichstag to hand the President a memorandum and resolutions passed at meetings held outside. A force of Noske's White Guards posted round the building, however, allowed no one inside. After some jostling a number of the workers' delegates succeeded in pushing through into the building but were ejected by reinforcements of troops sent in three automobiles. These troops then began to drive back the crowd from the Reichstag. It was difficult to see what followed, but I witnessed a number of serious collisions between workers and troops between the Bismarck Monument and the Reichstag steps. A number of the Noske troops were disarmed by the crowds, but I did not see any of them assaulted or injured at this stage.

> About three o'clock the troops suddenly opened fire from the steps of the Reichstag and a terrible pandemonium followed. A large number of demonstrators fell, and isolated detachments of troops were set on by the crowd and seriously handled. The tumult lasted some time, but the troops ultimately succeeded in driving the demonstrators away. The sitting of the Reichstag was suspended. (ibid., p. 63.)

The violence of the troops had left forty-two unarmed demonstrators dead.

As the Works Council Act was pushed through the Reichstag, Prussia was placed under martial rule, and powers were handed over to the military. Noske then declared that all public meetings would be dispersed by force and Independent Socialist and Communist newspapers were suppressed.

Although the Works Councils legislation was passed, these bodies survived in a limited form and with limited influence, mainly dealing with secondary matters, such as individual working conditions. Much of the 'industrial democracy' machinery was discarded by the employers, who did not care for state intervention and interference in their affairs.

Meanwhile, the Social Democrats were only interested in maintaining stability and avoiding "precipitated experiments [that] might destroy the last chance of saving the people from starvation." (Quoted in E. Anderson, p. 62.) But stability rather than 'experiments' were to deliver very little for the working class.

The government hoped that with 'order' restored and the new Weimar Constitution established, things would simply fall into place. The Constitution gave strong Presidential powers to Ebert, including the appointment of the Chancellor as well as his Ministers. This was to ensure stability. But, for the next sixteen months, the coalition government stumbled from one expedient to another. The minority position of the Social Democrats within the Cabinet provided them with some excuse for their lack of action. "Our hands are tied by the need to co-operate with the bourgeois parties," they would say. However, their defence of the status quo and their failure to tackle the problems facing the working class, was leading to increased despondency.

BAVARIAN SOVIET REPUBLIC

By early 1919 the workers' movement in Berlin was under Noske's iron heel, while the rest of Germany was still in a state of continual upheaval. Mass strikes were affecting the industrial heartland of the Ruhr; Bremen and Hamburg were beyond the government's writ; there were revolts in Oldenburg and East Frisa; Workers' and Soldiers' Councils in Rhine-Hesse, Oberhessen, the Palatinate, Hesse-Nassau and Württemberg decided to break away and form a Hessian Soviet Republic. However, it was in Munich where the most serious events were unfolding, described by Noske as a "carnival of madness".

Ever since the beginning of the German Revolution, Munich, the capital of Bavaria, had been at the epicentre of revolutionary upheavals. Bavaria had been the first state in the German confederation to overthrow its monarchy. On 7 November 1918, Kurt Eisner, a member of the USPD and recently released from jail, became the first head of the Bavarian Republic in Munich. While it provided a dangerous precedent for others to follow,

it was nevertheless an extremely unstable regime. In the ensuing Landtag state elections, Kurt Eisner and the USPD were humiliated, having gained only three seats. However, despite this defeat, he refused to stand down and for the following month maintained his position by manoeuvring between his own party, the SPD, and the Workers' and Soldiers' Councils. On 21 February, 1919, he was assassinated by a fanatical right-wing officer, Count Arco-Valley.

The news of the assassination shook Bavaria and provoked enormous turmoil throughout the region. The Bavarian Diet broke up in complete confusion. In Nuremberg and Munich general strikes broke out and armed workers patrolled the streets. Once again, they were facing a revolutionary situation in the province. After a brief interlude, the Social Democrats managed to fill the vacuum and created a government under Johannes Hoffmann on 17 March. But this government became rapidly unpopular and was forced to flee Munich, where it sought assistance from Noske, the Defence Minister, and the Freikorps.

Munich was plunged into a state of semi-anarchy. With economic conditions deteriorating rapidly, the number of unemployed rose to 45,000. However, as soon as the news reached Munich of the establishment of a Soviet Republic in Hungary, Ernst Toller, a playwright and leader of the USPD, proposed the establishment of a government of Workers' and Soldiers' Councils. With the political vacuum, such a government came to power without any resistance. Initially, the Bavarian Soviet Republic was ruled by USPD members such as Ernst Toller, and anarchists like the writer Gustav Landauer. However, it had a very eccentric character. Artists and poets, rather than those with a political understanding, were the driving force. The first act of the new Foreign Minister, Dr. Franz Lipp, was to declare war on Württemberg and Switzerland because of a refusal to loan sixty steam-locomotives to Bavaria! Perhaps not surprisingly, he had suffered from mental illness and had been admitted several times to psychiatric hospitals. To make matters worse, the government alienated the peasantry, which constituted the bulk of the population. Given its bizarre character, the KPD refused to enter such a government.

However, on the 13 April an unsuccessful right-wing coup attempt was made to reinstall Hoffmann, which was repelled by armed resistance led by the Communists. Following this, Toller's regime unceremoniously collapsed, and, once again, left another power vacuum. Such was the radicalisation, mass meetings throughout the city passed resolutions demanding that the government be handed over to the Communists. Even the Munich garrison declared itself in favour of a Soviet Republic.

At first the KPD leaders were extremely reluctant to accept, but the pressure from the workers became overwhelming. As a result, a new government was reconstituted, and although involving Toller, it was now dominated by the Communists, led by Eugen Leviné.

By this time, Hoffmann had gathered 8,000 troops ready to march on Munich. The danger of counter-revolution pushed the masses sharply to the left. It confirmed the prophetic words of Marx, "revolution sometimes needs the whip of counter-revolution to push it forward."

As with the Paris Commune of 1871, exceptional conditions had placed power in the hands of the working class. The Communists were faced with limited choices. The question was either retreat, which seemed impossible, or take the initiative. Therefore, a new Bavarian Soviet Republic was declared on 13-14 April. It was based on newly-elected Workers' Councils in the factories, whose immediate task was to organise resistance against the imminent threat from Hoffmann's troops.

On the 16 April at Dachau, Soviet forces managed to beat back a Freikorps advance. But on 20 April, the counter-revolution marched on Augsburg and took the city.

The Communist government made a number of serious mistakes. This included the calling of a ten-day general strike when the working class had already seized power and the key question was defence.

Leviné put a brave face on things, but was pessimistic about the eventual outcome of the struggle. The Soviet republic was isolated in one part of Germany and surrounded by the forces of reaction under the direction of the central government. Unless the revolution could be spread, its fate was sealed.

The mood in the capital became very volatile. Fear began to grip sections of the population. "They have not yet come face to face with the counter-revolution but they feel threatened and come to us for help," explained Leviné.

He then went on to sketch out the likely outcome:

We cannot avert the catastrophe, but a *revolutionary leadership* is responsible for the state in which the workers emerge from it: an honourable *death* and *experience for the future* is all we can salvage from the present situation.

He concluded:

We shall have to pay the bloody price either way for there can be no peaceful solution. But we must not die in vain. (E. Leviné-Meyer, *The Life of a Revolutionary*, p. 98, emphasis in original.)

Leviné understood that this could only come by spreading the revolution to other major cities of Bavaria and beyond. But there seemed little prospect of that.

Lenin had received greetings from the Bavarian Soviet Republic and replied with a message of solidarity. He was desperate for information. His letter was dated 27 April, only a matter of days before the Bavarian Republic was overthrown. It is short and worth quoting in full:

> We thank you for your message of greetings, and on our part whole heartedly greet the Soviet Republic of Bavaria.

> We ask you insistently to give us more frequent, definite information on the following. What measures have you taken to fight the bourgeois executioners, the Scheidemann's and Co.; have councils of workers and servants been formed in the different sections of the city; have the workers been armed; have the bourgeoisie been disarmed; has use been made of the stocks of clothing and other items for immediate and extensive aid to the workers, and especially to the farm labourers and small peasants; have the capitalist factories and wealth in Munich and the capitalist farms in its environs been confiscated; have mortgage and rent payments by small peasants been cancelled; have the wages of farm labourers and unskilled workers been doubled or trebled; have all paper stocks and all printing-presses been confiscated so as to enable popular leaflets and newspapers to be printed for the masses; has the six-hour working day with two or three-hour instruction in state administration been introduced; have the bourgeoisie in Munich been made to give up surplus housing so that workers may be immediately moved into comfortable flats; have you taken over all the banks; have you taken hostages from the ranks of the bourgeoisie; have you introduced higher rations for the workers than for the bourgeoisie; have all the workers been mobilised for defence and for ideological propaganda in the neighbouring villages?

Lenin continued:

> The most urgent and most extensive implementation of these and similar measures, coupled with the initiative of workers', farm labourers' and – acting apart from them – small peasants' councils, should strengthen your position. An emergency tax must be levied on the bourgeoisie, and an actual improvement affected in the condition of the workers, farm labourers and small peasants at once and at all costs.

> With sincere greetings and wishes of success. Lenin. (LCW, Vol. 29, pp. 325-326.)

The workers of Munich gritted their teeth for the struggle and took inspiration from the newly-formed Soviet Republic in Hungary. There was little choice but to defend their Soviet Republic with everything at their disposal. They knew full well that if they simply surrendered they would all be hanged or shot. Therefore, they felt that it was better to go down fighting, and leave a Communist tradition behind them, than to capitulate without a struggle. The main task now was to arm the proletariat and organise a serious defence. There were certain parallels here between the struggle in Munich and the Dublin Uprising of Easter 1916, where James Connolly led the insurrectionists, who would inevitably be defeated, but at least they would leave behind a tradition.

As Hoffmann's butchers closed in on Munich, however, divisions opened up within the revolutionary camp. The more faint-hearted types looked once again to Ernst Toller to help save them. Shamefully, Toller opened up a barrage of fierce criticism against Leviné, mixed in with lies and slanders. Toller favoured negotiations with Hoffmann, but Hoffmann demanded unconditional surrender. Toller had been placed in charge of the defence of the western part of Munich, but deliberately undermined the defence efforts by raising the restrictions on the bourgeois press, allowing them to spread their poison; denationalising requisitioned vehicles and releasing counter-revolutionary prisoners. The news of these treacherous deeds soon reached Hoffmann through his various spies, which added to his lust for revenge. The atmosphere within the besieged city quickly deteriorated but Leviné refused to give up or leave.

Hoffmann's troops encircled the city and placed it under siege, denying it food and fuel. "The Munich insane asylum must be put in order," demanded Noske, "even at the cost of bloodshed." Ebert also urged a speedy intervention. The leadership of the SPD played a treacherous role by vouching that "the troops of Hoffmann's Socialist Government are not enemies of the workers, not White Guards. They come to safeguard public order and security".

Scandalously, the Social Democrats appealed to the workers not to resist but to "help the soldiers to carry out their arduous task… to obey the orders of surrendering arms." (E. Leviné-Meyer, *The Life of a Revolutionary*, p. 132.) As suffering mounted and discontent and panic spread, the counter-revolutionary troops were reinforced by 20,000 more soldiers sent by Noske to Bavaria. With other Freikorps forces, their numbers had swollen to 35,000.

On May Day 1919, they finally entered the city and Munich was declared 'liberated'. The battle was relatively brief but bloody. The final Communist declaration stated: "Don't make the hangman's task easy. Sell your lives dearly." Some estimates stated that 2,000 workers were killed during the street battles and mopping up operations by the Freikorps. Gustav Landauer, one of the

leaders, was shot with a pistol and then kicked to death. There was still some resistance in the south of Munich until 3 May. Martial law was imposed, and people could be shot on the spot, a policy that had the full support of the SPD leaders.

A price of 10,000 marks was put on the head of Communist leader Eugen Leviné. His hideout was eventually found and he was arrested and put on trial. He used the court as a platform to make a revolutionary appeal. Defiant to the last, Leviné made a final speech against the counter-revolution and ended with the words:

> We Communists are all but dead men on leave. Of this I am fully aware. I do not know whether you will extend my leave or whether I shall have to join Karl Liebknecht and Rosa Luxemburg. In any case I await your verdict with composure and inner serenity. For I know that, whatever your verdict, events cannot be stopped…
>
> And yet I know, sooner or later, other judges will sit in this hall and then those will be punished for high treason, [those] who have transgressed against the dictatorship of the proletariat.
>
> Pronounce your verdict if you deem it proper. I have only striven to foil your attempt to stain my political activity, the name of the Soviet Republic with which I feel myself so closely bound up, and the good name of the workers of Munich. They – and I together with them – we have all of us tried to the best of our knowledge and conscience to do our duty towards the International, the Communist World Revolution. (E. Leviné-Meyer, *The Life of a Revolutionary*, pp. 217-218.)

Leviné was shot for high treason in defending the Soviet Republic on 5 June, another revolutionary martyr in the cause of Communism. As a mark of defiance, a protest general strike took place in Berlin.

To completely subdue the city, scores of revolutionary workers were shot by impromptu Freikorps court-martials, while others were simply brutally murdered. The working class was now completely disarmed and defenceless. Few leaders escaped the 'White Terror'. The ruthless ruling class, not for the first or last time, showed no mercy.

Following the defeats in Berlin and the crushing of the Bavarian Soviet Republic, another stage of the German revolution came to an end. The first initial assault of the working class in the direction of taking power had failed.

The young Communist Party leaders were being forced to learn how to struggle under the harsh blows of reaction. As Trotsky explained:

It is quite self-evident that such a road calls for enormous exertions and demands countless sacrifices. But there is no choice. It is the one and only road along which the class uprising of the German proletariat can unfold till final victory. (*Pravda*, 23 April 1918, *The First Five Years*, vol. 1, p. 46.)

The drive of the counter-revolution throughout 1919 in Germany coincided with an intensification of the Civil War in Soviet Russia. The Russian White Armies, backed by twenty-one foreign armies of imperialist intervention, were making gains at this time against Bolshevik government forces. In the words of Trotsky, the revolution was caught "between hammer and anvil". Such was the imminent threat, there was even talk of abandoning Petrograd and shifting the government to Moscow, but that idea was rejected at the insistence of the head of the Red Army, Trotsky.

In this war to the death between Red and White forces, Germany provided an important recruiting ground for the counter-revolutionary offensive against the Bolshevik government, involving German, Russian and British backers. On 19 August, 1919, Price wrote of the situation in the following terms:

The evidence that Germany is becoming a recruiting ground for the armies of the Holy Alliance against Soviet Russia increases every day. On the one hand half a million Russian workmen and peasants who are prisoners of war are held back from returning to their homes, and according to reliable information I have received, in West Prussia [they] are being used by the Junkers to work on their estates at 2 marks a day as strikebreakers because the German peasants demand better conditions. On the other hand, the Allied governments have no objection to Russians, and even Germans, entering military detachments that are being formed here as reinforcements for Kolchak, Denikin and Yudenich.

Last night the *Freiheit* [the USPD newspaper] published information about this public scandal. At the Russischer Hof hotel in Berlin there is a recruiting office for the Russian counter-revolutionary armies. The recruits receive 50 marks per head, uniforms and all outfit. At Jena another recruiting office is opening where recruits receive 300 marks and are promised all they can get from the Jewish population when they get to Russia. Last Saturday, 110 German recruits were sent in this way to the Baltic Provinces and more are following. In Latvia the 6th German Reserve Corps are reported to have joined Yudenich. In Hamburg, according to the *Freiheit*, recruits have been supplied with outfits from German war stores.

The alliance between Russian monarchists, Prussian Junkers and British brass hats is becoming daily more impudent and shameless. (M. Philips Price, *Dispatches*, p. 47.)

Meanwhile, the counter-revolution continued its rampage throughout Germany. In Berlin, the Central Bureau of the Workers' Councils was occupied by Noske's White Guards, who seized money and papers, sealed the building and ejected the Executive Committee members onto the street. In November, on the anniversary of the German Revolution, Noske arrested the strike leaders of the Berlin metal workers and declared the Workers' Councils abolished. He was determined to eradicate the last vestiges of the Revolution. The capitalists and militarists were once again to be masters of Germany.

Throughout Germany, a state of open civil war between the forces of revolution and counter-revolution existed, and the central government was determined to impose 'order' on a radicalised and battle-hardened working class, whatever the cost.

These events had served to radicalise the advanced sections of the German working class. The right-wing Social Democratic leaders were becoming discredited in their eyes. As a consequence, there was an explosive growth in the membership of the USPD, which more than doubled from 300,000 to 750,000. At its second party conference in November 1919, they adopted a new radical party programme, agreed unanimously, stating that "the Independent Socialist Party stands for the Soviet system and aims at the building up of Councils [...] as organs for realising the dictatorship of the proletariat." Parliamentary action was permissible, it explained, as long as it was with a view to destroying the capitalist system. The adoption of this programme took them very close politically to the Bolsheviks and the German Communists. This radicalisation also led them to take the decision to leave the Second International and declare their support for the Third International.

A year later, Lenin surveyed the situation:

History, incidentally, has now confirmed on a vast and worldwide scale the opinion we have always advocated, namely, that German *revolutionary* Social Democracy... *came closest* to being the party the revolutionary proletariat needs in order to achieve victory. Today, in 1920, after all the ignominious failures and crises of the war period and the early post-war years, it can be plainly seen that, of all the western parties, the German revolutionary Social Democrats produced the finest leaders, and recovered and gained new strength more rapidly than the others did. This may be seen in the instances both of the Spartacists and the left, proletarian wing of the Independent Social Democratic Party of Germany, which is waging an incessant struggle

against the opportunism and spinelessness of the Kautskys, Hilferdings, Ledebours and Crispiens. (LCW, vol. 31, pp. 33-34.)

In the same year, 1920, within a few months of Lenin's statement, the USPD finally took the historic decision to join the Third International, accept its Twenty-One Conditions, and create the largest Communist Party in the world, outside of Soviet Russia. It seemed that the basis was now being laid for a successful future socialist revolution in Germany.

CHAPTER FOUR: THE KAPP PUTSCH MARCH 1920

> The Party of Order... knew neither how to rule nor how to serve;
> neither how to live nor how to die; neither how to suffer the republic
> nor how to overthrow it.
>
> Karl Marx, *The Eighteenth Brumaire of Louis Bonaparte*

> When we started the international revolution, we did so not because
> we were convinced that we could forestall its development, but
> because a number of circumstances compelled us to start it. We
> thought: either the international revolution comes to our assistance,
> and in that case our victory will be fully assured, or we shall do our
> modest revolutionary work in the conviction that even in the event
> of defeat we shall have served the cause of the revolution and that our
> experience will benefit other revolutions.
>
> LCW, vol. 32, pp. 479-80

The first post-war revolutionary wave almost put an end to capitalism. The masses had come onto the scene of history and had taken power into their hands at different moments. The old order was facing collapse. But the working class found itself betrayed by its own reformist leaders, who rushed to rescue the capitalist system. Moreover, the inexperienced, young communist parties had hardly time to form, and were overtaken by events. They proved too weak to take advantage of the situation and made many mistakes. Within a few years the powerful mass ferment had begun to ebb.

Once the immediate threat of revolution had subsided, the capitalists plotted to get back control. The revolution had forced them to make enormous

concessions to save their system. Part of the plan to get back to 'normal' was the removal of the Noske-Scheidemann-Ebert government. The reformists had fulfilled their role willingly as a colossal brake on the revolution, but for the German ruling class it was time they stepped aside, as they were no longer needed.

"Democracy with us represents – nothing," stated the industrialist Fritz Thyssen. (D. Guerin, p. 35.) At best, it was an inconvenient cloak to fool the masses. But revolution had shown things had gone too far.

This was a similar picture to Russia in August 1917, when there was an attempt to get rid of the 'democratic' Kerensky government by General Kornilov. As in Russia, the capitalists and landlords looked to the installation of a strong militarist government that could eradicate any vestiges of the revolution and restore 'law and order'.

General Ludendorff expressed the collective contempt of the Generals for the reformists, who they tolerated only so long as they played a useful role in holding back the revolution:

> It would be the greatest stupidity for the revolutionaries to allow us all to remain alive.

> Why, if ever I come to power again, there will be no pardon. Then, with an easy conscience, I would have Ebert, Scheidemann and company hanged and watch them dangle. (R. Watt, p. 273.)

The Ehrhardt Brigade march on Berlin

Thus, spoke the authentic voice of the German military caste. Behind this mailed fist stood the bourgeoisie, which did not rest on ceremony.

The threat from the military establishment had been present since the November Revolution. The air was thick with intrigues, plots, and conspiracies aimed at overthrowing the Social Democratic-led government. The General Staff had been chafing at the bit to settle scores with the working class and put an end to the feeble Weimar Republic. Military coups had been attempted on two occasions in December 1918, but had been foiled by the diligence of revolutionary soldiers. Four others had been organised between September 1919 and March 1920. Eventually, they believed they would succeed. Then the Social Democrats and their communist friends would 'dangle' at the end of a noose.

In early 1920, the right-wing Social Democrat, Gustav Noske, acting as Commander-in-Chief, ordered the disbandment of one of the most feared of the Freikorps units, the Ehrhardt Brigade. But General Lüttwitz, the commanding general in Berlin, refused to obey the order. Instead, he demanded the dissolution of the National Assembly and the establishment of a dictatorship. When Noske and Ebert refused the general's request, Lüttwitz instructed the Freikorps to enter Berlin, overthrow the government, National Assembly and the Constitution, and institute military rule.

On 13 March, 12,000 Freikorps troops from the Ehrhardt Brigade and the Baltikum Brigade under General Lüttwitz's command marched on the capital. They were the crack troops of the counter-revolution. Their stated aim was the arrest of the ministers and to proclaim Wolfgang Kapp, a right-wing nationalist politician and founder of the old Fatherland Party, as the new Chancellor of a military government, who would act as their stooge.

Noske, who had proved his undying loyalty to the military establishment, called upon Reichswehr[1] officers to put down the rebellion of their fellow officers. This they refused point blank. The Berlin government was now faced with an open revolt by the entire military command. This posed a clear threat to the government's own survival. The head of the regular army, General Hans von Seeckt, simply washed his hands of the mutiny, saying "troops do not fire on troops," and announced he was going on "indefinite leave". It was quite obvious that the military High Command would not lift a finger to defend the Republic, which they viewed with complete disdain, and were in favour of the coup.

Terrified, the first act of the Social Democratic government ministers was to flee from Berlin, firstly to Dresden, where a Freikorps general threatened

1 The Reichswehr was the German army, established in 1919. The Versailles Treaty limited the standing army to 100,000 men, and a navy of 15,000.

to put the entire cabinet under arrest, and then to Stuttgart. In face of the military coup, instead of arming the workers, they fled like rats leaving a sinking ship.

The conservative trade union leaders, also fearing for their lives, were forced to take difficult decisions. They too could also abandon Berlin and leave the workers to the tender mercy of the Freikorps. Or they could put up some kind of token resistance before acquiescing. Neither option looked very appealing and, in the end, they chose a token resistance.

On 13 March, they issued an appeal for every worker to oppose the putsch and rally to the defence of the Republic. "We are therefore calling on all workers to go on strike everywhere immediately. All factories must be brought to a standstill," stated the appeal. (B. Fowkes [ed.], p. 113.)

Wels, one of the very few Social Democratic leaders left behind, took the initiative to attach the names of the departed government ministers to a proclamation, which backed the call for a general strike. Karl Legien, the patriarch of the revisionists, who had previously opposed general strikes as "general nonsense", now felt he had no alternative but to reluctantly call on such 'nonsense'. This was the first time for such expressions of 'bravery' on their part, but it would be the last. To their absolute astonishment, the strike call was energetically taken up by the militant workers of Berlin, many under the influence of the left-wing Independent Socialists.

The workers responded to the call as one united body. The response was so solid that it completely paralysed Berlin. By noon on the first day, everything had ground to a halt. "From midday on, no trams ran and all factories closed down; and what is more, the strike order was obeyed," observed Philips Price at first hand. (*My Three Revolutions*, p. 176.) Nothing moved. There was no supply of water, gas, or electricity. The sailors of Wilhelmshaven immediately mutinied and arrested their Admiral, together with 400 officers. Other regiments, in a display of solidarity, followed suit.

When 'Chancellor' Kapp threatened to shoot workers who had set up picket lines, he was firmly put in his place and told to be quiet for fear of provoking a civil war, which they were not likely to win.

In the end, the strike was so effective that a humiliated Wolfgang Kapp, the 'Chancellor' in-waiting, could not find a printer to print a poster proclaiming his new government. What's more, with the telegraph clerks on strike, even if he wanted to, there was nobody to issue any decrees. The military coup, despite its initial show of strength and bravado, had collapsed within the space of four short days. It reflected accurately the real balance of class forces at that time, where the working class had colossal reserves of energy.

TWO COUNTER-REVOLUTIONARY WINGS

Unfortunately, the young KPD had not shaken off its ultra-leftism. Its initial response to the general strike call was to issue a statement on 14 March, saying that the workers should remain *neutral* in this struggle "between two counter-revolutionary wings". The party statement declared:

> This bankrupt group [the trade union and Social Democratic leaders] calls on the workers to mount a general strike for the 'salvation of the Republic'. The revolutionary proletariat knows that it will have to enter a life-and-death struggle against the military dictatorship. But it will not lift a finger for the government of murderers of Liebknecht and Luxemburg, a government which has collapsed in ignominy and infamy. It will not lift a finger for the democratic republic, which was only a paltry mask for the dictatorship of the bourgeoisie.

What was needed, it said, "is to take up the struggle for the proletarian dictatorship." (Quoted in B. Fowkes [ed.], p. 115.)

In Leipzig, the Communists refused to sign the document calling for a general strike drafted by the other organisations. This ultra-left infantile stance only served to isolate the party. The idea that there was no difference between monarchist reaction and the republic was clearly absurd, especially for the workers who had been prepared to lay down their lives for the republic.

The Communist International's representative in Germany, M.J. Braun, tried to cover up this childish position by explaining that the KPD only reflected the "momentary mood of the Berlin workers." In reality, it was a major blunder.

Fortunately, in the space of twenty-four hours, and in the face of a highly successful general strike, the party was forced to carry out a 180 degree about turn. The following day, on 15 March, the Zentrale of the KPD issued a declaration, this time in favour of the general strike, but making it clear that such action could not be construed as support for the government. But the mass of German workers did not see it like that. It took unified action to defeat the military coup, defend the republic and defend their democratic rights. For ordinary workers, it was not simply the fate of the government that was at stake, but, more importantly, the gains of the Revolution, including the Republic. Given this unanimous response, the Communists had little alternative but to participate in the struggle and lend support to the strike called by the reformist trade union leaders.

The Kapp Putsch served to electrify the whole country. From Berlin, the strike spread throughout the Ruhr, central Germany and Bavaria. Such was the reaction to the coup that in nearly every city and town, the military were

driven out by mass demonstrations of workers and even the middle class. The
sheer scale of the resistance to General Lüttwitz's adventure was something the
country had never witnessed before. On 17 March, the coup had completely
collapsed and the Ehrhardt Brigade was forced to march out of Berlin, briefly
pausing twice to fire on some unarmed bystanders, more a display of its own
impotence. The coup had provoked a revolutionary response. If the workers'
leaders had wanted, they could have taken power peacefully. There was no
force that could have stopped them.

In the hotbed of the Ruhr, armed strikers began to join forces in a 'Red
Army' that put the Reichswehr to flight. The fighting force of this 'Red Army'
was estimated as 80,000 strong, fully equipped with modern weapons and
artillery left over from the war. On 18 March, the whole of the Westphalian
sector of the Ruhr had been liberated from the military, and within the next
four days, Essen also fell. The 'Red Army' became, for a period, real masters
of the Ruhr, the centre of gravity of the workers' struggle.

Workers took action all over Germany. In Chemnitz, the post office,
railway station and town hall were occupied by armed workers. The Executive
Council of Chemnitz was established on 15 March and was made up of ten
KPD members, nine SPD, one USPD and one Democrat, and extended its
authority over a radius of fifty kilometres. It was a typical scene of workers'
power throughout the country.

The success of the general strike was a testimony to the power of the
German working class. After the coup d'etat was defeated, the first demand
was for the immediate removal of the notorious collaborators in the
government. These were Noske, as well as two other ministers, Wolfgang
Heine and Eugene Schiffer. Events had meant that Noske's shameful role was
now at an end and his political career was in effect over.

Noske subsequently became Governor of the Province of Hanover from
1920 onwards. From there, he ended up supporting the reactionary von
Hindenburg in the elections for Reich President in 1925 and 1932. He was
discharged from his post on 1 October 1933 by the Nazi government. He
then moved to Frankfurt, but in 1944 was arrested by the Gestapo under
suspicion of involvement in the 20 July plot against Hitler and imprisoned
in the Ravensbrück concentration camp. He was finally freed by advancing
Allied troops from a Gestapo prison in Berlin. He died in Hanover on 30
November 1946 from natural causes while preparing for a lecture tour of the
United States. Noske has gone down in history as a treacherous man who will
never be forgiven for his dirty role in betraying the German working class,
including the murder of Liebknecht and Luxemburg.

In Berlin, as elsewhere, the general strike remained in force. Before the Strike Committee was prepared to call the strike off, they demanded a meeting with government representatives. At this meeting, they issued a series of demands, the most important being: (1) the creation of a new government in which the trade unions were to have a decisive influence; (2) severe punishment for the instigators and participants of the rebellion; (3) a thorough purge of the armed forces; (4) a thorough purge of the civil service; (5) the socialisation of all industries 'ripe for socialisation'. The government in a state of paralysis had no alternative but to accept these demands, and the strike was called off on 23 March 1920.

The trade unions, under pressure from the workers, had demanded a genuine workers' government composed of all workers' parties. However, nothing came of this demand as the Left Independents refused to co-operate or join a government with the Majority Socialists. This again allowed the SPD to form another coalition with bourgeois parties, but with Hermann Müller, the Social Democrat, replacing Gustav Bauer of the Centre Party as Chancellor.

LEARNING THE LESSONS

The movement of the masses against the Kapp Putsch has clear historical parallels. It was strikingly similar to the heroic uprising of the Spanish proletariat against the revolt of General Franco in July 1936. As in Spain, with a genuine revolutionary leadership, the German workers could have taken power very easily. Power was in effect in the streets. All they needed to do was to pick it up. Unfortunately, the lack of the subjective factor, the revolutionary party, proved once again decisive in saving capitalism.

Lenin compared the Kapp putsch to the Kornilov uprising of August 1917 in Russia. In a similar way the forces of counter-revolution attempted to overthrow the Kerensky government and restore the old regime of the tsarist monarchy. However, unlike the German communists, the Bolshevik Party did not hesitate and immediately threw itself into the front line in a 'united front' in defence of the revolution. In such a front, the Bolsheviks adopted the motto: *march separately, but strike together*. They did not hold back from the struggle, despite their fundamental political differences with Kerensky, but offered a united front to the Mensheviks and Social Revolutionaries to defeat the reaction. In so doing, they showed in practise the superiority of their tactics, determination and propaganda in defeating the attempted coup.

It was clearly a mistake of historical proportions on the part of the German KPD to advocate neutrality in such a life-and-death struggle of this kind. If the coup had succeeded then the precursor of fascism would have

come to power much sooner. It would have been a deadly regime, like the Horthy regime in Hungary. In face of this, a neutral position was the height of sectarianism and guaranteed the KPD's political isolation. Fortunately, as we have seen, this lunacy was very quickly abandoned.

In the end, the defeated Wolfgang Kapp fled abroad to Sweden. He then returned to Germany, was arrested but died before his trial had started. He was given a posthumous amnesty by President Hindenburg in 1925, 'for services rendered' to the ruling class. The Herculean efforts by the working class over four days guaranteed the collapse of the coup, but power still eluded them.

Equally, the defeat of the putsch did not mean the end of the Freikorps. These armed mercenaries continued to pose a constant threat to the government and the working class. The intentions of this 'Black Reichswehr' were encapsulated in a song composed at the time:

> Why should we cry when a Putsch goes wrong?
> There's another one coming before very long.
> So say goodbye – but remember, men,
> In a couple of weeks we will try it again.
> (R. Watt, p. 507.)

The first to challenge the false line of the KPD was Paul Levi, who was serving time in prison during the events of the Kapp Putsch, and was angry at the abstentionist line taken by the party. As a result, he wrote a sharp criticism to the Zentrale from his prison cell on 16 March:

> I have just read the leaflets. My judgement: the KPD is under threat of moral and political bankruptcy… It means you are attacking the greatest-ever action undertaken by the German proletariat from the rear. I always thought we were clear and united about the following point: if an action does come about – even for the stupidest of goals! – we support the action, and endeavour to push it on beyond its foolish objective. We do not cry at the outset "we will not lift a finger" if the goal does not suit us…

> These must be the party's demands: (1) Arming of the proletariat, that is to say the distribution of weapons to the politically organised workers, so as to secure the Republic; (2) Unconditional capitulation of Kapp and Lüttwitz. This is of the greatest importance, for sordid attempts at haggling with them are already being made. (3) The leaders of the putsch must be immediately arrested and condemned by an emergency proletarian court. Nothing more. What the Zentrale writes in its leaflet of 16 March is unusable. (B. Fowkes [ed.], p. 117.)

Paul Levi's criticisms were certainly damning. Levi had joined the Spartacus League in 1916 and assumed the leadership of the young Communist

Party after the death of Liebknecht and Luxemburg. The party had initially attracted a whole number of confused and romantic elements who rejected participation in the trade unions and parliament, and who regarded armed rebellion as the only 'revolutionary' way forward. Levi believed the party needed to be purged of such individuals so as to overcome these ultra-left tendencies, just as Lenin had expelled the 'Liquidators'[2] from the party in 1912.

THE SPLIT

At the Second Congress of the German Party in October 1919, Levi managed to push through a 'Declaration of Communist Principles and Tactics' and other important resolutions, which reaffirmed the need for parliamentary and trade union participation as well as the importance of building a centralised party. He laid down an ultimatum to the ultra-left elements within the party: either accept these communist principles and tactics or leave. "Members of the KPD who do not share these views on the nature, the organisation and the activity of the party must resign from it," stated the 'Declaration', which was adopted by thirty-one votes to eighteen at the Second Congress in October 1919. (ibid., p. 87.) Levi was to later find support for his actions in Lenin's 1920 work *'Left-wing' Communism: An Infantile Disorder*, which argued against the German ultra-lefts by name. Levi provoked a breach which led to a large split in the party, including within the leadership. The ultra-lefts, who were forced out of the KPD, took nearly half the membership with them, some 50,000, who went on to set up the Communist Workers' Party of Germany (KAPD) in April 1920.

Lenin, however, was not happy with Levi's methods. He thought that those with ultra-left tendencies, especially those displaying a healthy reaction to reformism, could be gradually won over and integrated into the Communist Party. He therefore preferred conciliation, not expulsion.

> If the split was inevitable, efforts should be made not to deepen it, but to approach the executive committee of the Third International for mediation and to make the 'Lefts' formulate their differences in theses and in a pamphlet. (LCW, vol. 30, pp. 89-90.)

He believed it much better to allow the ultra-lefts to put their position in writing so that it could be answered properly, and hopefully win them over in the process. That was the reason he wrote *'Left-Wing' Communism*, not as

2 The 'Liquidators' were a current within the Russian Social Democratic Labour Party who advocated the abandonment of the illegal party organisations.

a stick to beat them with, but to convince them. He implored the German leadership to re-establish unity with the 'Lefts'. But Levi refused to budge.

The split was damaging as the largest districts, with the exception of Chemnitz, supported the 'Lefts'. In Essen, for example, only a mere forty-three members out of 2,000 supported the theses of the Zentrale. Hamburg, Bremen, Berlin and Dresden were strongholds of the ultra-left. In order to assert their authority, the Zentrale acted swiftly to expel en bloc all those areas that rejected the leadership's political line. From February 1920 onwards, the party districts of North, North-East, West Saxony and Berlin-Brandenburg, comprising thousands of workers, were expelled.

Under pressure from Zinoviev, the KAPD was recognised as a 'sympathising section' of the Comintern. Lenin also supported their participation as a 'sympathising' group. Both parties co-existed, and there were attempts by the Comintern leadership to bring the KAPD back into the fold. However, given the acrimonious split, it would require a certain amount of time and preparation before such a fusion could take place. While the Comintern was politically very critical of the positions of the KAPD, they were welcome to participate in the Second Congress of the Communist International in the summer of 1920, to which they sent two delegates, Otto Rühle and August Merges.

The idea behind their participation was that genuine differences could be resolved, as far as possible, through discussion and debate, as long as there was good faith on both sides. The difference over participating in parliament, for example, was not a question of principle, but of approach, which did not justify two organisations. Such a view was stressed by the International: "There was no basis for splitting on this secondary question," explained the ECCI circular. However, this conciliatory attitude did not bring the sides closer. In fact, the differences grew wider as the ultra-leftism of the 'Lefts' became increasingly ingrained and even organic.

The existence of two separate parties affiliated to the International, whatever their exact status, was also confusing for German workers. Sooner or later there would be a fusion of the two parties or a parting of the ways. A long co-existence was untenable. As it turned out, there was a rapid parting of the ways.

The fate of the KAPD was sealed when its delegates to the Second Congress refused to accept the Twenty-One Conditions, describing them as "opportunist" and "centralist". In a typically ultra-left fashion, they walked out of the Congress. The fortunate side of this departure was that it diffused a potential row with the official German section, which was violently opposed to the participation of the 'Lefts'. Within a few years, the KAPD had split

and later disappeared, their members scattered to the four winds. The official party, once again, became the sole authoritative voice of communism in Germany.

Lenin later realised that making the KAPD a sympathising section of the Comintern had been a mistake. This was brought home when, in early January 1921, the leadership of the KPD sent an Open Letter to the national trade unions, the SPD and the remains of the USPD, in an attempt to forge unity in action over immediate questions. But this was derided by the German 'Lefts', as well as Zinoviev and Bukharin. Bukharin had been a consistent ultra-left in the first years of the Russian Revolution. Zinoviev was also open to these leftist moods. Lenin was always attempting to curb these excesses. On this occasion, he was forced to intervene and force the Comintern leaders to withdraw their objections and support the Open Letter initiative.

Lenin regarded this as a fundamental touchstone, a principled question, and the basis for the united front policy adopted at the following World Congress. On 10 June 1921, Lenin wrote a letter to Zinoviev regarding the Open Letter where he stated:

> Hence: the tactic of the Open Letter should definitely be applied everywhere. This should be said straight out, clearly and exactly, because wavering in regard to the 'Open Letter' is extremely harmful, extremely shameful, and *extremely widespread*. We may as well admit this. All those who have failed to grasp the necessity of the Open Letter tactic should be *expelled* from the Communist International within a month after its Third Congress. I clearly see my mistake in voting for the admission of the KAPD. It will have to be rectified as quickly and fully as possible. (J. Riddell [ed.], *To the Masses: Proceedings of the Third Congress of the Communist International: 1921*, pp. 1098-1099, emphasis in original.)

POLITICAL POLARISATION

Meanwhile, events were unfolding elsewhere in Germany. Bavaria had been convulsed by political upheaval ever since the November Revolution. At this time, General von Nohl, ungrateful for past services, forced out Johannes Hoffmann, the SPD Bavarian Premier, and established a more right-wing government led by the maverick Gustav von Kahr. Despite the provocation, the central government sat on its hands.

In the Ruhr, the workers of the 'Red Army', who had succeeded in stopping the Freikorps and the Reichswehr forces in their tracks, refused to lay down their arms until the state forces had completely withdrawn. A deal, called the Bielefeld Treaty, was brokered, which promised not only withdrawal but a democratisation of the army and the creation of local militias. In return,

the Red Army would stand down its forces. But the deal broke down as the more radical elements within the Red Army regrouped and refused to disarm.

This time, in complete contrast, the government in Berlin, headed by Hermann Müller, used the breakdown to despatch troops – precisely those who had supported the Kapp Putsch – to the Ruhr to put down the rebellious units. The government forces carried out their task with relish and much brutality, which led to the slaughter of over 1,000 workers. Most of these were killed in battle but others were rounded up, placed against the wall and shot.

"The whole thing was so outrageous that I could hardly believe what I now saw," wrote Philips Price, "the Majority Social Democratic leaders, using the people who had just overthrown them, to suppress the people who wanted to help them." (*My Three Revolutions*, p. 176.)

The state judiciary also colluded with the forces of reaction. More than eighteen months after the Kapp episode, 412 of those arrested for treason had been amnestied and walked away scot-free. Only one person had been sentenced to five years imprisonment by the courts for their involvement. This showed how the state apparatus, the judiciary, courts and their appendages, were completely fused with the military hierarchy.

However, the ramifications of the Kapp Putsch resulted in a shift in the political landscape. Given the growing disillusionment with the coalition government and its capitulation to the military, the government parties suffered a crushing defeat at the general election on 6 June 1920. The vote for the right-wing Social Democrats fell sharply from 11.5 million in January 1919 to 5.6 million in June 1920. This reflected a growing disillusionment with the coalition government and the right-wing socialists. It was also a reaction to the Kapp Putsch. The situation was summed up by Rudolf Wissell, a former SPD Minister for the Economy, when he said:

> Despite the Revolution, the people have been disappointed in their expectations. We have extended formal political democracy further, to be sure. But we have still done nothing more than continue the programme already initiated by the Imperial German government of Prince Max of Baden. (Quoted in B. Fowkes [ed.], p. 34.)

Workers transferred their allegiances to the more radical parties of the left, particularly the USPD. The Left Independents became the second largest party in the Reichstag with eighty-one deputies; in the Landtags of Saxony, Thuringia and Brunswick it became the largest party. Nationally, the USPD had managed to more than double its Reichstag vote from 2.3 million in 1919 to 4.9 million in 1920. The USPD membership had also grown spectacularly

to 800,000, the biggest party in Germany. It published some fifty-five daily newspapers and was a mass organisation in the true sense of the word.

While the SPD still remained the biggest party in the Reichstag, the vote for the extreme right also doubled at the expense of the liberals, indicating a growing political polarisation within Germany. The Democratic Party lost proportionately even more, as did the Centre Party. A new coalition minority government was formed of centre-right parties, from which the Social Democrats were now excluded. It was the first time since the November Revolution that representatives of the SPD were out of government.

The Communist Party, which took part in the elections for the first time, gained a little less than half a million votes. The combined vote for the workers' parties had fallen from 13.4 million to 11 million, but this disguised a significant swing to the left in the working-class vote, as well as a sharp swing to the right in the bourgeois camp. The two Rightist parties, the German People's Party and the German National Party, one based on big business and the other on landed interests, had a combined vote of 7.3 million, as against 4.5 million in 1919.

This sharp polarisation in society reflected the deep political crisis affecting Germany. The defeated coup d'etat added to this instability, as one governmental crisis followed another. This set the scene for the following decade and reflected a growing disillusionment with the results of the Weimar Republic and its inability to solve any of the burning questions facing the masses.

BUILDING THE COMINTERN

In this period, the Founding Congress of the International, or 'Comintern', was held in Moscow over four days in March 1919. It was attended by fifty-one delegates, from thirty-five organisations representing twenty-two countries. Many were exile groups living in Russia, as well as others from the national minorities within the former tsarist empire, including Ukraine, Estonia, Latvia, Lithuania and Belorussia. The arrival of a relatively modest number of delegates from abroad – only nine – was no mean achievement given the extreme difficulties of travel as well as the Allied blockade which meant that many were not able to make the journey, while some Communist groups were still in the process of formation.

It is true that Rosa Luxemburg had her doubts about the founding of a new International at this time. She felt it was premature and preferred to wait until more mass parties had been won over. In fact, Hugo Eberlein, the sole German delegate, was sent with a mandate to oppose its founding, preferring instead to call the international gathering a preliminary conference.

The comrades of the KPD were certainly committed to building a new international, but for them, it was a question of timing. The other delegates were clearly in favour of going ahead. After lengthy discussions with Lenin and other leaders, Eberlein was persuaded to abstain in the vote and allow the formation of the Third International to take place, with no votes against. With all other full delegates voting in favour, the new international was launched. Accepting the decision of the Congress, the German party duly agreed to affiliate to the Third International and pledged itself to building the International.

This Founding Congress was extremely important in drawing a sharp line between the revolutionary internationalists and the 'social chauvinists' of the Second International. In complete contrast to the old International, the Congress highlighted the importance of the proletarian revolution and the principles of soviet power. Its principal resolutions and theses, the key ones being drafted by Lenin and Trotsky, were discussed in the Congress, and placed the International on firm theoretical foundations.

The success of the Russian Revolution and the unfolding revolutions in Europe were having an electrifying effect on the working class, including within the parties of Social Democracy. Mass left-wing oppositions crystallised within these parties, which fought to break their parties away from the old Second International and join the new Third International. As a result, negotiations over affiliation involved a whole series of mass workers' organisations: The Independent Labour Party in Britain, the French Socialist Party, the USPD of Germany, the Italian Socialist Party, the Norwegian Labour Party, to name a few.

By 1920, a year after the Founding Congress, the possibility of creating a mass Communist International was finally taking shape. However, there were dangers. In particular, the greatest danger was allowing reformist and centrist figures into the new International. Many of the centrist leaders of the old organisations felt the ground shifting under their feet, and tried to reinvent themselves politically. Their verbal radicalism was an attempt to keep a firm grip on their leftward moving rank and file. Affiliation to the new Third International could serve to give these leaders a 'communist' colouring and would help burnish their tarnished political credentials. "The Communist International is, to a certain extent, becoming the vogue," noted Lenin, who was concerned about letting these centrist leaders in. (LCW, vol. 31, p. 201.)

Old leaders, like the Germans Wilhelm Dittmann and Arthur Crispien, took a semi-pacifist and opportunist line during the war; the French leaders, Cachin and Fossard, were also extremely patriotic; the Czech, Šmeral, had

been an agent of the Habsburg monarchy;[3] and finally, Ramsay MacDonald, head of the Independent Labour Party, was reformist through and through. They were all now sniffing at the door of the Third International.

To prevent such an influx of unwanted charlatans, while welcoming the rank and file workers, the Second Congress of the Communist International formulated Nineteen Conditions, under Lenin's guidance, for affiliation to the new International. These conditions included the recognition of soviet power, the dictatorship of the proletariat, the need to fight against social chauvinism, and the subordination of parliamentary struggle to the revolutionary struggle of the working class. One explicitly stated:

> It is the duty of parties wishing to belong to the Communist International to recognise the need for a complete and absolute break with reformism and 'Centrist' policy, and to conduct propaganda among the party membership for that break.

Another called for:

> Communist parties in countries where communists can conduct their work legally must carry out periodic membership purges (re-registrations) with the aim of systematically ridding the party of petty-bourgeois elements that inevitably percolate into them.

While these conditions were tough, an assortment of old centrist leaders were still seeking entry into the International, and were prepared to swallow the Nineteen Conditions. As a result, two extra conditions were added to ensure they were excluded. The final condition, the most stringent of all, was proposed by the Italian delegate, Amadeo Bordiga.

While Lenin was prepared to be flexible, he drew the line at creating a new version of the Second International or even a new 'Centrist' halfway house. In the words of Zinoviev, this meant they "put a lock on the doors of the Communist International... [and regarded it] necessary to put a reliable guard on the gate." (E.H. Carr, *The Bolshevik Revolution*, vol. 3, pp. 186-187.)

The extra two conditions stipulated that:

> Those parties that now wish to enter the Communist International but have not yet radically altered their previous tactics must, before they join the Communist International, see to it that no less than two-thirds of the Central Committee and of all their most important central institutions consist of comrades who even before the Second Congress of the Communist

3 This did not prevent him eventually entering the Communist Party and rising to become a member of the presidium of the Executive Committee of the Communist International under Stalin.

International spoke out unambiguously in public in favour of the entry of the party into the Communist International.

Finally, the last clause stipulated:

> Those party members who fundamentally reject the Conditions and Theses laid down by the Communist International are to be expelled from the party.

These Twenty-One Conditions would therefore "lock the door" and exclude such "notorious opportunists" as Kautsky, Hilferding, Turati, Modigliani, MacDonald, Longuet, and Hilquit, who were specifically named in the resolution. "We need an International to act as an international general staff of workers in all countries," read the ECCI statement. "We cannot transform the Communist International into a mere letterbox." (P. Broué, p. 437.) The reference to "letterbox" was the characterisation given to the Second International, which received many written reports from national sections, but did nothing with them.

Another condition made it clear that there was "the obligation to wage a stubborn struggle against the Amsterdam 'International' of yellow trade union organisations." This was the reformist International Federation of Trade Unions (IFTU), formed in 1913, which was linked to the Second International and had given its full backing to the imperialist war. In fact, it collapsed when two of its largest components (the British TUC and the German ADGB) backed their 'own' government on the outbreak of the war. It was the stronghold of the right wing. The IFTU, as expected, was

Lenin's opening speech at the Second Congress of the Third International

Delegates to the second congress of the Comintern at the Uritsky Palace in Petrograd. Amongst those pictured are: Karl Radek (third from the left); Nikolai Bukharin (fifth); Vladimir Lenin (tenth); Grigory Zinoviev (thirteenth); and Maria Ulyanova (nineteenth)

in conflict with the Communist controlled trade unions, and carried out expulsions of Communist members. In July 1921, The Red International of Labour Unions (RILU), also known as the Profintern, was formed with the aim of co-ordinating communist activities within the trade unions and as a counterweight to the reformist federation. The Red International, from its origins, opposed the ultra-left idea that groups or individuals should secede from the IFTU unions. A resolution at its first Congress resolved:

> This tactic of the withdrawal of revolutionary elements from the unions ... plays into the hands of the counter-revolutionary trade union bureaucracy and therefore should be sharply and categorically rejected.

Following on the expulsions of Communists, the RILU declared:

> This offensive tactic of the partisans of Amsterdam must be fought with firm and decisive resistance in the local branches, with the slogan 'Down with the splitters, long live the unity of the trade union movement!' In no case should we favour the aspirations of Amsterdam by willingly abandoning the trade unions: that would be too easy for the supporters of Amsterdam and too

damaging for the left wing of the labour movement. (Quoted in R. Sewell, *In the Cause of Labour*, p. 169.)

It nevertheless also sought to get militant trade unions to disaffiliate from the IFTU and join the ranks of the RILU, with the perspective of replacing the reformist trade union international altogether. But this was easier said than done.

THE HALLE CONFERENCE
The KPD had grown from around 3-4,000 members nationally in January 1919 to 78,000 immediately following the Kapp Putsch, despite the split with the ultra-lefts. It was, nevertheless, small in comparison to the two other mass parties, the SPD and USPD, each of which had hundreds of thousands of members. Under the impact of events, the ranks of the USPD were moving to the left, from reformism towards revolutionary Marxism. A new generation of leaders had emerged within the Left Independents and, at its Leipzig conference in March 1919, the party voted in favour of the dictatorship of the proletariat and a soviet republic. More importantly, it decided to send a delegation to the Second Congress of the Communist International in Moscow, which was being held in the summer of 1920. Finally, in December, the Left Independents voted by 227 to fifty-four to break with the Second International and begin serious negotiations with the Comintern with a view to affiliation. Given the mass membership of the USPD, this was an important turning point. As a result, Radek urged the KPD to take a bold orientation towards the Independents, and actively try to win them over. If it was possible to win the bulk of the USPD, it would transform the German Communist Party into a truly mass party of the German working class.

The affiliation question was debated at the USPD Congress in Halle in October 1920, following their participation in the Second Congress of the International. The President of the Comintern, Zinoviev, was present at Halle and addressed the delegates in German for four hours, urging them to accept the Twenty-One Conditions and affiliate to the Communist International. It was left to Hilferding, the centrist heavyweight, to oppose Zinoviev. Martov also spoke against affiliation, but seemed to have little effect. After considerable debate, a vote was finally taken, with 237 votes in favour of affiliation and 156 votes against. After the vote, Hilferding led a right split away from the USPD, which kept the name and lasted a couple of years as an independent grouping before dissolving back into the SPD.

More importantly, immediate negotiations with the KPD opened up following the decision, with a view to the founding of a new United

Grigory Zinoviev

Communist Party of Germany (VKPD). The new party was established in December, and had a combined membership of nearly 500,000 workers. This meant that German Communism had become transformed into a mass party overnight. From the outset, it owned thirty-three daily newspapers and could claim a quarter of the vote of the old SPD. In fact, outside of Russia, the German party was now the biggest Communist Party in the world. Under the guidance of Lenin and Trotsky, the party began to prepare itself for the coming revolution in Germany. This started with a turn to united front work under the guidance of Paul Levi and Ernst Däumig, the joint leaders of the new party.

Again, in December 1920, the 140,000-strong French Socialist Party also voted to accept the Twenty-One Conditions and affiliate to the Third International. The whole of the old Socialist Party apparatus, its headquarters, its secretariat, and its daily paper, *L'Humanité*, with a circulation of 200,000, were transferred to the new Communist Party of France. In Czechoslovakia, a mass Communist Party was formed out of a split in the Socialist Party, which joined forces with a split in the Sudetenland, and numbered more than 200,000 members. The Italian Socialist Party had rallied to the Third

International in March 1919, but its leaders refused to turn the party into a Communist Party, even in name. While Serrati, the centrist, carried the decisive majority, a clumsily-handled split took place, and the pro-Third International Bordiga faction walked out of the Socialist Party with around 60,000 members to form the new Italian Communist Party.

As we can see, these mass communist parties did not emerge from small sectarian groups on the fringes of the movement, but arose from deep crises within the traditional mass organisations of the working class. These parties were going through political turmoil due to the colossal events – revolution and counter-revolution – of the period. It again demonstrated that the mass of workers learns from bitter experience. It was the turmoil and revolutionary upheaval of the post-war period that served to transform these organisations and laid the basis for mass communist parties.

The Founding Congress of the Third International took place amid great hopes of a rapid victory of the European revolution. A year later, at the time of the Second Congress in 1920, it became obvious that more serious organisational and political preparation would be needed for the proletariat to gain victories in western Europe. Along with the creation of mass communist parties went the urgent necessity of educating and imbuing them with a real communist understanding of strategy and tactics.

As Trotsky warned:

> It would, however, be a mistake to expect of these young and just risen communist parties that they immediately master the art of revolutionary strategy. No! Last year's tactical experience testifies all to clearly to the contrary.

He went on to explain that:

> The art of tactics and strategy, the art of revolutionary struggle can be mastered only through experience, through criticism and self-criticism... The revolutionary struggle for power has its own laws, its own usages, its own tactics, its own strategy. Those who do not master this art will never taste victory. (L. Trotsky, *The First Five Years*, vol. 2, pp. 9-10.)

SCHOOL OF COMMUNISM

The Congresses of the Communist International acted as a class-conscious school of the world proletariat. Their task was to educate and arm the communist ranks with a rounded out understanding and prepare the working class for the conquest of power. The International stood on a higher political level than its national sections, and was based upon a far richer experience than any individual national party. It therefore debated and decided on the

main policies of the world communist movement. In the same way as the ruling classes had their military academies for the training of their general staff, so the working class needed its own schools and academies for the training of future leaders of the proletariat. The Bolsheviks understood that revolution was a serious business, which could not be improvised. Dedication and self-sacrifice, although essential, were not in themselves sufficient for victory. A revolutionary party needed to know how to struggle, manoeuvre, advance, as well as retreat, just like a professional army. It needed to know how to win over the working class and how to direct it to the conquest of power. In order to acquire this knowledge, it needed above all to assimilate the lessons of Bolshevism, the richest concentration of Marxism, which had proved itself in practice.

In 1919 and 1920, a number of ultra-left tendencies had appeared within the ranks of the newly-formed communist parties, not just in Germany. This reflected a certain revolutionary impatience, a kind of childlike simplicity, which, in turn, was a reaction against the opportunism of the old reformist leaderships. This ultra-leftism was an attempt to find a short-cut to success, which, however, did not exist. There was a tendency to exaggerate things and run ahead of the situation. There was the danger of mixing up the fifth month of pregnancy with the ninth, as Trotsky had pointed out. In effect, it was an attempt to deny reality and its difficulties. Verbal radicalism was a cover for the movement's weaknesses.

As we have seen, one of Lenin's most important works, *'Left-Wing' Communism: An Infantile Disorder*, was devoted to this problem. Lenin understood the problem as a healthy reaction to the opportunism and parliamentary cretinism of the old reformist leaders. He compared this tendency to a childhood illness which was an inevitable part of growing up. Lenin's book, together with the discussions at the Second Congress of the Comintern, was aimed at educating this layer in genuine Bolshevism.

Lenin wrote his book almost 100 years ago, and in it he explained:

> It is beyond doubt... those who try to deduce the tactics of the revolutionary proletariat from principles such as: "the Communist Party must keep its doctrine pure and its independence of reformism inviolate: its mission is to lead the way without stopping or turning, by the direct road to the communist revolution" – will inevitably fall into error. Such principles are merely a repetition of the mistake made by the French Blanquist Communards, who, in 1874, 'repudiated' all compromises and all intermediate stages. (LCW, vol. 31, p. 89.)

The task of the newly-formed communist parties was to absorb the method, tactics and strategy of Bolshevism as quickly as possible. The main task was to win a majority of the working class to the side of the Communist Party. One of the key tactics to achieve this end was to turn towards the masses by using the united front. This was a temporary agreement between mass organisations for practical ends. It was aimed at showing in practise the superiority of the communist methods of struggle over reformism. As the SPD had, at least nominally, more support in the working class, it was essential to turn towards them and offer them a programme of unity in action. Such an approach arose from the need for the maximum unity in the struggle. No successes would be possible without temporary agreements among various sections of the working class. This policy was taken up and championed in Germany by Paul Levi, who was chairman of the party.

In early January 1921, the leadership of the KPD[4] sent an Open Letter to the national trade unions, the SPD and the remains of the USPD, appealing to them to work together on immediate actions. This was a very important step forward.

> While proposing this basis for action, we do not conceal for one moment, either from ourselves or from the working masses, that the demands put forward by us cannot remove their misery and deprivation. Nor do we give up for one moment our endeavours to spread the idea of the struggle for the dictatorship, which is the only road to salvation. Nor shall we desist from summoning the working masses at every favourable moment to the struggle for the dictatorship, and leading them in that struggle. The VKPD is ready, along with the other parties which draw support from the proletariat, to carry out joint actions to achieve the measures indicated above.

> We will not hide the differences that divide us from the other parties. We declare instead that we do not want from them lip service to the proposed basis for action, but action itself. We do not ask the parties whether they regard these demands as justified. We assume this. We ask them rather: are you ready immediately to undertake an unyielding struggle for these demands, together with us?

> We expect this clear and unambiguous question to receive a similarly unambiguous answer. The situation itself requires a rapid answer. We therefore expect a reply by 13 January 1921.

> If the other parties and trade unions do not want to take up the struggle, the VKPD will regard itself as duty bound to lead the fight alone, and is

4 The KPD was briefly known as VKPD, which means United Communist Party. However, the V was dropped within a few months.

convinced that the working masses will follow it. From this day forward the VKPD addresses itself to all the proletarian organisations in Germany and the masses of workers gathered around them with the call to proclaim publicly their desire for joint defence against capitalism and reaction, and for the protection of their interests. (B. Fowkes [ed.], pp. 121-122.)

This united front approach served to extend the reach of the Communist Party into the working class, especially those who were under the influence of the SPD. While the Open Letter was rejected by the hierarchies of other workers' parties and trade unions, it had an effect among the rank and file. At the same time, the ultra-left tendencies within the German party were on the retreat, although a layer still resented the approach of the Open Letter, and by and large the party seemed to be on the correct path.

However, the Open Letter was sharply attacked by Zinoviev and Bukharin, who regarded the appeal as opportunist. "I do not believe that one can call on the workers to form an alliance with other workers' parties. I do not think real masses were drawn into this move. It was more a literary fantasy than a mass movement", stated Zinoviev. While Bukharin described it as "an opportunistic blabbering of Levi." (J. Riddell [ed.], *To the Masses*, p. 1064 and p. 1066.) Against the opposition of Radek, they actually persuaded the Presidium of the Executive Committee of the International, which ran its day-to-day affairs, to condemn the Letter. When Lenin found out, he reacted angrily and hastily intervened to get the decision overturned, urging that the matter be referred to the Third Congress. After a tumultuous year, the Comintern was to officially endorse the tactic of the united front and the turn towards the masses.

NEW VKPD LEADERSHIP

After the unification of the KPD and majority of the USPD to create the United Communist Party, a Zentrale was elected under the joint chairmanship of Ernst Däumig and Paul Levi. Levi had been a close friend of Luxemburg and had also met Lenin during the war, who was impressed by him. Levi had successfully pulled the KPD together throughout 1919, under grave difficulties, ridding the party of its ultra-left wing and steering it towards the masses.

However, in February 1921, after a violent disagreement over the Comintern's decision to split the Italian Socialist Party (PSI), Levi resigned his position within the German leadership together with four supporters, including Clara Zetkin and the party's co-chairman Ernst Däumig. Levi had advocated a more patient approach towards the centrist majority of the PSI under Serrati rather than rushing to a split, but Rákosi, the ECCI

representative, managed to sway the majority of the CC behind the tough line. Consequently, the leadership of the newly formed Italian Communist Party was in the hands of the ultra-left Bordiga.

New leaders were brought into the Zentrale to replace those who had resigned with Levi. These were Eberlein, Meyer, Wegmann, Sievers and Frölich, who joined the likes of Heinrich Brandler and August Thalheimer. Radek tells how Frölich, who was somewhat of a hothead, charged onto the scene declaring: "Today we shall break from the traditions of the party. Until now we have waited, and now we are taking the initiative and forcing the revolution." (P. Broué, p. 497.) This change of personnel served to tilt the party towards taking more risky adventures.

When Lenin heard about these resignations from the Zentrale, he was absolutely furious:

> Tell me, how could you commit such a capital stupidity, yes, indeed, a capital stupidity, as to leave the Central Committee?[5] Where was your understanding? I was angry about it, terribly angry. To act so senselessly, without regard to the effects of such a step and without letting us know anything at all about the matter or asking our opinion. Why didn't you write to Zinoviev? Why not to me? You could at least have sent a telegram…

He went on:

> That was simply stupid, quite stupid… But always look to the workers, to the masses, dear Clara. Think always of them and of the goal which we shall achieve, and such trivialities fade away into nothing. Which of us has been spared them? I have had to choke down my share of them, you can believe that. Do you think that the Bolshevik Party which you so admire, was ready and finished in one blow? Even friends have sometimes done most unwise things. But back to your sins. You must promise me never to take such unconsidered steps again, otherwise our friendship is at an end. (C. Zetkin, *Reminiscences of Lenin*.)

It is clear that Lenin had a friendly relationship with Clara Zetkin and appreciated her views on the German party. He was, nevertheless, quite firm with her and pulled no punches whenever it was necessary.

By August 1921, following Lenin's advice, Zetkin had been once again elected onto the Zentrale. Lenin continued to keep a close eye on developments within the German party, until a series of strokes severely restricted his political involvement.

5 Lenin uses the term Central Committee as a substitute for the *Zentrale*, which was the term used for the elected leadership in Germany until 1925.

The Comintern was very keen to help the German communists, given their vital importance to the European revolution. The apparatus of the International, which was headed by Zinoviev, was filled with émigrés of the Hungarian revolution, 'red' exiles in Moscow, together with others with limited experience. They were to use their considerable authority as functionaries to push the International in a more leftist direction. They were, unfortunately, revolutionaries of limited vision, lacking the necessary experience to guide the International. Thus, Hungarian Communist leader Béla Kun, who, ever since the crushing of the Hungarian Soviet Republic in August 1919, had been in Moscow, was now despatched to Berlin, with Zinoviev's blessing.[6]

This appointment of the Hungarian was to prove a grave error. As leader of the Hungarian Soviet Republic, Béla Kun had made very serious mistakes, including uniting their forces with the reformists. In fact, he had made one mistake after another, and as a result of his previous opportunism was now infected with ultra-left ideas after the defeat. His failure in Hungary had made him even more determined to prove his 'revolutionary' credentials, whatever the cost. Nevertheless, it also suited Zinoviev, who wanted pliable people, yes-men, who he could rely on to obediently carry out his orders. He placed Béla Kun and his comrades József Pogány and Matyas Rakosi, as well as August Guralsky, a veteran of the Jewish Bund in Ukraine, as the Comintern representatives in Germany. They were all open to ultra-left tendencies, which were encouraged by Zinoviev, Bukharin and even at times by Radek, to attack the 'passive' and 'defensive' positions of the SPD organisations.

THEORY OF THE OFFENSIVE

The new leaders of the United Communist Party, with the encouragement of the new Comintern representatives, looked increasingly for an excuse to wage a revolutionary struggle with the government. They were intoxicated with romantic notions. While Levi, Zetkin and others were out of the Zentrale, this tendency heroic for action was greatly reinforced.

6 On 21 March 1919, the Hungarian Soviet Republic was declared, composed jointly of Social Democrats and Communists. The rotten regime of Count Michael Karolyi had simply handed over its power to Béla Kun. Not a shot was fired. The Soviet Republic lasted 133 days, before the White Romanian army entered Budapest, bringing with it the counter-revolutionary government of Admiral Horthy. Had the Hungarian workers' state held out a few more months, revolution could have spread to Vienna and Berlin. Unfortunately, due to the ultra-left mistakes of Béla Kun, especially over the agrarian question, this heroic episode was drowned in blood in a reign of repression and a wave of White Terror.

The arrival of Béla Kun proved decisive. The Executive Bureau of the International in Moscow was dominated by these 'Lefts', who were eager for the German party to take the initiative, regardless of the objective conditions, regardless of the effects of the previous setbacks. Kun, with the full backing of the Bureau, immediately began by exaggerating the possibilities in the situation, as well as the need to come to the assistance of the Soviet Republic. According to Levi, who wrote to Lenin, Kun had told him that Russia found itself in a very difficult situation and it was therefore absolutely necessary that the country be relieved by revolutionary movements in the West, and, on that basis, the German Communist Party should immediately go into action to 'galvanise' the workers. According to Levi, Kun told him:

> "Today, the VKPD has 500,000 members and with that one could mobilise 1.5 million proletarians to bring down the government." He therefore favoured immediately joining battle with the slogan: 'Bring down the government!' (Quoted in P. Broué, p. 508.)

This ultra-left policy became the framework of the new so-called 'theory of the offensive', the whole essence of which was that the advance guard – the revolutionary party – could by its own actions 'electrify' the passive proletariat into taking revolutionary action. By these actions they would help save Soviet Russia from the difficulties it faced. The German leadership, under pressure from Béla Kun, Zinoviev and Bukharin, was eager to translate this 'theory' into practise at the earliest opportunity.

The situation in Germany was certainly becoming extremely tense following the occupation of Düsseldorf by French troops when the German government failed to pay its reparations in full. The leaders of the United Communist Party were now desperately searching for any pretext to launch an offensive action. The ground was laid by the party's press *Rote Fahne* which proclaimed the readiness of the workers to fight. It was not long before they found the pretext.

The head of the provincial government in Saxony, Otto Hörsing, a Social Democrat, decided to send security police into the area of central Germany to confront the miners, who were strongly under the influence of the communists, and put an end to "wildcat strikes, looting, robbery, terrorist and other expressions of lawlessness." This provocation took place ten days before the Easter holidays, making any counter-protest action more difficult.

The action centred around the Mansfeld copper mines, which was now occupied by the security police with instructions to pacify the area. The whole episode was of course a provocation. Philips Price states:

It is as if Winston Churchill sent 5,000 Royal Irish Constabulary to occupy the Rhondda Valley on the excuse that the South Wales miners refused to accept a wage reduction. The result is the mining villages have risen to one man. (*Dispatches*, p. 97.)

Miners and their families resisted the police occupation arms in hand under the leadership of Max Hölz, a militant legendary figure, who had more in common with the ideas of Robin Hood than Karl Marx, and had been expelled from the Communist Party after the Kapp Putsch. He was, despite his wild excesses, an honest revolutionary. The year before, he had waged guerrilla war single-handedly against the Berlin government throughout the Vogtland area of Saxony.

The battles now led by Hölz were chiefly local in character, which included robbing banks, stealing property from the rich, and fighting with the security forces. The Prussian government had therefore put 60,000 marks on Hölz's head. Despite their adventurous character, these struggles attracted sympathy from the broader working class, who were vehemently opposed to the police actions of Hörsing. Not unexpectedly, the armed resistance attracted the support of the ultra-left KAPD, who hailed Hölz as a popular hero. Not to be outdone, the KPD also rushed to support him.

The Communist Party immediately called for a general strike throughout central Germany and a full mobilisation in support of the miners. On 18 March, its paper brazenly proclaimed that every worker must defy the law, and immediately arm themselves. "Those who are not with us are against us," they said. This put the party on a collision course. "What followed was the famous *Märzaktion* ('March Action')," writes Evelyn Anderson, "without doubt one of the most pathetic chapters in the history of the German Labour movement." (E. Anderson, p. 9.)

While there was certainly sympathy for the miners, the party leaders had completely misjudged the mood and how far the workers were prepared to go. Even the call for a general strike, planned the day before Good Friday, fell on deaf ears, not least because the factories were to be closed for a four-day Easter break. The VKPD simply expected the working class to respond to calls for action from above, without any preparation from below. They were to discover that it was not possible to turn the working class on and off like a tap. Nonetheless, the party leaders ploughed on regardless, so blinded were they with the 'theory of the offensive'. Those who dared raise any doubts or put forward the need for *defensive* actions were ridiculed and condemned by the party leadership.

Once the 'offensive' had begun, the party became even more reckless and adventurous. For example, the VKPD leader, Hugo Eberlein, was

sent "to provoke an uprising in mid-Germany," and even went so far as to organise sham 'kidnappings' of Communists, which were then blamed on the government, dynamiting a munitions depot, blowing up a workers' co-operative in Halle, all of which was blamed on the police in order to fuel the anger of the workers.

Friesland later admitted that the idea was:

> [O]f making the revolution with the minority of the proletariat against the majority... And there is now a fatal idea which underlies the other, that we can also organise strikes against the majority of the proletariat. (P. Broué, p. 510.)

This attempt of a minority to force its will on the majority was always going to end in disaster. As Trotsky explained:

> If the majority of workers favour a strike, they can of course always compel the minority by forcibly shutting down the factories and thus achieving the general strike in action. This has happened more than once, it will happen in the future and only simpletons can raise objections to it. But when the crushing majority of the working class has no clear conception of the movement, or is unsympathetic to it, or does not believe it can succeed, but a minority rushes ahead and seeks to drive workers to strike by mechanical measures, then such an impatient minority can, in the person of the party, come into a hostile clash with the working class and break its own neck. (L. Trotsky, *The First Five Years*, vol. 1, p. 22.)

This was definitely a real danger facing the young party. On 24 March, groups of Communist Party workers were instructed by the leadership to occupy the huge nitrogen plant at Leuna, with rifles and grenades, but were driven out after a bitter confrontation. The party then organised the occupation of the docks in Hamburg in support of a partial strike, but once again it was soon dispersed. In the ensuing battles, isolated members of the VKPD were left to fight it out in single combat with the police. In Berlin, the strike was practically non-existent. In other cases, unemployed workers clashed with workers on their way to work. Nothing could have been more designed to split and divide the working class. One participant described these fratricidal battles when "broad masses turned against those in struggle, not only with words but by wielding iron bars in the factories to drive out those who called for a strike". (J. Riddell [ed.], *To the Masses*, p. 20.)

UNMITIGATED DISASTER

While, fortunately, the foolhardiest plans of the German party came to nothing, the damage was nevertheless far-reaching. The government acted with brute

force as military and police reinforcements flooded into the affected areas. Within ten days, the most exposed workers were mercilessly crushed. The 'March Action', launched by the 'Lefts', turned into an unmitigated disaster, which resulted in hundreds of deaths and thousands being imprisoned for their involvement. Victimisation of workers became rife as thousands were dismissed from their jobs. The ultra-left actions of many sincere communists only served to produce a serious division in the working class.

The German party became totally isolated. In the end, over 200,000 members, half its membership had dropped out or deserted the VKPD in disgust. This was a calamity of the first order, which if continued, threatened to wreck the entire party.

Max Hölz, the leading light of the miners, was caught and tried on charges of murder, arson, highway-robbery and fifty other counts and sentenced to life imprisonment. He was held in Breslau prison, but was eventually released and travelled to Moscow. There he was welcomed as a hero, awarded the Order of the Red Banner, and a factory in Leningrad was named after him. But when Hitler came to power in 1933, he asked for permission to leave Russia. The Stalinist authorities refused and he became furious and tried to create a stink. W.G. Krivitsky, who knew Hölz, wrote:

> A little later an insignificant notice appeared in the *Pravda* announcing that Hölz had been found drowned in a stream outside Moscow. In the OGPU[7] I was told that after the rise of Hitler, Hölz had been seen coming out of the German Embassy in Moscow. The fact is that Hölz was killed by the OGPU because his glorious revolutionary past made him a potential leader of the revolutionary opposition to the Comintern. (W.G. Krivitsky, *I Was Stalin's Agent*, p. 52.)

Embarrassingly, eight months after the March debacle, the SPD newspaper *Vorwärts* on 25 November took delight in publishing an internal report of the 'March Action' plans of the Communist Party, which had fallen into their hands. The document had been apparently seized from Clara Zetkin by police while she was on her way to Moscow to attend the Third Congress of the Communist International. It was then passed on to the Social Democrats.

The shocking report revealed an astonishing scale of adventurism. It read:

> 20 March 1921: A session of the District Directorate was held in Halle. The mood, it was reported, was so bad and so pessimistic that artificial measures would be needed to bring matters to a head.

7 The OGPU was the name given to the Russian secret service from 1922 to 1934. Later, it had other names such as NKVD and GPU.

23 March 1921: Eberlein arrived in Halle. He suggested that comrades Lemke and Bowitzky get themselves arrested in order to entice the Halle workers out into the streets. Attempts should be made to whip up tension among the workers so as to pull them into the struggle... There were, he said, two wagons full of grenades in Halle railway station. They should be dynamited...

On 22 March Eberlein proposed that the munitions depot in Seefen should be blown up, as well as the newly-acquired building of the Producers' Cooperative Society. For technical reasons it was impossible to carry out either of these plans. The Cooperative Society was not blown up because of a shortage of detonators... Lemke and I were supposed to disappear so that the news could be put out that we had been wounded and arrested by a SiPo unit[8] and taken to an unknown place... Eberlein repeated the order to blow up the Cooperative Society on two further occasions; the third time the District Directorate of the party energetically resisted this madness... If the building had gone up during daytime twenty of our comrades would have been killed. (Quoted in B. Fowkes [ed.], pp. 89-90.)

The Social Democrats took great pleasure in exposing and ridiculing the activities of the communists. It simply reinforced the stereotype image that the communists were capable of underhand, violent and unscrupulous deeds to obtain their objectives.

ECCI SUPPORTS GERMAN 'LEFTS'

The debacle in Germany provoked a serious crisis within the International, where supporters of the German 'Lefts' rallied to their cause, including some within the Comintern leadership. It had all the makings of a split. "The 'German Question' had become the question of the whole Communist International," remarked Clara Zetkin.

To begin with, the German party leadership was utterly blind to the consequences of the defeat and regarded the 'March Action', not as a setback, but as a *tremendous advance,* thus standing reality on its head!

A thesis was drafted by Thalheimer and presented to the Zentrale on 7-8 April 1921, which dressed up defeat as a victory. It stated:

The revolutionary offensive ended with a defeat for the VKPD, *viewed from outside.* The VKPD is *temporarily isolated* from broad sections of the working class. But in truth this result contains the fruitful germs of new, broader revolutionary actions. The fortifications have been breached; revolutionary propaganda can enter through the gaps, and in the final analysis the action

8 The Sicherheitspolizei (Security Police), often abbreviated as SiPo, was a term used in Germany for the security police.

must strengthen the confidence of the workers in the VKPD and with it the revolutionary impetus of the working class… Whereas in 1918 and 1919 the revolutionary vanguard conducted a defensive struggle, *it is now on the offensive. That is a tremendous advance. The 'March Action' is the first step the VKPD has taken in leading the German working class towards the revolutionary offensive.* (ibid., p. 93, emphasis added.)

The thesis concluded:

The ZA [Central Commission] sees the March campaign of the party as an action corresponding to this tactical situation, an action which was necessary… if the party wanted to become a party of revolutionary action rather than a party of revolutionary phrase-making. The *ZA* therefore approves the political and tactical position of the Zentrale and *condemns with the utmost severity the passive and active opposition of certain comrades during the Action.* It invites the Zentrale to place the organisation on a footing of the greatest possible fighting strength and to implement all the organisational measures for this. (ibid., p. 93, emphasis in original.)

They saw the 'Action' as a success and those who opposed had to be ruthlessly condemned! The thesis was adopted by twenty-six votes to fourteen, with the opposition being led by Clara Zetkin.

Even more serious was the fact that the 'Action' was immediately supported by the Executive Committee of the Comintern. Zinoviev sent a telegram on behalf of the ECCI on 6 April:

The Communist International says to you: You acted rightly! The working class can never win victory by a single blow. You have turned a new page in the history of the German working class. Prepare for new struggles. (J. Degras [ed.], *The Communist International*, vol. 1, p. 218.)

Lenin had not been involved in this decision as his attention was taken up with the introduction of the NEP and the rebellion at Kronstadt. It was all therefore in the hands of Zinoviev and the group around him, who had been consistently pushing the 'offensive' line.

As soon as Lenin found out what was happening, he intervened to restore a sense of reality. He tried to steer a course that would prevent a split, while at the same time reigning in the ultra-lefts. He had to use all his political authority and tactical skill to bring the situation under control.

Levi and Zetkin wrote to Lenin at the end of March, where they raised their criticisms of the German leadership. Lenin's reply, dated 16 April 1921, was very revealing. In his letter he admitted that he had no knowledge of the events surrounding the 'March Action', although he was willing to believe

the "silly tactics" likely came from Béla Kun. However, Lenin's instincts were clear and so were his criticisms of the 'Lefts'.

> Thank you very much for you letters, dear Friends. Unfortunately, I have been so busy and so overworked in the last few weeks that I have had practically no opportunity to read the German press. The only thing I have seen is the Open Letter, which I think is *perfectly correct* tactics (I have condemned the contrary opinion of our 'Lefts' who were opposed to the letter). As for the recent strike movement and the action in Germany, I have read absolutely nothing about it. I readily believe that the representative of the Executive Committee [of the Communist International] defended the silly tactics, which were too much to the left – to take immediate action 'to help the Russians': this representative is very often too Left. I think that in such cases you should not give in but should protest and immediately bring up this question officially at the plenary meeting of the Executive Bureau. (LCW, vol. 45, p. 124.)

Lenin was clearly resting on Levi and Zetkin to carry out a struggle, not least in the leadership of the International, but this plan was cut across when Levi created a row in the German party by publishing a sharp critique of the 'March Action'.

Radek got a hint of the impending struggle and on 1 April, wrote to the German leaders:

> Levi will doubtless raise the accusation of putschism, and the whole uproar will be revealed for what it is: the start of the clear crystallisation of the right-wing faction. (B. Fowkes [ed.], pp. 181-182.)

Clearly, Radek had no time for 'the rightist' Paul Levi, but he was correct about the "uproar".

Levi had taken the drastic step of publishing his fierce criticism of the March debacle in a pamphlet called *Unser Weg: wider den Putschismus* (*Our Path: Against Putschism*). His language was particularly sharp, even merciless, which did not sit well with the party's rank and file, who had, after all gone through this tough battle. He described the events as "the biggest Bakuninist putsch in history," which only angered the German leadership. He attacked Béla Kun without actually naming him.

> The initiative for this action did not come from the German party. We do not know who bears the responsibility for it. It has already happened often enough that emissaries from the Executive Committee [of the CI] have exceeded their powers, that is, we have observed after the event that the emissaries had not been granted full powers to deal with this or that affair...

So there has been a certain pressure exerted on the Zentrale to launch itself into action, now, immediately and at all costs. (P. Broué, p. 513.)

The tone, however, only served to alienate those it was supposed to influence. The language was not of a comrade-in-arms, but an outsider. Moreover, he took the fateful step of producing his criticisms, not as an internal contribution, but as a public pamphlet outside the structures of the party, which broke party discipline.

Levi could have achieved much more with a verbal discussion than simply rushing into print. But it was now too late. The German leadership immediately seized upon the pamphlet to expel him for breach of discipline, "gross disloyalty and severe damage to the party". After his expulsion, he was asked to resign his position as Communist deputy in the Reichstag. But he refused to comply, which added to the rancour.

LENIN ON GERMANY

As we have seen, Lenin was very concerned about developments in the German party. After all, it was the main party of the International outside of Russia. He was hoping to rectify the problem of the ultra-lefts without causing too much damage. But when he heard of Levi's intention to produce a pamphlet outlining his criticisms, he was very angry.

Now, Comrade Levi wants to write a pamphlet, i.e., to deepen the contradiction! What is the use of all this? I am convinced that it is a big mistake.

Why not wait? The Congress opens here on 1 June. Why not have a private discussion here, *before* the Congress? Without public polemics, without withdrawals, without pamphlets on differences. We are so short of tried and tested forces that I am really indignant when I hear comrades announcing their withdrawal, etc. There is need to do everything possible and a few things that are impossible to avoid withdrawals and aggravation of differences at all costs. (LCW, vol. 45, pp. 124-125.)

Lenin's sound advice to cool things down and correct the mistakes one step at a time came too late. When he wrote this, he was totally unaware that the pamphlet had already been published and that Levi had been expelled by the Zentrale.

Lenin's discussions with Clara Zetkin are also very revealing, not only about Paul Levi and the 'Lefts', but about the internal situation within the German party. She revealed these conversations with Lenin in her *Reminiscences*, written in January 1924:

Lenin smiled, his kind, self-confident smile.

"Since when have you joined the pessimists?" he asked. "Don't worry, the plant of the 'theory of the offensive' will not take root at the [Third] Congress. We are still here. Do you think that we could have 'made' the revolution without learning from it? And we want you to learn from it, too. Is it a theory anyway? Not at all, it is an illusion, it is romanticism, sheer romanticism. That is why it was manufactured in the 'land of poets and thinkers,' with the help of my dear Béla, who also belongs to a poetically gifted nation and feels himself obliged to be always more left than the left. We must not versify and dream. We must observe the world economic and political situation soberly, quite soberly, if we wish to take up the struggle against the bourgeoisie and to triumph. And we shall triumph, we must triumph."

He then continued:

"The Congress decision on the tactics of the Communist International and on all the disputed points connected with it must be consistent with, and considered in conjunction with, our theses on the international economic situation. They must form a whole together... At the moment we still pay more attention to Marx than to Thalheimer and Béla, although Thalheimer is a good and well-informed theoretician and Béla an excellent and true revolutionary. More can be learnt from the Russian Revolution than from the German 'March Action.' As I said, I am not afraid about the attitude that will be taken at the Congress."

While Lenin displayed an over-generous conciliatory tone towards Thalheimer and Béla Kun in this private conversation with Clara Zetkin, even mistakenly describing Thalheimer as a "well-informed theoretician", he gave a far blunter assessment of them in the Third Congress, where their ideas posed a grave danger to the movement:

The theses of Thalheimer and Béla Kun are radically false. That a representative of the Executive proposed a lunatic ultra-left tactic of immediate action 'to help the Russians' I can believe without difficulty: this representative [Béla Kun] is often too far to the left.

Lenin's appraisal of Béla Kun was accurate. Interestingly, in a conversation between Lenin and Trotsky, it was Trotsky who tried to defend Béla Kun against excessively harsh attacks. Lenin answered: "I do not dispute that he is a fighter, but as a politician he is worthless; the comrades must be taught not to trust him." (L. Trotsky, *The Challenge of the Left Opposition 1928-1929*, p. 185.)

In any case, it was Zinoviev, as head of the International, who was responsible for promoting Kun and giving him a key role in advising the German Communist Party. Zinoviev was keen to do this as he also agreed with Kun's Leftist ideas and the need for an 'offensive'. He believed the German party needed some encouragement in this regard. This position gave Béla Kun colossal political authority in the eyes of the German leadership – something he did not deserve – and influenced them to engage in the 'March Action'. It was a massive blunder but it suited Zinoviev's prestige politics.

Lenin continued to reassure Clara Zetkin about the situation, but also stressed the need for a 'compromise'. A 'compromise' would help to calm the 'Lefts' while condemning the policy. This showed Lenin's method. After a sharp polemic, he would offer a few friendly words to his adversaries so as to eliminate frictions and restore comradely relations. He had no intention of rubbing their noses in their defeat.

He also fully appreciated the fact that the communist workers were not to blame for the debacle and therefore should be treated with respect.

> "You opponents of the 'March Action' are yourselves to blame for not having done that. You only saw the distorted policy of the Centre and its bad effects, and not the militant workers of central Germany. Moreover, Paul Levi's entirely negative criticism, which lacked that 'feeling of oneness' with the party, and embittered the comrades rather more by its tone than by its content, diverted attention from [the] most important aspects of the problem. As far as the probable attitude of the Congress to the 'March Action' is concerned, you must realise that it is essential to have a basis for compromise."

Clearly, Clara Zetkin was somewhat surprised by this suggestion of a 'compromise'. But Lenin continued this argument:

> "Don't look at me with such amazement, and reproach; you and your friends will have to swallow a compromise. You will have to be content with the lion's share of the Congress spoils. The principles of your policy will triumph, triumph brilliantly. And that will prevent a repetition of the 'March Action.' The decisions of the Congress must be strictly carried out. The Executive will see to that. I have no doubts on the matter."

Lenin was trying to get the opposition to appreciate its responsibilities and to heal the wounds of the dispute. He went on to stress the tasks at hand, which were the most important thing, as well as to reassure Clara Zetkin of his support. Above all, Lenin was interested in the whole picture as well as safeguarding the general interests of the Communist International. The lessons of the 'March Action' could not be swept under the carpet and would

be acted upon. At the same time, Lenin believed, the comrades needed now to move on to other more pressing matters. But for the moment he stressed:

> "The Congress will utterly destroy the famous 'theory of the offensive,' will adopt the tactics which correspond to your ideas. But for that very reason it must also distribute some crumbs of consolation to the adherents of that theory. If, in criticising the 'March Action' we emphasise the fact that the workers fought under provocation from the lackeys of the bourgeoisie, and if, in general, we show a somewhat fatherly 'historical' leniency, that will be possible. You, Clara, will condemn that as hushing it up and so on. But that won't help you. If the tactics to be decided upon by the Congress are agreed upon as quickly as possible, and with no great friction, becoming the guiding principle for the activity of the Communist Parties, our dear Leftists will go back not too mortified and not too embittered. We must also – and indeed first and before all – consider the feelings of the real revolutionary workers both within and outside the party. You once wrote to me that we Russians should learn to understand western psychology a little and not thrust our hard, rugged methods upon people all at once. I took notice of that."

Lenin smiled:

> "Well, we shan't deal roughly with the Leftists, we shall put some balm on their wounds instead. Then they will soon be working happily and energetically with you in carrying out the policy of the Third Congress of our International. For that means rallying large sections of workers to your policy, mobilising them under Communist leadership and bringing them into the struggle against the bourgeoisie and for the seizure of power."

Lenin concluded:

> "The basis of the tactics to be followed was clearly stated in the resolution which you placed before the Central Committee. The resolution was not in the least negative, like Paul Levi's pamphlet; its criticism was positive throughout. How could it have been rejected, and after what discussion and on what grounds? And what a non-political attitude! Instead of using the difference between positive and negative to separate you from Levi, you were forced on to his side." (C. Zetkin, *Reminiscences.*)

LINES DRAWN

The 'theory of the offensive' did not simply have its supporters in the German leadership. As we have seen, it also had firm support from Zinoviev, Bukharin, and Béla Kun. This circle also often included Radek, who tended to advocate these ideas behind the scenes. This problem in the International leadership,

which included Russian leaders, was a much thornier question for Lenin. Such a dangerous situation had not existed before in the short years of the International.

The internal differences within the Russian Politburo were revealed by Trotsky in his 'Letter to the Bureau of Party History'. These differences showed how far things were finely balanced within the Russian leadership. The following is Trotsky's speech in the minutes of the Politburo soon after the Fourteenth Russian Party Congress:

> There was a danger at that time that the policy of the Comintern would follow the line of the March 1921 events in Germany. That is, the attempt to create a revolutionary situation artificially – to 'galvanise' the proletariat, as one of the German comrades expressed it... Before the Congress I wrote my impression of the March events to comrade Radek in a letter of which Vladimir Ilyich knew nothing. Considering the ticklish situation, and not knowing the opinion of Vladimir Ilyich and knowing that Zinoviev, Bukharin and Radek were in general for the German Left, I naturally did not express myself publicly but wrote a letter (in the form of a theses) to comrade Radek, asking him to give me his opinion. Radek and I did not agree. Vladimir Ilyich heard about this, sent for me, and characterised the situation in the Comintern as one involving the very greatest dangers. In appraising the situation and its problems, we were in full accord.
>
> After this conference, Vladimir Ilyich sent for comrade Kamenev in order to assure a majority in the Politburo. There were then five members in the Politburo. With comrade Kamenev, we were three and consequently a majority, but in our delegation to the Comintern, there were, on one side, comrades Zinoviev, Bukharin and Radek; on the other, Vladimir Ilyich, comrade Kamenev and myself. And, by the way, we had formal sittings of these groups. Vladimir Ilyich said at that time: "Well, we are forming a faction". During further negotiations as to the text of the resolution to be introduced, I served as the representative of the Lenin faction while Radek represented the Zinoviev faction.
>
> *Zinoviev*: "Now the state of affairs is changed."
>
> *Trotsky*: "Yes, it has changed. Moreover, comrade Zinoviev rather categorically accused comrade Radek at that time of 'betraying' his faction in those negotiations; that is, of making presumably too great concessions. There was an intense struggle throughout all the parties of the Comintern, and Vladimir Ilyich conferred with me as to what we should do if the Congress voted against us. Should we submit to the Congress whose decisions might be ruinous, or should we not submit?

The reflection of that conference you can find in the stenographic report of my speech. I said at that time, in agreement with Ilyich, that if you, the Congress, adopt a decision against us, I trust you will leave us a sufficient framework in which to defend our point of view in the future. The meaning of this warning was perfectly clear. I ought to add, however, that the relations then existing within our delegation, thanks to the leadership of Vladimir Ilyich, continued to be perfectly comradely. ('Minutes of the Politburo of the CPSU', 18 March, 1926, quoted in L. Trotsky, *The Stalin School of Falsification*, pp. 33-34.)

Trotsky later commented in a letter about Paul Levi, "The Central Committee of our own party, even before the opening of the Congress, had to correct certain leftist deviations in our own midst." (L. Trotsky, *The First Five Years*, vol. 2, p. 88.) In the end, the negotiations within the Politburo produced satisfactory results, and a common position was agreed, which was critical of the 'Lefts' and the 'March Action', but made the concession that it was 'a step forward' as a means of appeasing the Lefts.

Victor Serge, given his knowledge of languages, was in Moscow helping to prepare the Third Congress. He recalls a session of the ECCI where Lenin took Béla Kun to task over the 'March Action':

There were few present, because of the confidential nature of the discussion. Béla Kun kept his big, round, puffy face well lowered; his sickly smile gradually faded away. Lenin spoke in French, briskly and harshly. Ten or more times, he used the phrase 'les betises de Béla Kun':[9] little words that turned his listeners to stone. My wife took down the speech in shorthand, and afterwards we had to edit it somewhat: after all it was out of the question for the symbolic figure of the Hungarian Revolution to be called an imbecile ten times over in a written record. (V. Serge, *Memoirs of a Revolutionary*, p. 140.)

This controversy over the 'March Action' could only be resolved by an International Congress, where a common line could be agreed. It was only in such a Congress that the errors of the Left could be firmly rebutted, and the experience could be used to raise the entire political level of the International. It was at this point, let us remember, just before the Third Congress that Lenin realised it had been a mistake to call in 1920 for the KAPD to become part of the International as a sympathising section.

9 'The foolery of Béla Kun'.

THIRD COMINTERN CONGRESS

The Third Congress of the Comintern took take place from 22 June to 12 July 1921 in Moscow. Over 600 delegates from more than fifty countries gathered to discuss the world situation, the events in Germany, and many issues related to the building of the International. It was the biggest and most representative World Congress to date, much larger than the previous two years.

The 'Left' Communist supporters of the 'March Action' were very strongly represented, with delegates not only from Germany, but Austria, Italy and other sections, and even appeared at one point to have majority support at the Congress. That is why Lenin and Trotsky came out firmly on what they described as the 'Right Wing' at the Congress.

This is not the place for a detailed analysis of the Congress, only to say the main political reports, as usual, were given by Lenin and Trotsky. The Third Congress opened with a report by Zinoviev of the Executive Committee, which dealt with the work of the Comintern in various countries and lasted throughout the first day. He raised the slogan agreed with Lenin, 'to the masses', which became the central theme of the Congress. The report was overwhelmingly endorsed by the delegates. As an aside, Stalin did not attend the Congress.

The political report given by Trotsky on 'The Economic Situation and the New Tasks of the Communist International', was the main discussion and took up most of the sessions during the Congress. He apparently spoke for nine hours, where he presented his speech in Russian, then translated it himself into French and German. This opened up a debate on the fundamental developments in the world situation, the character of the period, the unstable equilibrium, the boom and slump cycle and how this affected the class struggle, especially in Europe, as well as the necessary change of tactics that arose.

The first phase of the revolutionary advance 1917-1921 had clearly come to an end, resulting in a relative stability and renewed confidence of the bourgeoisie. The capitalists had successfully resisted the first flush of revolution and brought about a realisation that the tasks of the proletarian revolution were far more complicated and complex than were originally believed. "The situation has become more complicated, but it remains favourable from a revolutionary point of view," explained Trotsky. However, the world revolution had been delayed and was not a question of months but "perhaps a matter of years". He explained that the struggles under present conditions of an employers' offensive would be defensive in character, which the communists should seek to lead.

He concluded:

> We do not yet have the majority of the world proletariat on our side. However, we have a much greater portion than was the case one or two years ago. Analysing this situation tactically – an important task of this congress – we must conclude that the struggle will perhaps be prolonged and perhaps will not stride forward as feverishly as one might wish; the struggle will be difficult, demanding many sacrifices. Accumulated experience has made us more astute. We will be able to manoeuvre in and through this struggle. We will know how to apply not only the mathematical line, but also how to utilise the changing situation for a purely revolutionary line. We will also know how to manoeuvre during the decay of the capitalist class, always with the goal of bringing the working-class forces together for social revolution. In my view, both our successes and our failures have shown that the difference between ourselves and the Social Democrats and Independents does not consist in the fact that we said we will make the revolution in 1919 and they responded that it will come only later. That was not the difference. The difference is that, in every situation, the Social Democrats and Independents support the bourgeoisie against the revolution, whereas we are ready and will remain ready to utilise every situation, whatever form it takes, for the revolutionary offensive and for the conquest of political power. (Thunderous applause.) (J. Riddell [ed.], *To the Masses*, p. 133.)

Trotsky's speech set the entire tone for the Congress. While many political questions were raised and debated, it was the 'March Action' and the 'Theory of the offensive' that dominated the proceedings.

Radek was next to deliver the report on 'Tactics of the Communist International', including an assessment of the 'March Action'. While he saw the actions of the German party as a "step forward", they were also accompanied by mistakes that, if repeated, would lead to "even greater defeats". While rejecting the "theory of the offensive", he did present a defence of the "March Action", which "showed a willingness to struggle". He went on to stress that the immediate task was not the conquest of power, but the conquest of the masses, and he put forward the idea of a transitional programme that would serve the needs of the movement.

> We have to point out to them, of course, that they cannot gain any lasting improvement in their situation unless we win power and take possession of the factories. But we must link up with what they are struggling for right now. (ibid., p. 440.)

The draft thesis on the 'March Action' was introduced by the Russian delegation, and was redrafted several times on Lenin's insistence, in order to strengthen it.

It gave rise to a heated debate, where the German 'Lefts' and others intervened to defend the 'March Action' and attack their opponents. According to Ernst Friesland, the German delegate, there was no harm caused to the German party:

> We did not lose any influence with the German working masses; on the contrary, our influence is growing from day-to-day, despite the errors, despite the poisonous campaign that you have carried out, despite the fact that everywhere you held the working masses back from preparing for new struggles. Despite all this, the Communist Party's ties with the working masses are growing. (ibid., p. 524.)

As expected, the Russian draft attracted a series of amendments, tabled by the Lefts from the German, Austrian and Italian sections, which attempted to justify the 'March Action' that "far from having impaired the organisation, has, on the contrary, strengthened its fighting spirit…" (L. Trotsky, *The First Five Years*, vol. 1, p. 272.) They also tried to delete references to the Open Letter, references to winning the masses, as well as talk of a struggle against left sectarianism. At one point, the Congress seemed in the balance and the Left amendments had looked likely to succeed. Umberto Terracini, the Italian delegate, gave a passionate speech in defence of the amendments, calling for their endorsement. Instead of a struggle against Leftist tendencies, he instead urged a further struggle against Centrist and opportunist tendencies, which he regarded as the main danger.

Lenin then took the floor of the Congress to answer the Leftists, including Terracini's arguments. He spoke with great authority:

> Comrades! To my deep regret, I must confine myself to the defensive. (Laughter.) I say 'to my deep regret' because, after hearing Comrade Terracini's speech and reading the amendments introduced by three delegations, I had a very strong desire to take the offensive. For faced with views such as those defended by Terracini and these three delegations, it is really essential to take the offensive. If the Congress is not going to wage a vigorous offensive against such errors, against such 'leftist' stupidities, the whole movement is doomed… We Russians are already sick and tired of these leftist phrases. (ibid., p. 465.)

He continued:

Then comes the following amendment: "On page 4, column 1, line 10, the words 'Open Letter', etc., should be deleted." I have already heard one speech today in which I found the same idea. But there it was quite natural. It was the speech of Comrade Hempel of the KAPD. He said: "The Open Letter was an act of opportunism." To my deep regret and shame, I have already heard such views privately. But when, at the Congress, after such prolonged debates, the Open Letter is declared opportunist – that is a shame and a disgrace. And now Comrade Terracini comes forward on behalf of the three delegations and wants to delete the words 'Open Letter'. What is the good then of the fight against the KAPD? The Open Letter is a model. This is stated in our theses and we must absolutely stand by it. It is a model because it is the first step in a practical method to win over the majority of the working class. In Europe, where almost all the proletarians are organised, we must win the majority of the working class. Anyone who fails to understand this is lost to the Communist movement; he will never learn anything if he has failed to learn that much three years after the great revolution. (ibid., p. 467.)

According to Zetkin, the whole Congress was following Lenin's every word. He continued:

It would, of course, be pedantic to say that not a letter in them must be altered. I have read many resolutions, and I am well aware that very good amendments could be introduced, perhaps in every line of them. But that would be pedantry. If, however, I declare now that, politically, not a single letter can be altered, it is because the amendments, as I see them, are of a quite definite political nature and because they lead us along a path that is harmful and dangerous to the Communist International. Therefore, I and all of the Russian delegation must insist that not a single letter in the theses be altered. We have not only condemned our rightist elements – we have driven them out. But if, like Terracini, people turn the fight against the rightists into a sport, then we must say: Stop! Otherwise we will be in very grave danger.

Lenin then drew his contribution to a conclusion:

The amendments do not contain any trace of Marxism, any trace of political experience, or of reasoning. It is very important to be critical of one's mistakes. (ibid., pp. 468-469.)

Following Lenin, Trotsky also intervened in the debate. He had not been entirely happy with the compromise made in the Russian Politburo and strove to weaken the characterisation that the 'March Action' was a 'step forward'. Nevertheless, he began firstly by recognising the courageous conduct of the

German Communist Party, which had shown itself "to be the party of the revolutionary proletariat of Germany". The courage of the party was never in doubt; they showed that they were prepared to go to the end. What was at issue was not courage but the policy, namely the 'March Action'.

Trotsky first of all replied to Thälmann and others who had protested that the International had wanted to disown them. Trotsky dismissed the suggestion by saying:

> [W]e don't want in any way to disavow the German party for it is one of our best parties. But the entire March offensive, the conditions of struggle and of victory are developed here in such a way that some of the articles, some of the speeches, some of the circulars of the German Central Committee and of its members must be understood as something that is very grave and dangerous. This is the main thing. (L. Trotsky, *The First Five Years*, vol. 1, p. 275.)

He continued:

> It is our duty to say clearly and precisely to the German workers that we consider this philosophy of the offensive to be the greatest danger. And in its practical application to be the greatest political crime. (ibid., p. 277.)

> When we say that the 'March Action' was a step forward, we understand by this – at least I do – the fact that the Communist Party... stands... as a united, independent, integrated and centralised party which has the possibility of independently intervening in the struggles of the proletariat. (*Protokol des III. Kongress*, p. 640, quoted in W. Held, *Why the German Revolution Failed*.)

Trotsky took the German leaders firmly to task for their whole approach, reflected in their attitude to the general strike:

> A general strike is not something to which the working class responds easily, at the party's very first call – especially if the workers have recently suffered a number of defeats, and, all the less so in a country where alongside the Communist Party there exist two mass Social Democratic parties and where the trade union apparatus is opposed to us.

> Yet, if we examine the issues of *Rote Fahne*, central publication of the Communist Party, throughout this period, day-by-day, we will see that the call for the general strike came completely unprepared. During the period of revolution there were not a few blood-lettings in Germany and the police offensive against central Germany could not in and of itself have immediately raised the entire working class to its feet. Every serious mass action must

obviously be preceded by large-scale energetic agitation, centring around action slogans, all hitting on one and the same point. Such agitation can lead to more decisive calls for action if it reveals, after probing, that the masses have already been touched to the quick and are ready to march forward on the path of revolutionary action. (L. Trotsky, *The First Five Years*, vol. 2, p. 20.)

He concluded:

To defend the March Action… will not succeed… If we now say that we are throwing Paul Levi out of the window, and utter only confused phrases about the March Action being the first attempt, a step forward, in short if we cover up criticism with phrase-mongering, then we have not fulfilled our duty. (*Protokol des III. Kongress*, pp. 643, 645-646, quoted in W. Held.)

Given the authority of Lenin and Trotsky, everyone present felt that the decisive blow had been struck. The 'theory of the offensive' had been defeated and laid to rest.

Of course, the perpetrators of the 'offensive' still occupied key positions within the Communist International. The immediate leadership of the affairs of the International was entrusted to Zinoviev, Radek, and Bukharin. However, in all questions of any great substance, Lenin and Trotsky would take part. That was the case with the March Action, which forced the others to retreat under pressure. But they still remained and continued with their manoeuvres. The 'Lefts' also held sway within the German party, which proved an on-going danger.

Clara Zetkin wrote to Paul Levi at the beginning of the Congress to update him on the situation.

It seems that a page has been turned. At first, we were treated like dead dogs, but now they wag their tails at us as if we are living creatures. I have spoken at length, very frankly, and without restraint with Trotsky and with Lenin, who came to me after his return along with Comrade Kamenev and has since then discussed the situation with me again. Trotsky and Lenin share our evaluation of the March Action, but they strongly reject your pamphlet in terms of their sense of party discipline and the party's character.

She went to urge Levi to co-operate and show restraint:

So, things are not going at all badly for us. On the other hand, your case is 'hopeless', for now. Of course, I will strongly oppose your expulsion in the Expanded Executive and the congress as a whole. Our friends will support me. But I must not sow any illusions on the chances of success. I urge you to assess the situation in all its seriousness but also with insight into the

fact that it will change, as demanded by the interests of the party. Lenin and Trotsky hold you in high esteem and are convinced that the door must be left open for you to become a leader of the party once again, as soon as possible. A rumour is going around that your expulsion will be upheld only for form's sake and for a brief period. I have reason to believe that this is more than mere talk. I implore you, in the interests of our cause, not to slam the door of the party violently and unwisely. You should keep a low profile for now, at least until I return with more precise information. I know this is a difficult sacrifice, but you must do this for the cause. After having jumped so bravely into the abyss, because you wanted to save the party, you must also now summon up the self-control to wait for a time and be silent, although there is nothing more dreadful than waiting. (J. Riddell [ed.], *To the Masses*, p. 1149 and p. 1151)

Lenin, of course, hoped that the youth of the party would learn the lessons of the mistakes in Germany. In a conversation that Lenin and Trotsky had with Zetkin following the March events, Lenin kept repeating to her, mildly and insistently: "The youth will commit many stupidities, but they will nevertheless make a good revolution." Zetkin replied: "They will not even make a bad one." Lenin and Trotsky looked at each other and were unable to restrain their laughter. (L. Trotsky, *Left Opposition 1928-1929*, p. 188.) In this case, history proved her right. But in 1923, faced with a real revolution, Zetkin neither understood the sharp change in the situation nor the need for a bold change in policy. She looked this time to Brandler, who was clearly not up to task of leading the party, and proceeded in a routinist manner.

The KAPD had been invited to send delegates to the Third Congress. Although they made no impact, Lenin was concerned that there was always the potential of the two ultra-left wings combining. However, their failure to build a left wing within the Communist International resulted in their decision to break and create their own 'Communist Workers' International', directed against the Comintern. But it proved a dying gasp on their part, and the KAPD soon split and went into decline. This was a satisfactory conclusion to the debate, although it did not eliminate the problem of ultra-leftism within the KPD itself.

The Third Congress had nevertheless shown that the 'March Action' was a dangerous and foolhardy strategy. Without calling a halt to this, it would have resulted in the smashing to pieces of the young communist parties. In the debates, as was shown, Lenin and Trotsky answered their opponents politically and never reverted to organisational measures to resolve political differences. This was in complete contrast to the methods used by Zinoviev, who tended to use organisational methods to solve political questions as well

as using bureaucratic methods to place pliant individuals into positions. Lenin had warned both Bukharin and Zinoviev about such methods:

> If you drive away all not particularly amenable, but intelligent, people and leave yourselves only obedient fools, you will *surely* destroy the party. (E.H. Carr, *Socialism in One Country*, vol. 3, p. 305, emphasis in the original.)

However, despite Lenin's warning, when he was ill and incapacitated, Zinoviev developed these bureaucratic methods further, which allowed him free reign in the International. After Lenin's death in January 1924, these methods were reinforced. With every change of line, individuals and whole leaderships were bureaucratically removed and new pliant leaders put in their place. In Germany, the Brandler Zentrale was removed. Later, the Maslow-Fischer leadership was expelled. In France, the central groups of several Central Committees were expelled – Loriot, Souvarine, Rosmer, Monatte, Treint, Suzanne Girault, and others. The same was the case in other parties.

Instead of allowing a Central Committee to be formed as a result of a serious party selection on the basis of the party's own experience, and with careful thought and assistance of the Comintern, they were simply dismissed. Increasingly, the Comintern was staffed with yes-men and yes-women. This allowed the Comintern to impose a change of political line with the least opposition. These Zinovievite methods of replacing independent-minded leaders with pliant, 'obedient fools' proved disastrous. It pushed out many good cadres, but also contributed to demoralising many of the rank and file, who saw their natural leaders being removed bureaucratically, leading to a negative selection of the membership, with the most critical minded often abandoning the parties and leaving behind a membership which was being educated to accept such bureaucratic methods. This policy was all done in the name of so-called 'Bolshevisation', but in reality, it was laying the basis for Stalinisation.

THE UNITED FRONT TACTIC

The Third Congress was an historic congress. Above all, it registered a new turn in the international situation and ordered a retreat from the direct line of fire. The first great revolutionary wave of 1917-1920 had now ebbed and capitalism had succeeded temporarily in stabilising itself. That meant that the revolution had been delayed for a period. Trotsky explained:

> We did not know whether it would be a matter of one, two, three or ten years, but we knew that we were at the beginning of an epoch of serious and prolonged preparation. (L. Trotsky, *Tasks before the Twelfth Congress of the Russian Communist Party*, p. 5.)

Given that the immediate struggle for power had been temporarily postponed, the tactics of the Comintern needed to change. The task of the Communist parties was to concentrate on the struggle for influence within the masses, with the aim of winning a majority. This would be assisted by putting forward a *transitional programme* and united front strategy to connect with the immediate day-to-day struggles of the working class and link them to the need for the socialist revolution.

"Had the Red Army of Soviet Russia in 1920 taken Warsaw," stated Zinoviev, "the tactics of the Communist International today would be other than they are." (E.H. Carr, *The Bolshevik Revolution*, vol. 3, p. 424.) Had the Red Army taken Warsaw, then the Soviets would have been on the border of Germany, and in the best possible position to give aid to the German revolution. But the pushing back of the Red Army from Poland, together with the ebb in the revolutionary wave, had placed the working class on the defensive.

For the Communist parties, this meant, for the most part, concentrating on the policy of the united front, based upon the drive for the maximum unity of working-class forces against capitalism. Such a policy was always implicit in the approach of the Bolsheviks in 1917, with their campaign in the soviets to break the coalition between the bourgeois and working-class parties, linked with the call for soviet power. In order to accomplish this 'unity in action' the Communist parties would need to appeal to the reformist organisations, especially the trade unions, to unite in a common struggle over wages, conditions, employers' attacks, etc. In this way, the united front – a programme for action – would draw the party ever closer to the mass of workers in struggle.

This change of tactics inevitably raised questions in the ranks of the Communist parties about whether it was correct to call for united action with the reformist organisations. "But, after all, didn't we split with them? Yes, because we disagree with them on fundamental questions of the working-class movement," Trotsky explained. He then went on to stress the importance of the united front:

> A policy aimed to secure the united front does not of course contain automatic guarantees that unity in action will actually be attained in all instances. On the contrary, in many cases and perhaps even the majority of cases, organisational agreements will be only half-attained or perhaps not at all. But it is necessary that the struggling masses should always be given the opportunity of convincing themselves that the non-achievement of unity in action was not due to our formalistic irreconcilability but to the lack of real

will to struggle on the part of the reformists. (*The First Five Years*, vol. 2, p. 95.)

"It is not enough to possess the sword," explained Trotsky, "one must give it an edge; it is not enough to give the sword an edge, one must know how to wield it." (ibid., p. 93.) That was the application of the united front, namely to unify the workers' organisations – the political parties and trade unions – in action against a common enemy.

> The reformist strives toward conciliation with the bourgeoisie. But in order not to lose their influence over the workers, reformists are compelled, against the innermost desires of their own leaders, to support the partial movements of the exploited against the exploiters. (ibid., p. 94.)

Such a policy did not mean the abandonment of the communist programme or mutual criticism under the pretext of united action. It was not permissible for the communists to dissolve themselves into the united front and become indistinguishable from everyone involved. They were to function within the united front as an independent force. In essence, the united front boiled down to the slogan: 'March separately under your own banners, but strike together!' It was precisely through this joint action of the mass parties that the KPD could demonstrate the superiority of its militant action over the limitations and half-measures of the reformist leaders. In this new period of temporary, relative stability, the communist parties needed to engage with workers in their partial, defensive struggles in order to win them over. The new KPD slogan following the Third Congress became: '*Face Towards the Masses!*'

The change in tempo was also summed up by Zinoviev in a speech to the enlarged session of the International Executive Committee of the Comintern in February 1922, where he stressed the double-sided consequences for the workers' movement:

> The strategic setback was followed by a political setback for the whole workers' movement. The Russian proletarian party was compelled to make extensive concessions to the peasantry, and in part also to the bourgeoisie [in the New Economic Policy]. That slowed down the tempo of the proletarian revolution, but the reverse is also true: the setback which the proletarians of the western European countries suffered from 1919 to 1921 influenced the policy of the first proletarian state, and slowed down the tempo in Russia. It is therefore a double-sided process. (Quoted in E.H. Carr, *The Bolshevik Revolution 1917-1923*, vol. 3, p. 424.)[10]

10 The attack on Soviet Russia by Poland in 1920 was beaten back by the Red Army. The Reds then advanced rapidly into Poland towards Warsaw. But overstretched, they were beaten

THE CASE OF PAUL LEVI

There remained the question of how to deal with Paul Levi. Clara Zetkin asked Lenin, "And Paul Levi! What about him?" This was clearly a thorny question. Again, Zetkin outlined Lenin's response in her memoirs about Lenin:

> "Paul Levi," Lenin answered. "Unfortunately, that has become a case in itself. The reason for that lies principally in Paul himself. He has isolated himself from us and run obstinately into a blind alley. You must have become aware of that in your work of propaganda among the delegations.

> "There is no need to try and convince me. You know how highly I value Paul Levi and his capacity. I got to know him in Switzerland and placed great hopes in him. He proved true in the times of worst persecution, was brave, clever, unselfish. I believed that he was firmly bound to the proletariat, although I was aware of a certain coolness in his attitude to the workers. Something of a 'please keep your distance.' Since the appearance of his pamphlet I have had doubts about him. I am afraid that there is a strong inclination towards solitariness and self-sufficiency in him, and something of literary vanity."

Lenin continued:

> "Ruthless criticism of the 'March Action' was necessary. But what did Paul Levi give? He tore the party to pieces. He did not criticise, but was one-sided, exaggerated, even malicious; he gave nothing to which the party could usefully turn. He lacks the spirit of solidarity with the party. And it is that which has made the rank and file comrades so angry, and made them deaf and blind to the great deal of truth in Levi's criticism, particularly to his correct political principles. And so, a feeling arose – it also extended to non-German comrades – in which the dispute concerning the pamphlet, and concerning Levi himself, became the sole subject of this contention, instead of the false theory and bad practice of the 'offensive theory' and the 'leftists'. They have to thank Paul Levi that up to the present they have come out so well, much too well. Paul Levi is his own worst enemy."

As can be seen, Lenin pulled no punches in his assessment. Clara Zetkin was forced to agree with Lenin's remark that Levi was his own worst enemy. However, she did not accept his judgement that Levi was vain or conceited.

back and forced to sign a harsh treaty. This was a decisive turning point and set the seal on Russia's isolation. After the end of the Civil War, the Soviet government abandoned the policy of War Communism and in 1921 introduced the New Economic Policy, which made concessions to the market and capitalism, although the decisive levers of the economy remained in the hands of the state. Nevertheless, Lenin honestly described the introduction of the NEP as a 'retreat'.

She was very close to Levi and defended him, saying he did not want to become the leader of the party at such a young age, but took on the responsibilities. In other words, too much responsibility had been thrust upon him.

> That is a fact. Even if he is not very warm in his dealings with our comrades, but rather a recluse, I am still convinced that every fibre of his being is at one with the party, with the workers. The unfortunate 'March Action' shook him to the depths. He firmly believed that the very existence of the party was frivolously put at stake and everything for which Karl, Rosa, Leo, and so many others gave their lives, squandered away. He cried, literally cried with pain at the thought that the party was lost. He thought that it could only be saved by using the sharpest methods. He wrote his pamphlet in the spirit of the legendary Roman who willingly threw himself into the yawning abyss to save the fatherland by the sacrifice of his life. Paul Levi's intentions were the purest, the most unselfish.

Lenin said that he was not prepared to argue with her over this, as it was not the central point. "You are a better advocate for Levi than he is for himself," he explained.

> "But you surely know that in politics we are not concerned with intentions, but with effects. Haven't you a saying which runs 'the road to hell is paved with good intentions'? The Congress will condemn Paul Levi, will be hard on him. That is unavoidable. But his condemnation will be only on account of breach of discipline, not of his basic political principles. How could that be possible at the very moment when those principles will be recognised as correct? The way is open for Paul Levi to find his way back to us, if he himself does not block the road. His political future lies in his own hands. He must obey the decision of the Congress as a disciplined Communist, and disappear for a time from political life. That will be extremely bitter to him. I sympathise with him and am truly sorry about it. You may believe that. But I cannot save him this period of heavy trial."

Lenin continued:

> "Paul must accept it as we Russians accepted exile and prison under Tsarism. It can be a period for diligent study and calm self-understanding. He is still young in years and young in the party. His theoretical knowledge is full of gaps; he is still in the elementary stage of the study of Marxian economics. He will come back to us with deeper knowledge, firm in his principles and as a better, wiser party leader. We must not lose Levi. For his own sake and for our cause. We are not over-blessed with talent and must keep as much of what we can. And if your opinion of Paul is correct, a complete separation from the revolutionary vanguard of the workers would be an incurable

Paul Levi

wound for him. Speak to him in a friendly way; help him to see the matter as it appears from the general standpoint and not from his personal viewpoint of 'being right'. I will help you in this. If Levi submits to discipline, bears himself well – he can, for example, write anonymously in the party press, or write some pamphlets – then in three- or four-months' time I shall demand his readmission [to the party] in an open letter. He has his trial by fire before him. Let us hope that he will survive it."

Unfortunately, Paul Levi did not survive the test. He wasn't prepared to follow Lenin's advice and he took the matter personally. Eight months after the Third Congress, Lenin wrote:

I did all I could to defend Levi. I suggested that perhaps he had lost his head (I did not deny that he had lost his head) because he had been very frightened by the mistakes of the 'Lefts'... Instead of honestly admitting that it was necessary for him to appeal for readmission to the party after the Third Congress of the Communist International, as every person who had temporarily lost his head when irritated by some mistakes committed by the Lefts' should have done, Levi began to play sly tricks on the party, to try to put a spoke in its wheel, i.e., actually he began to serve those agents of the

bourgeoisie, the Second and Two-and-a-Half Internationals.[11] (LCW, vol. 33, pp. 208-209.)

This view of Levi was confirmed by Trotsky, who in his work, *Germany: What Next?* explained:

> During the intimate conferences on the events of March 1921 in Germany, Lenin said about Levi, "The man has lost his head entirely... He, at least, had something to lose, one can't say even that about the others". The term "others" denoted Béla Kun, Thalheimer, etc. (L. Trotsky, *Germany 1931-1932*, pp. 131-132.)

We can see Lenin's initial friendly and comradely attitude towards Levi, even being prepared to campaign for his readmission into the party after three or four months. But Lenin could also be very sharp in his dealings when necessary. As Trotsky once said of Lenin, he could use the brush, but he also knew when to use the razor. But Levi refused to grasp the olive branch offered by Lenin. He took his expulsion from the party badly. Rather than seeking to work his way back, he took the decision to slam the door shut by publishing Rosa Luxemburg's book on the Russian Revolution, against Luxemburg's wishes. Lenin was furious when he heard about this.

> Paul Levi now wants to get into the good books of the bourgeoisie – and, *consequently*, of its agents, the Second and Two-and-a-Half Internationals – by republishing precisely those writings of Rosa Luxemburg in which she was wrong. We shall reply to this by quoting two lines from a good old Russian fable: "Eagles may at times fly lower than hens, but hens can never rise to the height of eagles" ... But in spite of her mistakes, she was – and remains for us – an eagle. (LCW, vol. 33, p. 201.)

After that, Levi's political evolution towards the right was almost inevitable, although he always remained part of the left-wing current. Very soon he returned to the rump of the USPD and, from there, into the left wing of Social Democracy. In effect, he jumped from communism into the swamp of reformism. It marked the end for Paul Levi. This desertion severed his links with the communist movement once and for all. He committed suicide in 1930 by jumping from a window in a deranged state of mind.

11 The 'Two-and-a-Half' International was constituted in February 1921, and the main component was the Austrian Social Democracy, the so-called Austro-Marxists, and other centrists. It maintained a precarious existence, mainly on paper, and collapsed with the outbreak of the Second World War.

BATTLE LINES DRAWN

In the year or so following the Third Congress, the KPD experienced a series of internal crises as a result of the abortive 'March Action'. After Levi was expelled, all those who openly supported him were also purged. Zinoviev was clearly behind this move. Friesland took over as general secretary of the party soon afterwards and Ernst Meyer became its president. However, Ernst Friesland began to draw similar conclusions to Levi, having studied the decisions of the Third Congress, and soon came into conflict with the ultra-left elements within the party. Within a matter of months, in January 1922, he was also removed from his post and then expelled from the party along with his supporters.

These splits were followed by other resignations such as those of Ernst Däumig and Adolf Hoffmann, both Reichstag deputies, who left to join Paul Levi's new group, the Communist Working Collective (KAG). In fact, a further ten deputies resigned and joined Levi, which reduced the KPD Reichstag faction to only fourteen members. By this time, Levi was moving to the right and Friesland was following in his footsteps.

The KPD leadership now fell into the hands of Brandler, Thalheimer, Walcher and Meyer, all of whom resisted the continual lurch to the Left. Their fingers had been badly burned by the March experience and they were determined not to repeat the adventure. The only problem was that they tended to bend the stick too far in the other direction. This was also to have serious consequences in the not too distant future. Pierre Broué pointed out that:

> From then onwards, they would be resolute 'rightists', systematically persisting in an attitude of prudence, armed with precautions against putschist temptation or even a simple leftist reflex. Convinced by the leadership of the International of the magnitude of their blunder, they lost confidence in their own ability to think, and often failed to defend their viewpoint, so that they systematically accepted that of the Bolsheviks, who had at least been able to win their revolutionary struggle. (P. Broué, p. 577.)

The factional atmosphere increased within the German party as two Berlin-based 'Lefts', Ruth Fischer and Arkadi Maslow engaged in a bitter struggle against the leadership, accusing it of political accommodation to centrism, especially to Levi's KAG. As expected, they vehemently opposed the Third Congress compromise, and continued to firmly defend the offensive tactic. In the ensuing struggle within the party they were able to whip up such ultra-left feelings that they won over almost half the membership to their side. The fact they were able to exercise such influence once again reflected

the politically unstable character of the party, which was still open to bouts of ultra-leftism.

Lenin was getting very frustrated with the situation within the German party, especially with the behaviour of the ultra-lefts around Fischer and Maslow. On 14 August 1921, he openly challenged Maslow in his *Letter to the German Communists*, in which he accused him of "playing with Leftism," and wishing to occupy himself by "hunting Centrists". Maslow's unreasonableness (to put it mildly) was also revealed while he was in Moscow, a fact that led Trotsky to remark that he should be kept out of harm's way by remaining in the Russian capital.

Lenin's *Letter* accused Maslow and his Leftist supporters of having "more zeal than sense," and urged the German Communists to "end the internal dissension, get rid of the quarrelsome elements on both sides, forget about Paul Levi and the KAPists[12] and get down to real work." (LCW, vol. 32, p. 519.)

Trotsky also had a very low opinion of Maslow and his supporters. They had failed to learn anything at the Third Congress, starting with a false understanding of the nature of the period. As with all the ultra-lefts, they denied that capitalism could experience any kind of revival. All they could see was slump and immediate revolution. They had no sense of proportion and stubbornly refused to face up to the reality of the situation. Both Maslow and Ruth Fischer proved to be inherent ultra-lefts who, following the debacle of 1923, would be propelled into the leadership of the party, with the full support of Zinoviev. "It is out of the question to consider them as Marxists," wrote Trotsky on 6 January 1922. "They convert Marx's historic theory into automatism and for good measure they add to it unbridled revolutionary subjectivism." (L. Trotsky, *The First Five Years*, vol. 2, pp. 87-88.)

The whole of Lenin's *Letter* to the Germans is full of important analysis and sound advice. Again, it deserves to be quoted extensively:

> What the German proletariat must and will do – and this is the guarantee of victory – is keep their heads; systematically rectify the mistakes of the past; steadily win over the mass of the workers both inside and outside the trade unions; patiently build up a strong and intelligent Communist Party capable of giving real leadership to the masses at every turn of events; and work out a strategy that is on a level with the best international strategy of the most advanced bourgeoisie, which is 'enlightened' by age-long experience in general, and the 'Russian experience' in particular...

Lenin continued:

12 The 'KAPists' Lenin refers to is the ultra-left KAPD.

Here I must explain to the German comrades why I defended Paul Levi so long at the Third Congress. Firstly, because I made Levi's acquaintance through Radek in Switzerland in 1915 or 1916. At that time Levi was already a Bolshevik. I cannot help entertaining a certain amount of distrust towards those who accepted Bolshevism *only after* its victory in Russia, and after it had scored a number of victories in the international arena. But, of course, this reason is relatively unimportant, for, after all, my personal knowledge of Paul Levi is very small. Incomparably more important was the second reason, namely, that *essentially* much of Levi's criticism of the March Action in Germany in 1921 was *correct* (not, of course, when he said that the uprising was a 'putsch'; that assertion of his was absurd).

It is true that Levi did all he possibly could, and much besides, to weaken and spoil his criticism, and make it difficult for himself and others to understand the essence of the matter, by bringing in a mass of details in which he was obviously wrong. Levi couched his criticism in an impermissible and harmful form. While urging others to pursue a cautious and well-considered strategy, Levi himself committed worse blunders than a schoolboy, by rushing into battle so prematurely, so unprepared, so absurdly and wildly that he was certain to lose any 'battle' (spoiling or hampering his work for many years), although the 'battle' could and should have been won. Levi behaved like an 'anarchist intellectual' (if I am not mistaken, the German term is *Edelanarchist*), instead of behaving like an organised member of the proletarian Communist International. Levi committed a breach of discipline.

By this series of incredibly stupid blunders Levi made it difficult to concentrate attention on the essence of the matter. And the essence of the matter, i.e., the appraisal *and correction* of the innumerable mistakes made by the United Communist Party of Germany during the March Action of 1921, has been and continues to be of enormous importance. In order to explain and correct these mistakes (which some people enshrined as gems of Marxist tactics) *it was necessary* to have been on the right wing during the Third Congress of the Communist International. Otherwise the line of the Communist International would have been a *wrong* one.

I defended and had to defend Levi, insofar as I saw before me opponents of his who merely shouted about 'Menshevism' and 'Centrism' and refused to see the mistakes of the March Action and the need to explain and correct them. These people made a caricature of revolutionary Marxism, and a pastime of the struggle against 'Centrism'. They might have done the greatest harm to the whole cause, for 'no one in the world can compromise the revolutionary Marxists, if they do not compromise themselves'.

I said to these people: Granted that Levi has become a Menshevik. As I have scant knowledge of him personally, I will not insist, if the point is proved to me. But it has not yet been proved. All that has been proved till now is that he *has lost his head*. It is childishly stupid to declare a man a Menshevik merely on these grounds. The training of experienced and influential party leaders is a long and difficult job. And, without it, the dictatorship of the proletariat, and its 'unity of will', remain a phrase. In Russia, it took us fifteen years (1903-17) to produce a group of leaders – fifteen years of fighting Menshevism, fifteen years of tsarist persecution, fifteen years, which included the years of the first revolution (1905), a great and mighty revolution. Yet we have had our sad cases, when even fine comrades have 'lost their heads'. If the West-European comrades imagine that they are insured against such 'sad cases' it is sheer childishness, and we cannot but combat it...

At the Third Congress it was necessary to start practical, constructive work, to determine concretely, taking account of the practical experience of the communist struggle already begun, exactly what the line of further activity should be in respect of tactics and of organisation. We have taken this third step. We have an army of Communists all over the world. It is still poorly trained and poorly organised. It would be extremely harmful to forget this truth or be afraid of admitting it. Submitting ourselves to a most careful and rigorous test, and studying the experience of our own movement, we must train this army efficiently; we must organise it properly, and test it in all sorts of manoeuvres, all sorts of battles, in attack and in retreat. We cannot win without this long and hard schooling...

Comrades, German Communists, permit me to conclude by expressing the wish that your Party Congress on 22 August will with a firm hand put a stop once and for all to the trivial struggle against those who have broken away on the left and the right. Inner-party struggles must stop! Down with everyone who wants to drag them out, directly or indirectly. We know our tasks today much more clearly, concretely and thoroughly than we did yesterday; we are not afraid of pointing openly to our mistakes in order to rectify them. We shall now devote all the party's efforts to improving its organisation, to enriching the quality and content of its work, to creating closer contact with the masses, and to working out increasingly correct and accurate working-class tactics and strategy. (LCW, vol. 32, pp. 512-523.)

Following the Third Congress, the orientation of the German Communists towards united front work saw a steady revival in the party's fortunes. It was recovering from much lost ground. The mistakes of the past were being rectified step by step, although an ultra-left opposition still remained. The annual report presented to the Leipzig Party Conference in 1922 painted

a picture of consistent progress: amongst women, youth and children's sections, the co-operatives and trade unions. Alongside its press agency, the party now had thirty-eight daily newspapers and numerous periodicals. They had papers for women, youth and even children. The party had sixty-six deputies at a state level in different Landtags. They possessed over 12,000 municipal councillors, with an absolute majority in eighty town councils and were the biggest party in a further 170 authorities. In the trade unions, they possessed nearly 1,000 organised fractions with 400 members in leadership positions. Out of 694 delegates to the National Congress of the ADGB (trade union federation), ninety were Communist Party members. There was also a rebirth of the factory committees, in which the Communists played an important role. 1922 was also the year which marked the maximum number of strikes, where 1.6 million workers were involved in 4,338 strikes, and the party vigorously intervened.

Even according to the testimony of the ultra-left Ruth Fischer:

> In the second half of 1922 the party was gaining in numbers and influence. In the third quarter of 1922 it had 218,555 members. It showed a sharp rise from the 180,443 of the previous year, just after the March Action.

The KPD was by far the biggest Communist Party in Western Europe and the composition of its membership was ninety per cent proletarian.

On 24 June 1922, the Foreign Minister, Walter Rathenau was murdered by the secret, extreme right-wing 'Organisation Consul', a cabal of reactionary ex-army officers. Although not a socialist, Rathenau was regarded as a man of principle. The gang that carried out the murder was a continuation of the political espionage department of the Schutzen Division, which held Berlin in a state of Terror for most of 1919 and helped organise the murders of Liebknecht, Luxemburg and others.

The murder of Rathenau therefore provoked a massive reaction. It was the culmination of hundreds of other political murders and there were growing fears of another attempted coup. As with the Kapp Putsch there was a massive movement from below, in which the workers were bound together in a unified struggle. In such a situation, the KPD was able to use the united front tactic to maximum effect. On 27 June, a demonstration over the murder took place involving a million strong turnout. The next day, there was a twelve-hour general stoppage throughout the whole of Germany. On 4 July, a massive demonstration, organised by all the workers' organisations also proved to be an outstanding success. The KPD had successfully engaged with the SPD over this action, but precisely because of its success, the worried Social Democratic leaders broke off relations with the Communists after only

four days, which, according to the reformists, had "placed itself outside the united action".

(4.1) Political Murders Committed (January 1919 - June 1922)

	Left	Right
No. political murders committed	22	354
No. persons sentenced for these murders	38	24
Death sentences	10	-
Confessed assassins found 'Not Guilty'	-	23
Political assassins subsequently promoted by the army	-	3
Average length of prison term for murder	15 years	4 months
Average fine per murder	-	2 Marks

(E.J. Gumbel, *Vier Jahre Politischer Mord*, quoted in E. Anderson, p. 87.)

Alongside this political turmoil, price inflation had begun to increase in the summer of 1922, which would soon turn into hyperinflation. Years of successive governments reverting to the printing press to pay for the war and plug their budget deficits had completely undermined the currency. This was Keynesianism before Keynes.[13] In November, the price of meat, eggs and margarine doubled in price. Butter and bread trebled in cost. There were 300 marks to the dollar in June; in August 1,000 marks to the dollar; by December, it was 8,000 marks, and by January 1923, 18,000 marks to the dollar. The resulting inflation had a shattering effect not only on the workers but also on the middle classes, particularly those on fixed incomes, who faced absolute ruin.

By this time, the German capitalists were very determined to take back all the concessions won by the working class in the November Revolution. In October 1922, as inflation reached new heights, the German bourgeoisie prepared their offensive. Their stated aim was to abolish the right of trade union recognition, tear up agreements, not to support company unions, de-recognise shop stewards' committees, end universal suffrage, and, above all, abolish the eight-hour working day. The powerful industrialist Fritz Thyssen addressed an open letter to the government which stated, "Germany's

13 John Maynard Keynes (1883-1946), was a British bourgeois economist. He advocated increased government spending and budget deficits to stimulate demand and thereby pull the economy out of the depression.

salvation can only come from a return to the ten-hour working day." (E. Anderson, p. 87.)

Two weeks later another leading industrialist, Hugo Stinnes, declared open class war:

> I do not hesitate to say that I am convinced that the German people will have to work two extra hours per day for the next 10 or 15 years... the preliminary conditions for any successful stabilisation is, in my opinion, that wage struggles and strikes be excluded for a long period... we must have the courage to say to the people: "for the present and for some time to come you will have to work overtime without overtime payment." (E. Anderson, p. 87.)

He went on:

> You cannot both lose the War and work two hours less. It's impossible. You must work, work and work again... (P. Broué, p. 623.)

The German bourgeoisie was clear in its intentions that only by driving down living standards to starvation levels could German capitalism be put back on its feet. Faced with hyperinflation and the state on the verge of bankruptcy, the government's days were numbered and the SPD-Liberal coalition of Dr. Wirth soon collapsed. This gave way to the right-wing bourgeois government led by Wilhelm Cuno, director of the Hamburg-Amerika Line.

This meant that there were no longer any Social Democrats in the government. The coming to power of the bourgeois Cuno government provided the green light for an all-out assault on the working class. But within less than two months, the government had defaulted on its reparations and the French army had occupied the Ruhr. Within two years of the decision to adopt the united front policy, Europe was again convulsed by a mighty paroxysm. A new convulsive chapter opened up in Germany, which again posed the question of the proletarian revolution.

CHAPTER FIVE: THE SPOILS
OF WAR

The proletarian revolution is knocking at the door in Germany: one must be blind not to see this. The coming events will have *world-historical* significance. We shall soon see that the autumn of 1923 marks a turning-point, not only for Germany, but for the whole of humanity. With trembling hands, the working class is turning the decisive page of the history of its world struggle. A new chapter in the history of the world proletarian revolution is opening.

Grigory Zinoviev, *Probleme der Deutschen Revolution*

The defeat of Germany in the 'Great War' of 1914-18 had serious consequences. The 'war to end all wars' had transformed Germany into one of the weakest links in the chain of world capitalism. The Allies, for their part, were determined to take the maximum advantage of this weakness. The Ruhr region had been occupied by Allied troops in the immediate aftermath of the First World War, as a buffer zone in the Rhineland. They were determined to extract their pound of flesh, and more, by imposing the brutal Treaty of Versailles in the summer of 1919. The aim of these victorious 'men of peace', the leaders of the Entente, was simply to bleed Germany white and reduce the country to a semi-vassal state. Thus, the Versailles Treaty was one of the most oppressive and predatory treaties in history, an act of plunder perpetrated by a gang of thieves against a weak and defenceless German people, all in the name of 'Justice', 'Liberty' and 'Democracy', the hallmarks of capitalist hypocrisy.

Although the Armistice was signed in November 1918, the formal end to hostilities between Germany and the Allied Powers only came in the summer

of 1919 with the signing of the Versailles Treaty. The Treaty document was made up of fifteen parts and 440 articles and was symbolically signed by all parties on 28 June, exactly five years after the assassination of Archduke Franz Ferdinand, and forty-eight years since the end of the Franco-Prussian war.

According to the leaders of the Entente, the German people and the Central Powers bore the full responsibility for the war and, therefore, had to pay the full cost for their heinous and treacherous acts. This revenge of the victors was to sow the seeds of hatred within Germany for years to come and helped to fan the flames of German nationalism. In this way, it also helped to prepare the way for the rise of Hitler and the nightmare of the Second World War.

While the champagne flowed like water at the victory celebrations in Paris, the spectre of revolution cast a long shadow over the festivities. The imperialists were haunted by Bolshevism, which had already conquered Russia and – as we have seen in previous chapters – was now threatening Germany, Bavaria and Hungary. But for now, what was uppermost in their minds was the dismemberment of Germany, and what share of the plunder they would each get.

Naturally, the defeated Central Powers, Germany, Austria, and Hungary were not invited to the Peace negotiations. Likewise, Bolshevik Russia was excluded, having concluded a separate peace agreement with Germany. The important powers around the table in Paris were Britain, France and the United States, the so-called Big Three. Italy had left the proceedings by this time and therefore the Big Three decided everything. But their differing war aims and national interests soon led to disagreements and conflicts.

After nearly six months of deliberations, the draft Treaty was finally finished. In the great hall of the Trianon were gathered the representatives of twenty-seven nations that had defeated the Central Empires. Presiding over the ceremony was Clemenceau. On one side of him sat President Wilson and on the other was Lloyd George.

The master of protocol announced: "Messieurs les délégués allemands!" The German representatives, after being kept out of the proceedings, were finally ushered in like prisoners at the dock. After being allowed in to hear their guilt, they were told, in no uncertain terms, of the demands contained in the Treaty, including the so-called 'War Guilt Clause', which weighed like a massive millstone on Germany's conscience. Following this humiliation, they were forced to listen to Clemenceau in his role as judge, jury and executioner of the vanquished:

> In the view of the Allied and Associated Powers, the war which began on the first of August, 1914, was the greatest crime against humanity

and the freedom of the peoples that any nation calling itself civilised has ever consciously committed … Germany's responsibility, however, is not confined to having planned and started the war. She is no less responsible for the savage and inhumane manner in which it was conducted.

He concluded:

The conduct of Germany is almost unexampled in history. The terrible responsibility which lies at her doors can be seen in the fact that not less than seven million dead lie buried in Europe, while more than twenty million others carry upon them the evidence of wounds and suffering, because Germany saw fit to gratify her lust for tyranny by a resort to war.

The Allied and Associated powers believe that they will be false to those who have given their all to save the freedom of the world if they consent to treat the war on any other basis than as a crime against humanity and right. (A. Read, pp. 229-230.)

The truth is that Britain had gone to war because Germany had become too strong and threatened British interests, dragging in France and the others who hoped to benefit from the conflict. In the past, Britain had relied on a foreign policy that played off one power against another. But simply giving support to France against Germany was no longer possible. Therefore, Britain had to depart from her traditional policy and go to war. It was nothing to do with 'democracy' or 'saving little Belgium', and everything to do with power, prestige and profits, and the protection of the British Empire. But the war had changed the balance of forces. With Germany's defeat, France was given more power, which it used to demand greater concessions from Germany. Britain objected as she wanted a weakened, but not a totally ruined Germany, to play off against France, whereas the United States needed a powerful France to counter Britain. Such were the real material interests involved in the game of imperialist diplomacy.

There was of course no discussion, only further humiliation, as the Germans were handed a single copy of the Treaty to ratify, in French and English, but not in German. Ulrich Graf von Brockdorff–Rantzau summed up the feeling from the German side: "We know the full brunt of hate that confronts us here. You demand from us to confess we were the only guilty party of war; such a confession in my mouth would be a lie."

The American Colonel Edward House observed that the proceedings were "not unlike what was done in olden times when the conqueror dragged the conquered at his chariot wheels." (R. Watt, p. 10.) All that was missing were the chariots.

According to R.T. Clarke, who summed things up perfectly, "Germany was to remain pilloried to eternity as the one great and horrible example and from that new world order the new revolutionary Germany was to be barred as a moral leper." (Quoted in E. Anderson, p. 63.)

On the other hand, despite the Treaty being clearly draconian, prominent figures on the Allied side, such as the French Marshal, Ferdinand Foch, who thought it too lenient and pursued a far tougher approach. The French were particularly hard on the Germans. There was even talk amongst the French of breaking up Germany piece by piece if they fell behind on their reparation payments, with France taking a major slice. The Americans, fearing this was a step too far, attempted to dissuade them from such lunacy.

The German delegation, Count Brockdorff-Rantzau, Foreign Minister of the Reich, followed by the other representatives, withdrew from the Paris Conference after being subjected to gross humiliation. They were given a fortnight to make any observations, but only in the form of notes.

The Social Democratic Chancellor, Philipp Scheidemann, refused to sign the Treaty and resigned as Chancellor. In a passionate speech before the National Assembly on 12 March 1919, Scheidemann called the Treaty a "murderous plan" and exclaimed: "Which hand, trying to put us in chains like these, would not wither? The Treaty is unacceptable." But the speech was all bluff and bluster. He offered no alternative. A refusal to sign would have meant an immediate Allied offensive against a broken Germany, which could only result in further humiliation. The German military command had been approached as to the possibility of resistance, but this proved impossible under the circumstances.

Therefore, on 2 June, the National Assembly in Berlin voted in favour of signing the Treaty by 237 votes to 138, with five abstentions. Within a matter of weeks, the Foreign Minister, Hermann Müller, and Johannes Bell travelled to Versailles to sign the Treaty in solemn circumstances on behalf of the German nation. As Müller stepped forward to sign the document, he was offered a fountain pen, a gift from a French city for this special occasion. But he refused the gift and used his own pen.

The Treaty was then ratified by the German National Assembly ten days later on 9 July 1919 by a vote of 209 to 116. Thus was born the national 'sell-out' of Germany, for which the right-wing nationalists and ex-military leaders immediately blamed the politicians, socialists, and communists for the betrayal. This was then used by the Nazis and other nationalists for the next thirteen years, who specifically laid the blame on Jews and 'traitors' for the growing plight of the German people.

SQUEEZE UNTIL THE PIPS SQUEAK

The most belligerent power opposed to Germany, as we have seen, was France, which had lost much more than any of the other victors during the conflict. The French ruling class therefore demanded retribution. The French Prime Minister, Clemenceau, was determined to take his tribute and more. The cunning British Prime Minister, Lloyd George, also wanted a slice, but instead preferred to bleed Germany by reducing its economic and military power, and thereby protecting Britain's markets and Empire. He had gone to Paris promising to "squeeze the German lemon until the pips squeak." But his overarching aim was to prevent France becoming a dominant power in Europe at Germany's expense.

Nevertheless, they both came up against what they regarded as Woodrow Wilson's so-called idealism. The American President's proposal for 'self-determination', while lacking any content, did not go down well with Lloyd George. The British and the French wanted to keep their empires and dominions and any talk of self-determination, however hollow, was considered a threat, which it was. They were not going to relinquish their old European empires for the benefit of the United States. Again, the US had arrived late in the war and had not been touched by German destruction. While the British and French fought tirelessly in the trenches, the Americans, in the words of Lloyd George, had been "loitering in the way" for three years.

But America was conscious of its own interests and was determined to pursue them. The reason why the United States entered the war late was to allow Germany and Britain to mutually exhaust themselves and then she would graciously step in. She had assumed the role that Britain had taken in previous wars, namely, to weaken one camp by playing it off against the other, and only intervening militarily to secure all the advantages for herself. As a growing imperialist power, the United States would soon displace both Germany and Britain to become the dominant power globally.

Although prone to more isolationist feelings, the United States worked to play off Britain and France by taking a softer approach toward the issue of German reparations. To add to the manoeuvres, Woodrow Wilson, simply to demonstrate that the United States was boss, put forward his own Fourteen Points. They included proposals that all "future world agreements" would be covenants of peace, "openly arrived at"; there was the insistence upon "absolute freedom of the seas"; the restoration of Alsace-Lorraine to France; the promise of "an independent Polish state"; and, the fourteenth point, the establishment of "a general association of nations", namely the League of Nations, dubbed by Lenin as "a gang of thieves." He could afford to be magnanimous to the Germans, as long as the United States got what

it wanted, including the repayment of its loans made to its European Allies, plus the interest. The Europeans were annoyed but were forced to keep their mouths shut in public. Of course, each knew the duplicity of the others, which was intended to conceal or distort their real intentions.

As compensation to the Allies in recompense for their destruction and hardship during the four years of war, Germany's colonies were divided up between the victors: Italy, France, Belgium, Japan and Britain, with the latter taking the lion's share. The Cameroons were divided up between France and Britain; Togoland was given to Britain, and Western Africa to Britain and Belgium. In the Pacific, Japan received the Marshall Islands and the Shantung Peninsula in China. Samoa was given to New Zealand, New Guinea to Australia, and the island of Nauru to Britain.

Germany was also to be dismembered: the Saar mines were transferred to France, as was Alsace-Lorraine, with its two million population and the three-quarters of German iron production that accompanied it. The southern part of Silesia, with its industries and mines were ceded to Poland, whereas the northern part of Schleswig went to Denmark. Other parts were distributed accordingly, through smaller 'adjustments' at the expense of Germany and its allies. The Rhineland was to become a demilitarised zone administered by Great Britain and France jointly. The port of Danzig with the delta of the Vistula River at the Baltic Sea was made the Free City of Danzig under the permanent governance of the League of Nations, without of course a plebiscite.

The victor powers carved up the military equipment between themselves, including 5,000 cannons, 30,000 machine guns, 3,000 mine throwers, 2,000 aeroplanes, 100 submarines and eight cruisers. The bulk of the German High Seas Fleet was disarmed and sent to England, then onwards to the Orkney Islands. However, the hot breath of the German revolution remained on board the ships, as German sailors established a 'Supreme Sailors' Soviet', which the British authorities refused to recognise. The fleet was then held in quarantine for fear that British sailors would be infected by the virus of revolution. The German army was drastically reduced to 100,000 men, an adequate number, it was deemed, to be used if need be against revolution. All monies taken from foreign banks were to be handed over. The naval blockade would, of course, remain in force.

But this stripping of Germany's military power would continue to be a deep source of resentment amongst the officer caste, many of whom turned towards the nationalist right, as the Versailles Treaty fanned the embers of German nationalism. Brockdorff-Rantzau never personally forgot the humiliation of the treaty. On his deathbed, in 1928, his last words to his

brother were, "Do not mourn. After all, I have really been dead ever since Versailles." (R. Watt, p. 523.)

CARTHAGINIAN PEACE

There were more sane voices who preached caution about the harsh policy of retribution, such as the economist John Maynard Keynes, who was present at Versailles as a representative of the British Treasury. He understood that simply squeezing Germany could lead to serious – and revolutionary – consequences. But the victor powers seemed oblivious to this fact. They were only concerned with the size of the booty they were going to get.

On 5 June, 1919, just a few weeks before the signing of the Treaty, Keynes tendered his resignation to Lloyd George. "I've gone on hoping even through these last dreadful weeks, that you'd find some way to make of the Treaty a just and expedient document," he wrote. "But now it's apparently too late. The battle is lost."

Keynes described the treaty as a "Carthaginian peace," left the Paris Peace Conference and retired to write his *The Economic Consequences of the Peace,* a scathing attack on the Conference and the Treaty's reparation terms. The opening chapter conveys Keynes' feelings in no uncertain terms:

> The spokesmen of the French and British peoples have run the risk of completing the ruin, which Germany began, by a Peace which, if it is carried into effect, must impair yet further, when it might have restored, the delicate, complicated organisation, already shaken and broken by war, through which alone the European peoples can employ themselves and live.

The Versailles Treaty simply bound together the German and European economies in a downward spiral and laid the foundation of further revolutionary upheavals. Keynes was alarmed by this state of affairs:

> Germany cannot export coal in the near future if she is to continue as an industrial nation [...] and will not furnish the Allies with a contribution of 40,000,000 tons annually [...] If the distribution of the European coal supplies is to be a scramble in which France is satisfied first, Italy next, and everyone else takes their chance, *the industrial future of Europe is black and the prospects of revolution very good.* (J.M. Keynes, *The Economic Consequences of the Peace*, emphasis added.)

These stone-faced politicians, Clemenceau, Wilson and Lloyd George, refused to grasp the implications of their actions. Keynes described Clemenceau as "dry in soul and empty of hope," Woodrow Wilson as "this blind and deaf Don Quixote," and Lloyd George as "a goat-footed bard". But behind these gentlemen, no matter their personal faults, there stood the material class

interests of their respective imperialist powers, each vying for its own prestige, power and profits. They were determined to extract their 'just' rewards, nothing more, nothing less, from the German people for their 'barbaric' actions.

As Keynes had predicted, the German government was unable to honour the reparation payments to France. France, in turn, had depended on German reparations to pay back her medium and long-term debts to the British and American governments, while the French government was churning out national defence bonds. From 1920 onwards, France's interest payments on foreign and domestic debt accounted for a staggering twenty-six per cent of the government's budget, government bonds lost sixty-two per cent of their value, and devaluation of the franc prompted a flight of capital.

Article 231 of the Treaty demanded Germany pay reparations. In 1921 the total cost of these reparations was assessed at 132 billion marks (then $31.4 billion or £6.6 billion, roughly equivalent to US $442 billion or UK £284 billion in 2018), a sum that was impossible for Germany to pay without completely destroying the country. In May of that year the hard-headed Allies demanded the full payment of 132,000 million gold marks in reparations. To soften the blow and demonstrate the Allies' generosity, the Germans were allowed to pay the reparations in kind, whereby Britain would receive tonnage for tonnage and class for class all her lost shipping during

French soldiers in the Ruhr, 1923

the war. The French were given 5,000 locomotive engines, 150,000 railway wagons, 10,000 lorries and 140,000 cows. The Belgians also received their payment in cattle. Germany was being economically stripped bare by the Allies. While the German nation, that is the working class, bore the brunt of this colossal burden, the bourgeoisie was able to make enormous profits from the inflation.

In November 1921, such was the dire situation, Germany requested a moratorium on the reparations. But there was no agreement as the negotiations between France, Germany, and Britain broke down. As German debts mounted, they had growing difficulty in honouring the reparation payments throughout 1922. These reparations led to acute shortages at home, as meat consumption fell to only thirty-seven per cent of pre-war levels; flour consumption fifty-six per cent; and coffee consumption twenty-eight per cent. The shattered German economy was so weak that only a small percentage of reparations were paid in hard currency. The bulk was in kind, made up of anything the Allies could carry. However, even the payment of a small percentage of the original reparations still placed an intolerable burden on the state. The government's response was to print more and more money, so that the amount of paper money in circulation rose six-fold from 1913. This was a two-edged blessing. While the devaluation of the currency meant a lighter burden of reparations, it resulted in hyperinflation that became rampant as the mark to the dollar exchange rate spiralled out of control.

French machine gun squad bound for guard duty in the Ruhr coal mines

FRENCH OCCUPATION OF THE RUHR

The economy went over a cliff in January 1923, when Germany finally defaulted on its reparation payments. This set in motion a chain reaction, causing the new French Prime Minister, Poincaré, to immediately dispatch General Degoutte at the head of 60,000 troops to occupy the Ruhr and seize its coal. They were accompanied by Belgian forces, who also wanted a share. This represented a devastating blow to Germany, as the Ruhr was the industrial heart of the country, where eighty per cent of its steel and seventy-one per cent of its coal production was concentrated. This colonial-type occupation was the gravest situation faced by Germany since 1918.

The reaction was instantaneous. The mood changed abruptly as national revulsion spread like wildfire throughout the length and breadth of Germany, with 500,000 people taking to the streets in Berlin alone. The ruling class were hoping that, as with the crisis of August 1914, *l'union sacrée*, national unity, would again emerge. The government of Cuno, the German industrialist, announced a campaign of 'passive resistance', in which all forms of co-operation with the occupying forces would be completely forbidden. Cuno called for a vote of confidence for the 'resistance', which was endorsed by the Reichstag by 284 votes to twelve, the Communists voting against. In other words, there was to be no collaboration and no reparation payments. It was like a state of war.

Ironically, it was the bourgeois parties that led the resistance campaign in its early stages. In fact, the Ruhr industrialists had organised a number of mass demonstrations against the French. But many workers were not fooled by the so-called patriotism of the likes of Krupp and Stinnes, who had already made sure that the cost of the resistance would be shouldered by the workers. During the occupation, the employers denounced wage rises as 'unpatriotic', as prices and profits soared. While the price of coal (calculated in stable currency) was twice as high as the peacetime price, miners' real wages had fallen by one-third of peacetime wages.

As the resistance intensified, the mood was becoming increasingly desperate and angry. The bourgeois parties, fearing the turmoil that passive resistance was causing, began to vacillate. In the meantime, the Communist Party swung behind the resistance and began to take a lead in the fight. The workers wanted to get rid of the occupation by French troops, but they also demanded the immediate stabilisation of the currency, which was eating away their wages at an ever-increasing speed.

The caution sounded by the Comintern Third Congress came abruptly to an end. The slow, patient work gave way to feverish activity. Revolutionary

events, which seemed to have been postponed indefinitely, were now back onto the agenda.

Workers in the Ruhr were forbidden to co-operate with the French authorities. Measures of resistance, strikes, go-slows and sabotage, bogged down the French authorities, who announced draconian measures to break the resistance by expelling some 10,000 in the first six months of 1923. In the Ruhr, the French occupation forces expelled 1,400 German railway workers from the area, and on 29 January, they proclaimed martial law.

This simply poured petrol on to the fire as a wave of militancy swept through the towns of central Germany. Acts of sabotage followed as power lines and telephone cables were cut, and railway lines pulled up. Arrests followed but they did not calm the situation. In fact, the entire Council of the Essen postal workers were arrested for planning a strike against the occupation. There were disturbances and shootings in Essen and other places.

"The struggle which had begun as national resistance against the French," wrote Evelyn Anderson, "ended in a period of the fiercest class war that Germany had ever experienced." (E. Anderson, p. 91.)

While the SPD lined up behind the Cuno government, the KPD took an independent position, calling on the workers to resist the occupation, but also resist the ruling class, which was deceiving them. Above all, they were opposed to the German nationalism espoused by the authorities and echoed by the extreme right. The ultra-left within the KPD, true to form, wanted the party to adopt a neutral position in the struggle, as they had done at the beginning of the Kapp Putsch; they even threatened to split the party over it. Only the intervention of the Comintern, which put the 'Left' in its place, avoided such an outcome. At the Eighth Congress of the KPD, held in Leipzig in late January, Brandler was chosen to replace Meyer as party chairman, while Thalheimer became its chief 'theorist'. This placed the German party firmly in the hands of the 'right wing', which continued to uphold the united front tactic, despite opposition from Maslow, Fischer and Thälmann.

The situation was becoming extremely favourable for the Communists, as long as they could reorientate themselves correctly. With bourgeois society shaken to its foundations, the objective situation was becoming pregnant with revolutionary potential. Marx explained there were times when "twenty years are more than a day – though, later on, days may come again in which twenty years are embodied." (K. Marx and F. Engels, *Selected Correspondence*, p. 140.) This was such a time, when events moved swiftly. What was now needed was a degree of vision and a bold leadership that could seize the moment.

HYPERINFLATION

As we have seen, inflation was giving way to hyperinflation as the situation deteriorated and living standards were cut to the bone. The price of a single loaf of bread in Berlin escalated from sixty-three pfennigs in 1918 to 250 marks in January 1923. Then prices rose at an astronomical rate – a loaf of bread cost 3,465 marks in July, 1.5 million in September, reaching a peak of 201,000 million marks in November 1923. The official dollar exchange rate is shown in Table 5.1.

(5.1) Official Dollar Exchange Over Time

Date	Marks	U.S. Dollars
1919	4.2	1
1921	75.0	1
1922	400.0	1
Jan. 1923	7,000.0	1
Jul. 1923	160,000.0	1
Aug. 1923	1,000,000.0	1
1 Nov. 1923	1,300,000,000.0	1
15 Nov. 1923	1,300,000,000,000.0	1
16 Nov. 1923	4,200,000,000,000.0	1

At this point, inflationary figures lost their meaning. The printing presses worked continuously to produce banknotes. By mid-1923, the Reichsbank was using 300 paper factories and 150 printing firms to supply Germany with the necessary paper money.

Soon, barrowfuls of rapidly devaluing money were required to buy the basic necessities, as workers dashed off as soon as they were paid before their wages became worthless. Million-mark notes were used to paper walls. Bundles of notes were sold as scrap paper. Wads of money were used to light stoves. As one commentator explained, "An object which had been previously worth twenty-four cents now cost a sum which would formally have equalled three times the entire wealth of Germany!" Dr. Schacht, Germany's National Currency Commissioner, explained that at the end of the Great War one could in theory have bought 500,000,000 eggs for the same price as one egg five years later. Those on fixed incomes literally starved as their incomes became worthless. War loans, mortgages, savings, insurance policies, etc., were all wiped out. Poverty became widespread overnight. The peasants refused to

A one-legged soldier begging on the streets of Berlin

sell their crops and the shops and markets were empty. Pensioners received 10,800 marks in July 1923, enough only for two journeys on a tram, if they were quick enough to spend it. A metal worker who earned 3,000 marks at the end of 1922, received 500,000 in March 1923, then four million marks in July.

Throughout the spring and summer, the crisis intensified. A clear indication of the suffering was the rise in the number of suicides, which reached record levels. Babies were abandoned on the doorsteps of children's homes and starving children were left to fend for themselves. As a consequence, the figures for infant mortality rose above the highest war-time level. One children's hospital reported that thirty per cent of its patients died within twenty-four hours of their admittance.

Larissa Reissner, an eyewitness, explained the situation:

Berlin is starving. In the street everyday people who have fainted from exhaustion are being picked up on the trams and in the queues. Starving drivers drive the trams, starving motormen urge their trains on along the infernal corridors of the underground, starving men go off to work or roam without work for days and nights around the parks and the city's outlying areas.

Starvation hangs on the buses, shutting its eyes on the spinning staircase to the upper deck while advertisements, desolation and motor horns reel past like drunks. Starvation stands guard over Wertheim's majestic counters, taking in twenty thousand million a week when a pound of bread costs roughly ten thousand million. Starvation serves fussily and attentively in the hundreds of deserted department stores that are crammed with riches, golden in the light and as clean and as respectable as the international banks. That young miss on whose pointed triangle of a face there are only bluish recesses for eyes, a little powder and an obsequious smile, points like a hunting dog to some ten-dollar boots and a thirty-dollar rug. While faint with hunger she is selling herself for a penny ha'penny at the old rate and yet she can calculate with a purely German thoroughness and at lightning speed the speculator's billions and trillions, enter them in the account in that exquisite handwriting possessed by this entire nation of highly literate people; as she waits for the next round of staff cuts, she resignedly undoes her shop assistant's overall but still without daring to detach that fawning hungry smile from her face. (L. Reissner, *Hamburg at the Barricades*.)

The German petty-bourgeoisie were ruined, destitute and in absolute turmoil. Peasants, shopkeepers, and even professionals looked desperately to the labour movement for a way out of the crisis. The Social Democratic workers increasingly looked to the Communists. In such an acute economic

Children play with worthless bank notes

crisis, the trade unions were collapsing. The membership dues from workers were now completely worthless. Newspapers and magazines disappeared as newsprint needed to be paid for in gold, but the newspapers sold for nothing. Remarkably, the Communist press made progress, given the thirst for ideas, far outstripping its Social Democratic rivals. The French occupation now seemed to be a minor problem in comparison to the struggle for survival.

While the masses suffered, the German bourgeoisie were able use these circumstances to accumulate vast fortunes. They received their profits in dollars and gold and paid their debts with paper money. Until 1922, the Central Bank interest rate was five per cent a year. In August 1923 it was raised to thirty per cent, and in September 1923 to ninety per cent. However, anyone with access to central bank loans could borrow money and pay it back with devalued currency. But only big business, the likes of Krupp and Thyssen, had access to such funds. Small firms were starved of credit. Industry, especially exporters, boomed as they could undercut competitors in devalued marks, while earning foreign currency. Hugo Stinnes, a wealthy businessman, used the inflation to buy up a vast industrial empire on credit that was later repaid with worthless paper marks. He would also ask for payment for his goods in dollars or gold. Rubbing his hands, he argued forcefully that "the weapon of inflation would have to be used in the future too". Likewise, industrialists such as Thyssen and Krupp accrued greater and greater profits.

On 5 October, the industrialists, including Stinnes, met in a conference with the leaders of the French occupation forces in which their spokesman Klöckner stated:

> The Rhenish-Westphalian coal industry has decided to reintroduce the pre-war working time, as from Monday next... The industry is, however, not in the position to carry out its plans without the support of the Occupation Forces. (E. Anderson, p. 99.)

But the French authorities refused to comply with this request, not wishing to get even more embroiled in an already difficult situation. However, when news of this request leaked out, there was widespread indignation. *Vorwärts* summed up the mood: "With the aid of French bayonets Stinnes tried to subject the German workers to the dictatorship of ruthless industrial exploitation." (ibid., p. 100.) The Ruhr industrialists were even accused of high treason.

While the capitalists lived off the fat of the land, the rest of society was being plunged into destitution. The struggle that had begun as one of national resistance against the French turned now into a bitter class struggle. On 31 March, 53,000 Krupp workers at Essen attempted to stop French troops

requisitioning lorries carrying food supplies. The incident resulted in thirteen dead and forty wounded. On 13 April, at Mülheim, the workers seized the town hall, established a Workers' Council and attempted to organise a workers' militia.

REVOLUTIONARY SITUATION

On May Day in Berlin, the mass procession was led by a vanguard of the 'Proletarian Hundreds' military formation, where 25,000 workers marched shoulder to shoulder with red armbands.

In May, a huge strike wave swept across the country demanding the overthrow of the Cuno government. The situation was becoming increasingly revolutionary. An unstable government was faced with an explosive movement from below. Moreover, the German workers were turning increasingly to the Communist Party for leadership. "At no moment were revolutionary aspirations so deep as in Germany during the summer of 1923," wrote Arthur Rosenberg. (P. Broué, p. 715.) All the objective conditions for socialist revolution, as outlined by Lenin, were rapidly crystallising in Germany: the ruling class was split; the working class was searching for a way forward; the middle class were in ferment and looking to the workers' parties. The situation was crying out for a revolutionary party.

Unfortunately, the KPD was now dragging its feet. After its previous ultra-left adventurism, it swung the other way and became overcautious. The erratic Radek, speaking at a meeting of the German Central Committee in May completely misread the situation:

> Today we are not in a position to institute the proletarian dictatorship because the necessary preconditions, the revolutionary will amongst the majority of the working class, do not yet exist. (ibid., p. 707.)

But the very next day, he was forced to eat his own words as the situation in the Ruhr exploded, with widespread strikes and street fighting.

The party had badly burned its fingers in the failed 'March Action' of 1921 and was determined not to repeat the same mistake. This shaped the psychology of the leadership. They feared leaping too far ahead of the working class. They had become too defensive and were bending the stick in the other direction. The party's correct opposition to putschism now seemed to extend to the very idea of insurrection. It was true that the tactic of patiently winning over the working class through the united front approach had been highly successful. But the new situation demanded that a new turn was needed. While the KPD leaders were wedded to a more cautious approach, sections of the bourgeoisie were growing increasingly alarmed at the situation. On

26 May, a senior German official, the deputy to the District President of Düsseldorf, Dr. Lütterbeck, wrote to the French General Denvignes, for permission for German police to enter the occupied zone to restore order:

> In the presence of these dangers, I take the liberty of emphasising the heavy responsibilities which the French High Command would incur if it showed itself to be indulgent towards anarchy. If it does not itself act, its duty is at least to leave the hands of the German authorities free to accomplish theirs... I take the liberty of recalling in this connection that at the time of the Paris Commune, the German Command did all it could to meet the needs of the French authorities taking repressive action. (ibid., p. 708.)

In response, the Communist Party issued a statement at the end of May which called for the removal of the Cuno government, the need for a workers' government and the arming of the working class. It concluded its call with the slogans:

> Down with the government of national shame and treachery!
> Down with a government which turns to the executioners of the Entente to ask for permission to shoot German workers!
> Down with a government which wants to hand over the railways to private capitalists!
> Down with a government which lets workers, craftsmen and small officials starve while it fattens up the capitalists!
> Up with the united front of all working people, workers by hand and brain in town and country!
> Up with a government of working people, enjoying the trust of the masses abroad, and in a position either to secure peace, even at the cost of sacrifices, or to organise the resistance of the German people if French imperialism refuses to agree to peace!
> To prison with the government's representative, Dr. Lütterbeck! Let him be brought before a People's Court, charged with treason!
> Let those who gave him the order to present the shameful request to the French generals also face a People's Court!
> Workers of the whole German Reich! Say what you think of this government in gigantic meetings and demonstrations!
> Arm to support the workers of the Ruhr! Arm to fight against the burdens the big capitalist capitulators are proposing to lay upon you!
> (B. Fowkes [ed.], pp. 216-217.)

In June, at the enlarged meeting of the Executive of the Comintern, Jakob Walcher estimated that over 2.4 million workers in the trade unions were under the influence of the communists. Heckert believed that between thirty and thirty-five per cent of organised workers were under the party's direction,

roughly 2.5 million. However, Zinoviev, the head of the Comintern, zigzagging from left to right, was now arguing for a more cautious approach: "Germany is on the eve of revolution," he said, adding, however, that, "This does not mean that revolution will come in a month or in a year. Perhaps much more time will be required. But in the historical sense Germany is on the eve of the proletarian revolution." (E.H. Carr, *The Interregnum*, p. 178.) Zinoviev was putting off the revolution for the indefinite future precisely when the mass of the workers were throwing their weight behind the Communist Party. The leadership of the party, unfortunately, was hopelessly out of touch with the mood that was developing, and was tied into an entirely different perspective. As often occurs in revolutionary situations, the masses had moved far to the left of the party, and the party ranks to the left of the party leadership.

LOOKING THE WRONG WAY

Zinoviev saw the approach of the revolution, but as in October 1917, balked at the idea of an insurrection, which he and Kamenev opposed. In fact, the main focus of the discussion at the June meeting of the ECCI was not about preparing for the struggle for power, but about the danger of fascism. Only a moment or two were devoted to the revolution in Germany. This fact alone clearly demonstrated they were seriously lagging behind events, which were changing by the hour. It should have been clear to these leaders that Germany was now in the grip of a revolutionary situation.

At the ECCI meeting, Clara Zetkin had delivered a statement on 'the struggle against fascism', which seemed to be the main preoccupation of the international leadership. In the debate that followed her speech, Radek made a very strange contribution, which referred to the upsurge of nationalism in Germany following the French occupation of the Ruhr:

> Throughout comrade Clara Zetkin's speech, I was obsessed with the name of Schlageter and his tragic fate. The fate of this martyr of German nationalism must not be passed over in silence or honoured only by a passing word. He has much to teach us as well as the German people. We are not sentimental romantics who forget hatred in front of a corpse, or diplomats who say that at a grave one must praise or be silent. Schlageter, the valiant soldier of the counter-revolution deserves a sincere homage from us soldiers of the revolution. His co-thinker Freks published a novel in 1920 in which he described the life of an officer who died in the struggle against the Spartacists. It was called *The Wanderer into Nothingness*. If those German fascists who want to serve their people faithfully do not understand the meaning of Schlageter's fate, then indeed he died in vain and they can inscribe on his

tomb: 'Wanderer into Nothingness'. (A. Rosmer, *Lenin's Moscow*, pp. 196-197.)

Alfred Rosmer, who was present at the meeting, reported that the "delegates were disconcerted. What did this strange preamble mean?" (ibid., p. 197.) The meaning soon became clear. There was to be a 'turn' towards the fascists in an attempt to win over their periphery. Behind Radek's initiative stood Zinoviev, who endorsed the policy. This new orientation became known as the 'Schlageter line' and was soon adopted by the KPD. As a result, the communists sought public debates with the fascists over the following month. After two or three debates with communist speakers, the Nazi Party formally forbid its members to enter into debates with the communists.

> "You're fighting Jewish finance," stated Remmele to the fascists, "Good! But also fight the other finance, that of Thyssen, Krupp, Stinnes, Klöckner and so on!", and he made the anti-Semites applaud the class struggle. "You are fighting the workers because your masters, the big capitalists, want to divide and rule, want to divide you people from the ruined proletarianised middle classes, from us proletarians!", and he got these reactionaries to applaud the united front of all the exploited. "Are you patriots?", he asked, and he showed how big German industry was linked in many profitable deals with French capital, selling it its manufacturing secrets, like the *Baden* aniline trust, preparing the way for the colonisation of Germany, and getting rich from the falling value of the mark. "Which of you wants to get killed for capitalist Germany?", and he got the whole hall to shout out: "None of us!" (Quoted by V. Serge, 'Observations in Germany'.)

While this campaign had a certain success, fascism was not going to be defeated in an ideological debate over who could best defend the national interests of Germany. The debates did, however, give ammunition to the Social Democratic leaders who denounced "the collusion of communist and fascist leaders". They even reproduced Radek's ECCI speech, as did the 'liberal' papers. *Vorwärts* headed its article, 'Radek celebrates Schlageter'.

The 'Schlageter line', while making some inroads into the base of the fascists, was not focusing the party on the real needs of the situation, namely the concrete preparations for revolution. The ECCI meeting was a missed opportunity to put the party back on track, but unfortunately neither Lenin, who was lying incapacitated, nor Trotsky were present.

Within a few weeks, while the Communist leadership were talking about fascism, Stresemann, a leading German bourgeois politician, and later Reich Chancellor, was talking of the dangers of socialist revolution. "We are dancing on a volcano and the revolution confronts us," he warned. (W. Held,

'Why the German Revolution Failed', from *Fourth International*, Vol. 3, No. 12, pp. 377-382 and Vol. 4 No. 1, pp. 21-26.) This bourgeois politician understood the situation in Germany more than the World Party of Socialist Revolution.

There was only one election held during the crisis of 1923, which was indicative of the real mood that existed. That was in the rural region of Mecklenburg-Strelitz in July, therefore not the most politically advanced area. The vote cast for the bourgeois parties in the election fell from 18,000 (in 1920) to 11,000. The Social Democratic vote similarly fell from 23,000 to 12,800, despite the reunification with the right-wing Independents the year before. While the Independents in 1920, regarded as the extreme left, won 2,257 votes, the Communist Party, standing for the first time in a region where they had no base, now received 10,853 votes, or about twenty per cent of the total vote cast. This was an astonishing result in such a rural area and reflected the massive radicalisation taking place.

The membership of the Communist Youth had increased from 30,000 in the autumn of 1922 to more than 70,000 by the summer of 1923. The number of communist factions in the trade unions grew from 4,000 in June to 6,000 in October. The KPD held a majority within the 2,000 factory committees. These factory committees went far beyond the limits of the factory council legislation and were becoming the principal points of support for the revolution. They in turn linked up with 'control committees', which were formed by housewives' groups set up to control prices, thereby deepening their roots in the working class. The communists also organised the 'Red' or 'Proletarian Hundreds', militant defence organisations of 100 men, which developed into extensive military organisations in Thuringia and Saxony. This was part of their call to establish workers' self-defence groups throughout the country. These, together with the shop committees, could provide the basis for organs of potential dual power, and a new workers' revolutionary government.

Meanwhile, hyperinflation continued to cripple economic life. "Paper money began to flow like water," wrote Philips Price. "Seven billion marks were printed in less than two and a half months. It was a paradise – of paper and on paper." He later reported:

> Prices are rushing upwards in a way that once would have seemed incredible, but to which we are now becoming accustomed. Food prices in the shops are higher at noon than in the morning, higher in the evening than at noon. And nobody thinks of tomorrow. Under these circumstances the centre parties are losing their hold and their morale. The drift is more and more to the extreme Right or to the extreme Left, because nobody sees any room for

hope in the existing order. (M. Philips Price, *Dispatches*, pp. 157-158 and p. 160.)

The extreme political polarisation in society, together with the loss of hope in the existing order, were characteristics of a revolutionary situation. The economic and social collapse had reached unbelievable proportions, with hardly a facet of 'normal' civilised life remaining. The comfortable living standards of the middle class had been completely wiped out. Doctors and professors were evicted from their apartments. Having sold their family heirlooms for bread and soap, many had been forced into the ranks of the swollen unemployed, which had consumed half the workforce. Yet unemployment benefit was not enough to buy a bottle of milk each week. The old and sick desperately rummaged through piles of rubbish for something to eat. The illusions in capitalist democracy were being forcibly torn away in this ongoing nightmare. In this struggle for survival, many were drawing the conclusions that a revolution was necessary. Demonstrations and strikes were clearly not enough, although there were those who, out of desperation, resorted to food riots, and shops were regularly looted. These layers naturally looked to the Communist Party for a revolutionary lead out of the situation, as tens of thousands of workers were attracted to the party through the factory committees and the unemployed workers' movement. They also joined through the 'Hundreds', which were being formed in every area in preparation for the coming showdown. By July, the Cuno government was on the brink of collapse.

ANTI-FASCIST DAY

The Reichswehr troops were in Bavaria. In Saxony, the bourgeois deputies had already walked out of the Landtag in protest at the 'Bolshevik' policies of the government. There were clear preparations being made to act against the left governments of Saxony and Thuringia.

The party felt there needed to be a show of strength against the increasing activities of the fascists. They therefore decided to call an 'Anti-Fascist day' for Sunday 29 July, with street demonstrations planned in all major the cities.

The bourgeois press immediately denounced the planned protests as an act of civil war. On 23 July, the Prussian government issued a ban on all open-air processions and demonstrations on 29 July. This was then followed by a ban throughout Germany, except in Saxony and Thuringia. Brandler, the chairman of the party, recognising the seriousness of the situation, and, preferring not to take lone responsibility, sought advice from Moscow.

By this time, Lenin had suffered a third stroke on 9 March 1923 and was no longer involved politically. Meanwhile, the intrigues in the politburo

had also hardened against Trotsky, who was opposed by the secret faction of Stalin, Zinoviev and Kamenev. The conspirators were determined to keep Trotsky from becoming Lenin's successor and manoeuvred to undermine him at every opportunity. "The year 1923 was the first year of the intense but still silent stifling and routing of the Bolshevik party," wrote Trotsky. (*My Life*, p. 432.)

When Brandler's telegram arrived concerning the ban on the anti-fascist demonstrations, only Radek was present in Moscow. Zinoviev, Bukharin, and Trotsky were on vacation in the Caucasus. However, when contacted, Zinoviev and Bukharin telegraphed their wholehearted support for the demonstrations and were in favour of breaking the government ban.

> It is only by such methods as the appeal issued on 12 July that the German Communist Party can become, in the eyes of the whole of the workers, the generally acknowledged champion and the united centre of the whole proletariat in the struggle against fascism. Without this, the sad experience suffered by Italy and Bulgaria will be repeated.

They concluded by attacking the apparent conservatism in the German leadership. "In the German Zentrale there are more than enough retarding elements, and elements standing for prudence and caution." (Communist Party of Great Britain, *Errors of Trotskyism*, p. 346.)

Radek was opposed to defying the ban, feeling it was too risky. Alarmed, he telegraphed Zinoviev and Bukharin warning that to force the struggle in Germany meant "steering towards a defeat in July for fear of a repetition of the Bulgarian events". Trotsky said he could not give a definite opinion as he was not sufficiently informed about what was happening on the ground. However, Stalin shared Radek's scepticism, and wrote a letter to Zinoviev and Bukharin, saying he was opposed to defying the ban and instead urged caution:

> Should the [German] Communists strive, at the present stage, to seize power without the Social Democrats? Are they sufficiently ripe for that? That is the question, in my opinion. When we seized power, we had in Russia such resources in reserve as (a) the promise [of] peace; (b) the slogan 'land to the peasants'; (c) the support of the great majority of the working class; and (d) the sympathy of the peasantry. At the moment, the German Communists have nothing of the kind. They have, of course, a Soviet country as neighbour, which we did not have; but what can we offer them? ... If the Government in Germany topple over now, in a manner of speaking, and the Communists were to seize hold of it, they would end up in a crash. That, in the 'best' case. Whilst, at worst, they will be smashed to smithereens and thrown way back.

The whole point is not that Brandler wants to 'educate the masses' but that the bourgeoisie plus the right-wing Social Democrats are bound to turn such lessons – the demonstration – into a general battle (at present all the odds are on their side) and exterminate them [the German Communists]. Of course, the Fascists are not asleep; but it is to our advantage to let them attack first: that will attract the whole working class to the Communists (Germany is not Bulgaria). Besides, all our information indicates that in Germany fascism is weak. *In my opinion, we should restrain the Germans, not spur them on.* (L. Trotsky, *Stalin*, p. 530, emphasis added.)

Although this letter is not in the Stalin *Collected Works*, its authenticity was verified by Brandler, who translated the letter from Russian into German. Brandler at this time was the vice-chairman of the Comintern. (See I. Deutscher, *Marxism, Wars and Revolutions*, p. 137.)

Following this, Radek, together with Stalin, telegraphed Brandler on behalf of the presidium of the Comintern to advise him to abandon the street demonstrations, fearing the party was heading for another abortive insurrection as in March 1921.

The retreat was announced publicly in *Rote Fahne*. It stated that "the workers were not sufficiently prepared," and that "we not only cannot offer a general battle, but should avoid everything that might give the enemy the chance to destroy us piecemeal." (E.H. Carr, *The Interregnum*, p. 188.)

The Comintern's advice was in complete contrast to the heightened revolutionary mood in Germany. On 26 July, the *Kreuz-Zeitung* newspaper wrote:

Without any doubt we are on the eve of another revolution – who could still be mistaken after seeing what is unfolding before our eyes.

The next day, *Germania* stated:

Confidence in the government of the Reich is deeply shaken... Discontent has reached a dangerous level. Fury is general. The atmosphere is electric. One spark and there will be an explosion... This is the mood of 9 November. (Quoted in P. Broué, p. 742.)

Politics may be defined as the art of taking advantage of favourable situations. The situation in Germany, according to many, was extremely favourable. However, Radek, once again, urged caution. "But do not let us seek a premature confrontation. Such is the situation in Germany. Such are the duties of the Communist Party." (ibid., p. 744.) As a result, this cautious position was adopted by Brandler at the Central Committee on 5-6 August. Being naturally hesitant, it was a line he felt comfortable with. He looked

forward to the collapse of the bourgeois government, but believed that it was premature to struggle for a proletarian revolution. He also thought that a section of the Social Democrats could still be won over by propaganda. He failed to understand that the Social Democratic workers were already looking to the Communists.

By August, inflation had accelerated even further. Prices were now doubling every few hours. Spontaneous strike movements, numbering roughly three million workers, culminated in a spontaneous general strike which began in Berlin on 11 August and rapidly spread throughout the country. Its central aim was the overthrow of the Cuno government, which epitomised all that was rotten in Germany.

Apart from the movement against the Kapp putsch, this strike was the largest and most intense ever experienced in Germany. Whereas in March 1920 the trade union leaders called for strike action from above, now the movement arose spontaneously from below.

Shipyards, gas, electricity, transport, even the printers printing the government's banknotes stopped work. The Reichsbank announced it was closing its operation, as it had run out of paper notes. Out of utter desperation and yearning for a revolutionary solution, hundreds of thousands of workers shifted from supporting the Social Democrats to supporting the KPD. The hour had arrived to strike. This was the equivalent of the month of October in Russia in 1917.

The storm was about to break, and finally on 12 August, faced by a widespread general strike, the Cuno government finally collapsed. As a result, the Communist leaders could no longer ignore the seriousness that faced the party. The majority of workers were behind them. All they needed to do was to act, but that was the problem.

Ebert tried to seize the initiative by calling on Gustav Stresemann of the National People's Party to form a new government. Stresemann represented the party of the industrialists and was a personal friend of Stinnes. He reflected the views of the Ruhr industrialists in particular, who were keen to abandon the Cuno policy of passive resistance. He cleverly pulled together a government of all parties, including the SPD, but which excluded, of course, the KPD and the extreme right. Four Social Democrats joined the government with the expressed intention of creating political stability. As they calculated, with Cuno gone, the mass movement would tend to dissipate. The Social Democrats and trade union leaders did all they could to restore order and defuse the situation, including putting an end to the strike.

In the middle of August, Zinoviev and the other Comintern leaders had woken up to the fact that Germany was on the brink of revolution.

Trotsky, hearing the news of the strike against the Cuno government and then the formation of the Stresemann government, invited two members of the German party, August Enderle and Jakob Walcher, who were in Moscow attending the Executive Committee of the Profintern, to visit him urgently in the Caucasus. "If Brandler is writing proclamations like this... then we are almost there," Trotsky told the two Germans. (I. Deutscher, *Marxism, Wars and Revolutions*, p. 162.) After the meeting, he asked one of them to return to Berlin as a point of contact. Within a week, the Russian leaders had all returned to Moscow to evaluate the situation in Germany.

The German leadership, including Brandler, were also hastily summoned to Moscow to discuss the abrupt turn of events. When they arrived, they were surprised to see the city covered in banners greeting the German comrades with the slogans: "Russian Youth Learn German! The German October is Approaching!" The German leaders were taken aback by the welcome.

On 23 August, in the extraordinary meeting of the Politburo, Radek gave an updated report on the situation in Germany. Trotsky, who had already realised the significance of what was happening, intervened decisively to explain that the German October was staring them in the face. For him, there were only a few weeks left to prepare for an insurrection. Zinoviev, however, preferred to count in months rather than weeks, but nevertheless broadly agreed. Stalin saw no revolution in the autumn; it might break out in the spring, but even that was dubious, he thought.

However, such doubts were put aside. The common feeling was that the German Revolution demanded urgent action. Maslow and Fischer, the Left leaders, were summoned to Moscow to play their part in the preparations and bind them to the agreement. There could be no loose ends left open which the Lefts could use to cause trouble.

PREPARING THE INSURRECTION

> There is a tide in the affairs of men
> Which, taken at the flood, leads on to fortune;
> Omitted, all the voyage of their life
> Is bound in shallows and in miseries.
> On such a full sea are we now afloat,
> And we must take the current when it serves,
> Or lose our ventures.
> (W. Shakespeare, *Julius Caesar.*)

The leaders of the International in discussions with the German Communists concluded that technical preparations for the insurrection should be undertaken immediately. The ECCI set up a commission to oversee the

preparations, composed of Radek, in charge of party relations; Pyatakov, who supervised military affairs; while Shmidt was to establish links with the trade unions.

In a secret meeting at the end of September 1923, Trotsky introduced the report by proposing that the German party set a date for the insurrection, which he proposed, as the symbolic date of the 7 November. Lenin had adopted the same attitude in pushing the Bolsheviks to set a date for their insurrection, saying that the success of the Russian and world revolution would be measured in days.

And yet Radek and Brandler rejected Trotsky's proposal. They were clearly equivocal about the revolutionary character of the situation in Germany. In private Brandler expressed doubts about whether the party was sufficiently prepared, politically or technically, for the revolution. He wanted to delay the plans. The same went for Radek and Stalin. Reluctantly, they went along with the general view.

Trotsky went into writing about the question of an insurrection in *Pravda* on 23 September, entitled 'Can a counter-revolution or a revolution be made on schedule?' Referring to the experiences of the Jacobins in 1789, the Bolsheviks in 1917, the coups of Mussolini, and those in Spain and Bulgaria, he explained that they had all set a date in advance. To adopt a waiting attitude in face of "the growing revolutionary movement of the proletariat" was Menshevism, he said. However, he deliberately avoided mentioning Germany in the article for diplomatic and security reasons.

Nevertheless, Brandler was adamant that the timing should be left to those on the ground, which, in a compromise suggested by Zinoviev, was eventually agreed. Brandler, who was feeling the weight of the task on his shoulders, requested that Trotsky, who he greatly admired, be sent to Germany to lead the decisive battle. This was firmly opposed by Zinoviev, who rejected the idea for prestige reasons. Behind the scenes, the troika were attempting to discredit Trotsky. The very idea that he should be sent to Germany to guarantee the success of the revolution, and all that meant, would only enhance his massive standing. For the troika, this would have been intolerable. They decided to send the German Commission instead.

The German party had already established its secret military organisation, the M-Apparat, which had been strengthened by Red Army experts. As we have already seen, in many towns and factories, armed defence groups had been established throughout the year, the 'Proletarian Hundreds'. These had first come into being during the Rathenau Campaign of 1922, but had arisen again. They were considered the shock troops of the revolution, numbering 300 in May and by October their number had reached 800, with more

than 100,000 men under arms in total. They were not simply made up of communists, but contained many from the trade unions and even members of the SPD.

According to Broué:

> The whole party was on a war footing. From the first days of September, with the help of several dozen specialists sent by the ECCI, tens of thousands of activists had gone underground. Members of the shock groups of the hundreds had left their factories, and known activists had changed their names and addresses. In all the big cities, men were sleeping, and sometimes spending entire days and nights, in apartments converted into dormitories or clandestine headquarters, where they studied maps of the cities and the region, and the location of the forces of order and of communications. Periodically, by action groups and hundreds, they carried out exercises in response to orders. (*The German Revolution*, p. 772.)

Within the leadership of the German party, however, there were those who still took a more cautious, longer-term perspective, such as Thalheimer. At the end of August, when the situation was still critical, he wrote:

> Consequently, we shall have to travel a long road, both on the political and the organisational plane, before we meet the conditions which will ensure the victory of the working class. History will decide how long the necessary interval will be. (ibid., p. 774.)

This statement would appear in the October issue of the British *Labour Monthly*, edited by Palm Dutt, when the German party should have been launching an insurrection.

By the end of September, inflation now spiralled completely out of control. A day's wage of a Hamburg docker came to 17 billion marks. Industrial production began to decline drastically and the 'resistance' in the Ruhr was becoming extremely costly for the German bourgeoisie. As a result, on 26 September, the new Stresemann government announced the end of passive resistance and the need for greater self-sacrifice, which opened up the possibility of a deal with Britain and the USA to help stabilise the currency, which was subsequently agreed.

As the passive resistance came to an end, a coup was carried out in Bavaria by the monarchist, von Kahr, who now installed himself as the High Commissioner. He then immediately declared martial law. In response to this threat to the unity of the Reich, Ebert declared martial law throughout the whole of Germany, with the full support of the Social Democratic ministers. In the ensuing conflict between von Kahr and the central government, the Bavarian army was ordered to oust Kahr, but General Lossow refused to obey

the orders from Berlin. This meant an open rebellion. But instead of sending the Reichswehr into Bavaria to restore order, Stresemann ordered the army to move instead against the left governments of Saxony and Thuringia, despite the fact they were perfectly constitutional.

These factors now entered into the tactics of the German party. Rather than in Berlin, the capital, insurrection would begin in Saxony. This was a surprise, as the party was much stronger in most other areas, including Hamburg, Berlin, or the Ruhr. The reason why Saxony was chosen was due to the fact that in the Saxon elections, the left – the SPD and KPD – had gained a combined majority over all other parties in the Landtag. There could have been an SPD-KPD coalition government, but this was vetoed by the ECCI, which pushed the Social Democrats into forming a coalition with the bourgeois parties. This coalition, however, broke down quickly, with the bourgeois parties abandoning the government. Therefore, since the beginning of 1923, a minority Social Democratic government under Zeigner ruled with the votes of the KPD. It was also made clear that if the KPD wanted to join the government in a coalition, they could do so whenever they wished.

OCTOBER DAYS

On 1 October, a telegram was sent by Zinoviev on behalf of the ECCI to the German party, calling for them to enter the state governments of Saxony and Thuringia and use them as a springboard for the coming Revolution. He explained that:

> Since we estimate the situation in such a way that the decisive moment will come in four, five, six weeks, we think it necessary to seize at once every position which can be directly utilised. The situation compels us to raise in a practical form the question of our entry into the Saxon Government. On the condition that the Zeigner people are really prepared to defend Saxony against Bavaria and the Fascists, [then] we must enter. Carry out at once the arming of 50,000 to 60,000 men, [and] ignore General Müller. The same in Thuringia. (E.H. Carr, *The Interregnum*, pp. 207-208.)

The headquarters of the party was to be moved from Berlin to Saxony, with certain members of the Central Committee.

Brandler strongly opposed this plan:

> I kept on explaining to them that the Saxon government was in no position to arm the workers because since the Kapp Putsch all weapons had been taken away from Saxony and neighbouring provinces, so much so that even the police were not armed. (I. Deutscher, *Marxism, Wars and Revolutions*, p. 137.)

But Zinoviev rejected Brandler's objections. The Comintern leadership reasoned that any military force used against these left governments could be used as the pretext for launching a revolutionary counter-offensive. Plans were then laid for a national general strike which would provide the basis for an insurrection. According to Ruth Fischer:

> After this brief, preparatory stage, a general uprising would be declared... The Red Army of Saxony would march to Berlin, and the Thuringians to Munich, the centres of the counter-revolution, and during its march the Red Army of central Germany would rally around itself all forces willing to overthrow the government. (Quoted in J. Braunthal, *The History of the International 1914-1943*, p. 280.)

Again, according to Brandler:

> I told myself that these people had made three revolutions. To me their decisions seemed nonsensical. However, not I but they were considered seasoned revolutionaries and I was just about to try to make one. Well, I had to follow their instructions. (I. Deutscher, *Marxism, Wars and Revolutions*, p. 138.)

Apart from Maslow, who remained in Moscow to prevent him from interfering, the other KPD leaders quickly headed back to Germany. On Brandler's arrival, on 12 October, he and two other communist state deputies entered the Saxon 'government of proletarian defence'.

Precious months that were needed to politically prepare the working class for the seizure of power had been lost due to the incapacity of the KPD leaders to judge the situation correctly. While the party's military preparations went ahead with feverish haste, the party's political preparations were largely carried on at the same pace as before.

Some time later, Brandler explained:

> During my return journey from Moscow to Berlin I bought a newspaper at the railway station in Warsaw. From this newspaper I learned that I had become a Minister in the Saxon government. What a situation! Things were being done behind my back and I knew nothing. (ibid., p. 138.)

In the Saxon government, Brandler became Assistant Secretary in charge of the state chancellery, Paul Bottcher became Minister of Finance, and Fritz Heckert became Minister of the Economy. Three days later, three other KPD deputies entered the government of Thuringia. But in neither case did the KPD control the government, so they were at the mercy of the Social Democrats. Their task, as they saw it, was to use these ministerial positions to speak over the heads of the reformist ministers to demand the requisitioning

of food, the establishment of factory committees, and the arming of the working class. The intention was to prepare the population for a life or death struggle with the regime nationally. But this strategy turned out to be very risky.

The situation was clearly coming to a head. On 20 October, the Reichswehr issued an ultimatum to the Saxon government to dissolve the 'Proletarian Hundreds' within its jurisdiction. They were given three days to comply. Zeigner, the head of the Saxon government, assured the Landtag that he was determined to resist these threats. Following this, the Landtag rejected General Müller's ultimatum. On 21 October, with the full backing of Stresemann, Müller's troops entered Saxony 'to restore public order'. It was a make or break situation. In the face of this, the KPD leaders acted to alert the party and implement the plans for an insurrection.

That same day, on Brandler's initiative, a trade union conference at Chemnitz was hastily chosen as the launching pad for a national general strike in defence of the left-led governments. The problem was there were no guarantees that the conference would back such a call. In effect, the delegates at the conference were handed a veto over the insurrection plans. The strategy was especially risky given that the trade union ranks tended to lag behind the real situation. It should be recalled that in Russia, the Mensheviks still controlled many trade unions even after the Bolsheviks had taken power in October 1917.

As feared, the delegates lagged behind the real mood in society. According to Rosa Leviné-Meyer, "it [the conference] was chiefly composed of moderate delegates equal to dealing only with current problems of workers' welfare." (R. Leviné-Meyer, *Inside German Communism*, p. 53.)

The Chemnitz conference opened with routine reports from three Landtag Ministers. Then Brandler intervened. He addressed the conference for several hours outlining the case for a general strike to oppose Müller's troops. He demanded that a vote on the strike call be taken immediately. But the vote was blocked by strong objections from the Social Democratic leaders. They argued that a general strike would simply provoke the army and play into their hands. "We must not provoke the reaction!" they cried. Georg Graupe, the Social Democratic Minister of Labour, argued that the conference was not competent to take a decision about a general strike. Such opposition was not unexpected. The Social Democrats were not prepared to lead a struggle against Berlin, nor organise a revolutionary general strike.

Graupe then held a pistol to the head of Brandler by threatening that the Social Democrats would walk out of the conference if the question of a general strike was put to the meeting. Instead, he proposed the setting up of

a parity commission of the SPD and KPD to 'consider' in more detail the proposal of the general strike. Thalheimer later commented that Brandler's proposal for a general strike had been met with an "icy" reception. "None of those present, not even Brandler himself, took it seriously," explained Rosa Leviné-Meyer. (ibid., p. 53.)

After this stonewalling, Brandler felt that there was no alternative but to abandon the plans for a general strike as well as the insurrection. This was now quickly endorsed by Radek and the other Comintern representatives. The party had been outmanoeuvred by the reformist leaders and was now completely disoriented with no alternative plans. The decision of the Chemnitz conference could not have been more calculated to produce the maximum confusion. Brandler and Thalheimer, in particular, had bungled the affair. But behind them stood the foot-dragging advice of the Comintern leaders, not least of all Stalin.

As expected, this debacle gave added encouragement to the military authorities. Within days, government troops under General Müller were able to remove the head of the Saxon government, Zeigner, without meeting any resistance. He was simply arrested and the state government deposed. This was followed by the government in Thuringia. The resistance simply crumbled.

General Müller assumed full powers in Saxony and placed a ban on all meetings and strikes. This open attack needed to be met head on, as with the Bolsheviks against Kornilov, if the reaction was to be stopped in its tracks. Facing this threat, the working class should have been armed, but Zeigner refused. In face of the onslaught, the Social Democrats put up a feeble verbal protest against Müller, but did nothing more. Under the circumstances, the call for a general strike by the communists was only partially supported and soon petered out. Despite one of the most favourable opportunities for taking power that had existed in Germany, it was completely wasted and the revolution was derailed.

In an interview with C.L.R. James in 1939, Trotsky briefly summed up the situation:

> I had many interviews with Brandler. He told me that what was troubling him was not the seizure of power, but what to do after. I told him "Look here, Brandler, you say the prospects are good, but the bourgeoisie is in power, in control of the state, the army, police, etc. The question is to break that power..." Brandler took many notes during many discussions with me. But this very boldness of his was only a cover for his secret fears. It is not easy to lead a struggle against bourgeois society. He went to Chemnitz and there met the leaders of the Social Democracy, a collection of little Brandlers.

He communicated to them in his speech his secret fears by the very way he spoke to them. Naturally they drew back and this mood of defeatism permeated to the workers. (L. Trotsky, *Writings 1938-39*, p. 261.)

After the disastrous Chemnitz conference, and the decision to call off the uprising, KPD emissaries were despatched throughout Germany to carry the news of the change of plans. But inexplicably Thälmann and Remmele, two Central Committee members, had left the conference before the end, under the impression that they had secured a majority for the general strike. They arrived in Hamburg on the evening of 22 October, and gave the go ahead for the uprising.

HAMBURG UPRISING

In Hamburg, as elsewhere, expectations were rising amongst the communists for a successful revolution. Tens of thousands had been involved in pitched battles with the police over their right to protest in the streets. Such was the revolutionary mood, even the police were affected and showed some sympathy with the starving workers. But the workers were also becoming anxious. A Hamburg worker described a telling incident on Monday 22 October:

A fellow worker, standing in front of a butcher's shop, looking at the meat, caught me by the hand and said, "If the Communists don't do something and do it at once, their party will fall apart".

That evening there was a women's meeting in a district of Hamburg. On the agenda was one item: Hunger. The meeting was packed and tempers were high after having spent the day vainly looking for something to eat. They were prepared for anything, including battle.

The Communist Party held a meeting that night to discuss the insurrection, news of which was awaited hourly from Chemnitz. The uprising was scheduled for the following day but, apparently, there had been little in the way of concrete preparations, apart from a general strike and the taking of police stations.

On 23 October, while the Reichswehr was advancing on Dresden, the capital of Saxony, 1,300 KPD members seized seventeen Hamburg police stations before 5:30 in the morning, and a number of barricades were erected in workers' districts. During the night, telephone lines had been cut to disrupt government communications.

Those without weapons were sent to the railway station and factory gates to get the workers to join the general strike. However, the response was muted and the workers remained generally passive, although 10,000 dockworkers did go on strike. During the uprising, most factories and workplaces worked

normally. The reality was, a small number of communists fought in single combat with the state forces, while the masses passively looked on.

Clara Zetkin described the events in Hamburg:

> Thousands went past these fighters every day, tens and tens of thousands of strikers. We were assured that in their heart they were sympathetic... but they themselves kept their hands in their pockets. (J. Braunthal, *History of the International*, p. 282.)

Those who participated in the action believed they were part of a general mass uprising throughout Germany. For three days, hundreds of brave communists fought heroically against the police in the Barmbeck and Schiffbek districts of Hamburg. Nevertheless, eventually the insurrection collapsed, as troops quickly arrived to crush the rebellion. A total of twenty-one insurgents lost their lives, 165 were wounded and 102 were taken prisoner.

Jan Valtin took part in the abortive uprising in Hamburg and described the scenes in his autobiography:

> I could still hear the sounds of rifle fire interspersed with heavier explosions. I wondered what the party was doing in Berlin, in Saxony, in Silesia, elsewhere. Like my comrades, I took it for granted that the Red Hundreds had gone into battle all over Germany...
>
> A thought burned in my brain: 'If the insurrection in other parts of the country had failed, we in Hamburg are lost.' The masses, idle in strike, were not willing to fill the gaps of our ranks. The Communist vanguard fought. The masses were passive. Perhaps the workers really did not want a revolution? I brushed the doubts aside. A skirmish line blocked the street ahead. (J. Valtin, pp. 70-71.)

He managed to escape, however.

Rosa Leviné-Meyer described what happened:

> There are conflicting versions about the origin of the 'Hamburg Barricades'. Some attribute it to a misinterpreted wave of Thälmann's hand at the Conference, others to his explicit order: it was alleged that he had to leave the Conference at an earlier hour and, without any doubt in his mind that an insurrection would take place, gave the signal. When the news of the misunderstanding reached him 'he had not the heart to terminate the battle...'
>
> Characteristically, even this abortive battle was looked upon with pride. The workers cherished the memory of 'The Hamburg Barricades', and it greatly enhanced, rather than damaged, the prestige of Thälmann, its unwitting initiator. (*Inside German Communism*, p. 54.)

In reality, the Hamburg events were simply one more abortive episode in the German revolution. The German Communist Party had been put to the test once more but had failed to live up to the challenge. The humiliating collapse of the general strike, the crushing defeat in Saxony and Thuringia, and now the bloody shambles in Hamburg, was a demoralising blow for the workers who looked to the communists for a lead. The missed opportunity was disastrous for the German and international working class, but above all for the Russian workers, who looked to the German revolution as a way out of their isolation.

The Zentrale of the German party met on 23 October and adopted a resolution which attempted to justify calling off the insurrection, but attempted to cover their tracks by placing the blame on the shoulders of the working class. At this time, the Hamburg uprising was still going on. Furthermore, the governments in Saxony and Thuringia had not yet been overthrown, but the KPD had already sounded the retreat.

It declared:

> The social and political antagonisms grow increasingly sharp by the day. Each day may bring decisive battles between the revolution and the counter-revolution.

> The vanguard of the working class – the Communists and part of the Social Democratic workers – wishes to engage in the struggle, but the working class as a whole is not ready to fight, despite its immense bitterness and appalling poverty.

It then continued:

> This is why it is necessary, by resolute agitation, to raise the reserves of the proletariat nearer to its vanguard. The party must develop a special approach that can help increase its influence amongst the strata of the proletariat which showed themselves disposed to fight, such as metalworkers, miners, railway workers, agricultural workers and clerks. The technical preparations must be continued with particular energy. In order to bring about the unity of the proletariat in the struggle, we must immediately begin discussions with Social Democracy at the central and local levels, in order either to force the Social Democrats to struggle, or to separate the Social Democratic workers from their treacherous leaders.

> In these circumstances, the party must as far as possible restrain the comrades from armed struggle, in order to gain time for preparation. If, however, extensive proletarian struggles break out spontaneously, the party will support them with every means at its disposal. It must also ward off the blows of the counter-revolution by means of mass struggles, such as

demonstrations and political strikes. As far as possible, it must avoid armed struggle in these conflicts.

The party throughout the Reich must call for protest strikes against the Stresemann ultimatum. Armed insurrection is ruled out during these activities. If the Social Democratic Party in Saxony does not undertake to struggle against the Stresemann ultimatum, our comrades in the Saxon government must break with it, and engage in struggle against it. (P. Broué, pp. 812-813.)

The instruction that the party should 'break' with the Saxon government unless it adhered to an ultimatum was a sign of weakness not strength and this ambivalence only added to the confusion. The party brushed over the question of insurrection by talking of a defensive united front with the Social Democrats against the forces of reaction. But the Saxon government was driven out by force by the military under Müller. The Communist Party called a general strike from below, but it collapsed after three days. This reflected the confusion and demoralisation which had followed the Chemnitz conference and the betrayal of Zeigler. Within days, in Saxony a new Social Democratic government was sworn in under the right-wing Dr. Alfred Fellisch to replace the 'untrustworthy' Zeigner. Once again, the right-wing Social Democrats had, when called upon, played second fiddle to reaction and stepped into the breach.

The whole experienced was summed up by R. Albert:

In Germany, in September, October and November, we lived through a profound revolutionary experience, still little known and often little understood. We were on the threshold of a revolution. The night watches were long. Zero hour was not signalled... A silent and hardly probable drama. A million revolutionaries were ready, awaiting the word to attack. Behind them were millions of jobless, starving, bruised, desperate, a whole suffering people, murmuring: 'We too! We too!' The muscles of this crowd were tense, their hands gripped the rifles with which they were to oppose the armoured cars of the Reichswehr... Nothing happened. There was nothing but the bloody clowning at Dresden, where a corporal with a few soldiers turned out of their ministries the workers' ministers who had made bourgeois Germany tremble. There were a few puddles of blood – sixty dead in all – on the streets of the industrial cities of Saxony. Now bankrupt Social Democracy can rejoice at having emerged from the massive and passive adventure, still ponderously loyal to its old abjurations. (Ibid., pp. 815-816.)

The missed revolutionary opportunity had turned into another fiasco, and the counter-revolution took full advantage of the debacle. On 23 November,

the KPD was declared illegal and its press closed down. Arrests soon followed. By the middle of November order had been restored, as General Seeckt, Commander in Chief of the Reichswehr, used his forces to crush all opposition and consolidate the position of the central government. He even went so far as to dissolve the Black Reichswehr, which he himself had established, as it was becoming a threat to his authority.

The party's Zentrale again met on 28 October and in the light of the news from Hamburg discussed three alternatives – from Ruth Fischer's call for an immediate mass strike and armed insurrection to simply a general strike and, lastly, to take no action at all. Instead, amid the confusion, it was decided to establish a commission of three to look for a way forward. The Zentrale meeting was still in session when Dr. Fellisch's Social Democratic government was being installed.

A resolution was then adopted which painted a very bleak picture of the situation, including the victory of fascism. In mitigation, it should be said that the term 'fascism' was used rather loosely at this time in the Comintern:

> Over the whole territory of unoccupied Germany, the November Republic has been delivered over to Fascism… The Fascist headquarters was established in Berlin itself, in the shape of the dictatorship of General Seeckt… The responsibility for the victory of Fascism falls completely on the leaders of the SPD…

The resolution proclaimed that the party, "calmly, resolutely and with iron self-belief declares a war to the death against the Fascist dictatorship." It then went on to raise the ultra-left idea that "the united front will be set up from below." (B. Fowkes [ed.], pp. 98-99.)[1]

The KPD hoped in this way to bypass the leadership of the trade unions and the SPD, but this was wishful thinking. If they were strong enough to bypass them, then there would be no need at all for a united front. This thesis of the Brandlerite Zentrale, which was an attempt to cover their tracks with verbal radicalism, was passed by forty votes to sixteen, as against the Left's thesis which sharply condemned Brandler.

1 Trotsky answered this point about 'from below' in his theses on the united front in March 1922: "Does the united front extend only to the working masses or does it also include the opportunist leaders? The very posing of the question is a product of misunderstanding. If we were able simply to unite the working masses around our own banner our practical immediate slogans, and skip over reformist organisations, whether party or trade union, that would of course be the best thing in the world. But then the very question of the united front would not exist in its present form." (L. Trotsky, *The First Five Years*, vol.2, pp. 93-94.)

The events of 1923 proved to be a turning point in the history of the German working class. It was a massive defeat from which the KPD leaders refused to draw the correct lessons. As a result, it was to prepare the ground, not for victories, but for future setbacks.

HITLER'S BEER HALL PUTSCH

In October 1922, a 30,000-strong counter-revolutionary gang of fascists had marched on Rome and, with the full approval of the King, managed to install Mussolini as premier. This followed the failure of the Italian revolution, when in September 1920, 500,000 metalworkers and others had occupied the factories, but failed to seize the reins of power due to the treacherous role of the reformist leadership of the movement. Terrified, the Italian bourgeois took fright and financed and organised the fascists to murder trade unionists, burn down their headquarters and generally terrorise the working class. This brought Mussolini's *fascisti* to their feet.

This Italian experience provided a model for the German fascists, who hoped to do the same thing by marching on Berlin and set up a fascist state. They hoped to capitalise on the deep-felt humiliation against the Versailles Treaty, which was being used to whip up right-wing nationalism throughout Germany.

However, Germany was not Italy. The Italian working class had been defeated and the conditions for smashing the revolution had matured by 1922. That explains why Mussolini had large well-armed and well-financed gangs of thugs under his command. Even then, Mussolini still had to govern through parliament and was only able to declare his dictatorship four years later in 1926. In Germany, the bourgeoisie was aware of the fact that they had to tread carefully. To hand over power to Hitler at that stage could have unleashed a backlash of the much more powerful German working class.

Adolf Hitler's National Socialist German Workers' Party (NSDAP) was one of several right-wing groups operating in Bavaria that wanted to establish a totalitarian state. The upstart son of an Austrian clerk built up his reputation using inflammatory writings and speeches, the more inflammatory the better. "How can we help the Fatherland?" yelled Hitler to a meeting. "I'll tell you how. By hanging the criminals of November 1918!" (Quoted by M. Philips Price, *Dispatches*, p. 155.)

Munich, the capital of Bavaria, became the centre of these conspiracies. Some years earlier, the Soviet Republic under Eugen Leviné had been overthrown by the reactionary forces of the Freikorps, transforming Bavaria into the centre of the counter-revolution. The Ehrhardt Brigade sought refuge there, following the failed Kapp putsch. Ludendorff and other disgruntled

officers also settled there. It was in Munich that political murders were planned, including that of Walther Rathenau, the Jewish Foreign Minister, shot dead in the street. It therefore provided fertile ground for Hitler and his anti-Semitic following.

By 1922, at the time when Mussolini had seized power, the NSDAP had established itself as the most active group in Bavaria. At that time, an assessment of the political situation in the region was made by Captain Smith to the United States Embassy in Berlin, which was forwarded to Washington on 25 November. Following the Versailles Treaty, and the danger of Bolshevism, the Americans were keen to keep their finger on the pulse of what was happening in Germany.

Smith's report explained:

> The most active political force in Bavaria at the present time is the National Socialist Labor Party.[2] Less a political party than a popular movement, it must be considered as the Bavarian counterpart to the Italian fascisti... It has recently acquired a political influence quite disproportionate to its actual numerical strength... (W.L. Shirer, *The Rise and Fall of the Third Reich*, p. 47.)

It was also at this time that the Nazis established their military wing, the SA or *Sturm-Abteilung*, largely from Strasser's National ex-combatants in Bavaria, in preparation for their bid for power.

The considerable increase in inflation, as well as an intensification of the crisis in 1922, alerted Hitler to the possibility of uniting the anti-republican forces to bring down the discredited Weimar Republic, as Mussolini had done. Hitler also attempted to channel to his own advantage the support for right-wing nationalism that the occupation of the Ruhr by the French was generating. "No – not down with France, but down with the traitors of the Fatherland, down with the November criminals! That must be our slogan," stated Hitler. (ibid., p. 63.)

During 1923, the Nazis joined forces with other armed 'patriotic leagues', which began to hold rallies and mass meetings in Nuremberg. The plan to march on Berlin, or at least the idea of a putsch, crystallised in Hitler's mind. Given the crisis consuming Germany, now, he thought, was the time to act. His idea of seizing power involved a plan which included the retired general Ludendorff, who he hoped would become the figurehead of the revolt.

As the crisis deepened further throughout the Autumn, the monarchist, Gustav von Kahr, had seized power in Bavaria and made himself State Commissioner and proclaimed martial law. And, as we have seen, the

2 A rough translation of the NSDAP.

Stresemann government reacted to this state of affairs by declaring a state of emergency throughout the Reich, which theoretically should have annulled the martial law in Bavaria. But the orders from Berlin for General Lossow to mobilise Bavarian divisions against Kahr were ignored. In fact, the Bavarian troops swore a new oath of allegiance to the Bavarian regime. There were fears Kahr would secede and was therefore left to his own devices.

Conspiracies were rife in the army, but the generals, who had assumed enormous powers already, preferred to bide their time before launching their own bid for power. They had burned their fingers in the failed Kapp Putsch and wanted to be sure of success next time. Ebert wanted to know where the army stood. General von Seeckt told him bluntly: "The Army, Herr. President, stands with me." (ibid., p. 64.) This was a reminder of where the real power was.

With von Kahr in charge of Bavaria, and in conflict with Berlin, Hitler saw this as an opportunity to ally his fascist movement with the Bavarian state. Such an alliance would provide an important springboard for his ambitions. Kahr, who was looking for points of support, was open to an alliance. But Hitler was also under intense pressure from his own rank and file fanatics. He had promised them his fascist party would carry out a coup, as Mussolini had done. They were demanding action and were getting increasingly restless. If there was no immediate progress, then Hitler could face opposition, rebellion or even the disintegration of his movement. "The day is coming," warned a SA commander, "when I won't be able to hold the men back. If nothing happens now, they'll run away from us." (ibid., p. 66.)

However, Kahr was having second thoughts about the upstart Hitler and was growing increasingly cool towards his rebellious plans. He instead preferred to wait for the generals to act, men that he felt were more in tune with the interests of the bourgeoisie. This meant that Hitler had no alternative but to go it alone, or face the disintegration of his movement. He still hoped to win over Kahr to support him, and with his help, would be able to march against Berlin. But the preparatory work for such a scenario had not been done. There were a lot of loose ends, starting with Kahr himself.

On 4 November, Germany's Memorial Day, there was a large military parade in the centre of Munich. Hitler chose this moment to act. He decided to use his ranks of stormtroopers to surround the proceedings and declare his 'national revolution'. When the day arrived, they were met with a heavy police presence and he was forced to postpone the plot for another six days. On 10-11 November, the new plan was that the fascists would march on the city at strategic points. This was again changed when Kahr announced a mass

meeting at a beer hall on the outskirts of the city for 8 November. Hitler now chose this moment as the time for his 'Revolution'.

He had arranged for his stormtroopers to march in and surround the beer hall. As the rally began, Hitler mounted the platform in an attempt to persuade Kahr and the other dignitaries to join him in a rebellion. However, rather than using sound arguments, he brandished a gun, perhaps to show he meant business, in order to persuade them. Astonished, they nevertheless refused. Hitler then introduced former general Ludendorff, who he had brought along. His presence influenced the dignitaries and they reluctantly acquiesced. "The Bavarian Ministry is therefore removed," Hitler shouted. But unexpectedly, the meeting began to break up. This created doubts in the minds of Kahr and his reticent company. With the reactionaries divided, the whole business now turned into a farce. Despite Ludendorff's help, Hitler was clearly isolated.

Very soon, the whole plot unravelled. The coup foundered as von Kahr and his supporters decided to oppose the adventure. "Of course, I want to march, but I shall not do so unless there is a fifty-one per cent probability of success," said General Lossow. (E. Anderson, p. 104.) Kahr ordered in the police and army to disperse the fascists, who were caught by surprise at this turn of events. At the first exchange of gunfire, sixteen fascists were shot dead and more were wounded. The rest cowered on the pavement to save their lives, including Adolf Hitler. Within days, all the leaders were arrested and the NSDAP was proscribed. Hitler was sentenced to five years' imprisonment, but was soon released after serving eight months. The fascist party was then reconstituted in February 1925 and was again allowed to operate legally. So ended the famous 'Beer Hall Putsch'. It had not been defeated involving a mass movement, as with the Kapp Putsch, but simply fizzled out due to lack of support.

It is quite evident that the same laws for revolution hold good for counter-revolution. The objective situation, balance of forces, planning and timing, but especially leadership, are vital ingredients for its success or failure. The army had backed Hitler in 1933, but in 1923 they wanted to pursue their own agenda, without reliance on a mediocrity. Later on, the ruling class would come to realise that they needed a mass movement to deal with the working class. But for now, Hitler had completely miscalculated, and his first attempt to seize power ended in ignominious defeat.

THE AFTERMATH OF 1923 DEFEAT

The fact remains that the German revolution of October 1923 was far more important than the 'Beer Hall Putsch' which was more of a local scuffle, and

had little importance on the scale of things. The balance of class forces had not yet swung sufficiently to the right to permit a Nazi takeover.

The real question here is what led to the outcome of the October events, where defeat had been ripped from the jaws of victory? All the elements for a successful revolution were present, including a mass revolutionary party. Conditions could not have been riper.

Rather than an honest appraisal, combined with an attempt to learn the lessons of that experience, the Comintern leaders attempted to cover their tracks. Zinoviev, in particular, was more concerned about his own prestige than drawing the necessary lessons. Thus, the blame for the defeat was deflected onto the leaders of the German party. While Zinoviev had approved the tactics and the decision to retreat in October, this was all to be buried and forgotten about. It was a prime example of *prestige politics,* which Zinoviev was an expert in.

At first, as the memory of what had happened was still fresh in the minds of all involved, Zinoviev and the Comintern leaders had accepted some responsibility, but still laid the blame on the Germans:

> Events have shown that our calculations were exaggerated. The KPD revealed many weaknesses and made a number of serious mistakes during those critical weeks, but we do not think it mistaken in not throwing the proletariat into a general battle in October… *The retreat should have been less passive. But the abstention from fighting a decisive battle was, in the, circumstances, inevitable.* (P. Broué, p. 818, emphasis added.)

Within two months, however, the Comintern's position began to change. The reason is crystal clear. Trotsky had written a letter on 8 October to the Russian Central Committee denouncing the rise of bureaucracy within the party and state. This pronouncement struck fear into the troika of Zinoviev, Kamenev and Stalin. This was the first open assault by Trotsky and was followed by a joint letter signed by forty-six leading Communists on 15 October, a week before the German defeat. This had put a similar line to Trotsky's. Up until then, the conflict with Trotsky had been behind closed doors, but now it was out in the open. This led to a sharpening polemic, which was even carried in the pages of *Pravda.*

The intervention of Karl Radek in the dispute served to raise the temperature. He openly sided with the Left Opposition, provocatively stating that the leaders of the most important Communist Parties, including the French and German, agreed with Trotsky's criticisms. Radek was also in close touch with Brandler. This fact greatly alarmed Zinoviev, who feared the creation of a political alliance. He therefore engaged in an offensive, this time

shifting the entire blame for the October defeat squarely on the leadership of the German party, including Radek. In a confidential letter to the KPD Zentrale, Zinoviev stated:

> The political error was a necessary consequence of your over-estimation of the degree of political and technical preparation. We here in Moscow, as you must be well aware, regarded the entry of Communists into the Saxon government only as a military-strategic manoeuvre. You turned it into a political bloc with the 'left' Social Democrats, which tied your hands. We thought of your entry into the Saxon government as a way of winning a jumping-off ground from which to deploy the forces of our army. You turned participation in the Saxon Cabinet into a banal parliamentary coalition with the Social Democrats. The result was our political defeat. And what was still worse, there was an element of comedy in the business. We can stand a defeat in battle, but when a revolutionary party on the eve of revolt gets into a ridiculous position, that is worse than a defeat. In the Reich, the party did not pursue a policy which could be and had to be the overture to decisive struggle. Not a single decisive revolutionary step. Not one even partially clear communist speech. Not a single serious measure to expedite the arming of the Saxon workers, not a single practical measure to create soviets in Saxony. Instead of that, a 'gesture' by Böttcher; who declared that he would not leave the government building until he was ejected by force.

He then concluded:

> No, comrades, that is not the way to prepare a revolution! (ibid., p. 821.)

Brandler and Thalheimer strenuously defended themselves against these attacks. According to them, the defeat was due to the change in the objective situation and not the mistakes of the party leadership. They insisted that the working class was not prepared for a revolution and therefore a retreat was inevitable. The Lefts around Ruth Fischer and Maslow saw this as an opportunity to capitalise on this assault on the "right-wing leadership" and remove Brandler. Under pressure, Brandler's majority in the Zentrale began to crumble. The majority of the German leadership (the 'centre') decided instead to vote in favour of Zinoviev's position, but refused to support the Left, which only won six votes out of nineteen. Only two votes went to Brandler and Thalheimer, their own votes. They were completely isolated as the weight of the Comintern bore down on the German party. The Russian Politburo then voted to condemn Radek for supporting the 'right wing'.

This vote left Brandler and Thalheimer dangling in mid-air. The battle was taken into the Comintern leadership, the ECCI, which, after behind the scenes pressure, supported Zinoviev's line. The Germans were made the

scapegoat for the defeat. Both Brandler and Thalheimer were removed from the party leadership under the campaign of so-called 'Bolshevisation', led by Zinoviev.

In March 1924, at the Fifth Congress of the Communist International, the leaders of the KPD were condemned for the defeat, which served to shift the blame from the Comintern leaders. While blaming Brandler, they reasoned that the situation in 1923 had been 'overestimated'. It is true that Brandler and the others were certainly not blameless, but neither were the leaders in Moscow. They were responsible, in the final analysis, for the preparation and conduct of the German party. The leaders of the International, particularly Zinoviev and Bukharin, had a duty to correct the mistakes of the German Communists. But they vacillated and transmitted this vacillation to Brandler and Thalheimer.

There is no doubt that Brandler, and the rest of the KPD leaders, were terrified of a repetition of the ultra-left mistakes of 1921, and tended to bend the stick towards the policy of the united front and the need to gradually win over the masses. This tactic had been correct up until the beginning of 1923, but then the situation changed. Despite this, the KPD leaders still clung to the policy of yesterday, rather than reorienting the party towards the new revolutionary possibilities. When the German leaders first asked for advice, they were met by Zinoviev and Stalin, who 'curbed' the Germans. Together with Bukharin and Radek, they deliberately held back the KPD at the crucial time.

After the defeat, instead of drawing out all the necessary lessons, Zinoviev, Bukharin, Stalin and the other leaders talked of the debacle as simply an 'episode'. They continued to believe throughout 1924 that Germany still continued to march towards revolution. They failed to recognise that the revolution had ebbed. In fact, the KPD had been banned and forced underground. They managed to turn everything on its head.

The next KPD National Congress took place in April 1924, a month after the Comintern Congress, which saw the 'Left' win a majority and where a resolution was passed calling for "all traces of 'Brandlerism' to be extirpated" from the party. The Congress recorded a membership of 121,400, compared to 267,000 in September 1923, a stark reflection of the severe defeat the party had suffered.

A new Zentrale was chosen by the Central Committee, formed of two members of the 'Left' and five from the 'Centre'. Remmele replaced Brandler, while Thälmann was reduced to a candidate member. In an attempt to prove themselves, the Zentrale immediately took a position against the "anti-Leninist" tendencies in the Russian Left Opposition. The fact that Brandler

and Thalheimer felt obliged to join in the attack on the Opposition did not save them.

There are some even today who argue that Brandler, Thalheimer, and Walcher were correct and that by October 1923 the situation had changed and revolution was no longer on the agenda. This was the argument also of Isaac Deutscher in his later years, who was close to Brandler. (See 'Dialogue with Heinrich Brandler', *Marxism, Wars and Revolutions,* pp. 164-165.) The Brandlerite school believed that the fall of the Cuno government was the turning point when the mood of the masses subsided. Therefore, Brandler was facing an ebb in the movement and was correct in calling off the insurrection. If he had not done so, in their opinion, it would have been another defeat on the lines of the Paris Commune. The idea of a revolutionary situation in October was therefore a 'myth' in their eyes.[3]

No one can deny the fact that, by October 1923, the upsurge of the preceding months had begun to wane. It can be said, in hindsight, that a revolutionary situation had been in existence from May onwards. By its very nature, however, a revolutionary situation cannot last indefinitely, lasting weeks or possibly months. The situation had certainly been riper for an insurrection throughout the summer months until mid-August. The resignation of the Cuno government was the height of the movement. There was a degree of exhaustion by October. But a revolutionary situation, if we compare the Russian events from February to October, is not a straight-line; it unfolds erratically. Within the revolutionary curve, there are sudden breaks. One of these was seen in July. However, by October, after the Bolsheviks had won majorities in the Petrograd and Moscow soviets following the Kornilov rebellion, there was a further surge. Lenin was urging the party leadership to take power and was worried that they were dragging their feet. Finally, the insurrection was carried through on 25 October, under Trotsky's supervision, to coincide with the Congress of Soviets. In October 1923 in Germany, there was nothing to prevent the German Communists from seizing power, only the leadership's inertia, which proved fatal.

According to the eyewitness Philips Price, writing on 18 October, a few days before the fateful Chemnitz conference:

> The condition of Germany now literally beggar's description. That is no exaggeration but naked truth. I have lived through some very critical times during the Russian Revolution in 1917-1918, but I do not remember a time quite as bad as this which has now befallen Germany. Even in the

3 See M. Jones, 'Germany 1923', *Revolutionary History,* Spring 1994, and 'The Decline, Disorientation and Decomposition of a Leadership', Autumn 1989, where he defends the Brandlerite mythology, mainly relying on 'Notes on Discussion with Trotsky' by Walcher.

worst times in Russia one could always have a feeling that the suffering was for some ideal which would make it all worthwhile. Today in Germany the economic catastrophe is worse than in Russia then, and in addition to that there is scarcely a ray of light on the horizon… The government of the Reich is bankrupt… The volcano is smouldering. (M. Philips Price, *Dispatches*, pp. 169-170.)

The situation in October was still clearly extremely unstable, as Price testifies. Trotsky remarked that the crisis was probably "without precedent in world history". The Stresemann government was a government of crisis and a state of emergency was in force. All the characteristics of a revolutionary situation were present. There was still a very deep crisis and inflation was raging. In fact, it was not until the middle of November that the currency stabilised. The Stresemann government collapsed in December, giving way to the government of Wilhelm Marx, who also ruled by emergency decree. The 'stabilisation', which was relative, only came after the introduction of the Dawes Plan in 1924.

The situation in October 1923 was still very favourable for the carrying through of a proletarian revolution. While the window of opportunity was closing, there was ample time, *given correct leadership*, for a successful transfer of power to the working class. It was a question of the Communist Party seizing the initiative. But this was lost by prevarication and misjudgement. As we have seen, Walcher and Brandler completely underestimated the situation in 1923 and tried to cover up their mistake by saying there was no revolutionary situation. Brandler and Thalheimer had vacillated in the same way as Zinoviev and Kamenev had vacillated in Russia in October 1917, believing the time was not ripe. But Brandler and Co. could not grasp this fact. Trotsky wrote:

> From this – the greatest experience of their lives – they learned nothing. Since they were obliged to defend themselves for quite some time, *they collected all the arguments for turning a revolutionary situation into a non-revolutionary situation*. (L. Trotsky, *Writings Supplement 1934-1940*, p. 576, emphasis added.)

He continued:

> Here we had a classical example of a missed revolutionary situation. The Communist Party executed the turn very irresolutely and after a very long delay… (they) viewed rather fatalistically the process of revolutionary development up to September/October 1923.

In Trotsky's view a real political ebb set in *following* the October defeat, in November. But the failure had nothing to do with the lack of revolutionary conditions. It was a question of leadership, which at critical junctures, can be decisive. It reflects the critical role of the subjective factor in history. When all other factors are present, leadership becomes decisive.

The *fundamental* responsibility for the October defeat rested with the Comintern leadership, which had colossal authority. The vacillations of Zinoviev and Stalin had devastating consequences. This had nothing to do with deliberately sabotaging the revolution. They all desired a successful revolution in Germany. However, without Lenin, they lacked a clear policy and firmness to carry it through. They were affected by inertia and conservatism. Had Rosa Luxemburg and Karl Liebknecht not been murdered, there is little doubt that they could have provided the necessary revolutionary leadership to guarantee the victory of the working class. Without them, there was no one in the German leadership that was capable of fulfilling this role. The Comintern could have helped, but under Zinoviev and the troika, they were not up to the task.

Trotsky was sharply critical, not only of Brandler's temporising, but also of the conduct of Radek and Pyatakov, the Comintern representatives in Germany, who gave 100 per cent support to Brandler. This had led to some confusion at the time of the January 1924 ECCI The troika tried to link Trotsky with Radek's failings. Unfortunately, Trotsky was ill and could not attend the executive meeting. Radek contacted him by phone and pleaded with him to put his name to the Radek-Pyatakov theses on Germany. This he agreed to do, which was then used to attack and slander Trotsky. In the compilation of articles entitled *Errors of Trotskyism*, issued in 1925 by the British Communist Party, O.W. Kuusinen, explained:

> At that time, the Executive of the Comintern, with the collaboration of leading German comrades representing all three tendencies, had drawn the balance of the unhappy German revolution. It is true that Comrade Trotsky did not participate personally in these sessions, but Comrade Radek submitted theses drafted, according to his official declaration, "by Comrade Trotsky and Pyatakov, and by me (Radek)."

> This thesis draft from the Right minority was rejected by the Executive of the Comintern, and has not been published to this day. In one part of these theses we read:

> "The Executive decidedly rejects the demand made by the leaders of the Berlin organisation, to the effect that the retreat made by the party in October is to be regarded as unjustified and even traitorous. If the party had

proclaimed the insurrection in October, as proposed by the Berlin comrades, it would now be lying prone with a broken neck. The party committed grave errors during the retreat, and these errors are the object of our present criticism. But the retreat itself corresponded to the objective situation, and is approved by the Executive."

We thus see that in January of this year, Comrade Trotsky was seriously of the opinion that the retreat was right during the German October, and was in accordance with the objective situation. The leaders of the Berlin organisation considered the retreat "entirely unjustified and even traitorous." But Comrade Trotsky protested most decidedly against this view of the matter. He demanded, together with Radek, Pyatakov and the chairman of the German party Central, Brandler, that the Executive should approve the retreat. (*Errors of Trotskyism*, pp. 339-340.)

This is a distortion. Trotsky never believed the retreat arose from the objective situation, but subjective failings. In 1931, while in exile, Trotsky clarified his earlier support for Radek, saying he had mistakenly allowed his name to be appended, in his absence, to Radek's thesis on the German revolution.

These theses were erroneous – to tell the truth, not so grossly in error as were the theses of the Comintern – and were in conflict with everything that I wrote and said prior, during, and after their compilation by Radek. Doubtless it was a blunder on my part. But there was nothing 'principled' in this mistake. The plenum of the Executive Committee of the Communist International found me ill in a village, forty kilometres away from Moscow. Radek communicated with me by phone, which functioned very poorly in winter. Radek was being hounded at the plenum. He was seeking support. He declared categorically that the views presented by the theses were identical with those I developed in my speeches and articles, and that Pyatakov had already signed them. He asked me to add my signature without insisting upon reading the theses since he had only half an hour before the decisive session. I agreed – not without inner wavering – to give my signature. Yes, I committed an error in placing too much confidence in the judgment of two comrades, Radek and Pyatakov. For, as a matter of fact, the two of them, perhaps even in agreement with Brandler, introduced into the theses a number of formulations which were intended to mitigate Brandler's guilt, and to justify the conduct of Pyatakov and Radek themselves, who supported Brandler in many things.

Trotsky emphasised that he had:

[N]othing in common with Radek's thesis (on the German revolution). This appraisal, which I arrived at approximately in July 1923, I have upheld

unaltered in its essentials to this very day. (*Writings, 1930-1931*, pp. 310-311.)

Trotsky's mistake in supporting the theses of Radek and Pyatakov was used repeatedly by Zinoviev, Stalin and their supporters to brand Trotsky incorrectly as a political ally of Brandler. This was never the case. What Trotsky objected to was the way in which Brandler was used as a scapegoat.

LESSONS OF OCTOBER

The German defeat was not the first time that the Comintern leaders had faltered. In Bulgaria, in June 1923, a right-wing coup led by Alexander Tsankov was launched against the Peasant Union government of Alexander Stambulisky. The Communist Party remained neutral, as was the case initially in the Kapp Putsch. As soon as Tsankov defeated the Peasant Union government, he turned on the communists. In September, when the movement was on the retreat, the Bulgarian communists prepared their own 'March Action'. It was a disaster and ruthlessly crushed. However, this adventurism was supported by the Comintern leaders, Zinoviev and Radek. As in Germany, they had allowed a favourable situation to go by the board in Bulgaria in June. Having missed the opportunity, they pushed for an unprepared insurrection. By this adventurism, many of its most loyal comrades were killed, imprisoned or tortured. Nearly a hundred were publicly hanged. After the debacle, those critical of the attempted rising were removed from the Bulgarian leadership.

> The Bulgarian revolution ought to have been a prelude to the German revolution. Unfortunately, the bad Bulgarian prelude led to an even worse sequel in Germany itself. (L. Trotsky, 'Lessons of October', *Left Opposition 1923-25*, p. 201.)

While the leaders of the Comintern attempted to cover up their hesitations and mistakes in relation to Germany (and Bulgaria), Trotsky used every possible avenue to spell out the lessons of the defeat, in particular drawing on the experience of the October revolution.

Trotsky's broadside against the Zinoviev-Kamenev-Stalin troika came in December 1923, with the publication of *The New Course*, a damning indictment of the regime, some of which had appeared as articles in *Pravda*. In the work, he dealt with a whole host of questions concerning the traditions of Bolshevism as well as internal democracy within the Russian Communist Party, which had been systematically undermined. In *The New Course*, he also dealt with the events in Germany:

If the Communist Party had abruptly changed the pace of its work and had profited by the five or six months that history accorded it for direct political, organisational, technical preparation for the seizure of power, the outcome of the events could have been quite different from the one we witnessed in November. There was the problem: the German party had entered the new, brief period of this crisis, perhaps without precedent in world history, with the ready methods of the two preceding years of propagandistic struggle for the establishment of its influence over the masses. Here a new orientation was needed, a new tone, a new way of approaching the masses, a new interpretation and application of the united front, new methods of organisation and of technical preparation in a word, a brusque tactical change. The proletariat should have seen a revolutionary party at work, marching directly to the conquest of power.

But the German party continued, at bottom, its propaganda policy of yesterday, even if on a larger scale. It was only in October that it adopted a new orientation. But by then it had too little time left to develop its dash. Its preparations were speeded up feverishly, the masses were unable to follow it, the lack of assurance of the party communicated itself to both sides, and at the decisive moment, the party retreated without giving battle. (L. Trotsky, *Left Opposition 1923-25*, p. 95.)

In a later article entitled 'Through What Stage are we Passing?' he explained:

It is very difficult for a revolutionary party to make the transition from a period of agitation and propaganda, prolonged over many years, to the direct struggle for power through the organisation of an armed insurrection. This turn inevitably gives rise to a crisis within the party. Every responsible communist must be prepared for this. One of the ways of being prepared is to make a thorough study of the entire factual history of the October revolution. Up to now extremely little has been done in this connection, and the experience of October was most inadequately utilised by the German party... a growth in the party's political influence was taking place automatically. A sharp tactical turn was needed. It was necessary to show the masses, and above all the party itself, that this time it was a matter of immediate preparation for the seizure of power.

Trotsky then went on to elaborate a number of changes that would have to take place to meet the new situation:

It was necessary to consolidate the party's growing influence organisationally and to establish a basis of support for a direct assault on the state. It was necessary to shift the full party organisation onto the basis of factory cells. It was necessary to form cells on the railways. It was necessary to raise sharply

the question of work in the army. It was necessary, especially necessary, to adapt the united front tactic fully and completely to these tasks, to give it a firmer and more decisive tempo and a more revolutionary character. On the basis of this, work of a military-technical nature should have been carried on.

The question of setting a date for the uprising can have significance only in this connection and with this perspective. Insurrection is an art. An art presumes a clear aim, a precise plan, and consequently a schedule. The most important thing, however, was this: to ensure *in good time* the decisive tactical turn toward the seizure of power. And this was not done. This was the chief and fatal omission.

Trotsky went on to explain that the KPD, having burnt its fingers in the March Action in 1921, avoided for a protracted period of time the very idea of organising the revolution:

The party's political activity was carried on at a peacetime tempo at a time when the denouement was approaching. The timing for the uprising was fixed when, in essentials, the enemy had already made use of the time lost by the party and strengthened his position. The party's military preparation, began at feverish speed, was divorced from the party's political activity, which was carried on at previous peacetime tempo. The masses did not understand the party and did not keep step with it. The party at once felt its severance from the masses, and proved to be paralysed. From this resulted the sudden withdrawal from first class positions without a fight – the bitterest of all possible defeats. (L. Trotsky, *Left Opposition 1923-25*, pp. 170-171.)

These valuable observations were later developed extensively in Trotsky's brilliant introduction to his Collected Works, called *Lessons of October*, published in September 1924, which compared the vacillations of the German leadership with that of Zinoviev and Kamenev on the eve of the October Revolution. In Russia, Lenin was able to overcome this vacillation; in Germany, there was no one like Lenin able to accomplish this task. The essay drew out the essential lessons of the Bolshevik Revolution and underlined the need for a far-sighted and resolute leadership, a factor that was missing in Germany and the Comintern.

... the leading comrades in the German party, in their attempt to explain away their retreat last year without striking a blow, especially emphasised the reluctance of the masses to fight. But the very crux of the matter lies in the fact that a victorious insurrection becomes, generally speaking, most assured when the masses have had sufficient experience not to plunge headlong into the struggle but to wait and demand a resolute and capable fighting

leadership... The transition from an illusory, exuberant, elemental mood to a more critical and conscious frame of mind necessarily implies a pause in revolutionary continuity. Such a progressive crisis in the mood of the masses can be overcome only by a proper party policy, that is to say, above all by the genuine readiness and ability of the party to lead the insurrection of the proletariat. On the other hand, a party which carries on a protracted revolutionary agitation, tearing the masses away from the influence of the conciliationists, and then, after the confidence of the masses has been raised to the utmost, begins to vacillate, to split hairs, to hedge, and to temporise – such a party paralyses the activity of the masses, sows disillusionment and disintegration among them, and brings ruin to the revolution; but in return it provides itself with the ready excuse – after the debacle – that the masses were insufficiently active. (L. Trotsky, *Left Opposition, 1923-25*, p. 234.)

Trotsky explained that:

The fundamental instrument of proletarian revolution is the party. On the basis of our experience – even taking only one year, from February 1917 to February 1918 – and on the basis of the supplementary experience in Finland, Hungary, Italy, Bulgaria, and Germany, we can posit as almost an unalterable law that a party crisis is inevitable in the transition from preparatory revolutionary activity to the immediate struggle for power. Generally speaking, crises arise in the party at every serious turn in the party's course, either as a prelude to the turn or as a consequence of it. The explanation for this lies in the fact that every period in the development of the party has special features of its own and calls for specific habits and methods of work. A tactical turn implies a greater or lesser break in these habits and methods. Herein lies the direct and most immediate root of internal party frictions and crises...

Hence the danger arises that if the turn is too abrupt or too sudden, and if in the preceding period too many elements of inertia and conservatism have accumulated in the leading organs of the party, then the party will prove itself unable to fulfil its leadership at that supreme and critical moment for which it has been preparing itself in the course of years or decades. The party is ravaged by a crisis, and the movement passes the party by – and heads toward defeat.

Trotsky goes on to stress the importance of timing in the revolution:

If time is, generally speaking, a prime factor in politics, then the importance of time increases a hundredfold in war and in revolution. It is not at all possible to accomplish on the morrow everything that can be done today. To

rise in arms, to overwhelm the enemy, to seize power, may be possible today, but tomorrow may be impossible.

But to seize power is to change the course of history. Is it really true that such a historic event can hinge upon an interval of twenty-four hours? Yes, it can. When things have reached the point of armed insurrection, events are to be measured not by the long yardstick of politics, but by the short yardstick of war. To lose several weeks, several days, and sometimes even a single day, is tantamount under certain conditions to the surrender of the revolution, to capitulation.

He ends the book with the advice:

Much has been spoken and written lately on the necessity of 'Bolshevising' the Comintern. This is a task that cannot be disputed or delayed; it is made particularly urgent after the cruel lessons of Bulgaria and Germany a year ago. Bolshevism is not a doctrine (i.e., not merely a doctrine) but a system of revolutionary training for the proletarian uprising. What is the Bolshevisation of Communist parties? It is giving them such a training, and effecting such a selection of the leading staff, as would prevent them from drifting when the hour for their October strikes. "That is the whole of Hegel, and the wisdom of books, and the meaning of all philosophy ..." (L. Trotsky, *Left Opposition, 1923-25*, p. 256.)

The appearance of 'The Lessons of October' enormously intensified the struggle within the Russian party leadership, evoking a new campaign against 'Trotskyism' far more intense than the previous spring.

The campaign of Zinovievite so-called 'Bolshevisation' of the Communist parties, rather than turning them into real revolutionary parties, was used by Zinoviev to transform them instead into pliant tools of Moscow. It was used in Germany by the 'Left' to eventually remove the opposition from the 'Centre' and 'Right' of the party. It was even used to undermine the legacy of Rosa Luxemburg, viewed as supposedly leaning too much towards Social Democracy and away from Leninism. Fischer claimed that "The Brandlerist deviations are the legitimate offspring of Luxemburgism." The struggle for this 'Bolshevisation', in the hands of these epigones, had a tremendously negative effect in Germany, as elsewhere. The policy of removing leaders who were out of favour was disastrous. The rank and file had no opportunity to learn from experience which leaders were good and those who were unsuitable for leadership. There is no short-cut, as the experience of Bolshevism showed. It was important to learn from mistakes, rather than attempt to establish the so-called infallibility of the leadership. In Germany, such methods paved the way for the rise of Ernst Thälmann as the Comintern's stooge in the leadership.

After 1923, the German party was effectively transformed in a series of stages from a revolutionary party, that was a living organism, to a mouthpiece for the emerging Stalinist bureaucracy. "The practise of scapegoating was entering a new era," remarked Pierre Broué. (*The German Revolution*, p. 865.) This would effectively seal the fate of the German revolution, as well as the fate of the Communist International.

CHAPTER SIX: THE INTERREGNUM

> After the period of turbulent high tide in 1923, began the period of
> a long-lasting ebb. In the language of strategy this meant an orderly
> retreat, rear-guard battles, the strengthening of our positions within
> the mass organisations, the re-inspection of our own ranks, and the
> cleansing and sharpening of our theoretical and political weapons.
>
> Leon Trotsky, *The Third International After Lenin*

The humiliating defeat of October 1923 proved to be an important turning
point. The situation had been ripe for revolution, and hopes for success were
very high. Such hopes, however, were again dashed and workers were robbed
of victory as in 1918, 1919 and 1920. This time, defeat was especially hard
and another opportunity had been squandered because of the lack of decisive
revolutionary leadership.

As with past defeats, it affected the morale of sections of the working
class and further demoralised the ruined petty bourgeoisie, who were
desperately seeking a way out of the crisis. The 'Proletarian Hundreds', the
shock troops of the insurrection, after being made illegal, simply disappeared.
But out of the ashes a new military defence formation called the 'Red
League of Front Fighters' emerged. Rather than operating as the advanced
guard of the revolution, the League now acted largely as a defence force,
providing protection for street demonstrations and rallies. In the same year,
the Reichsbanner, a Social Democratic military organisation, was formed,
which, although based mainly on Social Democratic workers, also drew some
limited support from the Centre and the Democrats. This military formation
recruited hundreds of thousands of members and supporters, organising

mass processions to demonstrate their strength. It was directly established to defend the republic and as a counterweight to the reactionary Stahlhelm.

This fact showed that the working class was still capable of resistance and was far from being crushed, which partly explains the fears and hesitations of the bourgeoisie in provoking the situation, and why they did not back Hitler's failed coup.

The defeat of 1923 provided a temporary breathing space and the grounds for a certain stabilisation for German capitalism. The bourgeoisie had been staring into the abyss, but with the defeat of the revolution, they managed to escape being overthrown. The stalemate in the class struggle provided the Weimar Republic with an interregnum, which the representatives of German capitalism used to shore up the system.

The German defeat had profound international repercussions. It cast a dark shadow over the workers' movement, not only in Germany. Within the Soviet Union, it undermined the hopes of the Russian masses, exhausted and isolated. They had been following the events in Germany with intense interest and anticipation. This defeat meant that their suffering would continue. The growing bureaucracy within the state and party fed from this demoralisation, allowing them to further consolidate their position, standing above the working class. The bureaucracy had arisen out of the isolation of the revolution under conditions of extreme economic and cultural backwardness. Composed of the millions of officials largely from the tsarist regime, this bureaucratic caste was strengthened each time the working class suffered setbacks and defeats. With each retreat, they assumed greater control over state and party. For them, the machinery of administration, the apparatus, became an end in itself, and was the basis of its bloated incomes and privileges. It was a parasitic growth on the workers' state. As Engels explained, when government, art, science and culture become the property of a small minority, it uses and abuses its position for its own ends.

The Soviet regime was afflicted early on with bureaucratic deformations, which was a product of the backwardness of the economy. This problem was explained honestly by Lenin, who never tried to conceal or prettify the situation:

> The apparatus we call ours is, in fact, still quite alien to us; it is a bourgeois and tsarist hotchpotch… we took it over from tsarism and slightly anointed [it] with Soviet oil. (LCW, vol. 36, pp. 605-606.)

Lenin knew full well what Marx meant in the *German Ideology*, when he said "when want is generalised all the old crap revives". With every setback, every difficulty, and every defeat, the bureaucracy grew in strength and

confidence. Unlike other bureaucracies in the west, the Soviet bureaucracy was a parasitic cast that fed off of the gains of the nationalised planned economy. It represented a Thermidorian reaction to the October Revolution, which would eventually end up with the victory of Stalinism, a bureaucratic political counter-revolution, but based upon nationalised property relations.

It is no accident that Lenin's last struggle, in a political bloc with Trotsky, was against the bureaucracy. His last writings, including *Better Fewer, But Better* (2 March, 1923), are a testimony to this struggle. He was planning a 'bombshell' against Stalin, but was prevented in carrying this out by a series of strokes which forced him to give up political activity. Lenin finally died on 21 January 1924, a few months after the defeat of the 'German October'.

These two events – the defeat in Germany and the death of Lenin – came as devastating shocks that severely undermined the morale of the Soviet working class. These were followed by a further disappointment in December 1924, when the Estonian rising also went down to defeat.

Victor Serge explained:

> Everything, in the last analysis, depends on the international situation. After the failure of the revolution in Germany in 1923 (the Chemnitz Conference, the Hamburg insurrection, the violent repression of the workers' government of Saxony, the dictatorship of General von Seeckt) a wave of depression passed over Russia, and the bureaucracy had its own way for three years. (V. Serge, *From Lenin to Stalin*, p. 42.)

The German Revolution had, as a consequence, more influence on Stalin than Stalin on the German revolution, noted Trotsky.

STRUGGLE SHARPENS

These events were to signal a sharpening of the struggle between Stalin, who had formed an unprincipled bloc with Zinoviev and Kamenev, against Trotsky's Left Opposition, which demanded a return to Leninism. The troika intrigued and conspired at every opportunity behind Trotsky's back to discredit him. They feared that the Opposition's criticisms would now be linked with the debacle in Germany and have repercussions throughout the International. For them, this was something that had to be prevented at all costs.

Trotsky wrote:

> The first palace coup, the result of a systematic organised conspiracy, was carried off in 1923-24, after being carefully prepared during the months when Lenin was struggling against death. Behind the party's back six members of the Politburo organised a conspiracy against the seventh. They

bound themselves by a pledge of mutual discipline; they communicated by means of coded telegrams with their agents and reliable groups in all parts of the country. (L. Trotsky, *Writings 1930*, p. 256.)[1]

The 1923 Opposition was formed by a leading layer of Old Bolsheviks who fought for, among other things, the restoration of internal party democracy and a plan to co-ordinate a more rapid development of industry and agriculture. The Opposition's slogans were: 'Against the merchant, the rich peasant, and the bureaucrat!' and 'Carry out Lenin's Testament!'

The Left Opposition was faced with a ferocious campaign by the apparatus, which cynically used all the old long-forgotten differences between Lenin and Trotsky, resolved in practise by the experience of the October Revolution, to discredit Trotsky. As Zinoviev later admitted, they had deliberately invented the term 'Trotskyism' as a means of driving an artificial wedge between Leninism and the views of Trotsky. Following Lenin's death in early 1924, the campaign against 'Trotskyism' began in earnest and was taken into the ranks of the Communist International.

In an article entitled *Bolshevism or Trotskyism*, Zinoviev asked:

What is then needed?

What is needed is that the party should *guarantee itself* against the repetition of 'assaults' on Leninism. Serious party guarantees are needed that the decisions of the party shall be binding on comrade Trotsky. The party is no discussion club, but a party – and a party operating in the complicated environment in which ours finds itself. The watchword of the day is:

Bolshevisation of all strata of the party!
Ideological struggle against Trotskyism!

Above all, enlightenment, enlightenment and once more enlightenment! (E.H. Carr, *Socialism in One Country*, vol. 2, p. 28.)

But there was no "enlightenment", only a campaign of denigration and falsehood against Trotsky and the Opposition. This went hand in hand with demands for loyalty to the ruling group.

SOCIALISM IN ONE COUNTRY

One thing inevitably led to another. Following these defeats, the bureaucracy, growing more confident, began to flex its muscles. It was a period of bureaucratic retrenchment within the Soviet Union. With this, Stalin came forward in October 1924 as its spokesman with the anti-Marxist, anti-

1 The seven members of the Politburo were Zinoviev, Kamenev, Stalin, Bukharin, Rykov, Tomsky, and Trotsky.

Stalin's book *Lenin and Leninism*

Bolshevik theory of 'Socialism in one country'. The theory was a direct reflection of the growing desire of the bureaucracy for stability. They wanted to put an end to the revolutionary upheavals of the past. Up until that moment Stalin had argued, along with everyone else, that socialism could only be attained with the support of several advanced industrial countries. As late as spring 1924, Stalin outlined Lenin's views on the building of socialism, as follows:

> The overthrow of the power of the bourgeoisie and the establishment of a proletarian government in one country does not yet guarantee the complete victory of socialism. The main task of socialism – *the organisation of socialist production* – still remains ahead. Can this task be accomplished, can the final victory of socialism in one country be attained, without the joint efforts of the proletariat of several countries? *No, this is impossible.* To overthrow the bourgeoisie, the efforts of one country are sufficient – the history of our revolution bears this out. For the final victory of socialism, *for the organisation of socialist production, the efforts of one country, particularly of such a peasant country as Russia are insufficient.* For this the efforts of the proletarians of several advanced countries are necessary…

Such, on the whole, are the *characteristic features of the Leninist theory of the proletarian revolution*. (J. Stalin, *Lenin and Leninism*, p. 40, quoted in L. Trotsky, *The Third International After Lenin* [Union Books ed.], pp. 34-35, also E.H. Carr, *The Interregnum*, pp. 358-359.)

With Lenin dead, there were no longer any restraints on Stalin. Within the space of months, this classic Leninist position had been abandoned in favour of the theory of 'Socialism in One Country'. The idea of the 'permanent revolution', closely associated with Trotsky and the early years of the Communist International, became an anathema to this bureaucratic stratum, which was demanding increased comforts and privileges on the back of the workers' state. In one fell swoop, if socialism could be built within the

Joseph Stalin

borders of a single country, the whole concept of world revolution could be thrown out of the window. Each defeat reinforced this outlook.

This abandonment of Marxism for political empiricism resulted in a series of zig-zags in party policy. The empirical reaction to events was reflected in swings between opportunism and ultra-leftism.

Trotsky had brilliantly predicted that the adoption of the theory of 'Socialism in One Country' at the Sixth World Congress of the Comintern in 1928 would inevitably lead to the reformist and nationalist degeneration of the Communist International. This prognosis was stunningly born out in subsequent years with the shift towards popular frontism and the abandonment of internationalism. Moreover, in the end, the Communist International, which had been founded in 1919 as the World Party of Socialist Revolution, was dissolved by Stalin in 1943, as a gesture to his Allies, Roosevelt and Churchill.

STABILISATION

In Germany, following the turmoil of 1923 and the October events, the bourgeoisie demanded drastic action to stabilise the political and economic situation. A state of emergency was introduced by Ebert, who invoked Clause Forty-Eight of the Weimar Constitution, which granted emergency powers to Gessler, the Minister of Defence, and the Commander-in-Chief, General von Seeckt. This state of emergency, which also banned the Communist Party and its activities, was to remain in place until February 1924.

Emergency economic measures were also taken. In order to squeeze hyperinflation out of the system, a new currency was introduced, the Rentenmark, by the Finance Minister, Hans Luther. This revaluation, which proved extremely painful, did help to squeeze out the excess liquidity from the system and helped stabilise things. On 15 November, the currency was stabilised on the basis of an exchange rate of 1,000,000,000,000 paper marks for one gold mark (one Rentenmark). While on 16 November 1923, the dollar exchanged for 2,520 billion marks, three days later the dollar was quoted in the new currency at 4.2 Rentenmarks. This shock therapy was welcomed by the serious sections of the ruling class, despite resulting in a wave of bankruptcies, especially amongst small and medium enterprises. These were mostly swallowed up by the big corporations, further increasing the concentration of capital.

Those capitalists who had made fortunes out of inflation and built new business empires overnight, now regarded stabilisation as a means of consolidating their power. While the measures served to stabilise the mark, borrowers had to repay their loans valued in inflated marks with lower-

denominated Rentenmarks. The deflation squeezed the fictitious cash out of the system, but at a massive social cost.

The Enabling Act pushed through by Hans Luther limited the revaluation of the paper currency debts to fifteen per cent of their original value. He also made sure that the government was exempt from the revaluation of its own debts until the reparations had been duly paid. This provoked great resentment, especially in the eyes of the ruined middle classes who were being driven down into the ranks of the proletariat and even lumpen-proletariat.

EIGHT-HOUR DAY ABOLISHED

Since December 1923, the government had been dominated by two bourgeois parties, the People's Party and the Catholic Centre Party, whose leader, Dr. Wilhelm Marx, became head of the government. Dr. Marx had ruled by decree, increasing indirect taxes while cutting taxes for the rich, and other such deflationary measures to assist the programme of 'economic recovery'. The eight-hour day, introduced during the 1918 Revolution, was finally abolished, to the great delight of big business. The Nationalists, who were absent from government, now felt excluded and wanted in, despite their ambivalence towards the Dawes Plan. Pressure therefore mounted for new elections. The Reichstag was soon dissolved and a new general election arranged for May 1924.

The most telling result of these elections was the humiliating defeat for the Social Democrats, who lost seventy-one seats and were reduced to 100 seats in the new parliament. They had been duly punished by the working class for their involvement in the discredited coalition of Stresemann in the autumn 1923.

The communists, on the other hand, who had been legalised shortly before the election, benefited from the political polarisation and radicalisation that had taken place, and succeeded in increasing their number of seats from seventeen to sixty-two. While the Social Democrats received six million votes, the communists saw their vote rise to nearly four million.

This changed again when further elections were called in December, by which time the effects of the stabilisation began to be felt. With the return of some semblance of hope, the fortunes of the Social Democrats also improved. This saw the SPD increase its number of seats in December from 100 to 137, and its vote rose to eight million, a substantial rise on May's result. In contrast, the relatively stable conditions had the opposite effect on the communists, who lost seventeen of their sixty-two seats and their vote went down to 2.7 million.

Another coalition government was formed, this time with Hans Luther as Chancellor and Stresemann as Foreign Minister. They were now joined in the Coalition by the German Nationalists (DNVP), who had also made sweeping gains at the expense of the German Democrats (DDP) and the People's Party (DVP). This, however, proved to be a very unstable government. The parties, especially the Nationalists, were wracked by a whole series of resignations and splits, which reflected the continuing political impasse in Germany.

The imperialist powers, especially the United States and Britain, had become alarmed by the revolutionary events of 1923, which came so close to overthrowing capitalism. They were alarmed by the prospect of Bolshevism sweeping through Germany and Europe unless the crisis over reparations was quickly resolved. Even in France the opinion of the majority was in favour of withdrawing its troops from the Ruhr. The victor powers were therefore forced to change their approach to Germany. This need for change was further strengthened by the election of the Left Bloc in France, which was keen to reach an agreement with the Germans.

Following the London conference of August 1924 and the acceptance of the Dawes Plan, the idea of squeezing the Germans 'until the pips squeak' was abandoned. The new London agreement secured the withdrawal of French troops, while American imperialism poured in colossal sums of cash in the form of loans to rebuild German industry. As a consequence, the payment of reparations was drastically reduced, while German big business received a loan of 5,000 million dollars to strengthen its gold reserves and help stabilise the economy. This loan was also used to underpin the new currency, the *Rentenmark*. The Dawes Plan marked the beginning of a German economic recovery.

ECONOMIC REVIVAL

With industry returning to 'normal', as workers began to regain their confidence, trade union struggles also returned, with the number of industrial disputes rising sharply. The employers resorted to lockouts, resulting in a ferocious class struggle. So, in 1924, there were more working days lost in strikes and lockouts than in any other year between the two world wars: 13.2 million days were lost through strikes and 22.6 million days due to lock-outs. The strikes were an attempt by the working class to claw back the lost ground, including efforts to restore the eight-hour day. Despite this increase in trade union activity, the membership of the trade union federations declined, falling from 7.8 million in 1922 to around 4.6 million in 1924. The terrible crisis of 1923 was mainly responsible for this state of affairs.

However, this upturn of industrial militancy did not last. In the period after 1924, strike figures fell sharply as state arbitration was increasingly used to settle disputes. A major factor in this development was the dramatic rise of unemployment and the fear of workers losing their jobs. The capitalists now held the whip hand. By December 1924, 1.5 million were registered unemployed, with a quarter of trade union members out of work and forty-seven per cent working short-time. Increasingly, the trade unions grew to rely, not upon their own strength, but on help from state intervention and arbitration.

The German economic recovery was described as 'an Indian summer'. The boom/slump cycle was certainly experiencing an upward phase in Europe and in America. In arguing against the ultra-lefts, Lenin and Trotsky had explained that a capitalist economy could not simply keep on shrinking. There would inevitably come a point when the laws of capitalism would sooner or later assert themselves and produce a recovery, however limited. The 'creative destruction' of capitalism would eliminate overproduction, and would lead to a renewal of investment and capital expenditure. This, in turn, would lay the foundations for a boom. And this is precisely what happened between 1924 and 1928 in Germany, as elsewhere.

Therefore, while German output in 1923 was fifty-five per cent of 1913 levels (the peak of pre-war production), by 1927 it was 122 per cent of the 1913 levels. By 1927, the average monthly production of iron ore and steel amounted to 1,136 million tonnes and 1,395 million tonnes respectively, as against 1,397 million tonnes and 1,429 million tonnes in 1913. Production levels rose rapidly in 1928 which resulted in a considerable increase of German exports by forty per cent. This economic upturn, largely based on international credit and loans, together with the new currency, eventually resulted in the reduction of inflation and the return to a period of economic growth.

By 1929, given the relative stability, Germany was able to pay 8,000 million Rentenmarks in reparations and in return had received 13,000 million Rentenmarks in loans of various types. Of course, these loans came with strings attached. The Reichsbank – the Central Bank – became an 'independent' institution, closely tied to its American creditors. For all intents and purposes, Germany had become a kind of appendage of the New York Stock Exchange. Despite this imposition, it was a price worth paying from the point of view of German capitalism, which had been rescued by the influx of dollars. Trading agreements, such as the Rapallo Treaty with the USSR, also offered new investment opportunities abroad, which further stimulated the economy.

The recovery, however, stood on weak legs. It was a period of 'borrowed prosperity', as it became known. The foreign indebtedness of Germany had increased to one half of its national income by this time. Many felt that they were living on borrowed money and borrowed time. Others felt that they were living on false hopes.

The economic growth, mostly artificially sustained, could not last on such a basis. It was far from being a 'Golden Age', or even the 'Roaring Twenties', and would finally be shattered with the arrival of the Great Depression from 1930 onwards. It was a depression that would hit Germany extremely hard.

It is no accident that it was in 1928, at the height of the boom, that the well-known economist Werner Sombart, who started his career as a 'Marxist', ended up revising all of Marx's ideas, published his own *Modern Capitalism* as opposed to Marx's *Capital*. It was translated into many languages and became the best know exposition of bourgeois economic apologetics at that time. He dismissed all of Marx's prognoses as false. According to Sombart:

> Capitalism will continue to transform itself internally in the same direction in which it has already begun to transform itself, at the time of its apogee: as it grows older, it will become more and more calm, sedate, reasonable.

Unfortunately for Sombart, his book appeared on the bookshop shelves not long before the greatest crash ever experienced by capitalism. Rather than becoming more 'sedate', capitalism was embarking on a catastrophic crisis, which would throw millions of workers on to the scrapheap, not least in Germany.

SOVIET-GERMAN RELATIONS

Germany had been crippled by the Versailles Treaty, not only economically, but also in terms of the severe military restrictions placed on its activities. The Reichswehr, as we have seen, was officially limited to only 100,000 men. The victors were determined that Germany was not to be crushed, but contained.

The Soviet Republic was also surrounded by hostile imperialist powers, led by Britain and France, and was searching for potential allies. Therefore, a degree of co-operation between the Soviet Republic and Germany was considered beneficial, although military matters had to be kept secret. Thus, the Treaty of Rapallo was signed on 16 April 1922 between Germany and the Russian Soviet Federal Socialist Republic (RSFSR), under which each party renounced all territorial and financial claims against the other. This meant the cancellation of the Treaty of Brest-Litovsk imposed by German imperialism in 1918. Both governments agreed to normalise their diplomatic relations and to "co-operate in a spirit of mutual goodwill in meeting the

economic needs of both countries". While publicly denying such close co-operation, they secretly established elaborate military partnerships between the two powers.

The Treaty of Rapallo now allowed the Germans to evade many of the stringent provisions of the Versailles Treaty. For example, as Germany was not allowed to maintain an air force, those Germans interested in aviation could get their initial training in Russia. The Treaty also provided a boost to the Soviet armaments industry by extending the co-operation with the German military and industrial experts. For instance, a new tank factory called Kama was established near Kazan as a joint enterprise of the Reichswehr and the Red Army. This was supplemented by the establishment of a tank training school on the river Kama. A German factory in Moscow manufactured 30mm. guns for the Reichswehr, as well as the Red Army. A large airfield was placed at the disposal of the Germans at Lipetsk in central Russia, north of Voronezh. This had two functions: training German pilots in military aviation, and the testing of modern military plans. The establishment was entirely a German creation. During the summer flying season, about fifty pilots and up to 100 technicians came from Germany for training. Clearly, such collaboration greatly benefited the young Soviet state, having faced years of blockade, civil war, and imperialist aggression.

UPRISING STILL REMAINS ON THE AGENDA

The communist movement was also experiencing upheaval. The October 1923 debacle had direct consequences for the KPD. In November, the party had been banned by General von Seeckt, and its members were subject to widespread repression and arrest. But, as we have seen, the seriousness of the defeat was very much played down in Moscow.

Zinoviev, now zigzagging back towards an ultra-left position, proclaimed that the situation in Germany had not changed, and that the insurrection and the conquest of power were still very much on the agenda. The Executive Committee resolution of 19 January 1924 stated:

> The fundamental estimation of the situation in Germany which was given in September [1923] by the ECCI remains essentially the same. The KPD must not strike off from its agenda the question of the uprising and the conquest of power. (B. Fowkes [ed.], p. 102.)

The resolution went on to proclaim that:

> The leading layers of German Social Democracy are at present nothing other than a faction of German Fascism under a socialist mask... The KPD rejects negotiations with the SPD, and also with the 'Left' SPD leaders until

they have the guts to break with the SPD leadership. The turn in tactics is therefore expressed in the words: *United Front from Below!* (ibid., p. 102.)

This leftist tone pre-dates the theory of 'social fascism', which was crudely elaborated by Stalin some months later in October 1924, when he said, "Fascism is the fighting organisation of the bourgeoisie buttressed on the active support of Social Democracy. Social Democracy is objectively the moderate wing of fascism." (E.H. Carr, *Socialism in One Country*, p. 86.) Stalin was simply echoing the views of Zinoviev. He was certainly no theoretician and borrowed his ideas from Zinoviev, then from Bukharin.

This ultra-left talk marked a decisive shift from the approach taken by the German party twelve months earlier. In February 1923, it had adopted a genuine approach towards the united front, not from above or below, or any other such gimmick, but in a genuine appeal to unite the mass organisations in a common front. A resolution from 1922 explained:

> The united front tactic is not a manoeuvre to unmask the reformists. Rather the reverse: the unmasking of the reformists is the means to building a firmly United fighting front of the proletariat... In every serious situation, the Communist Party must turn both to the masses and to the leaders of all proletarian organisations with the invitation to undertake a common struggle for the construction of the proletarian united front. The notion that the establishment of the united front is possible only through an appeal to masses to struggle (only 'from below') or only by negotiations with other organisations at the summit (only 'from above') is undialectical and rigid... (ibid., p. 123.)

This wild optimism about immediate revolution in Germany emanating from Moscow lasted for months. Even Stalin, who had little first-hand knowledge of the situation, but loyal to the others in the troika, insisted that the German revolution was undefeated and revolution was still on the order of the day.

> It is false to say that the decisive battles have already occurred, that the proletariat has suffered a defeat and that the revolution has been postponed for an indefinite period. (Quoted in L. Trotsky, *The Third International After Lenin*, p. 116.)

He even had the effrontery to accuse Trotsky of Liquidationism.

Trotsky answered Stalin:

> Liquidationism is the renunciation of the revolution, the attempt to substitute the roads and methods of reformism for the roads and methods of revolution... The Leninist policy has nothing in common with liquidationism; but it has just as little to do with a disregard of the changes

in the objective situation and with maintaining verbally the course towards the armed insurrection after the revolution has already turned its back upon us, and when it is necessary to resume the road of long, stubborn, systematic, and laborious work among the masses in order to prepare the party for a new revolution ahead.

On ascending the stairs, a different type of movement is required from that which is needed to descend. Most dangerous is such a situation as finds a man, with the lights out, raising his foot to ascend when the steps before him lead downwards. Falls, injuries, and dislocations are then inevitable. The leadership in 1924 did everything in its power to suppress both the criticism of the experiences of the German October and all criticism in general. And it kept stubbornly repeating: the workers are heading directly for the revolution – the stairs lead upward. Small wonder that the directives… applied during the revolutionary ebb, led to cruel political falls and dislocations! (ibid., pp. 116-117.)

The Comintern leaders could not keep denying that the October fiasco was not a defeat. Instead, they manoeuvred to shift the blame away from themselves. After all, they could not be held responsible for the debacle, especially at a time when they faced criticisms from the Left Opposition. This became their overriding concern.

FIFTH WORLD CONGRESS

In the summer of 1924, the Fifth Congress of the Comintern was held in the shadow of Lenin's death and the German defeat. This time, instead of twenty, the German party sent a delegation of forty, representing all the party's tendencies. There were 406 delegates from forty-one countries, of whom 341 were full delegates with voting rights.

When Trotsky appeared on the podium at the opening session of the Congress, he was greeted with loud applause, and was duly elected to the presidium of the Congress. But this warmness was soon curbed in the delegation meetings, where national leaderships were instructed to condemn the Russian Opposition.

In opening the Congress, Zinoviev repeated the words of Trotsky at the Third Congress, when he said, "We misjudged the tempo; we counted in months when we had to count in years." (E.H. Carr, *Socialism in One Country*, p. 74.) Despite this admission, he went on to place the full responsibility for the German failure onto the Brandlerite deviation to the Right, a position that had already been adopted by the ECCI and the German party.

In the debate, Radek put forward a defence of Brandler. He was then answered by Ruth Fischer, who declared that Radek and his Brandlerite

supporters no longer had any belief in the German or European revolution. (ibid., p. 78.) Brandler intervened to defend himself, but his arguments had little effect, if any.

This emboldened the German Lefts, who went on to criticise the draft theses of the ECCI, which had raised the idea that German capitalism could enjoy a temporary recovery, saying it was a dangerous illusion. The Lefts had stuck to the position they held in 1921, when they asserted that a recovery was impossible.

Not a single delegate raised any support for the Russian Opposition, including Radek. On the contrary, after being suitably primed, the leaders of the national parties joined in the chorus of denunciation of the Opposition. The Congress then formally endorsed the resolutions of the Russian party conference and congress, which had condemned the Opposition platform.

The key issue arising at the Congress was the 'Bolshevisation' of the Communist Parties, which was raised in Zinoviev's speech. In condemning Trotsky, the Russian leaders had proclaimed themselves the true Bolsheviks. The cure for any such possible deviations was an infusion of 'Bolshevism'.

When Zinoviev summed up the debate, he said it was "more extensive than ever before". To cover himself, he leaned to the Left by sharply attacking both Radek and the Social Democrats.

It was at this Congress that Trotsky and Radek were voted off the Executive Committee of the Communist International. Stalin, who played no role in Comintern affairs, was elected for the first time to the Executive.

Thus, the 'Bolshevisation' of the Communist Parties was the prime message that emerged from the Congress. Albert Treint, one of the French Party leaders, summed up the position with an attack against the Russian Opposition in an article: "Our motto is clear: no de-Bolshevism of the Russian Party, but on the contrary Bolshevism of all the communist parties." (ibid., p. 94.) It would not be long before he himself was expelled for his 'leftist opposition'.

The most important party outside the Soviet Union, was purged of 'Brandlerism' and then placed in the hands of the ultra-lefts, Ruth Fischer and Arkadi Maslow. In April 1924, the Ninth German Party Convention elected both of them as co-chairs of the Communist Party. Brandler did not win a single vote, meaning the party's right was completely defeated. With this shift, the 'centre' also collapsed. In the Congress, there was a sharp discussion on the trade unions, where a number of delegates said that it was not possible to work in the reformist unions. However, a compromise resolution was passed that agreed party members would continue to work in

the unions. This sharp turn to the left within the KPD served to throw the party from the frying pan into the fire.

Since the Fifth Congress in the summer of 1924, Brandler, Thalheimer and four other Rightists had been recalled to Moscow for 'other duties' to prevent them from intervening in KPD affairs. This allowed Fischer and Maslow a free hand, to the chagrin of the International leadership.

The resolution of the ECCI in April 1926 recorded that the Comintern "was obliged… to the transfer of leadership to the Left, in spite of the fact that it knew that Maslow, Ruth Fischer and Scholem were capable of committing the greatest ultra-left errors." (ibid., p. 98.) These leaders were repeatedly called to order, but with varying success.

In November 1923, a conference of the opposition within the trade unions, two-thirds of whom were communists, took place in Erfurt. Given the bitterness following the October defeat, the decision to formally leave the ADGB 'Free' Trade Union Federation was only narrowly defeated. In this atmosphere Fischer and Maslow conducted an active campaign against the reformist unions. In response, the leaders of the ADGB organised a campaign of mass expulsions of the communists from their ranks. Both the 'lefts' and the bureaucrats leaned upon one another.

In January 1924, the trade union leaders voted to expel anyone conducting communist propaganda. As a result, the expulsion of communists from the unions was a regular occurrence. This in turn stirred up feelings that communists should turn their backs on these 'yellow' trade unions. This feeling became widespread in the party. There were, however, repeated attempts to combat this tendency. Even Lozovsky from the Comintern stated that to leave a trade union was a "desertion in battle", but this seemed to have little effect. By March 1924, it was estimated that not more than twenty or thirty per cent of party members were enrolled in the unions as against seventy per cent a year earlier. Fischer and Maslow were complicit in this situation. They continually encouraged these ultra-left moods, and when combined with a rejection of the united front, this simply served to further isolate the party.

This saw the party's influence in the trade union movement fall dramatically. It was most evident in the fall in the number of communist delegates to the national Congress of the General German Federation of Trade Unions, the *Allgemeiner Deutscher Gewerkschaftsbund* (ADGB): in 1922 they had eighty-eight delegates out of 692, but by September 1925 they were reduced dramatically to only three delegates.

Under the Fischer and Maslow leadership, the German party's decline was catastrophic. The policies of ultra-leftism proved to be a complete disaster.

Trotsky with young leaders of recently-founded Communist Parties around the
world at the Fifth Congress of the Comintern in Moscow 1924

Even the Comintern leaders were forced to recognise this calamity with
growing impatience. As expected, the ground was cleared for their removal in
the Zinovievite manner.

REMOVAL OF FISCHER-MASLOW

Zinoviev used the ECCI to issue an 'open letter' to the German party
criticising the 'Ruth Fischer-Maslow group'. This reached the German party
by the end of August 1925, and was immediately endorsed by the central
committee of the KPD "without reservation". The political ground began
to shift. An article appeared in *Pravda* accusing 'the Ruth Fischer-Maslow
group' of wishing to be "more to the Left than Leninism" and condemned
their failure to win over the Social Democratic workers in the unions.

> Nearer to the Social Democratic workers! Real application of united front
> tactics, not in words but in deeds! Energetic strengthening of trade union
> unity! That is the political meaning of the ECCI letter! (ibid., p. 340.)

Thus began the general offensive against Maslow and Fischer, which did not
let up until they were finally removed.

"The attitude of the group of Comrade Maslow to the Comintern has
been incorrect and un-Bolshevik since the Third World Congress," stated the

ECCI in a circular to all members of the KPD. Zinoviev described them as intellectuals of the Left who had their own ambitions and it was necessary to put them in their place: "the pretension of these intellectuals was to lead not only the KPD, but the Comintern as well." (E.H. Carr, *Socialism in One Country*, p. 338.) This was followed by the KPD Congress passing a resolution condemning the party's ultra-left tendencies. On the instructions of Zinoviev, Fischer was summoned to Moscow as part of a German delegation in September 1925 and was held there for months. Meanwhile, Maslow had been in prison in Berlin since May 1924 on a charge of high treason, but this did not stop him from writing or communicating with party members.

Zinoviev and his entourage began to groom Ernst Thälmann, the chairman of the party, to become its new leader. He was viewed as the 'proletarian' and the true leader of German communism. He, in turn, tried to establish his credentials by immediately recognising the importance of the trade union work, in contrast to Fischer and Maslow. Eventually, Fischer and Maslow were duly expelled in August 1926 for "indiscipline" and "preparing a split". They were then replaced by Thälmann, who was altogether more pliant to the needs of Moscow. The 'centre' led by Ernst Meyer was essentially brought to heel. Meyer stated:

> It will hasten clarification. Whatever its ambiguities it indicates the right road. It is now our task to do the rest... It would be foolish on our part to deny Thälmann our wholehearted support, when the Central Committee genuinely accepts the new course. We must help the party to overcome the present crisis with the least amount of damage. We could not refuse to collaborate, for this was the policy we ourselves have been advocating for a long time. (R. Leviné-Meyer, *Inside German Communism*, p. 87.)

Hugo Urbahns took over the leadership of the German Lefts, but later came out in support of the United Opposition of Trotsky and Zinoviev and was duly expelled.

The apologist of Stalinism, the historian Eric Hobsbawm, tried to justify these manoeuvres which destroyed the internal life of the Communist Parties. He wrote: "Direct Comintern intervention in 1925 deposed the left leaders. *Nothing else could have been done,* and this established a sinister precedent." (E. Hobsbawm, *Revolutionaries*, p. 57, emphasis in original.) Hobsbawm, belonging to the Stalinist tradition himself, was incapable of understanding that with such methods you could only build a movement of 'obedient fools', and not thinking Marxist cadres.

Fischer and Maslow went on to help found the Leninbund in April 1928, an opposition group, based on support for the 'United Opposition'.

However, following Zinoviev's capitulation, they withdrew. By 1926, Zinoviev and Kamenev had in fact broken with Stalin and had come over to Trotsky, but this only lasted eighteen months, before they capitulated. Fischer and Maslow then formed a small 'International Group', which adhered to the International Communist League established by Trotsky, following a meeting with him in early 1934. They both participated in the Movement for the Fourth International, but quit the movement sometime in 1936. They eventually shifted to the right and ended up breaking with Communism.

The removal of Fischer and Maslow from the German leadership saw the end of a sectarian approach to the trade unions but, as was now becoming the norm, ultra-leftism gave way to a swing in the opposite direction. Within a year, a new, more opportunist policy was adopted by the Comintern, reflected in the formation of the Anglo-Soviet Trade Union Committee in Britain. The latter was an agreement between the British Trade Union congress (TUC) and the Russian trade unions to oppose war and carry out general co-operation. All this achieved was to provide a 'left' cover for the TUC leaders, especially the lefts on the General Council, to betray the 1926 General Strike.

In China, the same policy led to the Communist Party dissolving itself into the Kuomintang and supporting the so-called 'progressive bourgeoisie'. This led to the defeat of the Chinese Revolution at the hands of the nationalist butcher, Chiang-Kai-Shek. So far did the opportunism of Stalin go, that Chiang-Kai-Shek was even made an honorary member of the Executive Committee of the Communist International, with Trotsky's solitary vote against. This opportunist phase would last from 1925 to 1928, when the Sixth World Congress would see a further zigzag with a change of line and the adoption of the disastrous ultra-left madness of the 'Third' period.

From 1924 onwards, Zinovievite methods were used to crush all independence of thought and action within the German Communist Party. The same policy was applied throughout the Communist International. Meanwhile, the campaign within the International against 'Trotskyism' caused havoc, with expulsions, splits and resignations. In the Soviet Union, it ended up not only with the expulsion of the Left Opposition, but also, within a short period of time, with the expulsion of the Right Opposition of Bukharin, and the eventual domination of the Stalin clique.

There had been purges of the party in Lenin's time, but not of this character. Then, it was a question of removing careerists and place-seekers. Between the Tenth Party Congress in March 1921 and the Eleventh Congress in March 1922, the party membership had been reduced from 730,000 to 515,000. These purges were used to eliminate those undesirable elements charged with corruption, bribery, ambition, drunkenness, chauvinism, anti-

Semitism and abuse of confidence. "No profound and powerful popular movement in all history has taken place without its share of mud, without adventurers and rogues, without swaggering and noisy elements," explained Lenin. However, under Zinoviev and Stalin, the purges were carried out for political reasons, where opponents were framed and expelled for their ideas, which was a massive affront to genuine Bolshevism.

After such purges, the German leadership became a willing tool of the leadership in Moscow, and accepted every twist and turn of policy without question. Luxemburg was partially rehabilitated, but stress was still laid on her failings. According to Martynov, Stalin's henchman, despite Luxemburg's great service to communism, she was a semi-Menshevik who did not understand Marxism. (A. Martynov, *Luxemburg to Lenin or Luxemburg to Kautsky? The Communist International,* 6 July, 1929.) Stalin even claimed that Luxemburg and Parvus had developed the 'criminal' theory of 'permanent revolution', and not Trotsky. He wrote:

> They [Parvus and Luxemburg] invented a Utopian and semi-Menshevik scheme of the permanent revolution (a monstrous distortion of the Marxian scheme of revolution). (J. Stalin, *Some Questions Regarding the History of Bolshevism,* The Communist International, 20 August, 1931.)

This was a 'dastardly act' for which they were falsely accused.

Trotsky replied to Stalin's slurs about Luxemburg, who described the attack by him as "a vile and barefaced calumny about Rosa Luxemburg." He explained:

> Lenin understood Rosa Luxemburg's mistakes more profoundly than Stalin; but it was not accidental that Lenin once quoted the old couplet in relation to Luxemburg: "Although the eagles do swoop down and beneath the chickens fly, chickens with outspread wings never will soar amid clouds in the sky."

> Precisely the case! Precisely the point! For this very reason Stalin should proceed with caution before employing his vicious mediocrity when the matter touches figures of such status as Rosa Luxemburg. (L. Trotsky, 'Hands off Rosa Luxemburg!')

1925 PRESIDENTIAL ELECTION

The death of Ebert in February 1925 resulted in a new election for President. Seven candidates took part in the first ballot. The right-wing parties had put up a joint candidate, Dr. Jarres, the Burgomaster of Duisburg, a conservative, who won the first round of voting with 10.5 million votes. In second place came the Social Democrat, Otto Braun (the then-Prime Minister of

Prussia), with almost eight million votes. Dr. Wilhelm Marx, the leader of the Catholic Centre Party, got less than four million votes. He had headed a government in early 1924 which introduced severe deflationary measures against the working class and ruled by emergency decree. Then came Ernst Thälmann, the Communist candidate who received barely two million. They were followed by General von Ludendorff, who had been nominated by the Nazis, with less than 300,000 votes. This election marked the lowest level reached by the Nazi party up until this point. The Democrats and the Bavarian People's Party also put forward candidates who received respectively 1.5 and one million votes.

A second ballot became necessary, which saw a dramatic realignment of candidates. In the second round, the Social Democrats, despite gaining eight million votes, withdrew their candidate in favour of Dr. Wilhelm Marx of the Centre Party. Far from being a frontrunner, Dr. Marx had only received half as many votes as the Social Democrat, Otto Braun. The right had also changed their candidate from Jarres to the seventy-eight-year old Field Marshal von Hindenburg (advertised as 'the Saviour'), the former commander-in-chief of the Imperial Army, who newly entered the race. The Social Democrats had justified their support for the reactionary Dr. Marx as a policy of the 'lesser evil', where the evil Dr. Marx was considered more acceptable than the even more evil von Hindenburg. In reality, this was like choosing between Beelzebub and Satan, a bankrupt policy, which had fatal consequences in the pre-Hitler years. If Dr. Marx had been elected President, he would have been a willing tool of the generals and the capitalists, as he had been as Chancellor. This policy of appeasement on the part of the Social Democrats based upon alliances with the enemies of the working class could only lead to confusion and eventual capitulation. The Communist Party again put up Ernst Thälmann as their candidate. Although this was simply a show of strength, the Communists had no other choice but to stand. There was no fundamental or principled difference between the reactionary camps of either Dr. Marx or von Hindenburg, neither of which could be supported.

In the first election the Hindenburg-supporting parties had polled about 12 million votes. In the second election in April, the Field-Marshal received 14.6 million votes, followed by Marx with 13.7 million votes and Thälmann with barely two million. Thus, by a very small margin, the militarist von Hindenburg was elected President of the German Republic. Seeing himself as the real Commander-in-Chief of the Reichswehr, his election served to increase further military influence in German affairs. Once again, the Social Democrats were left with egg on their faces.

In a bizarre twist, the economic recovery had stimulated the old Hohenzollern monarchy, which had been dethroned, to demand indemnities for the 'troubles' in the 1918 revolution. This aristocratic elite demanded compensation for the act of revolution! After all, the revolution had caused them to leave in a rush without the question of their property claims being resolved. In the turbulent years prior to 1924, they dared not raise this vexed question. But with renewed stability and American loans, these princes chose to press their demands. If the indemnities were refused by the states, then these princely families threatened to bring legal action against them. This provoked absolute outrage, as the Imperial family engaged in a furious open quarrel with its former subjects over 'compensation'.

OPEN LETTER

In reply to these outrageous demands, the left raised the idea of the complete expropriation of their estates. The campaign for expropriation was first launched by the KPD, which then appealed in an Open Letter to the Social

Paul von Hindenburg

Democrats to organise a joint campaign for a plebiscite. At first, the reformist leaders refused, but under pressure from their rank and file, finally agreed. They were joined in this campaign by the well-known physicist and socialist Albert Einstein.

The SPD and the KPD agreed to join forces in introducing a bill in the Reichstag to end this scandal once and for all, by putting the matter to a plebiscite in accordance with the Constitution. The campaign was one of the most successful ever mounted by the workers' parties, and one of the few occasions when the united front was successfully implemented.

Both parties campaigned boldly for the complete expropriation of the property of the old nobility, without compensation, with the proceeds used to establish a fund for war invalids, old age pensioners and the unemployed. The expropriated property would be put to social use for the public good.

The joint SPD-KPD proposals for the expropriations determined that:

> The whole of the property of the princes who ruled in the parts of the German empire until the overthrow of that state in 1918, as well as the whole of the property of the princely houses, their families and their dependants, is to be confiscated without compensation for the benefit of the community...

> The castles, manor houses and other buildings expropriated will be used for general purposes of welfare, culture and education, and in particular for the establishment of convalescence and care homes for the war-wounded and surviving dependants, and state pensioners, as well as for the children's homes and educational establishments. (B. Fowkes [ed.], pp. 158-159.)

In this campaign, the Princes and their supporters managed to enlist the aid of Hindenburg, the President of the Republic, together with all those who feared for their property. After all, appetite comes with eating. It would begin with the property of the Hohenzollerns, but where would it end? In a widely distributed statement, Hindenburg stated:

> By exciting the instincts of the masses and by exploiting the misery of the people with regard to the individual case now in question, there may arise the method of continuing on the road of expropriation, with the aid of a similar plebiscite, which would rob the German nation of the very foundations of its culture, economic and State life. (E. Anderson, p. 119.)

The Social Democratic Party hit back with its own declaration:

> What connection is there between justice or morals and the fact that Wilhelm ll, who possesses property in Holland worth many millions, now demands

a further 300,000 *morgen*[2] of German land together with castles and other valuables worth 183 million gold Marks? (Quoted in ibid., p. 119.)

When the plebiscite was finally held in March 1926, it was a great success with 12.5 million supporting the princely expropriations. Nevertheless, according to the Constitution, in order for the plebiscite to succeed it would need to be followed by a further referendum, where more than half the entire electorate would need to support the proposal.

In the new referendum, a campaign was now organised by the pro-monarchist forces to force people not to vote so as the threshold would not be reached and the plebiscite nullified. The Right, through the big landowners, exerted massive pressure on the rural population, in an attempt to frighten them to stay away from the poll. These threats certainly had an effect. In East Prussia, the home of the landowning Junkers, only twenty per cent of the electorate voted.

The second round of voting took place in June 1926. Although the campaign for expropriation failed to achieve the necessary threshold of 20 million votes to succeed, namely half the electorate, the combined left forces won a very impressive 16.5 million votes. This certainly compared very favourably with the combined 10.5 million the two parties had recorded in the December 1924 general election. It was the most successful joint action between the left parties since the Rathenau murder in 1922 or the Kapp putsch of 1920. Unfortunately, it proved to be the last occasion for such a fruitful collaboration.

While a coalition government between the SPD and KPD was ruled out nationally, there was certain co-operation at a state level, most notably in Saxony and Thuringia, where the state government relied on communist support. But in other areas of the country, the SPD, mostly dominated by right-wing deputies, preferred coalitions with the Centre Party and the German Democratic Party (DDP). In Hamburg in 1927 the elections produced a 'red majority', but rather than unite with the KPD, the Social Democrats shamefully preferred a coalition with the Democratic People's Party (DVP), the more conservative wing of the liberals.

Following Gessler's resignation as Reichswehr Minister, Hindenburg appointed his former wartime chief of staff, General Groener in his place. Therefore, Generals von Hindenburg and Groener – the heads of the Supreme Command on 9 November 1918 – having outlived Ebert, were once again in control of the German Republic. Despite all of what had happened, how little the personnel had changed.

2 300,000 *morgen* equals 180,000 acres.

The period 1925 to 1929 were years of maximum stability for the Weimar Republic. Unemployment had fallen to 650,000 by September 1928, and retail sales were up twenty per cent over their 1925 level. It appeared that prosperity had begun to return to Germany. But this was not to last. It was the calm before the storm.

THE 1928 GENERAL ELECTION

By the time of the general election in May 1928, the boom was reaching its peak. Living standards had started to rise. Germany had been admitted into the League of Nations and the Dawes Plan was functioning. War and hyperinflation were now seen as things of the past. This gave rise to feelings of a certain relief, which once again resulted in electoral gains for the Social Democrats. In the 1928 election the SPD had polled over 9 million votes, an increase of 1.3 million over the previous election, and managed to win 153 seats. They were once again the largest party in the Reichstag.

The KPD also increased its vote to 3.2 million, a rise of half a million votes. The party had gained an extra nine seats, making fifty-four in total. Together with the Social Democrats, they were the only winners of that election, with just over forty-two per cent of the seats in the Reichstag – ironically, almost the exact number obtained by the Nazis in the terror election of March 1933.

Without exception, it was a bad election for the bourgeois parties, all of which faced a decline in support. The National Party lost thirty seats; the People's Party lost six seats; the Democratic Party seven seats. Hitler's Nazi party lost two seats, leaving it with only twelve seats (out of 474), and 810,000 votes. This reflected the political impasse in which the fascists found themselves. They were electorally at their lowest point, with a loss of 120,000 votes compared to the December 1924 election. The Nationalist Party's vote also fell by one third to four million, a considerable fall.

After four years of being out of office, the Social Democrats now returned to enter a 'Grand Coalition', headed by Herman Müller, the Social Democrat who had tasted power before. Despite the SPD being the largest party in the Reichstag, the new Grand Liberal-Social Democratic Coalition contained a minority of Social Democratic ministers. These included the former radical, now conservative, Rudolf Hilferding as Minister of Finance, with Karl Severing as Minister of the Interior, and Rudolf Wissell as Minister of Labour.

The 'Grand Coalition' was a very conservative government, which pursued pro-capitalist policies on all questions, especially on the economy. The Social Democrats, who had shifted further to the right, continued with their policy of 'toleration' towards the bourgeoisie, its system and its

representatives. This whole approach was underlined in what would become known as the 'armoured cruisers affair'.

The previous bourgeois government had included in its budget for 1928 the building of armoured cruisers. This policy became a prime target of derision during the election campaign, especially at the hands of the SPD. The socialists campaigned under the slogan: 'Food for school children or armoured Cruisers?'

With the formation of the new government, it was presumed that the plan to build the cruisers would be dropped. However, the General Staff were firmly opposed to this. They demanded the battleships' construction be completed as agreed. This placed the Social Democrats in a dilemma: either capitulate to the General Staff or provoke a Cabinet crisis and resign from the government. They preferred to remain in government, express their opposition, then reluctantly acquiesce. Given their minority position in the Cabinet, they would be outvoted and they could wash their hands of the final decision.

However, the pressure on the Social Democrats became intense. To make matters worse, the Democratic Party decided to oppose the construction. This meant that, together with the Social Democrats, there would be a majority in the Cabinet in favour of abandoning the project. Despite this, the Social Democrats changed their decision, and the Cabinet voted to go ahead with the cruisers.

This created a storm of protest throughout the German labour movement. Even the SPD Parliamentary party disavowed its own Ministers and tabled their own motion in the Reichstag demanding that the construction of the battleships be scrapped. The motion was defeated by a narrow majority. To save their embarrassment, the four Social Democratic Ministers absented themselves during the vote. As could be expected, there was widespread disillusionment with this 'Grand Coalition' government in the working class. The coalition would stagger along in office for a further twenty-one months.

Franz Petrich, a leading member of the party, wrote:

> Hilferding's activities in the Ministry of Finance, demonstrated every day that he was the prisoner of finance capital, and that he existed on its charity. The moment that he became superfluous to finance capital's needs he was removed from office. (B. Fowkes [ed.], p. 165.)

Hilferding was not so much a prisoner as a willing tool. Ironically, he had written a well-known book entitled *Finance Capital* more than a decade earlier, under the heat of the 1905 revolution. Now he had become the stooge of finance capital.

The SPD decided to withdraw from the 'Grand Coalition', which precipitated its collapse. New elections on 14 September 1930 resulted in a defeat for the Social Democrats and brought to power the right-wing government of Heinrich Brüning.

YOUNG PLAN

In June 1929, an international committee under the chairmanship of the American banker, Owen D. Young, signed a report, which supposedly placed Germany's reparations obligations on a new, more favourable, basis. For the first time, the Young Plan placed a time limit on the reparations. However, the expiry date for these payments was 1988, fifty years in the future. Most Germans regarded this as grossly unacceptable. It would mean that their grandchildren and great-grandchildren would still be paying Germany's reparations from the 1914-1918 War. This issue was taken up with vigour by the fascists and the right-wing Nationalists.

Thyssen remarked:

> I turned to the National Socialist Party only after I became convinced that the fight against the Young Plan was unavoidable if a complete collapse of Germany was to be prevented. (J. Pool and S. Pool, *Who Financed Hitler*, p. 225.)

The Plan so enraged Hugenberg, leader of the German National Party, that he resolved to fight it to the bitter end. Hitler, ever the opportunist, offered to take up the struggle as long as he had access to a large share of the resources and could act independently. They organised a joint nationwide plebiscite to defeat the Young Plan, but were heavily defeated. However, Hitler made maximum use of Hugenberg's newspapers to enhance his popularity.

By the late 1920s, Stalin had enormously strengthened his grip in the Soviet Union. Lenin's Testament, which called for the removal of Stalin as General Secretary, had been suppressed. In the troika, Zinoviev and Kamenev thought they were using Stalin, but in fact it was the other way around. Stalin used them in the fight against Trotsky and then he outmanoeuvred them. It was, after all, Zinoviev who had invented 'Trotskyism'. While Zinoviev and Kamenev were far superior theoretically to Stalin, they lacked his single-minded and ruthless character. Stalin controlled the apparatus, which he used to great effect to build up his support. He appointed those who showed loyalty towards the General Secretary to positions. Eventually, Zinoviev and Kamenev broke with Stalin over his rightward shift. He then entered into an alliance with Bukharin, who advanced the idea of socialism "at a snail's pace".

By this time, the Communist International had become increasingly transformed into a foreign policy tool of the bureaucracy. 'Bolshevisation', carried through by Zinoviev and Stalin, had made the Communist parties completely subservient.

Trotsky wrote:

> Beginning in late 1923 the same work was carried out in all the parties of the Comintern, some leaders were dethroned and others appointed in their places exclusively on the basis of their attitude toward Trotsky. A strenuous, artificial process of selection was accomplished, selection not of the best but of the most adaptable. The general policy was to replace independent and gifted people with mediocrities who owed their positions entirely to the apparatus. And the highest expression of that mediocrity of the apparatus came to be Stalin himself. (L. Trotsky, *Writings 1929*, p. 42.)

Boris Souvarine, a former leader of the French party, wrote:

> First in Paris and Berlin and then from New York to Shanghai, all communists who persisted in distinguishing between discipline and servility, all men capable and guilty of independent or original thinking were henceforth to be treated as suspect, denounced as opportunists, classed with counter-revolutionaries, and expelled, first singly and then in groups. Thus, a continuous series of expulsions and splits eliminated, in turn and by differing methods, the initiators of the contemporary communist movement in two hemispheres. (B. Souvarine, *Stalin: A Critical Survey of Bolshevism*, pp. 367-368.)

The defeat of both the British General Strike in 1926 and the Chinese Revolution of 1925-27, due to the false policies of Stalin and Bukharin, created further disappointment and reinforced the position of the bureaucracy. These international defeats were one of the chief psychological sources and strengths of Stalinism. With each international retreat, the Stalinist bureaucracy raised itself even further above the working class as an independent arbiter. Alarmed by these developments, in 1926, Zinoviev and Kamenev broke with Stalin and joined forces with Trotsky's Left Opposition, the backbone of which was a group of old revolutionaries. Lenin's widow, Krupskaya, who temporarily joined this 'United Opposition', warned in 1926 that if Lenin had lived he would have been in one of Stalin's prisons.

Stalin was determined to silence the new Opposition and so unleashed a terror campaign against it, which culminated in the expulsion of the leaders of the Opposition in November 1927. Within a few months, under Stalin's orders, Trotsky had been forcibly deported as a 'counter-revolutionary' to Alma-Ata in Central Asia and then exiled to Prinkipo.

In 1928, the Russian bureaucracy was faced with an acute crisis. This arose from Bukharin's policy, supported by Stalin, to move gradually to socialism, which resulted in concessions to capitalist interests in town and country. By 1928, the kulaks had enriched themselves sufficiently to threaten the Soviet government by withholding grain supplies.

This resulted in a panic and a 380 degree shift of policy. Concessions to the kulaks was replace with *forced* collectivisation of the land, which met with massive opposition from the peasantry. This policy was in marked contrast to Lenin's idea of *voluntary* collectivisation, assisted by mechanisation and other investments. In retaliation to Stalin's policy, the peasants slaughtered their cattle and livestock, resulting in famine and mass starvation in which millions died. In addition, a Five Year Plan was introduced, which the Stalinists ordained had to be completed in four years.

Within a few years, by 1930, Stalin had in turn broken with Bukharin and began a purge of all opposition elements, including the Right Opposition. Likewise, the Stalinists carried through a further purge throughout the Comintern, appointing in their place loyal, pliant, obedient stooges. Between 1928-1930, the Comintern had been completely housebroken and accepted without protest a whole series of zigzags in policy.

THE THIRD PERIOD

The Sixth World Congress took place in August 1928, which ushered in a new left turn in international policy. The Comintern leaders had burnt their fingers with opportunist policies in Britain and China, and now precipitated a new shift towards ultra-leftism. As Lenin had explained, opportunism and ultra-leftism were head and tail of the same coin.

At the Sixth Congress a key resolution was passed stating that the period of capitalist stability had ended and a new 'Third period' had opened up. According to the mechanical schema of the Comintern leaders, the so-called 'First period' (1917-1924) was that of the revolutionary upsurge of the immediate post-war, the 'Second period' (1925-1928) was one of relative stability, and now the 'Third period' (1928-onwards) was one of wars and proletarian revolutions.

The reality, however, was very different. In 1928, capitalism was at the height of an economic boom, which was accompanied by relative political stability. This was to last until the stock market crash in October 1929. The so-called 'Third Period' was an empirical reaction to the opportunist line of the previous period. Its adoption prepared the way for an absolute catastrophe internationally and particularly in Germany.

The 'Third Period' introduced the madness of 'social fascism' and the idea that the *main* danger now emanated from Social Democracy, especially its left wing. The Communist parties were therefore instructed to break with the reformist trade unions and establish 'red' trade unions wherever possible. Collaboration with Social Democracy became the worst possible crime, and the policy of the united front was abandoned altogether. In fact, everyone to the right of the communists was, in one form or other denounced as 'fascist'. We therefore had 'social fascists', 'liberal fascists', 'radical fascists' and 'Trotsky fascists', as well as the real fascists. It was not possible, in the famous words of Stalin, to regard fascism and Social Democracy as opposites, but only as twins.

The term 'social fascists', as we have seen, had originally been put forward by Zinoviev as early as 1924, when he accused the Social Democrats of behaving like fascists, but this was used very loosely. Shortly afterwards, Stalin stumbled upon the idea and turned it into a *theory*. According to him:

> Fascism is a fighting organisation of the bourgeoisie dependent upon the active support of Social Democracy. Objectively, Social Democracy is the moderate wing of fascism. (Quoted in A. Sturmthal, *The Tragedy of European Labour 1918-1939*, p. 79.)

This pernicious idea had its most disastrous effects in Germany, where it was taken up enthusiastically by Ernst Thälmann, the party's leading light. The KPD issued a pamphlet entitled, 'What is social fascism?', which explained that workers had to concentrate on "the struggle against fascism in its present most dangerous form, i.e. its Social Democratic form." This was simply a rehash of the position of the ECCI, which stated in July 1929:

> In countries where there are strong Social Democratic parties, fascism assumes the particular form of social fascism, which to an ever-increasing extent serves the bourgeoisie as an instrument for paralysing the activity of the masses in the struggle against the regime of fascist dictatorship. (ibid., p. 80.)

To add to the confusion, Thälmann stated in February 1930, with the formation of the Müller coalition government, "the rule of fascism has already been established in Germany."

It was a clear that this 'theory' only served to confuse and disorientate the communist workers. The idea that Social Democracy was fascist was complete nonsense. While the Social Democracy works to subordinate the working class to the enslavement of capitalism, it also needs to preserve its base within the working class, through the activities of the party, the trade

unions, educational and sports clubs, co-operatives, and many more. Its interests are therefore served by the preservation of bourgeois democracy, which fascism, on the contrary, seeks to destroy. Therefore, there exists a fundamental difference between fascism and Social Democracy. The latter rests on workers' organisations and their rights, while the former aims to destroy them.

The capitalist crisis radically transformed the situation. The growing numbers of unemployed in the severe winter of 1928-1929 were swollen by the increased numbers of sackings and layoffs. By February 1929, the unemployment levels rapidly climbed to over three million. This resulted in acute hardship, as up to half a million of those unemployed were excluded from state benefits. The winter was particularly cold and miserable, which added to the growing distress. The KPD attempted to capitalise on the hardship by facing towards the unemployed and organising hunger marches and demonstrations.

Faced with this situation, the trade union leaders put forward a job creation programme called the WTB Plan, from the initials of its authors. They hoped that this Plan, involving state expenditure, would alleviate some of the worst affected areas. Rather than giving it support, even critically, the SPD leaders repudiated the Plan, as they believed increased state spending would lead to rising inflation. They were committed to orthodox economic policies. In the end, the only political party to support the trade union Plan was Hitler's Nazi party.

The German Communists' swing to ultra-leftism and adventurism simply isolated the party from the broad labour movement. Under these conditions, the communists soon became a party, not of the industrial workers, as in the past, but a party of the unemployed. The percentage of unemployed members in the party rose from twenty-one per cent in 1927, to about eighty-five per cent at the end of 1932. This change in the social composition also reinforced the ultra-left mood in the party.

In conditions of economic and social crisis, the social and political tensions grew rapidly. Political violence was becoming a regular occurrence.

MAY DAY 1929

May Day in Berlin had always been a traditional demonstration of the united German labour movement. However, as a result of the poisonous theory of 'social fascism', the communists refused to march together with the Social Democrats. May Day 1929 was the first time that communists and socialists held separate events.

This division was reinforced by the decision of Karl Zörgiebel, the Social Democratic police chief of Berlin, to ban outdoor May Day demonstrations on the grounds of public safety. This ban was backed up by the Interior Minister of Prussia who threatened to use force to enforce the ban. This act was regarded as a blatant provocation to the working class of Berlin, as elsewhere. The ban not only angered the communists, but also the rank and file of the SPD, whose party had initiated May Day as part of the struggle for an eight-hour day. As expected, the KPD repudiated the ban and called on the workers to demonstrate in defence of their democratic rights as they had done under Bismarck and the Kaiser. This appeal found a big response.

The *Rote Fahne* of 13 April printed a statement:

The 1 May 1929 is a day of struggle. The 1 May 1929 is a symbol of the proletarian offensive against the crimes of capital, of the bourgeoisie and of Social Democracy. The Communist International and the Communist Party are the only force that can call on the workers to demonstrate on 1 May under the time-honoured slogans of proletarian solidarity and proletarian class struggle. Take up the fight in all the factories, in all the trade unions and mass organisations! Vote unanimously for work stoppages and the revolutionary mass demonstration!

No demonstration for 'battleship socialism' [as we have seen, Müller's SPD government had voted funds for the construction of battleship cruisers], for economic peace or economic democracy!

Demonstrate on 1 May in town and country under the slogans of the revolutionary class struggle, under the slogans of the Communist Party! Ignore the bans!

For the defence and strengthening of the Communist Party and the Red Front League of Fighters against the threatened bans of the bourgeoisie and Social Democracy! Against the social fascist policies of coalition, against the dictatorship plans of the bourgeoisie and their Social Democratic henchmen! For the dictatorship of the proletariat and for socialism! (O. Hippe, *And Red is the Colour of Our Flag*, p. 114.)

While the Social Democrats reluctantly kept to the ban on outdoor activities, they did organise mass indoor rallies. However, the KPD defied the order and instructed its members to take to the streets. On May Day, thousands of workers and unemployed streamed out of the proletarian districts and flooded the squares, paralysing the roads and traffic.

As the communists gathered for their processions in Berlin, the police were under strict orders to disperse the crowds. As a result, they were attacked by the demonstrators and shots were fired. The Social Democratic workers,

who were also incensed by the ban, joined in the fighting alongside the communists as soon as their rallies had ended. Running street battles went on throughout the night and the following day. Soon, barricades were erected and the police started shooting indiscriminately. They set about beating and arresting innocent bystanders and protesters alike. In the days following May Day, whole areas were placed under martial law. Following the police clampdown, 1,228 were arrested, 194 wounded and twenty-five had been killed. At least six of the dead were shot in their own homes after being hunted down by the authorities.

The Twelfth Congress of the KPD declared that these events were the opening of an immediate revolutionary situation:

> The Berlin May struggle represented a turning point in the political developments in Germany. The preconditions emerged for the approach of an immediate revolutionary situation with whose development the question of armed insurrection inevitably gets placed on the agenda. The May struggle was the first test for the KPD.

The Tenth Plenum of the ECCI held in Moscow in July 1929 concurred with these immediate revolutionary perspectives:

> On the background of the unfolding strike battles and the new revolutionary upsurge, the action of the Berlin proletariat on May Day acquires the very greatest significance. This struggle not only revealed the fighting initiative of the German proletariat, but also the strength of the influence of the Communist Party of Germany which, notwithstanding the prohibition of the demonstration by Zörgiebel and the reformist trade unions, succeeded in leading nearly 20,000 workers into the street. The party has not retreated one step under the onslaught of the reaction, nor did it allow itself to be provoked by the bourgeoisie to an armed insurrection which in the then existing situation would have led to the isolation of the revolutionary vanguard and the loss of its position.

> The Berlin May Days constitute a turning point in the class struggle in Germany and accelerate the tempo of the revolutionary upward trend of the German working class movement. (J. Degras, *The Communist International, 1919-1943*, Documents, vol. 3, p. 47.)

With 'revolution' supposedly on the agenda, the German Communist Party immediately launched a concerted attack on the 'social fascists' and their accomplices in the state, despite the fact that many of the dead and wounded in May were 'social fascist' workers. Rather than appeal to the Social Democrats for a united front against the repression, their ultra-left attacks simply increased the divisions in the working class.

May Day 1929 can be considered the high point of resistance when German Communists erected barricades and engaged in extensive street battles with the police. After this, there would be skirmishes but not of the same magnitude as those following May Day in Berlin.

The brutality of the police and the attitude of Zörgiebel was regarded with disgust. Zörgiebel, instead of apologising, simply blamed the workers for the violence. Very quickly, Zörgiebel became a symbol of hatred for German workers, as Noske had been in the early years of the revolution.

However, the KPD used this hatred to brand *all* Social Democrats as 'social fascists'. This also included the left-wing Social Democrats, who, according to the KPD, were even worse than the right-wing variety. Despite this, the communist leaders still persisted in describing the May Day confrontations as a clear indication of a revolutionary upsurge. This was typical of the Stalinists in this ultra-left period, where every counter-revolutionary danger was played down and every revolutionary opportunity was over-exaggerated. They constantly talked about the radicalisation of the workers and imminent prospect of revolution, but this spurious optimism had no basis in reality, especially given the deep divisions in the working class.

This ultra-leftism of the 'Third Period' was beginning to create a certain disquiet amongst sections of the communist rank and file, and even among some of the party leadership. Clara Zetkin, for instance, was opposed to it, but she only voiced her disagreements in private letters, memos and conversations. In a letter to Piatnitsky in June 1929, she wrote:

> The policy of the present Central Committee is harmful and dangerous. It stands in sharpest contradiction to the principles of Communist policy established under Lenin's leadership. (B. Fowkes, p. 176.)

She expressed all the old instincts of a Social Democrat, defending the 'old, tested policy' she had learned by rote. She had little independence of thought. For a long period, she had followed Rosa Luxemburg. After that, she followed Paul Levi, then to a certain extent Brandler. Within the Comintern she ended up as an increasingly decorative figure. In public she remained silent, suppressed her thoughts, and submitted loyally to the party line. Most of Clara Zetkin's work was conducted in Moscow on behalf of the International Executive Committee, where she lived after 1924. In the Russian disputes, she lined up behind Bukharin and Stalin against the United Opposition, forcefully calling for their expulsion. When Bukharin's Right Opposition was expelled, Zetkin, who opposed the ultra-left line, was completely isolated. As she took no part in deciding questions, Stalin left her alone and used her

authority to further his own position. Growing old and in ill-health, she finally died in Moscow in June 1933.

The KPD rank and file, while harbouring certain misgivings, had little choice but to submit. Any dissent was suppressed. By 1929, only two members of the KPD's Politburo had survived from the 1924 period – Thälmann and Remmele. Even Remmele was subsequently eliminated.

THE 1929 CRASH

The development of German capitalism throughout this period, based on investments and massive foreign loans, had by 1929 produced an industry that was the most advanced in the world.

Huge combines were built up with a productive capacity for which the internal German market was completely insufficient. Such companies were world giants in their own right. The industrialist, Gustav Krupp, who was to become a 'super Nazi', grumbled:

> We need markets, but the markets of the world are closed to us. Great Britain has erected tariff walls. In France, Italy, Sweden, the Balkans, in fact everywhere, German trade is up against barriers which little by little are becoming insurmountable. (A.R. Oliveira, p. 150.)

In October 1929, the Wall Street crash and the following slump in world production, then Depression, proved a catastrophe for German capitalism. In 1929, German exports amounted to 13,000 million marks, but by 1933 they had slumped by more than half to 5,000 million marks. Banks failed, foreign credit evaporated and Germany lurched into a deep crisis.

The Germans were not so much reliant on exports as they were on American loans, which had been propping up the Weimar economy since 1924. However, there were no further loans issued from late 1929, as American financiers began to call in existing loans. This had an immediate impact on the German economy, which could not cope with such retrenchment.

The German banking system was hit hard by the crisis as it struggled with demand for credit drying up. In 1931, there were several runs on German and Austrian banks and a whole host of them went bankrupt. The Credit-Anstalt was the most important. The German economy, as with the rest of the capitalist world, entered into a spiral of decline.

In the summer of 1930, the United States, which was the largest market for German industrial exports, put up tariff barriers to protect its own agriculture and industries. Therefore, German capitalists lost their access to US markets and found credit rapidly drying up. The economic crisis went hand in hand with a financial and banking crisis. Many industries went

bankrupt and were swallowed up by bigger conglomerates. By 1932, German industrial production was at fifty-eight per cent of its 1928 levels, a decline of nearly fifty per cent. The German bourgeoisie responded to the crisis with mass sackings and a general assault on the working class. Germany was once again thrown into the cauldron of profound social and political upheaval.

The introduction of the Young Plan by the Allies, which was strongly supported by the Social Democrats, was expected to last no more than a decade. But the world slump cut across the initiative and, in June 1931, reparation payments were suspended for twelve months under the 'Hoover Moratorium'. This was no more than a sticking plaster on a gaping wound. Then, in June 1932, at the Lausanne Conference, reparations were finally abandoned altogether.

The German 'recovery' had been abruptly snuffed out under the impact of the world crisis. With the slump, everything began to unwind. The sharp contraction in world trade meant that Germany could no longer attempt to export her way out of her difficulties, as all her rivals were trying to do the same thing. As in 1923, Germany fell into a severe crisis, which, by 1931-32, was the deepest crisis ever experienced by world capitalism.

In the first fortnight of January 1930, 40,000 workers were thrown out of work; Krupp had reduced his workforce from 100,000 to 50,000; the Gutehoffnungshütte from 80,000 to 36,000. Within six months unemployment had increased from just over one million to three million, and by early 1933, unemployment in Germany reached a staggering six million. This considered only the officially *registered* unemployed. Tens of millions were affected if you include whole families, possibly in the region of one-third of the population. With the rise of mass unemployment, destitution rose dramatically. The children suffered worst, with thousands dying from malnutrition and hunger-related diseases. Bread and potatoes, mostly bread, became the staple diet. In the words of one historian, "Germany became once more a country of beggars". (ibid., p. 151.)

The economic crisis produced a political crisis. The 'Grand Coalition' felt that the depression should "run its natural course". This laissez faire approach played a major role in its collapse.

BRÜNING GOVERNMENT

With the collapse of the 'Grand Coalition', the last Weimar government to rest on a parliamentary majority would come to an end. The Social Democrats would never share governmental power again.

Germany now faced an economic and social catastrophe, with mass unemployment and discontent spiralling. A decisive section of the German

bourgeoisie began to realise that parliamentary democracy, together with its mass workers' organisations, was more of a hindrance than a help. The 'normal' methods of parliamentarism had revealed their limitations. Even extra-parliamentary Bonapartist rule was likewise proving itself inefficient. They concluded that the only possible solution to the crisis would be an authoritarian one. Their callous attitude was summed up by Krupp, when he said he wanted only loyal workers who were "grateful from the bottom of their hearts for the bread we let them earn". In 1918, the German capitalists had been forced to give big concessions: the eight-hour day, trade union recognition, unemployment insurance, universal suffrage and other reforms, in order to prevent revolution. They gave these concessions with gritted teeth. Now it was time for revenge.

The apparent equilibrium in German society was crumbling. Once the Müller coalition had collapsed, Hindenburg asked Heinrich Brüning of the Centre Party to become Chancellor. Without a majority, the new government was forced to rule by emergency decree, under the provision of Paragraph Forty-Eight of the Weimar Constitution. It was a form of parliamentary Bonapartism, which balanced between the contending forces, but still using the formal trappings of parliament.

To avoid financial collapse, Brüning immediately decreed additional taxes, cut salaries and wages, and slashed unemployment benefits, which affected the living standards of millions of people. However, on 16 July, his fiscal budget was overturned in the Reichstag by a block vote of SPD, KPD, and Nazi deputies, among others. Then, in true Bonapartist fashion, the President used the Constitution to force the budget through parliament. But this budget met with further challenges in the Reichstag, which eventually passed a motion abrogating the decrees. Given this ongoing crisis, Brüning had no other recourse than to dissolve the Reichstag and call new elections for September 1930. This election was to prove a further turning point in the unfolding crisis.

In the autumn of 1930, the fascist Otto Strasser and others introduced a Nazi-sponsored bill in the Reichstag calling for a four per cent ceiling on interest rates, the expropriation of the holdings of "the bank and stock exchange magnates" and "eastern Jews" without compensation, as well as the nationalisation of the banks.

These proposed expropriations provoked serious divisions within the Nazi party. The original ideas of the National Socialists had been rooted in radical 'anti-capitalist' propaganda, as a means of appealing to the 'small man', and nothing more. They certainly were not supposed to be taken seriously.

When Hitler heard about the expropriation bill he was horrified. Such radical measures would alienate his big business backers, from which the party received a great proportion of its money. Threats of nationalisation and other radical measures would repel the likes of Thyssen, Cuno and Vögler, without whose help the Nazis would get nowhere. Hitler denounced the nationalisation bill as "Bolshevism" and demanded its immediate removal. The Nazi deputies carried out his instruction and withdrew it. Thereupon, the Communist deputies reintroduced it word for word in the Reichstag, but Hitler ordered his deputies to vote it down. Hitler clearly knew which side his bread was buttered on.

In reply to Strasser, who demanded nationalisation of industry, Hitler replied:

> Democracy has laid the world in ruins, and nevertheless you want to extend it to the economic sphere. It would be the end of the German economy... The capitalists have worked their way to the top through their capacity, and on the basis of this selection, which again only proves their higher race, they have a right to lead. (A. Bullock, *A Study in Tyranny*, p. 158.)

Strasser was soon driven out of the Nazi party and then set up his own Union of Revolutionary National Socialists, later known as the 'Black Front', but it soon disappeared. It was Hitler and not Strasser who captured the vote. With the backing of the German capitalists and bankers, within six months, the Nazis would win a series of spectacular elections. With the working class deeply split and the worldwide depression deepening, the rise of Hitler's fascism prepared the doom of the Weimar Republic and the emergence of the Third Reich.

CHAPTER SEVEN:
FASCISM'S RISE TO POWER

Herr Brüning has expressed it very clearly; once they (the Nazis) are in power, the united front of the proletariat will emerge and make a clean sweep of everything… We are not afraid of the fascists. They will shoot their bolt quicker than any other government.

Hermann Remmele, speaking in the Reichstag, October 1931

The coming to power of the National Socialists would mean first of all the extermination of the flower of the German proletariat, the destruction of its organizations, the eradication of its belief in itself and in its future. Considering the far greater maturity and acuteness of the social contradictions in Germany, the hellish work of Italian fascism would probably appear as a pale and almost humane experiment in comparison with the work of the German National Socialists.

Leon Trotsky, November 1931

Until late 1928, the fascist groups had no real social base except on the fringes of German society. They had consisted ever since the war of a multitude of small groups and petty military leagues, established by disgruntled army officers and made up of Freikorps elements, freebooters, fanatics, anti-Semites and other such human debris. Hitler's fascist organisation, the DNSAP, was just one amongst many conspiratorial groups, practically unknown to anyone outside a circle of would-be plotters. Other organisations included such groups as the Viking Bund, Oberland League, Thule Society, the Pan German League, and others with even stranger sounding names, inspired by

the Teutonic Knights. Along with these, the Nazis were very much a fringe group.

Hitler's party was established in 1919 and in the following year took the name National Socialist German Workers' Party, from which the name 'Nazi' was abbreviated. The word 'Socialist' was included in the title to broaden the party's appeal to disgruntled workers. It had, of course, nothing to do with genuine socialism. It was based on the strange ideas of Karl Lueger, the anti-Semitic, monarchist charlatan and demagogue, for whom Hitler showed some admiration. In fact, the Nazi party was very much anti-socialist and anti-labour movement, which were regarded as foreign Jewish imports. Bolshevism, likewise, was considered a foreign conspiracy, promoted by international Jewry, a reflection of the party's virulent anti-Semitism. Nevertheless, it paraded itself as 'anti-capitalist' and the idealists in the party looked forward to a 'Second Revolution' where the final 'socialist' vision would be implemented. Of course, this was never going to happen, as was shown when the troublesome demagogues of the SA were eliminated.

In its precarious early existence, the Nazi party attracted disaffected reactionary elements from the old army, consumed with a hatred of Bolshevism, the workers' organisations and the humiliating Versailles Treaty. Yet apart from attracting a small number of disgruntled cranks and psychopaths, its influence was extremely limited. In the early days, few people would even have known of the existence of this small anti-Semitic Bavarian party.

Hitler soon realised that his small group alone had little future, and only by uniting with other fascist groupings would there be any possibility of advance. Therefore, in 1923 he joined forces with a number of paramilitary nationalist groupings and disaffected Freikorps units in Bavaria, which together formed the Deutscher Kampfbund (German Fighting Union), with himself as one of its three main leaders. Mussolini's victory and march on Rome the previous year had led them to believe they could do the same in Germany.

On 9 November 1923, without the support of the army tops, Hitler, Röhm and Ludendorff staged an abortive putsch, known as the 'Beer Hall putsch', which failed miserably. The fascists were easily dispersed and Hitler arrested. The fiasco was a massive blow to the Nazis. Ernst Hanfstängl, one of the first to provide respectable hospitality to the fascists, complained to his friends about the thousand dollars, a fabulous sum in those days, he had loaned to the party: "What good is it now to have a receipt and a mortgage on the office furniture?" (J. Pool and S. Pool, p. 131.) Recruits became scarce and so did money. Splits opened up in the fascists' ranks and there were numerous desertions. During his spell in prison, in comfortable confinement

in Landsberg Castle, Hitler spent his time thinking and whiling away the hours by writing his autobiography, *Mein Kampf* ('My Struggle'). This period can be regarded as the 'dog days' of the fascist movement, isolated, weakened and very much in the doldrums.

On Hitler's premature release from Landsberg prison in December 1924 things were not any better, in fact they were decidedly worse. Hitler was faced with the demoralising news that the Social Democrats had massively increased their vote by thirty per cent (to nearly eight million) in the general election. By contrast, the Nazi party, together with a number of fascist groups under the name of Nationalist Socialist German Freedom Movement, saw their vote plunge, halved from two million in May 1924 to less than a million in December. This was hardly a movement that was going to march on Berlin and seize power.

With the collapse of his attempted coup in Bavaria, Hitler was forced to reconsider new tactics for the Nazi party. The idea of a seizure of power on the lines of Mussolini had flopped badly and had to be abandoned for the time being. Hitler was reported to have said:

> When I resume active work, it will be necessary to pursue a new policy. Instead of working to achieve power by an armed *coup*, we shall have to hold our noses and enter the Reichstag against the Catholic and Marxist deputies. If outvoting them takes longer than out-shooting them, at least the result will be guaranteed by their own Constitution. Any lawful process is slow... Sooner or later we shall have a majority – and after that, Germany. (A. Bullock, p. 130.)

This perspective was based more on hope than certainty; more on luck than judgement. For now, there seemed little alternative.

At this point, Nazism was facing a dead end. Despite Hitler's overblown ambitions, as was explained in a previous chapter, the services of fascism were not required, as yet, by Germany's ruling class. The bourgeoisie were still pursuing other ways of getting what they wanted, which meant resting on their traditional parliamentary parties. "The Nazis were able to attract few new members under such conditions," wrote James and Suzanne Pool. "But if new recruits were scarce in 1925, money was even harder to come by." (D. Guerin, p. 133.) While the German bourgeoisie were not prepared at this stage to bankroll the fascists, big business nevertheless supplied them with just enough funds to keep them in existence as a reserve weapon or insurance policy. They were kept on the payroll, as a nightclub owner employs a couple of bouncers on the door.

By the time of the general election in May 1928 Nazi support had shrunk even further to a mere 2.6 per cent of the total vote. This did not augur well for Hitler or the future of his party. The movement was not growing, but was in retreat. "At the end of 1928 Hitler was still a small-time politician," remarked Alan Bullock, "little known outside the south and even there regarded as part of the lunatic-fringe of Bavarian politics." (A. Bullock, p. 144.)

BIG BUSINESS TURNS TO HITLER

Small-time politicians, however, can play a key role when the conditions are ripe. And, in 1930, conditions were about to drastically change and provide the fascists with new opportunities. By the end of year, the economic situation had fallen off a cliff edge with the withdrawal of American funds following the Wall Street Crash. In the same year, the United States introduced the Smoot Hawley Tariff Act, which raised U.S. tariffs on over 20,000 imported goods and provoked a series of beggar thy neighbour policies worldwide. The economies of Central Europe, as well as German industry, had borrowed heavily from French and British banks. They began to default on their debts, driving the banking system into crisis. In May 1931, the Austrian bank, the Credit-Anstalt, collapsed, the first major bank failure that initiated the Great Depression, sending shock waves through Germany and the world. In July, this was followed by the failure of one of Germany's principal banks, the Darmstädter und Nationalbank, which was forced to suspend payments. Imports from Europe decreased from a 1929 high of $1.3 billion to just $390 million during 1932, while US exports to Europe decreased from $2.3 billion in 1929 to $784 million in 1932. Overall, world trade decreased by some sixty-six per cent between 1929 and 1934. The world economy was caught up in a maelstrom as a chain reaction of competitive devaluations took hold. Thus began the Great Depression, the likes of which the world had never seen before.

Germany experienced its deepest slump, part of the general world collapse of the productive forces. Given its more vulnerable position on world markets, it was the hardest hit of any other major country, resulting in a massive contraction of national output of nearly forty per cent. Mass unemployment rose to new heights – 6, 7 million and more – as one unstable government gave way to another. The living standards of the middle class suddenly collapsed, without any trade union organisation to furnish the least protection. Discontent and bitterness were rife as the Weimar Republic was racked with instability at all levels. Every attempt to correct the economic equilibrium simply produced social and political disequilibrium. The regime was suffering from an existential crisis. The traditional bourgeois parties, which

ADOLF, DER ÜBERMENSCH: Schluckt Gold und redet Blech

Adolf Hitler with a spine of coins. Originally printed in
Arbeiter-Illustrierte-Zeitung, it was created by the artist and
communist John Heartfield

the ruling class relied upon, were in serious crisis and had become ineffective. Governments lurched towards Bonapartist rule. The bourgeoisie once again felt threatened by proletarian revolution. As a consequence, sections of the big bourgeoisie began to look beyond the paralysis of parliamentary democracy. They instead turned towards the idea of a dictatorship that would allow them to place the full burden of the crisis onto the backs of the working class.

The German bourgeoisie, along with the ruling classes of Europe and elsewhere, were great admirers of Mussolini. He had brought to power a pro-business authoritarian government, which had suppressed the workers' movement, driven down wage costs and boosted profits. They reasoned that if 'order' could be restored to Italy, why not in Germany? It was clearly an example to be followed as parliamentary democracy had exhausted its role.

Consequently, German big business put its weight behind the fascists, pouring millions into their coffers and lavishly financing their propaganda. Apart from the seemingly unlimited resources, state institutions – the courts, army authorities, top civil servants, police chiefs – were used as a cover for fascist activities, whilst simultaneously clamping down on the Labour movement.

Fritz Thyssen, who was the chairman of the United Steel works (Vereinigte Stahlwerke), openly boasted in his book, *I Paid Hitler*, of personally handing over one million marks to Hitler. Thyssen had supported the fascists ever since 1923, but only formally joined the Nazi party in December 1931. He was instrumental in winning over important sections of the bourgeoisie to the Nazis. In particular, he was responsible for the connections between Hitler and the entire body of Rhenish-Westphalian industrialists. He wrote:

> I have personally given altogether one million marks to the Nazi party. It was during the last years preceding the Nazi seizure of power that the big industrial corporations began to make their contributions. But they did not give directly to Hitler; they gave them direct to Dr. Alfred Hugenberg, the leader of the Nationalists, who placed at the disposal of the Nazi party about one-fifth of the amounts given. All in all, the amounts given by heavy industry to the Nazis may be estimated at two million marks a year. (Quoted in ibid., p. 175.)

According to the historian William Shirer:

> [T]he coal and steel interests were the principal sources of the funds which came from the industrialists to help Hitler over his last hurdles to power in the period between 1930-33. (W.L. Shirer, p. 144.)

Bullock writes:

> In addition to Emil Kirdorf, the biggest figure in the Ruhr coal industry, Fritz Thyssen and Albert Vögler of the United Steel works, [Walter] Funk mentions Friedrich Springorum and Tengelmann, Ernst Buskühl and H.G. Knepper of the Gelsenkirchen Mine Company. Among bankers and financiers who, according to Funk, met Hitler in 1931-32 and, in some cases at least, helped him, were Stein and Schroder of the Stein Bank in Cologne; E.G. von Strauss, of the Deutsche Bank; Hilgard, of the Allianz Insurance Corporation; and two more bankers, Otto Christian Fischer and Fr. Reinhart. (A. Bullock, p. 173.)

Explaining the importance of these lavish subsidies, Hitler pointed out that:

> Without automobiles, airplanes and loud speakers, we could not have conquered Germany. These three technical means enabled National

Socialism to carry on an amazing campaign. (Quoted in T. Grant, *The Menace of Fascism*, p. 27.)

THE FASCIST HENRY FORD

Hitler received not only the backing of rich German capitalists, but also support from international capitalists, such as Henry Ford, the car manufacturer and at that time the world's most prominent industrialist. Like Hitler, he was an extreme anti-Semite. Ford's newspaper, *The Independent*, carried out a constant diatribe against the Jews and Jewish influence. On 22 May, 1920, the paper lashed out with an editorial entitled 'The International Jew: The World's Problem'. The following ninety-one articles covered a range of topics from Jews in a world government to Jews in American finance, in communism, theatre, movies, baseball, bootlegging and song writing. It produced inflammatory headlines such as 'The Gentle Art of Changing Jewish Names', 'What Jews Attempted When They Had Power', 'The All-Jewish Mark on Red Russia', and 'Taft Once Tried to Resist the Jews – and Failed'. He, like Hitler, believed that communism was a Jewish conspiracy to take over the world.

It is no wonder that when Hitler heard that Ford might run for American President, he said:

I wish that I could send some of my shock troops to Chicago and other big American cities to help in the elections... We look to Heinrich Ford as the leader of the growing fascist movement in America... We have just had his anti-Jewish articles translated and published. The book is being circulated to millions throughout Germany. (Quoted in J. Pool and S. Pool, p. 90.)

Hitler, in fact, praised Henry Ford in *Mein Kampf.*

"That Henry Ford, the famous automobile manufacturer gave money to the National Socialists directly or indirectly has never been disputed," said Konrad Heiden, one of the first biographers of Hitler. (ibid., p. 111.) The novelist Upton Sinclair wrote in *Flivver King*, a book about Ford, that the Nazis got $40,000 from him to translate and reprint his anti-Jewish pamphlets, and that an additional $300,000 were later sent to Hitler through a grandson of the ex-Kaiser who acted as intermediary. Other intermediaries were White Russians. The US Ambassador to Germany, William E. Dodd, said in an interview that "certain American industrialists had a great deal to do with bringing fascist regimes into being in both Germany and Italy." (Quoted in ibid., p. 111.)

Henry Ford's reward from Hitler finally came in July 1938, when on his seventy-fifth birthday he was awarded the Grand Cross of the Supreme Order

of the German Eagle. The presentation was made in Ford's Dearborn office in Detroit. He said:

> They [the Germans] sent me this ribbon band. They [the critics] told me to return it or else I'm not an American. I'm going to keep it. (ibid., p. 130.)

Mussolini had been given the honour by Hitler earlier in the year.

REICHSTAG ELECTION IN SEPTEMBER 1930

Up until September 1930, the Nazi party, although a threat, did not pose an existential threat to the existence of the labour movement. However, the situation was to change. Within the space of two years from 1928, the fascist party was to go from the smallest group in the Reichstag to the second largest.

In the middle of September 1930, 30 million Germans went to the polls, 4 million more than in 1928. In this election, ten parties received over 1 million votes each. This division of electoral support between so many different parties meant that there could never be a stable coalition. Following this election, no government would again rest upon a parliamentary majority in the Weimar republic.

The Social Democratic Party was still the largest group in the Reichstag with 24.5 per cent of the popular vote, but this had fallen by six per cent since September 1928. The KPD vote at 13.1 per cent had risen substantially by forty per cent, providing the party with 1,250,000 more votes. Their number of deputies increased from fifty-four to seventy-seven. This increased support was not, however, on account of the policies of the KPD, but, on the contrary, reflected the depth of the crisis of German capitalism. Overall, the combined percentage vote for the SPD and KPD fell a few percentage points from 40.4 per cent in 1928 to 37.6 per cent in 1930.

The three bourgeois parties, the Democrats, the People's Party, and the Economic Party (its full name was the Economic Party of the German Middle Classes) had, between them, lost 1.25 million of their 1928 vote. The German Nationalist Party had suffered the most, losing 2 million votes, with their percentage of the vote falling from 14.2 per cent in 1928 to only seven per cent in 1930. Its number of deputies fell from seventy-three to forty-one.

However, the outstanding change this time was in the massive rise in the vote for the Nazi party, which increased by 700 per cent, amounting to over six million votes, taking it from ninth largest to second largest party in the Reichstag. Their number of deputies rose from twelve to 107.

Their election campaign resonated among those who were being crushed by the economic depression, especially the peasants and small farmers. They were suffering from low prices and the burden of mortgage and loan

repayments. Hitler put forward a programme of state credits, reduction and remission of taxes, higher tariffs and the revision of the inheritance laws to attract support.

The British newspapers were fawning over the rise of the Nazis. *The Times* of London printed Hitler's assurances of goodwill at length, while Lord Rothermere's *Daily Mail* welcomed Hitler's success as a bulwark against the evils of Bolshevism.

Astonishingly, the KPD described the election as a victory for the communists and "the beginning of the end" for the Nazis. This stupidity represented a blind refusal to recognise the cold reality of a sharp increase in electoral support for Hitler's movement, despite the modest rise in support for the communists.

The membership of the Nazis had increased steadily from 27,000 in 1925 to 178,000 in 1929. By March 1930, it had grown to 210,000 and was still rising. At the time Röhm took over, in January 1931, the paramilitary brown-shirted SA numbered roughly 100,000. In 1932, the Brownshirts had risen to 300,000. Most of the recruits to the SA detachments came from the unemployed, the lumpen-proletariat and declassed elements, and were held together with soup kitchens and schnapps. "They were set up exclusively for the purpose of protecting the party in its propaganda," stated Hitler, "not to fight against the State." (A. Bullock, p. 165.) Hitler was careful not to clash with the forces of the state, which he attempted to woo to his side.

To be forewarned is to be forearmed. It was Leon Trotsky who sounded the alarm bells over the election results:

> The official press of the Comintern is now depicting the results of the German elections as a prodigious victory of Communism, which places the slogan of a Soviet Germany on the order of the day. The bureaucratic optimists do not want to reflect upon the meaning of the relationship of forces which is disclosed by the election statistics. They examine the figure of Communist votes gained independently of the revolutionary tasks created by the situation and the obstacles it sets up.

> The Communist Party received around 4,600,000 votes as against 3,300,000 in 1928. From the viewpoint of 'normal' parliamentary mechanics, the gain of 1,300,000 votes is considerable even if we take into consideration the rise in the total number of voters. But the gain of the party pales completely beside the leap of fascism from 800,000 to 6,400,000 votes.

He went on to argue that the only way forward was on the basis of a united front against fascism:

No matter how true it is that the Social Democracy prepared the blossoming of fascism by its whole policy, it is no less true that fascism comes forward as a deadly threat primarily to that same Social Democracy, all of whose magnificence is inextricably bound up with parliamentary-democratic-pacifist forms and methods of government...

There can be no doubt that at the crucial moment the leaders of the Social Democracy will prefer the triumph of fascism to the revolutionary dictatorship of the proletariat. But precisely the approach of such a choice creates exceptional difficulties for the Social Democratic leaders among their own workers. The policy of a united front of the workers against fascism flows from this whole situation. It opens up tremendous possibilities for the Communist Party. A condition for success, however, is the rejection of the theory and practice of 'social fascism,' the harm of which becomes a positive menace under the present circumstances. (L. Trotsky, *The Struggle Against Fascism*, p. 57 and p. 70.)

The massive vote for fascism in September 1930 constituted a serious change in the balance of forces. This was a deeply alarming development, which called for decisive action. The need for a united front of workers' organisations, to defend all proletarian organisations from fascism, was posed point blank. The fascists appeared on the verge of seizing power. The German labour movement was therefore faced with the life or death question of either to struggle with arms in hand to defeat fascism or see the mighty working class crushed.

But the Stalinists were blind to this reality. They had lost all sense of proportion, dismissed the gains of the fascists, and declared the September elections a massive victory for communism. A prominent party leader, Hermann Remmele, stated: "the only victor in the September elections is the Communist Party." The KPD issued an official statement on 16 September saying:

Hitler's electoral success bears within itself with inescapable certainty the germ of his future defeat. The 14th of September was the highest point of the National Socialist movement in Germany. What comes afterwards can only be decline and fall. (B. Fowkes [ed.], pp. 131-132.)

They held fast to the line of 'social fascism', the most destructive policy under the circumstances. As the Nazis became the second largest party in the Reichstag, the Stalinists still regarded the Social Democrats as the main enemy: "Socialists are again the largest party and the capitalists will continue to use them in order to gain time while the plans for the open Fascist dictatorship are maturing."

Trotsky and the International Left Opposition, aware of the rapidly deteriorating situation, immediately issued an appeal to the KPD to organise a united front with the Social Democrats to stop the fascists. This was no sudden warning. Throughout his exile in Turkey, he continually wrote articles appealing to the German workers. In his evidence to the Dewey Commission in 1937, he explained:

> I published, at that time, 'Germany, The Key to the International Situation,' written in 1931; 'What Next, The Problems of the German Proletariat,' published in New York; 'The Only Road,' a pamphlet. All of them are devoted to the fight against German fascism, and they were published in New York. The articles – 'The Impending Danger of Fascism in Germany,' 9 January 1932; 'What Is Fascism,' 6 January 1932; 'I See War with Germany,' 13 July 1932; 'How Can Fascism be Smashed in Germany,' 20 February 1933; 'The Tragedy of the German Proletariat,' 8 April 1933; 'Hitler and the Red Army,' 8 April 1933. (L. Trotsky, *The Case of Leon Trotsky*, p. 28.)

The Nazis represented not only a grizzly threat to the proletariat of Germany, but also a deadly threat to the workers of Europe and Russia. Trotsky predicted that a fascist victory in Germany would inevitably mean war with the USSR. The Stalinists nevertheless replied in the following terms:

> In his pamphlet on the question, *How will National Socialism be Defeated?*, Trotsky gives always but one reply: "The German Communist Party must make a block with the social democracy..." In framing this block, Trotsky sees the only way for completely saving the German working class against fascism. Either the CP will make a block with the social democracy or the German working class is lost for 10-20 years. This is the theory of a completely ruined fascist and counter-revolutionary. This theory is the worst theory, the most dangerous theory and the most criminal that Trotsky has constructed in the last years of his counter-revolutionary propaganda. (E. Thälmann, 'Closing Speech at the Thirteenth Plenum', September 1932, *Communist International*, No. 17-18, p. 1329.)

From the lips of Thälmann himself we get the following:

> Trotsky wants in all seriousness a common action of the Communists with the murderer of Liebknecht and Rosa (Luxemburg), and more, with Mr Zörgiebel and those police chiefs whom the Papen regime leaves in office to oppress the workers. Trotsky has attempted several times in his writings to turn aside the working class by demanding negotiations between the chiefs of the German Communist Party and the Social Democratic Party. (E. Thälmann's 'Closing Speech at the Twelfth Plenum, September 1932, ECCI, *Communist International*, No 17-18, p. 1329.)

In their hysteria, the main enemy for the Stalinists was not Hitler, but the Social Democrats. In fact, the party, through Heinz Neumann, proclaimed that: "Fascist dictatorship is no longer merely a threat, it is already here." The KPD issued orders for 'social fascist' meetings to be broken up.

On this basis, there could no talk of working-class unity. Even when the KPD leaders tilted towards 'unity', they only called for a united front 'from below', which was never going to happen.

NEUROSIS OF THE PETTY BOURGEOISIE

The capitalist crisis was forcing the working class to search for a way out, but the failure to change society only served to aggravate the situation. The crisis was crushing the middle layers of society and driving them into a frenzy. These layers were being caught between the two major classes, the capitalists and the workers, but were, as Marx explained, themselves incapable of playing an independent role.

In times of acute crisis, the frenzied petty bourgeoisie look for a swift, and, if need be, violent solution to their problems. When the aroused working class takes the lead and shows the way forward, it can draw in its wake large sections of the middle class. In their turmoil, the middle class was prepared to look towards the working class for a way out. Should it fail to find such leadership, however, the atomised and depressed masses of the petty bourgeoisie look for some other way out. Disillusioned with the proletariat, they can turn to reaction and be drawn into the whirlwind of fascism.

> The despair of the petty bourgeoisie, its yearning for change; the collective neurosis of the petty bourgeoisie, its readiness to believe in miracles; its readiness for violent measures; the growth of hostility towards the proletariat which has deceived its expectations.

These were all characteristics of this period, explained Trotsky. (*Writings 1939-40*, p. 412.)

Disillusioned by the failure of the working class to take power in 1918, 1919, 1920 and 1923, the desperate middle layers of society were turning elsewhere for a solution. The fascists, with their national hysteria, were offering hope and even miracles. But the fascists could not solve the problems of the middle class, they could only organise and regiment them in the service of monopoly capitalism.

By the end of 1930, the fascists had drawn significant sections of the despairing middle class to their banner by their demagogic appeals. The petty bourgeois searched in vain for a way out of the impasse, and the fascists seemed to offer solutions in abundance. The deeper the crisis, the more these

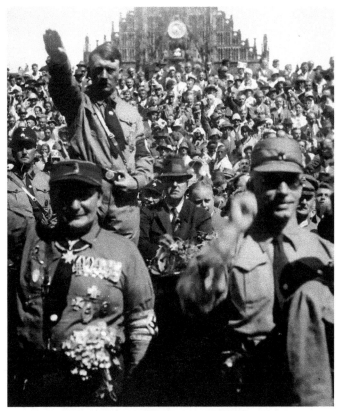

Adolf Hitler at a Nazi Party rally in Nuremberg

ruined layers were prepared to believe in anything. They suffered from a neurosis, as Trotsky explained, a mental disease associated with depression, anxiety, derangement and chronic instability.

The 'socialist' demagogy of the Nazis became increasingly vocal, without which they could not have won a mass base. Hitler recognised the "anti-capitalist longing of the masses," and directed his propaganda accordingly. Fascism gave these downtrodden sections a feeling of hope, of national identity, even glory, which they were desperate to grasp on to, especially in a situation of complete hopelessness. "Not every petty bourgeois could become Hitler, but a particle of Hitler is lodged in every petty bourgeois," stated Trotsky. (*The Struggle Against Fascism in Germany*, p. 399.) Hitler appealed to their aspirations to become something. "Give me the power and I will do everything for you that you cannot do yourself," he stated. (E. Anderson, p. 138.)

As we have seen, unemployment was rising rapidly. It reached 4 million in 1931, 5 million in 1932 and then 6 million the following year. On this

basis, large layers of unemployed people faced a bleak future of penury and destitution. Many professionals' living standards now fell below that of skilled workers. Cuts and austerity meant that a university professor was paid less than an unskilled worker. Not a few ruined professionals were turned into vagabonds, who scavenged in rubbish bins for food. Bankrupt shopkeepers, unemployed professionals, and those on depreciated fixed incomes became penniless overnight. At least for those workers who were organised, they could fall back on the limited protection of trade union contracts and unemployment allowances.

The rationalisation of German industry during the period of 'stabilisation' created an enormous concentration of capital, as many small businesses were rapidly swallowed up by the giant corporations. In previous crises, sections of the middle class were thrown into the ranks of the working class. Now, with the existence of mass unemployment, many from the middle class instead became paupers, and part of the lumpen-proletariat. After 1923, ninety-seven per cent of Germans were without any savings, which meant that they were literally living from hand to mouth. With the Depression, they had no cushion to sustain them. This was clearly a factor for the dramatic increase in the suicide rate.

The Nazis played on the frustrations and anger of those crushed by the banks and monopolies. The Jews became a scapegoat for their plight. The frenzied middle classes became completely disenchanted with the traditional capitalist politicians who stood for the status quo of hunger and destitution. Therefore, the ruling class had to shape a new means of duping the middle class. This was, in essence, the role of fascism.

"We need a Führer," sighed Moeller van den Bruck as early as 1923. In the late 1920s, many industrialists began to yearn for a "strong man of destiny to liberate us from our misery". By the end of 1928, they financed the fascists, built them up, and used them to exploit the problems and discontent of the petty-bourgeois layers. Through their anti-capitalist demagogy, the fascists were able to pull together this despairing mass, imbue it with a mission of salvation, and fill it with an intense hatred for the organised labour movement.

The fascist groups originated, not as a mass force, but simply anti-labour gangs, harassing and terrorising workers' organisations. These bands of mercenary thugs from the dregs of society formed the basis of Hitler's Stormtroopers, the Sturmabteilung (SA), and the SS (Elite Guard). This riffraff, made up of the lumpen-proletariat in the main, was able to become a mass force under certain circumstances. These circumstances were to mature in the late 1920s: a deep economic crisis combined with complete

disillusionment with the traditional political parties, which also affected the workers' parties, as these, having raised the hopes of the masses in the past, had now dashed those very same hopes.

In the previous period, the fascist paramilitary groups had mainly been used as auxiliaries to the police to break up workers' meetings. Now their activities were much broader. The fascist gangs were employed on the streets to break up demonstrations, attack workers, and carry out indiscriminate assassinations. Shootings and political assassinations now became commonplace. Oskar Hippe, a Communist Party member in Berlin, described how in March 1928 the infamous SA Storm Troop Thirty-Three shot at people attending a KPD meeting in Ahlert's Room in Berliner Strasse.

> The SA Stormtroopers had shot at those leaving the hall from their position in Lohmeyer Strasse. There were two dead and several injured. The police did nothing. Our attempts to catch the Stormtroopers failed when we were shot at ourselves, even though we had no weapons. (O. Hippe, p. 110.)

Clearly, the intention of these attacks and murders was to threaten and intimidate the working class, to create a climate of fear and paralysis.

Despite the advances of the fascists, the balance of forces was still heavily in favour of the workers' organisations. If the labour and trade union leaders had acted swiftly, the fascists could have been easily crushed at that moment. Even Hitler himself confessed:

> Only one thing could have broken our movement – if the adversary had understood its principle and from the first day had smashed, with the most extreme brutality, the nucleus of our new movement. (D. Guerin, pp. 111-112.)

This same admission was made by Goebbels:

> If the enemy had known how weak we were, it would probably have reduced us to jelly… It would have crushed in blood the very beginning of our work. (ibid., p. 112.)

But instead of mobilising the movement to sweep away this human debris, the workers' leaders turned to the bourgeois state for help in the very moment when it was fully backing the fascists.

STALINISM AND FASCISM

This was not the only problem. Rather than a workers' united front, in a bizarre twist, the communists and the fascists would on occasions unite against the Social Democrats, namely the 'social fascists'. This only served

to further poison relations between the workers' parties and disorientate the proletariat. This madness was revealed by the experience of Jan Valtin:

> A temporary truce and a combining of forces were agreed upon by the followers of Stalin and Hitler whenever they saw an opportunity to raid and break up meetings and demonstrations of the democratic front. During 1931 alone, I participated in dozens of such terroristic enterprises in concert with the rowdiest Nazi elements. I and my comrades simply followed party orders. (J. Valtin, p. 226.)

Valtin vividly describes in detail the breaking up of a Social Democratic transport workers' union conference in the spring of 1931:

> The conference took place in the House of Labour in Bremen. It was public and the workers were invited to listen to the proceedings. The Communist Party sent a courier to the headquarters of the Nazi party with a request for co-operation in the blasting of a Trade Union Conference. Hitlerites agreed, as they always did in such cases. When the conference opened, the galleries were packed with two or three hundred Communists and Nazis. I was in charge of operations for the Communist Party and the Stormtrooper leader Walter Tidow for the Nazis. In less than two minutes, we had agreed on a plan of action. As soon as the conference of Social Democrats was well underway, I got up and launched a harangue from the gallery. In another part of the hall Tidow did the same. The trade union delegates were at first speechless. Then the chairman gave the order to eject the two troublemakers, me and Tidow, from the building. We sat quietly, derisively watching two squads of husky trade unionists advance towards us with the intention of throwing us out. We refused to budge. As soon as the first trade union delegate touched one of us, our followers rose and bedlam started. The furniture was smashed, the participants beaten, the hall turned into a shambles... The next day, both Nazi and our own party press brought front-page accounts of how 'socialist' workers, incensed over the 'treachery' of their own corrupt leaders had given them a thoroughly 'proletarian rub-down'. (ibid., pp. 226-227.)

This insane position was fully supported by the leaders of the Comintern: "Without isolating Social Democracy there cannot be victorious struggle against Fascism and the capitalist offensive," proclaimed the ECCI (B. Fowkes [ed.], p. 197.)

The Stalinists went on:

> For the bourgeoisie the question is not fascism or Social Democracy but fascism... The bankrupt bourgeois democracy and its chief representative the Social Democratic Party are in this fight unconditionally on the side of fascism. (*Daily Worker*, 18 August 1930.)

They failed to grasp that Social Democracy was not compatible with fascism. That the fascists, if they came to power, would destroy the Social Democrats along with all other working-class organisations.

VIOLENCE SPREADS

As a result of this sectarianism, the Stalinists continued to openly incite the communist workers to attack and beat up Social Democratic workers, and physically break up their meetings. Thälmann even put forward the hysterical demand, "Chase the social fascists from their jobs in the plants and the trade unions". Following on this line from the communist leaders, the Young Communist organ *The Young Guard* advocated the slogan: "Drive the social fascists from the plants, the employment exchanges, and the apprentice schools."

The Drum, the organ of the Young Pioneers, which catered for the communist children, urged its members to carry the fight to the school children of Social Democrats in the playgrounds. Copying their adult comrades, they adopted the 'unifying' slogan: "Strike the little Zörgiebels in the schools and the playgrounds." This was indeed taking the fight against 'social fascism' to a new level.

The fountain head of this criminal policy was Stalin, who had rapidly consolidated his power within the USSR, and was the driving force behind this ultra-leftism. He argued that:

> Fascism is the fighting organisation of the bourgeoisie, which rests upon the active support of the Social Democracy. Objectively, the Social Democracy is the moderate wing of fascism. There is no reason to admit that the fighting organisation of the bourgeoisie could obtain decisive successes either in the struggles or in the government of the country without the active support of the Social Democracy... There is also little reason to admit that Social Democracy can obtain decisive successes either in struggles or in the government of the country without the active support of the fighting organisations of the bourgeoisie. These organisations are not mutually exclusive, but on the contrary are mutually complementary. They are not antipodes but twins. Fascism is a shapeless bloc of these two organisations. Without this bloc the bourgeoisie could not remain at the helm. (J. Stalin, quoted in *Die Internationale*, February 1932.)

This bankrupt policy was faithfully echoed by his puppet Manuilsky, who explained at the Eleventh Plenum of the Communist International in April 1931:

The Social Democrats, in order to deceive the masses, deliberately proclaim that the chief enemy of the working class is fascism... Is it not true that the whole theory of the 'lesser evil' rests on the presupposition that fascism of the Hitler type represents the chief enemy? (D. Manuilsky, *The Communist Parties and the Crisis of Capitalism*, p. 112.)

The tragedy of all this was that this fratricidal struggle between the two workers' parties – the Stalinists versus the Social Democrats – reduced the working class to impotence in the face of the fascist hangman.

THE 'RED' REFERENDUM

The sectarianism of the KPD went from bad to worse. In August 1931, to capitalise on their growing popularity, the Nazi party joined forces again with Hugenberg's Nationalists to launch a referendum to overthrow the Social Democratic-Centre Party government of Prussia, the most powerful state in Germany. At first, the KPD correctly attacked the plebiscite. Then, three weeks before the vote, under orders from Stalin, they joined forces with the fascists to bring down the main enemy, the Social Democrats. They then changed the name of the plebiscite to the 'Red Referendum' and referred to the fascists and the members of the SA as 'working people's comrades'. The Stalinists worked to collect the necessary signatures to make the fascist-inspired referendum legally binding. This created the disgusting spectacle of joint activity against the Social Democracy. This only served to alienate Social Democratic workers, and bind them even more to their reformist leaders.

Jan Valtin wrote:

The Communist co-operation with the Hitler movement for reasons of political expediency did not stop at wrecking the meetings and demonstrations of opponents. In the spring of 1931, the German Nationalists moved for a plebiscite to oust the Social Democratic government of Prussia. Together with the followers of Hitler, they collected the number of signatures required by law to force the Berlin government to make the plebiscite mandatory. Tensely we Communists awaited the answer to the questions. 'How are we to vote? If we vote with the Nazis, the Socialist government of Prussia might fall, and a combination of Hitlerites and Monarchists will come to power in Prussia, the dominant state within the Reich. Surely we are not to give our votes to make Hitler ruler of Prussia?'

The Communist high command, under Dimitrov, gave us the answer by telegram and letter, and through circulars, pamphlets and headlines in the party press! *'Down with the Social Democrats, the chief enemy of the workers! Communists, your duty is to sweep the Socialist traitors out of the government offices!'* So, while Communists and Nazi terror groups blazed away at each

other in nightly skirmishes, Communists went loyally to the polls to give their votes in support of a drive launched by the Monarchist Hugenberg and the Fascist Hitler. (J. Valtin, pp. 227-228.)

Their twisted logic demanded the defeat of Social Democracy before the Nazis could be beaten. "Without isolating Social Democracy there cannot be a victorious struggle against Fascism and the capitalist offensive," stated a resolution from the ECCI on 16 September 1931.

It continued:

The 'left' Social Democrats have been forced to reveal themselves openly as a buffer between the KPD and the mass of Social Democratic workers, and the Brandlerist and Trotskyist renegades have openly revealed themselves as a direct agency of social fascism. (B. Fowkes, pp. 197-198.)

At the Executive Committee of the Communist International, Piatnitsky even boasted how the line was changed:

You know, for example, that the leadership of the party opposed taking part in the referendum on the dissolution of the Prussian Landtag. A number of party newspapers published leading articles opposing participation in that referendum. But when the Central Committee of the party jointly with the Comintern arrived at the conclusion that it was necessary to take an active part in the referendum, the German comrades in the course of a few days roused the whole party. Not a single party, except the CPSU could do that. (From *Guide to the XII Plenum*, ECCI, September 1932, p. 42.)

It is true, as Piatnitsky says, no other party could shamelessly carry out such a volte face, except the Stalinists. But that reflected nothing more than the bureaucratic make up of the party.

When the referendum was held, despite the joint campaign of communists and fascists, it failed to get a majority. This was very fortunate, as a victory in the referendum would have simply brought Hitler to power in 1931, two years earlier. However, the Stalinists learned nothing from this episode, only that their actions were 'revolutionising' the situation. It was a hair-brained adventure that served only to confuse the working class and facilitate the success of the fascists. The old line was maintained. "Today the Social Democrats are the most active factor in creating fascism in Germany," declared Ernst Thälmann.

The British *Daily Worker*, the organ of the British Communist Party, applauded this criminal role:

The most important decision of the recent plenary session of the Central Committee of the Communist Party of Germany was to take over the

leadership of the campaign for the referendum of the dissolution of the Prussian Diet. This decision of great international importance may have a profound effect on the relations between the imperialist powers. In any case, it will undoubtedly serve as a great stimulus to the revolutionary energy of the German masses.

The overthrow of the Prussian Social Democratic coalition, which is the backbone of the Brüning government and the pacemaker in the reactionary struggle against the workers' revolution, will be a great blow to German capitalism. Originally the referendum was raked up by the fascists as a demagogic manoeuvre to side-track the mass indignation into fascist channels.

The action of the Communist Party, however, will turn this swindle into a mass challenge to Brüning, the Prussian government and fascism. *The bourgeois press is greatly perturbed at this brilliant piece of Communist tactics. Hard hit too are the Social Democratic leaders who are now snivelling at what they term the Fascist-Communist united front.* (*Daily Worker*, 25 July 1931, emphasis added.)

The referendum campaign was claimed as a *victory* for KPD tactics:

The fascist leadership which had initiated the referendum had to a great extent abandoned the campaign for it after the Communist Party decided to enter the lists and had mainly concentrated on attacking the Communists. Despite intensive police terror the Red mobilisation under the leadership of the Communist Party was a great success. In Berlin and all the industrial centres of Prussia, the referendum was completely under the leadership of the Communist Party. (*Daily Worker*, 11 August 1931.)

When the German Communist Party finally adopted the proposal for a united front, it became a meaningless slogan, insisting that it was only 'from below', and specifically excluded the SPD leaders. Such an approach meant that it was a united front consisting of the Communist Party and nobody else. Trotsky aptly described the Stalinists' call as "a united front with itself."

This ultra-left policy of the 'Third period' was adopted everywhere by all sections of the Comintern. In Britain, the Communist Party attempted to break up Labour Party meetings and engage in hooligan actions. But the British Stalinists were only a few thousand strong and therefore inflicted minor damage. Their language was nevertheless as hysterical as elsewhere.

Echoing its German counterpart, the British *Daily Worker* of 8 May 1931, explained: "fascism cannot be fought by supporting Social Democracy, for this means supporting fascism and the capitalist offensive". Again, the

same newspaper declared, "the socialists are the left and the fascists are the right hand of the same capitalist body".

BERLIN TRANSPORT STRIKE

In November 1931, we witnessed another Alice in Wonderland spectacle of the German Stalinists organising a 'united front' with the Nazis in the Berlin transport workers' strike. The strike was one of the most significant strikes in the last days of the Weimar Republic. However, it illustrated, in the words of Evelyn Anderson, "the agony, disunity and disintegration of the German Labour movement." (E. Anderson, p. 147.) The tram workers had taken unofficial action over a proposed wage cut, after a majority voted to strike. As the vote had failed to reach the necessary threshold of seventy-five per cent of the members, their action was declared 'unofficial' by the union leadership. The strike was nevertheless given full support by the KPD's 'red' trade union, the Revolutionäre Gewerkschafts-Opposition (RGO). For purely opportunist reasons, the strike was supported, to everyone's surprise, by the Nazis' trade union group, Nationalsozialistische Betriebszellenorganisation, the National Socialist Factory Cell Organisation (NSBO).

In the dispute, the fascists joined forces with the Communist Party in attacking scab trams and ripping up tram lines. Street collections were organised for strike funds. In Berlin, Communist and Nazi Party members stood together, rattling their collecting tins, and shouting in unison: "For the strike fund of the RGO" – "For the strike fund of the NSBO".

On 4 November, the strike was declared illegal and armed police were placed on the few trams that ran. The strikers blocked depots, ripped up track and fought with the police. There were hundreds of arrests and four people were killed by the police.

The *Daily Worker* carried a report with the headline: 'Unofficial strike ties up Berlin. Strike under leadership of opposition'. The article claimed:

> Despite the threats of the traffic trusts and the dismissal of over a thousand strikers, despite the open strikebreaking appeals of the trade unions and the Social Democratic press, despite the brutal police terror and over 700 arrests, the overwhelming majority of Berlin's traffic workers are firmly behind the revolutionary strike leadership. (*Daily Worker*, 7 November 1932.)

The strike lasted less than a week before it came to an end on Monday 7 November, the day after the elections to the Reichstag. This sight of KPD members and fascists linking up arm-in-arm added to the repulsion felt by many ordinary socialists and trade unionists.

By the end of 1932, the British Stalinists published a series of questions and answers about Germany. One of them was as follows:

> *Question*: Cannot the socialists and communists unite? Cannot all workers' organisations – the Communist Party, the Socialist Party and the trade unions and the co-operatives come together and do something to resist the drive of fascism?

> *Answer*: It is undoubtedly necessary to create working class unity but this must be unity between the workers in the factories and the streets, and not unity between the Communist Party and the Social Democratic Party, which is not a working-class party... for the Communist Party to unite with such a party would be to become an accomplice in the drive to fascist dictatorship. (*Daily Worker*, 13 August, 1932.)

The early British Trotskyists, who were part of the Communist Party, argued for the united front policy in Germany and in Britain, and were promptly expelled in 1932.

CRITICAL SITUATION

The situation in Germany was reaching a critical stage, with an ever-deepening sense of frustration and despair. The feeling that 'so kann es nicht weitergehen' (things can't go on like this) became widespread. The mood was one of growing dejection, disillusionment and anger. While the Nazis were able to capitalise on this mood and succeed in attracting the millions of petty bourgeois facing horrendous conditions, they nevertheless failed to win support amongst the organised working class. In 1931, the Nazis only achieved five per cent of the vote in the factory committee elections. By March 1933, despite all their efforts, it had declined to a mere three per cent. Hitler's appeal was mainly to the ruined middle layers, the bankrupt, the peasants, the long-term unemployed – and the amorphous non-political mass who did not bother to vote.

The crisis in Germany resulted in a series of unstable semi-Bonapartist governments. The fall of the Müller Government in March 1930, was followed by the even more right-wing administration of Heinrich Brüning. It was his unpopular deflationary policies, which prepared the way for Hitler's electoral successes in September 1930. The Brüning government, with its lack of a parliamentary majority, ruled by decree, but was nevertheless supported by the SPD Reichstag deputies "as the lesser evil". Between 1930 and 1932, the Social Democrats pursued a "policy of toleration" (tolerierung politik) towards Brüning, which ruled out any form of extra-parliamentary action. As Erich Ollenhauer explained in 1931, "the use of the vote is the only way

to fight Fascism which is in line with the traditions of Social Democracy." (B. Fowkes, p. 109.)

But under Brüning, the Social Democrats accepted everything, even the suspension of the Reichstag. This temporary dissolution of the Reichstag was a major step in undermining parliamentary democracy, which caused much alarm within the SPD. In their discussions with Brüning, the SPD leaders pleaded and grovelled, but soon accepted it. Dr. Breitscheid fretted that too much was being expected from the Social Democrats, including their ability to hold back the working class:

> One should, after all, also reflect on what it would mean for the SPD if the Reichstag vanished from the scene until October. The SPD would not [be able] make any objection to emergency powers… (ibid., p. 135.)

Despite their concerns, the Social Democrats swallowed everything in the end and dutifully abstained in the vote to bring down the government and suspend the Reichstag. The policy of 'toleration' had led to complete capitulation. On 8 December 1931, the President's decree enabled Brüning to introduce further reductions in wages and increase taxes. Those who raised objections in the SPD about their support for Brüning were soon expelled and went on to form the small SAP (Socialist Workers' Party) of about 20,000 members, which evolved in a centrist direction. A Brandlerite tendency, headed by Walcher and Frölich, entered the SAP and became dominant within the party. Willy Brandt at that time also joined the SAP, but eventually moved to the right, later becoming leader of the Social Democratic Party in 1964 and then elected West German Chancellor in 1969. The SAP came close to Trotsky's Left Opposition for a period, but did not formally join.

In August 1931, the German Trotskyists had issued an appeal in their newspaper, *Permanent Revolution*, addressed to all communists and the revolutionary workers of Germany:

> Even today the position of the German bourgeoisie is not certain… It makes every attempt to hang on to its social order that has long since been outdated… How is it possible for the German bourgeoisie, whose weaknesses are so manifest, to stand up so strongly to the working class? The responsibility for this must lie firstly with the SPD and the trade union leaders who have held the workers back in their fight against the bourgeoisie, because they had to support 'the lesser evil' of Brüning. The bourgeoisie not only achieved its goals without meeting resistance, but Fascism has also managed to continue growing… The role played by the SPD was made much easier by the incorrect policies of the present leadership of the KPD and Comintern. (O. Hippe, p. 126.)

But the Comintern learned nothing.

In December 1931, Trotsky made an urgent appeal to the ranks of the KPD:

> Worker-Communists, you are hundreds of thousands, millions; you cannot leave for any place; there are not enough passports for you. Should fascism come to power, it will ride over your skulls and spines like a terrific tank. Your salvation lies in merciless struggle. And only a fighting unity with the social democratic workers can bring victory. Make haste, worker-Communists, you have very little time left!

He went on to warn:

> It is the duty of the Left Opposition to sound the alarm: the leadership of the Comintern is leading the German proletariat towards an enormous catastrophe, the core of which is the panicky capitulation to Fascism!

> The coming to power of the German 'National Socialists' would mean above all the extermination of the flower of the German proletariat, the disruption of its organisations, the expiration of its belief in itself and in its future. (L. Trotsky, 'Germany: The Key…', Revolutionary Communist Party edition, December 1944, p. 23.)

This was no idle warning. The workers were anxious and willing to fight the Nazis and prevent them coming to power. Millions had been armed and trained in the Socialist and Communist defence organisations, a legacy of the German revolution. Without doubt, the organised working class constituted the mightiest power in Germany. However, what was lacking was a revolutionary policy, allowing them to defend themselves and then to pass over on to the counter-offensive. The necessary leadership was lacking and the working class was paralysed in the face of the fascist executioner. Instead, the leaders appealed to the capitalist state to help them, the very state machine that was protecting and shielding the fascists.

They had misjudged everything. Fascism was a serious threat, but they failed to appreciate this fact. Even on the very eve of the Nazis' accession to power, Schiffrin, one of the leaders of the Social Democrats wrote: "We no longer perceive anything but the odour of a rotting corpse. Fascism is definitely dead: it will never arise again." (D. Guerin, p. 120.) But the "corpse" rose up and crushed them. The line of the leaders of the Communist Party was, if anything, even worse. They declared that fascism was *already* in power in Germany and that the coming to power of Hitler would make no difference. In the Reichstag, Remmele, one of their leaders, declared, on 14 October 1931:

"Herr Brüning has put it very plainly once they [the fascists] are in power, then the united front of the proletariat will be established and it will make a clean sweep of everything." (Violent applause from the communists.) "We are not afraid of the Fascist gentlemen. They will shoot their bolt quicker than any other government." ("Right you are!" from the Communists.) (C.L.R. James, *World Revolution 1917-1936*, p. 334.)

Once again, the German Trotskyists issued an appeal to the leadership of the KPD in the October-November 1931 issue of their paper:

We are writing this letter in the full knowledge of the seriousness of the present situation. The events of the last few months have brought the crisis to such a point that we most likely face a decision now: either the seizure of power by the revolutionary proletariat, or, for the bourgeoisie, the possibility of crushing the workers' movement in blood with the terror of a Fascist regime...

In the KPD's assessment of the danger, there are two main lines of thought:

a) The victory of Fascism is the necessary prerequisite for the victory of the proletariat under the present conditions; we cannot 'leap over' this stage. We are not throwing ourselves into the fire, but are rather playing a waiting game, by observing the unavoidable victory of Fascism and its equally inevitable collapse; then and only then will it be our turn. The rule of Fascism does not frighten us; it will destroy the economy faster than any other government!

b) The victory of Fascism signifies the suffocation of the German revolution for years to come and also the certain death of the USSR; to prevent Fascism from coming to power is the revolutionary duty of the German proletariat; the fate of the proletariat is totally bound up with this task.

We consider that the idea of retreating and so letting the Fascists seize power 'provisionally', so that we can strengthen ourselves at its expense, is a *betrayal of the proletariat*. The experience of Italy speaks volumes. The Italian experience is as nothing compared to what European Fascism can achieve when supported by the bourgeois classes and the lumpen-proletariat. Even if we accept that the proletariat will suffer a defeat in the decisive battle against Fascism, then this fight is still unavoidable and absolutely necessary. A defeat in battle is still preparation for the future. But to be defeated after a powerless capitulation simply means burying the future for decades to come.

In addition to all that, we have no reason to believe that the decisive battle against Fascism *before* its seizure of power must necessarily end in defeat. The Fascists undoubtedly have the support of the professional fighting cadres of the officers; but the great mass of its hangers-on is largely composed of

human dross, and their fighting qualities are significantly less than those of the proletariat.

Victory is possible, victory is probable, we must do everything to secure it. That is the only possible way for revolutionaries to pose the question in the present situation. (O. Hippe, pp. 126-127.)

This appeal from what they called the gang of 'Trotsky fascists', was of course ignored by the Stalinist leaders of the Communist Party, who continued to argue for the same destructive policy.

In 1932 Thälmann, in a speech to the Central Committee, once again ridiculed the danger of fascism and condemned "the opportunistic over-estimation of Hitler fascism." This failure to recognise the imminent danger of Hitler, combined with extreme sectarianism, permeated their outlook. This policy would eventually lead to disaster.

HINDENBURG RETURNED

No fewer than five elections took place in 1932. Following a grim winter, new presidential elections were held in March, where the aging Hindenburg, now eighty-four, was persuaded to seek re-election. Hitler was not keen to challenge him as, being a conservative military man, Hindenburg would clearly gain the nationalist vote.

However, to maintain the momentum behind the fascist movement, Hitler had little choice but to stand. Hitler did have to overcome his little problem of being an Austrian and not a German citizen. Through a manoeuvre, he became a citizen of Brunswick and hence Germany. Having disposed of this minor problem, he was thus free to stand.

Nevertheless, a serious challenge would require a well-financed and well-organised campaign. This they carried out. The Nazi party launched into it with fervour, organising meetings and mass rallies everywhere. Even films and records were made and played to large audiences, a new innovation. It was estimated that the Nazis spent 200,000 marks per week on propaganda alone.

(7.1) German Presidential Election, 1932 – First Round

Name	Votes	Percentage
Paul von Hindenburg	18,651,000	49.6
Adolf Hitler	11,339,400	30.1
Ernst Thälmann	4,983,300	13.2
Theodor Duesterberg	2,557,700	6.8

Apart from Hindenburg and Hitler, there were two other candidates: Thälmann for the KPD and Duesterberg for the Nationalists. The Social Democrats, who had opposed the arch-militarist Hindenburg in 1925 as the 'greater evil', now decided to support him 'as the lesser evil' in this new election. The election results are shown in Table 7.1.

When the votes were counted, the Nazis had increased their number from just under six-and-a-half million in the federal election of September 1930 to just under eleven-and-a-half million in the Presidential race – an increase of eighty-six per cent. This now gave Hitler nearly one-third of the total German vote. However, this was still more than seven million votes behind Hindenburg. "Party circles badly depressed and dejected," wrote Goebbels in his diary. (W.L. Shirer, p. 158.)

But as Hindenburg failed by a whisker to get an absolute majority, the three with the most votes took part in a runoff in April. The result in this election is shown in Table 7.2.

(7.2) German Presidential Election, 1932 – Second Round

Name	Votes	Percentage
Paul von Hindenburg	19,360,000	53.0
Adolf Hitler	13,418,500	36.8
Ernst Thälmann	3,706,800	10.2

Although Hindenburg was victorious, the Hitler movement had doubled its electoral strength in seventeen months. Hitler had added more than two million votes from the first round of the Presidential election. Even the former Crown Prince, Friedrich Wilhelm, voted for Hitler. In contrast, the KPD vote had fallen by over a million votes. While the Social Democratic leaders, who completely underestimated the seriousness of the situation, consoled themselves with Hindenburg's victory. To their relief, the arch-militarist had beaten the fascist candidate. Now with Hindenburg back in power, they could sleep more soundly in their beds at night.

With the ground shifting under its feet, fearing that the Nazis could get too strong, even launching a coup, the Brüning government decided to ban the fascist SA and SS. This resulted in extreme commotion in the ranks of the Nazis, especially amongst the paramilitaries. Röhm urged resistance. They were disgruntled anyway at the political strategy of the party, which was based on the perspective of winning elections. Instead, these elements wanted to seize power by force, in the manner of Mussolini, but were being reluctantly held back by promises of electoral victory. Hitler urged caution. In

any case, the ban would be ineffective. The Brownshirts disappeared from the streets. But instead of 'dissolving' their gangs, the fascists simply reinvented themselves and paraded instead as ordinary party members. The generals demanded, in equal measure, the banning of the Reichsbanner, the Social Democratic military organisation. In fact, Schleicher renewed his contacts with the SA and Röhm. Although his idea was to incorporate them into the army.

The Brüning regime prevaricated. It had outlived its usefulness and needed to vacate the scene. Within six weeks of the order to dissolve the military groups, on 30 May, 1932, Hindenburg dismissed Brüning and in his stead appointed Franz von Papen and his government of 'barons and junkers', which included five appointed ministers from the nobility. In revenge, Brüning had Papen expelled from his Centre Party. This change in government was carried out after much behind the scenes manoeuvres involving General von Schleicher. Schleicher himself was keen to strike a deal with the Nazis and thought that von Papen would be the means of achieving this aim. He thought he could use them as a stepping stone for his own ambitions. The new Chancellor was told to construct a cabinet 'above the parties', which, given the fact that he was not even a member of the Reichstag, was the only thing he could do. Von Papen was going to rule in true Bonapartist fashion. After a short interval, he rescinded the ban on the fascist military organisations, which became a licence to kill trade unionists, KPD and SPD members. It served to unleash a terror campaign without parallel, leaving hundreds dead or wounded, and with every locality reporting deaths from assassinations by the Nazis. In Prussia alone between 1 and 20 June, there were 461 pitched street battles that cost eighty-two lives and 400 seriously wounded. However, this act earned Papen a measure of support from the Nazis, though this was nothing more than the support of a rope that supported a hanged man.

Despite this growing danger, the Stalinists still refused to organise a united front pact with the Social Democrats:

> To build up a steel united front with the Social Democratic and reformist trade union workers – that is the immediate and pressing task of the German Party and that alone can prevent the imposition of a fascist dictatorship in Germany such as already exists in Poland and Italy.

However, there was the inevitable qualification:

> Not of course a united front with the Social Democratic leaders but with the rank and file. As Thälmann recently put it: "Between the class content of the Social Democratic Party policy and ours there exists fundamental differences

of principle. Under no circumstances can we consider a united front with Severing, Zörgiebel or Hilferding. Between us and the SPD leaders lies the barricades and the blood of 33 workers murdered on the bloody May Day of 1929 under the instructions of the Social Democratic leaders." (*Daily Worker*, 28 June 1932.)

Papen moved quickly to shore up his position. On the pretext of a violent street battle with the Nazis in the working-class suburb of Altona in Hamburg, where nineteen lives were lost and 285 wounded, von Papen used emergency powers to ban all political parades prior to the 31 July elections. He also dismissed the long-standing Social Democratic coalition government of Prussia, with the excuse of their failure to halt the violence, and appointed himself the new Reich Commissioner. Martial law was declared in Berlin. This was nothing less than a coup carried out with the aid of only one lieutenant and ten armed men who were sent to clear out the government and make the necessary arrests. This act represented a serious blow to the SPD, which had continuously governed Prussia. Workers throughout the country looked eagerly to the Social Democratic leaders for a call to action to defend the elected government, as they had done against the Kapp Putsch of 1920. It was a decisive moment for German labour.

The 'Iron Front' had pledged itself to fight in defence of the Republic and were ready to move. "Rest assured that I shall mobilise the Reichsbanner as auxiliary police and arm them when the hour of danger comes," said the

May Day 1929

Socialist Minister of the Interior. But there was no mobilisation. Thus, the weakness of the labour leaders was laid bare.

The SPD leaders, while protesting against the "violation of the Constitution", rejected armed resistance or a general strike. Instead they looked for redress to the Supreme Court in Leipzig. They firmly held to the belief in the 'neutrality' of the bourgeois state and even hoped that the militarist Hindenburg would intervene on their behalf. The trade union leaders also turned down the call for a protest strike, and called for calm. Instead, the SPD raised the slogan of safeguarding the elections for the Reichstag promised in July. *Vorwärts* published on 20 July issued the rallying cry: "Everyone to the polls on 31st! Thus, will the politically-conscious working class of Germany put an end to the regime of the Barons." (A.R. Oliveira, p. 162.)

The Social Democratic leaders had capitulated without even a whimper. There was widespread disappointment. It was a glimpse of what was to occur months later when Hitler was appointed Chancellor.

The KPD issued a call for a general strike against the coup but, without the support of the unions, it was a sterile gesture. In any case, the Stalinists made it clear that one of the aims of such a strike would be "to strengthen still more the unmasking of the SPD, on the shoulders of which the Fascists have come to power." (B. Fowkes [ed.], p. 177.)

Once again, the opportunity to strike back was lost. The overthrow of the SPD-led Prussian government without any resistance was met with jubilation by the fascists. But for the workers, it was a humiliating experience.

Oskar Hippe wrote that:

> On that day, it became clear to us that the victory of Fascism was inevitable. A party which had the support of the Prussian police – at least, that is what they always said – as well as millions of factory workers, but was still unwilling to fight in such a situation, is condemned to defeat. The only tragic thing was that, with the SPD, millions of workers were also disenfranchised. (O. Hippe, p. 133.)

Within days of the Prussian coup, the KPD reverted to its attacks on the 'social fascists'. "The 'Anti-Fascist Action' does not signify even the slightest lessening of the struggle against social fascism," stated the Central Committee of the KPD. (B. Fowkes [ed.], p. 199.)

JULY 1932 ELECTION

Von Papen's rule, along with the Weimar Republic, was crumbling, and he was forced to promise new elections for the end of July 1932. He would only remain Chancellor for little more than three months. These elections

provided a further turning point, as the Nazi Party leapt forward to become the largest party in the Reichstag. The results for the major parties are shown in Table 7.3.

Once again, it represented a stunning victory for the fascists, who had dramatically increased their vote at the expense of all the other bourgeois parties, except the Centre Party. The combined vote for the People's Party, the Democrats, and the Economic Party of the German Middle Classes in 1928 was 5,582,500, but in 1932 it had fallen to 954,700 votes. The Nationalist Party's vote fell by 1.5 million. These votes went to the Nazis.

(7.3) German Federal Election, July 1932

Party	Votes	Percentage
National Socialists	13,745,800	37.4
Social Democrats	7,959,700	21.6
KPD	5,282,600	14.6
Centre Party	4,589,300	12.5
Nationalist Party	2,177,400	5.9

As a whole, the working-class electorate remained solidly behind the workers' organisations, and there was a steady increase in support for the KPD at the expense of the Social Democrats. The Communists became the third largest party. True to form, the Communists declared themselves as the '*sole victor*' of the election, ignoring the massive rise of the Nazis. It was clear from the vote that the middle and upper classes had gone over to Hitler. When the Reichstag met on 12 September, von Papen received a vote of censure, resulting in the Reichstag once more being dissolved and new elections called for 6 November. The Weimar Republic was in the process of collapse, ground between the class contradictions.

Hitler's Stormtroopers, crazed with victory, went on the rampage as Nazi terror swept through the country. In eastern Prussia, Silesia, and other cities, the Nazis engaged in a pogrom against their opponents. In Potempa, five Stormtroopers dragged the communist worker Pietrzuch from his bed and beat him to death in front of his mother.

The KPD leaders still refused to take the initiative in calling for a united front:

> The Communist Party is opposed, however, to a pact with the Social Democratic Party whose whole policy has helped Hitlerism. On what basis could the Communists have united with the Social Democratic Party? On

the basis of voting for Hindenburg? On the basis of handing Prussia over to Papen without a struggle? The real united front is being built by the Communists in the factories and in the streets. The mobilising of workers against the fascists and the chasing of the Nazis from the streets show that the front is beginning to march forward. (*Daily Worker*, 2 August 1932.)

Delirious, Thälmann once again warned against "opportunist exaggeration of Hitler Fascism," and again reiterated the Party's strategy of directing its "main thrust" against the Social Democracy. (D. Guerin, p. 120.) Even where the Communist Party leaders partially recognised the strength of fascism, they dismissed it out of hand. They even went so far as to declare that, if Hitler came to power, he would not last long, and coined the phrase: 'After Hitler, our turn!' This simply revealed their frivolous and arrogant attitude.

NOVEMBER 1932 ELECTION

But the Hitler movement was also becoming overconfident. They believed that their support would increase indefinitely. But they were in for a massive shock. They had been so used to making gains in the Reichstag elections that the setback in the November election came as a tremendous blow. The fascist movement had peaked early, losing two million votes, with a loss of thirty-five seats. It resulted in turmoil in their ranks, who had been promised an easy victory. "Great hopelessness reigns among the party comrades," wrote Goebbels. (W.L. Shirer, p. 169.) The election results in November are shown in Table 7.4.

The Nazis' vote was now less than the combined SPD-KPD vote. This was the last 'free' election of the Weimar Republic, where two-thirds of the population had voted against Hitler. The Nazis still remained the Reichstag's largest party, with 196 seats, but were far from having an outright majority. The Social Democrats had picked up 121 seats, while the Communist Party won 100 seats. The new support for the Communists came from disillusioned supporters of the Nazis and the Social Democrats looking for a genuine revolutionary party.

This election was the apex of the Nazi movement. On 3 December, elections in Thuringia showed nearly a forty per cent drop in the Nazi vote since July. It was a dangerous moment for them. "This year has brought us eternal bad luck... The past was sad, and the future looks dark and gloomy; all chances and hopes have quite disappeared," wrote Goebbels. (A. Bullock, p. 243.) They were in danger of losing their momentum. Without a continual movement forward, they could suffer a collapse in their febrile support. Everything was finely balanced. Unfortunately, the Stalinists drew insane conclusions from the vote, claiming once again that they were the winners.

(7.4) German Federal Election, November 1932

Party	Votes	Percentage
National Socialists	11,737,000	33.1
Social Democrats	7,248,000	20.4
KPD	5,980,000	16.9
Centre Party	4,231,000	11.9
Nationalist Party	2,959,000	8.8

Yet again, the Stalinists stressed that the Social Democrats were the main enemy:

> Undoubtedly the Social Democratic Party received a good share of those petty bourgeois votes which fell away from the fascists. However, this fact makes no difference to the role of the Social Democratic Party as the main social prop of the von Papen regime. On the contrary, the heavy defeat of the Hitler movement increases the significance of Social Democracy as the bulwark of capitalism against the proletarian revolution. (*Daily Worker*, 10 November 1932.)

The Stalinist O. Kuusinen, a few months before Hitler seized power, stated:

> The main blow, as I have already stated in my report, must in the present period of preparing for the revolution be directed against social fascism and the reformist trade union bureaucracy. (O. Kuusinen, *Prepare for Power*, p. 141.)

A mere *ten weeks* before Hitler assumed power in January 1933, the Stalinists proclaimed:

> The decline of the Social Democratic Party in no way reduces its role as the main social buttress of the bourgeoisie, but on the contrary, precisely because the Hitler party is at present losing followers from the ranks of the workers, instead of penetrating more deeply into the proletariat, the importance of the Social Democratic Party for the fascist policy of finance capital increases. (*International Press Correspondence*, 17 November 1932, p. 1100.)

At the eleventh hour, just before Hitler assumed the Chancellorship, Ralph Fox wrote in the *Communist Review* of December 1932:

> The Communist Party of Germany has now succeeded in winning the majority of the working class in the decisive industrial areas, where it is now the *first party* in Germany. The only exceptions are Hamburg and Saxony,

but even here the Party vote has enormously increased at the expense of the Social Democrats.

These successes have been won only by the most unswerving carrying through of the line of the Party and the Comintern. Insisting all the time that Social Democracy is the chief social support of capitalism, the Party has carried on intense and unceasing struggle against the German Social Democratic Party, and the new 'Independent Socialist Labour Party', as well as against the right wing and Trotskyist renegades who wanted the party of the proletariat to make a united front with social fascism against fascism.

A few days before the 6 November election, the Nazis and Communists had joined forces over the Berlin transport workers' strike. This had caused businessmen to withdraw their financial support from the Nazi Party. Goebbels wrote in his diary:

Scarcity of money has become a chronic illness with us. We lack enough to really carry out a big campaign. Many bourgeois circles have been frightened off by our participation in the strike. Even many of our party comrades are beginning to have their doubts. (W.L. Shirer, p. 172.)

On 17 November 1932, von Papen and his government resigned. Hindenburg immediately sent for Hitler, as leader of the largest party in the Reichstag. But the Nazis did not have a working majority. In the end, on 2 December, Schleicher was appointed Chancellor, with Hindenburg's support. There was much intrigue behind the scenes. "As the strife-ridden year of 1932 approached its end, Berlin was full of cabals, and of cabals within cabals," explained Shirer. (ibid., p. 175.) Without any sound parliamentary base, Schleicher's Bonapartist regime of crisis was to last only fifty-seven days, first reaching out to the 'left' Nazis, by offering Gregor Strasser the Vice-Chancellorship, then the trade union leaders, asking Theodor Leipart to enter the government. "I stayed in power only fifty-seven days," Schleicher remarked to the French ambassador, "and on each and every one of them I was betrayed fifty-seven times." (ibid., p. 175.)

In the meantime, on 5 January 1933, the Nazis staged a protest demonstration at Bülowplatz, directly opposite Karl Liebknecht House, the headquarters of the KPD. This was a direct provocation to the labour movement in this working-class neighbourhood, but the fascists had the consent of the Berlin police president, in contrast to the banned May Day 1929 demonstration. The Communist Party called a counter-demonstration to protect the building. Tens of thousands answered the call. The police tried to break up the demonstration, but were unsuccessful. The SA columns nevertheless remained firm. Oskar Hippe, who was present, wrote:

Finally, the police deployed two armoured cars, but again without success. The workers controlled the streets of the Central district until late at night. It was the last big demonstration in which the Berlin working class showed its willingness to fight. (*And Red is the Colour of Our Flag*, p. 137.)

REPRESSION AND BONAPARTISM

For the ruling class, repressive, brutal measures in defence of their interests were nothing new. They were always prepared, when necessary, to take the most ruthless action in defence of their property, power and income. But their turn towards fascism marked a decisive step in their attitude. Fascism was not simply a reactionary force; it was a special form of reaction connected to the decay and terminal decline of capitalism. Trotsky once correctly described it as "the distilled essence of imperialism". Fascism had its own unique features, which differed from all other repressive regimes. It constituted a deadly *mass* movement of the enraged middle class, the lumpen-proletariat, ruined peasants and even declassed workers, financed and organised by finance capital as a battering ram against the working class. Its prime task was to destroy the organisations of the labour movement, the elements of the new society within the old. "If the Communist Party is the party of revolutionary hope, then fascism, as a mass movement, is the party of counter-revolutionary despair," explained Trotsky. (*The Struggle Against Fascism*, p. 59.)

Under 'normal' conditions, the best form of government is its cheapest form: namely bourgeois democracy with its parliamentary system. The capitalists regard the state apparatus – with its armed bodies of men and their appendages – as costly, but necessary. However, if not held in check, the state bureaucracy and military caste can swell beyond recognition and consume an enormous amount of the surplus value. The advantages of bourgeois democracy are that it provides a safety valve for the discontent of the masses, as it allows them to blow off steam in a harmless fashion, and it allows the ruling class to detect any growing social discontent more easily. To paraphrase Marx, the masses can say and vote what they like every five years as long as the monopolies decide what happens.

Capitalism in crisis, however, forces the bourgeoisie to drive down wages even to below subsistence levels, forcing the worker into a semi-slave like existence. On the other hand, the workers, have fought for and won a series of democratic rights – freedom of speech, the right to organise, to strike, to vote. These rights become obstacles to the capitalist class in their efforts to push down living standards. However limited these rights may be, they do serve to obstruct the bourgeoisie in their unfettered drive to force down conditions and increase exploitation. As the crisis deepens, bourgeois

democracy becomes incompatible with the needs of capitalism, and the capitalists turn towards greater repression and ultimately the establishment of Bonapartist regimes (military-police dictatorships). The next step along the road is the fascist dictatorship.

Under Bonapartism, the capitalist state rises above the classes, becoming semi-independent of them, while balancing between the classes. It represents a regime of extreme crisis. Prior to Hitler coming to power, these were the regimes of Brüning, Schleicher and von Papen, which ruled without a parliamentary majority, by decree. To be more accurate, the Brüning government was a precursor or pre-Bonapartist government. Full blown Bonapartism came onto the scene in the form of the Papen-Schleicher governments. This type is different from the Bonapartism of capitalism's youth and the rise of the bourgeoisie. The Bonapartism of Napoleon I and even of Napoleon III had a social base in an expanding economy, which provided it with a certain stability. Bonapartism in the epoch of capitalist decline and senile decay has little social base and rests increasingly on state repression. The regimes of Brüning and General Schleicher shifted from one crisis to another without providing the bourgeoisie with any stability. This reflected the insoluble crisis at all levels of society.

It is clear that there are many forms that the bourgeois state can assume under capitalism, ranging from monarchy to parliamentary democracy, republic to autocracy, and fascism to Bonapartism. They all have a common thread in that each one, in the final analysis, bases itself on the defence of capitalist property relations, which determines their class character as bourgeois states. Bonapartism, as defined by Marx, is "rule by the sword". This is normally a military-police dictatorship, with the state, while remaining an instrument of the ruling class, abrogating to itself the role of 'arbiter' between the classes. To play this role, the 'arbiter' has to balance between the classes, striking a blow firstly at one side then the other. The Bonapartist regime rules by decree, standing above society and parliament, as a bureaucratic-police state.

History shows that, before the bourgeoisie is able to move towards Bonapartist rule, there are a host of variants in between which contain elements of Bonapartism. These have enhanced executive or presidential powers, cabinet government, or any formation where powers are drained away from parliament.

Trotsky explains Bonapartism in the following way:

> The government becomes 'independent' of society. Let us once more recall: if two forks are stuck symmetrically into a cork, the latter can stand even on the head of a pin. That is precisely the schema of Bonapartism. To be sure,

such a government does not cease being the clerk of the property owners. Yet the clerk sits on the back of the boss, rubs his neck raw and does not hesitate at times to dig his boots into his face. (ibid., p. 276.)

Yet Bonapartism, despite its repressive nature, was still insufficient to completely destroy the organisations of the working class, as its social base – a military-police apparatus – was too narrow. To accomplish such a task, a special form of reaction was required, namely fascism, which has a mass base.

As Trotsky explains:

> In the epoch of imperialist decline a pure Bonapartist Bonapartism is completely inadequate; imperialism finds it indispensable to mobilise the petty bourgeoisie and crush the proletariat under its weight. (*Writings, 1939-40*, p. 410.)

He continued:

> At the moment that the 'normal' police and military resources of the bourgeois dictatorship, together with their paramilitary screens, no longer suffice to hold society in a state of equilibrium – the turn of the fascist regime arrives. Through the fascist agency, capitalism sets in motion the masses of the crazed petty bourgeoisie, and bands of the declassed and demoralised lumpen-proletariat; all the countless human beings whom finance capital itself has brought to desperation and frenzy. From fascism the bourgeoisie demands a thorough job; once it has resorted to methods of civil war, it insists on having peace for a period of years. And the fascist agency, by utilising the petty bourgeoisie as a battering ram, by overwhelming all obstacles in its path, does a thorough job. After fascism is victorious, finance capital gathers into its hands, as in a vice of steel, directly and immediately, all the organs and institutions of sovereignty, the executive, administrative, and educational powers of the state: the entire state apparatus together with the army, the municipalities, the universities, the schools, the press, the trade unions, and the co-operatives. When the state turns fascist, it doesn't only mean that the forms and methods of government are changed in accordance with the patterns set by Mussolini – the changes in this sphere ultimately play a minor role – but it means, primarily and above all, that the workers' organisations are annihilated; that the proletariat is reduced to an amorphous state; and that a system of administration is created which penetrates deeply into the masses and which serves to frustrate the independent crystallization of the proletariat. Therein precisely is the gist of fascism. (L. Trotsky, *The Struggle Against Fascism*, pp. 155-156.)

HITLER BECOMES CHANCELLOR

Mass unemployment, a bitter winter, no coal, no bread, misery: What is to be done? The ruling class believed that only by bringing Hitler into government could there be any hope of stability. But he was not interested in a junior position in a coalition. He demanded to become the Chancellor. Nevertheless, he was prepared to compromise over the composition of the government, namely a coalition. Therefore, on 4 January, the decision to allow Hitler to become Chancellor was taken in a meeting in the home of von Schröder, a large Cologne banker, who had connections with Rhenish-Westphalian heavy industry. Those present were Schröder, Hitler and Papen. "We shall stake everything on one throw to win back the streets of Berlin," wrote Goebbels. The Nazis staged a mass demonstration in front of the Communist headquarters, Karl Liebknecht Haus, on 22 January. The government banned a Communist counter-demonstration as 10,000 SA Brownshirts, under armed police escort, paraded on the Bülowplatz to listen to Hitler and Goebbels.

Kurt von Schleicher's reign was even briefer than Papen's. A ring of iron was closing in on Schleicher. He alienated everyone. Without support within or outside of parliament, Schleicher could not remain long in office. The deadline was approaching when on, 31 January, the Reichstag was to reassemble or be dissolved if he could get Hindenburg's authorisation. In desperation, he even reached out to the trade union leader Leipart, with a plan involving the Reichswehr and a general strike, but Leipart turned it down fearing it to be 'unconstitutional'.

On 23 January, Schleicher asked Hindenburg for power to dissolve the Reichstag and rule by emergency decree. The President refused. A similar request on 28 January was likewise rejected. His fate was sealed. He was dismissed and forced to resign as Chancellor. He would be murdered a few months later by Hitler. On 29 January, 100,000 demonstrated in the centre of Berlin in opposition to making Hitler Chancellor. Sixty-three per cent of the German people were opposed to him.

Leon Trotsky wrote:

> It is quite possible that Hitler's courtesies to democratic parliamentarism may, moreover, help to set up some sort of coalition in the immediate future in which the fascists will obtain the most important posts and employ them in turn for their coup d'etat. (L. Trotsky, 'For a Workers' United Front Against Fascism', *The Struggle Against Fascism*, p. 133.)

This prognosis was amply confirmed by events within a short space of time.

But behind the scenes intense negotiations were complete and, on 30 January 1933, the deed was done: Hindenburg appointed Adolf Hitler, the petty official's son from Austria, as Chancellor of a coalition cabinet of Nazis and the Nationalists, in the same way as the King of Italy had appointed Mussolini as Prime Minister. The fascists were in a minority, but were given ministerial posts under Hitler: Wilhelm Frick as Minister of the Interior, and Hermann Göring, Minister Without Portfolio and Commissioner of Aviation.[1]

Von Papen was to serve as Hitler's Vice-Chancellor in a majority conservative Cabinet. He nurtured the illusion that he could 'tame' Hitler and his representatives. After all, Hitler had promised to abide by the Constitution. The bourgeoisie hoped to use the fascists to smash the labour movement, but at the same time keeping a firm grip on the state machine. But it was Papen who was tamed. On 22 February 1933, Sir Horace Rumbold, British Ambassador in Berlin, wrote, "Hitler may be no statesman but he is an uncommonly clever and audacious demagogue and fully alive to every popular instinct," and he informed the Foreign Office that he had no doubt that the Nazis had "come to stay." (G. Liebmann, *Diplomacy Between the Wars: Five Diplomats and the Shaping of the Modern World*, p. 74.) In fact, Hitler would soon boast that the Third Reich under fascism would last a thousand years.

Hitler's appointment as Chancellor was greeted with wild elation in the fascist movement. To celebrate, 15,000 members of the SA and SS led a torch-lit parade through the Wilhelmstrasse, which was a show of strength to make clear who was master. It was a foretaste of what was to come that would leave Papen and the others reeling. They were to discover, like the young lady of Riga, the dangers of taking a ride on the back of a tiger.[2]

Understandably, Hitler's assumption of power caused panic and strife in the working-class neighbourhoods. As Oskar Hippe explained:

> There was pandemonium; workers came into the building from Wall Strasse and the streets around – Wall Strasse being a workers' street – and everyone wanted to know: what happens now? We put forward the proposal that party officials and known members of the party should keep away from their homes, for we had to expect massive arrests.

1 He was, however, made Minister of the Interior for Prussia, in reality Prime Minister.
2 There was a young lady of Riga
 Who smiled as she rode on a tiger;
 They returned from a ride
 With the lady inside,
 And a smile on the face of the tiger.

The place was full to bursting, hundreds more comrades and sympathisers stood out on the street. Then the word raced through the crowd: some columns of SA and SS, who had been screaming their adulation of Hitler at the Chancellery, were now marching back to their districts. And indeed, after a short time, we heard the marching columns, singing the 'Horst Wessel' and shouting 'Death to the Communists!', and getting closer. One column, including Storm Troop 33, now came up Berliner Strasse from the 'Knee'. They turned into Wall Strasse and, as they tried several times before, they launched an attack on 'Werner'. But on this evening of 30 January, once more the Nazis were sent home with bloody heads. (O. Hippe, p. 138.)

Alongside reports of street murders, arrests, tortures and the smashing up of meetings, the KPD clung to the old line:

At the present time when it is necessary by extra-parliamentary mass action of the working class to overthrow the fascist dictatorship before it can fully set going the state apparatus of power, the social fascist clique of leaders oppose the fight. It has thereby become the most valuable buttress of the Hitler-Papen-Hindenburg dictatorship. The most important thing now is for the Communists in the factories and labour exchanges to overcome the sabotage of the Social Democratic and trade union leaders and lead the masses on the streets and into the fight. (*Daily Worker*, 3 February 1933.)

At the same time the paper reported on violent attacks by fascists on the so-called *social fascists*, namely the Social Democrats:

In Stassfurt, the Social Democratic Mayor Hermann Kasten was shot down and killed in cold blood by a young fascist who had lain in wait for him. Numerous other collisions took place in various parts of Germany. (*Daily Worker*, 7 February 1933.)

An article by Harry Pollitt, the general secretary of the British Communist Party, explained:

We Communists are for the united front – a united front with workers of all views in factories, trade unions, the Labour Party, the Independent Labour Party and on the streets. But not the united front from the top with those leaders who have so cruelly deceived the masses, who have led them to the position where they are today. (*Daily Worker*, 11 February 1933.)

With Hitler's rise to power, Leon Trotsky and his supporters called for armed resistance and the mobilisation of the full resources of the whole German labour movement in a life and death struggle with fascism. This meant the combined forces of the communists and the Social Democrats. Had they been prepared to face the issue of civil war, Hitler would have been crushed

by the working class. But this required a firm leadership. Spontaneous demonstrations took place throughout all the main cities in Germany, and expectations were high that the labour leaders would call them into action. The workers waited impatiently as their leaders dithered and prevaricated at this critical time.

'LEGAL MEANS'

So confident was Hitler of victory, he was prepared to use 'legal means' as a stepping stone to absolute power. He was willing initially to make the compromise of heading a coalition government, with the Nazis holding only three of the eleven cabinet posts. This was effectively grabbing power by the back door, a bridge to dictatorship. Hitler was now in a decisive position as Chancellor from which he could prepare the ground for his next move.

In these conditions, instead of rallying the masses for a fight, the German Social Democratic leaders scandalously issued "an appeal for calm." On 7 February, the head of the Berlin Federation of the SPD gave instructions: "Above all do not let yourselves be provoked. The life and health of the Berlin workers are too dear to be jeopardised lightly; they must be preserved for the day of struggle". They justified their actions by explaining that Hitler's appointment was "constitutional", as if the question was a legal nicety. The Constitution was a piece of paper, nothing more. But the workers' leaders were mesmerised by it.

The Social Democrats feared using their combined strength against Hitler as this would have meant civil war, and consequently revolution. They had serious doubts about being able to control the workers' movement once fighting had broken out on the streets. Workers' councils would have been thrown up. It was this fear of revolution that forced them to surrender submissively to Hitler's executioners. As they feared to die by another hand, they instead committed suicide.

Otto Braun, Otto Wels, Breitscheid, Hermann Müller, Crispien, Löbe, Severing, Leipart, Grossmann, and the rest of the Social Democratic hierarchy could be considered good Social Democrats and good administrators, but did not have an ounce of fight between them. In the end, as workers' leaders, they played a treacherous role.

Hitler continued to manoeuvre. Having deliberately failed in negotiations to win over the Centre Party to support his government, he twisted Hindenburg's arm to declare elections for 5 March 1933. Goebbels wrote in his diary on 3 February:

> Now it will be easy to carry on the fight, for we can call on all the resources of the state. Radio and press are at our disposal. We shall stage a masterpiece

of propaganda. And this time, naturally, there is no lack of money. (W.L. Shirer, p. 189.)

In seeking further financial backing from the German industrialists, Hitler promised in a secret meeting to swiftly 'eliminate' Bolshevism. Göring, now Minister of the Interior for Prussia, stressed the need for financial sacrifices as this election would be "much easier for industry to bear if it realised that the election of 5 March will surely be the last one for the next ten years, probably even for the next hundred years." (ibid., p. 190.) The Nazis got their cash from big business, thrilled at the thought of putting the working class in its place. The meeting of businessmen collected three million marks for the election coffers.

Goebbels wrote:

In a conference with the Führer we lay down the line for the fight against the Red terror. For the moment we shall abstain from direct countermeasures. The Bolshevik attempt at revolution must first burst into flame. At a proper moment we shall strike. (ibid., p. 190.)

Within a month, the Reichstag burned down.

On 1 February 1933, Göring issued a decree against communist propaganda. On 4 February, there was an emergency decree passed "for the protection of the German people", aimed at all anti-fascist forces. Göring then remodelled the state by purging hundreds of republican officials and replacing them with SA and SS officers. He then issued a statement to the police to avoid at all costs hostility towards the fascist military organisations, but to show no mercy to those hostile to the state. He then organised an auxiliary police force of 50,000 men, of whom 40,000 were drawn from the SA and SS. All they had to do was to put white arm-bands over their Brown or Black Shirts. "It was the equivalent of handing over police powers to the razor and cosh gangs," remarked Alan Bullock. (*A Study in Tyranny*, p. 261.) Prior to the election, the Hitler government banned all Communist Party meetings and closed down their press. Social Democratic rallies were either banned or broken up by SA gangs. The fascists instilled fear everywhere. The scale of violence was indicated by the fact that fifty-one anti-fascists, overwhelmingly communists, were murdered during the election campaign.

On 24 February, Göring's police raided the KPD headquarters, Karl Liebknecht Haus, which was stripped of propaganda and materials that were used as 'evidence' of a communist conspiracy to launch an immediate putsch. The place was empty, as the communists had abandoned the building, while some leaders had slipped across the border and headed for Moscow. The whole plot was fabricated as an excuse to clamp down on all opposition.

Shamefully, Pieck, one of the KPD leaders, wrote: "Let the workers beware of giving the government any pretext for new measures against the Communist Party!" (D. Guerin, p. 127.)

THE REICHSTAG FIRE

On 27 February, 1933, the Reichstag building was mysteriously burnt to the ground. This was a decisive event. The question of who was responsible has continued to be a subject of controversy to this day. The communists blamed the fascists and the fascists blamed the communists. The individual who was caught and charged with the fire was the former Dutch communist, Marinus van der Lubbe, who, it is claimed, acted alone.

But according to the historian, William Shirer, General Franz Halder, Chief of the German General Staff during the early part of World War Two, recalled at Nuremberg how on one occasion Göring had boasted of his deed:

> At a luncheon on the birthday of the Führer in 1942 the conversation turned to the topic of the Reichstag building and its artistic value. I heard with my own ears when Göring interrupted the conversation and shouted: "The only one who really knows about the Reichstag is I, because I set it on fire!" With that he slapped his thigh with the flat of his hand.

> Van der Lubbe, it seems clear was a dupe of the Nazis. (W.L. Shirer, p. 193.)

Certainly, the circumstantial evidence points to this conclusion. But we cannot be absolutely certain. Nonetheless, whoever was to blame, the event was nevertheless extremely opportune for Hitler. It could not have come at a better time for the fascists, who placed the entire blame for the fire on the shoulders of the KPD. This led to the accusation that the fire was part of a communist coup, which became the pretext to launch widespread violent repression against the communists and their allies.

Lubbe, together with three other Bulgarian communists, were put on trial. Lubbe was found guilty and the others were acquitted. He was sentenced to death and, a few months before his twenty-fifth birthday, he was beheaded. Later, the Stalinists engaged in a campaign against Lubbe, describing him as a Nazi agent. Whatever the exact truth behind the blaze, it was clearly the fascists who gained from the arson.

Following the fire at the Reichstag, Göring declared a final solution:

> This is the beginning of the Communist revolution! We must not wait a minute. We will show no mercy. Every Communist must be shot where he is found. Every Communist deputy must this very night be strung up. (ibid., p. 192.)

The SA and SS immediately went into action. More than 4,600 Communist and Socialist leaders were arrested on the night of the fire. An unspecified number were shot. The next day, President Hindenburg signed a decree suspending those sections of the Constitution that covered free speech, free press, assembly, etc. Armed with these powers, Hitler and Göring were able to take whatever action they pleased against opponents. The Communist Party urgently called on all anti-fascists to "fight the counter-revolution" but offered no physical resistance. They were now between hammer and anvil.

A swarm of Stormtroopers rushed through the streets of Germany, breaking down doorways, torturing and beating suspected communists. The fascists were flexing their muscles. The hammer was about to smash the movement into pieces.

These actions came as a terrible shock to the Stalinists and, within a few days, in a panic-stricken move, the Kremlin ordered a political about-turn. The idea of a united front 'from below' was unceremoniously dropped. The Party now called for unity with the Social Democrats, including their leaders, without conditions. Under the banner headline, 'Momentous Call for united front', the call was made for united action:

> A united front of the working class to struggle against the fascist offensive is proposed in a manifesto issued by the Executive Committee of the Communist International. The manifesto proposes that Labour and Social Democratic parties should join such a united front on the basis of the class struggle...

> "Owing to the peculiarity of the conditions", said the manifesto, "as well as the difference in the concrete fighting tasks confronting the working class in the various countries, an agreement between the Communist and Social Democratic parties for definite actions against the bourgeoisie can be carried out most successfully within the confines of each individual country. The Executive Committee of the Communist International recommends the Communist parties of the various countries to approach the central committees of the Social Democratic parties belonging to the Labour and Socialist International with proposals regarding joint actions against fascism and against capitalist offensive..." (*Daily Worker*, 8 March 1933.)

But this was a case of too little, too late. After years of vicious attacks on the 'social fascists', to make such a call two whole months after Hitler had come to power was certain to fail.

Throughout the election campaign, only the Nazis and the Nationalist Party were able to campaign without interference. On election day, 80,000 Brownshirts kept guard. The mass ranks of the petty bourgeoisie were stirred

The Reichstag fire

up into an absolute frenzy against the 'Bolshevik plotters' and the need for the Nazis to restore order throughout Germany.

According to Daniel Guerin in *Fascism and Big Business,* on the night of 5 March, the leaders of the Reichsbanner divisions in the principal cities of Germany went to Berlin begging to be given the order to fight. They received the reply from the Social Democratic leaders: "Be calm! Above all no bloodshed." (D. Guerin, p. 127.)

MARCH 1933 ELECTION

On 5 March the election results were known. They are shown in Table 7.5. Despite all the murders, terror, intimidation and destruction of the opposition, Hitler had failed to win an absolute majority. The vote for the Centre Party increased, the Social Democrats held steady, while the KPD lost a little more than a million, but still polled 4,848,000 votes. Oskar Hippe, who was a member of the small group of German Trotskyists, remarked:

> Fascism had succeeded in confusing sections of the working class. But they did not convince the broad layers, as was shown by the elections of 5 May [March] 1933,[3] the last 'free elections'. The KPD could only conduct illegal campaigns. Karl Liebknecht House was occupied at the end of February;

3 Hippe has here confused the election date, which was not 5 May, but 5 March.

machinery, matrices and manuscripts were confiscated. No one campaigning for the KPD was allowed to stand outside the polling stations; despite this, 10.5 million people still voted for the Communists and Social Democrats on 5 May [March] 1933. (O. Hippe, p. 148.)

(7.5) German Federal Election, March 1933

Party	Votes	Percentage
National Socialists	17,277,000	43.9
Social Democrats	7,182,000	18.3
KPD	4,848,000	12.3
Centre	4,425,000	11.7
Nationalist Party	3,137,000	3.8

The election was far from 'free', given the intimidation and violence. It was not the fascists, however, that confused the working class, but the workers' leaders. The German workers, leaderless, were now helplessly staring into a bottomless pit.

The results gave the Nazis 288 seats in the new Reichstag, which, together with its coalition partners, the Nationalists, amounted to a total number of 340 seats – a bare majority of sixteen – well short of the two-thirds majority needed to 'legally' change the Constitution and establish totalitarian rule.

However, unlike the Social Democrats, the fascists did not see this as a problem. They had already boasted that, whatever the result of the polls, they would remain in power. In any case, firstly, the KPD were now illegal and their deputies in hiding or 'detained' in prison. Secondly, Göring felt the SPD deputies could be dealt with simply "by refusing admittance" to the Reichstag. On 24 March, Hitler put forward an Enabling Act granting him full powers to legislate "without following the procedure established by the Constitution". With Nazi paramilitaries encircling the Reichstag building, Hitler said: "It is for you, gentlemen of the Reichstag to decide between war and peace". (A. Bullock, pp. 147-148.) The Act was passed with 441 in favour to ninety-four against, including the opposition of eighty-one Social Democrats.

Otto Wels declared that the government may strip the Socialists of their power, but could not strip them of their honour. Hitler, furious, stood up and howled:

You come late, but yet you come! … You are no longer needed… The star of Germany will rise and yours will sink. Your death knell has sounded… I

A German polling station in the middle of the Nazi terror

do not want your votes. Germany will be free, but not through you! [Stormy applause.] (W.L. Shirer, p. 199.)

The Act allowed Hitler and his Cabinet to rule by emergency decree for four years. What took Mussolini two years to accomplish was carried out in a few weeks in Germany. The Nazi deputies, joined by the Stormtroopers, stamped their feet frantically and then burst into the 'Horst Wessel' song. The Führer had become dictator of Germany, but the trade union and workers' leaders, paralysed, refused to act.

The Stalinists again drew radically false conclusions from the situation. Fritz Heckert, a member of the Central Committee of the German Communist Party and dizzy with optimism, made a report to the Comintern, which declared that the German workers were on the eve of revolutionary battles. At the same time, he blamed the Social Democrats entirely for Hitler's victory:

> On 1 April the presidium of the Executive Committee of the Communist International heard a report by Comrade Fritz Heckert on the situation in Germany. Having heard the report the presidium declared "that the political line and the organisational policy in Germany, led by Comrade Thälmann, before and at the time of the Hitler coup was quite correct".

The resolution of the presidium laid the blame for the victory of Hitler squarely on the shoulders of Social Democracy.

> … the mass of the Social Democratic workers who carried with them the majority of the working class of Germany, being fettered by their Social Democratic leaders, who were opposed to the revolutionary united front, and who maintained their reactionary united front with the bourgeoisie,

rejected the united front with the Communists on every occasion, and disrupted the struggle of the working class.

Meanwhile the Communists insisted on a revolutionary united front of the working class against the bourgeoisie, against fascism, the Social Democrats, on the contrary, impelled the workers in the direction of a reactionary united front with the bourgeoisie, against the Communists, against the Communist workers, destroying and repressing Communist organisations whenever and wherever this was possible...

The Communist Party was right in giving the name of social fascists to the Social Democrats ...

Every day of the Hitler government will reveal with greater clearness the manner in which the masses who follow Hitler have been tricked... The revolutionary upsurge in Germany will inevitably grow... (*Daily Worker*, 10 April 1933.)

Then, in July 1933, after the complete destruction of the organisations of the working class and the establishment of totalitarian rule, the same Fritz Heckert stated:

[T]he complete elimination of the social fascists from the state apparatus and the brutal suppression of the Social Democratic organisation and of its press do not alter the fact that *they represent now as before the main social buttress of the dictatorship of capital.* (E. Anderson, p. 157, emphasis added.)

The Social Democrats and their apologists fared no better. A few months later, at the Brighton Congress of the TUC, the Chairman, Walter Citrine, defended the reformist trade union leaders in Germany and their failure to call a general strike or offer resistance to Hitler in January 1933. He said:

Shortly after the elections the campaign of terror developed. The Socialist movement and the trade union movement were virtually suppressed on 2 May. There had been a great deal of concern about the apparent absence of resistance to the advent of the Nazi dictatorship. German trade union leaders and German Socialist leaders were openly attacked and criticised on platforms because of the absence of effective resistance. All we could say was that we knew from first-hand knowledge that very adequate means of resistance were prepared.

All we could say was that a general strike was definitely planned and projected, but the German leaders had to give consideration to the fact that a general strike, after the atmosphere created by the Reichstag fire, and with six and a quarter million people unemployed at the least, was an act fraught with the gravest consequences, consequences which might be described as nothing

less than civil war. We hoped they would never be put into a similar position in this country. We hoped they would never have to face that position. (W. Citrine, *The Menace of Dictatorship*, p. 8, quoted in *The Menace of Fascism*, p. 34.)

This represents a miserable capitulation. The labour and trade union leaders trembled in their boots before the fascist regime. This was where their 'lesser evilism' had led them – to the slaughter house. But it was, in the vast majority, the German working class that was asked to pay the price for fascism. Working class political life had come to an end, except in whispers in corners, and in the shadows of the underground struggle.

CHAPTER EIGHT: THE NAZI TERROR

> Personally, I regard it as a great honour when Mr. Trotsky calls upon German Communism at any price to act together with the Social Democrats, since National Socialism must be regarded as the one real danger for Bolshevism.
>
> Adolf Hitler

> I was beaten and tortured continually for ten days after my arrest by the Gestapo. Only complete exhaustion halted their curiosity about *La Verité* and the Fourth International. If I had dropped a single unwarranted word, it meant death. Tortures of all kinds were common in the camp, from marches in the snow to typhus injections… It's the return to barbarism, the inevitable consequences of the morbid will to survive of a class condemned to oblivion. As long as capitalism remains, such barbarism is bound to grow. In all cases – the Poulo Condor camp, where thousands of Indo-Chinese revolutionists perished, the Gurs camp, where the Spanish revolutionaries starved to death, and this most monstrous one of all at Buchenwald, first created for German Communists – the responsibility lies with the same decadent bourgeoisie.
>
> Marcel Beaufrere, May 1945

In the words of one historian, with the advent of fascism, "the gutter had come to power." But this was not simply a rabble; it had become a ferocious battering ram, a mailed fist, a deadly tool of finance capital. A united front of the SPD, the KPD and the trade unions, as Trotsky argued for, could have

entirely transformed the situation and blocked Hitler's path. This is no idle speculation. The German labour movement was the strongest in the world in terms of numbers, organisation and revolutionary traditions. It had every chance of success in defeating Hitler.

The potential for resistance was ever present, as the previous seven chapters of this book amply demonstrate. The problem was that this powerful working class faced the mighty obstacle of its own leadership. The united movement of the workers had smashed the Kapp Putsch in 1920 and they could even have taken power. Such a united force could have fought the Nazis, splitting the wavering middle classes from its ranks, and trampled the Hitler movement under foot. The working class would have fought like lions if the call had gone out from the leadership, but there was no call. It was their duty to resist Hitler, with guns in hand if necessary.

Julius Braunthal wrote that:

> If only the thirteen million, who had constantly supported the two socialist parties in the elections from the birth of the German Republic to the last vote before Hitler seized power, had been a united army, a genuine workers' alliance, a real band of brothers, the reactionaries, even if they had dared to raise their head, could certainly not have triumphed over the workers without a struggle. (J. Braunthal, *History of the International*, p. 390.)

This would have been a struggle with no holds barred. "But this would mean civil war!" argued the reformists. The reformists, in the name of avoiding violence and bloodshed, preferred to give up without a fight, preparing the nightmare that was to come.

Given the strength of the German working class, any such struggle would have been brief and the working class would have emerged victorious, especially with a resolute leadership. The only alternative to capitulation was to fight. It was infinitely more preferable than the horrors of the Holocaust and the Second World War, with fifty-five million dead and countless maimed and injured. World War could have been avoided if the working class had come to power. The responsibility for the victory of fascism lay squarely with the German labour leaders.

The workers were not pacifists. The Reichsbanner alone had around three million members in 1932, organised into more than 5,000 groups. They had access to arms. They were part of the military formation, the 'Iron Front', which could have been mobilised. They outnumbered the Reichswehr, Stahlhelm and Hitler's forces put together. A general strike, as in 1920, would have paralysed the army's operations. The workers were waiting for a signal for an all-out general strike from their leaders, but none came.

On the evening of 30 January 1933, with the news that Hitler was made Chancellor, spontaneous demonstrations took place throughout Germany. Delegations of workers arrived in Berlin requesting orders to fight. The same evening, a joint conference of trade union executives, the SPD, the SPD Parliamentary faction and the leaders of the Reichsbanner and Iron Front met and decided to act against Hitler. But following further deliberations, the leaders drew back and pleaded caution. Instead they proposed to act as soon as there was a breach of the Constitution. However, Hitler was cunning and pledged to uphold the Constitution. *Vorwärts* stated on 30 January:

> In the face of this government and its threats of a coup d'etat, the Social Democrats and the whole 'Iron Front' stands squarely on the ground of the Constitution and of legality. (ibid., p. 381.)

This was a programme of paralysis.

The crisis in Germany was, as Trotsky had warned repeatedly throughout this period, a crisis of leadership. In the end, the workers were like lambs led to the slaughter, but in this case they were led to the concentration camps, with their hands tied behind their backs. Others disappeared into the cellars of the Gestapo. This failure of leadership meant the beginning of a long and ghastly nightmare.

The Social Democratic leaders had supported every reactionary government and presidential candidate with their bankrupt policy of 'the lesser evil'. The problem, however, inevitably emerged when the 'lesser evil' became the 'greater evil'. These leaders, after clinging onto the coat-tails of Ebert, then clung onto the militarist, von Hindenburg. They held onto the coat-tails of every bourgeois politician, including Brüning, then Papen, while holding up the fascists as a scarecrow to justify their policy of capitulation. They were busy sowing illusions, instead of mobilising the working class. In this way, they disorientated, confused and demoralised the German working class.

They never understood the real meaning or nature of fascism, with all its implications, and shied away from fighting it. Instead, they appealed to the state to save them. But the state – the bourgeois state – was not neutral, and in the final analysis represented the ruling class. They thought the Constitution would save them. But this was a pipe dream. The crisis of capitalism was a crisis of the bourgeois regime. They failed to understand that fascism was a product of this crisis, in effect a mincing machine of finance capital. Only Leon Trotsky, the exiled Russian revolutionary, isolated in Prinkipo, clearly understood the phenomenon and sounded the alarm. He spelled out what was needed in plain language:

Fascism is not merely a system of reprisals, of brutal force, and of police terror. Fascism is a particular governmental system based on the uprooting of all elements of proletarian democracy within bourgeois society. The task of fascism lies not only in destroying the communist vanguard but in holding the entire class in a state of forced disunity. To this end the physical annihilation of the most revolutionary section of the workers does not suffice. It is also necessary to smash all independent and voluntary organizations, to demolish all the defensive bulwarks of the proletariat, and to uproot whatever has been achieved during three-quarters of a century by the Social Democracy and the trade unions.

He continued:

Nevertheless, says Hilferding, had the Social Democracy voted against Brüning's government and thereby overthrown it, the consequence would have been the coming of the fascists to power. That is the way, perhaps, the matter may appear on a parliamentary plane; but the matter itself does not rest on a parliamentary plane. The Social Democracy could refuse to support Brüning only in the event that it decided to enter upon the road of revolutionary struggle. Either support Brüning, or fight for the dictatorship of the proletariat. No third course is given. The Social Democracy, by voting against Brüning, would change at once the correlation of forces – not on the parliamentary chessboard, whose chess pieces might surprisingly enough be found underneath the table – but on the arena of the revolutionary struggle of the classes. After such an about-face, the forces of the working class would increase not twofold but tenfold, for the moral factor holds by no means the last place in the class struggle, particularly during great historical upheavals. Under the impact of this moral force, the masses of the people, one stratum after another, would be charged to the point of highest intensity. The proletariat would say to itself with assurance, that it alone was called to give a different and a higher direction to the life of this great nation. Disintegration and decomposition in Hitler's army would set in before the decisive battles. Battles of course could not be avoided; but with a firm resolution to fight to victory, by attacking boldly, victory might be achieved infinitely more easily than the most extreme revolutionary optimist now imagines. (L. Trotsky, *The Struggle Against Fascism*, p. 144 and p. 152.)

But Trotsky's clear advice was ignored by the leaders of both the Social Democracy and the Stalinists. Instead, they jointly prepared, in their own way, the greatest betrayal in history. The Stalinists blamed the Social Democrats and the Social Democrats blamed the Stalinists, resulting in complete paralysis. In this way they were slaughtered.

NO RESISTANCE

Shamefully, the National Socialists were able to seize power without any resistance. There was not a shot fired, no general strike, no barricades, nothing. The labour movement were given months, even years, to prepare for this outcome, but the workers' leaders lulled the working class to sleep with fairy tales. They preferred to take the line of least resistance, which did not exist, and this led them into the deepest of chasms.

Up until Hitler came to power, and beyond, the Communist leaders continued their relentless attacks on 'social fascism' as the main enemy. They therefore rejected a united front against fascism, unless it was 'from below'. On 30 January, while the KPD did not regard Hitler becoming Chancellor as decisive, they did issue a call for a general strike, but there was no response. This was hardly surprising given their continuous attack on the Social Democrats as being accomplices of Hitler. After this fiasco, the party made no further attempt to fight. Instead they continued to blame the Social Democrats.

In their declaration, entitled 'The Guilt of the Social Democrats', they declared:

> [T]hat careful examination of the overall situation showed that in February and March 1933 the conditions were not yet ripe for a victorious proletarian revolution… One of the basic conditions for successful insurrection was not yet present: the KPD had not yet captured the majority of the workers. Millions of workers were still under the spell of social fascism. They were not yet prepared to join the communists in a revolutionary struggle for power without, or against, the approval of their leaders. (J. Braunthal, *History of the International*, p. 389.)

The socialist leaders behaved in the exact same fashion, blaming the communists. Instead of resistance, they called for calm as the totalitarian state took shape before their very eyes. With this paralysis they prepared the ground for violence on an unheard-of scale, and rivers of blood would flow as a consequence. They cry, "Peace, peace, when there is no peace," states the Bible. (*Jeremiah*, 6:14.) All these leaders had to offer was a miserable whitewash to cover up their crimes.

The plebeian, fascist scum had risen to the top, assisted and financed by big business. The bourgeoisie thought they could control them, like some hired mafia gang. But they were badly mistaken. The fascists in power, while doing the bidding of the monopolies in crushing the working class, nevertheless had their own agenda. They were now in the saddle, with the full resources of the state behind them. In their eyes, they deserved a big slice

of the pie and weren't going to give it up. "Once we have the power we will never give it up," stated Goebbels. "They will have to carry our dead bodies out of the ministries." (W.L. Shirer, p. 167.) They were now masters of the state and they would determine society's fate. They had their noses firmly in the trough and refused to budge. The bourgeoisie had knowingly unleashed this fascist gang and would reap what they had sown. While they would keep their economic power, they would be forced to relinquish their *political* power to the fascist gang. They would still remain the ruling class, with their property intact, but would lose their political control. Some would even end up in prison; others kidnapped; others murdered. That was the price they paid for fascist counter-revolution.

The middle-class organisations were trampled underfoot. Even the 'Combat League of Middle-class Tradespeople', which had hopes of nationalisation measures and the running of industry, was swiftly dissolved, and the rule of Krupps, Thyssen and other heads of industry was secure, under fascist management.

The middle-class organisations were trampled under foot. Even the 'Combat League of Middle-class Tradespeople', which had hopes of nationalisation measures and the running of industry, was swiftly dissolved, and the rule of Krupps, Thyssen and other heads of industry was secure, under fascist management.

The fascist bureaucracy, however, while standing above society, was never an entirely independent entity. In the final analysis, it represented the bourgeoisie, but only in the final analysis, and in its own way. The bourgeoisie had hoped they could put the fascist sword back into its scabbard once the task of destroying the German labour movement had been carried out. But this was not to be. They were forced to live with the results of their actions, including the liquidation of all the bourgeois parties. Only the fascist party would remain. They had unknowingly conjured up forces that they could not control. It would be a long time before the fascist hydra would relinquish its domination over the state and society, and at a staggering cost.

In the face of this almighty calamity, the leadership of the German labour movement displayed complete bankruptcy. All they could do was wring their hands and grovel before the strongman Hitler, the Führer. This meant they were prepared to do anything to survive, even cut their own throats, as long as it did not mean breaking the Constitution.

Towards the end of March, well after the International Socialist press had exposed the Nazi atrocities in Germany, a number of members of the SPD Executive volunteered to go abroad, with assistance from Göring, so as

to stop the negative publicity because it was "apt to harm the position of the anti-fascists in Germany". (E. Anderson, p. 154.)

To appease the Nazis, Otto Wels, the chairman of the SPD, resigned from the Bureau of the Labour and Socialist International, but this did not save him. Disgracefully, the SPD leaders took disciplinary action against the Berlin Socialist Youth and others who undertook clandestine measures against the fascist regime. "Don't provoke the fascists!" they demanded. "You will only make matters worse." But it was their own inaction that made matters worse. As a result, the leaders sank deeper and deeper. The lower they sank, the more they debased themselves and the movement they were supposed to represent. They even ended up denouncing their own comrades abroad who attacked Hitler and his crimes, least they cause offence. They wallowed in self-pity as the iron heel of fascist reaction bore down on the necks of the German working class. It was a shameful spectacle of betrayal, worse than in August 1914.

MAY DAY APPEAL

While the KPD was banned, the party issued a May Day manifesto, but there was no mention or call for unity of the workers' organisations. It was instead full of platitudes and bravado.

> The German Communist Party has broadcast an appeal to the German workers, although they were working under conditions of terrorism, in which every action or even remark of a nature hostile to fascism is threatened with arrest and torture:
>
> "Who is giving the answer to your questions in this hour? Who is leading you on the way to socialism? Nobody – except the only party, which did not capitulate, the only party that did not and will never make its peace with the fascist bloodhounds, the only party which despite all terror will lift the Red Banner of proletarian internationalism higher than ever on this May Day 1933 – the Communist Party!
>
> "Make this May Day your first great trial of strength between the fascist dictatorship of Hitler and Göring and the unconquered giant, the German proletariat. The world must know that the German working class has not been defeated." (*Daily Worker*, 1 May 1933.)

Such hyperbole was clearly out of place as the axe fell. Within twenty-four hours, the German trade unions had been crushed, with not so much as a finger being raised.

While the KPD were driven underground, their property and assets confiscated, the SPD were allowed a temporary 'legal' existence, which was

a deliberate attempt to play one off against the other. The Social Democrats participated in the new election and sent their deputies to the Reichstag circus. They tried to preserve this precarious status through collaboration with the Nazis.

'Weakness invites aggression' is the old adage, and the more they grovelled, the more the Nazis stamped on them. In early May, the fascist police occupied the SPD buildings and its press and confiscated its property. Yet the leaders accepted their lot and bowed their heads lower. On 17 May, the SPD leadership, broken, humiliated and enfeebled, voted for Hitler's foreign policy, the 'Peace Resolution', in the Reichstag. But even this open display of 'support' would not save them.

A month later, in a reign of terror, the SPD was outlawed. The Catholic Bavarian People's Party dissolved itself, as did the Centre Party, followed by the People's Party and the Democrats. Better to liquidate themselves, they thought, than face liquidation. On 29 June, Hitler's coalition partners, the National Party, 'voluntarily liquidated itself' as the SA took over its buildings and offices. Despite this, there was not a peep from the workers' leaders. They were dead men walking, blindly accepting their fate.

DESTROYING THE UNIONS

On 7 February, 1933, Künstler, head of the Berlin Federation of the Social Democratic Party, gave this instruction to the Socialist workers:

> Above all do not let yourselves be provoked. The life and health of the Berlin workers are too dear to be jeopardised lightly; they must be preserved for the day of struggle. (Quoted in T. Grant, *The Menace of Fascism*.)

But the "day of struggle" never came. Only the day of capitulation arrived.

Following the March election, the trade union leaders made their feelings known. On 13 April, Hans Ehrenteit stated in the Provincial Congress of the Free Trades Unions of Hamburg:

> We are ready and able to fulfil the hopes and desires of the proletariat in the economic-social sphere, in agreement with the present rulers. We do not doubt for one moment that the events of 5 March represent a revolution of enormous depth and scope; a revolution which is to surpass the liberal and capitalist economic system; a revolution putting an end to that democratic parliamentarianism which for the past few years has been so deceptive. The trade unions have built bridges to the state and to its rulers. We must now proclaim our attitude in respect of the state and the nation. This attitude will have a foundation. The best course, in our opinion, is to build bridges for those who, through ignorance, would wish, today more than yesterday, to

destroy the trade union movement, and we hope to be able to assist in this. The function of the trade unions must be to continue to fulfil their social and economic mission. This same duty has been carried out by the present government of the Reich, and collaboration between the trade unions and the government is therefore possible. (*Freie Gewerkschaft*, No. 14, quoted in A.R. Oliveira, p. 196.)

This was nothing more than the official signing of the death warrant of the 'Free' trade union movement in Germany. This fawning gave increased succour to Hitler.

Cynically, Hitler declared 1 May a 'National' Labour Day, to which the trade union leaders humbly offered their full support. Even through the spring of 1933, the German trade union leaders humiliatingly co-operated with the fascist government. They issued a statement breaking off their links with the SPD and called on their members to take part in the rallies organised by the Hitler government. These celebrations were nothing more than a farce to further legitimise the regime. Finally, the German trade union leaders urgently telegraphed the International Federation of Trade Unions in an attempt to prevent it, as members, from protesting against the Nazi government's murder and torture of thousands of German workers. When the International refused, they resigned from the body, in the hope that by such grovelling they would escape persecution.

The official organ of the German TUC, *Gewerkschaftszeitung*, published an article for its May Day edition by Walter Pahl with the following scandalous statement:

> We certainly need not strike our colours in order to recognise that *the victory of National Socialism*, though won in struggle against a party [the Social Democrats] which we used to consider as the embodiment of the idea of Socialism, *is our victory as well*; because, today, the Socialist task is put to the whole nation. (E. Anderson, p. 155.)

To claim that Hitler's victory was also "our victory" was a vile statement that flew in the faces of those millions who opposed the fascists. It was to hoist the white flag of surrender. There was no talk of resistance, as resistance in their eyes was futile. These bureaucrats were only interested in saving their own skins. But the fascist regime was never going to let this happen. After the National Labour Day mass demonstration of 100,000, Goebbels wrote: "Tomorrow we will occupy the trade union buildings. There will be little resistance". (W.L. Shirer, p. 202.)

The next day, 2 May, the Stormtroopers occupied the trade union headquarters, the People's Houses, and turned them instead into 'Houses

of German Labour'. As Goebbels had predicted, there was no resistance. On 10 May, the 'German Labour Front' was set up, the only legal entity allowed, which included the 'co-ordinated' organisations, grouped into fourteen trade federations. On 16 May, the right to strike was abolished. Eventually, the federations were dissolved. The industrial organisations of the German working class had disappeared. With the trade unions 'reorganised' (dissolved) and their funds confiscated, the former leaders were arrested, loaded into trucks and taken off to Nazi concentration camps. It was simply a mopping up operation. They accepted their fate, heads bowed, in silence. Even in this darkest hour, Theodor Leipart and Peter Grossman, leaders of the Trade Union Confederation, still proclaimed their readiness to co-operate with Hitler. It was a miserable gesture. Despite their protests of loyalty to the Führer, the Nazis felt that Grossman and Leipart were better off elsewhere.

"The Leiparts and Grossmans," declared Doctor Robert Ley, assigned by Hitler to reorganise the trade unions into a German Labour Front, "may hypocritically declare their devotion to the Führer as much as they like but it is better that they should be in prison." (ibid., p. 202.) And it was to Plötzensee prison they went, where they prostrated themselves.

SPD BANNED

The end, when it came, was shameful and inglorious, the worst of all capitulations. There was no resistance to the totalitarian nightmare, only abject humiliation by the labour and trade union leaders, who were servile before Hitler. As we have seen, he cynically used them and then sent them, along with two million others, to the concentration camps.

Once the labour movement had been completely discredited, they destroyed it. The mightiest working-class movement in the world was obliterated. Not one stone upon another was left of its organisations. Even the workers' chess clubs were dissolved. The fascists created a network of spies and informers in every building, workplace, school and estate, a totalitarian vice that penetrated into every nook and cranny of life. The working class was atomised. This was the real meaning of fascism, as Trotsky had warned. The workers' movement was being reduced to particles of dust.

Hitler moved quickly. On 23 June, the SPD was officially banned. Its leaders were arrested, including the arch-appeaser, Paul Löbe. Their usefulness in creating the maximum demoralisation and confusion was over. The organised labour movement had vanished from the scene. On 27 June, Hitler expelled Alfred Hugenberg from the government, as the whole economy passed into the control of the Nazis.

On 14 July a new law was decreed which simply stated: "The National Socialist German Workers' Party constitutes the only political party in Germany". A one-party, totalitarian regime was in place and all opposition was mercilessly crushed. The regime was given a new name, the Third Reich. "The first Reich was that of Bismarck," explained Hitler, "the second that of the Weimar Republic, and the third is myself." (Quoted in A.R. Oliveira, p. 200.)

Jan Valtin related:

Communists were hunted down like mad dogs. Weaklings in our own ranks capitulated. Spies stepped from obscurity. The majority of the party's top-rank leaders saved their own hides by bolting across the frontiers to neutral countries. But some were captured…

Overnight the Communist Party had taken on the appearance of an ant-heap smashed by a sudden hail of sledge-hammer blows. On 2 March, the new terror laws against the Communist Party were decreed. Hitler's technique of victory was simple: concentration of the whole ferocity of the National Socialist movement against one enemy at a time, while manoeuvring the others into a false sense of security. (J. Valtin, p. 345.)

It was the Communist Party rank and file, along with the socialist workers, who bore the brunt of the Nazi terror. Once in power, the Nazis accomplished in months what had taken the Italian fascists four years to accomplish. The political parties were banned; the trade unions were destroyed; and the funds of the workers' organisations were confiscated for the benefit of the Nazis. The first concentration camp in Germany, Dachau, was founded in March 1933. Others were opened at Oranienburg, Esterwegen and other places, and a reign of terror commenced against the working-class Socialists and communists on a scale never witnessed in modern history.

A press announcement said that:

[T]he first concentration camp is to be opened in Dachau with an accommodation for 5,000 people. All Communists and – where necessary – Reichsbanner and Social Democratic functionaries who endanger state security are to be concentrated there, as in the long run it is not possible to keep individual functionaries in the state prisons without overburdening these prisons. (*Münchner Neueste Nachrichten*, 21 March 1933. The Holocaust History Project. Archived from the original on 6 May 2013.)

Himmler then expanded the role of the camps to hold so-called "racially undesirable elements", such as Jews, Romanis, Serbs, Poles, disabled people, and criminals.

The role of fascism was to root out every trace of socialist consciousness. Smashing the labour movement was the first task. Then all socialist, communist, and progressive literature was seized and destroyed. The Nazis even organised public book burnings, like scenes from the Middle Ages and the Spanish Inquisition.

Those workers caught by the Gestapo machine faced a most brutal end. Within a short period of time, two-and-a-half thousand communists were murdered on the spot. A further 130,000 were taken off to the concentration camps, to meet their death in the gas chambers, through beheadings, through the torture chambers of the SS, worked or starved to death, or simply shot.

Valtin describes the horrors of torture and murder that took place in the cellars of the Gestapo, which captured the very essence of fascism. He witnessed the situation in Plötzensee Prison:

> Those among us who awoke early in the morning, waiting for the bell to command us to rise, soon learnt to recognise the sounds accompanying an execution: the clatter of feet on Death Row at six in the morning, the creaking doors of the shed at the other end of the cobbled square facing Death Row – the shed where the guillotine stood hidden behind a canvas curtain: The sudden rattling of keys in ponderous doors, sometimes the sounds of a futile

The public burning of books in Berlin by students

struggle, roars of rage and screams for help, or a booming voice singing the *Internationale* and ending with a hoarse shout of farewell from the hundreds who lay listening in their cells still alive. (J. Valtin, p. 571.)

THE STALINIST RESPONSE

The Stalinists were incapable of recognising the catastrophic defeat that had taken place; they simply talked wildly of a new revolutionary upswing. In the midst of defeat, their organisation smashed to pieces, the Comintern leaders still declared:

> The current calm after the victory of fascism is only temporary. Inevitably, despite fascist terrorism, the revolutionary tide in Germany will grow… The establishment of an open fascist dictatorship, which is destroying all democratic illusions among the masses and *freeing* them from the influence of the Social Democracy, *will speed up* Germany's progress towards the proletarian revolution. ('The Situation in Germany': Resolution of the Presidium of the ECCI, adopted 1 April 1933, *International Press Correspondence,* 13 April 1933, p. 378, quoted in J. Braunthal, *History of the International,* p. 394, emphasis added.)

In other words, the victory of Hitler, with the annihilation of all the organisations of the working class, was regarded by the Stalinists as an *advantage* to the revolutionary movement. This ridiculous chest-beating was repeated by the Stalinist stooge Kuusinen:

> Even fascist demagogy can now have a two-fold effect. It can, in spite of the fascists, *help us* to free the masses of the toilers from the illusions of parliamentary democracy and peaceful evolution. (*International Press Correspondence*, 30 January 1934, p. 109, emphasis added.)

And then finally in May 1934, more than a year after Hitler's victory, Manuilsky states:

> Fascism does not only make the struggle of the working class more difficult; *it also accelerates the processes of the maturing revolutionary crisis.* (*International Press Correspondence*, 7 May 1934, p. 712, emphasis added.)

This lunacy simply reflected the further degeneration of the Stalinists who proved incapable of distinguishing between revolution and counter-revolution. They simply continued as though nothing fundamental had happened, only with increased hysteria. Despite the fact that the SPD was banned, its leaders imprisoned and its organisations wrecked, the German

Communists still declared the 'social fascists' as the *main* enemy. The KPD Central Committee at the end of May brazenly declared:

> The total removal of social fascists from the state machine and the brutal suppression of the Social Democratic organisations and their press, can do nothing to change the fact that the Social Democrats were, and still remain, the *chief prop of capitalist dictatorship... The Nazis beat the Social Democrats as they would beat a faithful dog who had outlived his usefulness.* (J. Braunthal, *History of the International 1914-1943*, p. 395, emphasis added.)

Given the seeming contradiction, even to many communists, an article appeared in *Rundschau* in July 1933, seeking to support this argument:

> The suppression of the Social Democratic Party by the fascist dictatorship, while certainly changing the forms and the methods of the social fascists' betrayal of the workers, does nothing to stop the betrayal itself... The ban on the SPD does not really operate against the policy and leadership of the party – despite the arrests [sic] – but against the Social Democratic workers and trade unionists and their efforts to fight together with the communists against fascism... Social fascist influence among the workers will not be destroyed by fascism, the twin brother of social fascism, but only by achieving Communist Party hegemony in the working class. (Quoted in ibid., p. 395.)

Madness was heaped on more madness. They were completely oblivious to the consequences of this crushing defeat. For the sake of prestige – their line was always correct – they denied reality. They were in denial about their erroneous policies which had split the labour movement and led to this disaster. On the contrary, the Comintern Executive met in April 1933 and noted with approval, "That the political line and the organisational policy followed by the Central Committee of the German Communist Party up to and during Hitler's coup was *perfectly correct*". (ibid., p. 388.) These leaders of the Comintern simply asserted that black was white, and *Pravda* described its German policy as a "resounding success". (ibid., p. 388.) Thus, as with the Second International in 1914, so now, the Stalinist Third International had become 'a stinking corpse', an obstacle to the Socialist revolution. All the lessons learnt during the days of the Comintern under Lenin and Trotsky – the first five years – where the International played a revolutionary role had been completely buried and forgotten.

DEFIANCE

The Nazis beat their victims to death or beheaded them in front of their comrades. But despite these horrors, many openly defied the butcher's axe. Valtin again described one scene:

First to be led from his cell was Johnny Dettmer... Cries came from the many cell windows: "Good-bye, Johnny!" – "Long live the revolution!" – "Nieder mit Hitler!" Cries of rage and cries of terror. When the headsman's assistants seized Johnny Dettmer, our comrade fought wildly. He fought silently, with all his strength. But his hands were shackled on his back. Guards tied his ankles together and strapped him in upright position to a board. The board swung to a horizontal position. Johnny's head protruded over the edge of the board...

"Good-bye Johnny, good-bye, good-bye." Most eyes were tearless. They were wide open and dry and staring. Before I could realise what was happening, the headsman raised his axe over comrade Dettmer's head. He did not strike. He simply let it fall on Johnny's neck.

"Your head will roll, too," Arthur Schmidt said to Prosecutor Jauch, straightening in sudden defiance. They then strapped him to the board... "All men must die sometime... I die for the proletariat... They can kill the worker Arthur Schmidt, but they can't kill his spirit..." [Then] the axe fell. (J. Valtin, pp. 518-519.)

In the meantime, Hitler talked of abolishing unemployment, doing away with misery and restoring 'German honour'. As expected, in the election of November 1933, the Nazi party, the only party remaining, won 92.2 per cent of the vote, with 3.3 million election cards declared void and 2.1 million abstaining. These were, of course, official figures. Nevertheless, the result reflected the terror and demoralisation in society. A polling station had even been established in the notorious Nazi concentration camp at Dachau, where most of the prisoners, mostly communists, were political opponents of the fascists. Following the election result, it was officially announced that a majority of inmates had voted for Hitler's party.

The Communist Party in spite of all this, once again refused to face up to reality. They explained the election result in the following terms:

The election result... represents a great victory of Thälmann's party... This army of millions of brave anti-fascists confirms the correctness of the statement, made already in October by the Central Committee of the German Communist Party, that a new revolutionary upsurge has begun in Germany. ('The Meaning of the Elections of 12 November in Germany', *Rundschau*, No. 43, 17 November 1933, quoted in E. Anderson, p. 159.)

Stalin was still pursuing friendly relations with Germany, even after the victory of Hitler and the crushing of the Communist Party. The German Ambassador in Moscow, Dirksen, noted that the Soviet Union's attitude towards the Hitler regime remained friendly, even to the point of suppressing

open displays of hostility towards the regime. In a report to Berlin in May 1933, Dirksen said that:

> ...a strong attack on Communism in Germany itself is entirely compatible with preserving friendly German-Russian relations... Yesterday [May Day] passed off without incident. Voroshilov's speech offered no occasion for special objections; the throngs of demonstrators refrained from calumniations of National Socialism or of leading Germans. The ceremony at the Embassy was extraordinarily well-attended (550 persons): after my speech three or four German [exile] Communists apparently sent to start a row, tried to 'heckle' me, but they were gently ousted. (Quoted by R. Blick, *Fascism in Germany*, appendix 111.)

On 16 May, Dirksen reported an interview with Litvinov, the Soviet Foreign Minister, where he stated that "the basic attitude of the Soviet government toward Germany had remained entirely the same: The Soviet government was convinced that it could have just as friendly relations with a Nazi Germany as with a fascist Italy". On 4 August, Molotov repeated this policy: "The Soviet government [is] striving for [a] friendly relation not only with other countries, but also with Germany, regardless of their internal political structure..." This provoked Dirksen to comment, "Molotov's statements, as one of the really authoritative men and closest co-workers of Stalin, undoubtedly deserves serious consideration". Molotov went even further in his fawning towards the Hitler regime, made public at the September 1933 session of the All-Union Central Executive Committee:

> We of course sympathise with the sufferings of our German comrades, but we Marxists are the last who can be reproached with allowing our feelings to dictate our policy. The whole world knows that we can and do maintain good relations with the capitalist states of any brand, including the fascist. (ibid.)

NIGHT OF THE LONG KNIVES

After suppressing organised labour, Hitler then moved to crush the restless idealists inside the Nazi party who were demanding a 'Second Revolution' to achieve 'National Socialism', by nationalising the monopolies, the banks, breaking up the department stores, etc. They were so deluded that they actually believed their own propaganda, not realising that it was all a sham, a ploy to fool the ruined middle class. In reality, the reverse was happening. The bourgeoisie ruthlessly used its supremacy in the factories after the destruction of the trade unions to organise a regime of terror. Wages were cut, conditions driven down, rights withdrawn, and strikes forbidden. The capitalists now

had the whip hand to do as they wished. Exploitation increased and the rate of profit rose. The fascist dictatorship was, in the final analysis, a brutal dictatorship of the monopolies. Hitler gave the capitalists everything they desired and, in turn, they gave him the freedom to do as he wished. As long as profits were booming and wages were driven down, they were content. The only promise Hitler kept was the persecution of the Jews, who were used as a scapegoat and an outlet for the growing disillusionment of the petty bourgeoisie.

While Hitler betrayed the middle-class base of fascism, he needed to deal with the threat from the SA. This paramilitary organisation, under Röhm, now numbered more than two million members – twenty times more than the army. "We are the incorruptible guarantors of the fulfilment of the German revolution," stated Röhm. (W.L. Shirer, p. 205.) Its ranks were made up of hard-line fanatics who demanded the 'Second Revolution', but they were to be disarmed and liquidated by Hitler in June 1934 in the famous 'Night of the Long Knives'. These mercenaries, Röhm, Strasser, Schleicher and hundreds more, were ruthlessly murdered after their dirty work was done. "The revolution is not a permanent state of affairs," explained Hitler, "and it must not be allowed to develop into such a state." (ibid., p.205) Hitler compared the 'Second Revolution' to 'national Bolshevism'. It was a threat, an embarrassing legacy of the years of struggle, that had to be eliminated. Behind the purge stood the army, which regarded the SA as a rival. More than 1,000 lost their lives in the blood-letting. However, in the place of the SA now came the SS, Hitler's elite, as a reward for carrying out the executions. To play down the purge, Goebbels forbade German newspapers from carrying obituaries of those who had been executed.

The *Sozialistische Aktion*, the illegal organ of the SPD, published abroad and smuggled into Germany, published an article on 12 July 1934 with the headline, 'Suicide of the Dictatorship'. The following issue stated, "The 30 June is the beginning of the end of National Socialism". (E. Anderson, pp. 169-170.) The Stalinists also said the same thing. But they were woefully deluded. As Trotsky had explained, such a terrible defeat at the hands of fascism meant the working class would not recover in two or three years, but for fifteen years.

The Nazi state apparatus was now fully in place. Into their clutches came the state organs, the judiciary, the civil service, the education system, the Church, everything down to the nurseries. All opposition was mercilessly eliminated.

Once in power, however, fascism began to lose its mass base and began to increasingly resemble a Bonapartist police state. Its mission had been

accomplished and the proletariat atomised. The multi-million strong German labour movement – with a Marxist tradition extending over seventy-five years – had been smashed to smithereens.

In a macabre twist, Stalin was suitability impressed by the news of Hitler's Night of the Long Knives and was inspired to come up with his own bloody purge in the Soviet Union. Months later, in December 1934, Stalin had Sergei Kirov, a high-ranking bureaucrat, assassinated. It would be the opening prelude to the infamous Moscow Show Trials, in which the Old Bolsheviks were judicially tried for supporting fascism, and executed. A river of blood now separated the regime of Stalin from the regime of Soviet Democracy under Lenin and Trotsky.

STALIN AND HITLER

Stalin was now particularly concerned that German communists could be a source of criticism of his leadership. Therefore, he would not be satisfied until all the KPD leaders, those thought to be inwardly critical of his policy in particular, had been eliminated. Thus, those whom the Nazis failed to hunt down and murder were butchered by Stalin's GPU gangsters in the cellars of the Lubyanka. Stalin and Hitler between them could, by 1937, claim to have massacred the majority of the KPD Central Committee, and untold thousands more of its middle- and lower-party cadres. In fact, Stalin succeeded in murdering more of the top party leaders than Hitler, as the following figures illustrate:

> *German Politburo*: those murdered by Stalin: Hermann Remmele, Heinz Neumann, Fritz Schulte, Hermann Schubert – four.
>
> *German Politburo*: those murdered by Hitler: Ernst Thälmann, John Scheer – two.
>
> *German Central Committee*: those murdered by Stalin: Hugo Eberlein (founder member of the Comintern), Hans Kippenberger (head of the KPD military apparatus), Leo Flieg (KPD Organisations Secretary), Willy Leow (head of the Red Front Fighters' League), Willi Koska (head of Red Aid), Heinrich Susskind and Werner Hirsch (chief editors of *Rote Fahne*, the KPD daily), Erich Birkenhauer, Alfred Rebe, Theodor Beutling, Heinrich Kurella (on the staff of *Rote Fahne*), Kurt Sauerland, August Creutzburg. Total – eleven.
>
> *German Central Committee*: those murdered by Hitler – nine. (Figures supplied by R. Blick, *Fascism in Germany*.)

According to Leopold Trepper, the leader of the 'Red Orchestra', the Soviet Intelligence network that functioned in occupied Europe during the Second World War, the German communists who fled to the Soviet Union were murdered by Stalin. "By 1937, not one of the principal leaders of the German Communist Party was left, except for Wilhelm Pieck and Walter Ulbricht". (L. Trepper, *The Great Game*, p. 55.)

'LEFT' HISTORIANS

The attempts by the bourgeois historians to explain the rise of fascism and the victory of Hitler are more than worthless. They are mere descriptions of events. In the realm of understanding, they generally meander into the subjective qualities of Hitler and the 'mistakes' of his opponents. As for the 'left' historians, they fair little better. For instance, the late professor Eric Hobsbawm in his book *The Age of Extremes* attempted to explain the victory of Hitler by blaming the Great Depression. It was a factor, but it is impossible to understand the reason why the mighty German labour movement was paralysed and crushed by Nazism without understanding the disastrous role of the leadership of both the Social Democracy and, above all, the Stalinists who deliberately split the working class.

Hobsbawm skates around this subject as if on very thin ice:

> The strengthening of the radical Right was reinforced, at least during the worst period of the slump, by the spectacular setbacks for the revolutionary Left. So far from initiating another round of social revolution, as the Communist International had expected, the Depression reduced the international communist movement outside the USSR to a state of unprecedented feebleness. This was admittedly due *in some measure* to the suicidal policy of the Comintern, which not only grossly underestimated the danger of National Socialism in Germany, but pursued a policy of sectarian isolation that seems quite incredible in retrospect, by deciding that its main enemy was the organized mass labour movement of Social Democratic and labour parties (described as 'social fascist'). (E. Hobsbawm, *Age of Extremes – The Short Twentieth Century 1914-1991*, pp. 104-5, emphasis added.)

With just a few short lines, which appear almost as a footnote, Hobsbawm sweeps aside with a slap on the wrist the disastrous role of the Communist Party in handing victory to Hitler, one of the greatest calamities of modern times. What Hobsbawm fails to understand is that it was not the Depression that "reduced the international communist movement outside the USSR to a state of unprecedented feebleness," but precisely the criminal ultra-left line of the Comintern, which was in turn dictated by Stalin as part of his struggle against 'Trotskyism' in Russia.

In another work, Hobsbawm explained that:

The history of the KPD is tragic. Perhaps it failed for German reasons: because of the inability of the German left to overcome the historic weaknesses of both the bourgeoisie and the proletariat of that great and ambiguous country. (E. Hobsbawm, *Revolutionaries*, p. 64.)

Once again, our apologist speaks in riddles, saying everything except laying the blame where it belongs, at the feet of Stalinism and the stooges he once fawned upon. Such 'historians' cannot accept that the policy of Stalin did more for Hitler's victory than the policy of Hitler himself.

AUSTRIAN UPRISING

Following the breakup of the Austro-Hungarian empire, the fate of Austria was always very closely linked to Germany. A day after the Kaiser abdicated, the Austrian Emperor followed suit. The Austrian Republic was formed under a new Social Democratic government, with the line of 'No bloodshed! For law and order!' They favoured the unification of Austria and Germany, not on the basis of a Soviet Republic, but on the basis of the Weimar Republic.

In Austria, in the 1920s, the fascists organised around the 'Heimwehr', a type of Home Guard, which specialised in strikebreaking and terrorising workers. The Social Democrats simply ridiculed them, but nothing more.

In 1926, following Mussolini's final declaration of the fascist dictatorship and the attempted coup in Bavaria, the Social Democratic Party pledged itself to take up arms if there was a fascist attack or coup in Austria. But this pledge was to prove to be just words. When the Heimwehr started killing and assaulting members of the Republican Defence League, nothing was done.

Repeatedly, fascist murderers would always get released without a sentence. Workers' tempers inevitably rose. In July 1927, when it became known that four fascist murderers had been released after killing two Defence League members, workers struck work and marched on the building of the fascist newspaper, setting it ablaze. They then marched on the Court House and set it on fire. Street battles broke out and the city was on the verge of a general strike. But when the Social Democratic leaders arrived on the scene, they urged everyone to go home.

It was becoming increasingly obvious that a showdown was inevitable. Then came news of Hitler's electoral victory on 5 March 1933 in Germany. Two days later, the Austrian Federal Chancellor, Engelbert Dollfuss, a devout Catholic, who only had a majority of one in parliament, carried out a coup in Austria. Socialist workers were ordered, under the threat of the sack, to join Dollfuss' new party, the 'Patriotic Front', which was to replace all parties

in the name of 'national unity'. Dollfuss declared that Austria would be the first country in the world to be ruled according to the ideas of Catholicism and the Pope.

While the fascist movement in Austria was weaker and more divided than in Germany, it started to grow in influence. Again, Austrian workers had shown they were prepared to fight. The Social Democrats were the strongest party in the country, proportionally bigger than its German counterpart and had the support of two-fifths of the electorate.

But when faced with the Dollfuss coup, they trembled at the thought of civil war. They were wringing their hands at the idea of an armed struggle, for which they were not mentally prepared. Instead, the leadership of the Party under Otto Bauer, the pioneer of so-called Austro-Marxism, put their hopes in negotiations and a peaceful solution. They therefore fell over themselves in making one concession after another to the Dollfuss government, all in the name of avoiding bloodshed.

Rebuffed by Hitler, who wanted complete capitulation, Dollfuss turned to Mussolini, who urged him to crush the Social Democrats. In effect, Austria had become an Italian protectorate. And yet, the Social Democrats still hesitated to call on the workers to act. Explaining the party's tactics to the Executive Committee, Otto Bauer stated:

> We knew that in an unequal battle against the tremendous powerful forces of the state, we could only win if the whole of the working class rose up together, with literally every single village where there was a handful of workers joining in. Hence we did not wish to give the signal for battle unless the dictatorship went to a point which was bound to raise popular anger and bitterness to a crescendo. (Quoted in J. Braunthal, *History of the International*, p. 409.)

So, the Social Democratic Party decided to wait and wait. They finally decided to call on the workers to take up arms as soon as the government proclaimed a fascist constitution or tried to suppress the organisations of the working class. But Dollfuss was not so stupid. He simply chipped away one piece at a time, and the Social Democrats remained silent.

The 6 February 1934, the day when the French fascists engaged in street violence against the Republic on the Place de la Concorde, heralded the collapse of Austria's democracy.

"Tomorrow," said vice-Chancellor Fey, "we are going to start cleaning up Austria; we shall make a complete job of it." (A. Sturmthal, p. 176.) Finally, on 12 February 1934, a year after Dollfuss had become dictator, the struggle broke out. Incredibly, the Social Democrats still hesitated and tried

to delay. But the Executive of the party was forced to act when the police and Heimwehr stormed their headquarters and shots were fired. The news spread rapidly throughout the country.

The next day, the party's Fighting Command mobilised the Republican Defence League and a general strike was called. The inevitable struggle had begun.

P. Berger wrote:

> It was ten o'clock in the morning, on 14 February, 1934, when the power in our little workshop in Vienna stopped. Our noisy machinery turned unusually quiet.

> "What's that?" I asked my foreman. "General strike!"

> Already, a neighbour was in to ask if our power had stopped as well. There was no argument. Everybody had expected some action of the Austrian working class, long famous for its militancy.

> When the three of us – my boss who was a little Polish Jew as poor as any worker, my foreman, a Hungarian engineer, and myself, the errand boy – walked through the town, the trams were dragged by army lorries to the depot to prevent the workers using them as barricades. All the bridges across the Danube Canal which divided the working-class suburbs from the city, were in the hands of the army. Nobody could leave the city without identification. Machine guns and barbed wire were placed in front of important buildings in the main roads. Soldiers in battledress were patrolling the streets. Great activity was manifested at the entrance of the war office. Everything was ready to smash capitalist democracy, under which the workers possessed some rights, and to establish a fascist dictatorship. This was the final moment for twenty years of Social Democratic 'constitutional leadership'. (P. Berger, 'Lessons of the 1934 Revolt in Austria: An Account of a Participant', *Fourth International*, p. 211.)

However, the general strike call fell on deaf ears. The working class had been continually held back, after a long series of defeats and humiliations which the Social Democrats had swallowed. They delayed and delayed, until finally it was too late. They failed to strike when the iron was hot. The working class was disorientated. The government then declared a State of Emergency and ordered the arrest of the leaders of the Social Democrats and the trade unions, including all its representatives and officials.

Only the Defence League took to arms and barricades were put up in Vienna. Dollfuss used artillery to crush the resistance. After three days of fighting, the insurgents were overwhelmed. The Austrian working class was not defeated by the class enemy. It was let down by its own leaders.

Otto Bauer and Julius Deutsch, the leaders of the revolt, fled to Czechoslovakia, and by 16 February the fighting was all over. Hundreds died in the fighting, while thousands were taken to concentration camps. Eleven members of the Defence League were hanged, including the deputy Koloman Wallisch. One of the wounded was brought to the gallows on a stretcher.

Once again, although there was armed resistance to Dollfuss, the Social Democratic leaders had played a dismal role by acting as a brake on the movement until it was too late. This was a product of their opportunism, dressed up as 'Austro-Marxism'. Like all the mandarins of Social Democracy, their appeals for negotiations, respect for the Constitution, and compromise, all served to sign the workers' death warrants. A few thousand heroic workers did take up arms, but the struggle was hopeless under the circumstances. They should have risen sooner, in March 1933. Again, the Austrian Social Democrats had been a bastion of international Social Democracy. But now they were finished, crushed and driven underground.

UNDERGROUND RESISTANCE

A whole generation, composed of many of the best revolutionary fighters, paid dearly for the crimes of the bankrupt leadership of Stalinism and Social Democracy – whose actions and policies bear complete responsibility for the victory of Hitler.

Despite the monstrosity of fascist barbarism, there was an underground resistance by heroic individuals. In fact, thousands and thousands of former members of the old organisations refused to betray their convictions. With spies on every corner, in every workplace, such opposition was obviously extremely dangerous. At first, given their inexperience, many were caught and found themselves in the cellars of the Gestapo. Those individuals who were caught were replaced by others and cells of resistance were gradually formed that carried on propaganda against the fascist regime. But given the risks, such voices were few and far between.

In early 1934, the following report was smuggled out of Germany, drafted by a person who was actively engaged in underground work. It is a detailed account of the mood and extreme difficulties of such illegal work in fascist Germany, a regime that was all-embracing and all-penetrating:

> One year only after the collapse, most of the remnants of the old organisations have largely been annihilated. I am not suggesting that their members have given up their faith or that all organised connections have ceased to exist. But it does mean that the movement and its activities have been reduced to microscopic size.

The communist movement seemed to be better prepared and, on the whole, more willing to offer resistance than the rest. They never questioned whether or not they should continue their work. Of course, they too, had traitors in their ranks, and men who willingly and quickly made their peace with Hitler – at least as many as any other section of the movement. Communist illusions as to their own exaggerated significance persisted also under the new conditions.

For the many tens of thousands who actively worked within the ranks of the Communist movement, the effect of these illusions was as devastating as the effect of reformist sluggishness had been in the Social Democrat camp. Nothing remains which resembles a coherent movement. Central as well as district and local headquarters have been hunted down by the police, time and again.

The basic units are, of course, the most active ones, the cells and little groups of purely local character, the so-called street-cells. They produce their own material, write it and duplicate and distribute it themselves in the houses of their districts or at the Labour Exchange. Increasingly they are reduced to maintaining contacts only in their closest vicinity. They have had too much bitter experience. Many, only too many, are caught – as recently in the Chaussee Strasse in Berlin – in the course of surprise raids on the huge working-class tenements. In that case as in most, every single person present, men, women and children, were questioned and searched by the police.

Camouflaged as study-circles for foreign languages some groups continue their theoretical political discussions, casually on a deplorably low level; they seem to have learnt as little as they have forgotten. Still, they are the most advanced section of the old communist movement, trying to remain politically alive and to serve the cause. Some are more than critical of the official Comintern line, but under the new conditions it seems no longer so dangerous to be a critical communist.

Even more bitterly they all complain of the failure of the central leadership in regard to organisation problems. In the case of Alfred Kattner, who was to be chief witness for the prosecution in the forthcoming Thälmann trial, it was found out that he had contacts with one of the illegal central headquarters. Two or three headquarters with whom he maintained contact were caught. Even after that, he remained in his position until later he was shot.

Kattner's betrayal of Johnny Scheer (a member of one of the central headquarters which were taken), of Steinfurt and others, has very seriously undermined morale – nothing is discussed more in illegal communist circles than the spy plague; still, they go on with their work.

There are instances of great heroism and devotion. A funeral of a comrade was attended by many workers. Within hearing of the police, the widow said at the grave: "I know you were not shot in an attempt to escape." And a worker said: "You fell for the worker's cause, you shall be revenged." The police did not intervene – they merely took photographs of a number of those present...

Of the former Social Democratic movement, it is, above all, the young who maintain contacts. Numerically few are left. In the borough of a large town which used to have an organisation of several thousand members, there is today a group of eight or nine younger party members. They maintain contact with a similar group in the neighbouring borough, consisting of only three. For protection they have joined one of the tolerated charity organisations to cover their frequent meetings. They are on the look-out for 'illegals' who, they understand, have firmer organisational relationship. Persons who are supposed, rightly or wrongly, to be associated with the 'illegals' are approached for advice and help. They are looking for an experienced instructor who could help them with their study circle and whose political views would be on the Left of the former party. Without knowing very much what it is all about, this group distributes a duplicated broadsheet issued by one of the illegal organisations. This then is the remnant of a formerly strong party organisation. It is a typical example – typical for its attitude, for the isolation of the individual, but also for the chance to reorganise the best elements, few though they may be in numbers.

In another district, regular meetings actually take place in the flat of a formerly well-known comrade. Here, too, an organisation once numbering many thousands can now assemble without difficulty in one room. They have many discussions, and are seeking a new way in serious political talks among young people conscious of their responsibility and aware of the possible consequences of their actions: concentration camp, torture and even death.

In a third district, meetings are held regularly in private houses and flats. Here they are more careful and therefore have far fewer casualties. They have refused to distribute material smuggled from abroad. "They don't know, anyhow, what conditions in Germany are like nowadays; that stuff isn't worth risking your head for." They also learnt from the sad experiences in their neighbouring district of Y. Their badly organised attempt to recommence the work resulted in many arrests. Among those who were left, there was abject depression and an atmosphere of mutual suspicion, general anxiety and fear. Now they say: "The last arrests have shown that you cannot trust

even your oldest comrades." Or, "It's no use; none of the former comrades will go on doing anything."

In one of the districts mentioned above, they believe that today as of old, activities can be increased and strengthened by success. But under present conditions success means above all not to be discovered, to expand as fast as one's own forces can 'digest' and not to try doing things with which one cannot cope and which tend to get out of control. They think it vital to give all comrades as much security as is humanly possible, to avoid senseless sacrifices and to assure steady progress by careful selection of the best individuals.

Many of those who with courage and energy took part in some badly organised activities have never recovered from their depression following the arrests of their friends. The mere news that the police got hold of a list of names has meant for many a complete breakdown in which some lost their nerves so completely that they even, though without malice, betrayed their friends to the Gestapo.

The younger ones of course learn quickest of all. A year ago, they merely kept in contact, met for outings or social evenings and went out hiking through the country. In the meantime, many of them have learnt more than they could have learnt during many years under normal conditions. Slowly they are acquiring political maturity and organisational skill. They are but few compared with the millions of German youth. But these few are the core of a new generation which can defeat fascism… (Quoted in E. Anderson, pp. 166-169.)

SITUATION REASSESSED

With the victory of Hitler, the German tragedy was laid bare for all to see. However, the Stalinists abroad continued to justify their suicidal position. Their role was summed up by Trotsky:

Since 1923, that is, since the beginning of the struggle against the Left Opposition, the Stalinist leadership, although indirectly, assisted the Social Democracy with all its strength to derail, to befuddle, to enfeeble the German proletariat: it restrained and hindered the workers when the conditions dictated a courageous revolutionary offensive; it proclaimed the approach of the revolutionary situation when it had already passed; it worked up agreements with petty-bourgeois phrase mongers and windbags; it limped impotently at the tail of the Social Democracy under cover of the policy of the united front; it proclaimed the 'third period' and the struggle for the conquest of the streets under conditions of political ebb and the weakness of

the Communist Party; it replaced the serious struggle by leaps, adventures or parades; it isolated the communists from the mass trade unions; it identified the Social Democracy with fascism and rejected the united front with the mass workers' organizations in face of the aggressive bands of the National Socialists; it sabotaged the slightest initiative for the united front for local defence, at the same time it systematically deceived the workers as to the real relationship of forces, distorted the facts, passed off friends as enemies and enemies as friends – and drew the noose tighter and tighter around the neck of the party, not permitting it to breathe freely any longer, nor to speak, nor to think. (L. Trotsky, *The Struggle Against Fascism*, p. 376.)

Despite everything, the Stalinists continued to claim they were correct and Germany was on the verge of revolution. Of course, they continued to denounce Trotsky. Even after the victory of Hitler, the Stalinists became increasingly rabid against Trotsky.

Trotsky, the lackey of the counter-revolutionary bourgeoisie, is unsuccessfully trying to prevent the Social Democratic workers coming over to the side of communism by his despicable attempts to form a Fourth International and by spreading anti-Soviet slanders. (*Minutes of the Thirteenth Plenum of the ECCI*, December 1933.)

In a long article by Fritz Heckert, a Stalinist leader of the KPD, Trotsky is subjected to the vilest of slanders:

The enormous treachery of the Social Democracy has called forth such a storm of indignation among the workers of all countries that other parties of the Second International have even declined to come forward in their defence.

But the Social Democrats have found one ally. And this is Trotsky. As a political cypher in the working-class movement he has nothing to lose. He slobbers over the fascist jackboot, calculating that he can make people talk about him, with the object of reappearing from his political oblivion for even one small hour at any price whatsoever. (*Daily Worker*, 4 May 1933.)

Trotsky hoped that the catastrophe and betrayal in Germany would shake the Communist International to its senses and give hope for its regeneration on Bolshevik lines. The Trotskyists had always regarded themselves as a Left Opposition within the Communist Party, despite being expelled. However, as for the KPD, the German Party had been smashed. Its activities now constituted the convulsions of a dying organism. More importantly, it had utterly failed to understand what had happened in Germany, confusing

counter-revolution for revolution. Therefore, rather than continuing with the idea of 'reform' of the KPD, Trotsky raised the idea of a new party.

REFORM OR NEW PARTY?

In an article entitled 'KPD or New Party?' written on 29 March 1933, Trotsky explained:

> We started out from the proposition that the key to the situation was in the hands of the KPD. That was correct. Only a timely turn on the part of the KPD could have saved the situation. Under such conditions, to oppose the party and, in advance, to declare it to be dead would have meant to proclaim a priori the inevitability of the victory of fascism. We could not do that. We had to fully exhaust all the possibilities of the old situation.
>
> Now the situation has changed fundamentally. The victory of fascism is a fact, and so is the breakdown of the KPD. It is no longer a question of making a prognosis or a theoretical criticism, but it is a question of an important historical event which will penetrate ever deeper into the consciousness of the masses, including the communists...
>
> It would be inadmissible to have any kind of illusions as to the illegal perspectives for the Stalinist apparatus or, in meeting it face to face, to be guided by sentimental instead of political-revolutionary considerations. This apparatus is corroded by paid functionaries, adventurists, careerists, and yesterday's or today's agents of fascism. The honest elements will have no compass. The Stalinist leadership will institute in the illegal party a regime even more contemptible and disreputable than in the legal party. Under such conditions the illegal work will be only a flash, although a heroic one; the result, however, can only be rottenness.
>
> The Left Opposition must place itself entirely on the basis of the new historical situation created by the victory of fascism. There is nothing more dangerous, at the time of sharp turns of history, than to hang on to the old customary and comfortable formulas; this is the direct road to decay. (L. Trotsky, *Writings 1932-33*, pp. 161-162.)

Trotsky, at this stage, still left open the fate of the Communist International. Could it be reformed, as before, or not? He hoped that the events in Germany would provoke a debate and re-evaluation within the ranks of the communist parties internationally. But that never happened. There was a monolithic silence. Instead, the ECCI, as we have seen, passed a resolution unanimously stating that the policies pursued in Germany were absolutely correct. But it was precisely this 'infallible' policy that guaranteed Hitler's victory. The Stalinist leaders then prohibited all discussion on what had happened in

Germany. There would be no international congresses and no discussion in party meetings or the press.

As a result, Trotsky concluded:

> An organisation which was not roused by the thunder of fascism and which submits docilely to such outrageous acts of the bureaucracy demonstrates thereby that it is dead and that nothing can ever revive it. To say this openly and publicly is our direct duty towards the proletariat and its future. In all our subsequent work it is necessary to take as our point of departure the historical collapse of the official Communist International. (L. Trotsky, *Writings 1932-33*, pp. 305-306.)

The conclusion posed the question of a new International. By 1935, Trotsky wrote in his diary of how, by some accident, everything now depended upon him. One by one, his old collaborators had fallen victim to Stalin's Terror during the Moscow Trials. Those who refused to recant were physically liquidated. Even those who thought they could escape through capitulation were not spared. One of the last to hold out was the great Balkan Marxist and veteran revolutionary Christian Rakovsky. As soon as Trotsky heard the news of Rakovsky's capitulation, he wrote down the following words in his diary:

> Rakovsky was virtually my last contact with the old revolutionary generation. After his capitulation there is nobody left. Even though my correspondence with Rakovsky stopped, for reasons of censorship, at the time of my deportation, nevertheless the image of Rakovsky has remained a symbolic link with my old comrades-in-arms. Now nobody remains. For a long time now, I have not been able to satisfy my need to exchange ideas and discuss problems with someone else. I am reduced to carrying on a dialogue with the newspapers, or rather through the newspapers with facts and opinions.

> And still I think that the work in which I am engaged now, despite its extremely insufficient and fragmentary nature, is the most important work of my life – more important than 1917, more important than the period of the Civil War or any other.

> For the sake of clarity, I would put it this way. Had I not been present in 1917 in Petersburg, the October Revolution would still have taken place – on the condition that Lenin was present and in command. If neither Lenin nor I had been present in Petersburg, there would have been no October Revolution: the leadership of the Bolshevik Party would have prevented it from occurring – of this I have not the slightest doubt! If Lenin had not been in Petersburg, I doubt whether I could have managed to conquer the resistance of the Bolshevik leaders. The struggle with 'Trotskyism' (i.e., with the proletarian revolution) would have commenced in May 1917, and

the outcome of the revolution would have been in question. But I repeat, granted the presence of Lenin the October Revolution would have been victorious anyway. The same could by and large be said of the Civil War, although in its first period, especially at the time of the fall of Simbirsk and Kazan, Lenin wavered and was beset by doubts. But this was undoubtedly a passing mood which he probably never even admitted to anyone but me.

Thus, I cannot speak of the 'indispensability' of my work, even about the period from 1917 to 1921. But now my work is 'indispensable' in the full sense of the word. There is no arrogance in this claim at all. The collapse of the two Internationals has posed a problem which none of the leaders of these Internationals is at all equipped to solve. The vicissitudes of my personal fate have confronted me with this problem and armed me with important experience in dealing with it. There is now no one except me to carry out the mission of arming a new generation with the revolutionary method over the heads of the leaders of the Second and Third International. And I am in a complete agreement with Lenin (or rather Turgenev) that the worst vice is to be more than 55 years old! I need at least about five more years of uninterrupted work to ensure the succession. (L. Trotsky, *Diary in Exile*, pp. 53-4.)

GERMANY PREPARES FOR WAR

German capitalism was in a parlous state, the worst country affected in Europe. The only way the fascist regime could survive was on the basis of a war economy. Thus, on 9 April 1934, Hitler publicly announced that he was rearming Germany – in defiance of the provisions of the Versailles Treaty. British arms manufacturers helped in this. Of course, as the military might of Germany was strengthened, it meant a massive spiralling of public debt and an unfavourable trade balance. It was a question of "guns, not butter," explained Hermann Göring. "Guns will make us powerful; butter will only make us fat," he said in a radio broadcast in the summer 1936.

The arms industry was busy making super profits. Colonel Thomas, head of the 'war economy' department of the Ministry of War, declared:

The execution is left as far as possible to private initiative. German war economy will not socialize war industry… The entrepreneur and the merchant should make money. That is what they are for. (Quoted in D. Guerin, p. 244.)

In 1935, military expenditure amounted to approximately half of government spending. Such expenditure put enormous strain on the economy, constituted a colossal drain, and was clearly unsustainable. The policy did, however,

allow Hitler to eradicate mass unemployment, but at an enormous cost. By 1939, some sixty-eight per cent of the German economy was made up of war production, which took the economy to the verge of collapse. Hitler was therefore faced with the stark choice of waging war or facing oblivion. The only way forward for the regime was conquest and plunder, which made war inevitable.

From late 1939, Germany waged war and conquered most of Europe, with all its resources, which were systematically plundered. With these plundered resources Germany increased its power and wealth, hoping to extend its domination. Hitler's vision was the unification of Europe under the heel of German fascism. In preparing for this, Hitler manoeuvred between the powers, resting on Britain for its rearmament. In July 1934, Britain and Germany concluded the Anglo-German Transfer Agreement – which was one of the pillars of British policy towards the Third Reich. By the end of the decade, Nazi Germany had become Britain's principal trading partner. "In 1937, for example, she provided a market for more British goods than any other two continents combined and for four times the amount taken by the United States," explained Guido Giacomo Preparata. (*Conjuring Hitler: How Britain and America Made the Third Reich*, p. 224.)

Furthermore, in December 1934, Montagu Norman, the Governor of the Bank of England from 1920 to 1944, advanced the Nazis a loan of about $4 million in order to "facilitate the mobilisation of German commercial credits", that is new money to pay old debts.

Both Britain and the US went on to make a number of highly lucrative arms deals with Hitler. For example, Vickers-Armstrong, the well-known British arms manufacturer, provided Germany with heavy weaponry. When asked in 1934 to give assurance that the company was not used for the secret rearmament of Germany, the Chairman of Vickers, Herbert Lawrence, answered: "I cannot give you assurance in definite terms, but I can tell you that nothing is done without the complete sanction and approval of our own government." In 1935, an Anglo-German Society was founded in which Unilever, Dunlop Rubber, the British Steel Export Association, and British Petroleum all participated.

At the same time, the United States was selling Hitler the most advanced aircraft engines, while American companies Pratt & Whitney, Douglas, Bendix Aviation, among others, provided German companies – BMW, Siemens and others – with patents and military secrets. All this is substantiated in *Conjuring Hitler: How Britain and America Made the Third Reich*.

SECOND WORLD WAR

In March 1938, German troops entered Vienna. The following March, Hitler took war seriously and seized Czechoslovakia with the excuse of protecting the rights of the Sudeten Germans. The British attempted to appease him by abandoning the Czechs, hoping to contain his ambitions, and so Chamberlain came back from talks with a piece of paper saying "peace in our time". But the paper was worthless, simply a manoeuvre by Hitler to gain time and wrong foot Britain. In late August 1939, to everyone's surprise, he made a Pact with Stalin, which was advantageous to him economically and strategically. At a banquet to celebrate the Pact toasts were made:

> Toasts: In the course of the conversation, Herr Stalin spontaneously proposed to the Führer, as follows: "I know how much the German nation loves its Führer; I should therefore like to drink to his health". Herr Molotov drank to the health of the Reich Foreign Minister and of the Ambassador, Count von der Schulenburg. Herr Molotov raised his glass to Stalin, remarking that it had been Stalin who – through his speech of March of this year which had been well understood in Germany – had brought about the reversal in political relations. Herren Molotov and Stalin drank repeatedly to the Non-aggression Pact, the new era of German-Russian relations, and to the German nation. (A. Hencke, *Nazi-Soviet Relations,* quoted in R. Black, *Stalinism in Britain*, p. 130.)

The Pact provided for the division of Poland between Germany and Russia. The Polish Communist Party did not object as it had been dissolved by Stalin in 1938, and its leaders branded as 'fascists'! Nearly all its leaders, in exile in Moscow, were murdered. Then, when the time was right, Hitler launched an attack on Poland, with Stalin's agreement, on 1 September. On 9 September, the Soviet Foreign Minister despatched the following telegram to the Nazi Ambassador in Moscow, Schulenburg:

> I have received your communication regarding the entry of German troops into Warsaw. Please convey my congratulations and greetings to the German Reich Government. Molotov. (ibid., p. 139.)

The Pact was hailed by the Communist Parties. In Moscow, Walter Ulbricht, head of the Central Committee of the German Communist Party wrote an article stating:

> If Hilferding and the other former Social Democratic leaders direct their war propaganda against the German-Soviet Pact, they do so because the English plan to bring about war between Germany and the Soviet Union

will succeed the less, the more deeply rooted is the friendship between the German people and the Soviet people in the toiling masses.

He continued:

> It is for this reason that not only the communists but also many Social Democrats and National Socialist workers regard it as their duty not to allow the Pact to be broken under any circumstances. Whoever intrigues against the friendship of the German and the Soviet peoples is an enemy of the German people and is being branded as an accomplice of English imperialism. Among the toiling people of Germany, the efforts increase to unearth the supporters of the Thyssen clique, these enemies of the Soviet-German Pact. In many cases the demand was raised to remove those enemies from the Army and the State apparatus and to confiscate their property. (Quoted in A. Sturmthal, p. 284.)

For Ulbricht and the other Stalinists, the prime duty, as they saw it, was to fight the so-called Thyssen clique among the Nazis, while the rest of the Nazi Party, including Hitler and Ribbentrop, had ceased for now to be an enemy of the working class.

From 3 September 1939, Germany was at war with France and Britain. For the British, Hitler's expansionist ambitions threatened the British empire, and that was something that they could not tolerate. After the conquest of France, where the ruling class preferred capitulation to revolution, Hitler turned his military attentions towards the USSR in June 1941. A key element in Hitler's calculation was the state of the Red Army, which had been weakened by Stalin's decapitation of its military leaders who he saw as being a threat to his own position.

A cocktail party in Berlin, 1940, with Molotov and Adolf Hitler sat adjacent

The Nazi attack on the Soviet Union was not 'unexpected', as Stalin claimed. Stalin had been repeatedly warned of an imminent attack, but refused to believe it. "However, Stalin took no heed of these warnings," stated Khrushchev in his 'secret speech' to the Twentieth Party Congress in 1956. "What is more, Stalin ordered that no credence be given to information of this sort, in order not to provoke the initiation of military operations." (P. Black, *Stalinism in Britain*, p. 147.) As a result, huge swathes of Soviet territory were lost in the first days of the war.

Napoleon once remarked that war was the most complex of equations. This was most certainly the case with the Second World War. In the end, the war was reduced to a titanic struggle between Hitler's Germany, with the entire resources of Europe at its disposal, and Stalin's Russia. The Americans and British hoped that, in this fight, both Germany and the Soviet Union would mutually exhaust themselves, allowing the Allies to intervene at the last moment and mop up. But the planned economy of the USSR – in spite of its bureaucratic deformations – showed its superiority in practice, allowing for a rapid restructuring of the economy for the needs of war. This allowed the

Vyacheslav Molotov, Soviet foreign minister, signs the Nazi-Soviet Non-Aggression Treaty in the Kremlin, Moscow on 23 August 1939. Stalin, Nazi foreign minister von Ribbentrop and others look on contentedly

Red Army to drive back the Germans, starting with the battle of Stalingrad in 1943. Eventually, the Red Army drove the German army all the way back to Berlin, to the horror of the Allies, who were forced to immediately launch the Second Front. Failure to have done so would have meant the Red Army could have met them on the Channel.

At this time, the British government published a confidential document in 1943, to aid top officials and civil servants who were being sent to Germany. It confirmed the role of German big business in supporting the Nazis and how Hitler's policies were benefiting them:

> Fritz Thyssen and Kirdorf in the Ruhr, and Ernst von Borsig in Berlin, chairman of the German Employers' Federation (*Vereinigung Deutscher Arbeitgeberverbände*), were the extreme supporters of Hitler. Among other financial supporters of earlier Hitler days were the famous piano manufacturers, Karl Bechstein (Berlin), the printer Bruckmann (Munich), the well-known art dealer and publisher, Hanfstaengl (Munich), and the Reemtsma Cigarette combine in Hamburg which, after Hitler came to power was granted an exclusive monopoly.

> But it was not only during the big crisis preceding the Nazi government that financial support by great industrial corporations began on a larger scale...

> At the meeting of the Düsseldorf Club of industrialists on 27 January 1932, after Hitler had enlightened them about his programme, the pact between heavy industry and the Nazi party was sealed. Here Hitler convinced his audience that they had nothing to fear from his 'socialism', and then he commended himself with his semi-military organisation as the bulwark against any kind of 'Bolshevism'.

> The economic policy carried on by the 'National-Socialists' nevertheless completely justified the confidence which the big industrialists had placed in Hitler. Hitler has in every other respect carried out their policy. He has destroyed the workers' organisations. He has introduced the 'leadership principle' in the factories. He has brought about an expansion of heavy industry in western Germany by means of an immense rearmament programme and has brought the firms enormous profits. The profits which the manufacturers of the Ruhr and Rhineland were able to make are clearly shown in the so-called 'Decree' regarding the surrender of 'dividends' of 1941. (Dividend en abgabeverordnung). This Decree, which like so many Nazi Decrees, means the opposite of what its name indicates, enabled the joint stock companies to realise profits which they had accumulated during 1933-38 and which had not been paid out in dividends by way of so-called 'rectification'. About 5,000,000,000 Rms. of accumulated profits, which

had been made in the pre-war years were distributed to the shareholders in the form of bonus shares. (Quoted in T. Grant, *The Menace of Fascism*, pp. 28-29.)

GENERAL'S PLOT

Despite all this, Hitler was a law unto himself and was not fully under the control of the very class whose interests he defended. Although he saved German capitalism from the real threat of Bolshevism, he later went on to threaten the interests of the capitalists with the way he conducted the war, and therefore needed to be reined in, otherwise everything would be lost.

In the hands of the Nazi bureaucracy, the state apparatus became independent of its class base. Hitler became increasingly consumed with his own self-importance, and pursued policies which ultimately rebounded on the German capitalist class. He was interested in pursuing his own vision of a thousand-year Reich, which did not coincide with the interests of the bourgeoisie. In the words of Lord Acton, the nineteenth century British politician, "power corrupts; absolute power corrupts absolutely". As time went on, Hitler became mentally unbalanced. Cushioned by his henchmen, he gradually lost touch with reality. He became mad in the same way that Stalin had become mentally unbalanced.

The German bourgeoisie attempted to regain control by ousting Hitler in the 'General's Plot' of 1944. But they failed. This allowed Hitler to pursue his reckless adventures to the very end. But with Germany in sight of losing the war, and the Red Army rapidly advancing towards Berlin, Hitler's blind refusal to come to a 'deal' with the allied Anglo-American powers resulted in the collapse of the Third Reich, victory of the Red Army and the loss of half of Germany to the camp of Stalinism.

Whereas the ruling class was able to restore the situation in Italy by replacing Mussolini with Marshal Badoglio in 1943, in Germany, a similar attempt failed. Fascism proved a costly experiment for the bourgeoisie in which they lost control of everything. The capitalists internationally learned a painful lesson from that experience, which they would not be keen to repeat.

It was also no accident that the rise of fascist barbarism in Germany was mirrored in the USSR by the consolidation of Stalinist totalitarianism, the Purge Trials and the murder of all the old Bolsheviks. Both phenomena were products of an extreme delay in the world revolution, in particular of the defeat of the German revolution.

FOURTH INTERNATIONAL

As an instrument of revolution and world socialism, the Third International, founded in 1919, was now dead. This was confirmed by Stalin himself when in 1943 he officially dissolved the International. Paradoxically, in the 1930s, a political ferment arose, not within the Communist Parties, but within the ranks of the Social Democracy internationally, resulting in the formation of centrist currents. It was towards these fresh layers that Trotsky urged his followers to turn, where they could get a ready audience for their ideas. In the five years that followed on from the 1933 defeat in Germany, despite all the setbacks on an international scale, Trotsky worked to establish a new international, the Fourth International. This was finally established at a Founding World Congress in Paris in September 1938. The 'Fourth' was heralded as the 'World Party of Socialist Revolution', and based upon the documents of the first five years of the Communist International.

The decision was taken to found the International largely on the basis of the prognosis of world revolution as a result of the coming world war. Trotsky explained in the *Manifesto on the Imperialist War and the Proletarian Revolution*:

> The Fourth International has already arisen out of great events: the greatest defeats of the proletariat in history. Although comprising small forces internationally, it looked to the future with confidence and determination. Above all, it was strong in terms of doctrine, programme, tradition, and in the tempering of its cadres. It adopted a Transitional Programme on which it aimed to develop a mass revolutionary current internationally.

> In the last twenty years, it is true, the proletariat has suffered one defeat after another, each graver than the preceding one, became disillusioned with its old parties and met the war undoubtedly in depressed spirits. One should not, however, overestimate the stability or durability of such moods. Events created them, events will dispel them. (L. Trotsky, *Writings 1939-1940*, p. 217.)

FUTURE PROSPECTS

Following Trotsky's death, however, the leaders of the Fourth International failed to understand the change in the international situation. The perspective in 1938 was correct, but the prognosis was falsified by the complexity and multiplicity of historical factors – above all, the outcome of the war and the role of Stalinism and Social Democracy. Stalinism emerged from the war enormously strengthened due to its advances into Eastern Europe,

which allowed the Stalinists to create the illusion that they were spreading 'international revolution'.

The leaders of the International failed to learn from the method of Trotsky and succumbed to the pressures of the epoch of reaction, namely the upswing of capitalism and the strengthening of Stalinism on the one hand and the strengthening of reformism on the other. The Fourth International therefore suffered a political degeneration and split into different sects.

The International, however, is first and foremost a *programme, policy, tradition and method*, while the organisation is the means of carrying these through. The great ideas elaborated by Trotsky at that time, and the tradition that he established, still remain today in the writings of Marx, Engels, Lenin and Trotsky. As with the Third International, built in the tumultuous events following the First World War, so a new revolutionary International will be forged in the storms and class battles of the period that lies ahead.

We are marking the centenary of the November Revolution of 1918. One hundred years on, we must reflect on past experiences, learn from them and also act, as Marx urged us to do. In drawing comparisons between then and now, it is also essential to have a sense of proportion, unlike those who cry 'fascism' at every rightward turn or shift of events. They remind one of the little boy who cried wolf too often. In the end, he met a sorry end when the wolf actually appeared and gobbled him up. This was precisely the mistake of the Communist Party, which declared different regimes 'fascist' after 1923, ten years before Hitler had come to power.

Something similar is present today within the left when fascism is seen everywhere, from Trump in the United States to Salvini in Italy. This merely reveals the total lack of any sense of proportion or understanding of what fascism really is. Despite the growth of some right-wing parties in the recent period, primarily due to a lack of a revolutionary alternative, there is no prospect of mass fascist reaction on the lines of the 1930s. The reason for that is to be found in the disappearance of the petty-bourgeois layers that Hitler and Mussolini leaned on, and also in the thinking of the capitalist class who are not willing to hand all power over the crazed fascist elements of today. Many of yesterday's fascists have sought electoral 'respectability', transforming themselves into right-wing reactionary conservative parties without the trappings of genuine mass fascist forces. The fascists of today are reduced to playing an auxiliary role at the service of the capitalist class. That does not mean that where such far-right or neo-fascist groups appear that they should be ignored. Far from it. The labour movement must mobilise its members to drive such groups off the streets.

Inevitably, with this deep crisis of capitalism, there will be sharp swings of opinion to the left and to the right. However, the working class is far from defeated and the crisis will furnish many revolutionary opportunities for the left. This will intensify in the coming period. The peasantry, which formed the main social base of reaction, comprised forty per cent of the population in many countries in the pre-war period. Today, however, it is less than two per cent. Moreover, with a completely different international balance of forces, the basis for extreme reaction has been weakened. Its reserves have been undermined everywhere. The middle classes have largely become 'proletarianised' with many white-collar workers becoming drawn into the trade unions. The students, who were a bastion of reaction in the past, have now become radicalised and have moved to the left. The proletariat is the crushing majority of the population.

The bourgeoisie also, having burnt their fingers in Germany and Italy, if faced with a choice, now prefer the instrument of military-police dictatorship to fascism. We see this in such regimes, as in Chile under Pinochet, which attempted to ape the methods of fascism, while lacking its mass base. The military officer caste is considered far more trustworthy by the capitalist class because, unlike the plebeian fascist gangs, they have far greater ties and links with the ruling class, and therefore are far more under their control.

Nevertheless, the ruling class would hesitate a thousand times before thinking of handing over power to the military or any mad dogs. In modern day conditions, with the proletariat being so preponderant in society, this would mean civil war. Given the balance of forces, they would be unsure whether they could win. That is why today the bourgeoisie is looking not to Bonapartism as a solution, but they prefer to lean as far as possible on the labour and trade union leaders to do their dirty work, in much the same way that they leaned on Ebert, Scheidemann and Noske in the early days of the crisis.

The present crisis – ushered in by the slump of 2008-9 – represents a fundamental turning point and is preparing revolutionary convulsions in Europe and on a world scale. The barriers to social progress still remain the private ownership of the means of production and the nation state. The present crisis of capitalism is preparing the conditions for a period similar to 1918-1923. Especially with the beginnings of trade war, the outlines of a new economic crisis and a likely Depression are already visible, but it will be a crisis on a far higher level than before. However, given the weakness of the bourgeoisie, and its inability to immediately move towards imposing social order, alongside the strength of the proletariat, the process will be protracted,

unfolding over a longer historical period compared to what we saw in the 1920s and 1930s.

A Marxist analysis of the period of revolution and counter-revolution in Germany in the 1920s and 1930s will serve the new generation very well for the storms that lie ahead. Theory is the generalised historical experience of the working class, and therein lies its great importance. The present new generation of workers and youth must learn the lessons of Germany between 1918 and 1933, through the years of heroic revolution and bitter counter-revolution, in order to arm themselves for the titanic events that will unfold in the coming period. The older generation is largely exhausted, ground between the heavy millstones of Stalinism and the ideological counter-offensive of the bourgeoisie. It is for the youth, especially the young workers, to pick up the banner of Revolutionary Marxism.

The present profound instability worldwide is but a prelude to a deeper revolutionary crisis. In this epoch of capitalist decline, the ruling class will be compelled to place democracy on the scales, weighing up its advantages against its drawbacks. The choice now as then will be between Socialism or Barbarism, to quote the famous words of Rosa Luxemburg.

The same task that faced Luxemburg and Liebknecht still faces us today, namely the need to build a strong revolutionary tendency. To begin with, it is necessary to win the advanced layers of workers and youth and arm them with a Marxist programme. On that basis, we can construct a fighting leadership that is capable of mobilising the colossal power of the working class to put an end to this system of exploitation of man by man, and put an end to the bankrupt system that spawned the monstrous fascist regimes of the inter-war period.

We leave the concluding remarks to Rosa Luxemburg speaking at the Founding Congress of the German Communist Party. They are as relevant today as when they were first pronounced:

> The ninth of November was an attempt, a weakly, half-hearted, half-conscious, and chaotic attempt, to overthrow the existing public authority and to put an end to ownership rule. What is now incumbent upon us is that we should deliberately concentrate all the forces of the proletariat for an attack upon the very foundations of capitalist society... It is well, I think, that we should be perfectly clear as to all the difficulties and complications in the way of revolution. For I hope that, as in my own case, so in yours also, the description of the difficulties we have to encounter, of the augmenting tasks we have to undertake, will neither abate zeal nor paralyse energy. Far from it, the greater the task, the more fervently will you gather up your forces. Nor must we forget the revolution is able to do its work with extraordinary speed.

I shall make no attempt to foretell how much time will be required. Who among us cares about the time, so long only as our lives suffice to bring it to pass? Enough for us to know clearly the work we have to do; and to the best of my ability I have endeavoured to sketch, in broad outline, the work that lies before us. [*Tumultuous applause.*] (R. Luxemburg, *Rosa Luxemburg Speaks*, p. 427.)

APPENDIX ONE: HITLER'S BRITISH CONNECTIONS

Important sections of the British establishment in the 1930s gave support to Hitler and the fascists. They believed that Britain could benefit from such a dictator as Hitler or Mussolini. On 3 February 1933, *The Times* of London, which had itself dabbled in anti-Semitism, wrote of Hitler, "No one doubts Herr Hitler's sincerity. That nearly 12 million Germans follow him blindly says much for his personal magnetism."

Montagu Norman, the then-Governor of the Bank of England, was certainly pro-fascist and hated Jews. On 30 September, 1933, the financial editor of the *Daily Herald* wrote an article exposing "Mr. Montagu Norman's decision to give the Nazis the backing of the Bank." Norman had made loans to the Hitler regime shortly after it took office in January 1933. According to his biographer John Hargrave, "It is quite certain that Norman did all he could to assist Hitlerism to gain and maintain political power, operating on the financial plane from his stronghold in Threadneedle Street." The money given to the Nazis was not directly from the Bank but through financial arrangements for the fascists from other sources, such as from the Schroder Bank of London. (Quoted in J. Pool and S. Pool, p. 311.)

> Before Rosenberg [a leading Nazi] left England he saw Lord Beaverbrook, the owner of the *Daily Express, the Sunday Express,* and the *Evening Standard.* The British press would play a very important role in helping the Nazis to obtain money. (ibid., p. 312.)

Beaverbrook described Rosenberg as "a strong anti-Semite, [and] is Hitler's representative".

Even more obliging than Beaverbrook was Viscount Rothermere, the owner of the *Daily Mail*. He gave the Nazis pages of praise in his newspaper. There is some evidence to show that he actually gave financial support to Hitler through Putzi Hanfstaengl, the Nazi's foreign press chief. But the publicity given by the *Mail* was worth far more than the money.

Shortly after Hitler's election success in September 1930, the Viscount went to Munich to have a long discussion with the Führer. When he returned, he wrote an article praising the fascists:

> These young Germans have discovered, as I am glad to note the young men and women of England are discovering, that it is no good trusting the old politicians. Accordingly, they have formed, as I should like to see our British youth form, a Parliamentary party of their own... We can do nothing to check this movement [the Nazis] and I believe it would be a blunder for the British people to take up an attitude of hostility towards it... We must change our conception of Germany... The older generation of Germans were our enemies. Must we make enemies of this younger generation too? If we do, sooner or later another and more terrible awakening is in store for Europe.

> Let us consider well before we lay our course toward that peril. If we examine this transfer of political influence in Germany to the National Socialists we shall find that it has many advantages for the rest of Europe. It sets up an additional rampart against Bolshevism. (*Daily Mail*, 24 September, 1930.)

On 10 July 1933, Rothermere continued:

> I urge all British young men and women to study closely the progress of the Nazi regime in Germany. They must not be misled by the misrepresentations of its opponents. The most spiteful detractors of the Nazis are to be found in precisely the same sections of the British public and press as are most vehement in their praises of the Soviet regime in Russia. They have started a clamorous campaign of denunciation against what they call 'Nazi atrocities' which, as anyone who visits Germany quickly discovers for himself, consists merely of a few isolated acts of violence such as are inevitable among a nation half as big again as ours, but which have been generalised, multiplied and exaggerated to give the impression that Nazi rule is a bloodthirsty tyranny.

On 7 December 1933, Hitler wrote to Rothermere in person:

> I should like to express the appreciation of countless Germans, who regard me as their spokesman, for the wise and beneficial public support which you have given to a policy that we all hope will contribute to the enduring pacification of Europe. Just as we are fanatically determined to defend

ourselves against attack, so do we reject the idea of taking the initiative in bringing about a war. I am convinced that no one who fought in the front trenches during the world war, no matter in what European country, desires another conflict.

In England, Rothermere became a well-known supporter of the British Union of Fascists, whose leader was Oswald Mosley and whose members wore fascist Blackshirts. On 8 January 1934, the headline of the *Daily Mail's* front page proclaimed: 'Hurrah for the Blackshirts'.

This was accompanied by a piece on Sir Oswald Mosley's British Union of Fascists that read, in part:

If the Blackshirts movement had any need of justification, the Red Hooligans who savagely and systematically tried to wreck Sir Oswald Mosley's huge and magnificently successful meeting at Olympia last night would have supplied it.

Subsequent articles emphasised the paper's unwavering support, and on 15 January 1934, the BUF was described as:

[A] well-organised party of the right ready to take over responsibility for national affairs with the same directness of purpose and energy of method as Hitler and Mussolini have displayed.

This parallels the *Mail's* similar enthusiasm for Fascist parties elsewhere in Europe, especially Adolf Hitler's burgeoning Nazi movement: "The sturdy young Nazis are Europe's guardians against the Communist danger".

The newspaper stated that Italy and Germany were "beyond all doubt the best governed nations in Europe today." More of this fascist propaganda filled the pages of the *Mail*, which claimed Hitler had saved Germany from "Israelites of international attachments" and the "minor misdeeds of individual Nazis will be submerged by the immense benefits that the new regime is already bestowing on Germany." (Quoted in J. Pool and S. Pool, p. 316.) Later, Hitler expressed his gratitude for the *Daily Mail's* "great assistance" for its pro-Nazi stance.

JANUARY CLUB

Apart from the open members of the British Union of Fascists, a powerful club composed of members of the ruling class was formed to back the Blackshirts. In a pamphlet entitled 'Who Backs Mosley' published by *Labour Research*, some enlightening facts were revealed:

On New Year's Day 1934 was formed the January Club, whose object is to form a solid Blackshirt front. The chairman Sir John Squire, editor of the

London Mercury said that it was not a fascist organisation but admitted that "the members who belonged to all political parties were for the most part in sympathy with the fascist movement". (*The Times*, 22 March, 1934) The January Club held its dinners at the Savoy and the Hotel Splendide. The *Tatler* shows pictures of the club assemblies, distinguished by evening dress, wines, flowers and a general air of luxury. The leader is enjoying himself among his own class...

The members of this club were:

- Colonel Lord Middleton: A director of the Yorkshire Insurance Co, Malton Investment Trust, British Coal Refining Processes Ltd, and three other companies. He owned about 15,000 acres of land and minerals in Nottinghamshire.

- General Sir Hubert de la Poer Gough, GCMG, KCB, KCVO: Commander of the Fifth Army 1916-18 and Chief of the Allied Mission to the Baltic, 1919 (Russian intervention), now director of Siemens Bros, Caxton Electric Development Ltd, Enfield Rolling Mills, and two other companies.

- Air Commodore Chamier, CB, CMG, OBE, DSO: Late Indian Army. Now aviation consultant and agent to, and lately director of, Vickers Aviation Ltd.

- Vincent Vickers: Director of the London Assurance Corporation and a large shareholder in Vickers Ltd.

- Lord Lloyd: Former Governor of Bombay.

- The Earl of Glasgow: Privy Councillor, brother-in-law to Sir Thomas Inskip, the Attorney General, who was responsible for the Sedition Bill in the House of Commons. The Earl owns Kelburn Castle, Ayrshire, and about 2500 acres.

- Major Nathan: Liberal MP for NE Bethnal Green. A member of the Jewish Agency under the mandate for Palestine. Chairman of the Anglo-Chinese Finance and Trade Corporation.

- Ward Price: Special correspondent to the *Daily Mail* and director of Associated Newspapers and *British Movietone News*.

- Wing Commander Sir Louis Grieg, KBE, CBO, RAF: Partner in J. and H. Scrimgeour, stockbrokers, director of Handley Page Ltd, and an insurance company and Gentleman Usher in Ordinary to the King.

- Lady Ravendale: Baroness, sister-in-law to Mosley and granddaughter to Levi Leiter.

- Count and Countess Paul Munster.
- Major Metcalfe, MVO, MC: Brother-in-law of Lady Cynthia Mosley and Lady Ravendale, late aide-de-camp to the Prince of Wales and the Commander in Chief in India.
- Sir Philip Magnus: Bart, a leading Conservative.
- Sir Charles Petrie.
- Hon. J.F. Rennell Rodd: Heir to Baron Rennell, and a partner in Morgan, Grenfell & Co.
- Ralph D Blumenfeld: Chairman of the *Daily Express*, formerly editor. He was once editor of the *Daily Mail*. He is the founder of the Anti-Socialist Union and a member of its Executive Committee. (Quoted in T. Grant, *The Menace of Fascism*, pp. 5-7.)

In the early days of the fascist movement, Mosley was enthusiastically backed by a number of prominent capitalist and military figures. True, later, when Mosley became discredited and it was clear that the movement was not timely, many of them dropped away or fell into the background.

This reflected the pro-fascist tendencies within the British ruling class before the war, who greatly admired Hitler as well as Mussolini. However, with the outbreak of war, they quickly exchanged their Blackshirts for more patriotic British colours. In turn, their fascism was rapidly shelved and they became ardent 'defenders of democracy'.

Hitler and Mussolini had other admirers. Lloyd George, the 'Liberal', described Hitler as a "bulwark" against Bolshevism. Churchill, speaking in Rome on 20 January 1927 only had praise for the fascists:

I could not help being charmed, like so many other people have been, by Signor Mussolini's gentle and simple bearing and by his calm, detached poise in spite of so many burdens and dangers. If I had been an Italian I am sure that I should have been wholeheartedly with you from the start to finish in your triumphant struggle against the bestial appetites and passions of Leninism. I will, however, say a word on an international aspect of fascism. Externally, your movement has rendered service to the whole world... Italy has shown that there is a way of fighting the subversive forces which can rally the masses of the people... She has provided the necessary antidote to the Russian poison. (ibid., p. 9.)

In regard to Hitler, he was just as flattering.

As early as February 1934, the British government published a memorandum which allowed for an immediate increase in all German armaments. "The German claim to equality of rights in the matter of

arms cannot be resisted and ought not to be resisted. You will have to face rearmament of Germany," declared the British Foreign Secretary, Sir John Simon, on 6 February, 1934. Export to Germany of unwrought nickel, cotton waste, the basis for gun cotton, aircraft and tanks rose tremendously. When asked in March 1934, if Vickers Ltd were engaged in rearming Hitler's Germany, the company chairman replied:

> I cannot give you an assurance in definite terms, but I can tell you that nothing is being done without complete sanction and approval of our own government. (H. Owen in *War is Terribly Profitable*, quoted in T. Grant, *The Menace of Fascism*, p. 10.)

Ted Grant explained:

> The big financiers and bankers openly advocated a policy of support and assistance for the Hitler regime. A short time after he came to power, the Governor of the Bank of England declared that loans to Hitler were justified as "an investment against Bolshevism".

Therefore, large loans were given freely to Hitler.

> His occupation of the Rhineland, the rearmament of Germany, the *Anschluss* with Austria, the seizure of Czechoslovakia – all were supported by the representatives of British capitalism. The reason: they feared a Nazi collapse and what might replace it. Just before the war, the British government, through R.S. Hudson, the then-Secretary of the Department of Overseas Trade, made an offer of a loan of a thousand million pounds to assist the Nazis and prevent them from expanding their influence at the expense of British imperialism, while at the same time maintaining a bastion against Communism, the German workers and the working class throughout Europe. (ibid., p. 10.)

In the 1930s, Winston Churchill looked upon the Nazis with unbounded approval. In the 1939 edition of *Great Contemporaries*, Churchill wrote about Hitler's rise to power in glowing terms:

> The story of that struggle cannot be read without admiration for the courage, the perseverance, the vital force which enabled him to challenge, defy, conciliate, or overcome, all authorities or resistance which barred his path. I have always said that if Great Britain were defeated in war, I hoped we should find a Hitler to lead us back to our rightful position among the nations. (Quoted in ibid., p. 11.)

Lord Beaverbrook, writing in the *Daily Express* on 31 October, 1938 said:

We certainly credit Hitler with honesty and sincerity. We believe in his purpose stated over and over again, to seek an accommodation with us, and we accept to the full the implications of the Munich document. (ibid., p. 11.)

Later, these views, of course, did not prevent Beaverbrook from holding ministerial office in the Coalition government in the 'war against fascism'.

The *Daily Mail* and *Evening News*, were both flunkeys of Hitler and Mussolini before the war. At the beginning of the 1930s, the then-Viscount Rothermere (Harold Harmsworth) owned the *Mail* and the *Mirror*.

In January 1934, Rothermere wrote – under his own byline – articles that appeared in both the *Mail* and the *Mirror*. While the *Daily Mail* had as its headline 'Hurrah for the Blackshirts', the *Daily Mirror* had the headline 'Give the Blackshirts a helping hand'.

Within the year, he had removed his support for Mosley's party, the British Union of Fascists, though he remained a staunch admirer of both Hitler and Mussolini. Indeed, he met and corresponded with Hitler, even congratulating him on his annexation of Czechoslovakia. So, we can therefore be under no illusion that Rothermere the First was a supporter of the Nazis.

ROYAL FAMILY

The British monarchy were also supportive of Hitler, especially King Edward VIII, who later became the Duke of Windsor. In April 1936, the King sent Hitler a telegram wishing him "happiness and welfare" for his forty-seventh birthday.

The Duke spoke at a meeting in Leipzig in the autumn of 1937, as Hitler's honoured guest. This representative of the House of Windsor told his audience:

> I have travelled the world and my upbringing has made me familiar with the great achievements of mankind, but that which I have seen in Germany, I had hitherto believed to be impossible. It cannot be grasped, and is a miracle; one can only begin to understand it when one realises that behind it all is one man and one will, Adolf Hitler. (Quoted in J. Pool and S. Pool, p. 318.)

During the twelve-day visit, Germany was bedecked with alternating Union Flags and swastikas, and Wallis accepted curtsies from high and low-born alike. She was even referred to as "Her Royal Highness", a title King George VI had pointedly denied her.

The former King gave a Nazi salute when he met Hitler and other leaders. He later confirmed he did salute Hitler during their private fifty-

minute conversation at his mountain retreat at Berchtesgaden, but insisted "it was a soldier's salute".

Recently, a telegram was discovered which had been sent from British intelligence to Alexander Cadogan, the Under-Secretary at the Foreign Office. It was found at the National Archives and reveals the close links between Hitler and the Duke and Duchess of Windsor, who were to be made King and Queen and head a government after a fascist victory in Britain.

C/4653
London
7 July, 1940

Dear Cadogan,

A new source, on trial, whom we know to be in close touch with Neurath's entourage in Prague, has reported as follows:

Germans expect assistance from Duke and Duchess of Windsor, latter desiring at any price to become Queen. Germans have been negotiating with her since June 27th. Status quo in England except undertaking to form anti-Russian alliance. *Germans propose to form Opposition Government under Duke of Windsor having first changed public opinion by propaganda.* Germans think King George will abdicate during attack on London.

Yours,
(Reported in BBC documentary on the 'House of Windsor', January 2017, emphasis added.)

Apparently, the strategy was formulated three years after the Duke and Duchess of Windsor visited Nazi Germany as guests of Adolf Hitler at Berchtesgaden – a visit which proved a little embarrassing to Edward's brother King George VI. According to *The New York Times*, documentations "confirm Hitler's view that the Duke of Windsor was an advocate of the Nazi cause and could be of future use." (*The New York Times*, 10 February, 1991.)

In July 1933, Prince Edward told former Kaiser Wilhelm II's grandson, Prince Louis Ferdinand, that it was "no business of ours to interfere in Germany's internal affairs either re Jews or re anything else."

Churchill personally urged the leaders of France and the United States to block publication of the captured German telegrams after the war. When the telegrams finally came to light in 1957, the Duke of Windsor denounced their contents as "complete fabrications... and gross distortions of truth." The British conservative government, meanwhile, supported the Duke of Windsor, stating that "he never wavered in his loyalty to the British cause."

The problem was Windsor regarded the 'British cause' as very much as the 'fascist cause'.

Edward VIII wasn't the only son of King George V to conspire with the Nazis leaders to create a World War Two Anglo-German alliance. Prince George, the Duke of Kent and uncle to Queen Elizabeth II, played a key part in planning a coup d'état with Hitler's deputy, Hess, to remove Prime Minister Winston Churchill and forge a treaty with the Führer. Some of the Windsors' Nazi-supporting German relatives were involved. For a period, one was a welcome visitor to Buckingham Palace. Former British Prince Carl Eduard (Charles Edward), the Duke of Coburg, also known as 'Charlie Coburg', was Queen Victoria's grandson, first cousin to King George V and confidant to the Duke of Windsor.

Coburg was employed by the Führer as a go-between for the German government to exploit the Royal Family's pro-German and pro-fascist leanings. *The Times*, via *The Weekend Australian*, reports that Coburg wrote in his diary of often visiting the royals at Buckingham and Sandringham Palaces.

But it's almost impossible, says Dr Karina Urbach, senior research fellow at the Institute of Historical Research at the School of Advanced Study at the University of London, that Coburg didn't have a deep understanding of the gas chambers and the plans for the extermination of the Jews. In fact, Coburg's cousin, Prince Josias Waldek-Pyrmont, was a high-ranking member of the SS and supervised one of the death camps in Buchenwald. The two men also shared a villa in Berlin where other SS officers constantly frequented.

An interesting piece of film footage came to light recently from the Royal archive, unbeknown to the Royal Family. There has been much debate about its context, but twenty seconds of footage obtained by *The Sun* newspaper, released in 2015 and thought to be shot in 1933 or 1934, appears to show Queen Elizabeth II, as a young girl, delightfully performing the Nazi salute before the camera, as coached by her Nazi sympathising uncle Edward. The Queen Mother is also pictured making the fascist salute. Yet, at this time, in 1933 or 1934, a network of concentration camps had already been established in Germany where political prisoners were being held, tortured and murdered.

Urbach writes that:

The video is pretty shocking. She was a child when this film was shot, long before the atrocities of the Nazis became widely known. But Edward was already welcoming the regime as Prince of Wales in 1933 and remained pro-Nazi after war broke out in 1939.

He could well be teaching the Queen and Princess Margaret how to do the salute. The film involves our monarch and is an important historical document that asks serious questions of the Royal Family.

We know that after '45 there was a big clean-up operation. The royals were very worried about correspondence resurfacing and so it was destroyed.

Churchill employed a top-secret team called 'the weeders', sent to Berlin to find and conceal anything that documented the Duke's relationships with Hitler and Nazi officials, to protect the Royal Family's reputation. For the next twelve years after the war, Winston Churchill, post-war Prime Minister Clement Attlee, American President Eisenhower and others in the political elite attempted to destroy or cover up the damning Windsor dossier.

However, a microfilm has come to light recently revealing the close relations between the Nazi regime and the Duke of Windsor. The Duke twice secretly contacted the Nazis via a Spanish diplomat, asking first if they would protect his two rented houses in Paris and Cannes and their contents. The captured microfilm revealed the potentially explosive negotiations – the Germans agreed to his request. Even the ambassador brother of Spanish dictator Franco was shocked by Edward's behaviour. "A prince does not ask favours of his country's enemies. To request the handing over of things he could replace or dispense with is not correct." (*Mail on Sunday*, 28 February, 2015.)

Moreover, the couple's defeatist attitude in private conversations greatly concerned the British ambassador. "The Duke believed that Great Britain faced a catastrophic military defeat which could only be avoided through a peace settlement with Germany," observed historian Michael Bloch.

The Duke even stunned the American journalist Fulton Oestler by saying in an interview during the war, when he had been appointed Governor of the Bahamas: "It would be a tragic thing for the world if Hitler was overthrown, Hitler is the right and logical leader of the German people. Hitler is a very great man."

Members of the Royal Family's fascist sympathies are well known. The fact that a future king of England, Edward, was flirting with the Nazis and the Blackshirts is public record.

Other connections have been buried deep. However, the sisters of Prince Philip were, indeed, married to German noblemen who were members of the Nazi party and the German army. When his sister Cecile died in a 1937 plane crash, Philip, then sixteen years old, was photographed marching in a funeral procession with men wearing Nazi uniforms. Another of Philip's sisters was

said to have had lunch with Hitler, hardly an informal chat over champagne and oysters.

Prince Philip has admitted that during those years there was "a lot of enthusiasm for the Nazis at the time, the economy was good, we were anti-communist and who knew what was going to happen to the regime?" and that in his sphere there were "inhibitions about the Jews" and "jealousy of their success."

The Royal connection is only one part of the British establishment's links with the fascist movement; others involve high-flying bankers, businessmen and politicians. They very much admired Hitler and Mussolini and thought the experiment could be tried in Britain. To underline the point, "Dictators are very popular these days," noted the Duke of Windsor. "We might want one in England before long."

APPENDIX TWO: THE CASE OF BÉLA KUN

On the eve of the Third Congress of the Communist International, 17 June 1921, Lenin addressed the International Executive Committee. At this meeting, Lenin defended Trotsky and sharply criticised Béla Kun and his ultra-left supporters. This is the session that Victor Serge referred to.[1] This speech was suppressed by Stalin because it was a strong defence of Trotsky, but was published in 1932. (See L. Trotsky, 'A Suppressed Speech of Lenin', *Writings 1932*, pp. 307-309.) The present translation is based on an uncorrected archival record by John Riddell, who has edited the documents of the Third International. It is certainly well worth quoting in its entirety:

> I arrived at just the right moment, during the speech by Béla Kun. I came here precisely in order to oppose the remarks by Béla Kun. I suspected that if Béla Kun opened his mouth, it could only be to defend the leftists, and so I wanted to find out on whose behalf he would speak. In Comrade Béla Kun's opinion, communism means defending the leftists. He is wrong, and this error must be most energetically opposed.

> It must be stated openly that if there are still opportunists in the French party (and I am convinced that this is true) if they are not Marxists (and that is quite accurate), the leftists, for their part, have also committed an error, in trying to appear as leftists in the mould of my friend Comrade Béla Kun and some of the French comrades. Comrade Béla Kun thinks that there are only opportunist errors, but leftist errors exist as well.

> According to the stenographic record of Comrade Trotsky's remarks, he said that if the leftist comrades continue to act in this manner, they will

1 See 'Lines Drawn' in Chapter 4.

be digging the grave of the communist and workers' movement in France. (Applause) I am strongly convinced of that as well. I have come here in order to protest the speech by Comrade Béla Kun in which he attacked Comrade Trotsky instead of defending him, as he was obligated to do if he was a real Marxist.

Marxism consists of determining what policy should be adopted in different types of circumstances. However, when Comrade Béla Kun comes here and talks of sangfroid and discipline, and of what was said about that in an article in *L'Humanité* with that title, it is he who understands nothing and is clearly in error. During a crisis such as that created by the mobilisation of French troops in the Ruhr, a party cannot launch slogans of that type. Anyone who does not understand that is not a Marxist.

Comrade Béla Kun believes that being revolutionary is a matter of defending the leftists, everywhere and under all circumstances. Preparing the revolution in France, one of the largest countries in Europe, cannot be done by a party on its own. What gives me the greatest pleasure is the fact that the French Communists have won over the trade unions. When I pick up this or that French newspaper – and I must frankly admit that I do this only rarely, because I do not have time to read newspapers – I notice the word 'cell' (noyau). I don't think you will find this word in any dictionary, because it is a purely Russian expression, which emerged from our long struggle against tsarism, against the Mensheviks, against opportunism and the bourgeois-democratic republic. It is our experience that gave rise to this organisational form. Cells act in concerted fashion, whether in the parliamentary fraction, in the trade unions, or in other organisations. And when communists commit this or that error, even if less serious than the blunder committed by Béla Kun, we do not give it our approval.

When I regard this outstanding work by the French party, these cells in the unions and other organisations, I must say that the victory of revolution in France is assured, provided that the leftists do not commit blunders. If people say, like Comrade Béla Kun, that sangfroid and discipline cannot be justified, that is a leftist blunder. And I have come here to tell the leftist comrades that if you follow that advice, you will dig the grave of the revolutionary movement, just as Marat[2] did. I am not trying to defend the Communist Party of France. I do not claim that it is a thoroughly communist party. Not at all. Comrade Zalewski quotes a passage from *L'Humanité*, saying that the

2 It seems that the reference to Marat is a slip either by Lenin or the stenographer. Lenin looked very favourably on the Jacobins of 1793 and had a high regard for Marat. It is possible the comment was supposed to be in reference to Robespierre.

demand is justified; it may well be that he is quite right, from his point of view. But we must not tolerate such a view.

Let us take another example, that of Marcel Cachin and others who defended the foreign policy of the Franco-British alliance in the French legislature and said it was a guarantee of peace, when in fact this alliance is nothing more than a gang of robbers. That is opportunism, and a party that tolerates its parliamentary representative taking such a political position is not a communist party. We have certainly referred in our resolution to various facts that must be emphasised, and to various actions that cannot be tolerated and are not communist. But criticism must be specific in character. The task is to condemn opportunism. But the pronounced opportunism expressed in Cachin's speech has not been criticised. Instead, criticism has been directed at this formulation and new advice has been proposed. Comrade Trotsky said the following in his speech: (Lenin then quotes a passage from the German stenographic transcript of Comrade Trotsky's speech.)

In addition, Comrade Laporte is quite wrong and Comrade Trotsky absolutely right in protesting against this statement. I am prepared to concede that the conduct of the French party is perhaps not fully communist. But in that given situation, a blunder of this type would destroy the communist movement in France and Britain. The revolution cannot be carried out by the class of 1919. And Comrade Trotsky was a thousand times right to emphasise this repeatedly. The same holds true for the Luxembourg comrade [Reiland] who charged the French party with having failed to sabotage the occupation of Luxembourg. He thinks this is a geographical question, as does Comrade Béla Kun. That's way off the mark. It is a political question. And Comrade Trotsky was absolutely right to protest against this. Yes indeed, it is an entirely leftist blunder, in which you appear to be very revolutionary, but which is in fact very harmful for the French movement.

The only thing that can prevent the victory of communism in France, Britain, and Germany is leftist blunders of this sort. If we pursue our campaign against opportunism without exaggeration, our victory is certain. We should openly criticise the French party. We should say that they are not a communist party. We should say bluntly that the policy advanced by Marcel Cachin regarding the alliance of France and Britain to exploit the working masses – and here, if I may use a word in an unofficial sense, they are robbers, and not only that, but robbers on a huge scale – we should state emphatically and entirely openly that the policy advanced by Cachin in this or that speech, in this or that article is not communist but opportunist. The Central Committee of the Communist Party and, I hope, the Communist International congress as well will not approve this policy. Nonetheless we

will not tolerate the even greater blunders committed by Comrade Béla Kun, or the blunders in the speech by the comrade from Luxembourg, or those of Comrade Laporte – even though he speaks so eloquently. I know that there are true revolutionaries among the communist youth. Criticise the opportunists in a specific fashion; demonstrate the errors of official French communism – but do not commit such blunders!

Now, as the masses are approaching you more and more closely and as you are advancing toward victory, you must win over the trade unions. Preparations are under way in outstanding fashion to win a majority in the unions. And when you win them over, it will be an enormous victory. The bourgeois bureaucracy is powerless. It is the bureaucratic leaders of the Two-and-a-Half International that have the upper hand in the unions. Our task is to win a firm Marxist majority and then we will begin to make the revolution. But not with the class of 1919 and similar blunders, in which Béla Kun excels, but through the struggle against opportunism, and against the leftist blunders now coming to light.

Perhaps, in that case, there will be no need for a struggle, but only a warning against Marcel Cachin's speech. An open struggle against traditions and opportunism, but only a warning against leftist blunders. That is why I have considered it my duty to support Comrade Trotsky's position, by and large. The position advanced by Comrade Béla Kun is not worthy to be expressed by any Marxist, by any communist comrade. It must be actively opposed. And I hope, comrades, that after the commission proposed here has done its work (and setting it up is a sensible move), and after an investigation of the French party's conduct, it will come to a conclusion that does justice to this idea. (J. Riddell [ed.], *To the Masses*, pp. 1,128-1,132.)

This speech showed clearly the closest affinity between Lenin and Trotsky, and was the reason for its suppression by Stalin.

GLOSSARY

ORGANISATIONS

ADGB (Allgemeiner Deutsche Gewerkschaftsbund, General German Trade Union Confederation): The main reformist trade union federation linked to the SPD.

Black Freikorps: Secret detachments trained by the Freikorps.

Centre Party: A catholic party based in the south of Germany.

COMINTERN: See 'The Third (Communist) International'.

Democratic Party: A bourgeois liberal party.

DNVP (Deutschnationale Volkspartei, German National People's Party): A party of big business, which was founded in 1918 from remains of the National Liberal Party. Before the rise of the Nazi Party, it was the major conservative and nationalist party in Weimar Germany.

DVP (Deutsche Volkspartei, German People's Party): A national liberal party in Weimar Germany, which moved to the extreme right after WW1.

DVFP (Deutschvölkische Freiheitspartei, German Völkisch Freedom Party): A National Socialist and anti-Jewish political party of Weimar Germany. It took its name from the Völkisch movement, a populist movement focused on folklore and the German Volk. It dissolved in 1924.

Freikorps: Right-wing mercenary gangs, which were linked to the military. Set up by the old army command and paid by the government War Ministry,

they were used by Noske to crush the 1919 Revolution. They murdered Rosa Luxemburg and Karl Liebknecht and Hitler took the Swastika from their insignia, and the SS took the Death's Head.

Gestapo: The secret police of the Third Reich.

KAPD (Kommunistische Arbeiter-Partei Deutschlands, Communist Workers' Party of Germany): An ultra-left group who were expelled from the KPD in 1919. They formed a party in April 1920 but eventually disappeared. The policies of some of its leaders were criticised by Lenin in *Left-Wing Communism: An Infantile Disorder.*

KPD (Kommunistische Partei Deutschlands, Communist Party of Germany): Formed in December 1918, mainly from the Spartacist League, it was led by Karl Liebknecht and Rosa Luxemburg. It merged with the Left Independents in December 1920 to form the United Communist Party (VKPD), but it dropped 'United' from the name soon afterward.

Left Opposition: Formed by Trotsky in 1923 to fight the growing bureaucracy in Russia, they were expelled from the Communist Party in late 1927. The International Left Opposition (ILO) was formed in 1930, bringing together the co-thinkers of Trotsky in a number of countries.

Left Radicals: Based in Bremen, they merged with Spartacist league in 1918 to form KPD.

National Party: A reactionary party based on landowning interests.

NSDAP (Nationalsozialistische Deutsche Arbeiterpartei, National Socialist German Workers' Party): The German fascist party, which was also abbreviated as 'Nazi Party'. Formed in February 1920 on the basis of a twenty-five-point programme drawn up by Hitler, out of the pro-war German Workers' Party.

Profintern (Red International of Labour Unions): Formed by the Comintern in 1923, it was an international body established by the Communist International with the aim of co-ordinating communist activities within trade unions. However, it met with little success and quietly disappeared in the late 1920s or early 1930s.

Proletarian Hundreds: Workers' self-defence organisations set up in 1923.

Red League of Front Fighters (Roter Frontkämpferbund, RFB): A paramilitary organisation under the leadership of the Communist Party of Germany during the Weimar Republic. It was banned in 1929.

Reichsbanner: The paramilitary wing of the SPD. It was set up in 1924, with over 1 million members by 1925. They could have provided a powerful force against Nazism, but the cowardice of the SPD leadership left them impotent.

Reichstag: German parliament.

Reichswehr: The regular army of Weimar Germany, made up of old units and the Freikorps, it later became the Wehrmacht.

Revolutionäre Obleute (Revolutionary Stewards): An organisation of German shop stewards during the First World War, which opposed the war and acted independently of official trade unions and the SPD.

SA (Sturmabteilung, Stormtroopers): Often referred to as the 'Brownshirts', this paramilitary force was set up in 1921 by Hitler. However, they became a threat to Hitler himself when they demanded a second, or 'social', revolution to follow the 'national' one. Thus, the leadership of the SA were liquidated by Hitler on 30 June 1934 in the 'Night of the Long Knives'. After this, the SA ceased to be an independent force.

SAP (Sozialistische Arbeiterpartei Deutschlands, Socialist Workers' Party of Germany): A centrist political party, which arose out of a left split from the SPD in 1931. It briefly collaborated with the International Left Opposition, but after 1933, it moved to the right. Those members who survived the war eventually re-joined the SPD.

Second International (or Labour and Socialist International): Was organised in 1889 as a successor to the First International (International Workingmen's Association) established by Marx and Engels in 1864. In 1914, almost all its national sections supported their own imperialist governments, and it fell apart during the war. It was revived as a completely reformist organisation in 1923.

Spartacus League (Spartakusbund): Named after the leader of the most famous slave rebellion against Rome, it grew from a revolutionary tendency in the SPD in 1914 opposed to the war. With members that included Rosa Luxemburg, Clara Zetkin, Franz Mehring, and Leo Jogiches, they left the SPD, joining the USPD in 1917, and forming the Spartacus League as a

public faction of the USPD in November 1918. They split from the USPD and formed the KPD in December 1918.

SPD (Sozialdemokratische Partei Deutschlands, Social Democratic Party of Germany): Often referred to as Social Democrats or, after 1917, as Majority Social Democrats, the Party was originally formed in 1875. It emerged out of a fusion between two socialist groups, one based around Ferdinand Lassalle and the other around August Bebel and Wilhelm Liebknecht, which was known as the Eisenach Party. It was seen as the leading Marxist party in the Second International, with over 1 million members in 1914. However, it became Marxist in words, but reformist in deeds.

SS (Schutzstaffel): Also known as the Blackshirts, this organisation was originally set up as a personal bodyguard for Hitler. However, it was reorganised in 1929, later controlling the Gestapo and the concentration camps, through its Death's Head units.

Third (Communist) International (Comintern): This body was organised under Lenin's leadership as the revolutionary successor to the Second International. Founded in March 1919, its first four congresses developed the genuine ideas of Bolshevism, but from the Fifth Congress in 1924, until its dissolution in 1943, Stalin's machine was in control.

USPD (Unabhängige Sozialdemokratische Partei Deutschlands, Independent Social Democratic Party of Germany): Also known as 'Independents', this Party was formed in April 1917 by the opposition expelled from the SPD. It participated in the provisional government of November-December 1918. In 1917, it had 120,000 members and, in 1919, it had 750,000. In 1920, the majority joined the KPD. The minority re-joined the SPD in 1922, although some joined the SAP in 1931.

Zentrale (Central): The day to day leading body of the KPD.

PAPERS

Die Neue Zeit (The New Times): The SPD theoretical journal from 1883 to 1923.

Die Freiheit (Freedom): The daily newspaper of the USPD, which was published between 1918 and 1922 as well as between 1928 and 1931. Rudolf Hilferding acted as the paper's editor.

Die Rote Fahne (The Red Flag): The paper of the Spartacus League and then the KPD.

Vorwärts (Forward): Founded in 1876, it was the central organ of the SPD for many decades.

INDIVIDUALS

Prince Max von Baden (1867-1929): Replaced Kaiser Wilhelm II as German Chancellor for two months in 1918, overseeing the end of the war and the establishment of the Weimar Republic.

Otto Bauer (1881-1938): The leader of so-called 'Austro-Marxism', who played a leading role in the Social Democratic Party of Austria, becoming its leader in 1918. Exiled from Austria to France after the failed uprising of 1934.

Eduard Bernstein (1850-1932): A member of the SPD, he was the first theorist of reformism within the Second International. He opposed the war from a pacifist standpoint, but was opposed to revolution. He was one of the founders of the USPD in 1917, but re-joined the SPD in 1920.

Otto von Bismark (1815-1898): The first Chancellor of the German Empire between 1871 and 1890. He oversaw the unification of German states into a national entity.

Martin Bormann (1900-1945): Joined the Nazi Party in 1927 and the SS in 1937. Initially Hitler's personal secretary, he was later given the title of Head of Parteikanzlei (Party Chancellory). He disappeared after Hitler's death and his remains were discovered in 1972 in Berlin, which confirmed that he had been killed as he tried to escape the city.

Heinrich Brandler (1881-1967): A member of the SPD from 1901, he later became a leading member of the Spartacists. He was also chairman of the KPD between 1921-24, where he stood on the right of the party. Expelled from the KPD in 1929 as a supporter of Bukharin, he then organised his own group, the KPO.

Heinrich Brüning (1885-1970): A member of the Centre Party, he became Chancellor from 1930-32. He fled Germany in 1934 and moved to the US.

Nikolai Bukharin (1888-1938): A member of the Bolshevik Central Committee. Having moved to the right, he became general secretary of

the EC of the Comintern (1926-29), but was expelled by Stalin from the Politburo in 1929. He was executed after the show trials of 1938.

Engelbert Dollfuss (1892-1934): A reactionary who became Chancellor of Austria in 1932. He dissolved parliament and ruled by decree from 1933 onwards, promoting so-called 'Austro-fascism'. He was assassinated by agents of Hitler in 1934.

Hugo Eberlein (1887-1944): Joined the SPD in 1906 and opposed the war in 1914. He was a member of the Spartacus League and KPD central committees. A delegate to the First Congress of the Third International, he played a leading role in the Comintern as a supporter of Brandler. He was exiled to the USSR after 1933, where he was arrested by the GPU during the Moscow purge trials. He was supposed to have been handed over to Hitler by Stalin in 1940, but died in prison.

Friedrich Ebert (1871-1925): An SPD leader who collaborated with Bebel. He supported a chauvinist position during the war and was Imperial Chancellor in 1918. Between November 1918 and December 1919, he was chairman of the Council of People's Representatives. He worked with the army to crush January rising and was President of Germany between 1919 and 1925.

Emil Eichhorn (1863-1925): An ex-glassworker, he worked for the SPD from 1893, heading the press bureau between 1908 and 1917. Between 1917 and 1920, he was a member of the USPD. His dismissal as chief of Berlin police – he had taken over control in 1918 – provoked the January uprising. He joined the KPD in 1920, and died in 1925.

Kurt Eisner (1867-1919): The editor of *Vorwärts* between 1900 and 1906. At first, he supported the war, but then moved into a pacifist opposition. He founded the Munich USPD and was imprisoned in January 1918. However, he led the November 1918 Revolution in Bavaria, and was made Prime Minister. Ultimately, he was assassinated by the monarchist Anton Graf von Arco auf Valley in February 1919.

Ruth Fischer (1895-1961): Joined the Austrian Social Democrats aged nineteen and was one of the first members of the Austrian Communist Party in 1918. After moving to Berlin, she led the ultra-left opposition. She was head of the KPD between 1924 and 1925, but was expelled in 1926, when she formed the Leninbund. She later became an anti-communist.

Paul Frölich (1894-1953): Joined the SPD aged eighteen and was on the extreme left of party. He supported Lenin's position at the Kienthal conference in 1916 and was elected to the KPD Central Committee at its founding congress. In 1928, he was expelled from the KPD as a 'rightist', and he joined Brandler's KPO (the right opposition Communist Party Opposition), then the centrist SAP (Socialist Workers' Party). After nine months in a concentration camp in 1933, he went into exile. He returned to West Germany and re-joined the SPD in 1950.

Joseph Goebbels (1897-1945): A leading Nazi and the Minister of Propaganda during the Third Reich. He killed himself in 1945.

Hermann Göring (1893-1946): An early member of Nazi Party, he later served as Minister Without Portfolio in the Third Reich, establishing the Gestapo. He was became the commander in chief of the Luftwaffe before being given the title of Reichsmarschall. After the war, he was tried at Nuremberg, but committed suicide before the sentence of death could be carried out.

Hugo Haase (1863-1919): An SPD member of the Reichstag in 1897 and co-chair of the party between 1911 and 1916. Whilst he opposed voting for war credits in 1914, he ended up voting for them under the discipline of the parliamentary group and, in 1916, he voted against the war credits. He was co-chair of the USPD 1917 and a member of the Council of People's Representatives between November and December 1918. He was assassinated by a monarchist in 1919.

Rudolf Hess (1894-1987): Deputy Führer to Adolf Hitler, but, in 1941, he secretly flew to Scotland to negotiate a peace deal despite having no authority to do so. Interned by the Allies, he was tried after the war and remained in prison until his death in 1987.

Paul von Hindenburg (1847-1934): Chief of the German Army during WW1 and effectively ran the state with Ludendorff during last period of the conflict. Elected President in 1925 and 1932, he appointed Hitler as Chancellor in 1933.

Adolf Hitler (1889-1945): The leader of the NSDAP (Nazi Party) and, later, dictator (Führer und Reichskanzler) of the Third Reich. He committed suicide in 1945.

Rudolf Hilferding (1877-1944): An Austrian-born politician and chief theoretician for the Social Democratic Party of Germany during the Weimar Republic, he was widely recognised as the SPD's foremost theoretician. He joined the SPD in 1922, became minister of finance in 1923 and again in 1928-30. He died in a Nazi prison in 1944.

Heinrich Himmler (1900-1945): He joined the Nazi Party in 1923 and later became leader of the SS and Head of Police. Given overall responsibility for the establishment of the death camps and the implementation of the Holocaust, he was arrested by the Allies in 1945, but killed himself before he could be tried.

Oskar Hippe (1900-1990): A Trotskyist and author of *And Red is the Colour of our Flag*. An active participant in all the key struggles of post-war Germany, he was imprisoned by both the Nazis and later by the East German Stalinist regime.

Max Hölz (1889-1933): An ex-metalworker, he joined the USPD 1918 and the KPD in 1919. He organised armed guerrilla action against the Kapp Putsch and was sentenced to life imprisonment for organising fighting in central Germany during the March Action. He was released in 1928, went to Moscow and died in an accident in 1933.

Jean Jaurès (1859-1914): A socialist who became leader of the French Socialist Party in 1902. He was assassinated in 1914 having opposed the war.

Leo Jogiches (1867-1919): Active in the revolutionary movement from an early age, he was a close collaborator of Rosa Luxemburg. One of the founders of the Polish revolutionary Social Democracy, and active in the 1905 Polish Revolution. He escaped to Germany in 1907 and became an organiser of the Spartacus group during the war. A member of the KPD central committee, he opposed the January 1919 uprising, and was arrested and murdered by the Freikorps in March 1919.

Lev Kamenev (1883-1936): A leading member of the Bolshevik Politburo in 1917, he was executed in 1936 after the first show trial.

Wolfgang Kapp (1858-1922): Founder of the extreme right-wing German Fatherland Party in 1917 and led the 1920 putsch attempt to re-establish a monarchy and military dictatorship.

Karl Kautsky (1854-1938): A collaborator with Engels, he was a founder and editor of *Die Neue Zeit*. He was also regarded as the chief theoretician of Marxism until 1914, when he adopted a pacifist stand, apologising for the Majority. A founder of the USPD and a supporter of the right wing, he opposed socialist revolution in Germany. He re-joined the SPD in 1922.

Béla Kun (1886-1939): Joined the Hungarian Social Democrats aged sixteen and joined Bolsheviks while a prisoner of war in Russia. In 1918, he founded the Hungarian Communist Party and, in March to June 1919, he was head of the Hungarian Soviet government. In exile in Russia, he became a Red Army commissar. A supporter of the ultra-left group, he was sent to Germany in 1921 and inspired the March Action. He worked in the Comintern apparatus until 1937, when he was arrested and killed without trial during the Moscow frame-ups.

Carl Legien (1861-1920): A right-wing SPD parliamentarian and the first chairman of the trade union body, the ADGB.

Theodor Leipart (1867-1947): A trade unionist and leader of the ADGB from 1922 to 1932.

Paul Levi (1883-1930): A member of the SPD from 1906, he was a revolutionary opponent of war and worked with Lenin in Switzerland during the war. He later became a member of the Spartacus League and KPD central committee, and was a central leader after the murder of Leo Jogiches in 1919. He opposed the ultra-left action in 1919 and became President of the VKPD in 1920. However, he resigned in 1921 and was expelled for publicly denouncing the March Action in the same year. In 1922, he joined the USPD, then SPD, where he organised a left opposition until his death.

Eugen Leviné (1883-1919): Took part in the 1905 Russian Revolution as a Social Revolutionary. He joined the SPD, then the USPD, then the Spartacus League during the war. He later became a leader of the KPD. He re-organised the Bavarian Communist Party in 1919 and was the leader of the second Bavarian Council Republic. In 1919, he was executed by the Social Democratic government after the overthrow of the Bavarian Republic

Karl Liebknecht (1871-1919): The son of a founder of the SPD, Wilhelm Liebknecht, he joined the party in 1900. He set up the Socialist Youth International in 1907 and was jailed in the same year for writing *Militarism and Anti-Militarism*. From 1912, he was a deputy in the Reichstag and he became the first member to vote against the war credits in December 1914.

A founding member of the Spartacists, he was jailed in 1916 for anti-war agitation. However, he was amnestied in 1918, and took part in preparations for the November actions. He led the Revolutionary Committee during the Berlin January uprising. A leader of the KPD, he was murdered by the Freikorps in 1919.

Paul Löbe (1875-1927): An SPD parliamentarian who served at various times as President and Vice President, he was arrested several times during the period of the Third Reich and sent to a concentration camp in 1944. After surviving this, he later served in the West German post-war parliament.

Erich Ludendorff (1865-1937): A German general who effectively ran Germany with Hindenburg during the last period of WW1. He represented the German Völkisch Freedom Party in the Reichstag and supported the Kapp Putsch. Under Hitler, he argued for total war.

Hans Luther (1879-1962): A member of the DVP, he was Chancellor from 1925 to 1926. He served as ambassador to the US under Hitler from 1933 to 1937 and, after the war, he became a banker.

Rosa Luxemburg (1871-1919): Joined the movement in Poland in 1887, and became leader of the SDKP (Polish Social Democrats). However, she was exiled in 1889 and joined the SPD in Germany in 1898. From 1903, she was on the Second International bureau. She became a leader of the left wing against the revisionist right and, after 1910, against the Kautskyite group. A leading revolutionary opponent of war, she was one of the founders of the Spartacus group. In prison for most of the war, she became the chief writer for *Die Rote Fahne* from November 1918 to January 1919. As founder and leader of the KPD, she opposed the call for the January rising, although this was not reflected in her articles. Her arrest was ordered by the Social Democratic government for her participation in the uprising and she was brutally murdered by the SPD-instigated Freikorps at the same time as Liebknecht.

Arkadi Maslow (1893-1941): Led the ultra-left trend in the KPD with Fischer from 1921. A leader of the KPD in 1924, he was imprisoned between 1925 and 1926, and expelled from the party in 1926. Afterwards, he co-founded the Leninbund with Fischer.

Franz Mehring (1846-1919): A German Communist who was a senior member of the Social Democratic Party of Germany during the German Revolution in 1918-19. Already in ill health, Mehring was deeply affected by

the death of his comrades Rosa Luxemburg and Karl Liebknecht in January 1919. He died just under two weeks later, on 28 January 1919, in Berlin.

Gustav Noske (1868-1946): A right-wing SPD leader, he was a member of the Council of People's Representatives between 1918 and 1919. Between December 1918 and March 1920, he was Minister of War in Social Democrat governments. He organised the suppression of the January 1919 uprising and resigned after the Kapp Putsch, becoming President of the province of Hanover, until he was dismissed by the Nazis in 1933. He was imprisoned twice by the Nazis: once in 1939 and again after the Generals' Plot.

Hermann Müller (1876-1931): Edited *Vorwärts* from 1916, he became Chancellor in 1920 and again between 1928 and 1930.

Benito Mussolini (1883-1945): The founder of Italian fascism, he was in power between 1922 and 1943. After this, he became leader of the German-controlled stooge state of the Italian Social (or Salò) Republic, based in the North, until he was arrested and executed by Italian partisans whilst trying to flee to Switzerland in 1945.

Franz von Papen (1879-1969): Advised Hindenburg during the Weimar Republic, he served as Chancellor of Germany in 1932 and as Vice-Chancellor under Adolf Hitler in 1933 to 1934. He was also an ambassador, first to Austria and then Turkey. He avoided being found guilty of war crimes at the Nuremberg trials after the war and spent the rest of his life trying unsuccessfully to claim that he had nothing to do with the rise of Hitler.

Karl Radek (1885-1939): Active in the Polish revolutionary movement from the age of eighteen and was involved in the 1905 Polish revolution. In Germany in 1908, he supported the SPD left. A member of the Zimmerwald Left bureau with Lenin in 1915, he joined the Bolsheviks in 1917, who sent him secretly to Germany in 1918. In February 1919 he was arrested and freed in January 1920. He supported the March Action, and supported the calling off of the October 1923 insurrection. He played a leading role on the Executive Committee of the Communist International and later became part of Trotsky's opposition to Stalin, being expelled from the Communist Party in 1927 and deported to Alma Ata. He capitulated in 1929 and became an apologist for Stalin. However, he was arrested in 1937 during the Moscow frame-up trials and died in prison.

Ernst Röhm (1887-1934): After WW1 he joined, first, the DAP and then the NSDAP, taking part in the Beer Hall Putsch of 1923. After plans his

to reform the SA were rejected, he left political life and became an advisor to the Bolivian army. He returned to Germany after 1930 and became SA Chief of Staff. He became part of the Nazi radical faction, which was hostile to capitalism, and demanded merger of armed forces under his control. However, in 1934, he was arrested and executed as part of the 1934 'Night of the Long Knives' purge.

Otto Rühle (1874-1943): Opposed WW1 and was a founder member of the KAPD, but later expelled. He joined the SPD in 1923, but left Germany in 1933 to go to Mexico.

Philipp Scheidemann (1865-1939): A right-wing SPD member in the Reichstag from 1898, he became a central leader of the party after Bebel's death in 1913. In 1914, he led SPD support for war, and became co-chair of the party in 1917. He was appointed Minister Without Portfolio by the Kaiser in October 1918, and declared the republic in November of that year. A member of Ebert's Council of People's Representatives, he presided over the suppression of the 1918-19 Revolution, becoming Chancellor in 1919. He was forced into exile by the Nazis in 1933.

Kurt von Schleicher (1882-1934): A German general who would be the last chancellor of the Weimar Republic, he recommended Hitler as his replacement and was later rewarded by being killed during the 'Night of the Long Knives.'

Victor Serge (1890-1947): A revolutionary and writer who was originally an anarchist, which coloured his politics and writings throughout his life. He travelled to Russia and joined the Bolsheviks in 1919 and later worked for the Comintern. However, when he broke with Stalinism, his writings were suppressed and he suffered periods of imprisonment. Eventually, he escaped to France (where he was also imprisoned) and then to Mexico where he died in 1947.

Otto Strasser (1892-1934): Joined the Nazi Party in 1920 having helped form the Freikorps in 1918, becoming a key party figure in northern Germany. He wanted to see capitalism overthrown under a fascist state, which led to a break with Hitler. In 1934, he was killed as part of the 'Night of the Long Knives' purge.

Gustav Stresemann (1878-1929): A monarchist politician who belonged to several parties during his career, he was Chancellor for 102 days in 1923 and then served as Foreign Minister from 1923 to 1929.

Ernst Thälmann (1886-1944): An SPD member from 1903, he led the USPD Left in Hamburg between 1918 and 1920. He joined the VKPD in 1920 and mobilised the unemployed during the March Action of 1921. He also played an important role during the Hamburg rising of 1923. After the removal of Fischer and Maslow in 1925, he led the KPD. However, he was arrested in March 1933 and executed by the Nazis in 1944 at Buchenwald.

August Thalheimer (1884-1948): Involved with the Spartacists during the war years and later played a key role in the KPD. He was critical of the ultra-left turns and was blamed for the defeat of the 1923 Revolution. Expelled from the KPD in 1929, he helped form the Left Opposition group in Germany. After being interned in France, he was exiled to Cuba.

Otto Wels (1879-1939): A right-wing SPD member. As military commander of Berlin, he was responsible for crushing the left in January to March 1919. He led the opposition to Hitler in the Reichstag in 1933, calling for "lawful, non-violent opposition", and, from 1933 he was exiled in Paris.

Kaiser Wilhelm II (1859-1941): Emperor of Germany from 1888 to 1918, when he abdicated.

Walter Ulbricht (1893-1973): Joined the KPD in 1920, becoming its leader in 1933 after death of Thälmann. He was a murderous arch-stooge of Stalin and survived to later become leader of East Germany.

Hugo Urbahns (1890-1947): First joined the Spartacist League and later the KPD. However, he supported the left of the KPD and was expelled in 1926. He lead the Leninbund, which advocated a united front against Hitler, and he moved to Sweden in 1933.

Jan Valtin (1904-1951): Author of *Out of the Night*, a semi-fictional account of the events in Germany from 1918-23 and the later rise of Hitler, he was also known as Richard Krebs.

Clara Zetkin (1857-1933): Played a key role in the left of the SPD and later in the KPD and in the Communist International. She was a member of the Reichstag and, as the oldest elected member, gave the opening speech of the 1932 session, attacking Hitler.

Grigory Zinoviev (1883-1936): Leading member of the Bolsheviks in 1917, he was later head of the Communist International with particular

responsibility for Germany. However, he was removed from leading positions by Stalin in 1926, and executed after the show trials of 1936.

BIBLIOGRAPHY

A. Adler (ed.), *Theses, Resolutions and Manifestos of the First Four Congresses of the Third International*, London, 1980

H. Afflerbach and D. Stevenson (ed.), *An Improbable War?: The Outbreak of World War One and European Political Culture Before 1914*, New York, 2007

E. Anderson, *Hammer or Anvil*, London, 1945

M. Beaufrere, 'The Trotskyists at Buchenwald', *Fourth International*, New York, 1945

M. Beer, *Fifty Years of International Socialism*, London, 1937

P. Berger, 'Lessons of the 1934 Revolt in Austria: An account of a participant', *Fourth International*, New York, 1944

R. Black, *Stalinism in Britain*, London, 1970

R. Blick, *Fascism in Germany*, London, 1975

R. Brady, *The Spirit and Structure of German Fascism*, London, 1937

J. Braunthal, *History of the International 1914-1943*, 1967
—*In Search of the Millennium*, London, 1945

P. Broué, *The German Revolution 1917-1923*, London, 2006
—'Germany 1921: The March Action', London 1964

A. Bullock, *Hitler: A Study in Tyranny*, London, 1962

E.H. Carr, *The Bolshevik Revolution 1917-1923*, in three volumes, London, 1953

—*The Interregnum 1923-1924*, London, 1954
—*Socialism in One Country 1924-1926*, vol. 2, London, 1970
—*Socialism in One Country 1924-1926*, vol. 3, London, 1964

Communist Party of Great Britain, *The Errors of Trotskyism*, London, 1925

D. De Leon, *Flashlights of the Amsterdam Congress*, New York, 1929

J. Degras (ed.), *The Communist International*, in three volumes, 1919-1943, Documents, London, 1955

I. Deutscher, *The Prophet Armed: Trotsky 1879-1921*, London, 1976
—*The Prophet Unarmed: Trotsky 1921-1929*, London, 1970
—*The Prophet Outcast: Trotsky 1929-1940*, London, 1970
—*Marxism, Wars and Revolutions*, London, 1984

D. Edwards, *On the Eve of Hitler's Victory*, 1974

R. Fischer, *Stalin and German Communism*, London, 1948

B. Fowkes (ed.), *The German Left and the Weimar Republic*, Haymarket, 2015

L. Fraina, *The Social Revolution in Germany*, London, 1977

P. Frölich, *Rosa Luxemburg*, London, 1940
—*Rosa Luxemburg*, Pluto Press (revised translation), 1972

W. Held, 'Why the German Revolution Failed', *Fourth International*, vol. 3, no. 12, December 1942 and vol.4, January 1943

O. Hippe, *And Red is the Colour of Our Flag*, London, 1991

E. Hobsbawm, *Age of Extremes: The Short Twentieth Century 1914-1991*, London, 1994
—*Revolutionaries*, London, 1973

J.M. Keynes, *The Economic Consequences of the Peace*, London, 1919

W.G. Krivitsky, *I Was Stalin's Agent*, London, 1939

N. Krupskaya, *Reminiscences of Lenin*, International Publishers, 1979

T. Grant, 'The Menace of Fascism', 1947, in *The Unbroken Thread*, London 1988
—'The Rise and Fall of the Communist International', London 1985
—*Russia: From Revolution to Counter-Revolution*, London, 2018

—*Writings: Trotskyism and the Second World War 1938-1942*, London
—*Writings: Trotskyism and the Second World War 1943-1945*, London
—*The Unbroken Thread*, London, 1989

D. Guerin, *Fascism and Big Business*, New York, 1973

C. Harman, *The Lost Revolution: Germany 1918 to 1923*, London, 1982

International Press Correspondence, 17 November 1932

C.L.R. James, *World Revolution 1917-1936*, London, 1937

K. Kautsky, 'The Dictatorship of the Proletariat', *National Labour Press*, 1919

G. Kuhn, *All Power to the Councils! A Documentary History of the German Revolution 1918-1919*, 2012

O. Kuusinen, *Prepare for Power: XII Plenum ECCI*, London, 1932

V. Lenin and L. Trotsky, *Lenin's Fight Against Stalinism*, New York, 1975

V. Lenin, *Collected Works*, in forty-five volumes, English Edition, Progress Publishers, Moscow, 1960-1972
—*What is to be Done?*, London, 2018

R. Leviné-Meyer, *Levine: The Life of a Revolutionary*, England, 1972
—*Inside German Communism*, London, 1977

G. Liebmann, *Diplomacy Between the Wars: Five Diplomats and the Shaping of the Modern World*

R.H.B. Lockhart, *The Diaries of Sir Robert Bruce Lockhart 1915-1938*, London, 1973

R. Luxemburg, *Rosa Luxemburg Speaks*, M. Waters (ed.), New York, 1970

D.Z. Manuilsky, *The Communist Parties and the Crisis of Capitalism*, Moscow, 1931

K. Marx and F. Engels, *Collected Works*, in fifty volumes, Moscow 1975-2004
—*Selected Correspondence*, Moscow, 1955

R. Medvedev, *Let History Judge*, London, 1971

N. Milton, *John Maclean*, London, 1973

Münchner Neueste Nachrichten, 21 March 1933. 'The Holocaust History Project'. Archived from the original on 6 May 2013.

J.P. Nettl, *Rosa Luxemburg*, vol. 2, London, 1966

A.R. Oliveira, *A People's History of Germany*, London, 1942

G.G. Preparata, *Conjuring Hitler: How Britain and America Made the Third Reich*, 2005

M. Philips Price, *My Three Revolutions: Russia, Germany, Britain*, London, 1969
—*Dispatches from the Weimar Republic*, London 1999

J. Pool and S. Pool, *Who Financed Hitler*, London, 1980

A. Rabinowitch, *Prelude to Revolution*, Indiana University Press, 1991

A. Read, *The World on Fire: 1919 and the Battle with Bolshevism*, London, 2008

L. Reissner, *Hamburg at the Barricades*, Berlin, 1923

Revolutionary History, 'Germany 1918-1923', vol. 5, no. 2, London, Spring, 1994

Revolutionary History, 'Germany: The Key', vol. 2, no. 3, London, Autumn 1989

Revolutionary History, 'The Comintern and its Critics', vol. 8, no. 1

J. Riddell (ed.), *Founding the Communist International: Proceedings and Documents of the First Congress: March 1919*, New York, 1987
—*The German Revolution and the Debate on Soviet Power: Documents 1918-1919: Preparing the Founding Congress*, New York, 1986
—*Lenin's Struggle for a Revolutionary International: Documents, 1907-1916 The Preparatory Years*, New York, Pathfinder, 1984
—*Workers of the World and Oppressed Peoples, Unite! Proceedings and Documents of the Second Congress: 1920*, two volumes, New York, 1991
—*To the Masses: Proceedings of the Third Congress of the Communist International: 1921*, Leiden, Brill, 2015; Chicago: Haymarket, 2016

A. Rosmer, *Lenin's Moscow*, London, 1971

E. Schneider, 'The Wilhelmshaven Revolt: A Chapter of the Revolutionary Movement in the German Navy 1918-1919,' *Marxists Internet*

Archive, http://www.marxists.org/subject/germany-1918-23/schneider/
wilhelmshaven-revolt.htm

V. Serge, *Year One of the Russian Revolution*, London 1972
—*Memoirs of a Revolutionary 1901-1941*, London 1975
—*From Lenin to Stalin*, New York, 1973

R. Sewell, *Germany: From Revolution to Counter-Revolution*, London, 1988
—*In the Cause of Labour*, London, 2003

W.L. Shirer, *The Rise and Fall of the Third Reich*, England, 1973

B. Souvarine, *Stalin: A Critical Survey of Bolshevism*, London, 1940

J.V. Stalin, *On the Opposition*, Peking, 1974

P. Spriano, *The Occupation of the Factories: Italy 1920*, London, 1975

H. Strachan, *The First World War*, London, 2006

A. Sturmthal, *The Tragedy of European Labour 1918-1939*, London, 1944

S. Taylor, *Germany 1918-1933: Revolution, Counter-Revolution and the Rise
of Hitler*, London, 1983

D. Thomson, *Europe Since Napoleon*, London, 1972

K. Tilak, *Rise and Fall of the Comintern*, Bombay, 1947

A. Tocqueville, *The Ancien Regime and the French Revolution*

L. Trepper, *The Great Game: Memoirs of a Master Spy: The Story of the Red
Orchestra*, London 1977

L. Trotsky, *My Life*, London, 2018
—*Writings (1929-1940)* in twelve volumes, New York, 1975-1979
—*Stalin*, London, 2017
—*The Third International After Lenin*, New York, 1936
—*The Third International After Lenin*, London 2018
—*The Struggle Against Fascism in Germany*, New York, 1972
—*Germany 1931-1932*, New Park, 1970
—*The Bolsheviki and World Peace*, 1918
—*The Case of Leon Trotsky*, New York, 1968
—*The Age of Permanent Revolution: A Trotsky Anthology*, New York, 1964
—*Leon Trotsky Speaks*, New York, 1972
—*The War and the International*, Ceylon, 1971
—*The History of the Russian Revolution*, three volumes, London, 1967

—*The Challenge of the Left Opposition 1923-1925*, New York 1980
—*The Challenge of the Left Opposition 1926-1927*, New York 1980
—*The Challenge of the Left Opposition 1928-1929*, New York 1981
—*Political Profiles*, London 1972
—*The First Five Years of the Communist International*, vol. 1, New York, 1945
—*The First Five Years of the Communist International*, vol. 2, New York, 1953
—*The Crisis of the French Section*, New York, 1977
—*The Stalin School of Falsification*, New York, 1937
—*Trotsky's Notebooks: 1933-1935*, New York, 1986
—'Germany: The key to the international situation', Revolutionary Communist Party edition, December, 1944
—*Tasks before the Twelfth Congress of the Russian Communist Party*, London 1975
—'Europe and America', London, 1971
— 'Terrorism and Communism', London, 1975
—*Diary in Exile*, London, 1958

J. Valtin, *Out of the Night*, London, 1988

G.L. Waite, *Vanguard of Nazism: The Free Corps Movement in Post-War Germany, 1918–1923*, Harvard, 1969

R. Watt, *The Kings Depart*, London, 1969

M. Waldenberg, *Il Papa Rosso Karl Kautsky*, Rome, 1980.

H.M. Wicks, *Eclipse of October*, London, 1958

E. Wollenberg, *The Red Army*, London, 1978

M. Woodhouse and B. Pearce, *Essays on the History of Communism in Britain*, London, 1975

A. Woods and T. Grant, *Lenin and Trotsky: What They Really Stood For*, London 2000

A. Woods, *Bolshevism: The Road to Revolution*, London 2017
—'The Hungarian Soviet Republic of 1919: The Forgotten Revolution', https://www.marxist.com/hungarian-soviet-republic-1919.htm
—'Introduction to Rosa Luxemburg's Reform or Revolution', 2018, https://www.marxist.com/prologue-to-rosa-luxemburgs-reform-or-revolution

C. Wright Mills, *The Marxists*, London, 1969

C. Zetkin, *Reminiscences of Lenin*, Marxists internet archive, https://www.
marxists.org/archive/zetkin/1924/reminiscences-of-lenin.htm

PERIODICALS CONSULTED
Communist International

Daily Worker

Fourth International

International Press Correspondence

Revolutionary History

INDEX

LIST OF TITLES BY
WELLRED BOOKS

Wellred Books is a UK-based international publishing house and bookshop, specialising in works of Marxist theory. A sister publisher and bookseller is based in the USA.

Among the titles published by Wellred Books are:

Anti-Dühring, Friedrich Engels

Bolshevism: The Road to Revolution, Alan Woods

China: From Permanent Revolution to Counter-Revolution, John Roberts

Dialectics of Nature, Frederick Engels

Germany: From Revolution to Counter-Revolution, Rob Sewell

History of British Trotskyism, Ted Grant

In Defence of Marxism, Leon Trotsky

In the Cause of Labour, Rob Sewell

Lenin and Trotsky: What They Really Stood For, Alan Woods and Ted Grant

Lenin, Trotsky and the Theory of the Permanent Revolution, John Roberts

Marxism and Anarchism, Various authors

Marxism and the USA, Alan Woods

My Life, Leon Trotsky

Not Guilty, Dewey Commission Report

Permanent Revolution in Latin America, John Roberts

Reason in Revolt, Alan Woods and Ted Grant

Reformism or Revolution, Alan Woods

Revolution and Counter-Revolution in Spain, Felix Morrow

Russia: From Revolution to Counter-Revolution, Ted Grant

Stalin, Leon Trotsky

Ted Grant: The Permanent Revolutionary, Alan Woods

Ted Grant Writings: Volumes One and Two, Ted Grant

Thawra hatta'l nasr! - Revolution until Victory! Alan Woods and others

The Classics of Marxism: Volume One and Two, by various authors
The History of the Russian Revolution: Volumes One to Three, Leon Trotsky
The History of the Russian Revolution to Brest-Litovsk, Leon Trotsky
The Ideas of Karl Marx, Alan Woods
The Permanent Revolution and Results & Prospects, Leon Trotsky
The Revolution Betrayed, Leon Trotsky
What Is Marxism?, Rob Sewell and Alan Woods
What is to be done?, Vladimir Lenin

To order any of these titles or for more information about Wellred Books, visit wellredbooks.net, email books@wellredbooks.net or write to Wellred Books, PO Box 50525, London E14 6WG, United Kingdom.

Lightning Source UK Ltd.
Milton Keynes UK
UKHW022224201020
371905UK00009BA/517